THE FLINTLOCK
ITS ORIGIN, DEVELOPMENT, AND USE

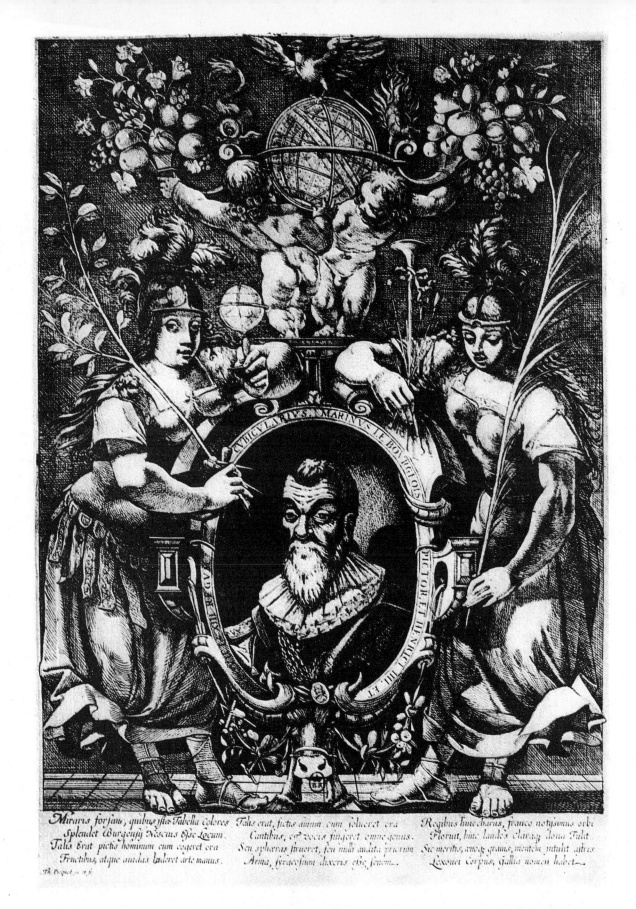

MARIN LE BOURGEOYS

Painter. Inventor. Died 1634.

THE FLINTLOCK
ITS ORIGIN, DEVELOPMENT, AND USE

Torsten Lenk

Translated by G.A. Urquart
Edited by J.F. Hayward

Skyhorse Publishing

www.skyhorsepublishing.com

10 9 8 7 6 5 4 3 2 1

ISBN-10: 1-60239-012-6 (paperback)
ISBN-13: 978-1-60239-012-6 (paperback)

The Library of Congress Cataloging in Publication Data is available on file.

Printed in Canada

List of Contents

Editor's Introduction

Dr Torsten Lenk, the author of this book, was born at Varnum in Sweden on 29 August 1890. He died in Stockholm on 13 December 1957, a few months after his retirement from the office of Director of the Swedish Royal Armoury which he had held since 1944. He joined the Royal Armoury and took up the study of firearms in 1924, and this book was the result of fifteen years of research. It was, in fact, his doctoral thesis; but even by Scandinavian standards, which are exceptionally high in this respect, *The Flintlock* is an altogether masterly work.

Just over a quarter of a century has passed since the first publication of *The Flintlock* in 1939, and since the end of the Second World War an ever increasing spate of books on the history of firearms has been published on both sides of the Atlantic. As a rule the original material contained in a new book is soon exploited by the lesser writers who follow afterwards: as a result what was at the time of publication a highly important new discovery soon becomes a commonplace. This most emphatically does not apply to *The Flintlock* which remains as original and valid a contribution to the history of firearms as it did when first published. There are two reasons for this. First, it was published in Swedish, a language that has been mastered by very few students of firearms outside the Scandinavian countries. In spite of the French résumé that was provided with the Swedish edition, it has been necessary to read Swedish in order to realize the full scope and outstanding scholarship of this work. The second reason is the small quantity of the original edition and the very high price it has always reached in the antiquarian book market. Working as he did in the Swedish Royal Armoury, Dr Lenk had at his disposal one of the major European collections of firearms. He was, moreover, within easy reach of the even larger collection of mainly seventeenth century firearms that had been accumulated by the Counts Wrangel and other Swedish noble families in the castle of Skokloster. Furthermore, in Copenhagen, a day's journey away, was the most comprehensive firearms collection in all Europe, that of the former Kings of Denmark, now distributed between the Arsenal Museum, the castle of Rosenborg and the National Museum. Although he had so much within easy reach, Dr Lenk travelled widely in Europe inspecting

collections of firearms no matter how remote. He spent, in particular, some months in Paris studying the French seventeenth century firearms with which this work is mainly concerned. As the title of the book indicates, Dr Lenk was especially interested in the early period of the flintlock, that of its origin and development. Seventeenth century firearms are dealt with in the greatest detail, while those of the eighteenth century are discussed in more general terms. Of the 134 plates illustrating many hundreds of fine firearms, only twenty-four show eighteenth century pieces. The seventeenth century is, on the other hand, magnificently represented. Practically all the photographs that were used to illustrate the book were taken specially for it; those familiar pieces that have been repeated so often in other books on the subject are conspicuously absent.

Torsten Lenk had a most perceptive eye when he looked at a firearm. No detail of its construction or decoration, no matter how insignificant it might at first appear, escaped his notice. His analysis of the changing forms of each element of the flintlock firearm is extraordinarily precise. It was based on personal examination of hundreds, even thousands, of guns and pistols in all the collections of Europe. Whether it be the top-jaw screw, the cock-screw or the spur on the front of the steel, the evolution of each one of these elements is pursued with untiring precision through each decade of the seventeenth century.

While most of the material in *The Flintlock* will, for the reasons given above, be unfamiliar to those who have read only the French résumé, there are a number of matters in it that are better known. Amongst these are many original discoveries that have been of vital importance to all his followers in the study of firearms. This book introduced to firearms students for the first time such topics as the invention of the true flintlock by Marin le Bourgeois of Lisieux, the extent and variety of the *Cabinet d'Armes* of King Louis XIII of France, the great gift of firearms made by Louis XIV to King Charles XI Gustavus of Sweden, the importance of the English snaphance and the existence of a magnificent example thereof in the National

Museum, Copenhagen, as well as many other novel ideas.

In only one respect has this book become slightly out of date, namely through changes of ownership of pieces illustrated or referred to in it. This is, however, of slight importance as the vast majority of the objects illustrated are in national possession and exempt from the frequent change of ownership that is the fate of those from private collections. Of the museums that are mentioned in this book four no longer possess some or all of the objects referred to as being in their collections. These are the Royal Artillery Museum in the Rotunda, Woolwich, the Dresden Army Museum, the Arsenal Museum (Zeughaus), Berlin, and the Löwenburg, Kassel. The more historic arms from the Rotunda have been transferred to the Victoria and Albert Museum, South Kensington, and to the Armouries of the Tower of London. The contents of the Army Museum at Dresden have been transferred in part to the Historisches Museum, Dresden and in part to the German Army Museum, Potsdam. The Berlin Zeughaus Museum has ceased to exist as such, but part of its collections remain in the same building in Unter den Linden, Berlin, under the name of the Museum of German History (Museum für deutsche Geschichte). This museum suffered considerable losses during and after the Second World War. A part of the Berlin collection has been incorporated in the Polish Army Museum in Warsaw, the remainder is lost. A certain amount was doubtless destroyed; much is believed to have found its way to private collections on the other side of the Atlantic. Another museum that had serious losses as a result of the Second World War is the Löwenburg; the final destination of the missing pieces is not known, but it is probable that they also will eventually be discovered in private collections. In dealing with the text of *The Flintlock* I have given the present location of every piece where known. If unknown I have left the location given by Dr Lenk. Thus a firearm still in Berlin will be given a location and inventory number of the Museum of German History; a firearm now missing from Berlin retains its Zeughaus location and number.

The Flintlock has been translated literally from the original Swedish by Mr G. A. Urquhart. Dr Lenk's style does not fall easily into English. Whereas English prose is distinctly economical in its use of words, Dr Lenk was never sparing with them. In editing this book I have not attempted to do more than to make the meaning clear and to eliminate from the text what in English appears to be superfluous. It has not been possible to achieve anything approaching a literary style. In those few cases in which more recent research has invalidated Dr Lenk's conclusions, I have pointed this out in the editor's notes. Alterations in ownership have been indicated in the same way, though in some cases, in order to avoid repetition, the alteration has been made in the text itself. Dr Lenk printed as an appendix a list of the present whereabouts of firearms bearing the inventory numbers of the *Cabinet d'Armes* of Louis XIII. This has been brought up to date and a few additional numbers added.

The Flintlock was not published as a commercial enterprise; its appearance in so sumptuous a form was made possible by subsidies from various Scandinavian sources. It seems unlikely that the fortunate chance that brought together so gifted an author and such munificent supporters will ever recur. *The Flintlock* is likely long to retain its position as the most splendidly produced and most scholarly work in the whole literature of firearms.

J. F. H.

INTRODUCTION

The Flintlock

To write a manual on the history of hand firearms is a difficult task. Some have tried, but with results of varying merit. Some of the best work has been done by writers who, by giving correct references to original sources, have contributed the primary material essential to research. Their labour has been of more permanent value than that of other research workers.

The rule which is common to all human knowledge, that synthesis must be preceded by analysis, applies also in the history of arms. The science of arms is still in the analytical stage. This is particularly true as regards firearms. Nothing is as yet known of the origin of the matchlock, the wheel-lock and the snaphance lock*. As far as the flintlock is concerned there is evidence pointing to a definite time and, perhaps, a definite person. France and England have both claimed the credit of inventing the percussion lock†. In such circumstances the only sensible course is to divide up the enormous amount of material into groups and to divide these in logical order. One individual interested in arms has quite seriously recommended the study of the function of the weapons as the only point of interest, but I remain unconvinced that by firing a gun one can discover how old it is and where it was

made. This is, however, the essential factor from the viewpoint of the history of civilization. If we can find our way to the right moment in time and space we have arrived at the original source of the arm. We must search there for the remaining data in archives, in literature, and then make comparisons with other pieces of similar origin and period. The ultimate aim is to dovetail the history of arms into the knowledge of human life and activity as a whole. The task is enormous and, if it is to lead to a positive result, calls for the co-operation of many industrious workers. Each and all must make his contribution.

I personally chose the study of the flintlock by chance. I thought of writing about Swedish flintlock weapons some twenty years ago and began to study the literature of the subject. One must know where to begin. The result was discouraging. It was clear that if I were to discover the origin of the Swedish flintlock I should have to find the prototypes myself. This book is the result. That about Swedish flintlocks is still unwritten.

The method I have adopted is the typological one. I have commenced with the definitely authenticated arms I have been able to find and, with these as points of departure, I continued my efforts in much the same way as one stakes

out a road. I have found that the main road is in France and that branch roads lead to various other centres of production. Every nation has added something of its own character to its own manufacture, but the source is always France, either directly or indirectly. I have endeavoured to make this clear in my book. As the subject is international I hope that others as well as my fellow countrymen will derive benefit from this primary arrangement of material which occupies so important a position in the history of arms.

I well realize that the last word has by no means been said on the flintlock. I hope that others will take on the subject after me and further my work. The difficulties are greater now after a great war has destroyed considerable quantities of the research material where it was best preserved: i.e. in those old historical collections which survived together with their relevant archives. In many cases the destruction has placed insurmountable obstacles in the path of research. The removal of ancient arms from the place in which they belong historically is one of these obstacles‡. Collectors with a sense of responsibility can help to surmount this problem by ensuring that documented evidence of provenance accompanies the objects they buy and sell.

In this English edition I have had the opportunity to make minor corrections as regards both text and illustrations. In exceptional cases references have also been made to literature which has appeared since 1939, the year of issue of the Swedish edition.

When wheel-locks and flintlocks are illustrated, I am of the opinion that they should be shown with the pan-cover closing the pan. The wheel-lock dog should be dropped forward on to the pan, while the flintlock cock should stand at half-cock. This is how these locks were designed. This is how contemporary pattern designers wished to see them.

The material presented in this book has been collected from many widely divergent quarters. I owe thanks for valuable assistance to a great number of museum officials, archivists, librarians and owners of arms. They will undoubtedly show indulgence if I cannot mention them all by name. I cannot, however, refrain from emphasizing the ready helpfulness shown to me in the museums and institutions in which I have been privileged to study my subject, among the most important being the Musée de l'Armée, Paris, the Tower and Wallace Collection, London, the Armoury, Windsor Castle, the Historisches Museum and Gewehrgalerie, Dresden, the Staatliches Zeughaus and Staatliche Kunstbibliothek, Berlin, and the Töjhus Museum, Copenhagen. The Metropolitan Museum of Art, New York, and many others have sent me photographs. Baroness Wera von Essen and Baron Rutger von Essen, the present owners of Skokloster (Sweden), have graciously thrown open to me the magnificent armoury of their castle.

A number of the photographs for the illustrations I have taken myself, but the majority of the Livrustkammare and Skokloster arms have been photographed by Mr Nils E. Azelius, photographer to the Livrustkammar, and by Mr Olof Ekberg of the Nordiska Museum, Stockholm. The numerous weapons in Danish hands have been photographed by Mr Sophus Bengtsson of the National Museum, Copenhagen.

TORSTEN LENK
Formerly Director of the Livrustkammare.

Stockholm.

Editor's Notes

* Since Dr Lenk wrote these lines the origin of the wheel-lock has been studied by C. Blair: 'A note on the early history of the wheel-lock', *Journal of the Arms and Armour Society*, Vol. III, p. 221 ff. and by A. Gaibi: 'Appunti sull' origine e sulla evoluzione meccanica degli apparecchi di accensione delle armi da fuoco portatili,' *Armi Antiche*, Anno III, p. 81 and Anno IV, p. 37.

† And, of course, the United States as well, see Lewis Wynant: *Early Percussion Firearms*, London, 1961, Chapter III.

‡ Dr Lenk was probably referring here to the removal of the collections of the East German Museums to Russia immediately after the Second World War. These collections have since been returned to their original resting-places.

CHAPTER ONE

Definition. Terminology. Types of locks, general. Literary references to the snaphance and flintlock

THE TERM flintlock is used in this work to mean a mechanism for igniting firearms by striking a steel or battery (frizzen)* with a flint. The steel and pan-cover are made in one piece, with a sear moving vertically. The tooth of the sear engages in notches cut in a tumbler to set the weapon at half and full-cock. For guidance as to the terms used here Figs. 1 and 2 (pp. 8 and 9) should be consulted. They are taken principally from Enander, *Anvisning till handgevärens kännedom, vård och istandsättände, Bihang* (Guide to the knowledge, care and repair of hand-guns, Appendix)[1]. During the earlier phase of the firearm's existence in Sweden the term 'flint-lock' was used both for snaphance and flint-lock; it was subsequently retained to signify the flintlock alone when the snaphance ceased to be used on military rifles and on guns of the upper classes. Earlier again it would seem that, in naming weapons with locks working on the flint and steel principle, attention was directed to either the construction or the flint. Thus snaphance guns were called during the earlier half of the seventeenth century, 'flint-guns' and

snaphance muskets 'flint muskets'[2]. An inventory of military models preserved in the Norrköping factory in 1688[3] affords much evidence of the expression 'flintlock' meaning snaphance. In the records and documents of the College of War of the 1680s there is further proof of this. The records of the earlier half of the seventeenth century refer to the Spanish 'snaphance locks' which were used in the Swedish army during the last quarter of the seventeenth century. In 1920 Gustav Schroder following tradition used the word flintlock in both senses[5]. In Denmark the term 'flint' was, according to evidence dating from the 1620s[6], also used in the sense of snaphance.

In England Hewitt used the term 'flintlock' for both snaphance and flintlock in 1860[7].

This Swedish term for both snaphance and flintlock has its equivalent in the French word 'fusil'. According to E. Littré[8] 'fusil' primarily means steel as well as tinderbox. Applied to firearms it means both a lock that includes a steel, therefore a snaphance as well as a flint-lock, and, furthermore, the entire weapon, though not a pistol. In the sense of a shot gun,

it is still employed (e.g. German 'Flinte'). The French term for flintlock is 'platine à silex'.

The French gunsmith François Poumerol gives evidence in his *Quatrains au Roy*[9] of 1631 of the word 'fusil' in its double sense of snaphance and flintlock. Its Italian equivalent is 'focile'. Both derive from the popular Latin 'focile', which is translated by Ernst Gamillscheg[10] as 'zum Feuer gehörig'. 'Focile' in its turn originates from the Latin 'focus' meaning a hearth.

For the French writer, Magné de Marolles, whose book *La chasse au fusil* appeared in its first edition in 1788, the term snaphance does not exist, but otherwise he gives the same explanation of the terms 'focile' and 'fusil' as has been given above[11].

Angelucci, in his catalogue of the Royal Armoury in Turin[12] gives an interesting account of the term 'focile'. He rejects the opinion expressed by Demmin in the *Guide des Amateurs d'Armes* that the flintlock, 'le fusil à batterie français à silex' was most probably invented in France about 1640 and is of exclusively French origin. Demmin bases his claim on the occurrence of the term 'fusil' in a French hunting ordinance of 1515. He considers that this term could have been used for firearms ('on doit admettre que le nom de fusil était alors applicable aux arquebuses des anciens systèmes'). Angelucci objects to this, claiming that it only proves that the construction in question was also used in France. He quotes the use of the term in the sense of a gun-lock in the year 1547 in a Florentine ordinance ('archibusi da ruota, da fucile, o vero da pietra, o da acciajuolo') and records its use in the sense of steel in considerably earlier instances. While it has not been possible to prove that the flintlock is an Italian invention, the use of the term to mean a gun-lock is known as far back as the earlier half of the sixteenth century. Both writers are on the verge of the right solution of the problem, as the French and Italian terms 'fusil' and 'focile' can both mean snaphance as well as flintlock and, furthermore, weapons fitted with such.

In early Swedish inventories the French term is used, more or less wrongly spelt.

The use of the Swedish word 'elddon' (tinder-box, lit. fire implement) for fusil/focile indicates that one may expect to see in the oldest spark-producing gun-locks, tinder-boxes attached to, and adapted for them. Thierbach expresses this view in his well-known manual on the historical development of hand-fire-arms. He mentions a mechanically operated tinder-box as the forerunner of the wheel-lock and the common spark-emitting tinder, steel and flint as the forerunner of the snaphance. As to wheel-locks, he quotes a statement regarding the existence of spark-striking tinder-boxes in the Tyrol and Upper Bavaria[13].

J. Alm quotes from Rathgen a reference in the Burgundian accounts of 1432 to the purchase of a tinder-box for kindling the fire for firing shots with firearms[14]. It is not possible to determine at this stage whether this refers to a gun-lock or not.

A more recent contribution on the problem of the origin of ignition mechanisms on hand firearms is an interesting article by Rudolf Cederström[15]. He calls attention to the existence of six tinder-boxes constructed on the principle of the wheel-lock. Although two of them, those in the Armería, Madrid, and in the Livrustkammare are of considerable age—both dating from the middle of the sixteenth century—they cannot be claimed to prove Thierbach's theory. By this date the wheel-lock had already passed through so protracted a development that these tinder-boxes might just as well have been constructed with wheel-locks as their prototype as the reverse.

More relevant are two drawings reproduced by Cederström from the Löffelholtz manuscript of 1505 in the Staatsbibliothek, Berlin (MS. germ. quart. 132). The purpose of this document, however, is to present new inventions, generally beginning with known objects, and the tinder-boxes depicted therein cannot therefore be considered to be common. Judging by the form of the cocks, the constructions on which they were based must, however, have been at a very early stage of their development. These are miniature vices that have been only slightly changed to serve their new purpose. Their resemblance to the original German snaphance which was subsequently adopted in

Sweden and Norway indicates that this must, in fact, be the most primitive of all spark-producing locks (Pl.1:1). The flintlock evolved from other and more developed lock constructions.

Cederström points out that at least one of the known drawings by Leonardo da Vinci in the *Codex Atlanticus,* which have hitherto been accepted as representations of gun-locks, in reality depicts tinder-boxes[16]. Thomas Th. Hoopes has published two hand firearms ('Pistolen oder Kurze Karabiner', Real Armería, Madrid Nos. K 62, K 63) with wheel-locks. These are closely related to Leonardo's tinder-boxes[17]. One of them (No. K 63) has the same spiral mainspring as the wheel-lock tinder-box just mentioned. The other (No. K 62) has the mainspring mounted in the stock, in the manner characteristic of the French wheel-lock, and not on the lock-plate. The lock has also other features which are characteristic of the French wheel-lock. These are mainly found on older specimens, they include the long lock-plate tapering to the rear with a round notch at the end, such as one finds on two guns in Musée de l'Armée, Paris (Inv. Nos. M 66 and M 82)[18], on a pistol, which is probably in the Bordeaux museum[19], on a pair of pistols in the Metropolitan Museum of Art, New York (Inv. Nos. 14.25, 14.33)[20] all dating from the latter half of the sixteenth century, and also on some later French wheel-lock firearms. The Armería's No. K 62 belongs to the French group, and it ranks as the oldest specimen known. The French wheel-locks can thus claim direct connection with the tinder-boxes. In fact they have hitherto hardly been studied and their origin is unknown.

The later specimens can, however, be proved to have been distributed over an area stretching across northern France and Lorraine. St Brieuc, Cherbourg and Abbeville are mentioned as places of firearms manufacture in the inventory of the French Royal *Cabinet d'Armes,* but no firearms from these towns have yet been found. The names of Paris, Vitré and Metz in France and Nancy, Lunéville and Epinal in Lorraine are, however, to be found on existing firearms from this armoury[21]. To these manufacturing centres Rouen[22] can be added. This northerly area of distribution, taken together with certain

German features in the older French guns and pistols, tends to confirm the opinion expressed by some writers, that the wheel-lock in general, irrespective of the place of its manufacture, has a basic German connection and that wheel-locks made in northern Europe, in the Netherlands, in France, on the Iberian Peninsula and in Italy should be regarded as offshoots from this central area of development†.

To find a connection between the older German wheel-locks and the tinder-boxes one must look to the group of wheel-locks with the cock-spring placed around the wheel as a starting-point[23]. No one has yet followed this line of investigation‡. The earliest guns of this type go back to 1532 and the wheel-locks to the 1520s. Starting from these we can gain some instructive ideas concerning other hand firearms with spark-producing locks of different construction.

The history of hand firearms is, on the whole, far from explored, that of the earlier ones least of all. We may, however, assume that at least from the close of the sixteenth century the central distribution area of the wheel-lock was surrounded by border districts in which both wheel-locks and snap-locks were used, the extent to which each occurred varying in a very marked degree. In the mid sixteenth century snaphance types of German origin, as well as German wheel-locks, occur in northern Europe[24]. The snaphance appears here in three variants, a Swedish, a Baltic and a Norwegian. The Swedish variant is also to be found in Norway. Rudolf Cederström has shown that the Swedish variant has the back of the upper jaw dovetailed into the neck of the cock (Pl.1:1). On the Norwegian type the corresponding part of the upper jaw is bent and inserted through a hole in the neck of the cock (Pl.1:4)[25]. On the Baltic variant, however, this end is spread out in the form of a leaf which covers the neck[26]. There is proof that the Swedish variant dates from the middle of the sixteenth century, the Norwegian from the seventeenth century, whereas the Baltic is by all accounts later. The construction with the upper jaw of the cock with a pin passing

through it, is, in fact, found on the 'Mediter-
ranean locks', on the Italian and Spanish types
as well as on their variants in Algiers, in the
Balkans, in Turkey and Russia, and also on
most wheel-locks.

Finally, we have the Netherlands snaphance
(Pl. 2:7) used in the English Channel region,
and its near relation the Scottish (Pl. 3). This
Netherlands lock has its offshoots in Morocco
and in Russia. It is to be found in Italy and
probably also, though only for a short period,
in northern Europe[27]. The true area of distri-
bution of the Netherlands lock, as far as this
can be at present defined, coincides largely with
the flint region of western Europe, just as those
using the northern snaphances found it easy to
obtain flints from the deposits on both sides of
the southern Baltic.

The distribution of wheel-locks referred to
above applies in certain instances, as we have
said, to the sixteenth century, in others round
about 1600. As regards the first period men-
tioned we know from Swedish archive accounts
and from firearms[28] preserved in the Livrust-
kammare that snaphances were manufactured
at the time in Nuremberg and consequently
that the Germans had both wheel and snap-
hance locks. They probably served different
purposes, as was the case in Sweden during the
latter part of the sixteenth and the greater part
of the seventeenth centuries. There is every
reason to suppose that the production of both
constructions in southern Germany about the
middle of the sixteenth century was nothing
new. Just as different types of tinder-boxes
were produced at the time when the Löffelholtz
manuscript was composed, so were different
types of gun-locks made in the course of the
first half of the century. As far as Italy is con-
cerned the ordinance of 2 June 1547, which
mentions 'archibusi da ruota, da fucile, o vero
da pietra, o da acciajuolo' as being in use at the
same time should be noted. It may be that the
wheel-lock and snaphance constructions had
spread from Germany§. Whereas the snap-
hances had become widely adopted in the
border regions they seem to have been aban-
doned fairly soon in Germany.

In Sweden the manufacture of snaphances

appears to have been begun in the middle of
the sixteenth century at the same time as the
immigration of the German gunsmiths[29]. Solér
ascribes to Simon Marcuarte, the son of an
immigrant German (of the same name), the
invention of the most familiar type of Spanish
snaphance (the Miguelet)[30].

Mention should also be made of a snaphance
construction which Alm has found on muskets
in Dresden, Nuremberg, Coburg and Copen-
hagen[31]. It likewise occurs on a three barrelled
pistol in the Musée de l'Armée, Paris (Inv. No.
M 1763), on a gun in Oxford (Pitt-Rivers
Museum, Inv. No. 1139)[32] and on a pistol in
the Tower of London Armouries (Inv. No.
XII:736. Pl. 1:5). The construction is charac-
terized by a sliding pan-cover which is moved
from the pan by an external sear and attached to
the pan by a bolt. This bolt is released by a
projecting arm on the descending cock. The
mainspring is mounted inside the lock and the
sear is of wheel-lock construction. The steel
and pan-cover are separate. The upper jaw of
the cock is secured by a pin which passes
through the lower jaw. Alm reproduces the
musket preserved in the Töjhus Museum,
dated 1572. The Tower of London pistol has
a barrel bearing the Nuremberg mark‖. Lord
Dillon assumes that its lock is an early example
of the German snaphance and points out that
the sear is reminiscent of that of the wheel-
lock[33]. He regards the tumbler as a wheel in
miniature and also shows that the pan-cover of
this construction is common on wheel-locks.
It is very possible that the construction should
be regarded as German, although thorough
research into the problem is required.

This type of lock gives rise to much specula-
tion. It has certain details—the sliding pan-
cover, the sear and the shape of the lock-plate—
in common with the Netherlands lock. The
construction of the cock with the pin holding
its upper jaw passing through the under jaw is
found on the 'Mediterranean locks'. The cock-
screw ring which is usual on the latter is found
on the three barrelled pistol in Paris. A con-
nection may perhaps also be found between the
winged-nut of the Tower of London pistol and
the moveable nut round the head of the jaw-

Plate 1.

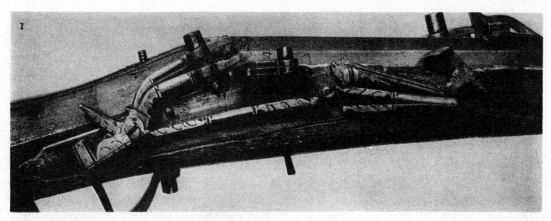

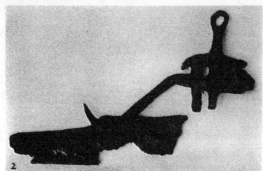
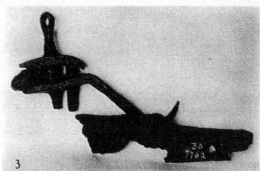

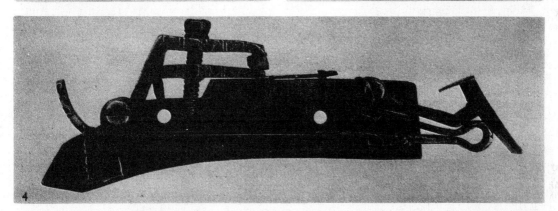

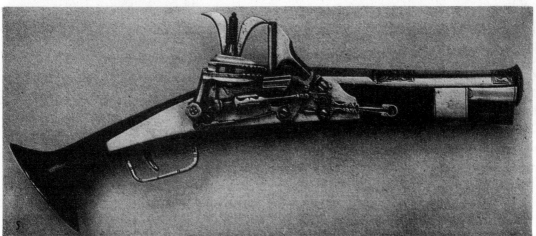

Scandinavia and
Germany.
1500s and 1600s.

1. Snaphance of German type dating from the middle sixteenth century; Stockholm, Livrustkammaren 1208. 2 and 3. Snaphance-lock, defective Netherlands close of sixteenth century (?) Amsterdam, Rijksmusem 30.7762. 4. Norwegian snaphance lock from Telemarken; Stockholm Nordiska Musem 56.592. 5. Snaphance pistol. Nuremburg. Latter half of sixteenth century; London, Tower Armouries XII: 736.

Plate 2.

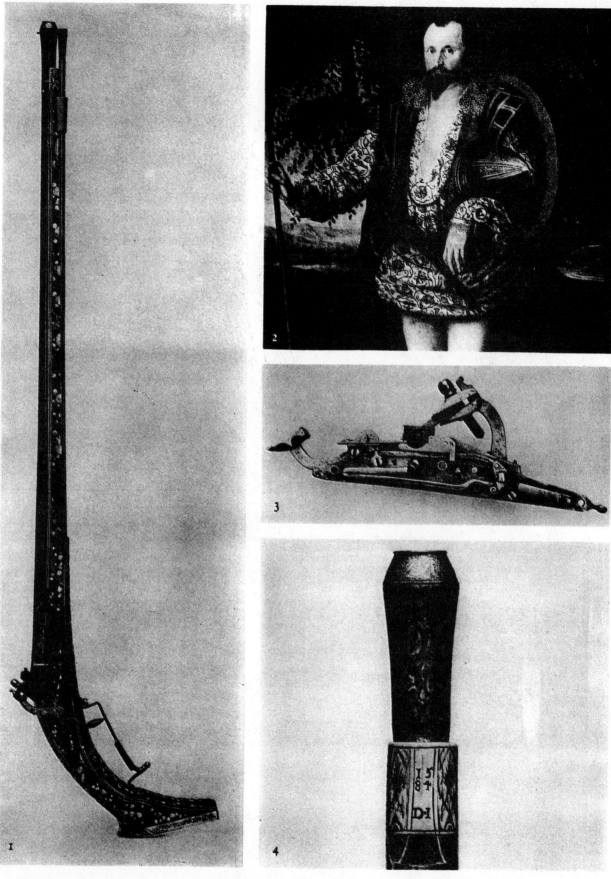

England.
End of sixteenth century.

1, 3 and 4. Petronel. 1584; Copenhagen National Museum, Department II 10.428. 2. Portrait of Captain Thomas Lee, 1601.

Plate 3.

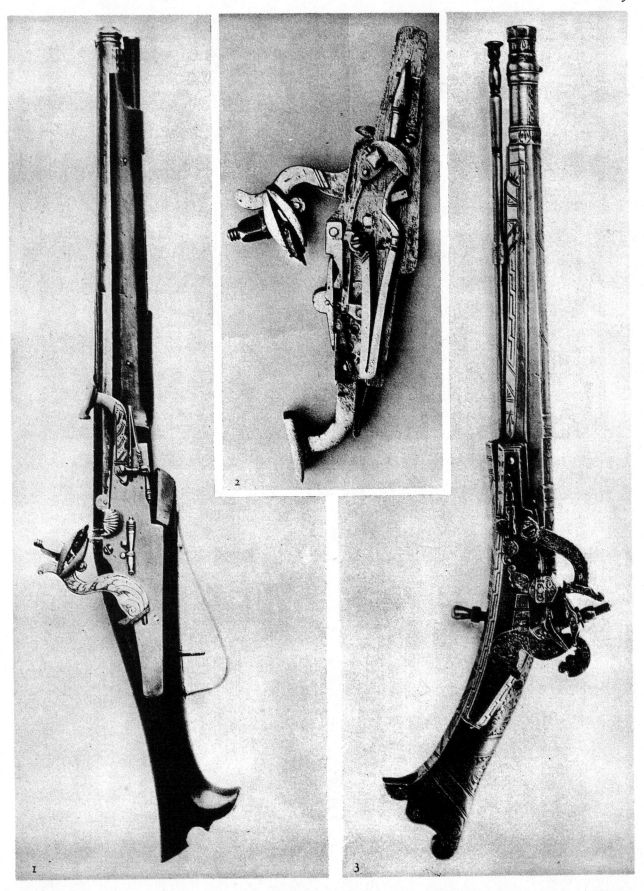

Scotland.
Beginning of seventeenth century.

Scottish snaphance pistols. 1 and 2; Copenhagen, Töjhusmuseet B 345. 3. 1620; Pauilhac Collection, Paris.

Plate 4.

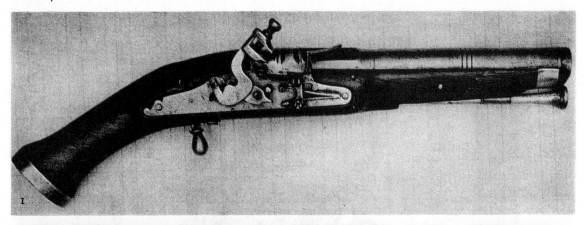

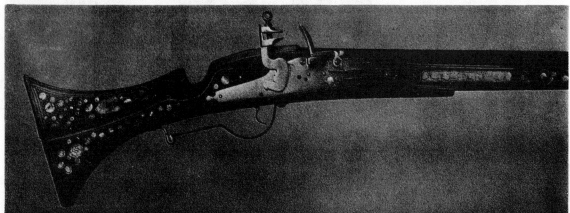

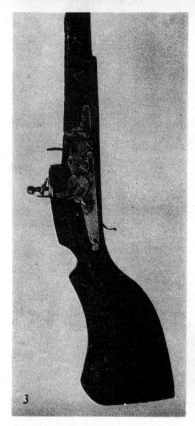

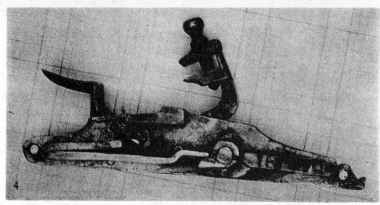

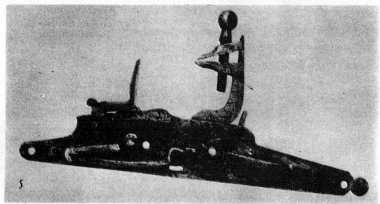

England.
Seventeenth century.

1 and 4. Pistol with dog-lock. 1620–30s; Renwick Collection, Ravenswick (Mass., U.S.A.). 2. Musket with dog-lock. Stock dated 1619, lock later; Windsor Castle 364. 3 and 5. Gun, defective, with dog-lock. Mid seventeenth century; Stockholm, Livrustkammaren 06/1010.

Plate 5.

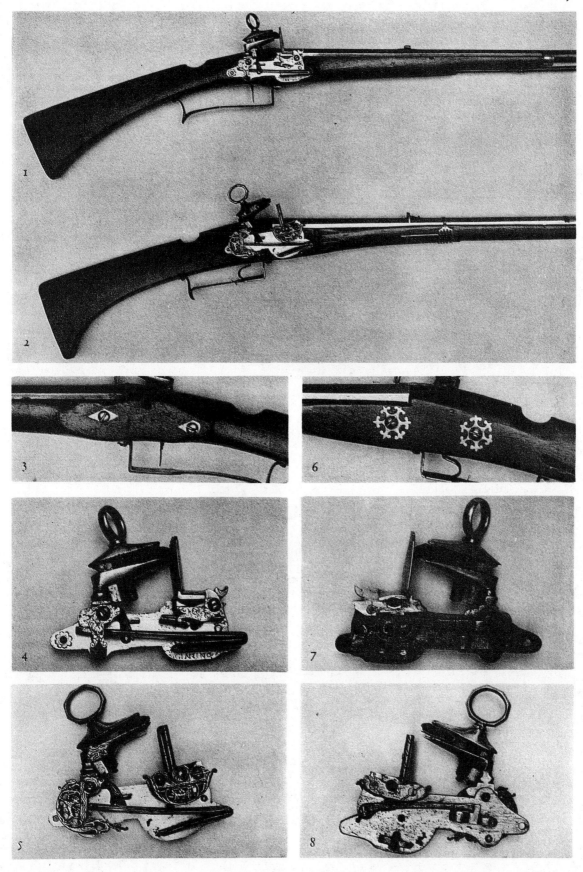

Spain.
Mid seventeenth century

Spanish snaphance guns. 1, 3, 4 and 7, signed 'Gianino'.
2, 5, 6 and 8, signed 'Atienza'; Dresden, Gewehrgalerie
1186 and 1184.

Plate 6.

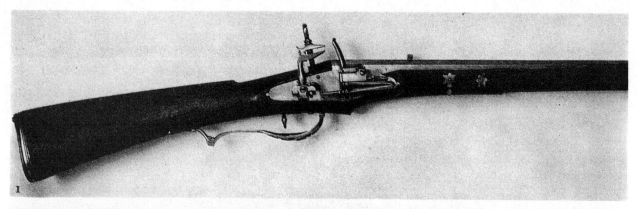

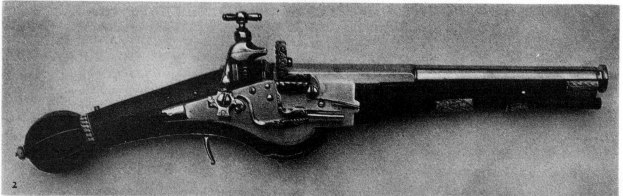

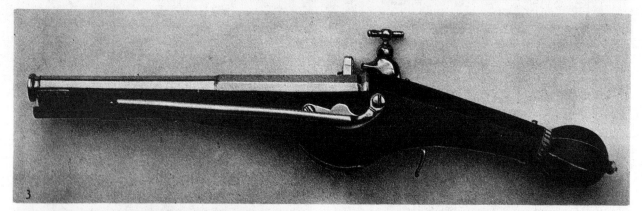

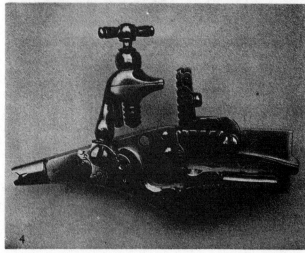
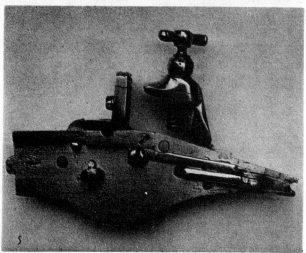

Italy and France. Earlier half of seventeenth century.

1, Italian snaphance gun, second quarter of seventeenth century; Schwarzburg 988. 2–5, pistol with snaphance of Italian type, beginning of seventeenth century. French or made from French prototype; Dresden, Historisches Museum P.Z. 405.

Plate 7.

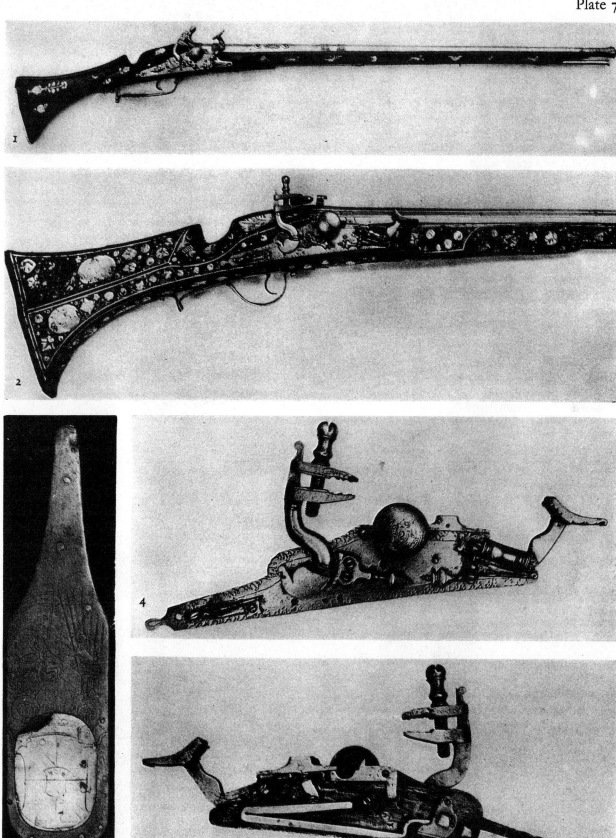

France and Holland. Beginning of seventeenth century.

1. Gun with Dutch snaphance lock 1622. France (?); Renwick Collection, Ravenswick (Mass., U.S.A.). 2–5. Jacob De le Gardie's target gun with Dutch snaphance; Paris, Musée de l'Armée M. 688.

Plate 8.

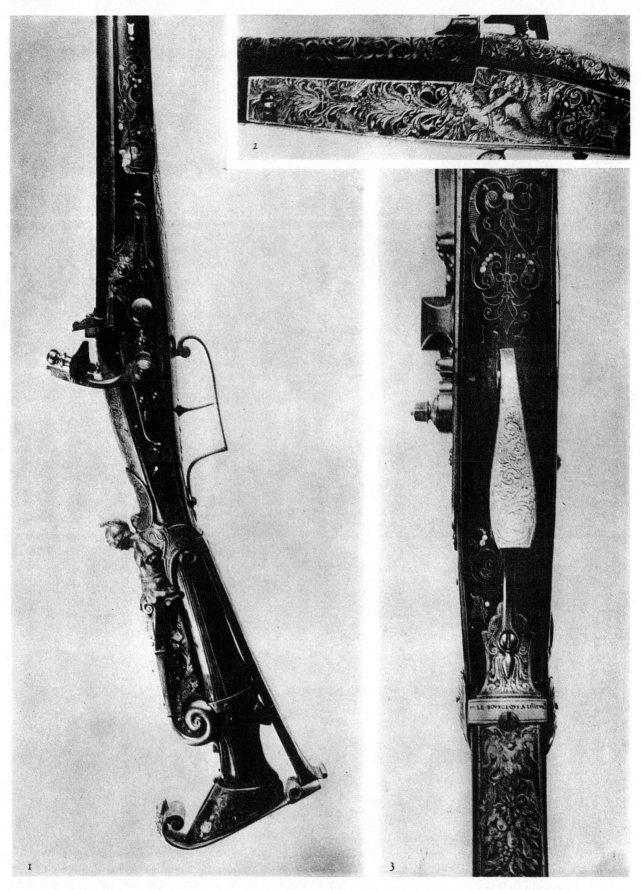

France, Lisieux.
Beginning of seven-
teenth century.

1. Henry IV's (?) flintlock gun by 'M. Le Bourgeoys à
Lisieul'; Leningrad, State Hermitage F 281.

screw which is characteristic of the Kabyle Arabian guns. This nut is also found on an identical construction known to be of Ripoll manufacture represented in the Töjhus Museum, Copenhagen (Inv. Nos. B 342, B 343). Whether the Kabyle guns should be regarded as developing from Spanish prototypes does not call for discussion here. Such an explanation would, however, be very natural. The same type of cock fitted with a cock-screw ring occurs on the snaphance fragment discovered in the Dutch settlement on the Barents sea (Pl. 1:2, 3). This must be included in the Nordic group by reason of the rear spur of the cock and has its 'next of kin' in the Norwegian snaphance. The ring of the cock is also characteristic of the Baltic snaphances and of those of seventeenth-century Swedish muskets.

Alm considers that the snaphance locks as a whole are advanced constructions and that they all derive from a common basic type[34]. The constructional details mentioned above support this view. There is, however, no reason to exclude the wheel-lock from such an assumption. While the sparking-lock constructions were being developed from their primitive stage to perfection details were evidently exchanged between wheel-lock and snap-lock. This, in its turn, indicates that the cultural and geographical region within which these constructions originated was not particularly large. We may even assume that there were different types of tinder-boxes within the same area, an assumption to which the drawings of the Löffelholtz manuscripts may also lend colour.

It is still an open question what course the development took. A series of special investigations must be made before a survey with reasonably well-grounded claims for authenticity can be advanced.

From the close of the eighteenth century a series of books dealing with firearms have been published in which certain claims constantly recur but remain to a great extent uncorroborated. One of these claims the year 1630 as the time, and France as the country of origin, of the flintlock. The source is, so far as can be judged, Diderot and d'Alembert's encyclopedia[35], which states: 'Il (le fusil) fut inventé en France en 1630 pour substituer au mousquet qui était alors l'arme ordinaire de l'infanterie; mais on ne l'adopta que quarante ans après.' As regards the wheel-lock it states, with indication of the sources (art. arquebuse), that it is older.

Another opinion that prevailed in the literature of the entire nineteenth century was that the snaphance lock was a Spanish invention. No exact statement was given as to the source of this information, but in all probability it was founded on the very brief reference to Simon Marcuarte as the inventor of the miquelet-locks, which were regarded as Spanish at the end of the eighteenth century, ('se debe la invencion de las llaves de patilla, que hoy llamamos à la Española'). This is recorded by Solér in the work above quoted on the gunsmiths of his native city of Madrid[36]. According to him the matchlock was succeeded by the unreliable wheel-lock. The latter was slow in use and was ousted in its turn by the Spanish lock.

The Spanish lock is, it is true, a snaphance-lock but a highly developed one. Solér's statement does not justify any assumptions regarding the snaphance-locks, but is, if it can be proved, most interesting with reference to the origin of the flintlock.

A few years earlier than Solér, Magné de Marolles, an official at the French court (d. 1792), published his book *La Chasse au fusil* which was in many respects a model publication in giving references to sources, etc. Concerning the flintlock he quotes (ed. 1836, p. 39) Pietro della Valle's description of his travels of 1617, 'pistole a focile, che non s'ha da perder tempo a tirar sù la ruota', to show that the ordinary flintlock, 'la platine actuelle', already existed at that time. This is true, but it is not very likely that Pietro della Valle's 'pistole a focile' was fitted with a flintlock. It undoubtedly has reference to a snaphance-lock, a construction which appears to have escaped Magné de Marolles's otherwise sharp eye. This is also why, when quoting on the same page Vita Bonfadini's statement that the wheel-lock in Italy was already replaced about 1550 by 'arquebuses à fusil (a focile)' he assumes that these latter were equipped with flintlocks, 'la

platine moderne'. In this case a snaphance-lock must, of course, be meant.

To Magné de Marolles the wheel-lock is a German invention, which existed in 1540 but which most probably is older. The matchlock which had simultaneously been in use for a long time is the precursor of the wheel-lock.

In passing, mention may be made of a *Beschrijving van een aanmerkelijke snaphaan . . . van Ao 1573* by J. le Francq van Berkhey. This publication gives neither place nor year but evidently dates from the close of the eighteenth century. The picture which he appends shows a typical flintlock gun of the latter half of the seventeenth century.

In England Grose heads the procession of historians of arms but has little or nothing to say of the flintlock[37]. When Meyrick published his survey of the types of locks in 1829[38], Italy was advanced as being the country of origin of firearms. The wheel-lock was considered to be an Italian invention, known in 1521, and soon after introduced into Germany, France, the Netherlands, and England first got to know of the construction by importing it.

Meyrick refers to the 'fusil'. It is not clear what he meant by this term, but it probably is a flintlock, as he indicates—presumably from the French encyclopedia—that the construction originated in France in 1630 and that 'fusiliers', soldiers who derived their names from the gunlocks, were equipped with such weapons in England, Scotland and Wales. Meyrick also points out that Benvenuto Cellini in his memoirs for the year 1536 mentioned a 'fusil' (actually sciopetto) which Duke Alessandro (Medici) received from Germany.

Referring to a portrait of an English Commonwealth officer Meyrick points out that the flintlock was used in England as early as the middle of the seventeenth century. The construction is connected by him with the snaphance lock and in another passage he describes it as French from the period about 1635 and in general use for military purposes in 1680. In 1645 Markham recommends the flintlock in the *Souldier's Accidence* in preference to the snaphance locks.

The gun and its development[39], the work of

W. W. Greener, one of the earlier English writers, has had the widest circulation. The first edition appeared in 1881, by 1899 it had been published in no fewer than seven editions. Greener also considered that the matchlock was the oldest lock construction and that the wheel-lock came next. The wheel-lock was invented in Nuremberg in 1515 and was improved there in the years 1517, 1573 and 1632, and also in Venice in 1584. By flintlock Greener means both snaphance and flintlocks. According to the most authentic sources Spain is the country of origin of the snaphance and its construction dates from early in the seventeenth century, prior to 1630. Its first form was the 'Lock à la Miquelet', a name which it received after a Spanish regiment made up of Pyrenean robbers. Grose and other English writers are of the opinion that the construction is of Netherlands origin and that it was first used by poultry thieves ('snaaphans') who constructed the lock after studying the wheel-lock. Soon after these snaphance locks had begun to be used, flintlock guns were introduced, called 'fusils' after the flint ('fucile'). The oldest lock has the mainspring on the outside, the later ones on the inside. The Spanish type is illustrated by the lock of a Spanish gun in The Royal Collection (Gewehrgalerie), Dresden.

De Beroaldo Bianchini[40] lists the lock constructions in the following order: matchlock, wheel-lock (also called the German lock), the Spanish lock, which has a half-cock, the Austrian imitation of the Spanish, with the mainspring reversed, and finally, the flintlock. He gives no dates, but considers the wheel-lock to be older than the flintlock.

The Danish writer Budde-Lund[41] views the appearance of the lock constructions in the following manner: oldest is the matchlock, which the writer knows during the period 1378–1722. The wheel-lock was invented in Nuremberg in 1517, used until 1640 and was called 'the German lock'. The Spanish lock, illustrated by a Swedish snaphance lock, was invented not long after the 'German'. The flintlock (Steenlaasen, Steinschloss, Batterischloss, platine à silex) was first mentioned in France in 1630 and had been used right up to

the writer's own day. The oldest specimen known is on a Scottish pistol (in the Töjhus Museum). Among the flintlocks reference is also made to 'the external lock' called, too, 'the Spanish lock', characterized by the lock parts being placed on the outside of the plate.

Closely related views are expressed in the work of the Saxon captain, J. Schön, *Geschichte der Handfeuerwaffen*, printed in Dresden in 1858. This book contributes a considerable amount of information towards research and has been frequently used by later writers. Schön also begins with the matchlock, the construction of which he assigns to the earlier half of the fifteenth century (p. 12). The wheel-lock 'the German lock or wheel-lock' is considered to have been invented in Nuremberg in 1515 and to have attained perfection two years later (p. 24). The Spanish, as well as the Netherlands snaphance lock, is said to have been constructed at the close of the sixteenth century with a question mark as to which originated first (p. 36). The statements made by certain writers that the snaphance had been invented at the same time as the wheel-lock are repudiated as unacceptable, as no book, either contemporary or later, mentions both of them. This assumption is contradicted by the sliding pan-cover of the Netherlands snaphance lock. It is exactly the same as that of the wheel-lock and consequently cannot well be contemporary (p. 50). As an example of the Spanish snaphance lock, Schön reproduces an ordinary Spanish snaphance and also a Kabyle lock; the Netherlands are represented merely by a Scottish snaphance and a reference is made to other such locks in the Historisches Museum, Dresden, bearing the years 1598, 1611 and 1615 (p. 37).

Schön explicitly calls the flintlock 'these new gun-locks invented in France in the year 1640' (p. 66), and reproduces (Fig. 52) a lock that is certainly not French[42]. It has a tumbler with full cock notch only, a flintlock sear and the sliding pan-cover and steel of the Netherlands lock. This lock gives Schön the idea that the flintlock developed from the Netherlands snaphance. Further improvements include the adoption of the steel of the Spanish snaphance made in one piece with the pan-cover, a

bridle above the tumbler and, finally, the half-cock. The flintlock thus perfected was adopted by a part of the French army in 1648. Passing mention is also made of the Courland snaphance lock, which is illustrated (Fig. 54) by a relatively late Baltic snap-lock with the mainspring on the inside of the lock-plate (p. 68).

On the foundation laid by Schön, M. Thierbach built further. His main work is *Die geschichtliche Entwickelung der Handfeuerwaffen*. To him also the matchlock is oldest. As a precursor of the snaphance lock he mentions the match-snaplock. According to Thierbach the wheel-lock was constructed in 1517, the snaphance at the beginning of the sixteenth century. The wheel-lock is German, the snaphance Spanish, both being derived from the tinderbox. He thus expresses his views regarding the origin and first distribution of the snaphance lock (p. 51): 'Die erste praktische Verwertung obiger Ideen (tinderbox-snaphance lock) fand ohne Zweifel in Spanien statt, wenigsten sind dort die ältesten noch erhaltenen Schlösser dieser Art gebaut und von dort aus weit verbreitet worden, weswegen man diese Art auch „das spanische Schnappschloss" nennt'.

Thierbach expresses the same opinions in his paper "Über die Entwickelung des Steinschlosses"[43] in which he denies to the Spanish snaphance all influence upon the further development into the flintlock. This he considers to have taken place exclusively in France and in Germany. The Spanish snaphance has, on the other hand, been of importance for Africa and the Orient, whither Spanish trade commodities were mainly sent. As examples of early snaphances he reproduces in his book a Swedish 'lägg-lock' dating from the middle of the seventeenth century (Fig. 119), mounted on a gun at Ettersburg. The barrel of this weapon is dated 1540. Thierbach expressly calls it German and considers as German the snaphance guns in Darmstadt, which Fleetwood[44] later proved to be Swedish, as he also did with the Swedish snaphance guns in Skokloster.

In the small catalogue of the Thierbach Collection in the Dresden Arsenal museum[45] the Spanish snaphance lock is described as having been imitated in the Netherlands.

Flintlock

Muzzle

Fore-sight

Forward
Ramrod pipe

Ramrod Groove

Middle
Ramrod pipe

Ramrod

Barrel

Middle
Ramrod pipe

Stock

Rear
Ramrod pipe

Back-sight

Chamber

Breech-plug

Lock

Pontet

Trigger guard finial

Trigger

Trigger guard

Small of Butt

Nose of Comb

Tang of
Trigger guard

Flange of Butt

Comb of Butt

Butt

Heel of Butt

Toe

Boss of Pommel

Spur of
Pommel

Butt cap or Pommel

Ring Back-sight
seen from above

Side plate

Thumb-plate or Escutcl

Tang

Butt-plate

Butt-plate screw

Butt-plate screw

8

Fig. 1

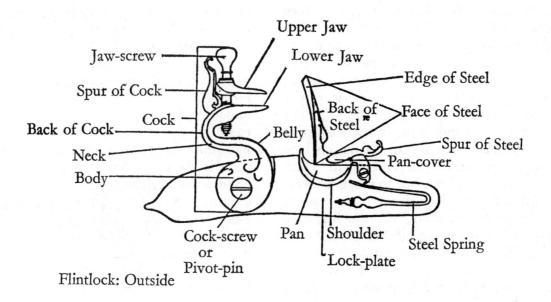

Flintlock: Outside

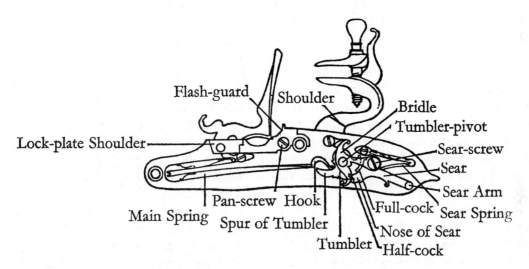

Flintlock: inside

Fig. 2

The development of the snaphance into the flintlock Thierbach considers to have taken place gradually, and he finds the boundary line between snaphance and flintlock unclear. The construction cannot be the work of one man (such an inventor has, as a matter of fact, never been heard of) but had developed through changes and improvements originally in the matchlock and, later, in the snaphance lock. Particular stress is laid on the cocking and trigger arrangements. A lock in which steel and pan-cover are made in separate pieces is regarded as a flintlock, if the other features of the flintlock are there, viz. the half-cock secured by a sear and tumbler. The solution of the problem begins with the transfer of the mainspring to the inside of the lock-plate, setting at half-cock by a pin passing through a hole in the lock-plate, and at full-cock by a catch on the horizontally moving sear which engages over a ledge on the tumbler. Alternatively a hooked (dog) catch is substituted for the half-cock. Finally, both full and half-cock are provided by notches in the tumbler. The system with a vertically moving sear commences with a tumbler which has two rectangular notches (example an Italian lock, dated 1647), and continues with acute-angled notches (example another Italian lock known to have been bought in 1665). This settles the flintlock question.

Thierbach further points out that the flintlock originally had no bridle over the tumbler. Its further development finds expression in the appearance of this in two stages. In the first the bridle merely supports the tumbler, but in the second it has been extended and also supports the sear. The fully developed flintlock exists in 1659, judging by Berain's design plates with which Thierbach was acquainted, in a dated set in the royal library at Sigmaringen[46]. The flintlock is indebted chiefly to French masters for its final design, so that it has also previously been called the French lock[47]. The Thirty Years War had a retarding effect upon the development of the flintlock.

In Boeheim[48] we find, in the main, a repetition of Thierbach's statements. He considers, however, that the Spanish snaphance 'das Urbild des späteren Flintenschlosses' first appears in the latter half of the sixteenth century and that it already possesses the essential features of the flintlock mechanism. Only the tumbler with its notch is lacking. In addition the main part of the mechanism lies on the outside of the lock-plate. The Netherlands snaphance has undoubtedly sprung from the Spanish and is based on the same system. The fact that the mechanism is placed on the inside of the lock-plate is an improvement. It is regarded as a disadvantage, however, that the battery consists only of a steel on an arm. The first flintlock guns, luxury sporting weapons, were made in Paris (p. 464). If a search were to be made for their inventors, or for the improvers of the snaphance, an enquiry would have to be made as to what gunsmiths were active in Paris in 1648. Boeheim states as a fact that the Parisian Philippe Cordier d'Aubeville [*sic*] known from 1635 to 1665, shows a flintlock in an engraving dated 1654. A still older original, signed 'Felix Werder Tiguri Inventor 1652' (Pl. 32:2), is in the Kunsthistorisches Museum, Vienna[49]. There is no doubt that it is the existence of this dated lock, with its local characteristics, that caused Boeheim in his lecture on 'Die Waffe und ihre einstige Bedeutung im Welthandel'[50] to consider that the place of origin of the early flintlock was probably Switzerland about 1630. This weapon, taken together with the information in the Diderot encyclopedia, is probably the ground for Boeheim's opinion. In England a special type was made at an early stage. The snap or flintlocks vary in detail but have some main elements in common, viz. the cock, pan, pan-cover, steel and steel-spring. In *Meister der Waffenschmiedekunst*[51] the same writer points out the existence in the castle of Frauenberg, of a revolver gun fitted with a flintlock which he dated 'not later than between 1620 and 1630'.

Demmin states that the flintlock was probably constructed in France or Germany between 1620 and 1640[52]. Of later writers two whose works have attained wider circulation should be mentioned, viz. Jackson[53] and Pollard[54]. The former admits: 'Although the flintlock proper is said to have been invented in Spain about 1630, I must confess my inability to discover,

either in museums or private collections, any weapon of quite so early a date fitted with this form of lock' (p. 15). The latter points out the insufficiency of the available sources: 'The date of introduction of the flintlock has been attributed by most writers to 1630–40, but it is not easy to find on what evidence they based their facts' (p. 45). To George[55] the matchlock, which is the older weapon, the wheel-lock and the snaphance or the flintlock, which is the latest, were all in existence at the beginning of the seventeenth century. Neither the time nor the place of its origin is definitely established. The distinction between snaphance and flintlock has been made by modern writers. The early snaphance or flintlocks were, according to George, intended chiefly for military use.

In English works[56] repeated mention is made of a gun in the Tower of London Armouries (Inv. No. XII:63), dated 1614 on the barrel and lock, as the oldest known flintlock weapon. Because of the roses and thistles which decorate the stock it is attributed to Charles I. The attribution seems to be based on the report of the *Proceedings of the Archaeological Institute* printed in the *Archaeological Journal*[57] for 1859. Mr Hewitt referred to a remarkable fowling-piece briefly described by mentioning the rose and thistle decoration, the dating and mark, which includes the letters 'R A' (Richard Atkin, gunsmith, of London). The conclusion reads: 'From the facts already enumerated, it seems impossible to doubt that this piece belonged to Prince Charles'. How so definite a conclusion was reached is not clear. Hewitt, however, accepted the attribution which accompanied the gun when it was transferred from Woolwich in 1820[58].

We must, however, delete this weapon from the examples of the oldest flintlock. This ffoulkes has already done[59]. His illustration of the gun shows that it is a typical Scottish snaphance gun. It is, moreover, considered such by Whitelaw[60]. The decoration of the stock may have some bearing on the attribution of the gun to a certain owner. The shield engraved on the barrel which should have contained the coat of arms of the owner[61], is empty, and what is more, the weapon bears number 129 in the

French Royal *Cabinet d'Armes*, the inventory of which gives a full description of it[62].

ffoulkes states that the gun came to the Tower of London Armouries about 1820 from the 'Military Repository, Woolwich'[63]. Regarding the Woolwich Collection, Meyrick definitely says that it is booty from France, that it formed a part of the collection kept in the palace of St Germain, and that it contained Chevalier Bayard's arms[64]. There will be reason to refer to this again later, but the existence of other French Royal weapons in the Woolwich Collection may be mentioned at this stage. It confirms Meyrick's statement.

The gun in question has incorrectly attracted attention as the oldest dated flintlock weapon and the statement that its first owner was Prince Charles—subsequently Charles I—has often been repeated. It seems, therefore, important to point out here that both statements are entirely unfounded. It is in fact a Scottish snaphance gun dated 1614 and it belonged to the French Royal *Cabinet d'Armes*. It is included in the inventory of the latter, completed in 1673, as Number 129, with which number the gun is moreover marked. This does not exclude the possibility that the gun was a gift from a member of the British royal family to Louis XIII. Héroard mentions in his diary several such gifts, including arms[65].

In the work *Eldhandvapen* I[66] I quoted above, the Swedish writer J. Alm provides the most comprehensive and best résumé of the older literature, other than that in French and English, together with the results of his own research work. He adopts a critical attitude towards the opinions of the earlier writers, pointing out the weakness of their sources and absence of research. Against the claim that the snaphance lock was invented in Spain he stresses the fact that 'the specially Spanish type of lock is so highly developed that it can hardly be the original type'. As early evidence of the flint snaphance-lock he indicates, following Angelucci, an ordinance issued at Ferrara of 14 February 1522 (p. 54). The wording implies that this construction must be meant: he further quotes, with reference to the wheel-lock, Feldhaus's statement in *Schuss und Waffe*,

Vol. III, p. 197, that the use of wheel-locks was forbidden at the Geisslingen shooting meeting¶. A notice in '*Zeitschrift für historische Waffenkunde*', Vol. VII, p. 26, states that there was a gunsmith and wheel-lock maker Hans Luder in Goslar in 1509. The Emperor Maximilian's prohibition of 'feuerschlagende Büchsen'** (p. 69) he considers may possibly have applied to the flint or snaphance-locks[67]. This might possibly explain why this particular construction 'did not acquire any importance in Germany'. The area in which the different types of snaphance-locks were used surrounds that in which the central European wheel-lock was preferred.

Certain types of snaphance-locks were developed under the influence of the wheel-lock construction. The range of distribution of the Netherlands snaphance-lock embraces Scotland, and most probably England and France too. It should therefore really be called western European. It was also an article of export to Morocco and Russia.

'The flintlock has been developed from the Netherlands snaphance-lock and differs only from it in the arrangement of the cock and the construction of the shoulder of the cock and the steel' (p. 216). Alm also states that the flintlock was invented in western Europe in the 1620s without, however, indicating his source of information (p. 220). He mentions that there is a gun in 'the Artillery Museum, Paris', with a combined flint and matchlock which is dated 1636. In the middle of the seventeenth century the bridle appears and is fully developed by 1670 (p. 219).

It should be evident, from the above brief extracts from the earlier literature, that the evidence which can be extracted from it varies a great deal and is contradictory as regards the time and place of the origin of the various types of locks. The authors often fail to give their sources. In such circumstances it seems as if the entire problem should be taken up from the beginning. The fact that each spark producing type of lock has at least some detail in common with another main type leads us to the working hypothesis that the origin of all sparking types of locks should be traced back

to a relatively small area. Now, if Spain can be eliminated as the country of origin of the snaphance-locks, it is only natural that research should primarily be directed towards southern Germany. The very lively trade with Italy, the northern countries, the Netherlands and England may well have furthered a rapid spread of the types. Benvenuto Cellini's statement about Duke Alessandro's gun that had come from Germany is undoubtedly no mere accident. In 1546 the Council of Augsburg considered it necessary to forbid the export of guns as the masters were so overwhelmed with orders from elsewhere that the town itself could not get its own requirements supplied[68]. The fact that monarchs and princes introduced foreign masters has naturally, together with exportation, played an important part in the distribution of lock constructions. Marcuarte is one of these emigré German masters. German gunsmiths came to Sweden in the middle of the sixteenth century. This fact, as has already been pointed out, should be linked with the first mention of the snaphance in Swedish documents at that time. German gunsmiths worked in England as early as the reign of Henry VIII.

A complete account of the history of the development of the types of locks must in any case be preceded by a long course of detailed research.

Editor's Notes

* The term steel is here used in preference to the dialect form 'frizzen' which was not introduced into arms terminology until the twentieth century.

† Recent research by Blair and Gaibi has shown that the Italian wheel-lock, if it did not precede the German version, was probably an independent development.

‡ These locks have since been studied by Dr A. Hoff: 'Hjullaase med seglformet hanefjer', *Vaanbenhistoriske Aarbøger*, Vol. III, p. 68.

§ Dr Lenk here repeats the view, now no longer generally accepted, that the Italian wheel-lock derived from Germany.

Plate 9.

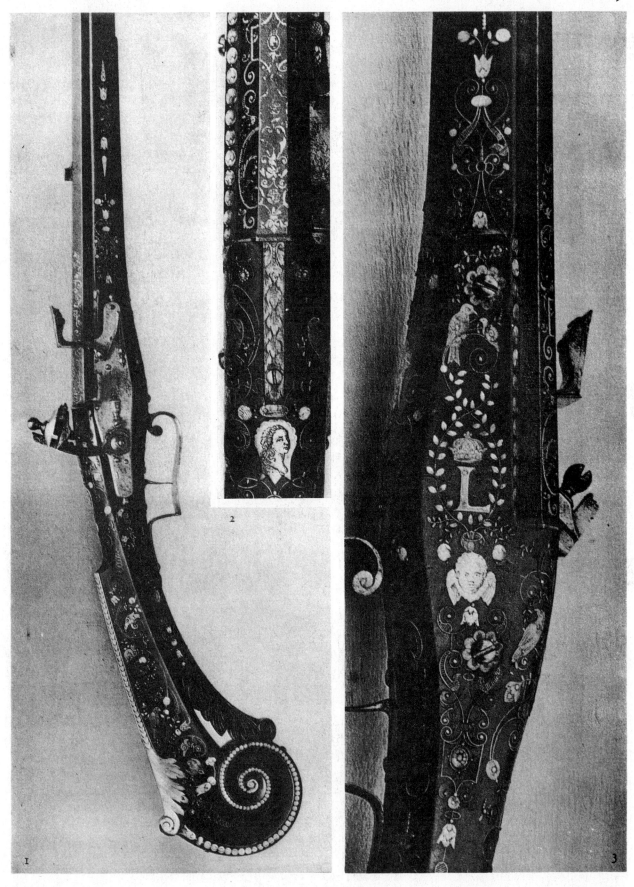

France, Lisieux. Beginning of seventeenth century.

Louis XIII's flintlock gun, marked 'I B', probably Jean Bourgeoys of Lisieux, 1615; Renwick Collection, Ravenswick (Mass., U.S.A.).

Plate 10.

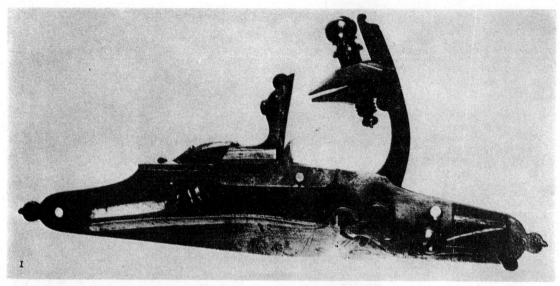

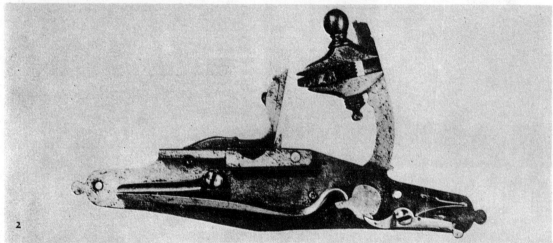

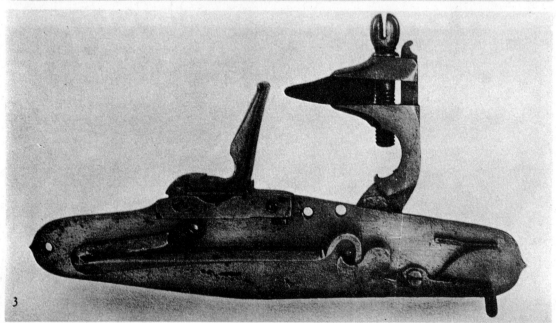

France, Lisieux. Beginning of seventeenth century.

1. Inside of lock of gun Pl. 8. 2. Inside of lock of gun Pl. 9. 3. Inside of lock of gun Pl. 11:3.

Plate 11.

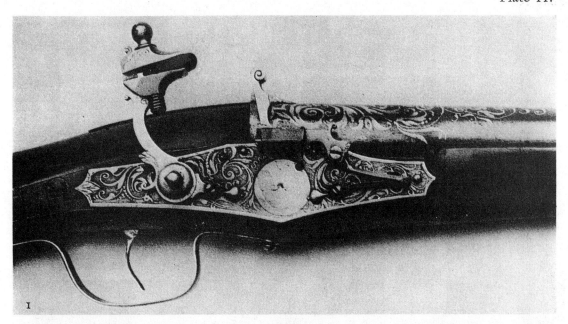

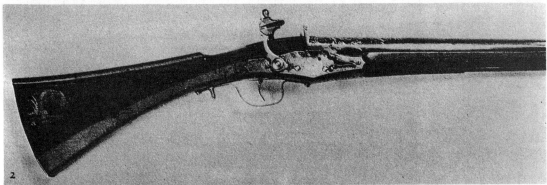

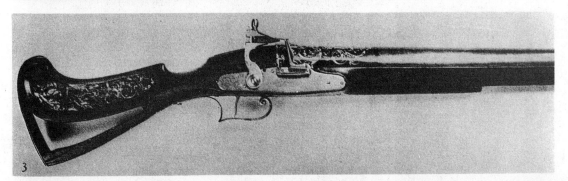

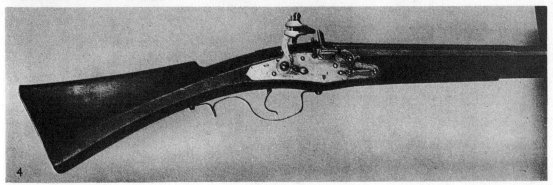

France.
Beginning of seventeenth century.

Flintlock guns. 1 and 2. Decorated by Marin Le Bourgeoys of Lisieux. 3. Louis XIII's flintlock gun by 'M. le Bourgeoys', 1620s. 4, c. 1615; Paris, Musée de l'Armée M. 529. M. 435, unnumbered.

Plate 12.

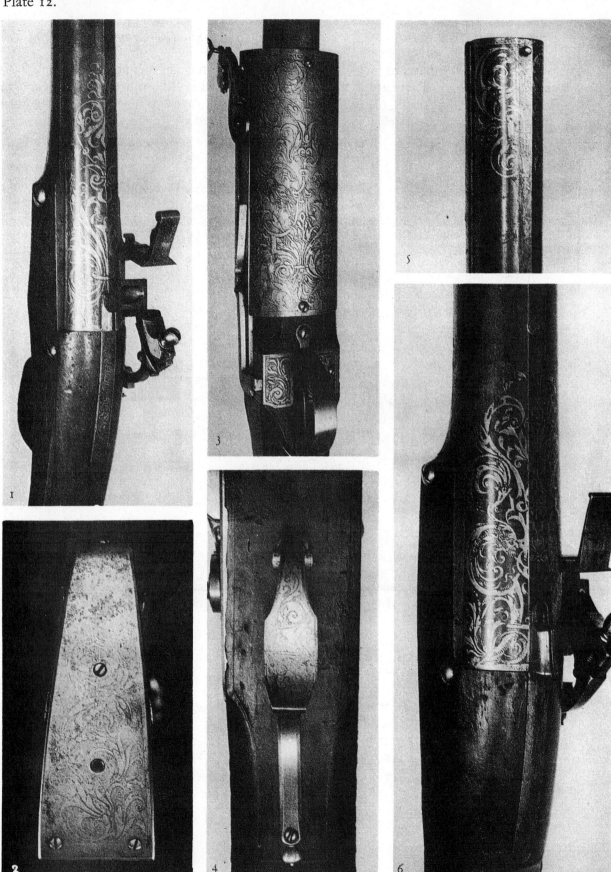

France, Lisieux.
Beginning of seven-teenth century.

Arms decoration by Marin le Bourgeoys. 1. Detail of gun
Pl. 11:2. 2. Detail of gun; Paris, Musée de l'Armée M. 369.
3–6. Details of gun Pl. 11:3.

|| This pistol is now considered to have been restocked at a later date. There are reasons to think it may be of French origin, see J. F. Hayward, *The Art of the Gunmaker,* Vol. I, p. 105.

¶ C. Blair, 'A note on the early history of the wheel-lock', *Journal of the Arms and Armour Society,* Vol. III, p. 221 ff. has shown that the first two sources quoted by Alm are in fact devoid of foundation. Most recent research accepts the Leonardo drawings as the earliest record of the wheel-lock and certain Italian combined crossbows and wheel-lock guns in the Palazzo Ducale, Venice, as the earliest surviving examples of the construction.

** This prohibition could apply equally to wheel-locks or snap-locks.

Notes to Chapter One

1. I have adopted in this work the terms 'cock (retaining) screw' for the screw that fixes the cock, and 'jaw screw' for that which holds the flint.
2. Alm, *Eldhandvapen* I. P. 170.
3. Norrköping Factory's account 1688.—War Archives.
4. Alm, 'Svenska muskötsnapplås på Carl XI's tid.' *Svenska Vapenhistoriska sallskapets arsskrift.* 1934–37. P. 89 ff.
5. Schröder, *Jaktminnen från fjäl/och sjö.* Pp. 260, 261.
6. Claus Pommevechi's inventory 23/3/1620 'I gammel flintebös'. Helsingörs Skiftebog, fol. 114. Landsarkivet, Copenhagen.—Delivery from Copenhagen Arsenal to Malmö 12/7/1624. '1000 flindt rör'. Archive Accounts, Arrear Payments Book. Rigsarkivet, Copenhagen. Information from Arne Hoff, Inspector of Museums, Copenhagen.—Cf. also Blom, *Kristian den fjendes Artillery.* Pp. 63, 85.
7. Hewitt, *Ancient armour and weapons in Europe.* Supplement. Pp. 657, 710.
8. Littré, *Dictionnaire de la langue française.* T. I, 2nd part. D—H.S. 1805, 1806.
9. Poumerol, *Quatrains au Roy.* Printed by Rocolet au Palais 1631. The only known original in Bibliothèque de l'Arsenal, Paris. Reprinted in Bibliothèque Elzevirienne 79: VI, Paris 1856 entitled *Varietés historiques et littéraires.*
10. Gamillschag, *Etymologisches Wörterbuch der französischen Sprache.* P. 448.
11. Magné de Marolles, *La chasse au fusil.* P. 39, note. (A smaller publication entitled *Essai sur la chasse au fusil* appeared in 1781. The edition of 1836 is used in the present book.) 'Le mot *focile* (fusil), signifie également, tant en italien qu'en françois soit le caillou, soit l'instrument d' acier, dont on se sert pour en tirer du feu, soit la partie de la platine appeleé batterie, soit la platine entière; et l'on a fini, en France, par appliquer cette dénomination à l'arme même, en cessant de l'appeler arquebuse, lorsque les platines à rouet ou à mèche ont été tout-à-fait abandonnées'. 'Arquebuse' was the usual French term for gun before 'fusil'. Cf., for example: Héroard, *Journal sur l'enfance et la jeunesse de Louis XIII (1601–28). Passim.*
12. Angelucci, *Catalogo della Armeria Reale.* Pp. 420–24, note.
13. Thierbach, *Die geschichtliche Entwickelung der Handfeuerwaffen.* Pp. 27, 50, 51.
14. Alm, *Eldhandvapen* I. P. 28. 'Achat d'un fusy tout garny servant à allumer le feu pour tirer desdites couleuvres'. Rathgen, *Das Geschutz im Mittelalter.* P. 535.
15. Cederström, 'Ha gevärslåsen uppstått ur elddon?' *Livrustkammaren,* Bd. I. H.4. Pp. 65–76.
16. Cf. Feldhaus, 'Das Radschloss bei Leonardo da Vinci'. *Zeitschrift für historische Waffenkunde.* Vol. IV. Pp. 153, 154 and Feldhaus, 'Feuerwaffen bei Leonardo da Vinci'. *Zeitschrift für historische Waffenkunde.* Vol. VI. Pp. 30, 31.
17. Hoopes, 'Drei Beitrage zum Radschloss, 2. Radschlosser nach Leonardo da Vinci'. *Zeitschrift für historische Waffen- und Kostümkunde.* Vol. XIII. Pp. 225–27. Pl. XI and XII.
18. Le Musée de l'Armée. *Armes et armures anciennes.* T. II. Pp. 111–14. Pl. XXXVIII.
19. Micol, *Panoplie européenne.*

20. Dean, *Handbook of arms and armour*. Fig. 115. Second pistol from top.

21. Guiffrey, *Inventaire général du mobilier de la couronne*. T. 11. Pp. 43–84.

22. Héroard, *Journal*. 21 Oct., 1611.

23. Cf. Lenk, 'Den förgyllda bössan'. *Gustav Vasaminnen*. Pp. 135–41.

24. Alm, *Eldhandvapen* I. Pp. 131–38, 142–44, 159. Malmborg, *Stockholms bössmakare*. B. 1 ff. Cederström and Malmborg, *Den äldre Livrustkammaren 1654*, P. 53 and 68.

25. Alm, *Eldhandvapen* I. P. 159. Fragments of such a lock are part of the Barents discovery in the Rijksmuseum, Amsterdam (Inv. No. 30. 7762. Pl. 1:2 and 3) and may probably indicate the source of the construction, unless the lock or the weapon was dropped on the place it was found by Norwegian hunters. Barents broke away from Nova Zembla in 1597.

26. Gun with the inscription 'Narva' in the Royal Armoury, Windsor Castle. Laking, *The armoury of Windsor Castle. European Section*. P. 96. No. 304.

27. Blom, *Kristian den fjerdes Artilleri*. Pp. 63, 66. Enander, *Anvisning till handgëvarens kännedom*. P. L. Jakobsson, *Lantmilitär beväpning och beklädnad under äldre Vasatiden och Gustav II Adolfs tid*. Append., 2–5. Pp. 412–29.

28. *Inventarium på thet lille Archliedt . . . 1557*. Kammararkivet, Stockholm. Strödda administrativa handl. 9. Cederström and Malmborg, *Den äldre Livrustkammaren 1654*. Pl. 53.

29. Alm, *Eldhandvapen* I. P. 138. Malmborg, *Stockholms bössmakare*. P. 1.

30. Solér, *Compendio historico de los arcabuceros de Madrid*. P. 40.

31. Alm. *Eldhandvapen* I. P. 98.

32. ffoulkes, *European arms and armour in the University of Oxford*. P. 49. No. 104. Pl. XIV.

33. Dillon, 'On the development of gunlocks, from examples in the Tower'. *Archaeological Journal*, Vol. L. Lond. 1893. P. 127.

34. Alm, *Eldhandvapen* I. P. 69.

35. Diderot and d'Alembert, *Encyclopédie*. P. 378.

36. Solér, *Compendio historico de los arcabuceros de Madrid*. Pp. 40, 41.

37. Grose, *A treatise on ancient armour*.

38. Meyrick, 'Observations'. *Archaeologia*, Vol. XXII. Pp. 59–105.

39. Greener, *The gun and its development*. P. 64 ff.

40. De Beroaldo Bianchini, *Abhandlung über die Feuer- und Seitengewehre* I. P. 156 ff.

41. Budde-Lund, *Haandskydevaabnenes Historie*. P. 116 ff.

42. This lock, which by reason of its pan-cover and steel is quite definitely not French, can be dated from the 1650s or 1660s.

43. Thierbach, 'Über die Entwickelung des Steinschlosses'. *Zeitschrift für historische Waffenkunde*. Vol. III. Pp. 305–11.

44. Fleetwood, *Svenska 1600—talsbössor i Hessen*. (Rig 1923. Pp. 25–36.)

45. *Kurze Darstellung der geschichlichen Entwicklung der Handfeuerwaffen*. P. 15.

46. Cf. below, page 139.

47. 'Hauptsächlich französischen Meistern ist die Vervollkomnung dieses Schlosses zu danken, weshalb es auch früher „französisches Schloss" benannt wurde.' (Thierbach, 'Über die Entwickelung des Steinschlosses'.) *Zeitschrift für historische Waffenkunde*. Vol. III. P. 311.

48. Boeheim, *Handbuch der Waffenkunde*. P. 453 ff.

49. Flintlock carbine. Kunsthistorisches Museum, Waffensammlung. Inv. No. A 1454. Boeheim, *Album Hervorragender Gegenstände aus der Waffensammlung des Allerhöchsten Kaiserhauses*. (I) P. 19. Pl. XXXVI: 6.

50. Boeheim, 'Die Waffe und ihre Einstige Bedeutung im Welthandel'. *Zeitschrift für historische Waffenkunde*. Vol. I. P. 180.

51. Boeheim, 'Meister der Waffenschmiedekunst von XIV. bis ins XVIII'. *Jahrhundert*. P. 55.

52. Demmin, *Die Kriegswaffen in ihren geschichtlichen Entwickelungen*. 3. ed. P. 961.

53. Jackson, *European hand firearms*.

54. Pollard, *A history of firearms*.

55. George, *English pistols and revolvers*. Pp. 4–7.

56. For example Dillon, 'On the development of gunlocks.' *Archaeological Journal.* Vol. L. P. 127 and Ashdon, *British and foreign arms and armour.* Pp. 369, 370.

57. 'Proceedings at the Meeting of the Archaeological Institute.' *Archaeological Journal.* Vol. XVI. Pp. 353–56.

58. Communicated by Major Charles ffoulkes, Tower of London.

59. ffoulkes, *Inventory and survey of the armouries of the Tower of London.* Vol. II. P. 340. Pl. XXXIII.

60. Whitelaw, *A treatise on Scottish hand firearms.* (Jackson, *European hand firearms.* P. 87.)

61. Cf. Axel Oxenstierna's pistols in the Livrustkammare, Inv. No. 1726, 1727. Livrustkammaren. *Vägledning 1921.* P. 61, No. 467.

62. Guiffrey, *Inventaire général du mobilier de la couronne,* T. I 1. P. 59. 'Un petit fusil irlandois [the Scottish weapons are constantly called Irish in this inventory] de 4 pieds, le canon couleur d'eau, doré en trois endroits sur le bout, le milieu et la culasse, sur laquelle est gravé 1614; la platine de cuivre doré gravée en taille d'espargne, le chien et la batterie gravez sur un bois rouge enrichy de quelques ornemens de pointes d'argent et d'une rose, et un chardon sur la crosse.' (Cf. below, pp. 16–17.)

63. ffoulkes, *Inventory and survey of the armouries of the Tower of London.* Vol. II. P. 340.

64. Meyrick, *A critical inquiry into ancient armour.* Vol. III. P. 114.

65. Héroard, *Journal sur l'enfance et la jeunesse de Louis XIII.* I, II. *Passim.*

66. A Part II, dealing with the constructions from the first percussion lock, appeared in 1934.

67. Jähns, *Entwicklungsgeschichte der alter Trutzwaffen.* P. 371.

68. Boeheim, 'Die Waffe und ihre einstige Bedeutung im Welthandel.' *Zeitschrift für historische Waffenkunde.* Vol. I. P. 179.

CHAPTER TWO

The immediate precursors of the flintlock, the 'Mediterranean lock' and the Netherlands snaphance

RESEARCH INTO the earlier history of the flintlock ceased to be concerned with vague theories when the extant early flintlocks were published. The fact that Boeheim and Gessler[1] called attention to the Zürich master Felix Werder's garniture dated 1652 (Pl. 32:2, 3) in Vienna and Zürich was the beginning. In his *Vägledning för besökande i kungl Livrustkammaren* of 1915 Rudolf Cederström attributed, for stylistic reasons, a signed French flintlock gun in the Livrustkammare (Pl. 20:1) to the 1640s[2], and in 1927 a gun dated 1636, preserved in the Musée de L'Armée, Paris (Pl. 17:1)[3] was reproduced and described. In the catalogue of a loan exhibition in the Metropolitan Museum of Art, New York, in 1931 Stephen V. Grancsay dated a gun with a very early flintlock to about 1630 (Pl. 9)[4]. Even if this attribution must be rejected—the gun is undoubtedly some twenty years older—it nevertheless showed that a flintlock gun already existed at the time to which so many of the earlier writers ascribe its first invention.

Grancsay stated, referring to an inventory of which he gave no details, that this gun belonged to Louis XIII and Louis XIV of France. This inventory was published by Jules Guiffrey[5]. As it is an important source for the knowledge of the work of earlier gunsmiths it deserves to be mentioned in greater detail. Guiffrey[6] states in the first part of his publication that the inventory was probably begun in 1663. The first lists were not, however, signed by Du Metz de Rosnay, who was then 'intendent et controleur général du mobilier de la couronne', until 20 February 1673. The originals are in four *de luxe* volumes in the Archives Nationales (O[1] 3330—3333). They are the first in a series of inventories of the Royal Wardrobe of which Guiffrey gives an explanatory list. This includes, among others, a set of inventories in eight volumes (O[1] 3334—3341) signed on 31 December 1721, by de Fontanieux. He was probably Du Metz's second successor. The fourth volume contains the list of the *Cabinet d'Armes* in the same order as the previous one, which it largely copies[7]. This latter inventory was used to identify the arms published in the illustrated catalogue of the Musée de l'Armée of 1927[8].

On 20 February 1673, the inventory contained 337 items and on 30 January 1681, 347. Four more items were added so that the inventory of arms in the older folio ends with No. 351. The inventory of 31 December 1729 contains 455 items with six added later. Apart from marginal notes regarding objects lost or destroyed, there are notes in the earlier inventory of a rifle (No. 56), a sword (No. 305) and a suit of armour (No. 325) belonging to Louis XIII. These were sent in 1698 by the Jesuit priest Bonnet (or Bouvet) as a gift to the Emperor of China. There are similar notes regarding two Turkish swords (Nos. 338, 340) which were sent to Siam in 1686. A half-suit (No. 332) was handed out on 18 December 1686 to 's. de Lagny', perhaps for a similar purpose.

Most of the objects contained in the list seem to have been old arms which were no longer in use when the inventory was made, and it may be supposed that the inventory describes a collection preserved mainly for its historical and material value. The items identified confirm this assumption and, what is more, show that the most important part dates from the reign of Louis XIII. As to the remainder, a number of objects are attributed definitely to certain owners. A suit of armour (No. 357) is assigned to Philip Valois (d. 1350), but even the description in the inventory shows that the attribution is romantic. Other French kings are with greater probability, and sometimes with certainty, represented, such as Francis I, Henry II, Louis XIII and Louis XIV. One of the Polish kings, Casimir, is represented by a sword, and of French, non royal personages Cardinal Richelieu and an unnamed 'grand écuyer de France' are mentioned. Certain other objects in the inventory can be attributed on the evidence of inscriptions or heraldic bearings.

Most of the items of the inventory are hand firearms. For wheel-lock guns the term 'arquebuse' is used consistently, and for guns with snaphance or flintlock 'fusil'. No. 138 ('Dix huit fuzils françois') is the only item which expressly describes the weapons as French. Ten items are, however, stated to have been made in France at a given place, and in the case of twenty-eight items the French gunsmith's name is given. Masters in Lorraine are included as French. Actually the number of French arms is almost certainly considerably larger. The inventory refers to the manufacture of firearms at the following places: Vitré, St Brieuc and St Malo in Brittany, Cherbourg and Lisieux in Normandy, Abbeville in Picardy (Launnoy in Flanders), Sedan on the boundary of the then Netherlands, Paris, Montmirail in Champagne, Nancy in Lorraine, Dijon and Autun in Burgundy and Grenoble in Dauphiné. To them we can add from other recorded signed arms Metz[9], Lunéville[10], Epinal[11], Turenne[12] and Fontenay[13]. According to Héroard[14] we can add Rouen in Normandy and, according to Gay[15], Blamont near Lunéville and also St Etienne in the Loire. Gay's evidence as to this last mentioned town is derived from Bellefort, *Cosmogr.* T.I. p. 317 and refers to 1575. The French manufacture of hand firearms was evidently extensive and its products were distributed all over France. The firearms of Grenoble manufacture[16] identified from the inventory are by no means French in character, and the output at Turenne can, on account of the small size of both castle and town, scarcely have been large. This information about arms producing centres could certainly be supplemented. It seems fairly definite, however, that the earlier French firearms manufacture was centred in the north and was orientated coastwise in the northwest and, near the frontier, northwards towards the Netherlands. The firearms made in Lorraine, which still belonged to Germany in the beginning of the seventeenth century, were French in style and construction.

The inventory includes ten firearms with an Italian signature, but only one with a German. Scottish snaphance guns are described as 'à l'Irlandois'. One gun (No. 130) is also indicated as being a 'fusil à l'Angloise' (Pl. 7:1).

Three items are mentioned as Spanish, one 'choc à l'Espagnol'[17], dated 1613 (No. 358), a second 'arquebuse à l'Espagnole' (No. 78) and a third 'fusil espagnol' (No. 131). Other terms used are 'arquebuse à l'allemand' (a German wheel-lock gun) and 'turc' or 'de Turquie'.

The significance of this term is not clear. It is sometimes used for arms with Oriental barrels, but also occurs in the case of a west European matchlock target gun that belonged to Cardinal Richelieu (Musée de l'Armée No. M 37)[18].

These details in the inventory relating to the nationality of the firearms are among the few which cannot be read on the weapons themselves and must therefore have been known by this or some earlier recorder. The descriptions are, however, those of the keeper of the wardrobe, not of an arms expert. In other respects they are rather brief. They nevertheless contain sufficient information to enable the arms to be identified, though the measurements they give are not always reliable.

Certain identification is made possible by the marking of each object. In the case of the firearms this is done by means of figures (cf. Pl. 8:3) stamped into the underside of the stock in front of, and above the trigger-guard. But incised numbers also occur on the wheel-lock gun No. 64, now in the Musée de la Porte de Hal, Brussels (Inv. No. 94 D) and on the Scottish pistol, No. 193, in the Pauilhac collection; in this case the number is etched on the iron stock (cf. Pl. 3:3). The series of figures struck in the stock looks like this:

1234567890

This series has been drawn from the numbers on guns in the Musée de l'Armée, Paris. These figures are stamped quite deeply with thin, sharp dies.

This old type of marking was also adopted at other places. The armouries of Skokloster afford many examples of this, so that there must be agreement between number and the description in the inventory for identification[19].

The investigation of the history of the French *Cabinet d'Armes* is a fascinating and interesting subject. It is certainly also an arduous and time-absorbing task. Revolutions, wars and the art trade have scattered parts of it to every corner of the earth and it will obviously be no easy task to find all that may still be preserved. As to the date of its dispersal Mr Charles ffoulkes has stated that the arms which are in the Tower of London and Woolwich came from Paris in the years 1815 and 1816 after the Battle of Waterloo, doubtless as booty. S. R. Meyrick's[20] statement that they came from St Germain, which must have been the armoury's last repository before being dispersed, has already been quoted. It is probable that it was kept in several places since so much of it still remains in France. In this connection Magné de Marolle's statement may be recalled that he had seen old firearms in the 'garde meuble'[21].* The identification of arms from this armoury is relatively easy, at least in so far as the firearms are concerned, thanks to their being marked with numbers. For the use of those who may wish to make further research in this direction a list is given here of identified items[22]. It must not, however, be taken to be complete even for the armouries and collections that are mentioned, but only as a first step in the identification of this armoury†.

Having given this explanation necessitated by Grancsay's statement we can now return to our subject.

It is commonly asserted that the flintlock developed from the snaphance. Among the earlier writers, Schön holds the opinion that the flintlock is a combination of the Spanish snaplock and the Netherlands snaphance lock, and, among later writers, Pollard takes the same view[23]. The combined pan-cover and the steel should then have come from the Spanish snaplock. This detail is characteristic not only of the type of lock which is regarded as a Spanish national type, but also of other, closely connected constructions whose origin and distribution are still little known, but which can without doubt be regarded as 'Mediterranean locks'. Spain and Italy head the list as producing countries. As far as the Spanish snaplock is concerned there are difficulties in tracing it far enough back to place it before the invention of the flintlock.

The earliest dateable evidence is probably Philippe Cordier Daubigny's engraving, which is dated 1634[24]. This coincides in date with Velasquez's portrait of Philip IV in hunting

attire (Louvre, Paris, and El Prado, Madrid). In it the king carries a gun of much the same type as Nos. 1186 and 1184 (Pl. 5) in the Gewehrgalerie, Dresden. The latter is reproduced by M. v. Ehrenthal in the gallery catalogue of 1900 and is attributed to about 1680[25]. It is not known on what authority this date is based. The other gun appears to be older. In contrast to the gun in Philip IV's portrait it has a half-stock, but otherwise the two are rather alike. It is very probable that we should date a combined weapon, a horseman's hammer and pistol, in the Wrangel Armoury at Skokloster[26] still earlier, perhaps the beginning of the seventeenth century. The material available to me at present is, however, too scanty and uncertain to allow any definite conclusions to be drawn.

In explaining the origin of the flintlock it must be remembered that it is only the steel that was borrowed from the 'Mediterranean locks' and as it occurs on both Spanish and Italian locks we can leave the question open whether the source is to be sought in Spain or in Italy. The oldest flintlocks appear—as we shall see—earlier than 1615, the year in which Louis XIII married the Infanta Anna and as a result things Spanish became more fashionable at the French court. In view of the intimate relations between France and Italy in the time of Maria de Medici it is tempting to speculate whether the flintlock construction derived from Italian firearms, but of this nothing is known.

According to Magné de Marolles[27], who based his statement on *Excellenza della Caccia* by Cesare Solatio, a work printed in Rome in 1669, the practice of shooting flying birds began in Italy about the year 1510. Such a novelty called for a new construction of lock, as well as a stock of convenient form. What was required was a half-cock lock which is really what the Mediterranean snaplocks are. Much the same applied in northern Europe. In Stradanus's well-known series of engravings of 1580 there are no flying shots, not even shots at running animals. Magné de Marolles quotes a poem by Claude Gauchet, *Le plaisir des champs,* of 1583[28] which clearly shows that it was not customary for French sportsmen of

that period to shoot birds on the wing or running game. Light shot-guns suited for shooting birds in flight are, nevertheless, to be found among the oldest flintlock arms. It is well known that this kind of sport continued to be practised with flintlock guns.

The German writer Fleming as late as 1719 regards shooting birds on the wing as a French speciality[29].

It is probable that we may see in the flintlock the French solution of the same problem that was solved in the Mediterranean countries by the adoption of the half-cock snaplock. It is also reasonable to imagine that these constructions originated within a relatively short period, and this makes it difficult to prove that weapons of one type or the other are the earlier. A pistol in the Historisches Museum, Dresden (P. Z. 405. Pl. 6:2–5) demonstrates the existence of a 'Mediterranean lock' with a half-cock and steel which is just as old as the earliest flintlock, and perhaps older. The form of the lock-plate has been borrowed from the French wheel-lock, and the stock is likewise typical of that of an early seventeenth century French wheel-lock pistol. This stock was made for this lock, because it lacks the hole for the wheel-axis which would otherwise have been there, and also the pivot-pin for the mainspring which, in the case of the French wheel-lock arms, passes right through the neck of the butt. The existence of this pistol would seem to justify us in assuming that the 'Mediterranean lock' with steel and pan-cover in one piece was being made in France just at the time we need. Until the French provenance of this pistol (Inv. No. F 329) of typically French shape and construction can be exactly determined, caution must, however, be exercised—especially when we find in the same museum a pair of pistols dated 1615 on the barrels and signed by the Dresden master Georg Gessler. The decoration of the barrels is of typical Saxon fashion. There is reason to point out, however, that the prototype of this snaphance pistol must be French, even if it was not actually made in France. It at any rate strongly supports the assertion that the flintlock steel was derived from the 'Mediterranean locks'.

For a period only some decades later than this snaphance pistol we can definitely prove that locks of the same construction were manufactured in Italy. An example is a gun in the Schwarzburg Arsenal (Pl. 6:1) signed 'Angone' on the barrel and 'H G H'[30] on the stock. Ossbahr regards the gun as Italian, but calls the lock Spanish. It is open to doubt if this attribution is correct. For the time being it seems to be more correct to consider the lock to be an Italian type which was later copied in Spain.

The steel of the Dresden pistol is short and broad, exactly as on the Spanish snaphance-locks. The face of the steel is made in a separate piece so as to be changeable, and fastened with a screw, the head of which juts out from the back of the steel. This construction is also found on Spanish snaphance-locks, e.g. on the gun mentioned above in the Gewehrgalerie, Dresden, No. 1184. The grooved surface—cross-grooved on the Dresden pistol—suggests that the stone screwed into the jaws of the cock was iron pyrites.

The normal shape of steel for this kind of 'Mediterranean lock' is, however, long and narrow. What is evidently the authentic lock of an otherwise not entirely genuine pistol in the Army Museum, Dresden (Inv. No. O IV: 7 d) has such a steel. Judging by stock and trigger-guard, it dates from the 1620s. This lock also has a separate screwed striking face on the steel.

The second starting point for the flintlock is, according to the writer quoted above, the Netherlands snaphance-lock. The epithet 'Netherlands' is hardly adequate, as the region of distribution of the construction is greater than the Netherlands were when the flintlock appeared during the last quarter of the sixteenth century. The adoption of this term for the design in question has, however, acquired a certain usage which justifies its retention. Schön reproduces, as has been mentioned above, a Scottish snaphance as Netherlands (Schön, Fig. 42). In view of this his statement regarding the development of the flintlock from the Netherlands snaphance is less comprehensible. Should he, however, mean what the present age understands by a Netherlands snaphance, he is undoubtedly right.

Both of these snaphance constructions are variants of one and the same type. The only difference is that the Scottish lock has a simple trigger sear, a snaphance sear, and perhaps represents for this reason an older or simpler stage. Furthermore, the cock has a jaw screw passing from below with a nut on the top of the upper jaw. The Netherlands snaphance has an ordinary wheel-lock sear and sear support, and the upper jaw of the cock is regulated by a screw from above. In both instances a steering groove is filed into the back of the upper jaw in which a rib on the comb of the cock engages. On the older Scottish snaphances the comb has a plume-like spur pointing downwards at the back.

Whitelaw in his admirable treatise states that the Scottish snaphance guns originated from the Netherlands, but he does not say how this took place[31]. He begins his description of Scottish guns with the oldest one ascribed to the 1590s which already has the fully developed Scottish form and decoration. A pistol in the Töjhus Museum, Copenhagen (Inv. No. B 345. Pl. 3:1, 2), seems, however, to have some connection with the Netherlands. The neck of the cock is only slightly curved, and what is more, the shoulder of the cock and the steel spring have the turned details typical of the Netherlands snaphances. They are also not unusual on west European wheel-locks. The barrel is of tower-like form with a ring reinforcement at the muzzle. The stock, unfortunately, cannot be relied upon. It is probably copied from the original. This is known to have been done with other arms in the same museum when the originals were seriously infested with wood-worm. Even if this is the case it can still give valuable information. The butt has very much in common with the fishtail butt that is typical of a group of Scottish pistols; nor is it altogether unlike the butt of the pistol in Captain Thomas Lee's portrait in the exhibition of English art at the Royal Academy in London, 1934, catalogue No. 126[32].

Lee's pistol (Pl. 2:2) has the jaw screw of the Netherlands snaphance, and as regards construction (with the possible exception of the

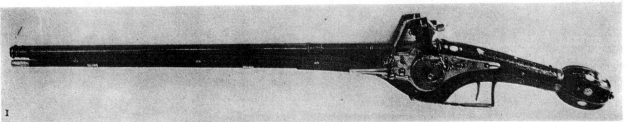

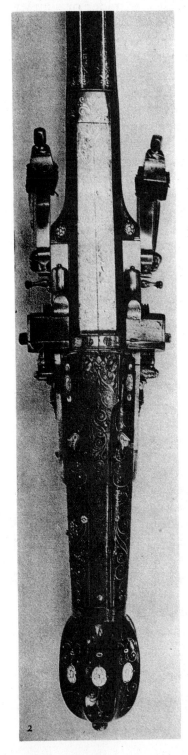

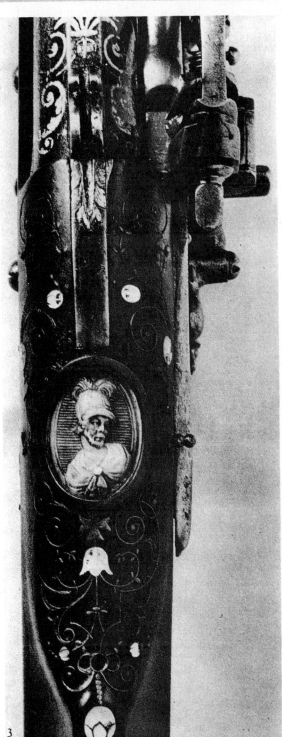

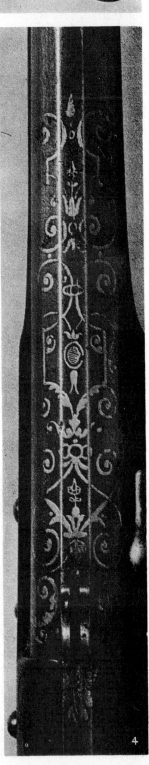

France, Lisieux. Beginning of seventeenth century.

1 and 2. Wheel-lock pistol, marked 'I B', probably Jean Bourgeoys of Lisieux, 1615; Pauilhac Collection, Paris. 3 and 4. Details of Louis XIII's wheel-lock gun with same mark; London, Wallace Collection 1133.

Plate 14.

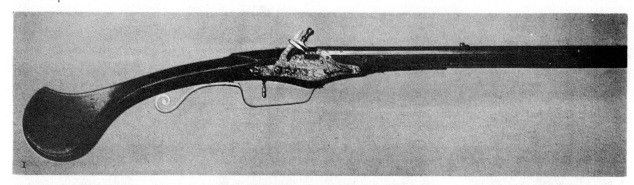

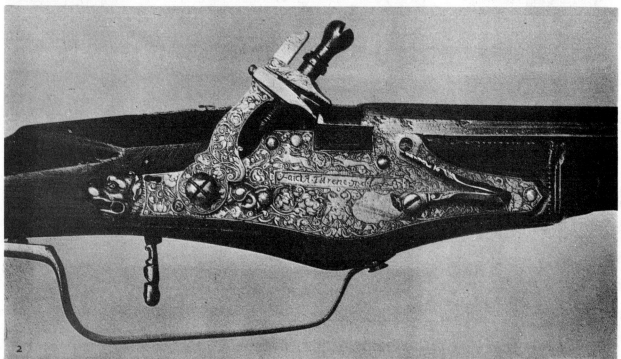

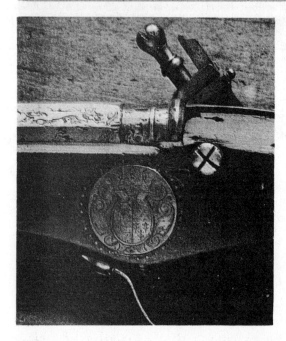

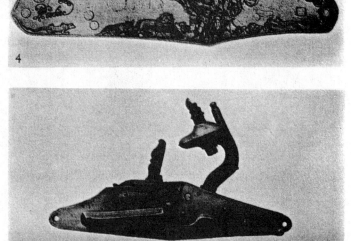

France.
Earlier half of seventeenth century.

1–3. Flintlock gun signed 'Faict A Turene m.d.'; Windsor Castle 316. 4. Rubbing of lock signed 'P. Cordier'; Paris, Bibliothèque Nationale, Cabinet des estampes Le 24. 5. Inside of lock of gun Pl. 15:1.

Plate 15.

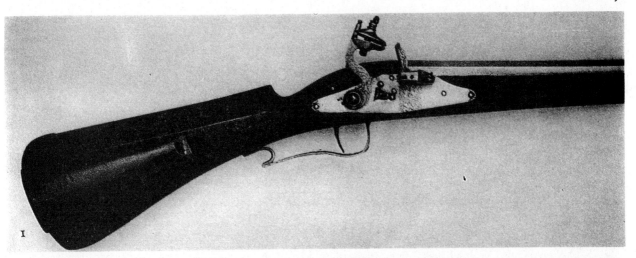

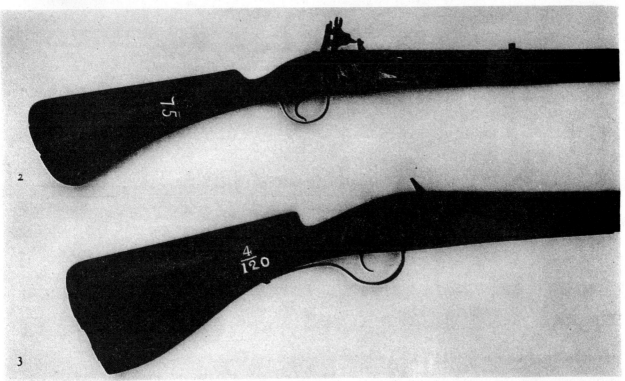

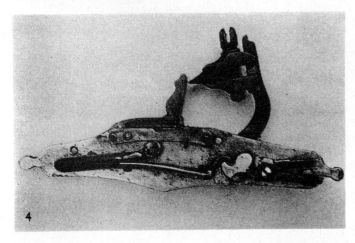

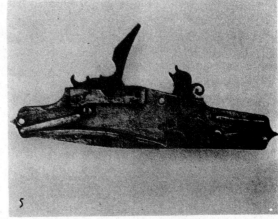

France.
Earlier half of seventeenth century.

1. Flintlock guns, London, Tower Armouries XII, 1131.
2 and 4, Victoria and Albert Museum: M.6–1949. 3 and 5,
Tower Armouries XII, 1441.

Plate 16.

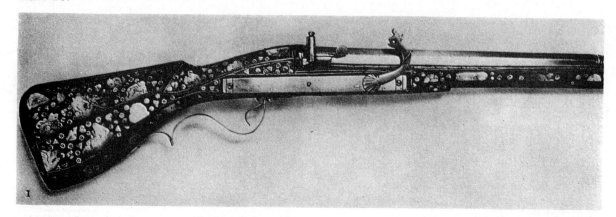

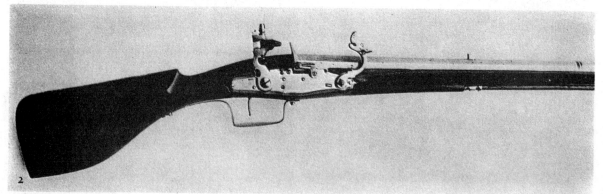

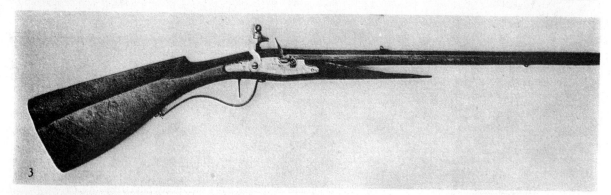

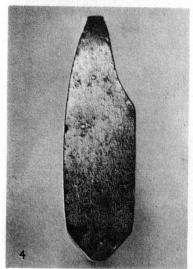
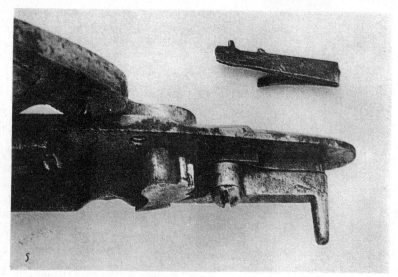

Western Europe.
1620–30s.

1. Matchlock musket, 1629; Paris, Musée de l'Armée M 35.
2. Gun with flint and matchlock, 1630s; Paris, Musée de
l'Armée M 411. 3–5. Charles X Gustavus's flintlock gun,
c. 1630; Stockholm, Livrustkammaren 1307.

Plate 17.

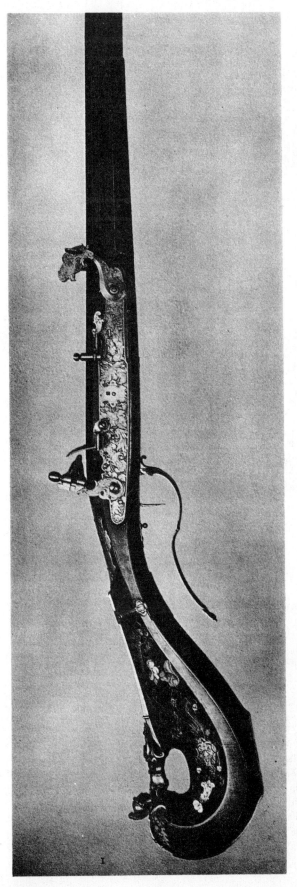

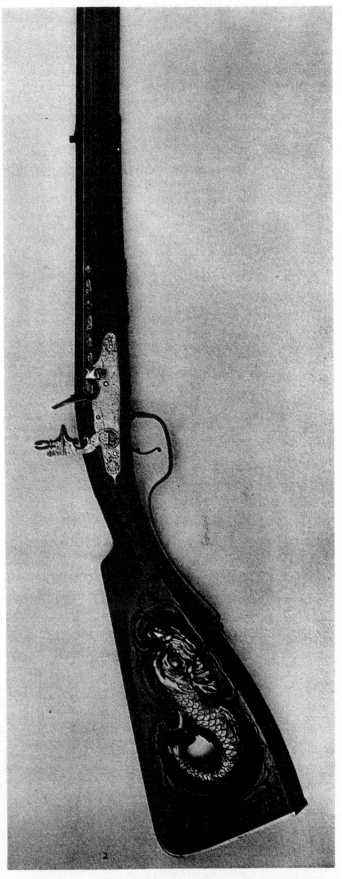

France.
1636, 1638 (?)

1. Louis XIII's gun with flint and matchlock, signed 'F du clos' (François Duclos, Paris), 1636; Paris, Musée de l'Armée M 410. 2. Louis XIII's gun, 1638 (?); formerly Berlin, Zeughaus A D 9404.

Plate 18.

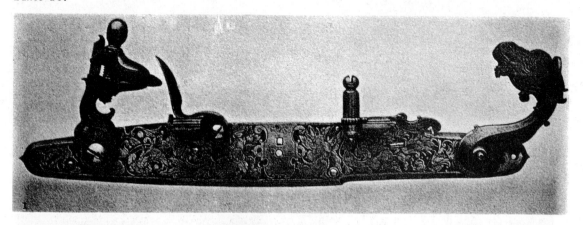

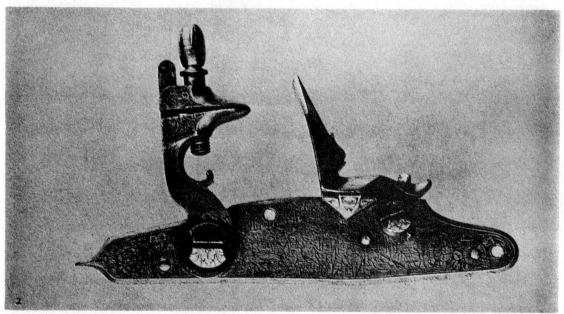

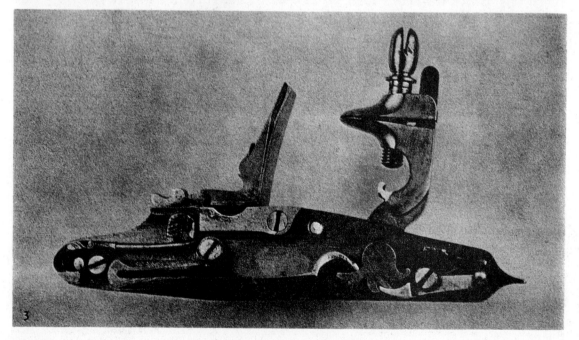

France.
1636, 1638 (?)

1. Lock of gun on Pl. 17:1. 2 and 3. Lock of gun on Pl.
17:2.

Plate 19.

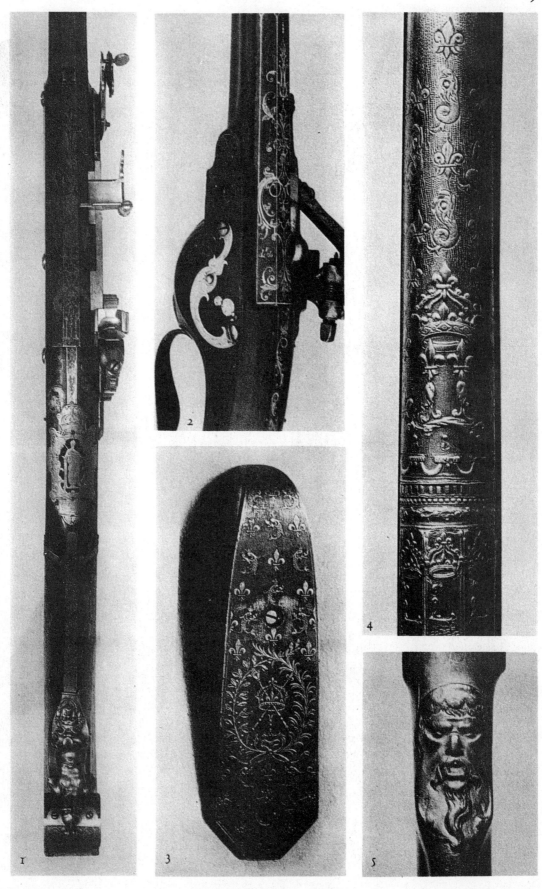

France.
1636, 1638 (?)

1. Gun Pl. 17:1 from above. 2. Detail of wheel-lock pistol, signed 'F du clos' (François Duclos, Paris); New York, Metropolitan Museum of Art 04. 3. 192. 3–5. Details of gun on Pl. 17:2.

Plate 20.

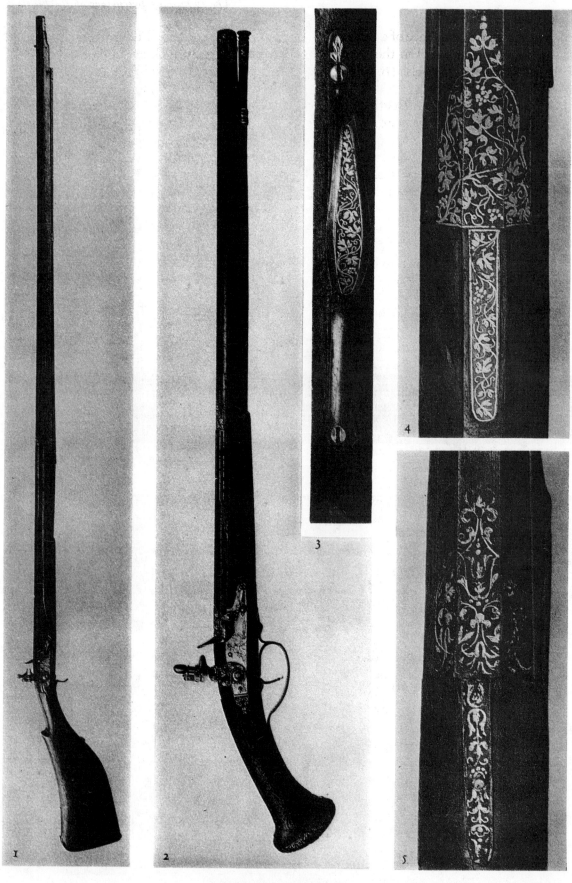

France, Paris.
1640s.

1 and 5. Charles X Gustavus's gun by P. Thomas of Paris.
2–4. Queen Kristina's pistol, one of a pair, by P. Thomas
of Paris, garniture with preceding; Stockholm, Livrust-
kammaren 1347, 3983, 1608.

sear), stock, trigger and the absence of a trigger-guard, is closely allied to a pistol in the Musée de la Porte de Hal in Brussels (Inv. No. 115 D)[33]‡.

Of English type and origin is the petronel in the National Museum, Copenhagen (Section II. Inv. No. 10428. Pl. 2:1, 3, 4), the stock of which is signed 'D 1' and dated 1584. The lock and barrel are marked with the letters 'R A' and a lily. This stamp is of the same kind as those found on the Scottish snaphances.

There is literary evidence for the manufacture of snaphances at Norwich in 1588. Even so there were earlier places of manufacture[34]. London and Greenwich§ were the other centres of arms manufacture, but this was also carried on in the environs of London at Southwark, Deptford and Erith. A Dutchman of the name of Henrik was in charge of the manufacture of firearms at the beginning of the seventeenth century. Flemings had already been called in as instructors of English gunsmiths[35] by Henry VIII. The petronel in the National Museum, Copenhagen, mentioned above, must be regarded as being of English manufacture, likewise a gun with the coat of arms of the Spens family in the Livrustkammare (Inv. No. 1349)[36], also dating from the close of the sixteenth century. Its decoration is very similar to that of the pistol reproduced in Captain Lee's portrait.

As a purely English type we may also regard the 'dog-locks' which are mentioned chiefly in the English literature of the subject. They have steel and full-cock in the ordinary manner of the Netherlands snaphance and half-cock formed by tumbler and nose of the sear. It is necessary to distinguish between the older type constructed in this way and illustrated by a pistol in the Renwick Collection (Pl. 4:1, 4)‖ from the 1620s–30s[37] and a later type dating from the middle of the century. In this latter type a hooked catch (dog) engaging the heel of the cock has been added and has given the construction its name. Such a lock is mounted in a musket stock in the Windsor Castle collection of arms (Pl. 4:2)[38]. This stock is dated 1619, but the date is that of the stock, not that of the lock. This is pointed out here as this date cannot serve as evidence of the age of the lock,

which was fitted later. Full agreement in date between stock and lock exists, however, on an otherwise defective gun in the Livrustkammare (Pl. 4:3, 5); this dates from the middle of the seventeenth century.

The English 'dog-locks' have been dealt with in detail by George[39]. The presence of a dog-catch implies a date later than the origin of the flintlock. No examples of the older type are known which are early enough to have influenced the origin of the flintlock.

Even if there is every indication that the Netherlands snaphances deserve their epithet, no such weapon from the period before 1600 has, as far as is known, been yet identified. A gun with such a lock from the end of the sixteenth century in the Livrustkammare (Inv. No. 1251)[40] is called Scottish in Gustavus Adolphus's inventory, although it otherwise looks continental¶. It should perhaps be pointed out that the form of the stock below the lock is similar to the early Scottish pistol in the Töjhus Museum. The pistol in the Musée de la Porte de Hal, which also dates from the end of the sixteenth century, was probably made on the Continent to the south-east of the English Channel. The many details which this type of lock has in common with the wheel-lock also suggest its Continental origin.

When we come to the seventeenth century the probability of the Netherlands snaphance-lock's manufacture on the Continent becomes a certainty.

Jacob De la Gardie's armoury inventory of 1628[41] describes as 'ny nederlandsch' a target gun, which has found its way by unknown routes, but most recently via Algiers to the Musée de l'Armée, Paris (Inv. No. M 688. Pl. 7:2–5). Count De la Gardie's coat of arms (he became a count in 1615) is engraved on the butt-plate (Pl. 7:3). This is of copper with an oval panel of mother-of-pearl inserted for the escutcheon and coronet. In the years 1616 and 1617 a Netherlands embassy visited Jacob De la Gardie in Russia and it seems that the gun might be attributed to that period. Otherwise it would appear to date from the 1620s.

A gun with a Netherlands snaphance in the

21

Wrangel Armoury at Skokloster (No. 298) can be identified as of Netherlands origin by its butt with a supporting rest. There are such rests on several target guns and cross-bows of definitely Netherlands provenance. The Musée de la Porte de Hal, Brussels, and the Rijksmuseum, Amsterdam, provide relevant material for study. There was more such material in the Claes collection, Antwerp, now dispersed. To this can be added representations of a sculptured and gilded stone from the Amsterdam city gate on the Utrecht road, known from Rembrandt's 'Night-Watch', the *Kloveniersdoelen*. The stone is preserved in the city museum (the collections in St Antoniswaag) and shows two crossed target guns with matchlocks and exactly the same stocks and trigger-guards as the Skokloster gun just mentioned.

The existence of the Netherlands snaphance in Italy may be due to indirectly transferred Dutch influence. Arms of Italian design were, it is true, produced also outside Italy. We cannot therefore be absolutely certain that the pistol No. 119 D in the Musée de la Porte de Hal, Brussels, is of Italian origin even if it is Italian in design. It dates from before the middle of the seventeenth century—probably in the 1630s—and may be regarded as a precursor of the Italian flintlocks. The latter also were offshoots from the north.

The Netherlands snaphance probably found its way to Russia through the Dutch artisans who worked in the service of the Czar and the aristocracy. No. B 345 in the Töjhus Museum with stock of west European form belongs to this group. There are several others in the armoury in Moscow[42]. Some of these are reproduced in Lenz's work on the Scheremetew Armoury[43]. The group is also represented in the Livrustkammare by three guns which the Swedish envoy in Moscow, John Gabriel Sparfvenfeldt, presented to Charles XI and Prince Charles (XII)[44] (Inv. Nos. 1699, 1700 and 3897).

The Netherlands snaphance was widely used for military purposes. Count John of Nassau-Siegen states in 1608 in his *Discours das itzige Teutsche Kriegswesen belangend* (Dillenburg Archives, Wiesbaden, No. K 398), that the

dragoons (tragous), a type of troops common in France and the Netherlands, had muskets with 'Füer oder Schottische Schloss'[45]. The use of the adjective 'Schottische' so early in the century is worthy of notice.

An English price-list for gunsmiths of the year 1631[46] includes, amongst other things, 'horseman's pistols fitted with snaphances' and 'carabin with a snaphance'. Judging by the opinion expressed by Pollard[47], Cruso in *Militarie Instructions for the Cavallerie* (1632) probably reproduces military snaphance guns. In 1625 Markham writes in his *Souldier's Accidence* that the modern cavalry of that day ought to be armed with 'pistols, firelocks (if it may be), but snaphances where they are wanting'[48]. There is good reason to consider that these English military snaphances were dog-locks.

The Netherlands snaphance survived even after the flintlock became widely known. Examples can be cited from the Berlin Zeughaus and the Rotunda at Woolwich. The Töjhus Museum, Copenhagen, preserves two guns (Inv. Nos. B 655, B 656) with Ebbe Ulfeld's name and coat of arms and the date 1649. One has a perfectly typical Netherlands snaphance. Even after the tumbler and sear were altered to the flintlock construction the sliding pan-cover and separate steel of the Netherlands snaphance were retained in some quarters. The Moroccan types of the construction have survived over a very long period.

If we are to accept the idea that the flintlock evolved from the Netherlands snaphance it is of importance to prove that this occurred on French soil. A starting point can be found in the already mentioned gun No. 130 (Pl. 7:1) from the *Cabinet d'Armes* now in Mr William G. Renwick's possession. The gun, dated 1622 on the pan-cover, was exhibited in 1931 at a loan exhibition in the Metropolitan Museum of Art, New York[49]. The inventory describes this gun as 'un fusil à l'Angloise'. It would be well to remember that this was written some time during the decade 1663–73 and probably an expression of the writer's opinion of the existence of ancient constructions on the other side of the Channel. It is in any case interesting to observe that nowhere in this inventory do

we find the epithet 'hollandois' for any 'fusil', but, on the contrary, evidence that the type is regarded as being English. A comparison with the barrel of the Danish National Museum's petronel (Pl. 2:1, 3, 4) is both interesting and fruitful. Both are trumpet shaped, bulging round the muzzle with a transverse band behind the latter. The chamber is bordered in front by two such bands. It is of the same shape as that on the barrel of the Spens gun in the Livrustkammare (Inv. No. 1349) and is closely related to the barrels on Scottish pistols. In other respects the gun might well fit in with Continental production, especially the decoration of the stock**. Because of its presence in the inventory of the *Cabinet d'Armes* the gun has a certain French history. It is of a later date, however, than the earliest period of the flintlock. The fact that it was not the only one is shown by a gun formerly in the Zeughaus (Inv. No. A D 8664), now in the Polish Army Museum, which is almost identical in form. The trigger-guard differs slightly from that on Mr Renwick's gun. Both the locks have the same safety device and were made by the same smith, this is shown by the mark stamped in both instances at the foot of the plate between the cock and the shoulder of the cock. The round and convex fence mounted on the pan of the Berlin gun bears the Bourbon-Condé coat of arms underneath the crown of the royal princes.

This heraldic coat of arms and in particular its position afford good grounds for the belief that the gun No. 142 of the *Cabinet d'Armes*, which is described as bearing the arms of France on the pan, had a Netherlands snaphance[50]. This would also provide the requisite evidence that locks of this construction were manufactured in France, as the gun is said to have been made at Montmirail. Seeing that the drafter of the inventory regards this, but not the gun of 1622, as 'ancien', we may perhaps consider that this weapon dates from a period prior to the origin of the flintlock.

Dating from a later epoch, the early 1630s, is a gun in the Berlin Zeughaus, Inv. No. A D 8693. It was, as far as can be judged, made in a district of French culture and has a lock which, taking it as a whole, is a Netherlands snaphance

though it shows certain differences. Of the same period is the French gunsmith Francois Poumerol's poem referred to above. In it he mentions the Netherlands snaphances in such terms that we must presume they were usual on French soil both then and earlier.

Editor's Notes

* For a reference to the firearms in the *Garde Meuble*, see J. F. Hayward, *The Art of the Gunmaker*, Vol. II, p. 30.

† The firearms listed in the appendix as in the collection of the Berlin Zeughaus were nearly all lost in 1945. Many of them are now in the Polish Army Museum.

‡ There is some reason to think that this pistol is, in fact, of English manufacture.

§ Greenwich was the site of the Royal Armoury established by Henry VIII, but there is no evidence for the manufacture of firearms there. Southwark was also for a time the site of an armourers' workshop, while Erith and Deptford were mainly concerned with cannon founding.

‖ The English lock of the first half of the seventeenth century is not now generally known as a dog-lock, as it does not necessarily have the dog-catch from which the name is derived. The dog-catch is not necessarily a development of the middle of the century, but seems to have been more or less contemporary with the first introduction of the lock, see J. F. Hayward, *The Art of the Gunmaker*, Vol. I, p. 275.

¶ This gun is, in fact, without doubt English. Dr Lenk was unaware that an important group of English snaphance firearms exists, sufficient enough, indeed, to justify the French *Cabinet d'Armes* description of a gun with this action as 'fusil à l'angloise'. For a discussion of the English snaphance, see J. F. Hayward, 'English Firearms of the sixteenth century', *Journal of the Arms and Armour Society*, Vol. III, p. 117 ff.

** It is, however, established that bone inlay was also a feature of high quality English firearms of the sixteenth century. There is

at present no means of distinguishing between Dutch and English firearms equipped with snaphance ignition. See J. F. Hayward, *The Art of the Gunmaker,* Vol. I, p. 128.

Notes to Chapter Two

1. Boeheim, *Handbuch der Waffenkunde.* P. 464. Gessler, 'Der Gold- und "Büchsenschmied" Felix Werder von Zürich, 1591–1673'. *Anzeiger für Schweizerische Altertumskunde. Neue Folge.* Vol. XXIV. Pp. 113–17.

2. Livrustkammaren. *Vagledning 1915.* P. 95. No. 380.

3. Le Musée de l'Armée, *Armes et armures anciennes.* T. II. Pp. 133, 134. Pl. 41, 41 bis and 46.

4. Grancsay, *The Metropolitan Museum of Art. Loan Exhibition of European arms and armor.* P. 66. No. 252. Reproduced earlier in Bulletin 1927 of the same museum. P. 198.

5. Guiffrey, *Inventaire général du mobilier de la couronne.* T. II. Pp. 43–84.

6. Guiffrey, *Inventaire général du mobilier de la couronne.* T. I. Avertissement.

7. A copy of this has been placed at my disposal by Captain R. Villemin and M. Georges Pauilhac.

8. Le Musée de l'Armée, *Armes et armures anciennes.* T. II.

9. Wheel-lock gun by Jean Henequin 1621. Bayerisches Nationalmuseum. Pl. 104. Cf. Hoopes, 'Ein Beitrag zum französischen Radschloss'. *Zeitschrift für historische Waffen- und Kostümkunde.* Vol. XIV. Pp. 50–53.

10. Wheel-lock gun by Jean Simonin 1627. Le Musée de l'Armée. *Armes et armures anciennes.* T. II. Pp. 130, 131. Pl. XL.

11. Wheel-lock gun by Claude Thomas, Epinal 1623. Counts of Erbach's armoury. *Catalogue of a valuable collection of armour and weapons, which will be sold by auction by Messrs. Sotheby & Co . . . on . . . July, 1930.* P. 17. No. 15. Reproduced on p. 26. There was previously in this armoury a pair of pistols which made up a garniture with this gun.

12. Flintlock gun. Pl. 14:1–3. Laking, *The armoury of Windsor Castle. European section.* P. 100.

13. Post, 'Ein Paar französischer Radschloss-pistolen von Isaak Courdier Daugbigny'. *Zeitschrift für historische Waffen- und Kostümkunde.* Vol. XIII. Pp. 235–38. Post, 'Ein Paar Steinschlosspistolen von Isaac Cordier Daubigny'. *Zeitschrift für historische Waffen- und Kostümkunde.* Vol. XIV. Pp. 54, 55.

14. Héroard, *Journal.* T. II. P. 86.

15. Gay, *Glossaire Archéologique,* T. I. P. 68.

16. Guiffrey, *Inventaire général du mobilier de la couronne.* T. II. P. 69. No. 203. Now in the Renwick collection.

17. 'Choc' is a small light gun.

18. Le Musée de l'Armée. *Armes et armures anciennes.* T. II. Pp. 138, 139. Pl. XLI.

19. The conformity between the numbers and the inventory must have been known to the publisher of the Paris Museum album. The writer had however, irrespective of this, an opportunity to find this conformity when visiting the Berlin Zeughaus in 1931 and as a result identify in other places arms from the scattered French *Cabinet d'Armes.*

20. Meyrick, *A critical inquiry into antient armour.* Vol. III. P. 114.

21. Magné de Marolles, *La chasse au fusil.* P. 63, note.

22. Appendices. P. 167.

23. Pollard, *A history of firearms.* P. 38.

24. Boeheim, 'Die Luxusgewehr—Febrication in Frankreich im XVII und XVIII. Jahrhundert'. *Blätter für Kunstgewerbe 1886.* P. 34. Fig. 1. The year is altered to 1654 on the original of Boeheim's reproduction. Lenk, 'De äldsta flintlåsen'. *Konsthistorisk tidskrift III.* P. 132.

25. Ehrenthal, *Führer durch die Königliche Gewehr-Galerie zu Dresden.* P. 62.

26. Lenk, 'De äldsta flintlåsen, deras dekoration och dekoratörer'. *Konsthistorisk tidskrift 1934.* P. 124. Fig. 3.

27. Magné de Marolles, *La chasse au fusil.* P. 41.

28. Ibid. Pp. 42–45.

29. Fleming, *Der vollkommene teutsche Jäger.* I. P. 341.

30. Ossbahr, *Das fürstliche Zeughaus in Schwarzburg.* P. 93. No. 988.

31. Whitelaw, *A treatise on Scottish hand firearms.* (Jackson, *European hand firearms.* P. 57.)

32. The portrait has long been known and referred to in the literature of the history of arms (Dillon, 'On the development of gunlocks'. *Archaeological Journal*, Vol. L. 1893. P. 127.) It bears the inscriptions 'Sr Henry Lee of Ireland' and 'Aetatis suae 43, An Do 1594'. Sir James Mann informed me that these were added later.

33. Lenk, 'De äldsta flintlåsen deras dekoration och dekoratörer'. *Konsthistorisk tidskrift 1934*. P. 124. Fig. 2.

34. Hewitt, *Ancient armour and weapons in Europe,* Supplement. P. 657.

35. Boeheim, 'Die Waffe und ihre einstige Bedeutung im Welthandel'. *Zeitschrift für historische Waffenkunde.* Vol. I. Pp. 178, 179. Greener, *The gun and its development.* P. 208.

36. Livrustkammaren. *Vägledning 1921.* P. 86. No. 693.

37. Communicated by Mr William G. Renwick who has also sent photographs.

38. Laking, *The armoury of Windsor Castle. European Section.* P. 115. No. 364.

39. George, *English pistols and revolvers.* Pp. 9–15.

40. Cederström and Malmborg, *Den äldre Livrustkammaren 1654.* P. 59. Pl. 54.

41. Lund University Library. De la Gardie Collection. *De la Gardie 9 d.*

42. *Opis moskovskoj oružejnej palati.* Passim.

43. Lenz, *Die Waffensammlung des Grafen S. D. Scheremetew in St. Petersburg.* Pp. 145–55. Pl. XII, XIII, XV.

44. Livrustkammaren. *Vägledning 1921.* Pp. 85, 98. No. 688, 689, 782.

45. Jähns, *Geschichte der Kriegswissenschaften* II. P. 915.

46. Meyrick, *A critical inquiry into antient armour.* III. P. 86.

47. Pollard, *A history of firearms.* Pp. 45, 46.

48. Meyrick, *A critical inquiry into antient armour.* III. Pp. 87, 88.

49. Grancsay, *Loan exhibition of European arms and armours.* Pp. 65, 66. No. 251.

50. Guiffrey, *Inventaire général du mobilier de la couronne.* T. II. P. 60. Un fusil ancien, le cannon très beau, et riche, couleur d'eau, la culasse à huit pans avec quatre fils d'argent, enrichie d'ornemens d'or et d'argent de rapport, le milieu rond orné de deux trophées d'armes et le bout de quatre fils d'argent, de coeurs entflamez et de flèches entrelassées de palmies; la platine unie, sur le bassinet de laquelle est appliqué l'escu de France, à simple couronne, monté sur un bois rouge orné de compartimens de petit fil de cuivre et pointes d'argent, long de 4 pieds; sur le couvercle du bassinet est gravé *fait à Montmirail.*

CHAPTER THREE

The origin of the flintlock. The flintlock with separate buffer on the plate

THE MOST REASONABLE explanation of the origin of the flintlock has been given by C. A. Ossbahr. He writes: 'The flintlock, an improvement made upon the Netherlands snaphance in France in the 1630s–40s, is composed of the same parts as the latter. But whereas the sear in the snaphance engages the foot of the cock through an opening in the lock-plate, in the flintlock this part is located on the inside of the plate. In addition, the "half-cock" has been added[1].' Ossbahr does not mention the steel.

We continue our investigation along the path thus indicated and begin by describing the construction of the Netherlands snaphance (cf. Pl. 7). The pan is attached to the lock-plate by a 'pan screw' passing through from the outside and placed behind the pan. Externally this pan terminates in a flash-guard or fence, which is usually round on earlier weapons but can also be square. Subsequently it is often in the form of a shell. The pan-cover is borrowed directly from the wheel-lock. It slides on the upper edge of the lock-plate and is attached in a groove underneath the plate to an arm on the inside of the latter. The lower end of the arm is pivoted on a screw fixed from the inside. A

spring is screwed over the arm from the inside. The steel and steel-spring (the latter with the 'u' bend to the front) are attached from the outside of the plate. These screws are often —perhaps almost always—connected by a bridle. The cock and its axle are made in one piece. The axle passes through a hole in the lock-plate, the part inside the plate being of square section. The square part of the axle passes through a tumbler which is fixed to the axle by a pin passing through the latter. A spur projects outwards and downwards at the foot of this tumbler. The long arm of the main-spring presses down on this spur. A forward pointing sear is attached by a pin at the top of the tumbler. The other end of the sear is engaged by the arm of the pan-cover when the cock is set and pushes back the pan-cover when the cock drops. This sear attached to the tumbler is of spring-steel. If the pan-cover is pushed on to the pan when the cock is lowered the sear slides over the arm of the pan-cover. The sear and its arm are also taken from the wheel-lock. The nose of the main sear passes through a hole in the lock-plate and rests above the foot or tail of the cock. The lower jaw of the cock is fixed. The upper jaw

is grooved at the back; the spur of the cock runs in this groove. The spur is straight at the back and ends in a backward scroll. The jaw-screw, with a grooved head, is actuated from above. To prevent the cock from striking the pan in its fall it is checked by a buffer or shoulder fixed with one or two screws from the outside. The lock is, as a rule, attached with three screws. These, as well as those holding the parts of the lock, pass right through the lock-plate.

The mechanism of the Netherlands snaphance is undoubtedly practical. When the weapon is loaded it can be rendered safe in a similar way to the wheel-lock by moving the steel forward. The pan-cover can be moved over the pan even if the cock is lowered for it is held at a suitable distance from the pan by the shoulder. When the steel is dropped forward and the cock rests on the shoulder the lock is at rest. Some of the existing guns also have the ordinary wheel-lock safety which stops the sear-arm with a hook. The main advantage of this device is that when the weapon is held at the ready it can be disconnected by a simple movement of the thumb. The disadvantages of the construction are, like those of the wheel-lock, that it is complicated. The mechanism of the flintlock is likewise a simplification of the older construction.

The change-over from the Netherlands snaphance to the flintlock can be described more fully as follows: the sliding pan-cover of the Netherlands snaphance and a steel mounted on an arm are exchanged for a pan-cover and steel in one piece (a battery or frizzen). This is forced open by the pressure of the falling cock. The flash-guard disappears, but the steel-spring is retained, though without a bridle. The steel is borrowed directly from the 'Mediterranean lock'.

Two notches are filed in the tumbler, which no longer needs a sear for the pan-cover. A sear moving vertically and giving full and half-cocks by a nose engaging in the two notches is substituted for the horizontally moving one. A transitional form with only one bent is hardly to be expected as the construction must have been devised in order to provide a solution of

the half-cock problem. There are, in fact, several examples of one-bent tumblers, but these belong to other types of locks, such as the Nordic snaphances with the main-spring on the inside of the lock-plate. They can be explained as derivations from the flintlock.

The vertically moving sear which engages in a notch in a tumbler can hardly be regarded as a new invention but is merely derived from the crossbow lock.

The most radical simplification was effected by the adaptation of the steel. This dispenses with the arm of the pan-cover and its spring, as well as with the secondary sear projecting from the tumbler.

The function of the steel is to be opened by the cock so that the sparks can reach the priming powder. The cock cannot therefore be lowered completely as it can on the Netherlands snaphance when the weapon is set. At the same time the position of the cock at full bent involves a risk. This risk is avoided by providing the half-cock bent. The latter is so constituted that the nose of the sear cannot be raised from the half-cock bent by pressure of the trigger on the sear.

The flintlock consists of two basic features, viz. the half-cock formed by a vertically moving sear engaging in a notch filed in the tumbler and the combined steel and pan-cover. Other means have, however, been adopted to provide the half-cock in the cultural sphere with which we are now concerned. In doing so the horizontal action of the sear has been retained. The English dog-locks have already been mentioned. The half-cock has also been obtained by means of a dog-catch alone. Two guns dating from the 1630s–40s in the Musée de l'Armée (Inv. No. M 530) are examples of this. The next step forward was to provide the dog-catch as an additional safety device. This construction was widely adopted in the Swedish military flintlocks. The Kabyle gun (Schön, Fig. 41) also forms the half-cock with a catch. Judging also by a pair of Ripoll pistols of early seventeenth century type in the Töjhus Museum, Copenhagen (Inv. Nos. B 342, B 343), and a similar one in the Pauilhac collection, Paris, previously in the Estruch collection[2],

this construction was introduced in the earlier half of the seventeenth century.

Another solution of the half-cock problem, while retaining the horizontal action of the sear, is achieved by lengthening the sear. This passes through the lock-plate and serves as a rest for the breast of the cock at half-cock. The full-cock is then provided on the tumbler. Earlier examples of this construction are one of Queen Kristina's guns in the Livrustkammare (Inv. No. 1280)[3] which should probably be dated to the 1630s, though this date is uncertain, and a gun with half-cock lock in the same collection, Inv. No. 1333 (Pl. 39:3, 5. Cf. below, p. 65)[4]. The construction can be found in later Scottish weapons (Livrustkammaren Inv. Nos. 1742, 1743, 4925, 4926) and similar constructions in many Spanish and Italian firearms dating from the close of the eighteenth century (Livrustkammaren Inv. No. 5323, gun by Mariano of Naples)[5]. This construction, like the dog-catch, is probably of more recent origin than the flintlock.

The close connection of the flintlock with the Netherlands snaphance is evident from a literary source which has already been briefly mentioned (p. 6). This source proves that the construction is earlier than the 1636 gun of the Musée de l'Armée, Paris. The gunsmith François Poumerol presented a gun and a pistol to Louis XIII. At the same time he presented a poem which concludes with a hope that he might be allowed to enter the king's service. These *Quatrains au Roy* were printed in 1631 by Pierre Rocolet 'au Palais'.

Poumerol states that he is over fifty years of age. He was apprenticed at the age of twelve, consequently not later than 1593, and must therefore have been an expert gunmaker just at the time at which the invention of the flintlock can be expected.

The character of the poem as a petition is of less interest. It seems, however, to have led to his employment, not by the king but by his brother, Gaston, 'Monsieur', later Duke of Orléans[5].

These *Quatrains au Roy* deal chiefly with the art of judging the quality of a firearm and how to preserve its splendour and quality. They show that the writer prefers simple weapons, and that he has a good knowledge of military arms and is conversant with guns both 'à rouet' and 'fusils'. Among other things he gives the following information:

Et, pour ne rien celer en se discours des armes,
Parlant des pistolets, je diray nettement
Que je suis estonné qu'en ce temps plein d'alarmes
L'usage des fuzils s'y voit aucunement.

Car, tant que la guerre est, je ne puis me resoudre,
A faire des fuzils que pour le cabinet.
Le feu s'y fait trop haut au-dessus de la poudre,
Et s'escarte en tombant autour du bassinet.

En outre ce deffaut, un autre est au couvercle
Qui ne s'ouvre en haussant qu'apres le coup du chien;
Ce coup fasisant le feu, ce feu trouve un obstacle
Qui l'empesche d'entrer où la poudre se tient.

Et neantmoins, au temps d'une paix asseuré,
Pour la chasse, en tous lieux unis raboteux,
Les fuzils sont aisez et de longue durée;
Mais au besoin de Mars ils sont un peu douteux.

A ces fuzils nouveaux il y faut une pierre
Mince et large, à l'esgal de la pièce devant
Et, selon qu'elle s'use (ouvrant ce qui la serre)
Il en faut mettre une autre, ou le tourner souvent.

Les fuzils à l'antique, estant de bonne force,
Le bassinet s'ouvrant à temps et par ressort,
Semblent estre meilleurs, d'autant que sur l'amorce
Le coup du feu s'y fait plus à plomb et plus fort.

Mais le plus asseuré, où le plus j'acquiesce,
C'est quand le bassinet est libre au coup de feu,

Plate 21.

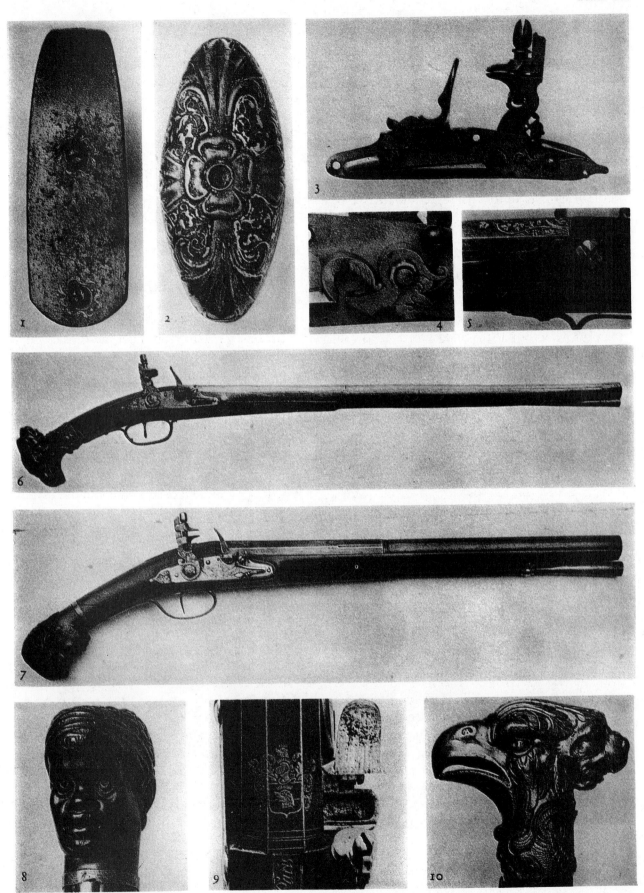

France, Paris.
1640s.

1. Detail of gun on Pl. 20:1. 2–5. Details of pistol on Pl.
20:2. 6 and 10. Pistol by Laon (Langon) of Paris; Lowenburg Castle W. 1157. 7–9. Pistol, one of a pair, Devie of
Paris; Dresden, Historisches Museum P. Z. 272.

Plate 22.

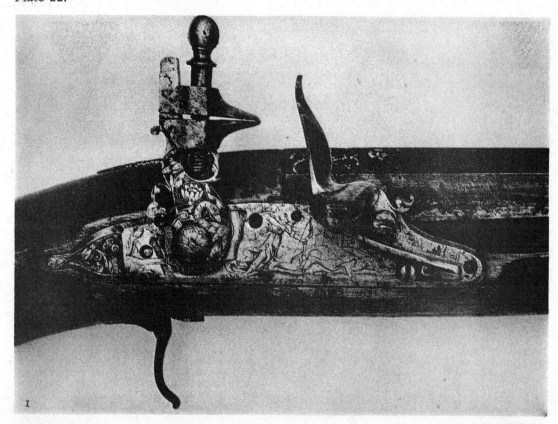

France.
1630–40s.

1. Lock of Gun on Pl. 20:1. 2 and 3. Rubbings of lock-plates; Berlin, Staaliche Kunstbibliothek O.S. 825.

Plate 23.

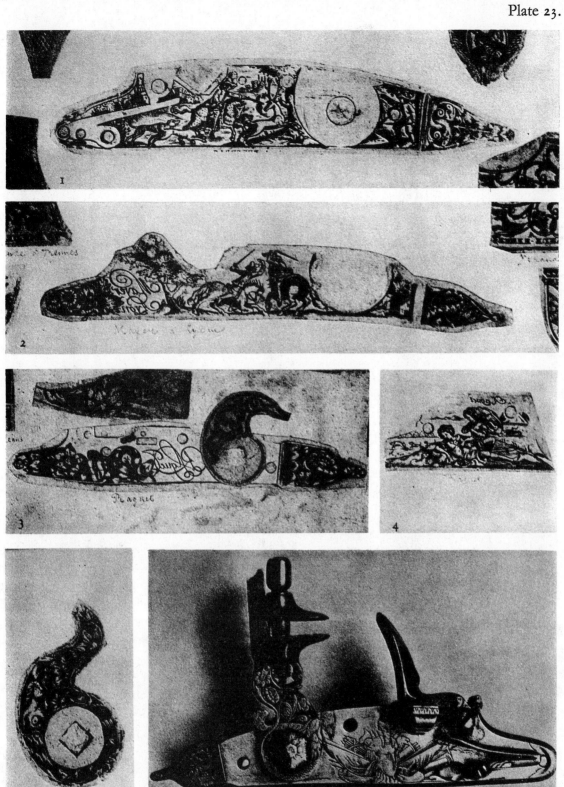

France.
1640s.

1–5. Rubbings of lock-plates. 1. 'A Bergerac', 2. 'Mayer à Lyon', 3 and 4. 'Raguet'; Berlin, Staatliche Kunstbibliothek O.S. 825. 6. Lock of pistol on Pl. 21:7.

Plate 24.

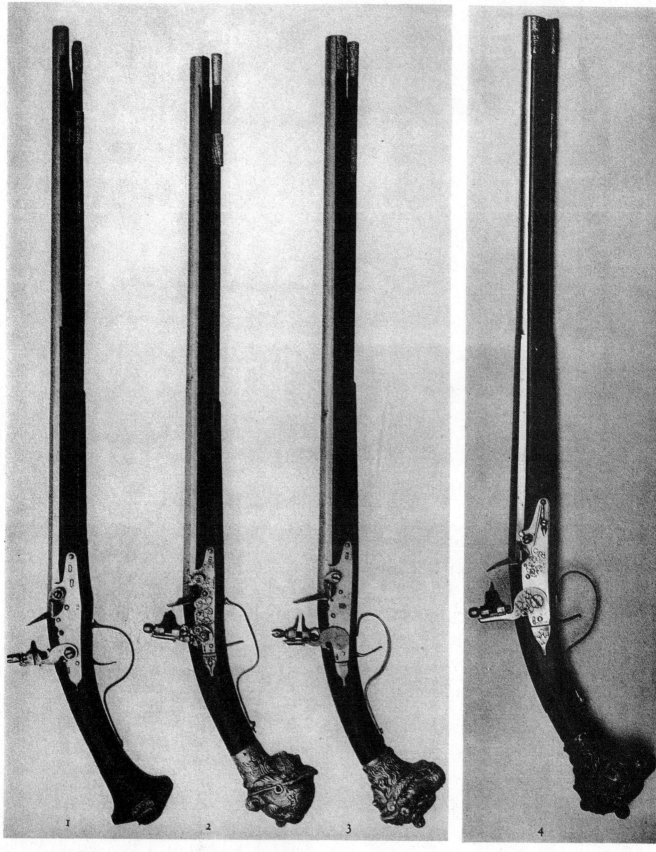

France.
1630–40s.

1. Pistol with butt-cap and ramrod pipes of stamped silver sheet, 1630s. 2–4. Pistols with butt-caps of chased silver and stamped or engraved ramrod pipes 1630–40s. 1–3; Skokloster, Wrangel Armoury 61, 70 and 68. 4; Dresden, Gewehrgalerie 1551.

*Et que ce coup bas n'hausse, ains pousse l'avant-
pièce.*
Le feu s'y fait plus bas, et bas s'escarte peu[6].

The importance of these quatrains lies in the
fact that the writer knows of two kinds of
'fusil'; the one 'nouveau', the flintlock, the pan-
cover of which is raised when struck by the
cock, the other 'à l'antique' the Netherlands
snaphance the pan of which is opened by a
spring.

Now if this theory of the origin of the flint-
lock, which is supported by Poumerol's
Quatrains, is correct, it should be possible to
find extant flintlock arms which are clearly
linked to the Netherlands snaphances. Such do
exist and the link is the shoulder of the cock.
The Hermitage Museum in Leningrad possesses
a flintlock gun (Inv. No. F 281, Pl. 8) which is
reproduced by E. Lenz in his *Collection d'armes
de l'Ermitage impérial*, St Petersburg, 1908,
Pl. 29. The text states that the gun bears the
coat of arms of France and Navarre and that,
according to tradition, it had belonged to Louis
XIII of France. The same author's catalogue[7]
issued the same year in Russian gives the
following details regarding the gun: that it
came from Prince Condé's armoury at Chantilly,
that the barrel is blued and has golden orna-
ments, that the stock is inlaid with mother-of-
pearl, silver and brass, that the coats of arms of
France and Navarre are applied on a round
plate on the small of the butt, that a plate at the
trigger-guard contains an engraved inscription,
'M. Le Bourgeoys à Liseul', and that a number
'152' is cut into the stock. (It will be seen from
Pl. 8:3 that the number is stamped in the stock
in front of the trigger-guard.) If we take this
number as a clue and look up the inventory of
the French *Cabinet d'Armes* we find the
following description under No. 152: 'Un beau
fuzil de 4 pieds 3 pouces, le canon rond avec un
petit pan doré en couleur d'eau sur le bout, et
sur la cullase de rinseaux; le platine couleur
d'eau, gravée en blanc, ayant un rond doré uny
sur le milieu, sur un bois de poirier, qui forme
un pied de biche dans la crosse, fait par
Bourgeois à Lizieux'[8]. The inventory of 1729
adds: 'au haut de laquelle (la crosse) est une

plaque de cuivre ciselée et gravée de rinceaux
dorés, avec les armes de France et de Navarre'[9].
The identity is unquestionable.

A gun of the same construction and same
decoration is preserved in the Musée de
l'Armée, Paris (No. M 529, Pl. 11:1, 2). It has a
heavy hog's back barrel, the gold decoration
against a light blue (couleur d'eau) ground,
producing a charming colour contrast. The lock
has many features similar to the gun in the
Hermitage Museum: the form of the cock and
the way it is attached, the shoulder on the plate,
the high steel terminating in a scroll, the out-
ward bulge at the bottom of the lock-plate and
the pointed finish at each end as also the round
medallion under the pan. The differences are:
the shorter arm of the steel and the angular
outlines of the Paris gun. The etched decoration
of the lock-plate is of the same type in both
instances. The same kind of ornament is also
painted in gold on the butt of the gun in the
Musée de l'Armée. In addition it is decorated
with thin inlaid silver lines. A comparison
between the decoration of this weapon and that
on still another flintlock gun in the same
museum (Inv. No. M 435: Pl. 11:3, 12:3–6),
signed 'M. le bourgeoys' at the foot of the butt-
plate, leaves no room for doubt that M 529 was
also decorated by the same hand. No. M 435
will be dealt with below. The original source of
these guns can then be located in Lisieux, in
the eastern part of the Department of Calvados.
Their number can be increased by a matchlock
gun in the Musée de l'Armée (Inv. No. M 369,
Pl. 12:2)[10].

As the above has given us a name and a place
for the earliest flintlocks it would be most desir-
able if a thorough investigation of their manu-
facture could be made. This, unfortunately, is
rather a large undertaking. It would first mean
going through a great amount of material in the
Municipal Archives at Lisieux. But it is to be
hoped that such scattered notices as can be
collected will be compiled and published now
that attention has been called to the importance
of such research.

Georges Huard has contributed a consider-
able amount of interesting information[11] in a
number of articles on Marin Le Bourgeoys, his

life and work. Previously it was known that Le Bourgeoys was one of 'les illustres' who had received a 'brevet de logement' on 22 December 1608, in the recently completed Louvre Gallery. He was at that time 'peintre et vallet de chambre et ouvrier en globes mouvans, sculpteur, et aultres inventions mécaniques'[12].

According to M. B. Fillon, Marin Le Bourgeoys was probably born in the middle of the sixteenth century, and he became 'peintre ordinaire' on 11 June 1589, to the Governor of Normandy, François de Bourbon, Duke of Montpensier (d. 1592). He became 'vallet de chambre' to Henry IV in 1598, and in this capacity and as painter to the King he appears on the wage lists right up to the end of 1633[13].

Huard declares that Marin Le Bourgeoys belonged to a family of locksmiths, watch-makers, cross-bow makers and gunsmiths resident in Lisieux. He also seems to have worked there all his life, in spite of the royal favour and the dwelling granted to him in the Louvre. He is first mentioned in 1583, when he, along with another painter, executed decorations for the entry of the Duke de Joyeuse into Lisieux. As a painter he seems to have been very versatile, and his talents sufficed for many other tasks. He was a sculptor and maker of musical instruments. He made a terrestrial globe which Henry IV deposited in the large gallery of the Louvre together with other of his works. In the second edition of *Les éléments de l'artillerie*, Paris, 1608, from which these details have been taken, Rivault de Flurance speaks of an air-gun with a copper barrel. In 1605 Bourgoys is definitely called a 'harquebuzier' (gunsmith). He then receives a travelling allowance to enable him to hand over a gun, a hunting bugle and a cross-bow, 'le tout de sa façon' to the king in Paris. Marin Le Bourgeoys was moreover an art-dealer, according to de Peiresc's correspondence[14], Louis XIII 'visita le cabinet d'un nommé Bourgeois'.

Now that this information is available and is, furthermore, supported by Marin Le Bourgeoys' signed guns, one of which has a flintlock of the earliest type, both the construction and the manufacture can reasonably be ascribed to him, the more so inasmuch as this latter assump-

tion is supported by entries in the inventory ('Fait par Bourgeois'). This may indeed be the case, but there are other facts which sound a note of caution. Le Bourgeoys' signature can be read in both cases on the mounts and not on the locks. In the round medallion on the lock-plate of the unsigned gun in Paris there are the remains of a very damaged mark with two initials. The first, 'I', is quite distinct, the second can be read as 'C'. This 'I C' must then have made the lock and Le Bourgeoys executed the decoration.

The inventory mentions six weapons as having been made in Lisieux. Two of these are attributed to Le Bourgeoys. One is the gun in the Hermitage Museum; the other No. 134 of the Inventory 'fait à Lisieux'[15] is identical with the already mentioned No. 252 in Grancsay's catalogue of the Metropolitan Loan Exhibition of 1931[16]. It belongs to Mr William G. Renwick (Pl. 9). The construction is the same as that of the early flintlock already described. As to form and decoration it shows a distinct link with the Hermitage Museum gun. Marin Le Bourgeoys certainly had something to do with this gun. Even if he did not personally have a hand in its manufacture it is nevertheless probable that it originated in close proximity to him and not only derives from the town of Lisieux but from his immediate circle.

A mark with a cross-bow and the letters 'I B' is stamped on the chamber close to the breech-block[17]. Marin Le Bourgeoys had a brother Jean (d. 1615)[18]. This Jean Bourgeoys or Le Bourgeoys—the members of the family wrote their name with, as well as without the article—was a gunsmith and watchmaker. This is evident from the 'Compte des deniers communs' in Lisieux for 1603. According to it 'Jean Le Bourgeoys, armurier', was entrusted[19] with the care of the town clock. He is also called 'maistre armurier et horloger'[20] in his daughter's marriage contract of 1627. It is rather unlikely that there was another gunsmith with the initials 'I B' in the tiny town of Lisieux during the first two decades of the seventeenth century. We can, therefore, undoubtedly agree with Stöckel when he states that this mark is that of Jean Bourgeoys.

Additional reasons for attributing the mark to this period can be found in a group of fire-arms of consistent form and decoration. Chief of these is a double barrelled pistol with two wheel-locks (Pl. 13:1, 2) in the Pauilhac collection in Paris. It bears No. 238[21] of the French *Cabinet d'Armes* and is so closely related to Mr Renwick's gun that as regards material, technique and decoration the weapons might have belonged to the same set. Decoration in the typical technique of Marin Le Bourgeoys is to be found on the barrels and mounts on the upper side of the small of the butt. Other pieces in this group are No. 211 in the French *Cabinet d'Armes*, a pair of wheel-lock pistols, one of which is No. 9178 in the Zeughaus, Berlin*, the other No. 842[22] in the Wallace Collection. In addition a wheel-lock gun of Louis XIII in the Wallace Collection (No. 1133, the French *Cabinet d'Armes* No. 61)[23] bears the same mark in the same place†. It also closely resembles Mr Renwick's gun, especially in the decoration of the barrel and in a mother-of-pearl medallion with an antique warrior figure cut in relief and inset in the small of the butt. That in the Renwick Collection has a medallion with a woman's figure in the same place. The pistols enable us to date the group. They are more archaic than No. 257 of the French *Cabinet d'Armes*, a wheel-lock pistol made by Marin Masue at Vitré in 1612[24], or a pair of wheel-lock pistols at Rosenborg in Copenhagen, Inv. Nos. 7–137. These can be dated by comparison with No. 40 of the French *Cabinet d'Armes*, a wheel-lock gun, now in the Musée de l'Armée, Paris, No. M 95[25]. This bears the date 1613 on the barrel. No other directly comparable dated weapons of French origin are known, but there is in the Livrust-kammare a pair of pistols, Inv. Nos. 1576, 1577[26], dated 1603. Their barrels and cocks agree so closely with those of the pair of pistols in Berlin and the Wallace Collection that they must have been made about the same time. This in its turn involves the entire group stamped with the 'I B' mark and brings it into the very period when Jean Bourgeoys lived and worked in Lisieux. The inventory of the French *Cabinet d'Armes* actually states that

Mr Renwick's gun was made in that town.

If we thus have every reason to accept the view expressed by Stöckel, but not yet proved, namely that the 'I B' mark is that of Jean Bourgeoys, this gives a definite *terminus ante quem* for the gun in the Renwick Collection, viz. 1615, the year of the master's death, and consequently also for the origin of the flintlock. For the *terminus a quo* the gun itself provides the necessary information by reason of the 'L' (cf. Pl. 9:3) surmounted by the royal French crown on the left-hand side of the stock opposite the lock. This indicates that the gun was made for Louis XIII, and since he became king in 1610 the gun must have been manu-factured some time during the period 1610–15.

To this, the earliest group of French flintlock weapons, belongs another gun in the Musée de l'Armée, Paris (unnumbered, Royal Inventory No. 139, Pl. 11:4)[27]. This is of slightly later date than the first group. It differs from them in that the body and neck of the cock are broader. The pan is, as on the Netherlands snaphances, attached by a screw the head of which is behind the pan on the outside of the lock-plate (the pans of the Lisieux weapons are riveted). The steel is squat and abruptly truncated at the top like the pistol mentioned above with a snap-hance lock in the Historisches Museum, Dresden (Pl. 6:2–5). This gun shows other features that differ from those of the authentic Lisieux weapons. Directly below the pan at the lower edge of the lock-plate, a mark with the initials 'P L' is stamped in an angular, crowned shield[28]. This gun provides further useful evidence in dating the origin of the flintlock by its similarities, among them the form of the butt, to a wheel-lock gun by D. Jumeau, dated 1616 (No. M 102) in the same museum. Jumeau, according to Michel de Marolles, lived in 'les galeries du Louvre'[29].

Besides these flintlocks with buffers on the lock-plates three more have been discovered, one on a gun in the Tower of London Arm-ouries (Inv. No. XII: 1131. Pl. 14:5, 15:1) and on two guns formerly in the Museum of Artillery in the Rotunda, Woolwich (Inv. No. VI: 75 and IV: 20. Pl. 15: 2, 4, 15:3, 5). Of the two latter the first has since been transferred to

the Victoria and Albert Museum (No. M 6–1949), the latter to the Tower of London (No. XII: 1442). It is included in No. 138[30] of the French Cabinet d'Armes.

Finally mention may be made of a small-bore gun in the Royal Armoury, Windsor Castle (Inv. No. 316. Pl. 14: 1–3). It was presented by Lord Fife in 1823, and it would not be surprising if it had come to England with the troops returning home from the Napoleonic wars. The gun is published by Laking, who states that it has a snaphance lock ('The lock is upon the snaphance principle'), that it is dated 1630 and he records an assumption that Marshal Turenne was its owner[31]. The lock-plate bears an inscription which Laking makes out to be 'Faict À Turene'. He moreover deciphers a '1630', which is not to be found. Of this (cf. 14:2) 'Faict À Turene' is quite clear so that the place of manufacture can be recognized as Turenne near Brive in the Department of Corrèze. This is not far from Tulle which was later to become famous for the manufacture of arms. The rest of the inscription permits different interpretations. It is out of the question, however, to make '1630' of it. What were thought to be the final figures have on closer examination proved to be part of the decoration. What precedes this are the initials 'm. d.', which would mean 1500 if the inscription signified a date. Since the gun dates from the beginning of the seventeenth century this interpretation is also excluded. It then remains to interpret 'm. d.' as the initials of a signature. Marshal Henri de la Tour-d'Auvergne, vicomte de Turenne, is also ruled out, for the gun bears an owner's coat of arms (Pl. 14:3) opposite the lock, those of Phelipeau la Vrillière, although reversed and under a ducal coronet. So far as is known, no member of the family could claim it.

Two engravings by J. Henequin of Metz are relevant to this piece. One belongs to a series of six plates preserved in Paris (Bibliothèque Nationale, Cabinet des estampes. Le 24. Pl. 103:1). The other belongs to the Kunstgewerbe Museum in Hamburg (O. 1905. 226. Pl. 103:3)[32]. Both illustrate cocks and buffers, the latter a cock which accords in form and construction with those on the Hermitage gun and on Mr

Renwick's gun. Henequin's period of activity is given by the year 1621 on a wheel-lock gun signed by him in the Bayerisches National Museum, Munich (Inv. No. 1733. Pl. 104)[33]. The fact that he worked for the French Court is evident from Louis XIII's monogram and coat of arms. These are engraved on the butt-plate of the gun (cf. Pl. 104:3).

Before proceeding further it might be well to eliminate from the discussion on the origin of the flintlock a rubbing of a lock-plate which might be taken to be one of the earliest[34]. It is preserved in the volume Le 24 in Bibliothèque Nationale, Paris, Cabinet des estampes, and is reproduced here reversed (Pl. 14:4). The lock is signed 'P. Cordier', in all probability the same Philippe Cordier Daubigny who signed a number of pattern plates for gunsmiths (Pl. 108)[35]. It is probably this rubbing which Boeheim refers to in his statement regarding 'der Abdruck einer überaus schön gravierten Schlossplatte, bezeichnet "Jean Cordier fecit"' which was in 'l'Institut' in Paris. No collection of rubbings is, however, kept there, but there is certainly one in the Bibliothèque Nationale.

It can be proved by the marks of screw-holes and pins that this lock had a buffer in front of the cock on the outside of the lock. The hole for the sear-screw can be seen behind the hole for the axle of the cock and immediately above it there is yet another which can be explained as a screw-hole for a dog-catch. The short distance between the holes for the axle of the cock and sear-screw is evidence that the lock was not one of the earliest types. In the latter this distance, which is governed by the length of the nose of the sear, is greater.

The earliest flintlocks are in one way or another connected with the royal house of France. It is evident from what has already been said that the firearms of this earliest type which have been preserved with the buffer all belonged to the *Cabinet d'Armes,* with the exception of the Tower of London No. XII: 1442‡ and the Windsor gun. Henequin worked for Louis XIII.

The evidence at our disposal in dealing with the earliest flintlock weapons is extremely limited. To assemble these pieces in a typo-

logical series may seem from the nature of the case to be doomed to failure. The typological way of looking at things is, on the whole, uncertain. The types may correspond or just overlap as regards time but can nevertheless—correctly analysed and placed side by side—indicate the rate of development and the direction of progress. The information thus obtained indicates probable solutions. In the present investigation, where the absence of documentary sources is very noticeable and may be expected to persist, the typological method is the only feasible one.

The butt-forms offer favourable possibilities for compiling a typological series as a guide to dating.

The two principal types of gun-butts are the German and the musket-butt. The straight German butts were laid against the cheek, the musket-butts, at least in most cases, against the shoulder or chest[36]. Sir Roger Williams, the English author, expresses this latter view in his *Discourse of Warre*, printed in the time of Queen Elizabeth. He definitely calls the curved musket-butts French[37]. Viewed from behind both types are formed from a rectangular central part with a triangular comb. The musket-butt has, in addition, a triangular lower edge. On the straight German butt the cheek spreads downwards and outwards from the inner side of the central part. The musket-butt is characterized by the downward trend of the central part and the bold upward trend of the comb. The high comb probably originated when it became customary to press the butt against the shoulder. The two early French wheel-lock guns mentioned previously (p. 3), Nos. M 66 and M 82 in the Musée de l'Armée, Paris, show the musket-butt at an early stage. It develops along two lines. On the one hand the central part and underside descend in increasingly bolder curves and the comb sweeps in a corresponding manner upwards. The most exaggerated forms are to be found in the Netherlands during the decades around 1600. A group of wheel-lock guns dating from 1596 and a matchlock musket, all in the Livrustkammare and all with the Amsterdam mark[38], may be cited as examples. This type of butt with

increasingly rounded forms still survives on muskets throughout the whole of the earlier half of the seventeenth century. Their last offshoots are to be found on the Moroccan guns with Netherlands snaphances. In the second instance—and this applies precisely to France—it is true that the comb of the butt becomes definitely larger and at the same time acquires a slightly upward swing about 1600. The central part on the other hand becomes straighter and tends to lose its slight sweep. The comb of the butt is occasionally very thin at the top and the upper edge reinforced, terminated in a torus at the thumb-rest. About 1615 the forms were very austere. The line defining the comb at the top was quite straight and the underside turned almost imperceptibly downwards. No. M 95 of the Musée de l'Armée in Paris, the wheel-lock mentioned above, which is dated 1613 and signed 'Aumon fait tel' and 'F. P.'[39], as well as the wheel-lock gun by Jumeau, dated 1616, afford examples of this development. A typical specimen is the wheel-lock gun with the mark of Masue, the Vitré master, in the Löwenburg on Wilhelmshöhe at Cassel (Inv. No. W 1253). It can be dated by comparison with the wheel-lock in the Tower of London Armouries just mentioned (Inv. No. XII:1075). According to the inventory of the French *Cabinet d'Armes* (No. 257) it bore the inscription 'à Vitré par Marin Mazüe 1612'; this is now partly effaced, but it still bears the same mark as the gun in the Löwenburg.

In the 1620s the thumb-rest disappears and the downward sweep of the underside becomes bolder. Examples are the wheel-lock gun signed and dated by 'Jean Henequin à Metz 1621' in the Bayerisches National Museum (Pl. 104) and a wheel-lock gun in the Musée de l'Armée, Paris (Inv. No. M 131), signed and dated 'Jean Simonin à Luneville 1627'[40]. A gun of the same period signed 'J. Habert à Nancy' (French *Cabinet d'Armes* No. 43)[41] is in the Pauilhac collection, Paris. The form and the carved band passing obliquely across the stock in front of the lock enable us to date it approximately[42].

Not only the wheel-lock signed by Jumeau but also Aumon's gun of 1613 and Masue's gun of about 1612 enable us to date No. 139

33

(Pl. 11:4) of the French *Cabinet d'Armes* to about 1615. All four have butts of the same form. The butt of No. M 529 (Pl. 11:2) of the Musée de l'Armée, decorated by Marin Le Bourgeoys, is very closely related but has a slightly more curved profile which would seem to indicate an earlier date. With the help of the Renwick gun (Pl. 9) it should be possible to penetrate still further back. The Lisieux weapons generally have, as a matter of fact, butts of a very individual form, especially that in the Hermitage Museum with its deer's foot, a trophy of its sporting owner, as a striking feature.

With this comparatively reliable starting point for dating according to form, it is possible by analysing No. 139 of the inventory in Paris (Pl. 11:4) and comparing it with other weapons to get an idea as to what is early and what is late. A close similarity to snaphance weapons should then lead to earlier dating, and similarity to reliably dated later weapons to later dating.

No. 139 of the Paris inventory has a rather narrow, slightly 's' shaped cock attached from the outside by a screw into the square of the tumbler. The head of this screw is rounded and grooved. The spur of the cock is straight and has a scroll at the top. The upper jaw slides on the spur of the cock which has a notch at the back, and the head of the jaw-screw is almost ball shaped. There is an ornament in the form of a scroll in the curve at the rear of the cock. This scroll swings out into a point immediately above the cock-retaining screw. Just opposite there is a projection on the belly of the cock with a leaf ornament. This projection rests against the buffer when the cock is lowered. The buffer touches the cock directly opposite the cock-retaining screw, and the part of it behind the screw is very short. This projection on the cock, the short buffer and its position on the lock-plate are typical features of the earliest flintlocks. It might be supposed that this also applies to the Netherlands snaphance made in French territory from which the flintlocks were directly developed. No such actual weapon has hitherto been found, however. It is true that those known to be of

English or Netherlands provenance have, if they are late, short buffers pointing towards the base of the cock, but there is no projection in the latter. The buffers of the earlier ones are long and engage to the belly or simply the neck of the cock.

The gun most closely related to No. 139 of the inventory is No. M 529 in the Musée de l'Armée, Paris (Pl. 11:1, 2). The 's' form of its cock is not quite so accentuated. The neck is much more slender, the projection on the belly of the cock is undecorated. Instead the leaf shaped ornament in the curve of the back of the cock ending in a volute below is all the more emphatic. There is also a small scroll on the neck in the angle of the lower jaw. The cock-retaining screw has a convex, round head which covers most of the body and terminates in a square end which can be turned with a key.

The snaphance cocks are thin at the beginning of the seventeenth century and have a decidedly straight neck which continues the profile of the spur and forms below it a distinctly bulging belly. The straight and thin form is to be found on the Renwick gun and the Hermitage Museum gun (Pl. 8, 9), but the curve of the belly is considerably modified. The closest affinity to the snaphance cock is to be found on Henequin's pattern sheets (Pl. 103:1, 3). The sheet in Hamburg shows the square head of the tumbler and all the other projections and scrolls. Henequin has only filled in the recess at the back of the snaphance cock and left the foot of the cock, which on the snaphance engaged half cock, in the rudimentary form of a scroll. A ribbon passing across the body of the cock shows that this is intended to be flat, like the corresponding part of De la Gardie's gun in the Musée de l'Armée (cf. Pl. 7:4).

It is possible that Henequin's engraving of a flintlock cock in the Cabinet des Estampes, Paris, should be regarded as representing a still earlier stage. The reason is that Henequin has designed the foot of the snaphance cock as a scrolled, scaly tail and the cock is attached from the inside like the Netherlands snaphances. It consequently has no tumbler-square.

In dealing with the steel a different line can

perhaps be taken. Those of the Netherlands snaphances are slender and tall. They are thickest at the middle where the arm, the length of which depends on the space required by the pan-cover, is attached and they terminate above in a scroll. When the change-over to flintlock takes place, the arm of the steel is moved down to the edge of the pan-cover but retains a great part of its length. The steel is still thickest at the middle. The Hermitage Museum gun and the Renwick gun have a separate striking surface attached by a screw through the thickest part of the plate. This is the surest proof of the link with the 'Mediterranean locks' and at the same time a reason for regarding these weapons as the oldest. All the arms considered here to be of early date have long steel arms. No. M 529 of the Paris museum and that of the Victoria and Albert Museum No. M 6–1949 are slightly shorter than the others. They also have, with one exception, slender steels which do not extend the whole width of the pan-cover. The low, broad steel of No. 139 of the *Cabinet d'Armes* in Paris does, however, extend right across it and this, as has already been pointed out, is also reminiscent of the 'Mediterranean locks'.

An interesting point about the pans is that in the case of the Hermitage Museum gun, the Renwick gun and the Victoria and Albert Museum No. M 6–1949, they are set in a rectangular recess in the lock-plate. In longitudinal section the pans of these guns are rectangular, bevelled in front and at the back. On No. M 529 of the Paris museum and No. 139 of the French *Cabinet d'Armes* in the same museum this bevelling is gradual so that the section of the pans is triangular with the lower apex cut off. The pan of the Netherlands snaphance is attached from outside by a screw passing behind it. This is also the case on a few of the oldest flintlocks. The pans of the others are riveted to the lock-plate. The method of attaching the pans does not seem to help in dating according to type. The fence of the Netherlands snaphance became so traditional a feature of the lock-plate to the gunsmiths that it has been rendered in embryo on the lock-plate of the Hermitage Museum gun. On the

gun No. M 529 in the Musée de l'Armée, Paris, Marin Le Bourgeoys has depicted this relic of a guard as an empty circle in the ornamentation. In the middle of it the unknown master 'I C' has stamped his mark.

The Netherlands snaphances are, as a rule, attached with three screws, the flintlocks with two. A comparison between the De la Gardie gun on the one hand and the Hermitage Museum gun and the Renwick gun on the other shows that the step from the Netherlands snaphance lock to the flintlock is very short. At the beginning of the seventeenth century the plate of the Netherlands snaphance generally terminates at the back with a drop like prolongation. Both the flintlock guns have this finial in somewhat modified form at each end of the plate. The upper edge of the Netherlands snaphance lock rises at first rather gradually from the rear, but acquires a pronounced ledge or outward bulge at the foot of the cock and then rises steeply towards the pan. The plates of the flintlocks are more uniform. They are, on the whole, narrower since room is no longer needed for the various parts of the sliding pan-cover. They have a tendency, however, to acquire a more or less marked downward bulge; it is not clear whether this is due to a desire to increase the strength of the lock-plate or to the influence of the wheel-lock construction. The upper edge of the lock-plate of the Hermitage gun rises rather sharply towards the pan. Just in front of the cock there is a swelling which is explained by comparison with the snaphance. As regards the outside surface of the locks all that needs to be added is that the forms are flat and that both the screws by which they are attached and those with which their parts are fixed project through the plate, as in the case of the snaphances. The tumbler and sear also provide indications of date. The idea of tumblers with notches could, as mentioned above, have been derived from the cross-bow. The simplest and most circular tumblers are found on the Renwick gun and the Hermitage gun with No. 139 of the French *Cabinet d'Armes* in the Musée de l'Armée and the Tower of London Armouries (XII: 1131) next in close resemblance. Common

to all is the fact that they lack any indication of a counter-cocking bent on the tumbler§. On the Windsor gun (cf. Pl. 14:1–3) the spur of the tumbler has become much more robust and has a notch below it. This is followed by a counter-cocking bent on the tumbler in the next stage of development. A long sear with a long nose is old fashioned. It is longest on the Hermitage gun and on the Renwick gun (cf. Pl. 10:1, 2). All the other locks mentioned here have a shorter sear-nose.

Marin Le Bourgeoys seems to have had his own type of trigger-guard (cf. Pl. 8, 9 and 11:3). But both No. M 529 of the Paris museum, which was decorated by him, and No. 139 of the French *Cabinet d'Armes* in the Musée de l'Armée (Pl. 11:1, 4) have trigger-guards that revert to a closely related type of cross-bow trigger. This is known to have existed in southern Germany in the middle of the sixteenth century as is shown by the Livrust-kammare wheel-lock gun (Inv. No. 1215) dating from the 1540s[43], among others. It is also found on the gun No. M 66[44] with a French wheel-lock in the Musée de l'Armée, Paris.

The back part of the trigger-guard on the English petronel of 1584 in the National Museum, Copenhagen (Section II 10428. Pl. 2:1) is of rounder and broader section. Twelve years later the Netherland-ish wheel-lock guns of 1596 in the Livrustkammare, mentioned above as examples of the butt formation of about 1600, have had this back part pressed in. It is shortened and thinner. The musket in Windsor Castle with the dog-lock added later (Inv. No. 364. Pl. 4:2), which is dated 1619, shows the next stage in development. Jacob De la Gardie's target gun with snaphance lock in the Musée de l'Armée (Pl. 7:2) also belongs to this stage.

The form of the trigger-guard on No. 139 in the French *Cabinet d'Armes* (Pl. 11:4) also suggests a date about 1615, the same date at which we have already arrived from the form of the butt.

The stock of the Hermitage Museum gun has a peculiarity which is also to be found on Netherland-ish snaphances and on wheel-lock guns. The lock is fitted in a flat surface terminating in a pronounced ledge slightly in front of the lock (cf. Pl. 8). This feature accounts for this weapon being regarded as one of the very earliest flintlock arms. If to this point are added our observations on the form of the cock, the steel, the long arm of the steel, the screwed-on striking surface, the fence moved down to the lock-plate and the form of the plate itself, one is strongly inclined to regard the Hermitage Museum gun as the oldest of the flintlock arms now known and, perhaps, the very first. Next comes the Renwick gun. After that No. M 529 of the Paris museum and No. 139 of the French *Cabinet d'Armes* in the same museum. Of these, the first three are of Lisieux manufacture.

The early flintlock gun in Windsor Castle (Pl. 14:1–3) does not fit into a series with the other oldest flintlocks. But if, for example, we take the De la Gardie gun as a starting point, we shall find affinity in the pronounced upward contour of the lock-plate behind the pan, then again in the flat, thin jaws of the cock and in the proportions of the head of the cock-screw, similarities in the construction of the cock and form of the pan to the other oldest flintlocks. As to the stock, the flat part in front of the lock and also the pattern of studded silver lines recall the Bourgeoys guns. The barrel with its rounded finish at the rear is reminiscent of arms dating from the beginning of the seventeenth century, and the thick triangular finial of the butt round the tang of the barrel is recorded on French territory in the year 1613.

The form of the tumbler with its broad spur, straight finish and its early counter-cocking also indicates a later date than the Hermitage Museum gun and the Renwick gun.

The place of manufacture of this gun, Turenne, is remarkably isolated from northern France in which all the oldest flintlocks can apparently be located. A natural explanation of this fact might, however, be found in the location of Sedan, the original principal seat of the Masters of Turenne, of the family de la Tour-d'Auvergne. This flintlock gun of the earliest construction is so isolated that it is difficult to give it an acceptable date. It can

Plate 25.

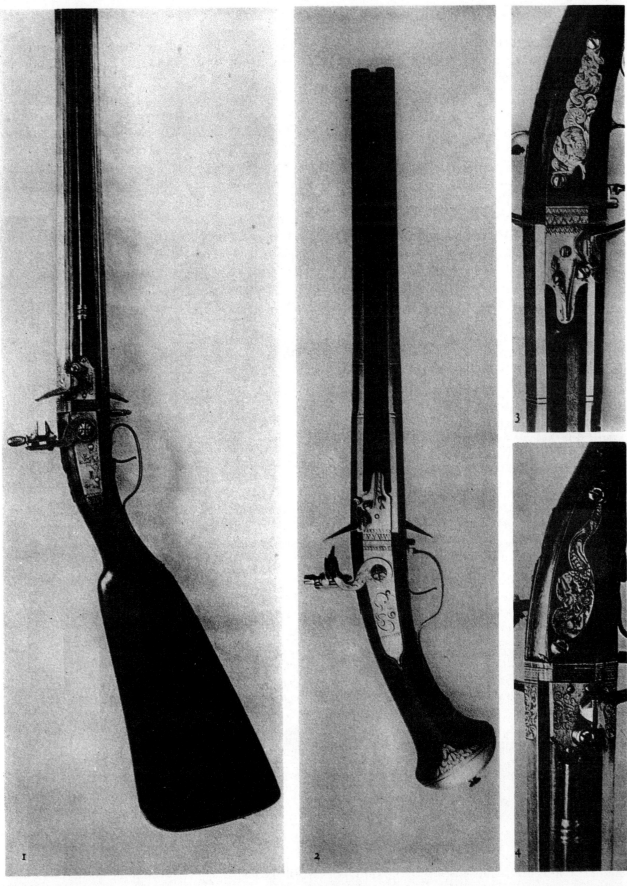

France. Paris.
c. 1650.

1 and 4. Wender gun by Thobie of Paris; Lowenburg
Castle W. 1339. 2 and 3. Wender pistol, one of a pair,
by Choderlot of Paris; Copenhagen, Töjhusmuseet B 673.

Plate 26.

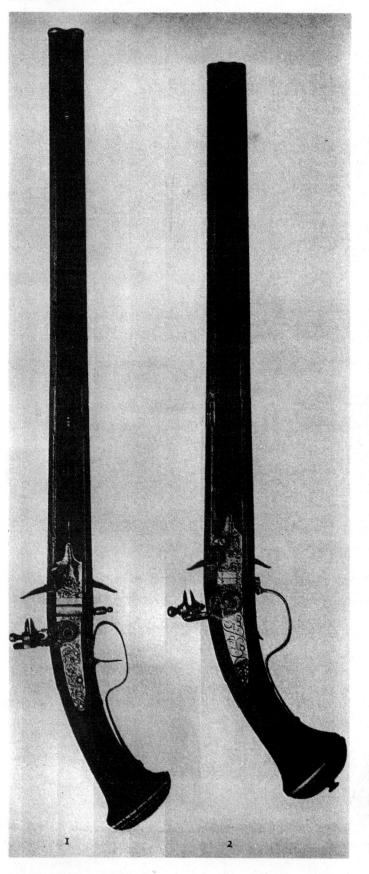

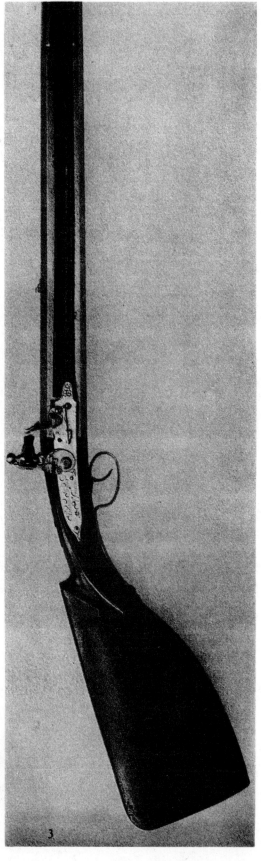

France, Lyons and Switz-
erland, Geneva.
Mid seventeenth century

1. Wender pistol, one of a pair, by Claude Roux of Lyons.
2. Wender pistol, one of a pair, by Cunet of Lyons; Skok-
loster, Wrangel Armoury 64 and 63. 3. Double barrelled
gun by Abraham Meunier of Geneva; Copenhagen,
Töjhusmuseet B 680.

Plate 27.

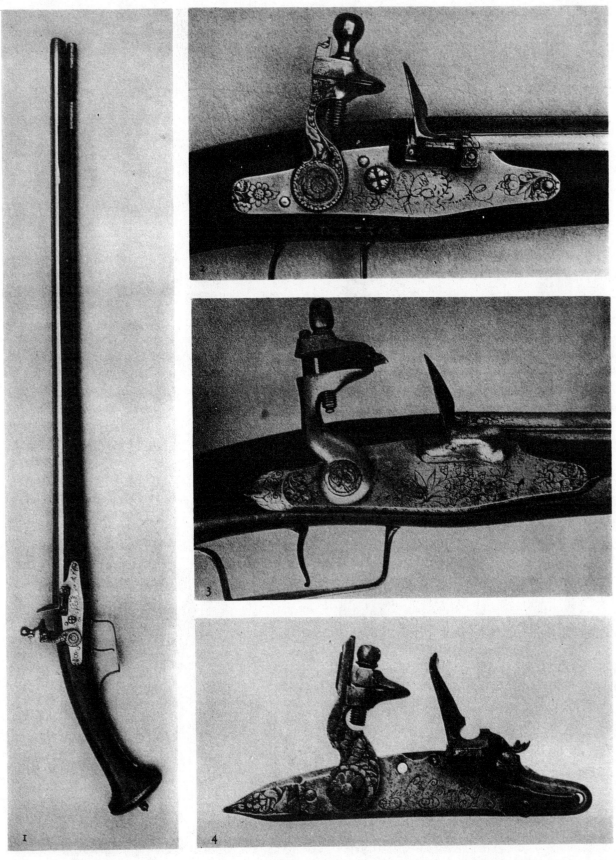

France, Sedan.

1 and 2. Pistol by 'Ezechias Colas à Sedan' Type of 1630s; formerly Berlin, Zeughaus A D 13367. 3. Lock of pistol, one of a pair, by same master; Berne, Historisches Museum 3902. 4. Lock of pistol, one of a pair, by Gabriel Gourinal of Sedan. *c.* 1650; Stockholm, Livrustkammaren 1694.

Plate 28.

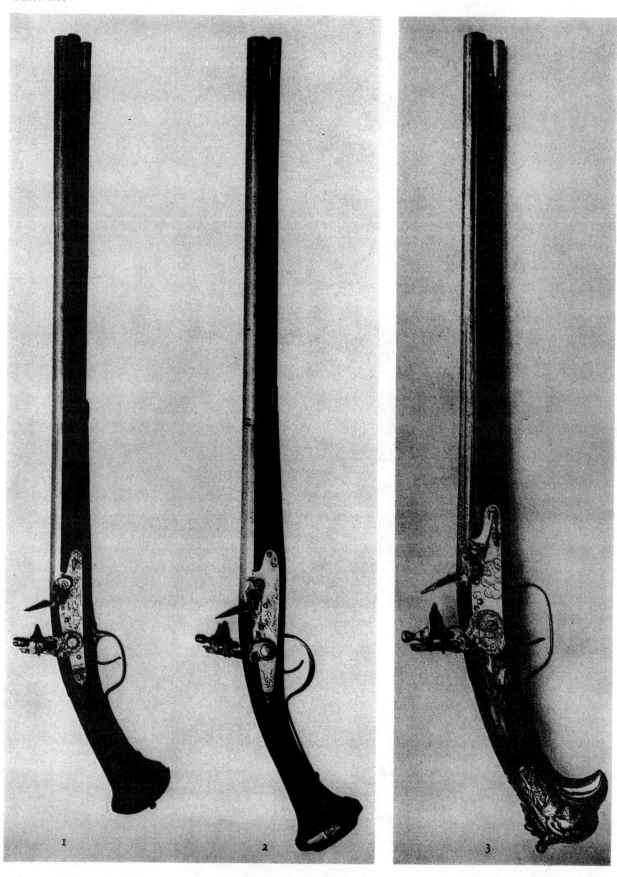

France, Sedan and Metz. 1640s.

1. Pistol, one of a pair, by Jean Dubois of Sedan. 2. Pistol, one of a pair, by Jean Prevot of Metz; Skokloster, Wrangel Armoury 44 and 33. 3. Pistol with cast pommel by Montaigu of Metz. *c.* 1650; Pauilhac Collection, Paris.

Plate 29.

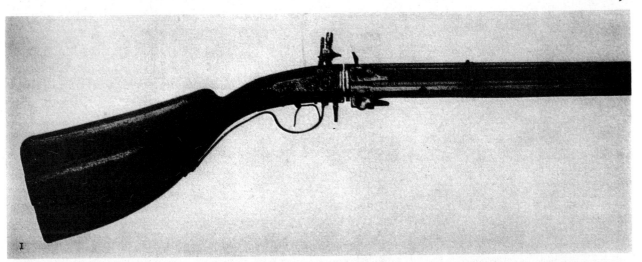

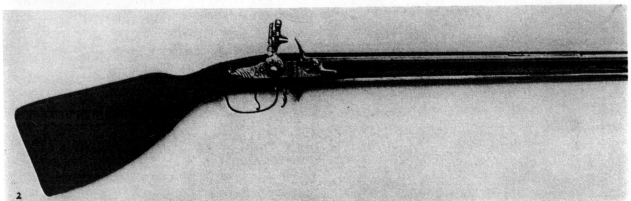

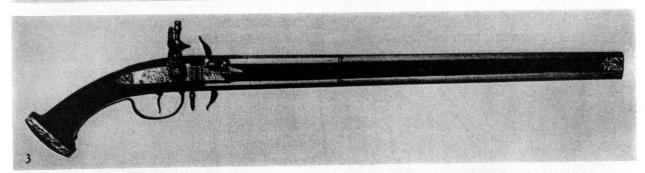

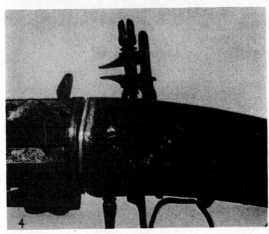

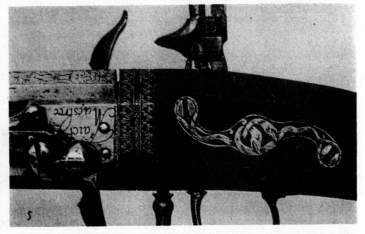

Belgium, Liege, and Netherlands, Maastricht. Mid seventeenth century.

1 and 4. Wender gun by David of Liége. Livrustkammaren 5305. 2. Wender gun by Jan Kitzen of Maastricht; Löwenburg Castle W. 1338. 3 and 5. Wender Pistol, one of a pair, by La Pierre of Maastricht; Skokloster, Wrangel Armoury 71.

Plate 30.

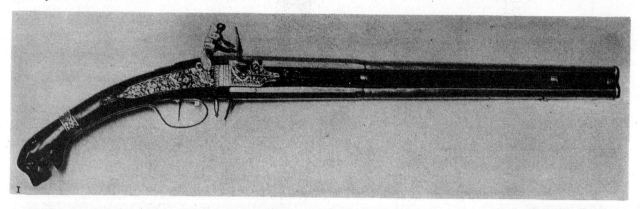

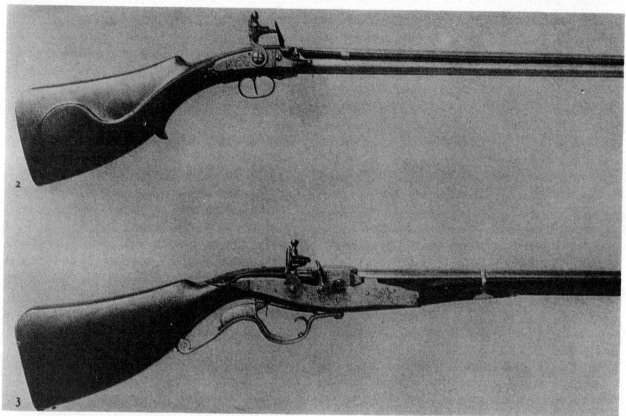

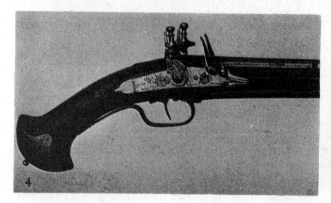

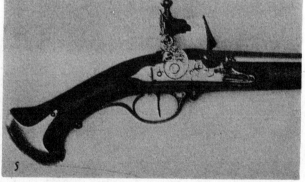

Netherlands, Zutphen and Utrecht.
Mid seventeenth century

1. Wender pistol, one of a pair, by Van den Sande of Zutphen. 2. Wender gun by Jan Flock of Utrecht. 3. Gun by Cornelis Coster of Utrecht 1652; Copenhagen, Töjhusmuseet B 619, B 625. 4. Double barrelled pistol, one of a pair, by same master; Skokloster, Wrangel Armoury 53. 5. Admiral Martin Tromp's (d. 1653) pistol, one of a pair, by Jan Knoop of Utrecht; Amsterdam, Rijksmuseum 6098.

Plate 31.

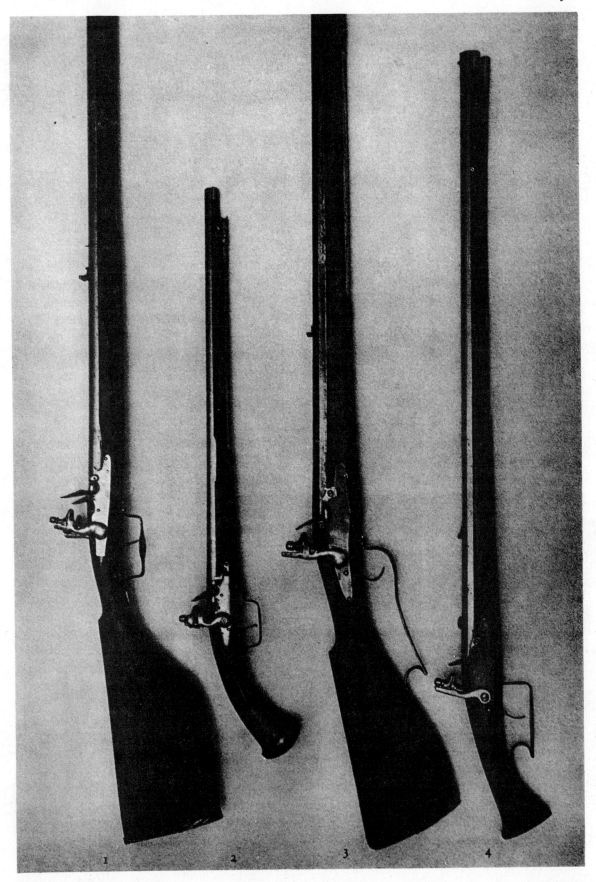

Western Europe and Germany (?)
Mid seventeenth century.

1 and 2. Garniture of gun and pistol one of a pair, with two locks for one barrel. 3. Gun, Germany (?); Skokloster, Wrangel Armoury 233, 62 and 244. 4. Queen Kristina's pistol, one of a pair; Stockholm, Livrustkammaren 1610.

Plate 32.

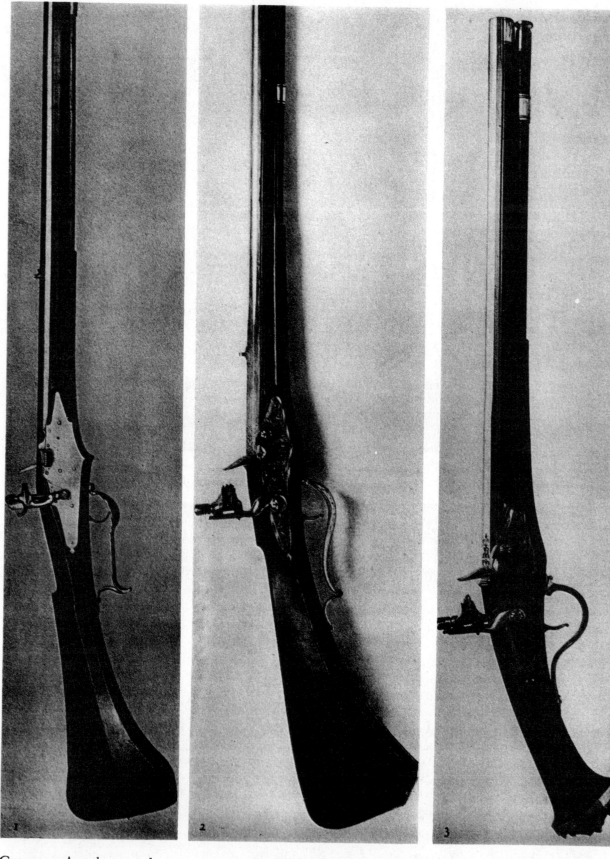

Germany, Augsburg and
Switzerland, Zürich.

1. Gun by Martin Kammerer of Augsburg; formerly
Berlin, Zeughaus A D 8694. 2 and 3. Garniture of flintlock
carbine and pistol, one of a pair, by Felix Werder of Zürich
1652; Vienna, Kunsthistorisches Museum, Waffensammlung
A 1454. Zürich, Schweizerisches Landesmuseum K.Z. 5316.

Plate 33.

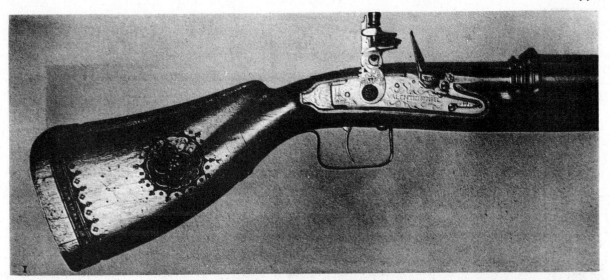

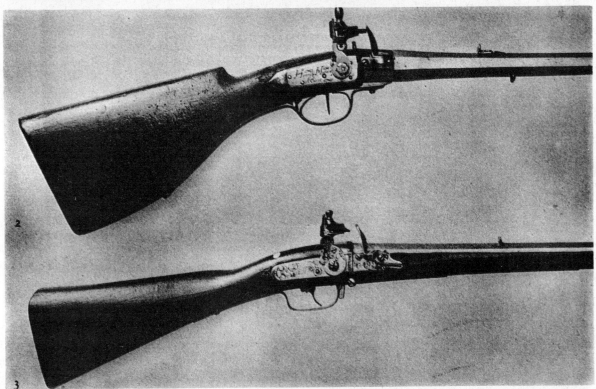

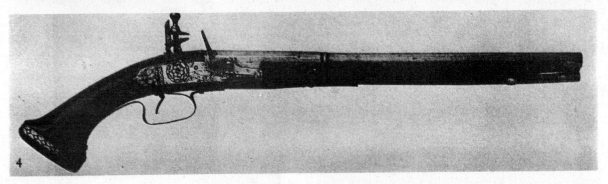

Germany.
1650–75 (?)

1. Blunderbuss by Valentien Tribel; Oslo, Artillerimuseum
A 41. 2. Breech loading gun by Henrich Morietz of Cassel.
3. Breech loading gun, signed 'Jean Hennere Albrechtt
1667 zu Braunfels gemacht', Copenhagen, Töjhusmuseet B
543 and B 572. 4. Charles XI's pistol, one of a pair; Augs-
burg. Stockholm, Livrustkammaren 1734.

Plate 34.

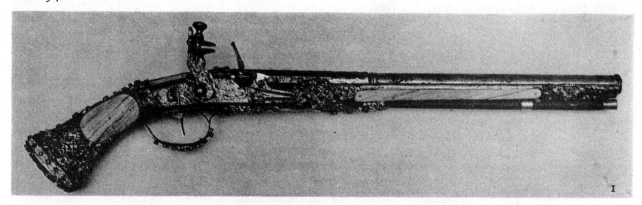

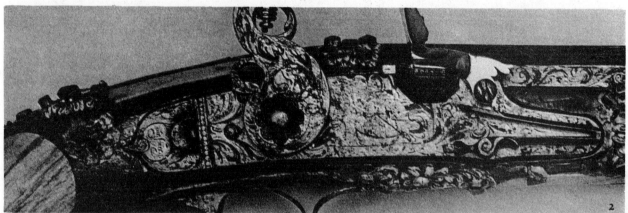

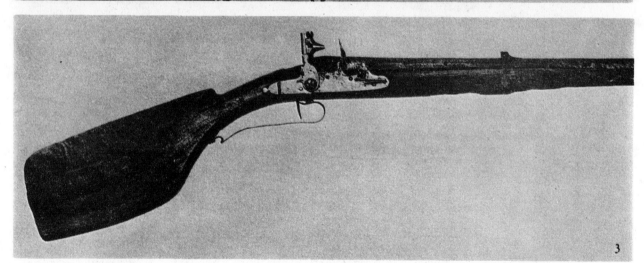

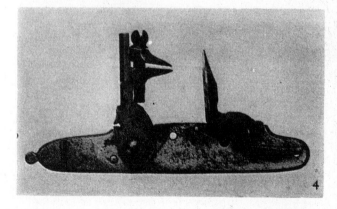
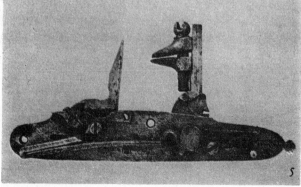

Germany, Augsburg and
Sweden (?)
1650–75.

1 and 2. The Elector John George II's pistol, one of a pair.
Signed 'Augsburg'; Dresden, Gewehrgalerie 354 b. 3–5.
Flintlock gun, Sweden, (?) c. 1660; Stockholm Livrustkam-
maren (Sack Armoury) 42/125.

Plate 35.

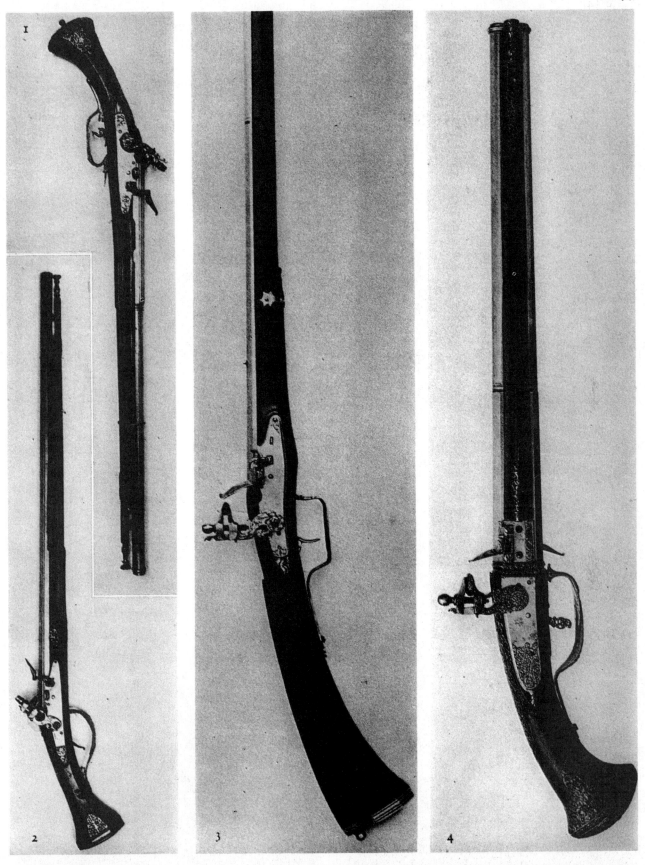

Italy, Brescia.
Mid seventeenth century.

1. Pistol, one of a pair, signed 'Giovanni Francese in Brescia', 2. Pistol, one of a pair, the barrels signed 'Lazzarino Cominazzo'; Moscow, Oružejnaja palata 8094, 8095. 3. Flintlock gun; Paris, Musée de l'Armée M. 544. 4. Wender pistol, one of a pair; Stockholm, Livrustkammaren 20/9.

Plate 36.

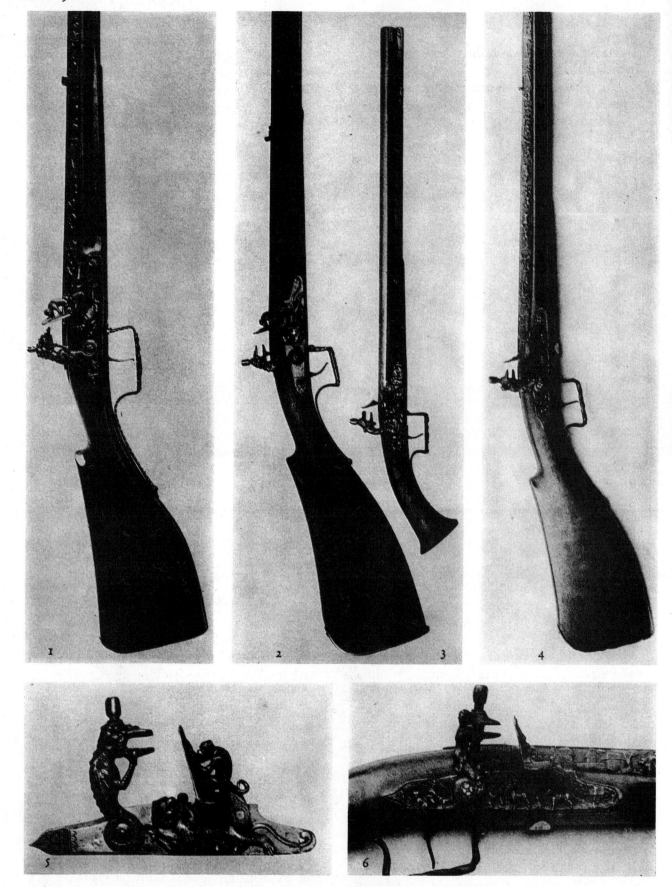

Western Europe.
1630–40s.

1. Gun; Copenhagen, Töjhusmuseet B 660. 2 and 5. Gun
3. Pistol, one of a pair; Skokloster, Wrangel Armoury 250,
30. 4 and 6. Gun; Kranichstein at Darmstadt, Jagdmuseum
223.

probably be best described at present as a retarded form.

This also applies to the Tower of London Armouries gun No. XII: 1131 (earlier Rotunda No. MA 928. Pl. 14:5, 15:1), one of the French *Cabinet d'Armes's* guns No. 138. Like the Netherland-ish snaphances its lock is attached with three screws to the stock instead of the usual two of the flintlock. The steel-spring is placed below the pan. The steel is narrower than the pan-cover, thickest at the middle and surmounted by a scroll; the arm is relatively short. The pan has had an out-turned terminal (a fence) (now lost). The head of the cock-screw is of the high, square type with which we are already acquainted from the majority of the earliest flintlocks. In the same way the cock has a definite 's' form, with rounded jaws and chubby spur with a turned button on the top. The projection on the shoulder is in the form of a scroll. On the corresponding place on the upper 's' curve, on the neck of the cock, there is a pendant without any function. This form of cock can be explained if we imagine the cocking foot of the snaphance cock to be cut off, the lower curve at the rear retained and the neck slightly flattened out. Tumbler and sear are most reminiscent of the Hermitage Museum gun. The flat part of the stock in front of the lock on the Hermitage gun is also found here. The form of the butt is confusing until we recognize the style of the 1610–20 period in its angularity, the deep thumb-grip, the straight contour of the butt and the long downward curve of the underside. The central section, however, has been widened considerably to make room for the butt-trap and its sliding cover. Having seen this butt and convinced myself of its affinity with the lock, I believe that the form of Victoria and Albert Museum M 6–1949 (Pl. 15:2) is correct even if it is a copy‖.

This Victoria and Albert Museum M 6–1949 is in many respects more closely allied to the definitely earlier flintlock, but if the Tower of London Armouries XII: 1131 is a retarded form so must it be also. This would mean that the Tower of London XII: 1442 (Pl. 15:3, 5) with its still later forms should be dated later.

In order to decide if the cocks on the Henequin engravings are flintlock cocks or not, it is necessary to have some knowledge of the tumblers and sears of the locks to which they are supposed to belong. There is no indication of a nose of the sear passing through the plate. As long as no snaphance lock has been found with the characteristic spur to engage with the buffer in the body of the cock there is every reason to consider them as flint-lock cocks. They are consequently of the greatest interest.

Henequin worked for the French king, so far as is known for Louis XIII only. Marin Le Bourgeoys worked also for Henry IV. The Renwick gun bears Louis XIII's monogram and is earlier than 1615. The Hermitage Museum gun, which is slightly more old fashioned, has no monogram but the coats of arms of France and Navarre. Can it possibly be the 'arquebuse' which Marin Le Bourgeoys presented to Henry IV in 1605? This is quite within the range of possibility, and this master consequently takes a leading place when we seek the maker of the flintlock.

The material presented in this chapter does not, it is true, amount to much and it is difficult to get a firm grip of it. It permits us, however, to draw definite conclusions concerning the manner in which the flintlock originated, the borrowing of the steel of the 'Mediterranean lock' and the change in the cocking device of the Netherlands snaphance construction to a half-cock with tumbler and vertically moving sear. The date of the construction has also been advanced very definitely towards the beginning of the seventeenth century. As regards place this must lie in the northern part of France. There is a good deal to suggest Lisieux as the place where the flintlock was invented and Marin Le Bourgeoys as its inventor.

Editor's Notes

* Numerous references are made in the text to the Zeughaus Museum, Berlin. Since World War Two this has been re-named the Museum für Deutsche Geschichte and, though it retains a very important collection of arms and armour, it is no longer speci-

fically an arms museum. A large part of its collections are kept in store. The war time and post war losses were very heavy and none of the pieces illustrated in this work— on Plates 17, 27, 32 and 85—are now in the museum. The firearms referred to in the text on the following pages but not illustrated are also missing—A D9178 (p. 31), A D8664 (p. 31), A D8693 (p. 23), A D9048 (p. 46) and A D9477 (p. 48). The remainder, referred to on p. 74 and p. 157, 23.10 (now numbered W.1144) and 28.13 a.b. (now numbered W.1145 a.b.) are still in the museum. As the present whereabouts of the missing pistols are unknown, it has seemed simpler to leave the Zeughaus reference in the text or on the captions. Only where the weapons are still in the museum have the new name and numbers been given.

† The Wallace Collection Catalogue Vol. II, 1962, suggests that the mark is 'P B' and not 'I B' with a cross-bow.

‡ This gun is one of the considerable number removed by order of the British Commandant from the Paris Arsenal after the battle of Waterloo. Many of these eventually found their way to the Rotunda Museum at Woolwich. There is no reason to doubt that this gun belonged originally to the *Cabinet d'Armes* of Louis XIII.

§ The term 'counter-cocking bent' is unfamiliar in English terminology. Dr Lenk means by it the notch cut in the tumbler at the base of the hooked spur that forces back the main-spring when the lock is cocked. When the cock falls the tip of the sear engages in this bent, preventing the tumbler from turning further and allowing the main-spring to slip free of the spur. On later locks this function is performed by the shoulder or ledge cut on the inside of the cock, which engages with the upper edge of the lock-plate.

‖ The fore-stock is restored, but the remainder is original.

Notes to Chapter Three

1. Livrustkammaren. *Vägledning 1894*. P. 37.

2. Estruch y Cumella, *Museo-armería*. Pl. 143. No. 1014.

3. Livrustkammaren. *Inventory 1683*. P. 56. Palace Archives.

4. Livrustkammaren. *Vägledning 1921*. P. 87. No. 703.

5. Livrustkammaren. *Vägledning 1921*. P. 98. No. 788.

6. [Guiffrey], 'Liste des peintres . . . et autres artistes de la maison du roi'. *Nouvelles archives de l'art français* I. P. 99.

7. Poumerol, *Quatrains au Roy*. ([Reprinted in] *Bibliothèque Elzevirienne* 79: VI. Pp. 131–65.)

8. Lenz, *Imperatorskij Eremitaž*. P. 262.

9. Guiffrey, *Inventaire général du mobilier de la couronne*. T. II. Pp. 61, 62.

10. Paris, Archives Nationales O¹ 3334.

11. I take this opportunity to correct a mistake in my article on the oldest flintlocks in Konsthistorisk tidskrift 1934, in which I state that the signed butt-plate belongs to this gun.

12. 'Marin Bourgeoys, peintre de Roi.' *Bulletin de la Société historique de Lisieux, 1913*. 'Marin Bourgeoys, peintre de Henri IV et de Louis XIII.' *Bulletin de la Société de l'histoire de l'art français, 1926*. 'Thomas Picquot et les portraits de Marin Bourgeoys.' *Aréthuse*. IV. 1927. *Etude de topographie lexovienne*.

13. Berty, *Histoire générale de Paris. Topographie historique du vieux Paris*. P. 101.

14. Fillon, 'Marin Le Bourgeoys. Peintre du Roi (1591–1605)'. *Nouvelles archives de l'art français*. [IV.] Pp. 141–45.

15. Peiresc, *Lettres*. Pp. 754, 755.

16. Héroard, *Journal*. T. II. P. 247.

17. Guiffrey, *Inventaire général du mobilier de la couronne*. T. II. Pp. 59, 60. Un beau fusil de 4 pieds 4 pouces, fait à Lizieux, le canon roud, couleur d'eau, ayant une arreste sur le devant et à pams sur la derrière, doré de rinceaux en trois endroits, la platine unie ornée de quelques petites pièces dorées sur un beaue bois de poirier noircy, enrichy de plusieurs petits ornemens d'argent et de nacre de perle, la crosse terminée en console par le dessous, sur laquelle il y a une longue fueüille de cuivre

doré de rapport, et sur le poulcier un mascaron d'argent et une L couronée vis à vis la lumière.

18. [Grancsay], *The Metropolitan Museum of Art Loan. Exhibition.* P. 66.

19. Stöckel, *Haandskydevaabens Bedömmelse.* I. P. 49.

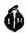

20. Huard, *Etude de topographie lexovienne. Tableau généalogique* . . .

21. Lisieux, Archives municipales CC 149. Communicated by M. Georges Huard.

22. Communicated by M. Georges Huard.

23. Guiffrey, *Inventaire général du mobilier de la couronne.* T. II. P. 74. Un autre pistolet à deux canons, de 25 pouces, les canons rounds et séparez dur le devant, unis et à huit pams inégaux sur la derrière, dorez en couleur d'eau; les roüets unis, montez sur un bois de poirier orné de quelques fillets de cuivre at de nacre de perle.

24. Laking, *Catalogue of the European armour and arms in the Wallace Collection at Hertford House.* P. 231.

25. Ibid. P. 299. Guiffrey, *Inventaire général du mobilier de la couronne.* T. II. P. 50. Une arquebuse de 3 pieds 4 pouces, le canon rond, un petit pam tout au long doré en couleur d'eau, le roüet tout uny, montée sur un bois rouge orné de quelques fleurons d'argent, de cuivre et de nacre de perle; il y a aux deux costez de la crosse deux L couronnées.

26. Tower of London Inv. No. XII: 1075. Transferred from the Rotunda at Woolwich.

27. Le Musée de l'Armée. *Armes et armures anciennes.* T. II. Pp. 123, 124. Pl. XL, XL bis.

28. Cederström and Malmborg. *Den äldre Livrustkammaren 1654.* Pl. 71.

29. Guiffrey, *Inventaire général de mobilier de la couronne.* T. II. P. 60. Six gros mousquetons à gros calibres, tous simples et communs à fuzils, longs de 4 pieds ou environ.

30.

31. Michel de Marolles, 'Le Livre des peintres et graveurs'. *Bibliothèque Elzevirienne* 46. P. 88.

32. Guiffrey, *Inventaire général du mobilier de la couronne.* T. II. P. 60. Dix huit fuzils françois, tout simples et communs, depuis 5 jusqu'à 6 pieds de long ou environ. Two more guns (IV: 112 and IV: 114) with the same number, 138, in the inventory of the French *Cabinet d'Armes* were formerly preserved in the Rotunda at Woolwich. One of these, however, has a Netherlands snaphance with Italian forms. The shoulder is located behind the tumbler on the inside of the lock-plate. A hook which engages in a notch at the foot of the hammer-base serves as safety device. The other gun has a steel, shoulder and only full-cock formed in the tumbler by means of a ledge on which the wheel-lock sear rests. The lock is Italian in form and at the foot of the inside there is an oval stamp with a crown, double eagle and the letter 'M'.

33. Laking, *The armoury of Windsor Castle. European Section.* P. 100. H.M. King George VI granted permission to study and reproduce this weapon and others preserved in Windsor Castle and dealt with in this thesis.

34. Communicated by Mr Åke Meyerson, M.A., who also provided a photograph of it.

35. Hoopes, 'Ein Beitrag zum französischen Radschloss'. *Zeitschrift für historische Waffen- und Konstümkunde.* Vol. XIV. Pp. 50–53.

36. Cf. Lenk, 'De äldsta flintlåsen, deras dekoration and decoratorer'. *Konsthistorisk tidskrift*, III. Pp. 130, 131.

37. Boeheim, *Meister der Waffenschmiedekunst.* Pp. 55, 56.

38. Examples of early German butts to rest against the shoulder are: a wheel-lock gun from the middle of the sixteenth century in the Rotunda at Woolwich (Inv. No. IX: 5) and mercenaries' muskets in the Bayerisches Arméemuseum, reproduced by Alm, *Eldhandvapen* I. P. 81. That this is an early custom is proved by Jacob van Oostzanen's painting of David and Abigael in The State Museum for Art, Copenhagen (No. 77). It clearly shows a man with the gunbutt pressed against his shoulder.

39. Meyrick, 'Observations upon the history of hand firearms, and their appurtenances'. *Archaeologia*. Vol. XXII. P. 71.

40. Cederström and Malmborg, *Den äldre Livrustkammaren 1654*. Pl. 55, 56 and 52.

41. Le Musée de l'Armée. *Armes et armures anciennes*. T. II. Pp. 123, 124. Pl. XL.

42. Ibid. Pp. 130, 131. Pl. XL.

43. Guiffrey, *Inventaire général de mobilier de la couronne*. T. II. P. 47. Une carabine de 3 pieds 9 pouces, le canon couleur d'eau, enrichy d'or et d'argent, où sont deux aigles dans le milieu, le roüet uny sur un bois de poirier garny de petits ornemens d'argent, faite par Habert, à Nancy. Signature; cf. Pl. 134:5.

44. A wheel-lock gun from the Armoury of the Counts of Erbach, signed and dated 'Claude Thomas à Epinal 1623' is an exception to this evolutionary series. Both butt and decoration are old fashioned.

45. Cederström and Malmborg, *Den äldre Livrustkammaren 1654*. Pl. 65. Lenk, *Den förgyllda bössan*. (*Memories of Gustavus Vasa*. Pp. 135–41.)

46. Le Musée de l'Armée. *Armes et armures anciennes*. T. II. Pp. 11, 12. Pl. XXXVIII.

47. Le Musée de l'Armée. *Armes et armures anciennes*. T. II. Pl. XL. No. M. 95.

CHAPTER FOUR

The French flintlock with flat surface.
1620-60

WHEN WE TRY to connect the oldest flintlocks with the first flintlock that is actually dated to the year 1636 we encounter difficulties from lack of material, particularly as regards the 1620s[1]. The picture of the flintlock during that decade is still very vague and unsatisfactory. The explanation must surely be that the earliest flintlocks were never widely distributed. It undoubtedly took some time before the superiority of the construction was recognized. The suspicion which everything new encounters applied also to the flintlock. Poumerol testified to this when he speaks of 'ces fusils nouveaux'.

At present there is only one flintlock which may with reasonable certainty be ascribed to the period about 1620, or to the early 1620s. This is the gun No. 435 in the Musée de l'Armée (Pl. 10:3, 11:3, 12:3–6). It belonged to the French Cabinet d'Armes of which it bears the number 122[2]: it is signed at the foot of the butt-plate 'M. le bourgeoys' (cf. Pl. 134:2). The reason for dating this gun later than those dealt with in the preceding chapter is the greater breadth of the cock, the slight change in form between neck of the cock and lower jaw and, not least, the transfer of the

shoulder from the lock-plate to the inside of the neck. This shoulder is formed by a ledge which projects at a right angle and rests against the upper edge of the lock-plate when the cock is set or lowered (Pl. 10:3). It is only as a result of this change that the flintlock becomes a fully developed construction.

The steel of this gun has a thinner form, as has the pan. A definite guide to this later dating is provided by the shape of the butt. Like most of the Le Bourgeoys guns it displays an interest in experiment, which is to be expected from the presumed inventor of the flintlock. The central section is in openwork in order to make room for a metal weight in the form of a toad. This was needed to balance the weapon. It is now missing. The heel of the butt is in the form of a volute. The triangular underside is apparent in the neck of the butt, but behind that point it merges into the central zone. However much Le Bourgeoys's butts may vary, most of them follow in the main (as regards the contour of the comb and underside) the general trend. This trend is manifested in the 1620s by the underside of the butt curving upwards—in the opposite direction to that of the gun in the Renwick Collection.

The new type with angular profile is illustrated by a matchlock musket in the Musée de l'Armée (No. M 35. Pl. 16:1). It is dated 1629 on the butt-plate. This musket gives us a welcome indication for the dating of the late Le Bourgeoys gun, No. M 435. Although difficult to place exactly, it can probably be ascribed to 1620 or thereabouts, possibly somewhat later.

The earlier claim that the flintlock was constructed in 1630 does not hold good, as we have shown above. It would be more reasonable to claim the 1630s as the period of its breakthrough; during this decade the material becomes much richer and can be assigned with less discussion than is necessary in the case of the earlier flintlock arms.

First to be mentioned are Philippe Cordier Daubigny's pattern sheets (Pl. 108. See pages 125–127) dated 1634 and 1635. Few of these illustrate flintlocks. Then comes the gun of 1636 which has just been briefly mentioned. It bears No. M 410 in the Musée de l'Armée and figures in the inventory of the French *Cabinet d'Armes* as No. 151 (Pl. 17:1, 18:1, 19:1)[3]. It was published in the collection of illustrations of pieces from the Musée de l'Armée[4]. It is identified by its number and by a cartouche on the neck of the butt with the crowned monogram of Louis XIII, a figure of justice and an inscription which is reproduced word for word in the inventory. The date 1636 just mentioned is also on this cartouche. Its master, François Duclos, received a 'brevet de logement' in the Louvre Gallery on 2 January 1636, along with Thomas Picquot[5]. Duclos' signature, which has almost disappeared, is inlaid in gold on the chamber of the barrel. That it really is his signature is proved by a pair of wheel-lock pistols in the Metropolitan Museum of Art (Inv. Nos. 04. 3. 192, 193), previously in the duc de Dino's collection (Pl. 19:2, 134:17)[6].

Thomas Picquot played an important part in providing information about the flintlock arms of the 1630s through his album of engraved designs for gunsmiths published by van Lochum, Paris, in 1638 (Pl. 109, 110)*.

An unsigned gun in the Berlin Zeughaus (AD 9404. Pl. 17:2, 18:2, 3, 19:3–5) may be ascribed to the same year or to the immediately succeeding ones. It is difficult to decide if it was made in Paris or not, but its character is at any rate thoroughly French. It can be authenticated both as regards owner and date. It is also of very great interest because of its form and ornament. The gun is No. 163 in the French *Cabinet d'Armes*[7]. The description tallies in all but two details. First, the sight has been replaced by a new one, and secondly the inscription 'Desrogez m'a donné au Roy' is missing. According to the inventory this should be legible on the tang of the breech-plug, a usual place for signatures in the middle of the seventeenth century. As the numbering and description conform in other respects we certainly do not err in thus identifying it. Paul Post in the Zeughaus Guide of 1929 regards this gun as a classic example of the Louis XIV style and attributes it to Louis, 'le grand dauphin', b. 1661, d. 1711[8]. There is, however, sufficient material to show that French firearms during the lifetime of this dauphin were quite different in style. The auricular ornament, which surrounds the dolphin inset in the butt, never played a prominent part in French ornament, but it makes the gun more typical of the Louis XIII style. As the gun cannot for stylistic reasons be considered to have belonged to 'le grand dauphin' its strongly accentuated dolphin motif, together with the heraldic lilies and crowned 'L', must refer to Louis XIV as dauphin. Its origin is thus restricted to the years 1638–43.

A comparison between the locks of this gun and of other pieces dating from the 1630s described above shows definite agreement. Add to this the report that the gun was a gift to the king, a report which may well have been founded on fact, for there is good reason to suppose that the birth of the wished-for son was the occasion of this gift to a monarch in whose life shooting played a prominent part. It is certain, however, that we are dealing with a French flintlock gun, that it dates from the years 1638–43 and that it corresponds to other pieces dating from the 1630s.

If the decade 1630–40 in France is comparatively well represented we must in the case of

the 1640s begin with the garniture of a gun and a pair of pistols (Nos. 3983, 1347, 1608, 1609. Pl. 20, 21:1–5, 22:1)[9] in the Livrustkammare. They have been ascribed by Rudolf Cederström to this decade. Their character as a garniture is an advantage, as this brings pistols also into the series. There is no doubt of their French origin as the pistols are signed on the locks 'P. Tomas' and the gun—also on the lock—'thoma à Paris' (Pl. 22:1). Cederström states that the pistols belonged to Queen Kristina. This is confirmed by the 1683 inventory[10], which was in all probability Cederström's source of information. The same inventory states that the gun belonged to Charles X Gustavus[11]. As the weapons constitute a garniture we must accept the fact that they were in Sweden when the Queen abdicated in 1654. The date of their manufacture is, however, shown to be earlier by comparative material dating from the beginning of the 1650s (cf. Pl. 30:3–5), or about 1650 (cf. p. 49). The only possible course is to attribute the garniture to the 1640s, as it clearly does not correspond to pieces already discussed.

The conformity in shape, especially of the locks, makes it possible to add to this garniture three pistols signed by Parisian masters, a single pistol signed on the lock 'Pierre Langon à Paris' and on the barrel 'P. Laon' in the Löwenburg, Cassel (No. W 1157. Pl. 21:6, 10)[12], and a pair in the Historisches Museum, Dresden (P.Z. 272), signed on the barrel tang 'Devie à Paris' (Pl. 21:7–9, 23:6, 134:18). These are characterized, like most of the undoubtedly French flintlock arms of this period, by their high quality. They have pommels of ebony in the form of negro heads finely sculptured in a decidedly individual manner. The coat of arms of the von Blumen family[13] is inlaid in gold on the chambers (Pl. 21:9).

With the material just assembled we have reached the middle of the seventeenth century. Examination of it and a comparison of the results will give us a standard by which other flintlock arms from about 1620 to about 1650 can be recognized and dated.

The cocks appear to have been very sensitive

to fashion and development. It has been mentioned that one of the reasons for ascribing No. M 435 of the Paris Musée de l'Armée to 1620, or a year or two later, is the greater breadth of the neck and the gradual transition between neck and lower jaw. The square head on the cock-screw survives from the still older flintlock, as do the straight spur and the neck. The projection for the buffer remains as a barely noticeable rudiment on the belly since its function has been transferred to the neck. The rudimentary cocking foot of the snaphance also remains in the form of a minute scroll, and a similar ascending scroll breaks the long line formed by the front of the cock. The earlier spherical head of the jaw-screw has become plum shaped.

The two cocks on Picquot's pattern-sheets of 1638 resemble this type. The foliate terminals of the volutes are slightly more developed and the head of the cock-screw is decorated with rosette shaped ornaments. The design of the jaws at the front and back is of interest, but at present we cannot produce any lock with these details executed in this manner. In Philippe Daubigny's designs the volutes of the cocks display an exuberance which cannot be reproduced in steel. It would also prevent the normal functioning of the cock. The heads of Daubigny's jaw-screws are spherical and the dividing line between the lower jaw and neck is strongly marked. In this respect they are old fashioned and represent the period before 1620. On the other hand, however, the cocks are broad and the scrolls develop upwards both at the front and rear, thus confirming their connection with the 1630s. A detail which is worthy of mention is the decoration of the jaws with an eye and a jaw representing the head of a monster. In this instance the decoration is engraved. In the case of J. Henequin, Metz, whose designs have been attributed to the 1620s, the monsters' heads are sculptured in relief, thus signifying a different cultural and geographical area (we shall return to this in a later chapter). The engraved monsters' heads of the 1640s belong to the cultural area with which are now dealing.

Of the two 1630 guns, that of the dauphin in

Berlin appears to have the older type of cock, being very close to Picquot's design.

The Musée de l'Armée gun No. M 410, dated 1636, has a flintlock cock, the lower jaw of which is definitely separated from the neck (Pl. 18:1). It has also the same rudimentary projection for the buffer as No. M 435 and the head of the jaw-screw is plum shaped. The scroll on the back has, however, become an ornament filling up the entire curve. Daubigny's engraving shows a certain tendency to do so, the side of the back of the comb being straight from the upper edge of the spur to the front of the cock-screw. The point of the foliage ornament on the front has begun to move up towards the lower jaw. The neck and the base of the cock have become more robust. The cock-screw has a low head with a groove. This tendency is continued in the cocks of the Thomas garniture in the Livrustkammare, where the ornament on the front extends to the lower jaw and encircles the lower end of the jaw-screw†. The entire ornament has moved upwards so that the jaw-screw can no longer be screwed right up when the cock is not provided with a flint. This can happen in all earlier Netherlands snaphance and flintlock cocks.

The lower jaw of the cock in the Thomas garniture is distinctly separated from the neck, but on the pistols the transition is gradual. In both instances the 's' form is more accentuated than on earlier pieces by reason of a round projection at the back immediately beneath the spur. The projections with which the upper jaw engages the comb are—viewed sideways—rounded off at the rear. This is another new feature, as are the shaped forms of the corners of the mouths. The heads of the cock-screws are in the form of roses, engraved on the gun, in relief on the pistols and reminiscent of Picquot's pattern-sheets. The sheet in Marcou's series which is marked '4' (cf. p. 135) shows exactly the same stage of development as this garniture. In it the contour of the rear edge of the lower jaw is also rounded.

The cock of the Langon pistol in the Löwenburg conforms to Marcou's sheet '4', except for the head of the jaw-screw. When the plum shape could not be further elongated the ends were flattened and pinched in the middle. This is also the case on Marcou's sheet '10'. The Devie pistols in this respect are of transitional form. Both forms of jaw-screw head may occur at the same time, but typologically the Langon pistols are later.

An examination of the steels and pans leads to the same result. The oldest forms are illustrated by No. M 435 (Pl. 11:3). In contrast to earlier clumsy steels, that on this gun is cut straight on the front outer edges. At the bottom a semi-circular recess has been filed which runs out on one side in the pan-cover and on the other in the arm of the steel. The face of the steel is still rectangular. The steel-spring is placed below the pan, which in section is a long shallow rectangle. The lock-plates on Picquot's pattern-sheets have recesses of the same form where the pan should be. The gun, Tower of London XII: 1442 (Pl. 15:3, 5), has the same shape of steel as that of No. M 435, but the scroll is missing. It has also a steel-spring with arms of equal length and turned leaf finial mounted outside the lock-plate[14]. This, as also the presence of a buffer and the square head on the cock-retaining screw, may be reckoned as old fashioned features of the lock. It has also an upright ledge at the rear of the three cornered pan similar to that required to stop the sliding pan-cover of the wheel-lock and snaphance lock. In this detail it resembles No. M 410 of the Musée de l'Armée. All locks belonging to this group, except No. M 435, have pans with a triangular section against the lock-plate. They were subsequently bevelled at the outer corners and thus multi-angular. In the 1630s and later, the upper corners of the steel were cut off, and in the 1640s we find some steels abruptly truncated at the top while others are rounded at the top. Both types are, however, somewhat angular. The Livrustkammare Thomas set (Pl. 20) and Marcou's engraving (Pl. 111, 112) provide relevant evidence in this respect. In the 1630s the steel-spring was moved to the inside of the lock-plate. In the 1640s the same spring with a long upper arm and a short lower one is found on the outside of the plate held

Plate 37.

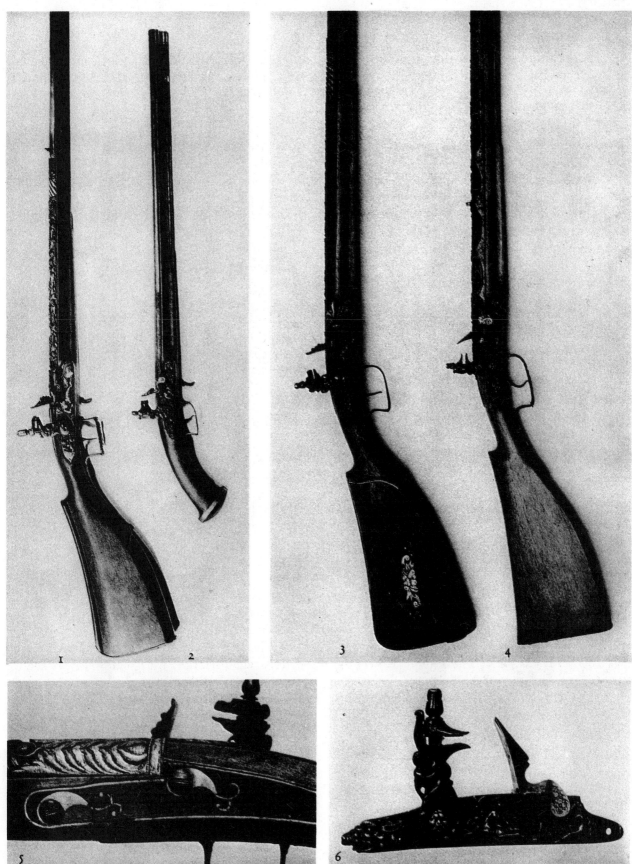

Western Europe.
1640s.

1 and 2. Garniture of gun and pistol, one of a pair; Vienna, Kunsthistorisches Museum, Waffensammlung D 316 and A 1154. 3 and 5. Charles X Gustuvus's gun, gift from Charles Gustavus Wrangel. 4 and 6. Gun; Stockholm, Livrustkammaren 1297, 1545.

Plate 38.

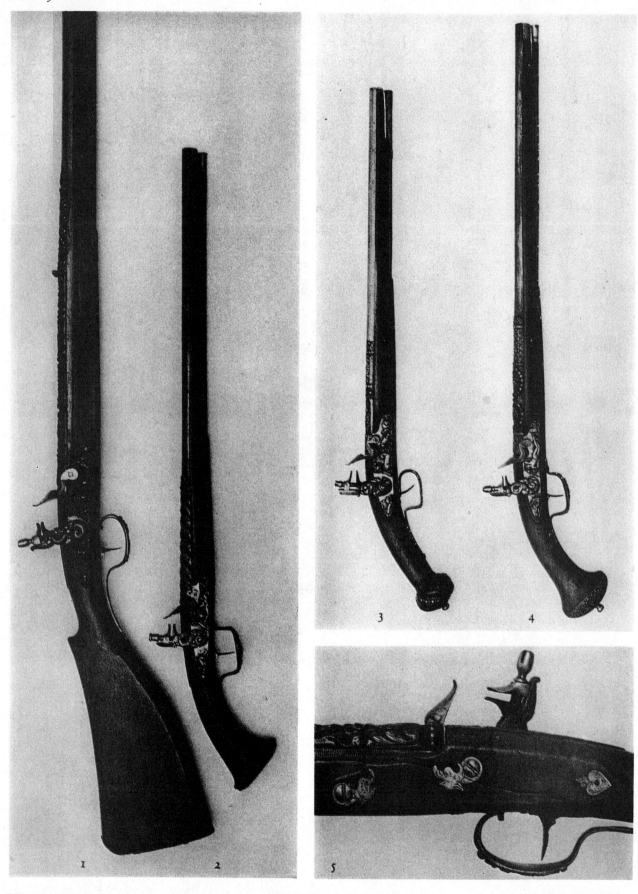

Western Europe.
1640s.

1, 2 and 5. Garniture of gun and pistol, one of a pair; Stockholm, Livrustkammaren 1298, 1612. 3 and 4. Pistols, each one of a pair; Skokloster, Wrangel Armoury 43, 67.

Plate 39.

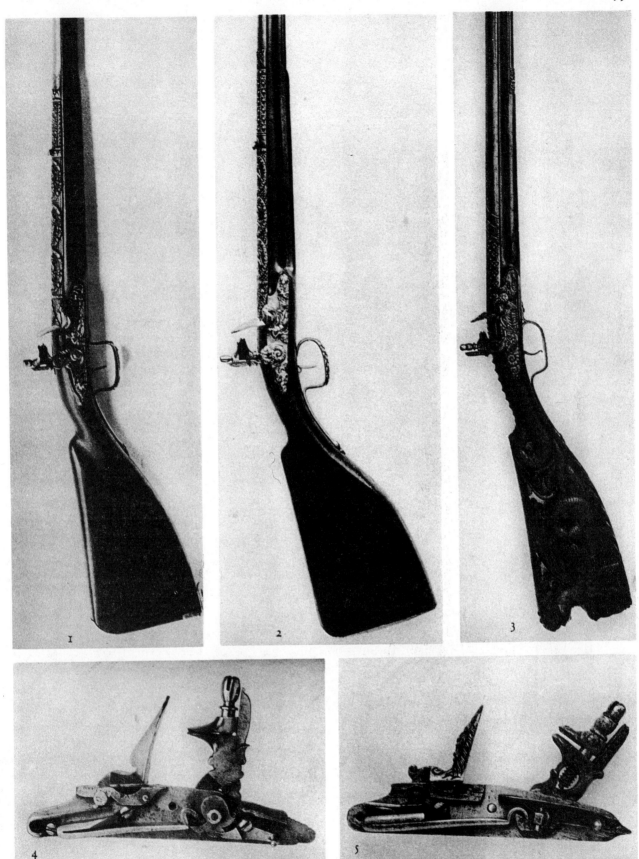

Western Europe.
Mid seventeenth century.

1. Gun; Vienna, Kunsthistorisches Museum, Waffensamm-lung D 362. 2 and 4. Gun; Copenhagen, Töjhusmuseet B 661. 3 and 5. Charles XI's gun with half-cock lock which is not a flintlock; Stockholm, Livrustkammaren 1333.

Plate 40.

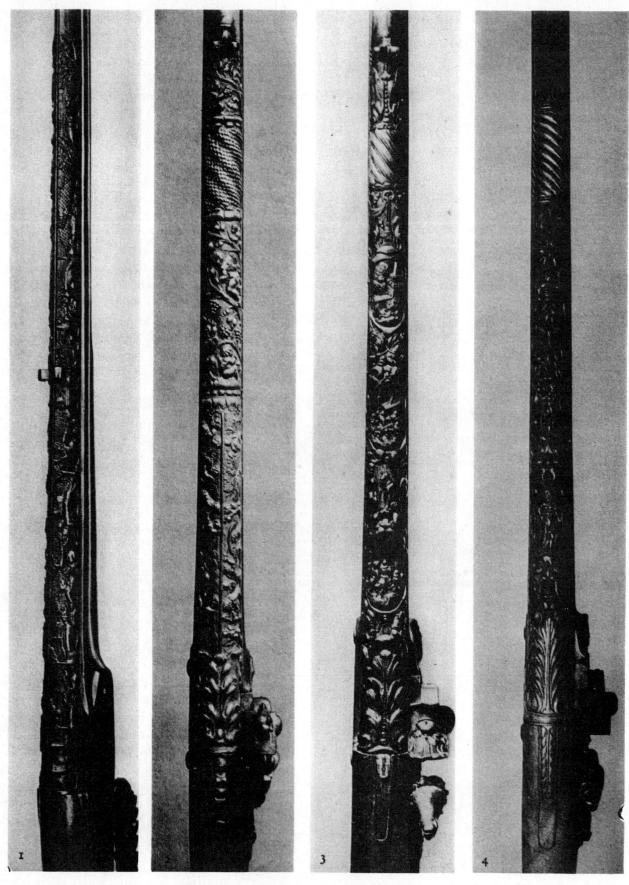

Western Europe.
1630–40s.

1–4. Decoration in relief on the barrels of the gun on Pl. 36:1, of gun No. M 14 in Sala d'armi, Palazzo ducale, Venice, and of guns on Pl. 37:1 and 37:3.

by a screw from the outside. The gun of the Thomas garniture has no leaf finial on the steel-spring. On the pistols this spring is engraved, but on the Langon pistol in the Löwenburg it is chiselled in relief. The steel-springs of the locks on Marcou's design-plates also have leaf finials. Sheet '4', which is more old fashioned than sheet '10', shows a steel-spring with a long and a short arm like the Thomas set. On the latter sheet, however, the upper arm and the lower, as well as the leaf, are all the same length, as on the Langon pistol.

The oldest flintlock plates terminate in a semi-circle at each end with a drop shaped finish or blunt angular finish tapering into a short point. They are broadest at the pan and have, with two exceptions, the rectangular edges found on the Hermitage Museum gun and the Renwick gun. The plain, bluntly rounded form is usual. Daubigny adds small foliage ornaments on his pattern sheets. This gives them an old fashioned touch. Duclos has designed the upper edge of the lock-plate behind the pan of No. M 410 of the Paris museum in a 's' curved recess (Pl. 18:1). This occurs on several other locks of the period. The edges of the plate of the Bourgeoys gun M 435 are slightly bevelled like the two early flintlock guns just mentioned, but not between the cock and the pan. This bevel becomes more pronounced so that the Duclos gun has a lock with 'broken' edges. These edges become broader where the lock-plate rises above the surface of the stock. Hitherto the ornamentation has been uniform all over the plate and the surface unbroken, but from the period of the Thomas garniture, about half the area behind the cock was on a lower plane. The ledge thus formed was usually decorated with naturalistic flowers. The rear point was drawn out to a rounded tongue. On the whole the profile of the entire plate has become less abrupt and more drawn out. This is most obvious on the pistols of the garniture, where the bottom edge curves inwards and upwards beneath the cock.

The tumbler and sear have also undergone changes. The tumbler on No. M 435 has a strongly curved spur (Pl. 10:3) corresponding

to the hook of the mainspring which was now more curved than before. Above the full-cock notch there is just an indication of an outward curve. In later locks this becomes a more or less triangular projection and corresponds to the upper edge of the nose of the sear. On the lock of No. M 435 the nose of the sear is short but the part behind the screw long. On No. M 410 of 1636 in the Musée de l'Armée this part is also shortened. The tumbler in the latter has the triangular projection just mentioned, in this instance with the point rolled up to form a volute. The tumbler and sear of this gun are also examples of a construction which is usual in this early period. It is found on the Livrustkammare gun No. 1307 (Pl. 16:5). Thierbach devotes a detailed description to this construction[15]. It is characterized by the sear being divided into an outer part in one piece with the sear-arm in the ordinary way, and an inner one with a slightly longer nose. This inner part is secured by an extra spring in the half-cock bent. As this inner sear cannot be actuated by the trigger it provides an effective safety device. In the nose of the tumbler forming the full-cock the corresponding part has been filed away. The construction seems to have been abandoned shortly after the middle of the seventeenth century.

One of the reasons for ascribing the Paris gun No. M 435 to about 1620 or a year or two later, is the form of the butt. It resembles the type represented by the matchlock musket in the Musée de l'Armée, Paris (Inv. No. M 35), dated 1629 on the butt-plate (cf. Pl. 11:3 and 16:1). Here the central part and underside bend out and downwards, and have been rendered heavier by placing the belly towards the rear. The earlier heel which was too sharp has been rounded off. In other respects the butt, which is short, retains its pronounced angularity. The section of the butt of this musket and that of the Paris No. M 410 of 1636 have practically the same form.

Development continues with the butt becoming elongated and rounded off, the first step being for the comb of the butt to increase in volume. The stage between No. M 410 and the Livrustkammare Thomas garniture is

45

represented by the Dauphin's gun in the Berlin Zeughaus (Pl. 17:2). In it the body and comb have merged, the latter having been given a volume corresponding to the body. The angularity is confined to the underside and the curved thumb-rest. In other respects the section is gradually rounded and narrows off towards the comb. The Thomas garniture shows an even more rounded gun butt. Only the boundary between the body and the underside is indicated by an angle and the comb of the butt has increased in volume. The outline of the comb is turned slightly outwards and the belly of the underside moved forward about two-thirds the length of the butt from behind. A detail of the Thomas garniture which deserves special attention is the small carved leaf (Pl. 21:5) on the left side of the stock in the angle by the breech. It occurs on several stocks made about and after the middle of the seventeenth century.

There are entirely plain butts dating from the first half of the seventeenth century (Livrust-kammaren Inv. No. 1280), but generally they had some kind of mount. Once the heel of the butt has become rounded and broad enough, as in the case of the early guns in the Tower of London Armouries (XII: 1131) and the Victoria and Albert Museum (Pl. 15), it is protected by a sheet of metal. Other guns have a thin plate nailed to the back, as for instance Livrustkammaren Inv. No. 1307 (Pl. 16:4) and the Paris De la Gardie gun. Much more common, especially in finer arms, however, is a thick butt-plate attached with three screws. This butt-plate, often richly decorated, occurs at an early stage, definitely by the beginning of the seventeenth century. A French wheel-lock gun in Berlin (Zeughaus Inv. No. A D 9048), the Aumon gun of 1613 in the Musée de l'Armée (Inv. No. M 95) and the Henequin gun of 1621 in the Bavarian National Museum (Inv. No. 1733. Pl. 104:3) are examples. As long as the butt has a straight finish at the back the top screw is placed as high up as possible and marks the position of the rod which is occasionally used to strengthen the comb of the butt. When the heel of the butt is rounded off the butt-plate extends a short distance along the

comb. Here, as a rule, it is abruptly cut off so that the screw passes obliquely or straight from above as on the Zeughaus gun No. A D 9404 and the Livrustkammare Thomas garniture.

What has been said is quite sufficient to show how the arms chosen here as representatives of the group can invariably be placed in the same order whether we follow the development of the cocks, lock-plates, butts or of other details. Only one note should be added here about the trigger-guards as an additional factor by which French seventeenth-century arms can be dated with even greater certainty. If we compare No. M 529 (Pl. 11:1) and No. 139 of the French *Cabinet d'Armes* both in the Musée de l'Armée, which belong to the decade 1610–20, with the Paris musket of 1629, we find in the latter a closely related trigger-guard that indicates a development and resembles Inv. No. A D 9404 (Pl. 17:2) of the Zeughaus. The entire rear part here is pressed in against the small of the butt, and the angle of extension at the rear has been made as small as possible. The pistols of the Thomas garniture (Pl. 20:2, 3) have trigger-guards in which this rear part has been set in close to the butt and the front end split and folded, one flap forward and one backward with the screw passing through the former. On the Langon pistol in the Löwen-burg (Pl. 21:6) the rear part of the thin trigger-guard is also divided. There are triangular apertures between the flaps. The actual guards on the trigger-guards of most French wheel-lock guns and the Bourgeoys guns are quite broad, although they look thin when viewed from the side. The trigger-guards of French flintlock arms of the 1630s and several decades later are moderately broad and are, in the earlier part of this period, also thin when seen sideways.

The Florentine gunsmith Antonio Petrini was the author of a treatise *De arte fabrile* dated 1643, one copy of which, dedicated to Lorenzo Medici, is preserved in the Biblioteca Magliabecciana (XIX: 16)[16] while another is in the Tower of London Armouries[17]. This publication deserves to be printed in its entirety‡. Parts of it are reproduced by Eugène

Plon in his great work on Benvenuto Cellini[18]. Petrini mentions that the French barrels have a bead-sight at the muzzle and that they are half round, half square in section. This last statement seems obscure but is explained if we assume that Petrini only counted the edges one sees on the barrel and not those hidden by the stock. In the present thesis the word octagonal is used to describe this formation.

⊕ · ∞ · ⚖ · ☺ ·

perche sono frangibili, e

· *N. D. S. A.*

Petrini reproduces six marks (reproduced above) with the information that they are found on French barrels. For the rest Petrini considered that the French barrels were fragile, burst easily, and were badly forged[19].

The round bead which Petrini claims to be typical of the French barrels is found on Marin Le Bourgeoys' guns of the 1620s (cf. Pl. 12:5). Such beads are by no means general and as a matter of fact the sights vary most considerably in form and position up to the middle of the seventeenth century. The statement that the chamber is octagonal does not hold good until the 1630s and even then not without exception. Indeed there is a type in which the edges of the chamber gradually merge into the round form of the rest of the barrel. No. M 410 (cf. Pl. 17:1) of the Musée de l'Armée is an example of this, and there are several others. The chambers of the Thomas garniture, on the other hand, are clearly outlined in front, and the edges of the angles are bevelled so that the chamber is sixteen sided. The barrel is, as a rule, attached with pins and with a screw passing up through the trigger-guard into the tang.

The ramrod-pipes are cylindrical up to the 1640s when a slight profile portends the very elaborate forms of the following period. The absence of a rear pipe on all definitely French guns before the middle of the seventeenth century is noticeable. The ramrods have, as a rule, a long closed ferrule. The ramrods of the Thomas garniture are finished off with a turned finial which is not, however, new in French gunsmiths' work. It is on the Henequin gun in Munich and on a pair of wheel-lock pistols dating from 1610-20 in the Chronological Collection of the Kings of Denmark at Rosenborg, Copenhagen (Inv. Nos. 7-137, 7-147. Pl. 51:1). It is, in fact, not unusual on early Scottish snaphance pistols as well as on Netherlands and Italian arms of the middle of the seventeenth century.

To summarize: No. M 435 of the Musée de l'Armée is ascribed to about 1620, or somewhat later. Picquot's pattern-sheets have much in common with the style of the 1620-30 decade and are at any rate old fashioned for the year of their publication, 1638. The same can be said of Daubigny's sheets dated 1634 and 1635, although the old fashioned features are less prominent. The gun No. M 410 of the Musée de l'Armée, dated 1636, can be regarded as being an advanced type, but with certain minor features surviving from Marin Le Bourgeoys's period, such as the elaborate butt. In comparison with this, No. A D 9404 of the Berlin Zeughaus has a butt which is more in keeping with the current fashion. The Thomas garniture in the Livrustkammare can be confidently placed in the 1640-50 period. This also applies to the pair by Devie because of the necessity of dating the more advanced Langon pistols in the Löwenburg to the 1640-50 period also. They are pushed back into that period by comparison with the succeeding Wender group and the rest of the examples of the 1650-60 period illustrated in Chapters Six and Seven. Sheets '4' and '10' of Marcou are contemporary with the Thomas garniture and the Langon pistol. On this basis it becomes possible to date quite a number of arms, the placing of which is impossible by any other method. No great number of French flintlock weapons of the decade 1620-30 is to be expected. I do not at present know of any examples other than those already produced. Circumstances are different for the 1630-40 and 1640-50 periods. It can also be said that the flintlock had by this time emerged

from the experimental stage and was ready to be manufactured on a large scale.

The gun No. 1307 (Pl. 16:3–5) in the Livrustkammare, a gun with both flint and matchlock in the Musée de l'Armée (No. M 411. Pl. 16:2) and a small number of pistols with butt mounts and ramrod-pipes of sheet silver with delicate, neatly executed ornament can be ascribed to the 1630–40 period. The best preserved pair is in the Wrangel Armoury at Skokloster (No. 61. Pl. 24:1)[20]. It is signed on the lock-plate with the initials 'I D'. A pair of pistols in the Berlin Zeughaus (Inv. No. A D 9477) closely related to these have been very largely restored and deprived of nearly all their original mounts. A third pair is preserved in the Musée de l'Armée (Inv. No. M 1724)[21]. They have been very much shortened, the joint on the fore stock having been concealed by an engraved silver band. Its decoration indicates that the change was made during the latter half of the eighteenth century. In the fine collection of rubbings of details on French flintlock weapons belonging to the Staatliche Kunstbibliothek, Berlin (O. S. 825) there is one of a magnificent lock-plate on sheet '3' (if the title page is reckoned as number '1', Pl. 22:2) that can definitely be assigned to the 1630–40 period. This shows, among other things, the rectangular recess for the pan, an old fashioned feature, and the steel spring on the inside of the plate. For the 1630–40 period the rubbing of the large lock-plate on sheet '22' (Pl. 23:3) of the Berlin collection may also be taken into consideration.

Another group, also of pistols, with stamped ramrod pipes but with coarser decoration and with pommels of thin sheet silver follows closely upon the group of pistols just mentioned. The Wrangel Armoury at Skokloster contains three pairs of this group (two pairs illustrated here, No. 68. Pl. 24:3, and No. 70. Pl. 24:2). There is still another pair in the Gewehrgalerie, Dresden (No. 1551. Pl. 24:4) stamped by the master 'F C'). He also signed the pair No. 70 in Skokloster, but in this case with engraved initials. The pair No. 68 which is signed on the lock-plates with a stamp bearing the initials 'I L' and a star in an angular, crowned shield[22] has pommels of exactly the same design as the pistols in Dresden. These are perhaps some ten years later. Definitely attributable to the 1640–50 period is a pair of pistols in the armoury of Malta (Inv. Nos. 96, 98)[23] signed 'Mathieu Desforets fecit à Paris'. These have pommels similar to the pistol in the Löwenburg. Among the rubbings in Berlin there is one on sheet '5' and two on sheet '10' which represent the form of the 1640–50 period in France: these show the varying lengths of the steel-spring arms and the signature on the bevelled edge (cf. the Thomas gun in the Livrustkammare). Unfortunately the signatures cannot be read except partially in one instance, '. . . A Bergerac'[24] (Pl. 23:1). This, however, provides interesting evidence of the distribution of the manufacture of flintlocks at this time.

For the 1640–50 period several rubbings in Berlin may be mentioned. The names of Beradier, Cunet and Mayer (Pl. 23:2)[25], all three in Lyon, and Raguet (Pl. 23:3), who does not mention where he lives, appear on these. This again shows that there was a widely spread manufacture of fine quality flintlocks as early as the 1640–50 decade, probably all over France.

During the period from 1630–50 it had not yet become the rule to sign firearms. For this reason the question of nationality of the flintlocks of this period is often rather difficult to answer. Stamped ramrod-pipes and pistol pommels, the presence of a rear ramrod-pipe, an upper-jaw sliding with a projection in a groove on the spur and the construction mentioned above with a split sear are details pointing to the region on both sides of the northern and north-eastern borders of France.

It is therefore probable that the Livrustkammare gun with Inv. No. 1307 (Pl. 16:3, 4, 5) may be described as French. The gun is an early one. It has a butt that is rather more old fashioned than that of the matchlock musket dated 1629 in the Musée de l'Armée (Pl. 16:1). Its trigger-guard is of the same kind, the head of the jaw-screw is of short plum shape, the tumbler can be compared with that on the Windsor gun and Tower of London XII: 1442 (Pl. 14, 15) and the sear is of an old fashioned

length. If we date the gun about 1630 there is a greater chance of its being earlier rather than later. The upper jaw of the lock slides with a projection in the groove of the spur and the sear is divided. The gun with combined flint and matchlocks on the same plate in the Musée de l'Armée (Pl. 16:2) has a ramrod-pipe. The pistols No. M 1724 in the same museum, the pair, No. A D 9477, in the Zeughaus, and those at Skokloster (Pl. 24) show the characteristic stamped ramrod-pipes. The trigger-guard on the pistol (Pl. 24:2), moreover, is of characteristically wide form and has two almost right-angled bends, a form that obviously precedes the rounder one.

In the middle of the seventeenth century the flintlock seems to have reached a stage of its development that enabled the designers to concentrate their interest on another problem. This was the manufacture of flintlock arms with which several shots could be fired in rapid succession. The most pronounced expression of this endeavour is the Wender construction. The German term 'Wender' is used here because it has to a certain extent become customary, whereas the French terms 'fusil tournant', 'carabine tournante', etc., are seldom met with in the international literature of arms. The term 'revolver' again is apt to be associated with nineteenth century constructions. The Wender type (cf. Pl. 112:2) is confined to flint-lock weapons and implies that two or more barrels, each provided with a pan and steel, are mounted with the ends of their breech-plugs in an oval plate. This plate, with the barrels, rotates around a pin fixed in a corresponding plate in the butt portion of the weapon. These plates are controlled by a bolt which locks the constructions either by a separate pin or one attached to the moveable trigger-guard. The barrels are turned by hand. The part of the lock comprising the cock and mainspring is mounted on the butt portion of the weapon and has a horizontal mainspring at the rear. This gives the tumbler a special shape.

The Wender construction appears to have been most popular for some ten years after its invention. It was used, though on a minor

scale, until the end of the century and during the eighteenth century in Germany, but hardly at all after that in western Europe. Pieter Starbus Sr., who had immigrated from Amsterdam, made Wender guns in Stockholm at the close of the seventeenth and the beginning of the eighteenth centuries. The Wender construction called for great skill on the part of the smiths. Its weak point is that the member connecting the barrel and butt sections rapidly becomes worn when in use and consequently soon becomes slack. During the Napoleonic Empire the manufacture of Wender arms was resumed in France.

Among the signed Paris examples are three good specimens of this construction dating from the middle of the seventeenth century. One is a Wender gun, signed 'Thobie à Paris' on the lock, in the Löwenburg at Cassel (No. W 1339. Pl. 25:1, 4). The others are a pair of pistols, signed on the lock 'Choderlot à Paris', in the Töjhus Museum, Copenhagen (No. B 672, B 673. Pl. 25:2, 3). In dating these arms the weapons of the 1640s mentioned above constitute the *terminus post quem*. For the *terminus ante quem* no French arms dated to a definite year are at present available. Comparison with the Töjhus Museum gun No. B 625 (Pl. 30:3) provides such clear guidance that we may take its date 1652 as the latest possible year: the development may even date from a few years earlier. The Töjhus Museum gun is signed by Cornelis Coster of Utrecht. Further support for this dating can be found in a pair of pistols by Jan Knoop, also an Utrecht master. The pistols are in the Rijksmuseum, Amsterdam (Inv. No. 6098. Pl. 30:5). According to tradition they belonged to Admiral Martin Tromp (d. 1653). His coat of arms is on the pommels.

With this criterion certain other French Wender arms manufactured in Lyons can also be dated, and in this way the group enlarged. Amongst these are a pair of pistols in the Wrangel Armoury at Skokloster (No. 64. Pl. 26:1) signed by Claude Roux[27], another pair in the same armoury (No. 63. Pl. 62:2) signed by Cunet, and, finally, a Wender gun in the Töjhus Museum, Copenhagen (No. B 675)

signed 'Claude Cunet à Lyon'. All are signed on the locks. With the help of these Lyon arms the examples are sufficiently varied to enable us to work out a development in the Wender group. They display somewhat later forms than the Paris made Wender arms.

The locks of the Wender group are flat like the earlier flintlock arms. The cocks on the Paris made weapons are simpler, without volutes, and have a very characteristic straight spur, flat in front with a groove in which the upper jaw moves by means of a flat projection. The heads of the cock-screws have a cruciform groove and are chiselled in relief. The jaw-screw of the Thobie gun is elongated and plum shaped, that of the Choderlot pistols compressed and slightly contracted in the middle. This is a form which we recognize from the Langon pistol in the Löwenburg (cf. Pl. 21:6). Of the Lyons pieces, the pistols by Claude Cunet show an ordinary French cock with volutes and jaw-screw head of an elongated pear shape. The jaw-screw heads of the Cunet weapons are pear shaped. On the gun the upper jaw embraces the straight spur, but the spurs of the pistol cocks are of purely Wender type. The most striking change has taken place in the neck and body of the cocks, which have been given the form of animals, on the gun a dog whose tail becomes a coil with leaves and flowers, on the pistols, winged monsters.

All the steel-springs of the group are of the same kind with short under-leaves. This we have learned to recognize as a feature of the 1640–50 period. The foot as well as the spur of the steel is very small. The Thobie gun, however, has a spur in the form of a curled leaf although the steel-spring is placed on the inside of the plate.

A very remarkable novelty in the Wender group is the side-plate. In most cases it takes the form of one, or a pair of fantastic animals and serves as a more or less broad connecting-link between the lock-screw heads. On some non-French arms the side-plates are so strongly reminiscent of those on the French wheel-lock weapons (cf. Pl. 29:4, 5 and 108:4), that one is tempted to assume there must be some connection. A Wender by David of Liège (Pl.

29:1), is so old fashioned in comparison with French examples that it might well be asked if the construction was first made outside France, and French manufacture was a later development.

The trigger-guards of most of the Wender arms are very simple. This looks retrogressive but is explained by the fact that they fulfilled the function of both catch and spring for the Wender mechanism and could not therefore be made strong or forked. Where the bolt of the mechanism works in another way the trigger-guards were nevertheless of thin and simple construction.

The gun by Thobie helps us with the typology of the gun-butts by its rounded butt in which every angularity has disappeared. Its similarity with Cornelis Coster's gun of 1652 is striking. The comb is in both cases curved slightly outwards, the underside curved with the belly placed rather far forward. The Cunet Wender in Copenhagen is still at the stage where the butt is angular at the foot and retains the curious flattened projection of the side of the butt as seen on the gun in Pl. 30:2. The ramrod-pipes are slightly profiled. In a few cases folding iron ramrods take the place of the ordinary straight wooden ones in the pistol butts. The ends of these ramrods form a button in the middle of the butt-caps (cf. Pl. 25:2, 26:2).

The pistol pommels are an interesting and important aid in dating. They will be dealt with later. Attention should however be called at this early stage to the short spurs on the butt-caps of the Choderlot pistols. Admiral Tromp's pistols by Jan Knoop of Utrecht, have butt-caps with still longer spurs. This gives us reason to suppose that the Admiral did not acquire them long before his death in 1653. The Choderlot pistols are important evidence in assigning the origin of these spurs to as early as *c.* 1650 or the late 1640s.

It remains to be said of the Wender group that the signatures are engraved with characteristic calligraphic flourishes, a way of signing that is restricted, at the most, to some ten years in the middle of the seventeenth century.

On account of its close conformity of style a gun of Bock construction (two fixed barrels, one above the other; two locks) by Abraham Meunier, Geneva, preserved in the Töjhus Museum, Copenhagen (No. 680. Pl. 26:3), can be included in this Wender group. The locks have the usual characteristic features of this group, but the butt is old fashioned. This gun, which is intimately connected with purely French arms, has been chosen to introduce in the following chapter the question of the distribution of flintlock manufacture.

Editor's Notes

* A facsimile edition of this was published by the Swedish Royal Armoury in 1950 with an introduction by Dr Lenk.

† In other words the cock is ring-necked.

‡ This treatise has since been published by General A. Gaibi in *Armi Antiche*. Part I in the issue for 1962, Part II in that for 1963.

Notes to Chapter Four

1. I have previously (*Konsthistorisk tidskrift*. III. Pp. 132, 137) expressed the opinion that Philippe Cordier Daubigny's pattern sheets (Pl. 108) show the types of the 1620s although they are dated from the middle of the 1630s. This opinion is untenable. They are undoubtedly in the main an expression of current types.

2. Guiffrey, *Inventaire général du mobilier de la couronne*. T. II. P. 58. Un fusil de très gros calibre, de 4 pieds 4 pouces, le canon couleur d'eau, doré de rinceaux sur le bout et sur la culasse; la platine gravée en taille d'espargne sur un bois de poirier, dont la crosse est vuidée en console, peinte de rinceaux d'or sur un fond rouge des deux costez, dans laquelle il y a un crapeau de plomb.

3. Guiffrey, *Inventaire général de mobilier de la couronne*. T. II. P. 61. Un très beau fuzil, de 4 pieds 7 pouces, pour servir à mesche et à fusil, le canon doré en couleur d'eau sur le bout et sur la culasse où sont les armes de France; la platine gravée en taille douce

et taille d'espargne, ayant un mascaron doré et appliqué sur le milieu sur un bois noir, dont la crosse est gravée d'une piece de rapport de cuivre doré, représentant la Justice, au bas de laquelle est escrit *hæc Lodoice oculos tibi cæca reliquit, fait par Duclos.*

4. Le Musée de l'Armée. *Armes et armures anciennes.* T. II. Pp. 133, 134. Pl. XLI, XLI bis and XLVI.

5. Guiffrey, *Logements d'artistes au Louvre.* (Nouvelles archives de l'art français. II. Pp. 65, 128.)

6. Cosson, *Le Cabinet d'armes de Maurice de Talleyrand-Périgord, duc de Dino.* P. 100. No. K. 8.

7. Guiffrey, *Inventaire général du mobilier de la couronne.* T. II. P. 63. Un grand fuzil très riche, de 5 pieds ½, le canon couleur d'eau, rond par devant et à pams sur la culasse enrichie de fleurs de lis, dauphins et d'L couronnées, ayant un dragon de cuivre doré de relief qui sert de visière; la platine gravée d'une chasse de cerf en taille douce sur un bois d'ébeine; la crosse persée dans laquelle est enchassé un dauphin de cuivre doré; sur la queue de la culasse est éscrit: *Desrogez m'a donné au Roy.*

8. Post, 'Das Zeughaus'. *Die Waffensammlung.* T. I. P. 138.

9. Livrustkammaren. *Vagledning 1921.* P. 54. No. 380. P. 61. No. 466.

10. *Livrustkammaren 1683.* P. 53. No. 3. Palace Archives.

11. Ibid. P. 60. No. 28.

12. Communicated by Captain Joh. Stöckel, Copenhagen.

13. Communicated by Dr Erna v. Watzdorf, Dresden.

14. A leaf forms the extension of the rigid arm of the spring beyond the screw. This elongation usually is in the form of a leaf.

15. Thierbach, *Die geschlichtliche Entwickelung der Handfeuerwaffen.* P. 66.

16. Boeheim, *Meister der Waffenschmiedskunst.* P. 56.

17. ffoulkes, *Inventory and survey of the Armouries of the Tower of London.* Vol. I. Pp. 89, 90.

18. Plon, *Benvenuto Cellini.* Pp. 397–401.

19. 'Le Canna Franzese hanno un bottone in cima, e sono mezze tonde, e mezze quadre, in esse Si trovano varie impronte. Le quali son queste. Queste non sono molto, perfétte, perche sono frangibili, e facili a crepare, e mal tirate.' Petrini, *De arte fabrile,* manuscript in the Tower of London.

20. This number, like others on weapons in the Wrangel Armoury, is indicated by the figures stamped into the stock.

21. Robert, *Catalogue des collections composant le Musée d'Artillerie—1889.* T. IV. P. 309. 'Pair de petits pistolets probablement italiens, de la deuxième moitié du XVIII:e siècle.'

22.

23. Laking, *A catalogue of the armour and arms in the armoury . . . in the palace, Valetta, Malta.* P. 10. Pl. VII.

24. Town in Dordogne.

25. A lock signed 'Mayer à Lyon' belongs to the Musée de la Porte de Hal, Brussels. Inv. No. 5105.

26. Example in the Brahe-Bielke Armoury, Skokloster.

27. There is a gun signed 'Claude à Lyon' in the Örbyhus (Sweden) Armoury.

Plate 41.

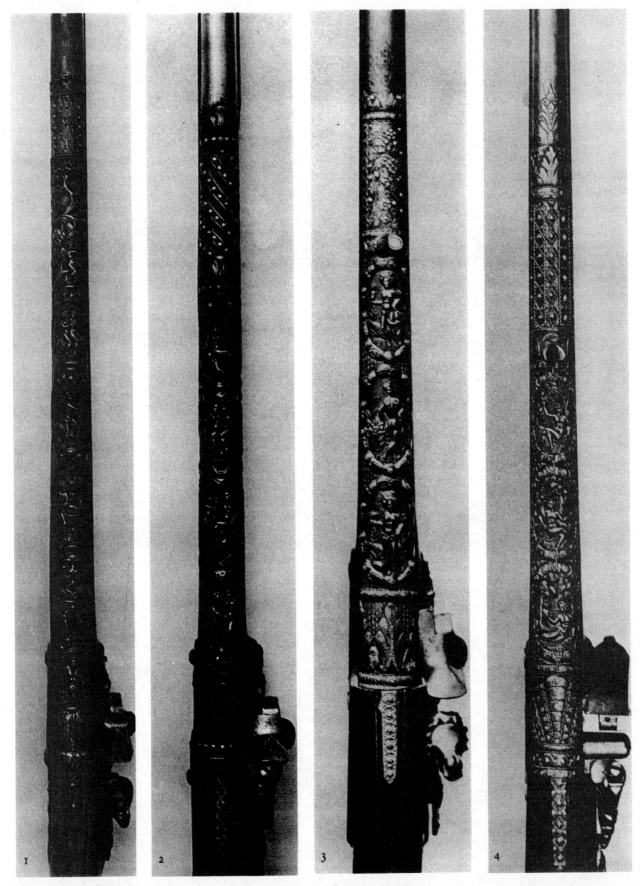

Western Europe.
Mid seventeenth century.

1–4. Decoration in relief on the barrels of the guns on Pl. 37:4, 38:1 and 39:1 and 2.

Plate 42.

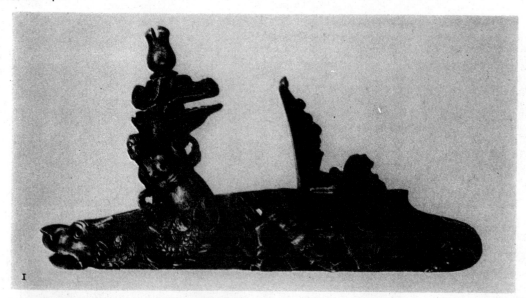

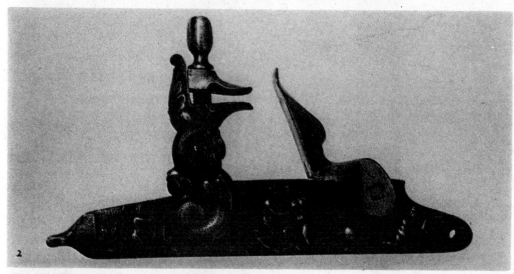

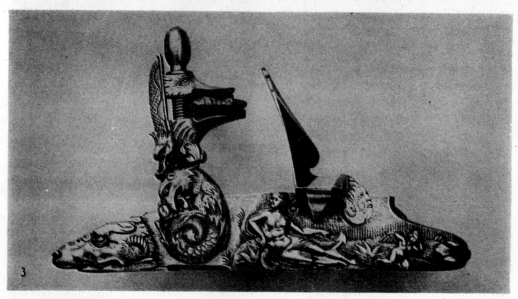

Western Europe.
1640–50s.

Locks of the guns on Pl. 37:3, Pl. 38:1 and 39:2.

Plate 43.

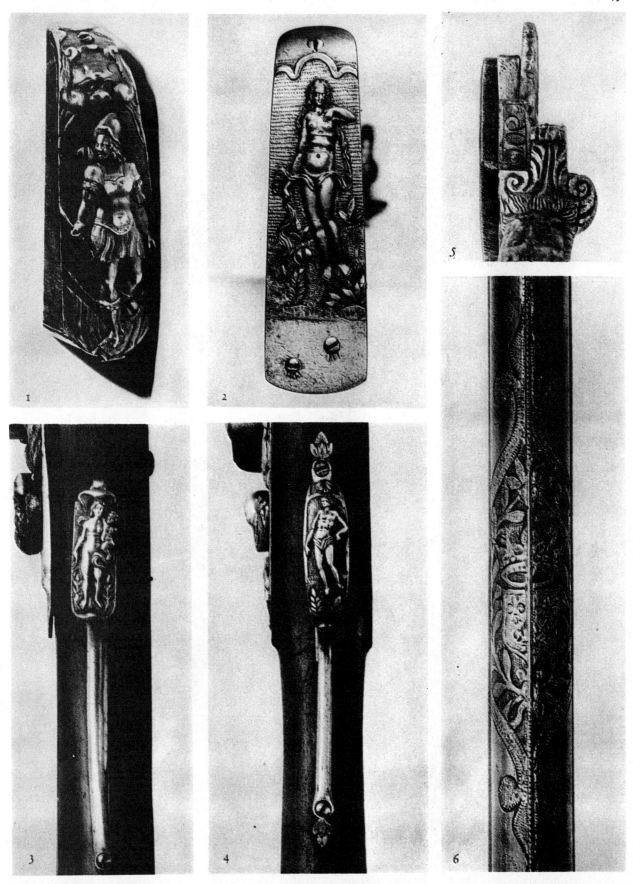

Western Europe.
1640–50s.

1 and 2. Butt-plates of guns on Pl. 37:1 and 39:2. 3 and 4.
Trigger-guards on the guns on Pl. 36:2 and Skokloster,
Wrangel Armoury 112. 5 and 6. Details of the gun on Pl.
39:3.

Plate 44.

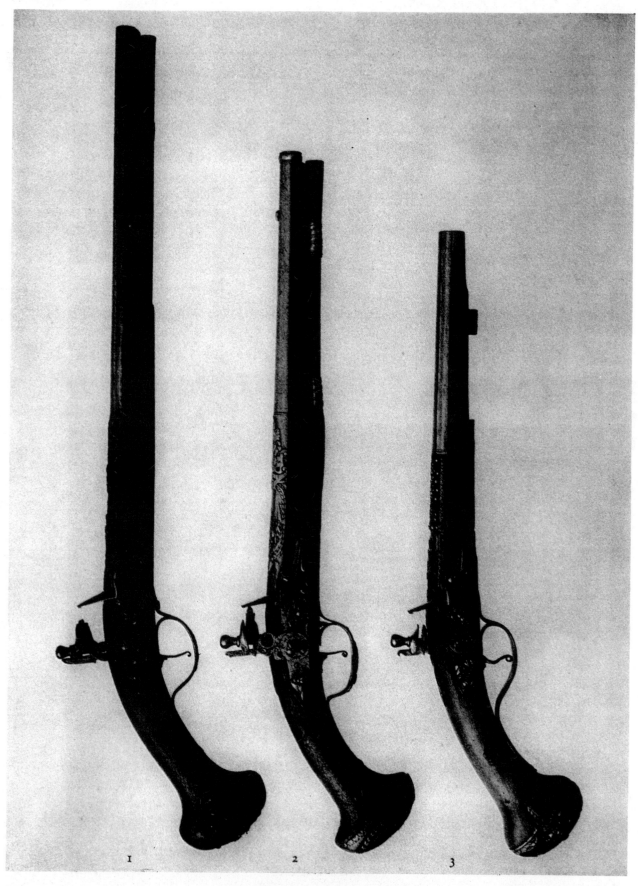

1 2 3

Western Europe. Pistols, each one of a pair. 1. Skokloster, Wrangel Armoury
1650s. 46. 2. Restocked. Säbylund. From the Wijk Collection.
 3. Stockholm, Livrustkammaren 4813.

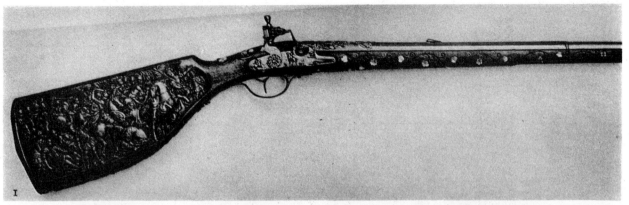

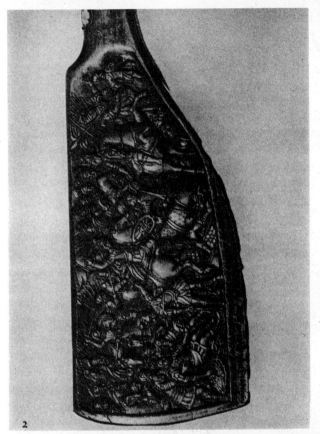

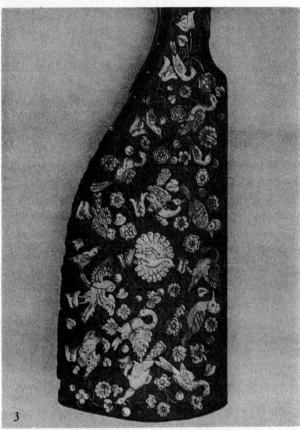

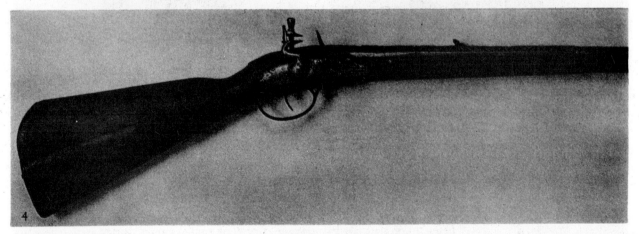

Plate 45.

Western Europe and France, Sedan. *c.* 1660.

1–3. Gun. Stock signed 'Johan Eberhard Somer'; Stockholm, Livrustkammaren 48/1. From the Saxon Grand Ducal Armoury in Schloss Ettersburg. 4. Gun, signed 'I. R.' and 'Sedan'. Schwarzburg 1002.

Plate 46.

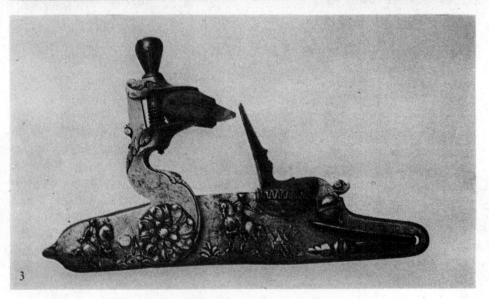

Western
Europe.
1650s.

1. Lock of Pistol on Pl. 44:1. 2. Lock of pistol on Pl. 44:3.
3. Lock of gun Pl. 45:1.

Plate 47.

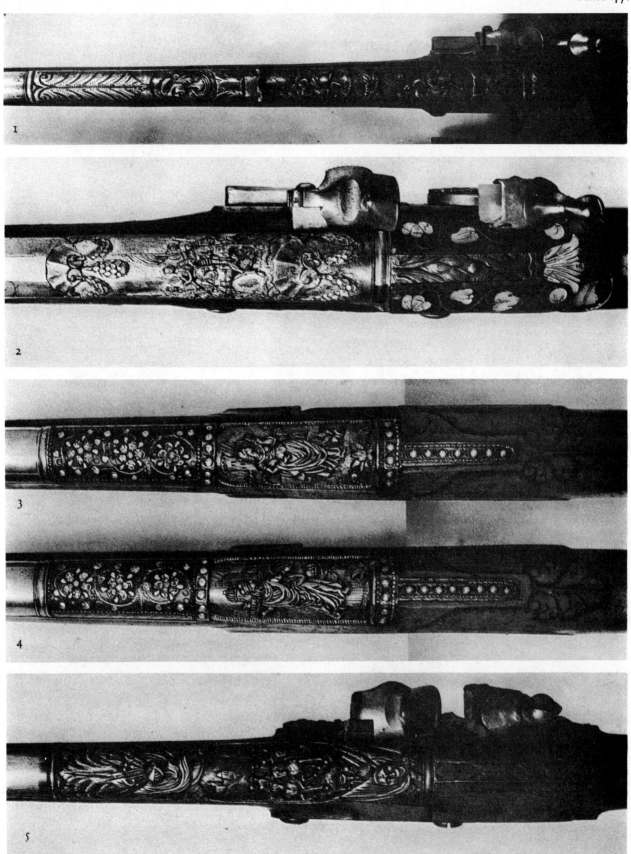

Western Europe and France, Sedan. 1650s and *c.* 1660.

Decoration in relief on barrels. 1. The gun on Pl. 45:4. 2. The gun on Pl. 45:1. 3 and 4. Pistols; Stockholm, Livrustkammaren 4813 (Pl. 44:3), 4814. 5. The pistol on Pl. 44:1.

Plate 48.

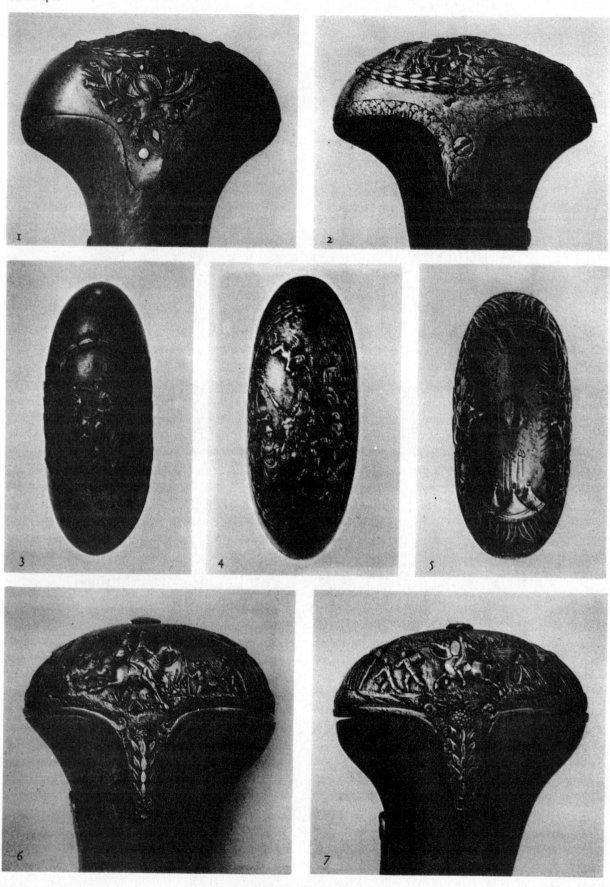

Western Europe.
1650s.

Butt-caps. 1 and 3. The pistol on Pl. 44: 1. 2 and 4. The pistol on Pl. 44:2. 5–7. Pistols; Stockholm, Livrustkammaren 4813 (Pl. 44:3), 4814.

Plate 49.

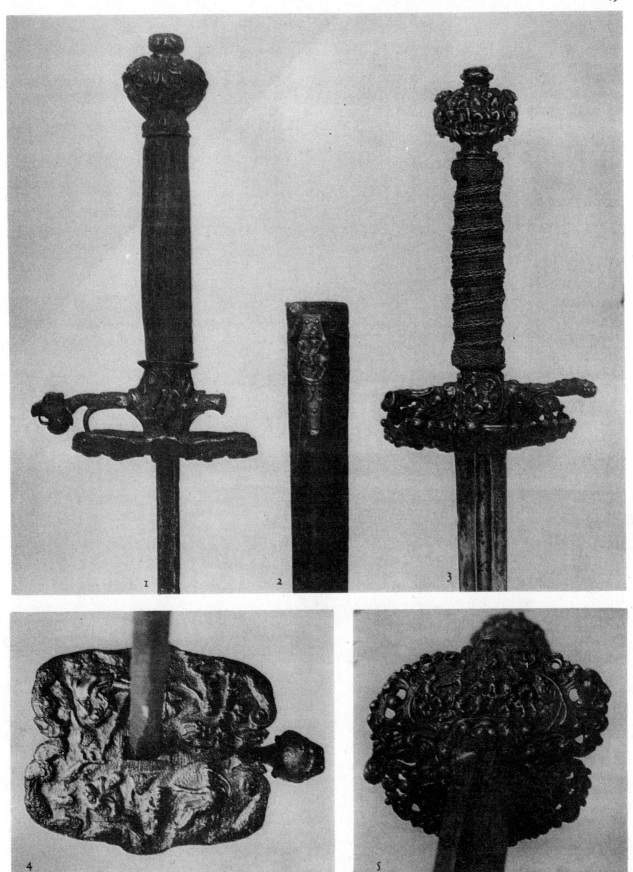

France.
Mid seventeenth century.

1 and 4. Sword with same motif as the lock on Pl. 37:6.
2, 3 and 5. Charles X Gustavus's sword, bought in Paris
1654; Stockholm, Livrustkammaren 5817:1, 3869.

Plate 50.

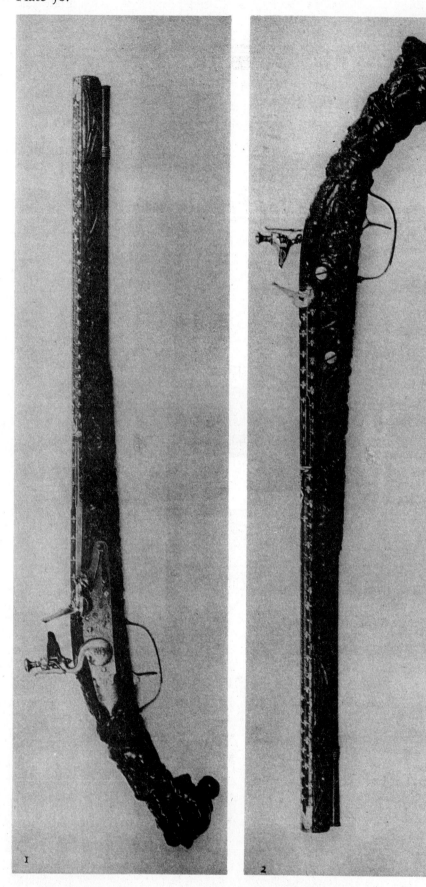

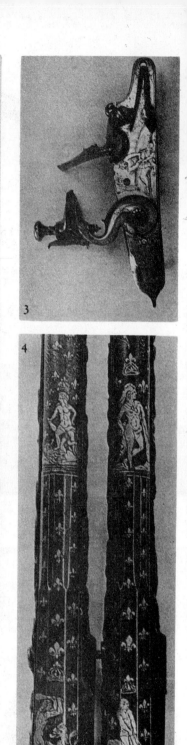

Western Europe.
c. 1660.

Pistols made for Louis XIV; London, Wallace Collection
V: 916, V: 917.

Plate 51.

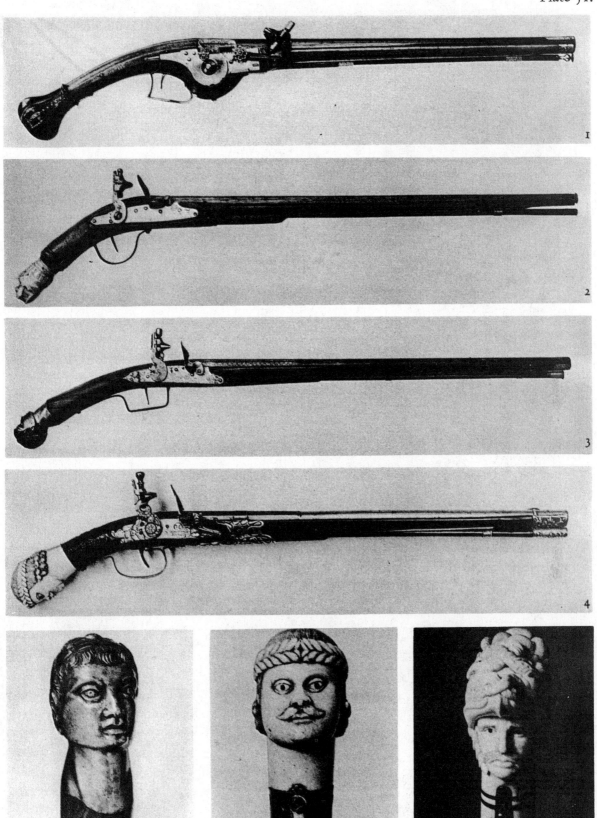

Western Europe.
1610–60.

Pistols, each one of a pair. 1. Wheel-lock pistol. French.
1610–20; Copenhagen, Rosenborg 7–137. 2. Flintlock
pistol, 1630–40s. From Akero (Sweden). 3 and 5. Pistol
1630–40s; Skokloster, Wrangel Armoury 66. 4 and 6. Pistol
by Johan Ortman of Essen. 1640s. Lowenburg Castle W
1159. 7. Butt-ball of pistol on Pl. 52:1.

Plate 52.

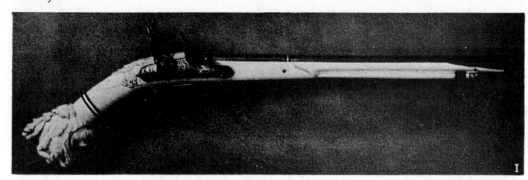

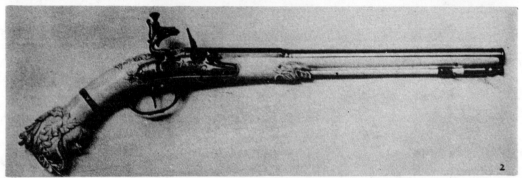

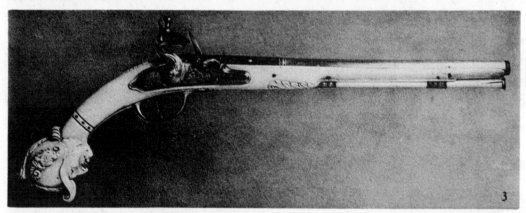

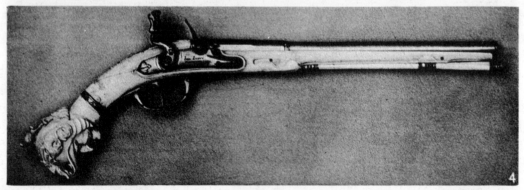

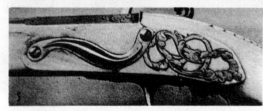

Netherlands, Maastricht. 1650–60s.

Ivory stocked flintlock pistols, each one of a pair. 1. By Louroux; Skokloster, Wrangel Armoury 56. 2. By same master; Ilgner Collection, Berlin. 3 and 5. By Jacob Kosters; Copenhagen, Töjhusmuseet B 920. 4 and 6. By Johan Louroux; Stockholm, Hallwyl Museum A 16.

CHAPTER FIVE

The distribution of flintlock manufacture up to the middle of the seventeenth century

ARMS OF THE types described in preceding chapters as French of the 1640–50 period and Wenders were made about the same time. We also find that flintlock arms of this period which are not definitely French show features derived from both types. An example is the pistol with chased silver pommel illustrated in Pl. 24:4. It has the spur and side-plate of the Wender group, although otherwise it belongs in type to the other pistols illustrated in the same plate.

During the period from 1630 to 1650 the manufacture of flintlocks had already become widely spread, and in the middle of the seventeenth century it existed in the Netherlands, England, Germany, Switzerland and Italy. This statement is based on the existence of arms which, according to the system worked out above for dating French firearms, should bear that early date. Some time lag must, however, be taken into account. Before making an exact estimate of the spread of flintlock manufacture, more detailed local investigations should be undertaken. In doing so it must be remembered that the signing of firearms only becomes common in the middle of the seventeenth century. The identification of many

unsigned weapons and of others with undeciphered marks might show this distribution in a different light. The armouries at Skokloster offer important and interesting material for such a study.

That Metz may come to be reckoned among the earliest places of manufacture is shown by Jean Henequin's pattern-sheets. A pair of pistols by 'Jean Preuot à Metz' of about 1630 in the Wrangel Armoury (No. 33. Pl. 28:2) gives further support to this assumption. Outwardly they resemble flintlock weapons but have a horizontally moving sear which forms a half-cock in front of the cock. It is also worthy of special note that they have a rear ramrod-pipe and fore-end plate.

In the Pauilhac collection is a pistol by 'Montaigu à Metz' (Pl. 28:3) with barrels decorated in a technique reminiscent of the Dauphin's gun in Berlin (cf. Pl. 19). This again has a simple trigger-guard divided in front, a steel-spring with short under-arm and a cast silver pommel in the form of an eagle's head and a grotesque mask pointed upwards. All this taken separately would justify its being attributed to the early 1640s. At the same time, however, the cock in the form of a monster,

the constricted jaw-screw head, the signature with calligraphic flourishes and the well developed spur of the steel point very definitely to the period about 1650.

A pistol in the Zeughaus, Berlin (Inv. No. A D 1336. Pl. 27:1, 2) made in Sedan is the earliest known piece after that of Metz. This pistol is signed on the barrel 'Ezechias Colas à Sedan' (Pl. 134:6). The cock is very simple and straight. The belly shows an uneven contour just where one might expect a ledge if the lock had had a buffer. The neck is curved in a similarly suggestive manner. The cock has a scroll at the bottom of the back with a definite upward curve. The cock is attached to the tumbler by a screw from the inside, and has a rose engraved on the base. The steel-spring is placed beneath the flat pan. The lock-plate is flat with floral decoration engraved at both ends against a dark, stippled background. The part of the guard immediately beneath the trigger is very broad and is abruptly curved. The front end of the trigger-guard serves as a screw. The edges of the chamber are accentuated by filed ridges which fade into the round section of the barrel. The butt-plate is a long oval plate of iron fixed with a screw. The spherical head of the latter can be turned with a pin through a lateral hole. The screw has a small turned ball on the top.

As a whole this pistol shows so many old fashioned traits that it might be representative of the 1630–40 period. A further detail is worthy of notice: the safety catch for the tumbler. The sliding button of the latter with its cruciform groove is placed on the outside of the plate. The triangular fields formed by that groove are chiselled with leaves. This way of decorating the head of the cock-screw was adopted during the 1640s and 1650s. The pistol probably need not be attributed to a later date. It is worth while calling attention to this detail as archaic forms were often preserved, especially in provincial centres.

Similar archaic forms appear on another pair of pistols signed by the same master in the Historisches Museum, Berne (Inv. No. 3902. Pl. 27:3)[1]. As a whole they show great similarity to the Berlin pistol. They are, however, con-siderably shorter, and the spur of the cock is shaped like a round peg. This fits into a hole in the upper jaw of the cock. The locks are rounded in form. We shall return to this below. On a pair of pistols signed 'Jean du boy A Sedan' on the locks (Skokloster, the Wrangel Armoury No. 44. Pl. 28:1) we find the same old fashioned features in the barrels with ridges fading away and the steel-springs placed inside of the lock-plate. Everything else, however, indicates that they are later: the slightly fuller forms, the very full scrolls of the cocks and the acorn shaped head of the cock-screw, the short, sunken ledge with naturalistic flowers on a dark, stippled ground at the back of the lock-plate and, not least, the trigger-guard. The forward, divided end of this is formed in front as a lobate leaf. Apart from this the angle formed by the two arms is filled by a fluted ornament. It is difficult to say how much earlier than 1650 these pistols could be dated, but taking everything into consideration they must belong to the latter half of the 1640s. The pair of pistols in the Livrustkammare (Inv. Nos. 1694, 1695. Lock Pl. 27:4) can be dated with more confidence to the 1640s. They are signed 'Gabriel g a S' on the barrels and 'gabriel gourinal A.S.' on the locks. The round heads of the jaw-screws are old fashioned. The simple trigger-guards and the spur are typical of the group.

In his history of Liège, Gobert expresses the opinion that the world-wide fame of the city as a producer of arms is due to its production of flintlocks. He bases this on information in Hertslet, *Diplomatic and consular reports No. 650*[2]. It is difficult to judge now how true this may be. It is nevertheless certain that Liège, because of its favourable situation, and its capacity as a free state, could supply anyone willing and able to pay. This was the case during the Thirty Years War, the very period when the flintlock first became an article of export, and its manufacture thereafter increased all over Europe. Right from the Union of Utrecht to the Peace of Westphalia in 1648 there was close co-operation between Liège and Maastricht[3] in the manufacture of arms.

As far as the former town is concerned we

have evidence in a three barrelled Wender in the Livrustkammare (Inv. No. 5305. Pl. 29:1, 4) signed 'David à Liège' on the lock. This was probably Arnold David, master of a four barrelled but somewhat later Wender in the Musée de la Porte de Hal, Brussels (previously in Consul-General Jean Jahnson's collection at Stensund, Sweden). The Livrustkammare gun has a flat lock-plate with a bevelled edge, finished off at the back with a chiselled trilobate leaf. The corners of the mouths of the cock-jaws are similarly treated and the jaw-screw head is slightly constricted in the middle. This along with strongly 's' curved side-plate (Pl. 29:4) enable us to date it about the middle of the century. Otherwise there is a suggestion of local tradition in the trigger-guard which is only divided at the near end and stands clear of the stock right up to the butt-plate screw, in the ridged octagonal barrel with multi-lateral chamber and especially in the butt with its clearly defined and angular body. It is the existence of this gun in particular that has given rise to the hypothesis already mentioned that the Parisian Wender arms may go back to an older, non Parisian type. Of about the same time is a pair of pistols signed 'Jan Aerts Mastricht' in the Renwick collection, previously in the Edwin E. Brett collection[4]. They are closely related in style to the Livrustkammare's Thomas garniture but have the constricted jaw-screws just mentioned. This indicates a date about 1650. The ornament is characterized by naturalistic flowers on lock, butt mounts, ramrod-pipe, fore-end and ramrod mount. The presence of a rear ramrod-pipe is remarkable. Another Maastricht master who was active at the same time was Jan Kitzen. As examples of his work a Wender gun in the Löwenburg on Wilhelmshöhe, Cassel (Inv. No. W 1338. Pl. 29:2), and a pair of Wender pistols in the Wrangel Armoury, Skokloster (No. 63), may be mentioned. All three arms are signed on the locks, the gun being also marked on the barrels with 'I K' and a star above a double eagle[5]. They are all so alike that they might belong to a garniture. The body and neck of the cocks are formed as monsters. The upper jaw runs with a projection in a groove in the spur of the cock.

The lock-plates are finished off behind with heads of monsters in relief. On the pistols the counterparts of these are carved in the left sides of the stocks. The trigger-guards belong to the type that is divided at the forward end, and the triangular hollow thus formed is filled up. The rear arm lies close alongside the stock and terminates in a leaf. Very representative is also a pair of pistols in the Wrangel Armoury, Skokloster (No. 71. Pl. 29:3, 5) by La Pierre, Maastricht. Their side-plates are closely related to those on the David Wender in the Livrustkammare.

From the large town of Aachen, which is very close to Maastricht, we have a Wender pistol, formerly in the Löwenburg, Cassel (now missing) (Inv. No. 1204), signed 'Mateis Nutt in ach' and furnished with a mark containing a stag's head[6]. Both the signature and the mark are on the barrels. The lock-plates have at the rear end the same monster heads in relief as the Maastricht weapons just mentioned.

In Gelderland where the Berkel runs into the Ysel lies Zutphen. From this town comes a pair of Wender pistols signed 'Te Zutphen' and 'Van densande' (Pl. 30:1)[7]. These pistols have several French features of the 1630–40 period, such as the flat lock-plates and the trigger-guard which is only bent upwards and backwards at the front. But the steel-spring with a long and a short arm belongs to the 1640s. The rounded lobes of the upper jaw with which it engages the spur of the cock are also later in type. Finally, the jaw-screws, constricted from above, and the presence of embryonic side-plates date the pistols to the middle of the seventeenth century.

Signed pieces from Utrecht are more numerous but later. The starting-point is the gun mentioned above in the Töjhus Museum, Copenhagen, by Cornelis Coster which is dated 1652 (Inv. No. B 625. Pl. 30:3). The lock-plate has much in common with the Livrustkammare Thomas garniture, but is thicker. The sunken ledge at the back has an engraved grotesque mask. The corners of the mouths of the cock-jaws are chiselled in relief according to the type noticed in the Thomas garniture and the

upper jaw runs with a projection in a groove in the spur of the cock. The head of the jaw-screw is constricted at the top. The trigger-guard is also distinctly heavy yet old fashioned. The completely rounded butt fully corresponds to our expectations on the basis of the conclusions we have reached above. It is curved downwards both on the upper and under sides and the lower edge of the body is faintly outlined on the left side. Leaves are carved at the lock and breech. There is a rear-pipe and the ramrod is turned with a distinctly raised profile.

By the same master and dating from about the same period is a pair of signed pistols in the Wrangel Armoury at Skokloster (No. 53. Pl. 30:4).

We have already mentioned Admiral Martin Tromp's pistols by Jan Knoop, Utrecht (Pl. 30:5). They give a good basis for dating flint-lock arms of the middle of the seventeenth century.

The Töjhus Museum, Copenhagen, possesses a number of arms by Jan Flock (also 'Flocke'), Utrecht. Two three barrelled Wenders, Inv. Nos. B 618 and B 619 (Pl. 30:2) may serve as examples. The steel-springs with equally long arms indicate a somewhat later date of manu-facture than the other Utrecht weapons. In other respects, however, these guns are more old fashioned. The ledges on the lock-plates, strikingly elongated, are emphasized by bevel-ling and engraving. The cocks with forms of about 1650 have plum shaped heads on the jaw-screws. The sculptural treatment of the cock-screw heads looks forward to the next group in date. The butt of the one gun corres-ponds with the Coster gun of 1652 mentioned above, but the other still retains a pronounced body which sweeps upwards and terminates in a projecting roundel on each side of the butt. From the under side a spur turns outward—as on the 'pistol butt' of our own day. A pair of Wender pistols in the Livrustkammare (Inv. No. 19/17) and a pair of pistols in the Wrangel Armoury at Skokloster (Inv. No. 248) can be included in this early flintlock production of the mid seventeenth century. Both pairs are signed by Kasper Dinckels (Deinckels), also of Utrecht. They lack side-plates and rear-pipes

and are therefore old fashioned. The Wender pistols have the round barrels usual in the Netherlands and, like the Livrustkammare Thomas garniture, butt-caps without spurs. The second pair has barrels with octagonal chambers. These are bevelled in front into sixteen sides like the barrels of the Thomas garniture. The caps have short spurs along the sides of the butts, thus foretelling the future trend. The butt-caps of both pairs are decorated with coarse reliefs.

The part played by the Netherlands in the early manufacture of the flintlock is un-doubtedly considerably greater than is apparent from the material presented here. It would be of great importance if this could possibly be investigated.

Among the unsigned flintlock arms which are early enough to belong to this chapter is a group with two locks for one and the same barrel. This is represented in the Wrangel Armoury at Skokloster (Inv. Nos. 223, 62. Pl. 31:1, 2) by a gun and a pair of pistols (Inv. No. VI: 116), in the Rotunda at Woolwich by one of a pair of pistols* and in the Historisches Museum, Dresden (No. F 464), by still another pair of pistols. The barrels have the elongated ridges which we already know from the pistols by Ezechias Colas of Sedan, and Montaigu of Metz. On a number of the locks in this group the upper jaw of the cock glides on a circular peg, as do the Colas pistols in Berne. These facts may serve as a guide in finding the centre or centres of production of the group. This has not yet been achieved. It is true that the group offers certain similarities to another, larger one, thus throwing some light on the first appear-ance of the flintlock on German territory. This problem of the initial spread of the construction on German soil is very complicated. A few hints only can be made towards the solution here.

As our starting point we choose a fully developed flintlock gun preserved in the Zeughaus, Berlin, with the Augsburg master Martin Kammer(er)'s mark on both the barrel and the lock, and with his initials on the barrel (Inv. No. A D 8694. Pl. 32:1). It bears a striking likeness to two snaphance guns in-cluded under No. 138 in the inventory of the

French *Cabinet d'Armes* formerly preserved in the Rotunda, Woolwich, and now in the Victoria and Albert Museum, Nos. M.4, 5-1949. The lock of the latter especially offers points of comparison. In the Berlin Zeughaus there is also a snaphance gun† which has much in common with those at Woolwich. In the Wrangel Armoury, Skokloster, there are still other pieces that can be included in the group.

Judging by the form of the lock-plates one is rather inclined to call these locks Italian. Like the latter they are also marked on the inside of the plates, except two at Skokloster, which are marked on the outside.

Whether the types of locks regarded as Italian, really are of Italian origin or not is open to argument. The typical character of these locks, here considered as Italian, is that the lower edge of the lock-plate expands in the middle, usually forming a point, and that between this and the fore end of the lock-plate there is a round notch in the edge. This notch is still more prominent on the wheel-locks. It is found on a very early group of wheel-locks with the lock-plate extending as far forward as the dog-spring and in which this latter has a very long upper and a short under-arm. In the under-edge of the lock-plate a notch is made corresponding to the part of the upper spring-arm projecting beyond the lower shorter one. This detail is found at an early date on pistols in the Armería, Madrid (Nos. K 30, K 35)[8], and recurs on a pistol in the Livrustkammare (Inv. No. 1573)[9]. On this the notch is shorter, and still more so on the six Netherlands wheel-lock muskets in the Livrustkammare of 1596[10] (Inv. Nos. 1204–1206, etc.). As to southern Germany we may mention a wheel-lock gun in the Musée de l'Armée, Paris (Inv. No. M 142). This has a Nuremberg mark and is ascribed by the author of the select catalogue of this museum (Part II, 1927), to the close of the sixteenth century[11]. He states that before the beginning of the seventeenth century Italy imported locks from Germany, especially from Suhl and Nuremberg. It would be very interesting to examine the evidence on which this opinion is based. It seems probable, however, that this was the case‡.

The same tendency to rhomboidal lock-plates also occurs in France. It is still discernible in the 1630s and is only discontinued during the latter half of the century. In the German group with which we are dealing we encounter 'Italian' form both on retardatory pieces in the style of the 1630s and also on pieces that follow the contemporary style.

The Kammerer gun in Berlin which, as far as the form of the lock is concerned, is an example of a direct borrowing, should be given an early date in view of the period in which this master is known to have worked. A gun made by him in the Historisches Museum, Dresden, is dated 1654[12]. It has been possible to attribute the gun in Berlin to master and place by the marks. A further study of marks will probably add much more material to this group.

It is to this group that we assign the garniture of gun and pistols signed by Felix Werder, Zürich (Pl. 32:2, 3). The gun, a light flintlock carbine with the signature 'Felix Werder Tiguri Inventor 1652' is preserved in the Kunsthistorisches Museum, Vienna (Waffensammlung No. A 1454)[13], to which it came from Amras. It was once considered to date from the very earliest days of the flintlock (cf. above, p. 10). This probably gave rise to the theory that the construction was a Swiss invention. The pistols were published by E. A. Gessler[14]. He gives a detailed history of the origin of the garniture.

The gun No. 244 in the Wrangel Armoury, Skokloster, and a pair of pistols belonging to Queen Kristina in the Livrustkammare (Inv. Nos. 1610, 1611. Pl. 31:3, 4)[15] show such great similarities that they might form a garniture. They are unsigned but belong to the same group as those by Kammerer and Felix Werder with which we have just been dealing. Locks and trigger-guards provide convincing comparisons, and the dating, based on the form of the butt and on these comparisons, is to the middle of the seventeenth century. There is another gun in the Wrangel Armoury, Skokloster (No. 252) that belongs to the group. It has a flat lock-plate stamped with a mark on the outside. The group is, however, as has been indicated above, considerably larger.

57

From the middle of the seventeenth century it became usual to sign flintlock weapons, and with the help of these signed weapons it becomes easier to establish the centres of flint-lock manufacture in Germany. The lock of a blunderbuss signed 'Valentien Triebel' in the Artillery Museum, Oslo (Inv. No. A 41. Pl. 33:1)[16] illustrates in certain respects the French type, but is simpler and coarser. The butt belongs to the completely rounded type with slightly downward bend and is therefore quite un-French in its form. Triebel does not tell us where he lived, but 'Heinrich Moritz à Cassel' on the other hand does so—on the lock of a breech-loading gun with turn-off barrel in the Töjhus Museum, Copenhagen (Inv. No. B 543. Pl. 33:2). The gun is still more closely connected with French or Netherlands prototypes with its volute decorated cock, slightly constricted plum shaped jaw-screw head and a chiselled rose in place of the cock-screw, and trigger-guard of divided form. The upper jaw slides with a projection in the groove of the comb of the cock. Another early German flint-lock with dog-catch is fitted on a gun with stock by Johann Michael Maucher of Schwäbisch Gmund[17]. Maucher is known from works dated between 1670 and 1693. The Örbyhus[18] gun should most probably be dated before 1670; how much it is difficult to say at present. The lock is based on western European forms of the 1640–50 period, as is the trigger-guard. This is divided at the near end where a lobate leaf form recalls the 1640–50 period. In Germany there was a considerable time lag in the development of the flintlock. A striking proof of this is provided by a breech-loading gun in the Töjhus Museum, Copenhagen (Inv. No. B 572. Pl. 33:3). It bears on the lock the signature 'Jean Hennere Albrecht', and, on the barrel, the inscription '1667 zu Braunfels gemacht'. Dating by French standards we would have placed it in the 1650s.

In Augsburg too French influence can be recognized from the middle of the seventeenth century. A pair of pistols with tortoise shell veneered stocks in the Livrustkammare (Inv. Nos. 1734, 1735. Pl. 33:4) conform most closely to the western European Wender style, but the stocks show Italian influence. They can be localized by the presence of the Augsburg pine cone mark on the undersides of the barrels. Later in style, but according to French standards not after 1650, is a pair of pistols in the Historisches Museum, Dresden (Inv. No. 354 b. Pl. 34:1, 2)[19]. They form part of a large sporting gun garniture which includes a wheel-lock gun dated 1669. This is signed by Melchior Wetschgin. A gunsmith of this name is known to have lived at the time in Vienna[20], but 'Augsburg' is engraved on the lock-plates of the pistols. These pistols were influenced by a style which first appears in Paris in the 1650–60 decade.

Gessler states in his guide to the Swiss Landesmuseum that the French flintlock was introduced in Zürich in 1656[21]. From the point of view of form there is nothing against two flintlock muskets illustrated in the same guide (Pl. 45) belonging to this period. They have flat lock-plates. A flintlock gun by Jakob Erhardt, Basel, with a curious lock—it has three cocks on the same plate, rotating steels and catches[22]—shows, on the whole, the forms of the middle of the seventeenth century. It is included in an arsenal inventory of 1662.

Flintlock manufacture in Sweden is first definitely recorded during the 1670s and there are Swedish flintlock weapons dating from this period[23]. They show a western European style characteristic of the 1660–70 period. There is evidence, however, which indicates an earlier manufacture, viz. the Swedish Board of Trade letter to Reinhold Rademacher of Eskilstuna, of 25 April 1662, in which the Board makes rules for the amount of work the employees in his factory should be able to do in a week. Under the heading: 'Fyrlååsmacharen allena om weckan' (The firelock maker alone per week) is included 'Fysien till montera . . . 8 à 9 st.' (The assembling of . . . 8 to 9 guns), and 'Leuff (Lauf) eller Röörsmeden medh 2 Gåssar' (Barrel or Gunsmith with two boys) should manage 9 'Fysien pipor' (Gun barrels)[24]. The letter does not actually mention flintlocks; wheel-locks and snaphance locks, on the other hand, are mentioned. This tallies very well with a gun in the Livrustkammare (the Sack

Armoury. Pl. 34:3–5), the skilfully made flint-lock of which is in definite contrast to the coarse barrel and birchwood stock. These are probably of Swedish make. The lock has the older, flat form with cruciform-grooved cock-screw head, the upper jaw sliding on a projection in the groove of the spur, the cock related to those we have already mentioned in the form of monsters and the steel-spring with one long and one short arm. Tumbler and sear are old fashioned in comparison to western European forms of about 1650 (the Wender group). On the inside of the lock is a stamp with the letters 'LIS'[25]. Captain Joh. Stöckel has kindly supplied the information that marks of this type are found on locks made in Suhl and Zella. Stock and trigger-guard on the Livrustkammare gun are also related to German forms (cf. the gun in Pl. 31:3). It is most closely allied to the earlier German group, to which it must indeed belong if the theory of Swedish mounting proves untenable.

The manufacture of flintlocks was also begun in Italy at an early date. In studying the north Italian manufacture of arms in the middle of the seventeenth century we should bear in mind Evelyn's note in his famous *Diary* during a visit to Brescia in 1646. He mentions that the population of the town consisted mostly of craftsmen (artists) and that every shop was full of arms. Most of the craftsmen came from Germany[26]. This may be a satisfactory explanation of the direct borrowing of contemporary Italian forms of arms in Germany during the decades about the middle of the seventeenth century. When the flintlock appears in Italy it is, however, of French type.

A painting, *Vanitas* by Boel and Jordaens in the Musée ancien, Brussels[27], shows a collection of worldly goods with which vain man persists in filling his existence. Among numerous magnificent things lies an Italian gun with a flintlock. The cock is modelled in the form of a monster, the jaw-screw is of an elongated plum shape, the lock-plate flat, finished off at the back with long pointed ledge, and with an internal steel-spring. All these details point to the 1630–50 period in France. The lock is mounted in an Italian walnut stock with pierced iron mounts. This gun has its direct counterpart in a pair of pistols in the Moscow armoury (No. 8094. Pl. 35:1)[28], the barrels of which are signed 'Lazarino Cominazzo', and the locks, characteristically enough, 'Gio Francese in Brescia'. Another pair of pistols in the same armoury with quite flat locks practically in the French manner of about 1640 (No. 8095. Pl. 35:2)[29] shows still more clearly how locks of a French type were mounted in what were otherwise purely Italian weapons. A gun in the Musée de l'Armée, Paris (No. M 544. Pl. 35:3), is reminiscent of that in the Boel and Jordaens painting. It is not so beautiful in form, but it is of the same type and of the same period.

The immediately subsequent development can be studied in a pair of Wender pistols in the Livrustkammare (Inv. No. 20/9. Pl. 35:4). They are typical of the middle of the seventeenth century, and in the Walters Art Gallery, Baltimore, is another pair of pistols which were published by Stephen V. Grancsay in *The Art Bulletin* for June 1936[30]. These also have the forms of the Wender group and are very reminiscent of some of the relief decorated arms that form the subject of the following chapter. Grancsay attributes them to the period about 1670 and bases this dating on comparison with a pair of wheel-lock pistols in the Armeria, Turin (Nos. N 41, N 42)[31], which are dated 1665 and 1666 on the locks. I consider, however, that the pistols in Baltimore are somewhat older. The question of dating Italian hand firearms is not yet solved. Grancsay points out the great interest of the pistols published by him, namely that they are signed 'Gio. Batt. Francino' on the barrels, 'Piera Alsa in Brescia' on the locks, and 'Gio Marno in Brescia fece' on the stocks.

Editor's Notes

* This pistol is now in the Victoria and Albert Museum (No. M 86–1949). It is illustrated in *European Firearms*, J. F. Hayward. Pl. XV, No. 32. The pair to it, once in the Berlin Zeughaus, is now in the Polish Army Museum, Warsaw.

† Presumably yet another one from the Paris Arsenal, which was, of course, looted by the Prussian troops under Marshal Blücher as well as by the British under Wellington.

‡ Certainly locks were imported from Germany into Italy, but this does not mean that there was not, at the same time, a healthy local production at Brescia and elsewhere.

Notes to Chapter Five

1. Communicated by Captain Joh. Stöckel, Copenhagen.
2. Gobert, *Liège à travers les âges. Les rues de Liège*. T. II. P. 29. C'est surtout à partie de ce XVI:e siècle, avec l'introduction du fusil à silex, que Liège conquit la renommée universelle en la matière.
3. Gobert, Ibid. P. 69, based on Laminne: *Note sur la manufacture d'armes au pays de Liège.*
4. (Grancsay), *The Metropolitan Museum of Art. Loan exhibition of European arms and armor.* P. 82. No. 329.
5. Cf. Stöckel, *Haandskydevaabens Bedömmelse.* I. P. 229.
6. Cf. Stöckel, *Haandskydevaabens Bedömmelse.* I. P. 229.
7. Photograph kindly given to the author by the firm of E. Kahlert and Son, Berlin.
8. Valencia, *Catálago histórico-descriptivo de la Real Armería.* P. 305. Fig. 287 (should be 278).
9. Cederström and Malmborg, *Den äldre Livrustkammaren 1654.* Pl. 79.
10. Ibid. Pl. 55, 56.
11. Le Musée de l'Armée. *Armes et armures anciennes.* T. II. Pp. 109, 110. Pl. XXXVII.
12. Ehrenthal, *Führer durch die Königliche Gewehr-Galerie zu Dresden.* P. 19. No. 169.
13. Grosz and Tomas, *Katalog der Waffensammlung.* P. 204. No. 9.
14. Gessler, 'Der Gold- und Büchsenschmied Felix Werder von Zürich.' *Anzeiger für Schweizerische Altertumskunde. Neue Folge.* Vol. XXIV. Pp. 113–17.
15. *Livrustkammarinventarium 1683.* P. 53. No. 5. Palace Archives.
16. *Katalog över Artillerimuseet på Akershus.* P. 26.
17. Boeheim, *Meister der Waffenschmiedekunst.* P. 129.
18. Communicated by Baron Rudolf Cederström.
19. Ehrenthal, *Führer durch die Königliche Gewehr-Galerie zu Dresden.* Pp. 29, 30.
20. Stöckel, *Haandskydevaabens Bedömmelse.* P. 317.
21. Gessler, *Schweizerisches Landesmuseum, Führer durch die Waffensammlung.* P. 122.
22. Thierbach, *Die geschichtliche Entwickelung der Handfeuerwaffen.* P. 78. Fig. 176. Gessler, 'Ein Dreischussegewehr mit Steinschloss aus der Mitte des siebzehute Jahrhunderts.' *Zeitschrift für historische Waffenkunde.* Vol. VI. Pp. 139, 140.)
23. Lenk, *Flintlåstillverkningens införande i Sverige.* (Personhistoriska bidrag. Rig. 1935. Pp. 135, 136.)
24. Hellberg, *Eskilstuna.* (En svensk märkesstad. D.I. Pp. 196, 199.)
25.
26. Evelyn, *Diary*, Vol. I. P. 268.
27. Fierens-Gevaert and Laes, *Catalogue de la peinture ancienne.* P. 56. No. 237.
28. *Opis moskovskoj oruzejnej palati.* Picture 416. Text vol. III. P. 309.
29. *Opis moskovskoj oruzejnej palati.* Picture 416. Text vol. III. P. 309.
30. Grancsay, 'A pair of seventeenth century Brescian pistols'. *The Art Bulletin.* 1936. Pp. 240–46.
31. *Armeria antica e moderna di S. M. il Re d'Italia in Torino.* Ser. 3. Pl. 179.

Plate 53.

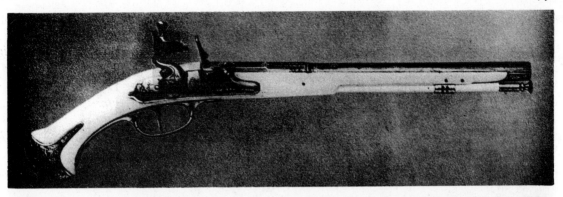

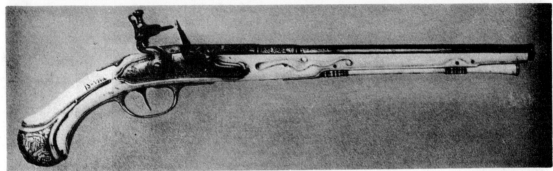

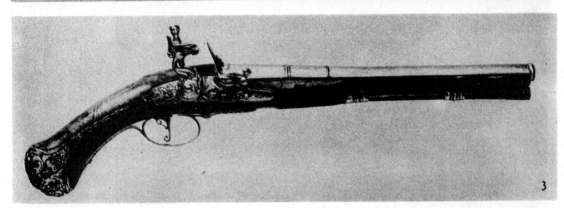

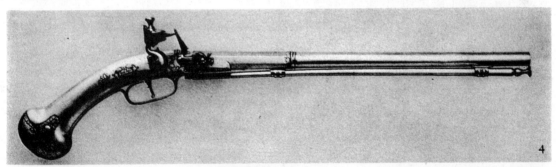

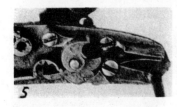

Netherlands, Maastricht; Germany Grevenbroich. 1660–70s.

1, 6 and 7. Christian V's pistol, one of a pair, by De la Pierre of Maastricht; Copenhagen, Töjhusmuseet B 918. 2. Frederic IV's pistol, one of a pair, by De la Haye of Maastricht; Copenhagen, Rosenburg 13–848. 3 and 5. Pistol by 'H. Renier'; Buch Collection, Copenhagen. 4. Pistol with iron stock by 'Jan Cloeter à Grevenbroch'; Copenhagen, Töjhusmuseet 904 B 904.

Plate 54.

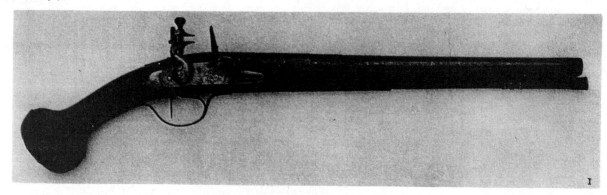

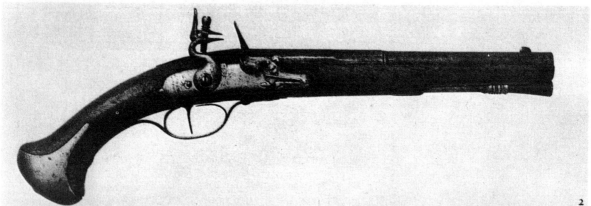

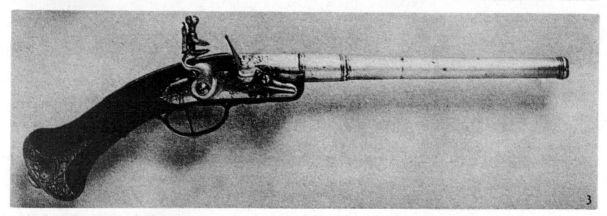

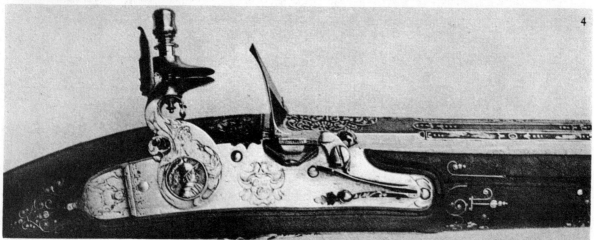

Western Europe.
Mid seventeenth century.

1. Charles X Gustavus's pistol, one of a pair, by Barroy; Stockholm, Livrustkammaren 1629. 3. Pistol, signed 'A Lesconné'; Lowenburg Castle W. 1210. 4. Part of lock of pistol on Pl. 55:1.

Plate 55.

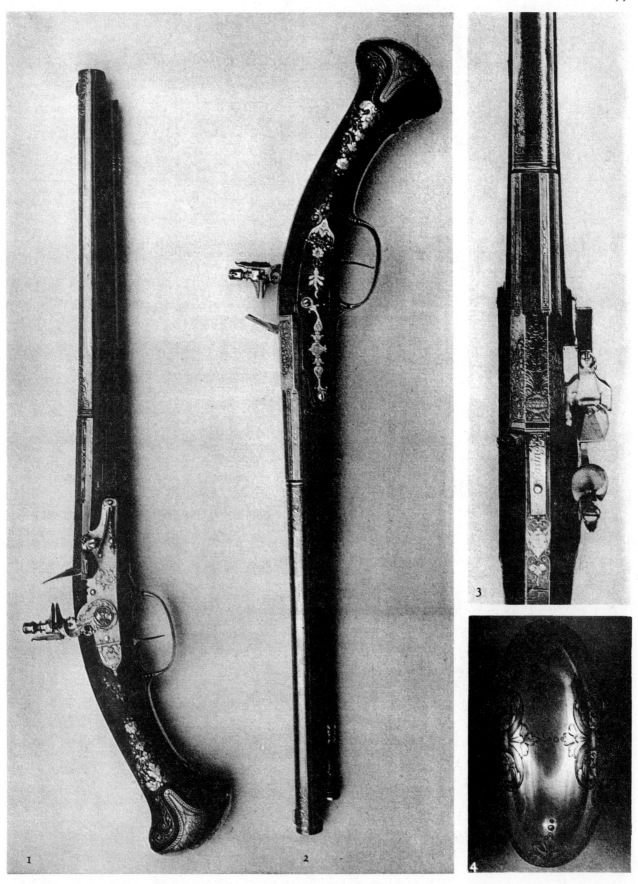

France, Paris.

Augustus the Strong's pistols by Casin of Paris; Dresden, Historisches Museum H.19.

Plate 56.

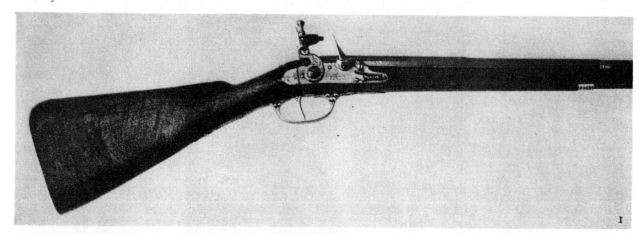

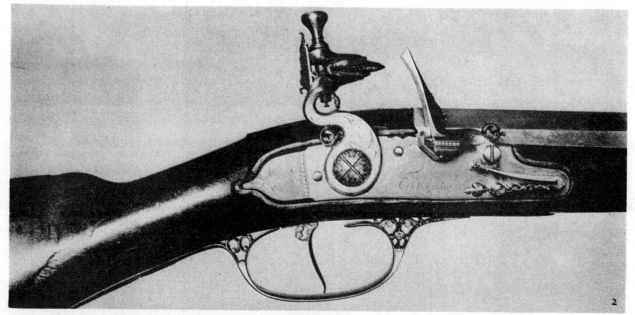

France, Paris.
c. 1660

Gun by Thuraine and Le Hollandois of Paris; Copenhagen,
Töjhusmuseet B 662.

CHAPTER SIX

Mid seventeenth century flintlock arms with relief decoration

IN SKOKLOSTER AND the Livrustkammare are preserved a number of guns and pistols whose mounts are chiselled with ornament so similar that they can be identified as a group. There are similar weapons in other places, but the majority is to be found in Sweden. The group was probably never very large and was probably produced over a short period in a restricted area. These arms are of the type that was preserved for artistic reasons and as curios, while other simpler and commoner pieces became worn out and disappeared. It has not been possible to establish definitely the place (or places) of production for this whole group. It is, however, so closely bound up with what we already know of the Franco-Netherlands manufacture of flintlocks during the earlier half of the seventeenth century that it may be considered to have originated there. The reasons given in previous chapters for dating by form are also applicable to the weapons belonging to this group. De Lucia asserts that the two guns, belonging to this group and preserved in the Armoury in Venice, are Italian[1]. Ossbahr, however, has published in his catalogue of the Schwarzburg Zeughaus a gun belonging to this group which

is some ten years later than those in Venice and is signed 'A Sedan'[2]. He regards another, somewhat earlier, gun in the same repository as French, though with some hesitation[3]. In early guides to the Livrustkammare the same writer was more convinced of the French origin of the group. Later guides also state that they are French, but with some hesitation. This opinion was repeated by Otto Smith in the Töjhus Museum 1938[4] centenary publication. In the Livrustkammare inventories of the end of the seventeenth century they are called by the French term 'fusil' ('fisin')[5]. This does not however prove French manufacture.

A general division of the material gives us three sub-groups with transitional forms in between. One is characterized by chiselled ornament running lengthways on the barrels. It is usually associated with a certain amount of repetition in the decoration on the lock including, in particular, a monkey on the fire steel. A second group is chiselled in relatively high relief with a few figures framed in cartouches. Finally there is a third group with low relief chiselling, in most cases with small figures. The second group is the largest.

To the first group, that with the relief

61

designs running along the barrels, belongs a gun in the Töjhus Museum, Copenhagen (Inv. No. B 660. Pl. 36:1), another in the Wrangel Armoury, Skokloster (No. 250. Pl. 36:2, 5) and a third in the castle of Kranichstein outside Darmstadt (Inv. No. 223. Pl. 36:4, 6)[6]. Besides these I know of two barrels with later mounts, one of which is with a lock signed 'Cunet à Lyon'[7], privately owned in Sweden, the other on a gun signed by the Stockholm stockmaker Jonas Schertiger Jr. and quite typical of his period (Livrustkammare Inv. No. 1813). The Töjhus Museum and the Skokloster guns have locks with almost identical decoration. The cock takes the form of a dragon snapping at a monkey which has taken refuge in front of the blade of the steel. An enraged lion chiselled on the lock-plate defends itself against the flames from the dragon's jaws. On the Töjhus Museum gun an insect is carved on the lion's tail and, in the background, is an animal resembling a camel[8]. There is also a material difference in that the lock on the Töjhus Museum gun is rounded in form, the pan is convex and the steel gently rounded. The lock of the Skokloster gun has, on the other hand, a flat plate with 'broken' edges and a marked ledge at the back, together with a convex pan and steel. In both instances the heads of the jaw-screws are plum shaped, the Skokloster one being of a somewhat rounded, cylindrical form. We have seen in previous chapters that the forms we encounter on these locks are characteristic of French flintlock arms of not later than the middle of the seventeenth century and that the sharp angles in the trigger-guards justify a still earlier attribution. The butt of the Skokloster gun is most closely related to the 1640 garniture by P. Thomas in the Livrustkammare (Pl. 20). An attribution of the Skokloster gun to the beginning of the 1640s would therefore be the most convincing solution. The Töjhus Museum gun with its more pronounced angular butt and carved moulding along the comb of the butt is more old fashioned and, as far as can be judged, goes back to the 1630–40 period unless it is to be regarded as a retarded form.

The Kranichstein gun seems by reason of its entirely rounded butt to be later in date. The period within which these guns were manufactured cannot, however, exceed ten years. The Kranichstein gun thus brings us to 1650 at the latest. The ornament of the lock of this gun differs from both the others (cf. Pl. 36:6). The relief is still high, but the wild animals are replaced by a winged deity on the cock and a jovial, smiling old man's face on the steel. On the lock-plate St Hubert kneels in front of Christ in the form of a stag while a hunter behind the cock is busy with his dogs and carries his gun on his shoulder. This huntsman wears a costume in the fashion of the mid seventeenth century. This fact enables us to check the accuracy of the general dating of the group.

The reliefs on the barrels of all three guns, as well as the other barrels mentioned here, are divided by a ridge running along the top of the barrel. On both sides of this ridge are carved scenes from the chase directed alternately towards the breech and towards the muzzle. This transmits a rhythm which is further accentuated by trees placed at definite and equal distances (cf. Pl. 40:1). The Töjhus Museum gun and the Skokloster gun show exclusively hunting scenes, whereas pastoral motifs have found their way into the hunting scenes of the Kranichsetin gun.

To this early group of the flintlock weapons with relief ornament of the mid seventeenth century belong a pair of pistols in the Wrangel Armoury, Skokloster (Inv. No. 30. Pl. 36:3). They probably form a garniture with the gun just mentioned. They have plain barrels with longitudinal ridges like the pistol by Ezechias Colas, Sedan, in Pl. 27:1, trigger-guards with sharp angles, cocks of 's' form chiselled in relief, plum shaped heads on the jaw-screws and, on the lock-plates, a scene with Orpheus playing to the wild beasts.

The connection with the next group is established by the two guns in the Venice armoury (Inv. Nos. M 14, M 15). On the lock of the second we find both the monkey and lion, but the cock has a different form. On the lock of the first we see the monkey only, while the

lion's place has been taken by children at play. The reliefs on the barrel of No. M 14 (Pl. 40:2), which are also peopled by children at play, extend along the front part of the chamber and the barrel and are divided by a ridge along the top. In front of this the direction of the relief changes so that on the forward part the decoration points towards the muzzle and on the rear part towards the breech. The decoration continues towards the muzzle with a spiral part through which tendrils intertwine towards the sight.

On the second gun in the Venice armoury (No. M 15) the entire relief decoration runs upwards towards the muzzle. The tendency towards a rhythmic arrangement which can be recognized in the placing of the groups of trees on the longitudinal reliefs is given another form by framing the figures in cartouches. The butt of this gun is more old fashioned than that of No. M 14, though not so much so as that of the Töjhus Museum gun.

The trigger-guards of both the Venice guns are of the same kind, bending gradually with the fore-end folded in and forming a screw. The rear part stands free of the stock for its full length. It is then fixed in the stock by a screw passing through a hole pierced in it. These trigger-guards have the closest affinity to that of the Dauphin's gun in the Zeughaus, Berlin (cf. Pl. 17:2) attributed to the period 1638–43, the first year most probably being the correct one. To this may be added the elongated plum shaped heads on the jaw-screws—so that all the evidence points to the period about 1640.

The figures on both of these guns display a lively and vigorous Baroque style. On the one the cartouches are of the doughy sculptural form characteristic of Italian and Nordic Baroque, and also—though less markedly—of French Baroque inspired by these sources. Other weapons with this same kind of cartouches are known. Of these a gun in the Kunsthistorisches Museum, Vienna (Waffensammlung Inv. No. D 316. Pl. 37:1, 40:3 and 43:1), is typologically older. The cartouches are filled with groups of tiny figures and should for this reason be included in the last sub-group. Its other features, however, assign the gun to the sub-

group of larger figures. A pair of pistols in the same museum (Inv. No. A 1154. Pl. 37:2) date from the same period and probably form a garniture with the gun. On these only the locks are decorated in relief, like the pistols in Skokloster.

The cartouches on a gun in the Livrustkammare (Inv. No. 1297. Pl. 37:3, 5, 40:4 and 42:1) are still more doughy and form grotesque masks. This weapon was a gift from the builder of Skokloster, Charles Gustavus Wrangel, to Charles X Gustavus[9]. On our system of dating it should be ascribed to the 1640–50 decade—preferably in the earlier years. This attribution is endorsed by the trigger-guard, sharply angled at the back and rounded in front. The thin, inlaid bone or horn lines on the butt are related to the inlaid silver wire used in ornamenting angles on those flintlock arms discussed in the preceding chapter, dealing with earlier guns decorated by Marin Le Bourgeoys up to the 1640s. The head of the jaw-screw is constricted at the middle, a shape which, together with the plum, belongs to the period about 1650. The reliefs on the lock are rather coarse. At the back of the plate grins the head of a monster of the kind found on Lorraine and Netherlandish arms of the first half of the seventeenth century. Under the pan a warrior in a Roman suit of armour sprawls on a somewhat uncomfortable bed of trophies. This very warrior and the trophies are reproduced on sheet '21' (Pl. 112:1) of Marcou's pattern book (cf. p. 135), the cock on sheet '2', the steel on sheet '8' and monsters' heads of very similar form appear on several of the sheets. The presence of the decorative features of the lock in Marcou justifies our assumption that the gun is French*.

In western European—especially French—art the trend is from the flaccid, doughy form typical of the cartouches of the present gun to one of greater restraint. By applying this principle we can classify the variant style to which Charles X Gustavus's gun in the Livrustkammare belongs. This is characterized by a few figures of large size. It will then be found that locks, butts, trigger-guards, etc., constitute a convincing typological series which

63

illustrate a natural growth. We must of course allow for an occasional exception, but the main trend of development becomes evident in this way.

Next to Charles X Gustavus's gun comes another in the Livrustkammare (Inv. No. 1545. Pl. 37:4, 6, 41:1)[10]. The barrel of this gun is decorated with scenes from the story of Hercules in cartouches formed as open lion's mouths. In comparison with the cartouches on Charles X Gustavus's gun these show greater definition and stability. The rectangular heel of the butt is more old fashioned, but in other respects the guns are so alike in their construction that we can assume them to be fairly contemporary, though Charles X Gustavus's gun is likely to be the older.

A garniture comprising a gun and a pair of pistols in the Livrustkammare (Inv. Nos. 1298, 1612, 1613. Pl. 38:1, 2, 5, 41:2 and 42:2)[11] should be dated slightly later. The gun belonged to Charles X Gustavus, the pistol to Queen Christina[12]. The set offers so many similarities to the Thomas garniture of the Livrustkammare that its origin in the 1640–50 period can be accepted. The butt of the gun is of the same curved type, angular at the foot, and the trigger-guard is gently rounded and folds in at the front. The pistol trigger-guards, on the other hand, have not yet lost the two sharp bends, even if these have been slightly modified. The pistol butt-caps have unfortunately been lost but we can nevertheless note that they had embryonic spurs. The pistols have angular steels and pans, and the corresponding parts of the gun are rounded. The head of the jaw-screw of the gun is long and plum shaped; on the pistols it is compressed above and has a ring top. The simultaneous use of the rounded and flat forms lasts throughout a lengthy period. The variations in the heads of the cap-screws and trigger-guards and the tangs of the butt-plates indicate, however, a transitional period of shorter duration.

The chiselled decoration of the garniture expresses the same delight in life as that on the Livrustkammare gun with scenes from the legend of Hercules. The cartouches are still decidedly Baroque and invite comparison with

Dutch pilaster designs. A novel feature has been introduced in the decoration: small, inlaid silver roses. Those on the spiral section in front of the sight greatly enhance the effect of this part.

Definitely more classical in style is a pair of pistols with figures of animals in the Wrangel Armoury, Skokloster (No. 43. Pl. 38:3). Their maker has found abundant opportunity to make use of the silver roses just mentioned on barrels and pommels. These latter are rather like turbans in shape. This form may seem out of place, but it is quite normal when compared with the sulptural design of the pommels dealt with in the following chapter. Steels and pans are angular, the heads of the jaw-screws compressed in the middle. The date is the decade 1640–50.

No. D 362 (Pl. 39:1 and 41:3) in the Waffensammlung, Kunsthistorisches Museum, Vienna, is a gun of which the large figured allegorical reliefs are enclosed in a framework of leaves and flowers. Among these we again find encrusted silver roses. The part that used to be spiral has become plain with roughly incised surface ornamentation, the surface enlivened with silver inlay. This gun is aesthetically the most satisfactory piece amongst the earlier ones in the group. The reliefs are carved with unfailing elegance by a master at the height of his skill. In contrast, the butt-plate is of rather clumsy workmanship. The date, following the principles adopted here, must be in the 1640–50 period, not later than 1650.

Of the same period and of the same character is a garniture in the Wrangel Armoury, Skokloster (Nos. 112, 67. Pl. 38:4). The butt of the gun has been altered later. Within the wreaths of leaves and flowers we find some of the exuberance and liveliness of the motifs of the Livrustkammare garniture. The design is, however, superior. There is reason to believe that this is due to the increasing skill of one and the same master. This in itself is not impossible, especially as the development moves in the expected direction, that is, the transition from Baroque to Classicism.

Last in the series of classical medallions with floral decoration are those on a gun in the

Töjhus Museum in Copenhagen (Inv. No. B 661. Pl. 39:2, 41:4, 42:3 and 43:2)[13]. The reliefs, lower than those just mentioned, are the work of a very skilful master. The motifs continue to be allegorical, female figures with birds, cornucopiae and flaming hearts. The trigger-guard of the gun is gradually curved with the fore-end turned in and the rear-end closely following the small of the butt. The latter has only a slight trace of its previous angularity. With this gun we have definitely reached the period about 1650.

The guns in the relief decorated group have round fore-sights. There is not always a back-sight. On the earlier weapons this is usually formed by a dove-tailed piece of iron in which a wide 'v' sight is cut. This is the case with No. B 660 of the Töjhus Museum, the gun in Kranichstein and No. 1545 of the Livrust-kammare. The Skokloster gun with the elong-ated reliefs (Wrangel No. 250) and one of the guns in Venice (No. M 14) have the usual sight with a foot. On the gun of the Livrust-kammare garniture (No. 1278) the sight is formed by the upper edge of a cartouche which has been opened up and given the requisite shape. On the first gun with classical medal-lions, that in Vienna (No. D 362), this kind of sight has been replaced by two small wings placed on a circular moulding above the top medallion (cf. Pl. 41:3). The gun of the Skokloster garniture (Wrangel No. 112) has the same wings but on a slightly larger scale and with a somewhat sharper angle between them. The last group, No. B 661 of the Töjhus Museum, shows the same tendency but the sight has become heart shaped (cf. Pl. 41:4). With this series of sights, whose form is deter-mined by the need to shoot flying birds, we have been able to check the correctness of the order of date in which the weapons have been arranged.

After these arms it is time to turn to one of Charles XI's guns in the Livrustkammare (Inv. No. 1333. Pl. 39:3, 5). It is described in the guide of 1921 as French of the middle of the seventeenth century[14]. There is nothing against this attribution. It is confirmed by the form of the butt, by the trigger-guard with its forked

fore-end and by the head of the jaw-screw com-pressed in the middle. The lock forms half-cock by a sear moving horizontally through the plate and resting against the belly of the cock. The full-cock is formed by means of a pro-jection on the tumbler. It is true that the barrel has no reliefs and no cartouches, but its chamber is ornamented in exactly the same manner as the part of the barrel above the medallions on the Skokloster garniture and No. B 661 of the Töjhus Museum. Furthermore it has the French coat of arms underneath the crown of the princes of the blood royal in the middle of the barrel (Pl. 43:6). The cock is designed as a dolphin.

It is worthy of mention that there was a gun (Inv. No. 145)[15] in the French *Cabinet d'Armes* exactly like that of the Livrustkammare except that the coats of arms of France and Navarre were engraved on the studded silver plaque of the butt. On the Livrustkammare gun this is vacant. As the French king's gun is also included in the inventory of 1729, the Livrust-kammare one and it cannot be identical.

The manufacture of flintlock arms with chiselled ornament appears to have begun in the 1630s, to have had its main output in the 1640s and, for the most part, to have terminated in the 1650s. In 1930 there was a lock for sale on the Stockholm art market, with a com-pressed, pear shaped jaw-screw head and rounded forms. On the lock-plate was a representation of an equestrian battle. In many respects it resembled the group with which we shall now deal. This lock represents the later form of the type and is interesting as an example of the appearance of the pear shaped jaw-screw head in the 1650–60 period.

A pair of pistols in the Wrangel Armoury at Skokloster (No. 46. Pl. 44:1, 46:1 and 47:5) introduces the small figured group. The *motif* in the only cartouche on the barrels, two horse-men and a warrior in armour bearing a standard against the background of a castle on high mountains, has a definite connection with the barrel decoration on the Vienna gun mentioned above (cf. Pl. 47:5 and 40:3). The cartouche has, however, become a medallion and the relief is more elegant and not so high. The

flat cock is quite different from those formed of monsters and fantastic beings with which we have hitherto been dealing. It shows a distinct affinity with the type represented by the Parisian Pierre Thomas's firearms of the 1640s, i.e. with the earlier, undoubtedly French type of lock with flat face. In spite of this the lock is not the same. The upper jaw moves with a projection in the groove of the spur. This is usual in the sub-group with the few figures in high relief. The jaw-screw head is pear shaped. This form is only found along with the plum shaped jaw-screw heads of the 1630s and 1640s and that of the 1660s which is compressed at the top and with a turned cavity below. The steel is rounded and the rear-end of the lock-plate is very much widened and provided with a projecting tongue. The rounded steel and the pans are universal in the sub-group with numerous figures chiselled in low relief. The size of the group is not large, totalling seven flintlock weapons and a pair of wheel-lock pistols, so that it hardly justifies far-reaching conclusions. The consequences within the group are, however, of importance. The butts of the pistols are flatter than before and larger in contour when viewed from the side. The pommels, which on the Skokloster set are directly attached to the butt, and on the Liv-rustkammare set fixed with very short spurs on the sides, have in the case of the former pair longer spurs and their inner profile curved. This characteristic is also general. Then again they are decorated with equestrian figures within a laurel wreath and with groups of trophies. The trigger-guards are, as on the Thomas garniture, forked in front and gently curved.

One of the novel features on this pair of pistols and one of the most important is the nature of the chiselled ornament on the lock-plate. This is a military scene with a horseman charging at the gallop in front of a camp. Something similar is to be found on a pair of pistols which at one time were in the collection of Count G. A. F. V. von Essen at Wijk in the province of Uppland. It is now in the possession of Baron Carl von Essen at Säbylund in the province of Närke (Pl. 44:2, 48:2, 4). Unfortun-

ately the stocks look later and the side-plates are some ten years later than the barrels, lock and mounts. The external steel-spring with its long upper, short lower arms is of the same kind as the definitely French steel-springs of the 1640s. All the rest conforms with the pair of pistols at Skokloster just mentioned and is even slightly more advanced. An attribution to the 1650s is therefore acceptable. Conformity with the definitely French examples is closer in detail, viz. the design of the upper jaw with two arms which slide on either side of the cock-spur. Later dating is also denoted by the screw-like ornament in the empty space at the forked fore-end of the trigger-guard. Another reason for this dating is the scene (cf. Pl. 48:4) on one of the pommels representing a horseman whose steed is led by Hercules and Minerva, while Fama, the goddess of rumour, blows her trumpet and a flying genius is in the act of crowning the horseman with a laurel wreath. The rider, by reason of his sceptre decorated with fleurs-de-lis, can be identified as Louis XIV, King of France. He is represented as an adult, thus giving us reason to date the pistol from the latter half of the 1650s.

The next example of this group is decorated in a very costly manner and is also of interest by reason of its allusions to the French king. It is a gun in the Jakobsson collection (Pl. 45:1, 3, 46:3 and 47:2). It belonged to the armoury of the Grand Dukes of Saxony in Ettersburg Castle until 1927 when it was sold by auction. In the auction catalogue it was described as probably being southern German of about 1680[16]. It appeared again in an auction catalogue in 1932 and was then regarded as French about 1650[17]. The barrel with decoration in relief is strongly classical, it is embellished with a group of figures with a horseman accompanied by two others carrying banners. The back-sight deserves special notice. It is of the same heart shaped type as on the later weapons in the sub-group with large figures (Vienna, Skokloster and Copenhagen). It is elongated, however, and consequently is one of the details which lead us to place the sub-group, to which it belongs, in the chain of

development after the one with large figures.

The Ettersburg gun is a magnificent specimen. The left side of the butt is richly inlaid with silver and engraved mother-of-pearl in a maze of arabesques, flowers and exotic birds. The right side is entirely covered by a skilfully carved relief in which warriors in antique armour are engaged in a wild mêlée. There is a Latin inscription below this relief:

'Scipio, cui magnum dives dedit Affrica nomen
pugnant em ad Trebia litus mane patrem
eximit ingenti pressum discrimine belli
jam puer et tuta sub statione locat.'

There is also the signature 'Johan Eberhard Soṁer'. The translation of the Latin text is as follows: 'Scipio to whom rich Africa gave a great name gives already as a boy safe shelter to his father fighting on the banks of the Trebia and removes him from the fearful dangers of the oppressive war'. This inscription contains allusions to French history in the middle of the seventeenth century, the outbreak of war with Spain in 1635 and the very precarious situation during the immediately succeeding years. Then the brilliant victories during the boyhood of Louis XIV; Rocroi 1643, Gravelines 1644, Courtrai and Dunkirk 1646, Lens 1648 and finally the Battle of the Dunes 1658. This is the period to which one would wish to date the barrel, lock and trigger-guard of the gun[18]. The stock, especially the butt, is, however, old fashioned. There is no avoiding this dating of the weapon as a whole, even if we take into account the existence of the gun with a Dutch inscription and the year 1646 on the barrel which was sold by auction at Sotheby's in London on 2 July 1936[19]. The contour of the butt of this gun dated 1646 resembles that of the one at issue. The engraved horn inlay of the stock is very like that of the mother-of-pearl inlays just mentioned although they are more stylized. The lock and the trigger-guard on the 1646 gun are, however, of the type one would expect at this date. The lock of the Ettersburg gun on the other hand corresponds to other locks which must be dated for various reasons to the 1650–60 period. The general

impression one obtains of flintlock weapons dating from this period, shortly before the introduction of the classical Louis XIV style, is a confusing variety in which the group with relief ornament represents but one phase. As to the gun butts they will in this case have to be considered as subject to time-lag.

We avoid this dilemma of dating the sub-group with the small figures by reference to a pair of pistols in the Livrustkammare (Inv. Nos. 4813, 4814. Pl. 44:3, 46:2, 47:3, 4 and 48:5, 6, 7). The length of the spurs of the pommels and the pear shape of the jaw-screw heads favour a date from the 1650–60 period. A horseman rides at the gallop, receiving an ovation from soldiers, on the lock-plate of one of the pistols. On the head of the cock-screws there is a picture of a youthful man in the long, curly hair (wig?) and the wide hanging cape in which Louis XIV is depicted at that very time. It is in fact very probably he who is represented, as also on the barrel of one of the pistols where a crowned prince offers, with an inviting gesture, the crown and sceptre to a lady carrying a fan on the other barrel. Both personages are seen against city walls lined with spectators. The marriage of Louis XIV and the Spanish Maria Theresa took place in 1660.

It is perhaps unnecessary to enter into details regarding the barrels belonging to the group. They are to be seen in the Musée d'Armes, Liège, the Musée de la Porte de Hal, Brussels, and the Victoria and Albert Museum in London. Nor need we discuss the wheel-lock pistols with hunting *motifs* in the Livrust-kammare (Inv. Nos. 1762, 1763). This material has nothing very new to offer. The two guns in the Schwarzburg Zeughaus (Nos. 1002, 1007) referred to at the beginning of this chapter deserve some further attention as their existence implies a continuation of the large figured group. The earlier of these, No. 1007, has locks with flat forms, but rounded steel and pan, steel-spring with a long upper and short lower arm, heads of monsters on the rear of the lock-plate, and a cock irregular to the extent that its upper jaw slides with a recess on the spur of the cock. The head of the

jaw-screw is round. The cartouches of the barrel depict St George and the Dragon and also a gentleman and lady. The former has the same large wig and the same cape just mentioned. The near end of the trigger-guard is decidedly round with the belly on the underside of the butt pushed far back. It can, broadly speaking, be dated to the decade 1650–60. The second gun at Schwarzburg (No. 1002. Pl. 45:4 and 47:1) should be dated later. The reliefs of the cartouches are mostly composed of small figures, the butt is entirely rounded off and the belly of the underside missing so that it looks triangular from the side. The trigger-guard is divided at the near end and the lock-plate is quite convex. The jaw-screw head is in the form of a truncated cone with an angular ring at the foot. The cock is so bent that its neck is almost horizontal.

Apart from the importance of this gun in judging the forms of flintlock firearms immediately preceding the 1660s it also throws valuable light on the source of the relief decoration group as a whole inasmuch as the lock-plate bears the engraved inscription 'A Sedan'. The barrel is signed in front of the chamber with the initials 'I R'. This brings us up against the problem of the manufacturing area of this group, a problem which will be difficult to solve and cannot be finally solved until irrefutable evidence has been found in the archives. That such a gun was completed in Sedan is an important piece of information. It is supported by the same signature on the pistol lock mentioned above, that privately owned in Sweden, belonging to a barrel decorated in relief of the same kind although of coarser workmanship. With both these weapons we have definite proof of France as the source of at least part of the group, though only for a border town. The signature 'I P' on the lock of the gun presented by Drakenhjelm of the Cameral Board to Charles XI and now in the Livrustkammare (Pl. 43:5) does not help us much. All the weapons belonging to the group are unsigned, but several of them have marks, all stamped beneath the barrels. None of these marks have been deciphered so that in this case we must deal with probabilities.

A few of the barrels decorated with longitudinal reliefs are stamped with a flagon, the Töjhus Museum gun No. B 660[20], the barrel mounted by Jonas Schertiger Jr. in the Livrustkammare, the gun presented by Charles Gustavus Wrangel to Charles X Gustavus in the same institution and Queen Kristina's pistols there, Inv. Nos. 1612, 1613[21]. Samuel Doepfer (Töpfer), barrel and locksmith, who was granted burghership in Strasbourg in 1658 and died in 1681[22], used a flagon and the initials 's. D.' in his mark. A flintlock musket in the Musée Curtius, Liège, dated 1635, which is probably Dutch, also has a mark with a flagon on the barrel. The evidence is too meagre and too uncertain to permit any conclusions to be drawn. Nor can it be proved at this stage that the five pointed star under the pistols No. 43 (Pl. 38:3) in the Wrangel Armoury at Skokloster can be identified as the five pointed star in the arms of the town of Maastricht, though it may be possible and indeed probable that this is the case. As a matter of fact the barrel of the gun, Inv. No. 1333 in the Livrustkammare, is stamped with an oval mark with the letters 'I P' beneath a crown[23]. We find ourselves on safer ground with the mark containing the letters 'I R' separated by a crowned star or flower[24]. It is struck under the barrels of the already mentioned pistols from the Wijk Collection belonging to the group with small figures. The same mark is known, among others, on three pairs of pistols with ivory stocks; a pair in the Livrustkammare (Inv. Nos. 5757, 5758), signed by Jakob Kosters of Maastricht, a pair in the Hallwyl Museum, Stockholm (Inv. No. Ä 16. Pl. 52:4)[25], signed by Johan Louroux, also of Maastricht, and a pair in the Livrustkammare signed by Vivier de Sedan. It is not known where Vivier worked. All three signatures can be read on the locks. The barrels of the last mentioned pair are signed 'Lazarino Cominazzo', a signature which does not in this case seem convincing.

The two wheel-lock pistols with hunting *motifs* in the Livrustkammare (Inv. Nos. 1762, 1763) have a very characteristic mark[26] of a type which always contains a sign in the form of a horseshoe and three letters. The first of

Plate 57.

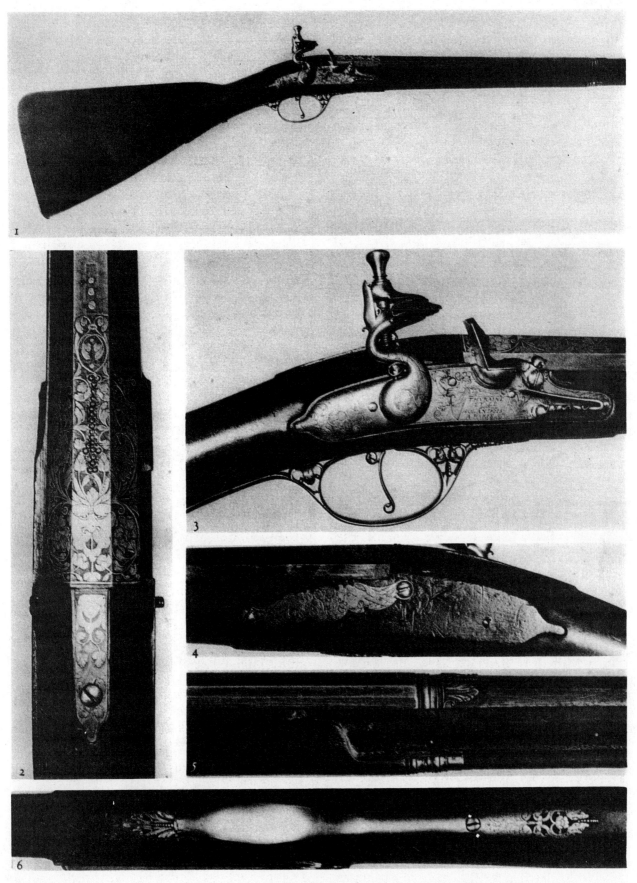

France, Paris.
c. 1660.

Gun by Thuraine and Le Hollandois of Paris; Copenhagen,
Töjhusmuseet B 663.

Plate 58.

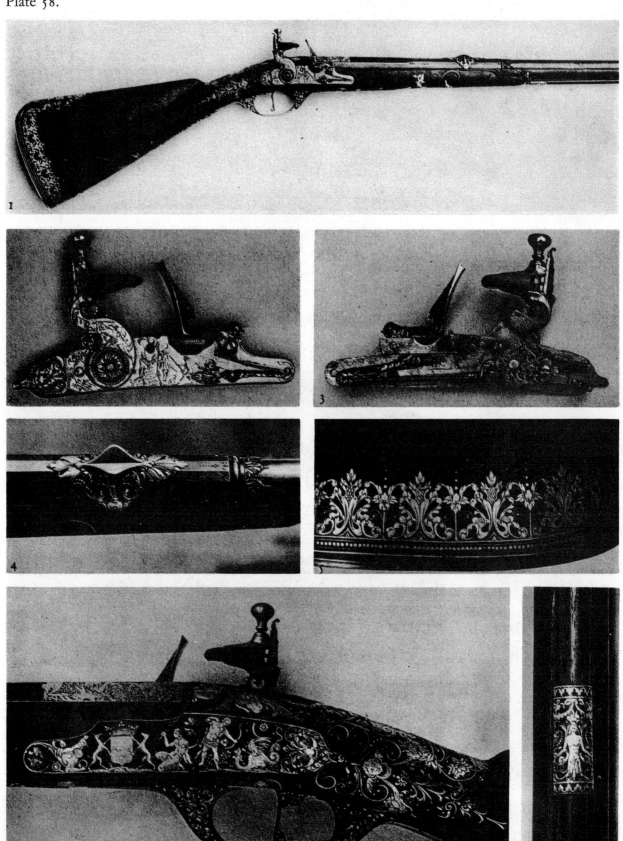

France, Paris.
c. 1660.

Gun by 'Le Couvreux au Palais Royal'; belonged to
Nicolas Nicolay, Marquis de Goussainville, d. 1686; Paris,
Musée de l'Armée M. 588.

Plate 59.

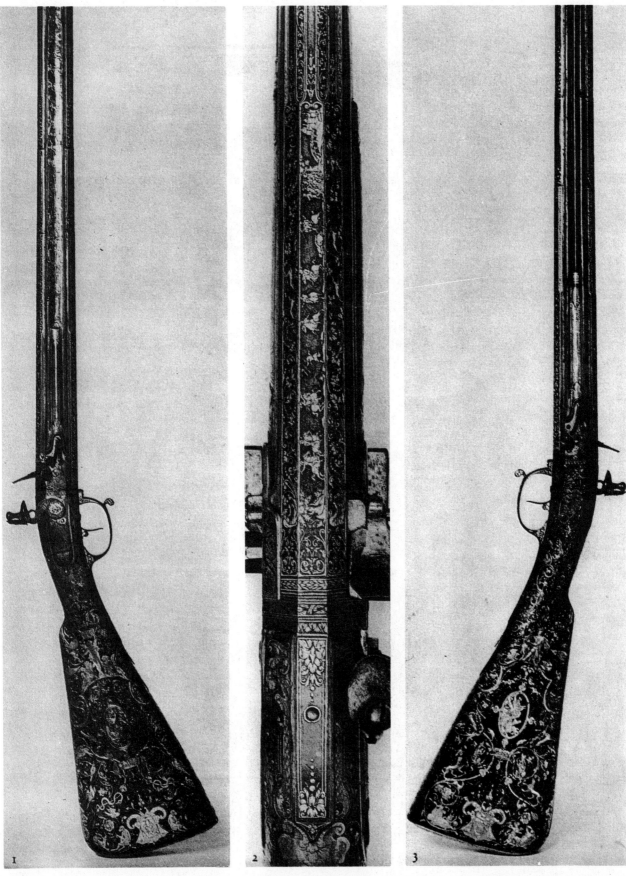

France, Paris.
Early 1660s.

Louis XIV's Wender gun by Le Conte of Paris. Inlaid
decoration of the stock signed 'Berain fecit'. Gift to Charles
XI 1673; Stockholm, Livrustkammaren 3888.

Plate 60.

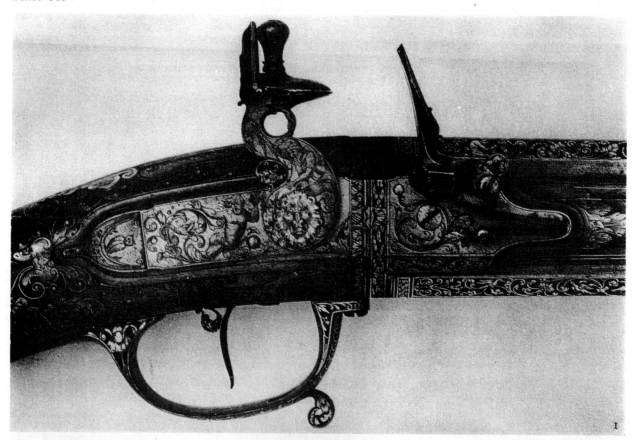

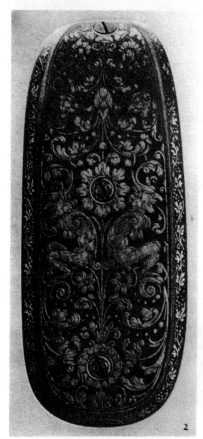

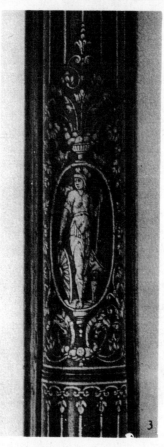

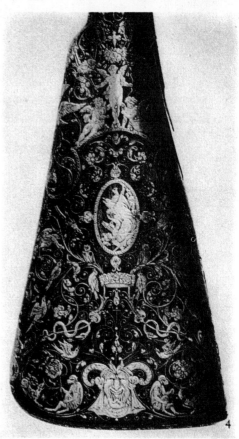

France, Paris.
Early 1660s.

Details of gun on Pl. 59.

Plate 61.

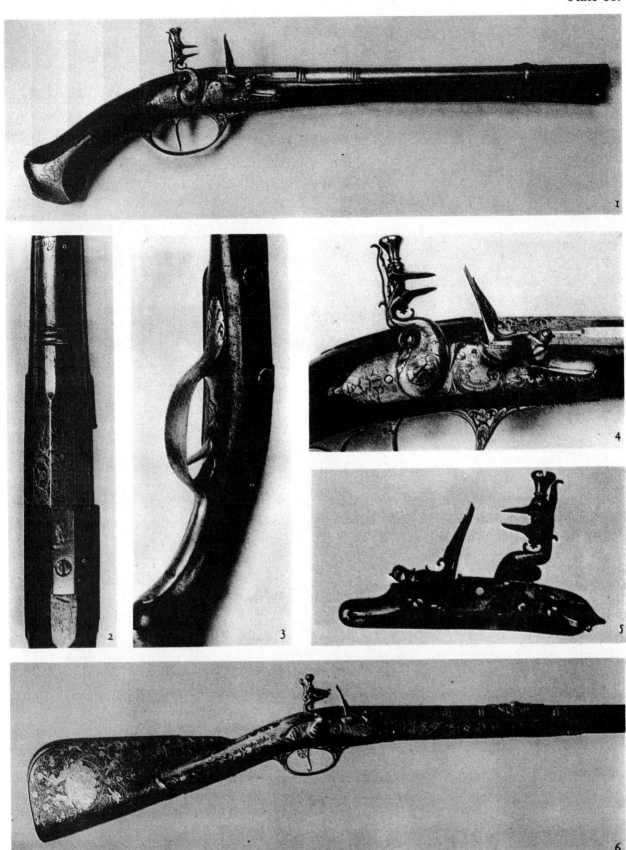

France, Angers and Paris.

1–5. Pistol, one of a pair, by Monlong of Angers; Schwarzburg 1288. 6. Louis XIV's gun by De Foullois le jeune of Paris. *c.* 1665; Pauilhac Collection, Paris.

Plate 62.

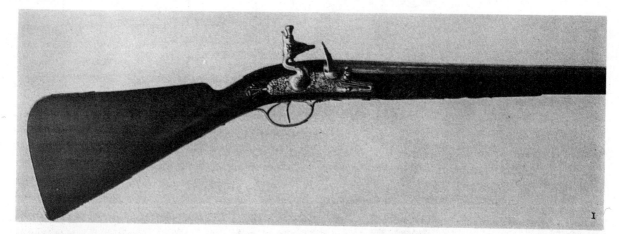

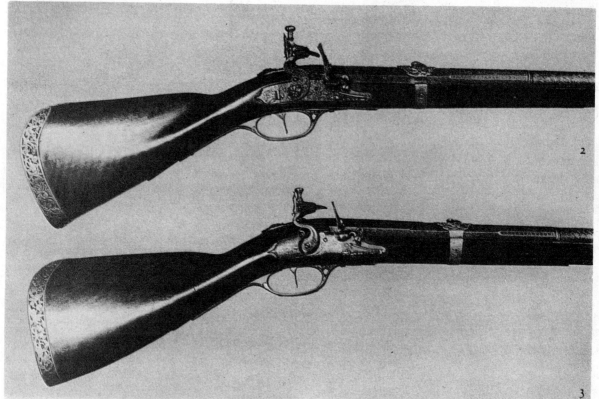

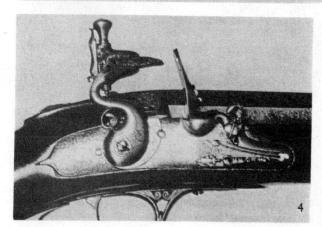

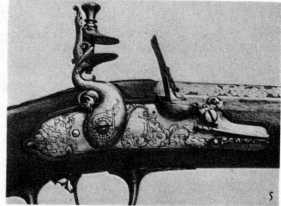

Netherlands, Utrecht and
Heidelberg,
Germany. 1650–60s.

1. Gun with Utrecht mark on the barrel. 2. Gun by Jan
Knoop of Utrecht. 3 and 4. Gun by same master, 2 and 3
belonged to Ove Bielcke of Østraat, Chancellor of Norway
(b. 1611, d. 1674); Copenhagen, Töjhusmuseet B 608,
B 602 and B 603. 5. Section of lock of gun by 'David René
à Heydelberg'; Skokloster, Wrangel Armoury 100.

Plate 63.

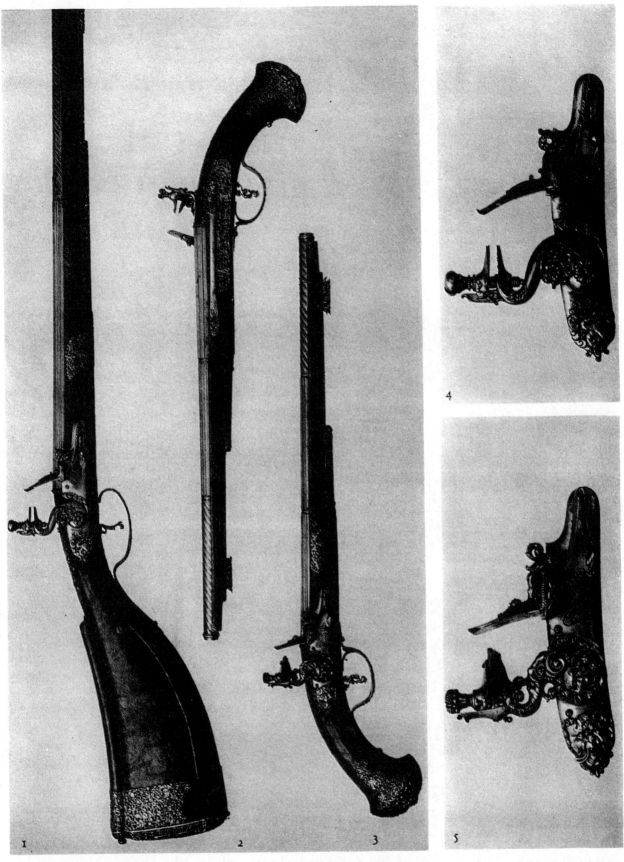

Italy, Brescia.
1660s (?)

1 and 5. Charles XI's gun, barrel signed 'Vinsenso Lanse'.
2–4. Charles XI's pistols by Paolo Francesse of Brescia,
barrels by Lazano Lazarino Cominazzo; Stockholm, Livrust-
kammaren 1335.

Plate 64.

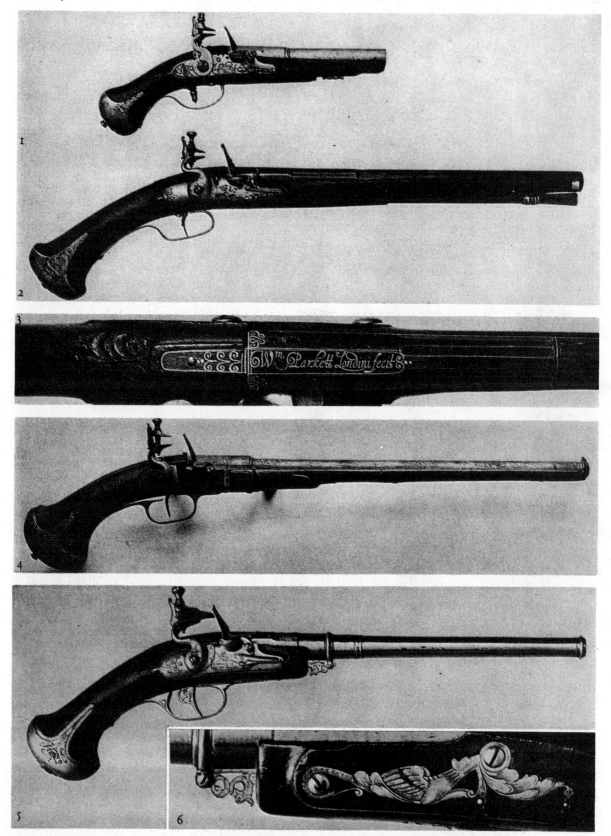

England, London and Wootton Basset. 1650–60s.

1. Pistol, one of a pair, by William Parket of London. 2 and 3. Pistol, one of a pair, by same master; Skokloster, Wrangel Armoury No. 93 and Brahe-Bielke Armoury. 4. Breech loading pistol, one of a pair by Harman Barne of London. 5 and 6. Pistol, one of a pair, signed 'R. Hewse of Wootton Basset'; Copenhagen, Töjhusmuseet B 1019.

Plate 65.

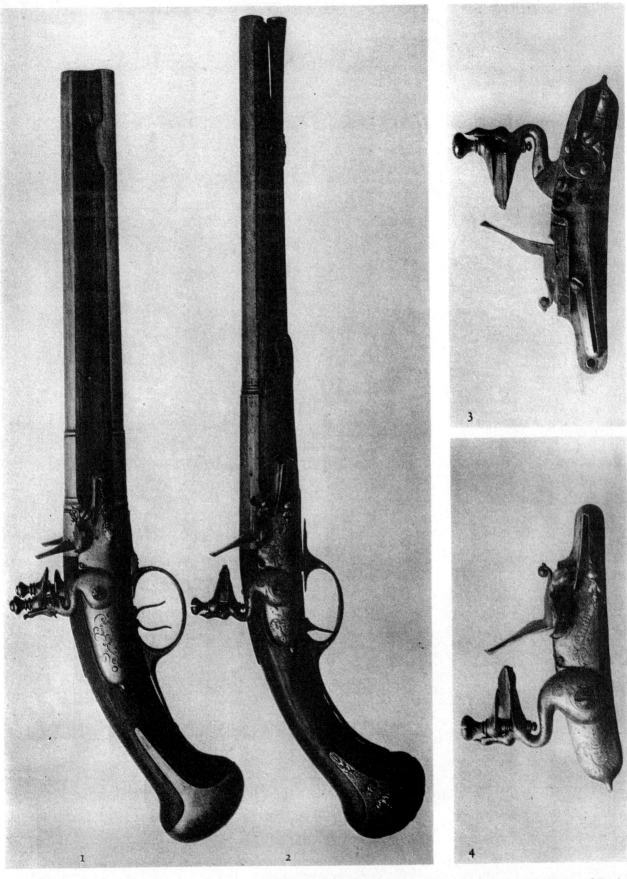

France, Paris.

1. Double barrelled pistol, one of a pair, by Du Bois of Paris; Skokloster, Wrangel Armoury 49. 2–4. Pistol by De Foullois of Paris; Stockholm, Livrustkammaren (Saxon Armoury).

Plate 66.

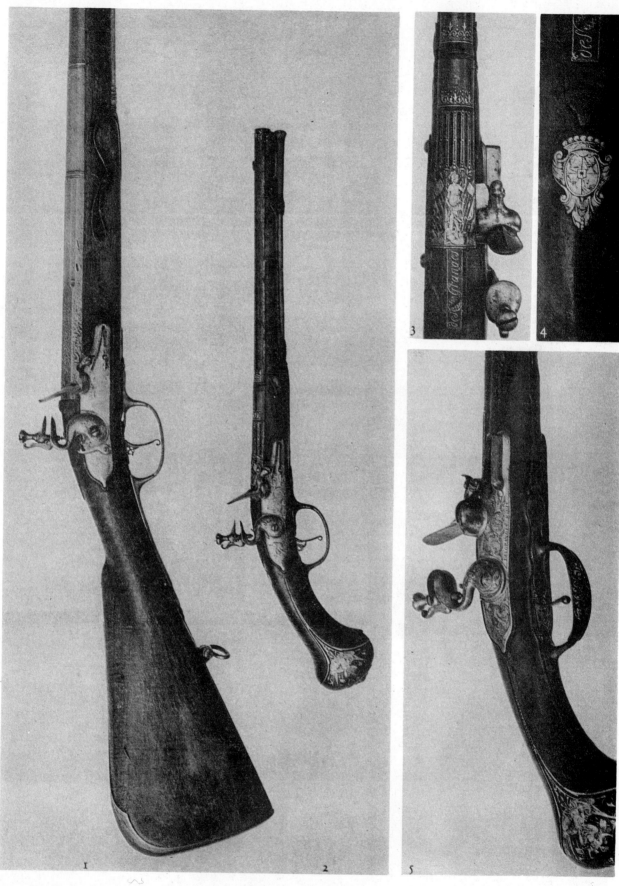

France, Paris.

1. Gun by Des Granges of Paris, ordered by Erik Dahlberg in 1668 for Svante Banér, King's Councillor; Sturefors, Bielke Gun Armoury No. 40. 2–5. Pistol, one of a pair by same master, ordered in Paris in 1668 by a Baron Gyllenstierna of Ulaborg; Stockholm, Livrustkammaren 1637.

Plate 67.

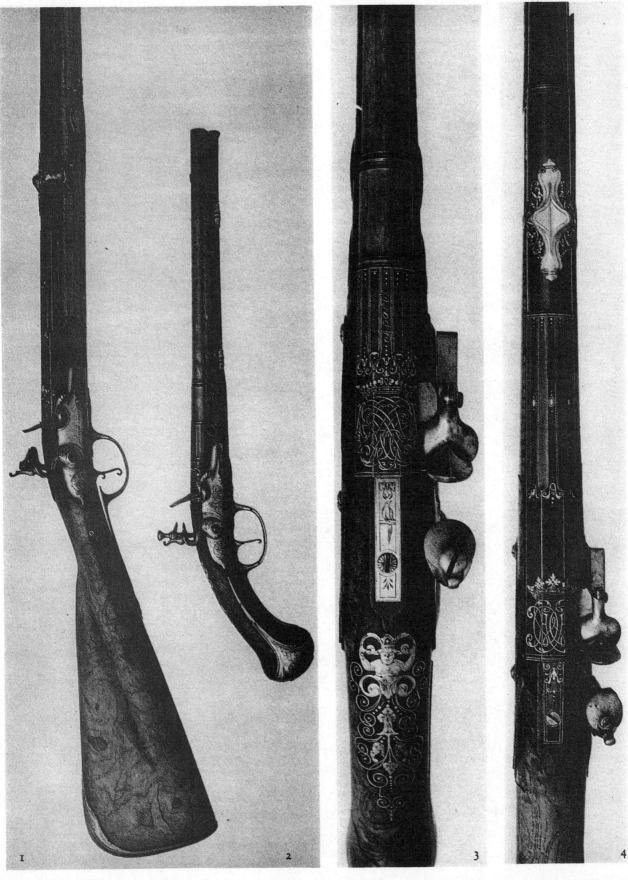

France, Paris.
1650–70.

1 and 4. Gun by Deverre of Paris, Skokloster, Wrangel
Armoury 116. 2 and 3. Pistol, one of a pair, by Cuny
and Lahitte of Paris. Skokloster, Brahe-Bielke Armoury.

Plate 68.

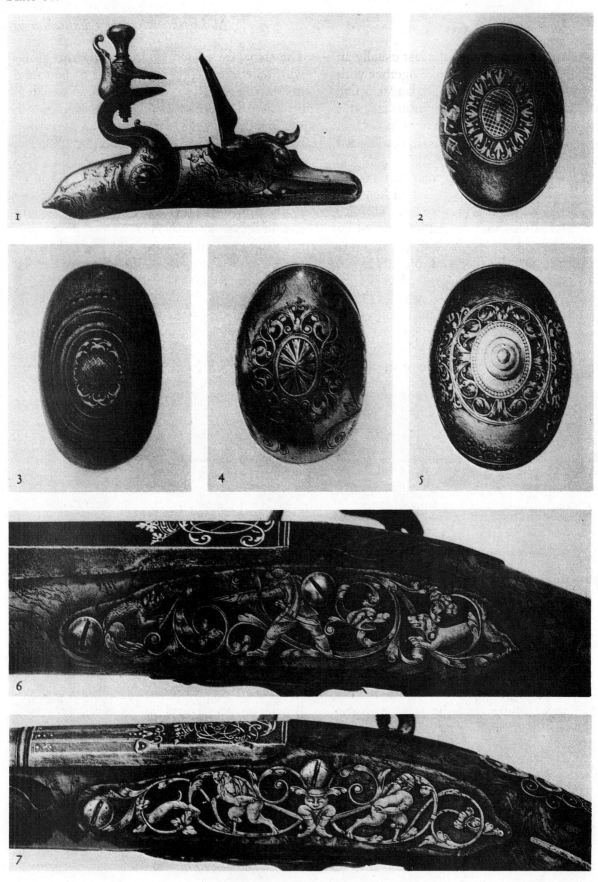

France, Paris. 1 and 2. Details of the pistol on Pl. 66:2. 3, 4 and 5. Butt-caps of pistols on Pl. 65:2, 67:2, 69:2. 6 and 7. Side plates of gun and pistol on Pl. 67:1 and 2.

these is nearly always an 'M', the last usually an 'L' and the middle one varying. Together with the initial 'K' and a double eagle under a five pointed star (Jan Kitzen of Maastricht) this type of mark occurs with the letters 'M A L' on several simple horseman's pistols in the Emden Zeughaus (Nos. 1321–1324)[27]. A 'M I L' mark is on at least one of the barrels of a Wender of not later than 1660, signed Leonard Cleuter in the Wrangel Armoury at Skokloster (No. 113). It is also on a wheel-lock pistol by Arnold David of Liège in the Töjhus Museum, Copenhagen (No. B 654), and on a pair of flintlock pistols by Abraham Meunier of Geneva in the same museum (Nos. B 684, B 685). There are further examples of Netherlands arms with marks of this type, but what has been said should suffice to show where to seek the place in which this type of mark was used. Beneath the barrels of the Livrustkammare pistols Nos. 4813, 4814 (Pl. 44:3), are stamped the letters 'Colas'[28], the name of a gun-making family with members resident in Sedan[29].

With these marks as evidence we might be inclined to regard the group with relief decoration as of Low Countries origin, or belonging to the border districts between France and the Netherlands. It is indeed likely that this is the case, but just as likely that the area of manufacture was larger and extended southwards. All the marks mentioned above denote gunsmiths. When we remember that barrels were often articles of commerce, bought, finished off, and assembled in other places, the fact that the stamps are largely associated with Maastricht does not prevent the weapons having been finished in other places. There are further reasons for assuming that the type was also manufactured on French territory.

The chamber of M. Pauilhac's pistol (Pl. 28:3) signed by Montaigu of Metz is decorated in the same technique as the Bourbon gun in the Livrustkammare (Pl. 43:5). This widens the frontiers for the type of decoration. If we examine the Dauphin gun in Berlin (Pl. 19:3, 4), we shall find that the ornament of the barrel and the butt-plate is very closely related to the relief decoration of the flintlock weapons.

The strongest reason for regarding the group with relief decoration as French is to be found in Marcou's pattern album. This work gives several examples of such relief work, which we recognize from the earlier group with large figures and with cocks designed as monsters or fantastic creatures. In this album too we find the elements which compose the decoration on the lock of Livrustkammare gun No. 1297.

The steel chisellers who decorated firearms also designed sword guards. The Livrustkammare has a sword (Inv. No. 5817:1. Pl. 49:1, 4) whose reliefs show exactly the same *motifs* as the lock on the gun Inv. No. 1545 (Pl. 37:6) in the same museum. It belongs to the earlier group with a few large figures. To the later group belong two swords in the Livrustkammare (Inv. No. 3869. Pl. 49:2, 3, 5 and No. 3870)[30]. They were purchased in Paris in 1654 by Pierre Bidal for Charles X Gustavus's impending coronation. The guards are of silver so that we can assume that they were cast. As these can be proved to have come from Paris this provides a further reason for regarding the group of firearms with relief decoration as French.

If we now sum up our conclusions concerning firearms with relief ornamentation, the result will be as follows: with dated examples from the 1630s as a guide we can assign the earliest to this decade. Two parallel groups are attributed to the period from, let us say, the close of the 1630s onwards. The rare group with longitudinal reliefs on the barrels and locks in which, as a rule, a monkey, a lion and a dragon play prominent parts in the decoration, come to an end in the period around 1650. The other with the figures or groups of figures—usually a few figures in comparatively high relief—is framed in Baroque cartouches. In the later weapons these were transformed into oval medallions and continue into the 1650s. The *motifs* are as a rule taken from contemporary emblematic or allegorical subjects. In both groups the cocks are generally designed as grotesque monsters or fantastic creatures. Finally, there is a group with low reliefs of the 1650s. They chiefly have martial *motifs* and may be regarded as taken from French political

history with distinct relevance to the king himself. The Netherlands and France must be considered as the areas where the type was made.

For one of the aims of this thesis—to be able to date west European flintlock firearms by their form—those with relief ornamentation make quite a number of contributions. The barrels of the 1630s are generally longer than those of the middle of the century. The earliest forms of the ring back-sight have been mentioned already, as has the occurrence of the constricted jaw-screw head during the 1640s and the pear shaped jaw-screw head of the 1650s. Our information concerning the development of the trigger-guard and steel-spring placed on the outside of the lock-plate has received significant additions. We have also seen that the finish of the rear of the lock-plate becomes blunt and broad with a short tongue. The tendency to fill up the empty triangle caused by dividing the near-end of the trigger-guard is another new feature. The transformation of the gun butt from angular and curved to rounded off and triangular in profile can be followed in the group with relief decoration, as also the transition of the pistol butts to a compressed and broadened form. Then again the origin and initial development of the spurs of the pistol pommels during the 1640s and 1650s. Flat locks and convex locks appear simultaneously as early as the 1630s. About the middle of the seventeenth century a distinctly higher percentage of convex locks can be observed. On one gun, No. 1298 in the Livrustkammare, which belongs to a garniture of the middle group dating from the 1640s, we find the precursors of the side-plate, screw-washers of iron, adorned with heads of monsters facing one another. In the gun No. 1002 of the Schwarzburg Zeughaus, made at Sedan towards 1660, we have an interesting example of the later development from the large figured group and a starting point for further discussion.

The interest in relief decoration of which the group dealt with in this chapter is evidence, can also be recognized in a pair of pistols with plain barrels but richly carved butts. They are preserved in the Wallace Collection (Inv. Nos.

V: 916, 917. Pl. 50)[32]. Unfortunately these pistols are not signed.

In the high relief carving of the stocks we see Hercules killing the lion and Samson slaying the Philistines with the ass's cheekbone. Draped lion skins adorn the front of the stocks. On one of the locks the killing of the lion is repeated, on the other Hercules flays his victim. The entire course of events is described in gold inlay on the barrels right up to the proud moment when Hercules, leaning on his club, wears the lion's skin as a trophy. The demigod, who is usually represented as a bearded man, is here a youth with the French royal crown suspended above his head. Moreover fleurs-de-lis are strewn on the blued barrels.

These allusions, otherwise not particularly difficult to interpret, are explained in the inscription on the barrels. According to this Louis bears the Belgian emblem (the lion) just as Hercules wore the skin of the vanquished lion[32].

Louis XIV, for whom the pistols therefore were made, had neither reason nor occasion to bedeck himself with the skin of the Belgian lion before the Treaty of the Pyrenees of 1659, or if we choose, before the Battle of the Dunkirk Dunes the previous year. We must probably assume that the expression of homage which these pistols imply was conveyed while the motive was fresh and opportune. This will give us the dating. To anyone who dates still more advanced forms to the 1650s certain details in these pistols will be strikingly old fashioned. These include the absence of the side-plates and the very simple trigger-guards reminiscent of the Wender group. The raised narrow plaques on the underside are reminiscent of the corresponding ones on Netherlands trigger-guards. The design of the barrels, the octagonal chamber, more than one third of which is polygonal, are as we expect them to be: so also the lock-plate which is practically flat but rounded at the rear with rather a long projecting point and a distinct demarcation between the flat and the rounded part. Then there are the rounded cocks with hints of volutes and convex steels and pans. The jaw-screws are high and narrow, terminating in

broad and round forms with a groove at the top. The upper jaw slides in the groove of the jaw-screw.

The medallion plates on the trigger-guards indicate that the place of manufacture of these pistols should be sought in the north of France. In their lock design with rounded clocks, steels and rear points of the lock-plate they conform to the purely French weapons dealt with in the following chapters.

Editor's Note

* This is not convincing, as there is evidence that Marcou's pattern book circulated outside France and was used there.

Notes to Chapter Six

1. De Lucia, *La Sala d'armi*. P. 94.
2. Ossbahr, *Das fürstliche Zeughaus in Schwartzburg.* P. 97. No. 1002.
3. Ibid. P. 99. No. 1007.
4. Smith, *Det kongelige partikulaere Rustkammer,* I. Pp. 47, 50. Nos. 90, 102. Pl. 23, 24.
5. *Livrustkammarinventarium 1683.* P. 60. Nos. 26, 27. Palace Archives.
6. *Inventar über die in der Grossherzoglichen Gewehrkammer befindlichen Waffen und sonstigen Gegenstände.* P. 14. Communicated by Baron Georg W. Fleetwood.
7. Communicated by Baron Rudolf Cederström.
8. There is another lock (No. N 11) in the Armeria Reale, Turin, and in private ownership in Stockholm still another. The mounting of the one in Turin differs, however, from those mentioned here. Cf. Angelucci, *Catalogo della Armeria Reale.* Pp. 452, 453.
9. *Livrustkammarinventarium 1683.* P. 60. No. 26. Palace Archives. Livrustkammaren *Vägledning 1922.* P. 54. No. 379.
10. Livrustkammaren *Vägledning 1921.* P. 54. No. 378.
11. Ibid. P. 54. No. 377. P. 60. No. 471.
12. *Livrustkammarinventarium 1683.* P. 60. No. 27. P. 53. No. 4. Palace Archives.
13. Smith, *Det kongelige partikulaere Rustkammer.* I. P. 47. No. 90. Pl. 23, 24. 'Ca. 1655. French (?)'.

14. Gift to Charles XI from 'Blessed Drakenhjelm', probably Böös, member of the Cameral Board, ennobled Drakenhjelm (b. 1624, d. 1676). Livrustkammaren. *Vägledning 1921.* P. 87. No. 703. *Livrustkammarinventarier 1683.* (Zacharias Renberg's inventarium 1686.) P. 256. No. 11. Palace Archives.
15. Guiffrey, *Inventaire général du mobilier de la couronne.* T. II. P. 61. Un beau fuzil de 5 pieds, le canon fonds couleur d'eau, les armes de France couronnées dans le milieu dans un ornement doré, la culasse enrichie de petittes roses et pointes de diamans d'argent, la platine cizelée d'un dragon et le chien d'un dauphin; le bois de poirier, dont la crosse est tailée à jour, représentatant une Sirenne au devant de laquelle sont gravées les armes de France et de Navarre sur une petitte plaque d'argent.
16. [Binder], *Grossherzoglich sächsische Gewehrsammlung Schloss Ettersburg.* P. 9. No. 51.
17. *Catalogue of a choice collection of swords, firearms . . . etc. The property of Major Th. Jacobsson of Stockholm.* Pp. 4, 5. No. 10.
18. A stock maker Eberhard Sommer is known in Künzelsau am Kocher (Würtemberg) at the time in question so that my argument in so far as it refers to French political history hardly applies. As Künzelsau is situated near the district to which I have assigned the group with ornament in relief, the conclusion will be that the district is somewhat larger and also comprises a part of Germany. [*Postscript by Lenk to his personal copy.*]
19. *Catalogue of valuable armour and weapons . . . which will be sold by auction by Messrs. Sotheby & Co. . . . 2nd of July, 1936.* P. 13. No. 89. III. On separate plate.
20. Smith, *Det kongelige partikulaere Rustkammer.* P. 50.
21. Livrustkammaren. *Vägledning 1921.* P. 14. Mark No. 263.
22. Stöckel, *Haandskydevaabens Bedömmelse.* I. P. 76.
23. ✿ ⊕

24.

25. [Claudelin], *Katalog över vapensamlingen i Hallwylska musset*, Stockholm. P. 69.

26.

27. Potier, *Inventar der Rüstkammer der Stadt Emden*. Pp. 82, 83.

28.

29. Some of this data has been taken from Captain J. Stöckel's rich collection of marks.

30. 'One silver sword and appendant gilded spurs with scabbard.'

'One ditto with spurs and with scabbards.' Wardrobe Account. 1654. P. 114. Palace Archives.

31. Laking, *Catalogue of the European Armour and Arms in the Wallace Collection at Hertford House*. P. 251.

32. Belgicus ecce leo gallorum subactus
Gerionae hispano trista fata parat
Sunt nobis lilia cordi.

Ut pellam (Alcides) devicti insigni leonis
Sic Ludovicus ouans [*sic!*] belgica signa gerit
Sunt nobis lilia cordi.

CHAPTER SEVEN

Pistol butt-caps and pommels during the earlier half of the seventeenth century. Ivory stocked pistols

IT HAS BEEN shown in the preceding chapters that the oval, convex pistol butt-caps developed a spur or tail on each side prior to 1650 and that these spurs subsequently grew in length and are of great help in dating. This kind of butt terminal is, however, only one of several. A closer study of pommels and butt-caps furnishes valuable data for our further investigation.

Two main types of pommels have to be considered at the beginning of the seventeenth century. One is merely an extension of the butt, the other consists of a plum shaped ball distinctly separated from the small of the butt, a successor to the heavy 'Afterkugel' (ball-butt) of the sixteenth century pistols. The end of the former type is often reinforced with a metal ring round the edge. Italian pistols and guns of the earlier half of the seventeenth century have butts of this type with the end covered with a delicately pierced ornamental metal plate over the entire surface. In western Europe a convex plate of some other material is usually laid on the flat butt. It may be of wood, horn, bone or of metal, usually iron,

which then merges into the ring and then into a long slender oval butt. It is sometimes attached with a screw passing through a hole in the middle, sometimes with a round headed screw pierced laterally for the insertion of a rod for unscrewing (cf. Pl. 27:1). It is still found in France in the 1650s, when it was fluted from the edge towards the centre and secured by a screw with a tall head (cf. Pl. 26:1, 2). The same kind of butt-caps, though without such screws, occur on butts which are plump and round in profile and resemble those on the relief decorated group with small figures. They are to be found in a pattern book with engravings by C. Jacquinet after designs by Thuraine and Le Hollandois dating from about 1660. These will be dealt with below. Of the various types the Wender group has the flattest and roundest pommels. One of the engravings just mentioned (Pl. 115:2) shows a butt-cap with a spur slightly longer than the breadth of the cap seen from the side. This pommel is made as to one half like a ball without a spur; this half is narrower than the other half. This might be regarded as accidental if the existing specimens

did not show the same difference between the two types of pommel. Pistols that have butt-caps with spurs of the same length as those on Jacquinet's and Berain's engravings (cf. Pl. 117:2) should, by virtue of this pattern book, be attributed to the period 1650–60. This applies, for example, to the group of pistols with small chiselled figure decoration in the Livrustkammare Inv. Nos. 1629, 1630 signed 'Gilbin à Paris' (Pl. 54:2) and the Töjhus Museum Nos. B 918, B 919 with ivory stocks signed on the locks by De la Pierre of Maastricht (Pl. 53:1).

When the spurs become long enough they hold the cap in its position on the butt, but the actual fixture is usually effected by means of a peg which enters the butt from the middle and is fastened by a pin or is simply driven into the wood like a spike. This peg, which supplants the screw, has a large head which may assume quite a number of profiles or be chiselled or engraved. There are examples in Jacquinet's engravings of Thuraine and Le Hollandois's designs and on all three pommels in Berain's pattern plates.

The engraved pattern sheets provide evidence for the typology of pommels and caps as follows: Thomas Picquot 1638 (cf. p. 129) a sheet with two patterns for pommels 'pour le bout d'un pommeau' (without spurs); Marcou 1657 (cf. p. 135) a butt-cap with pronounced relief and short spurs (cf. Pl. 113:1), hence dating from the period round about 1650; Jacquinet after Thuraine et Le Hollandois four pommels, which are very rounded in profile, one without spurs, two and a half with a recess in the side for decoration of the pommel in relief or for an inlaid engraved metal plaque, and a further half with a spur of medium length. Berain illustrates three pommels representing three stages in the evolution of the pommel spur to slightly more than half length (cf. Pl. 117). They give a good idea of how the spurs developed through the 1650s.

As in all typological investigations this series is only an aid and does not provide a definite basis for dating. A pair of Frederick III's (d. 1670) pistols at Rosenborg, Copenhagen (Inv. Nos. 7–180, 7–184) have butt-caps without spurs although they date from the close of the 1660s. A pair of pistols in the Livrustkammare (Inv. Nos. 1699, 1700) which arrived in Stockholm in 1673 and were made for Charles XI, as is shown by his cypher and coat of arms, have butt-caps with half-length spurs. Both these pistols are signed by Des Granges of Paris. The pommels of the last mentioned pair are approximately round in profile though they are actually at the same time compressed from the side.

We return to the plum shaped pommels of the beginning of the seventeenth century. Some of the French pistols have, as do some of the French and other pommels of the sixteenth century, a pronounced ring, usually of metal, at the joint between pommel and small of the butt (cf. Pl. 13:2). There are also examples of metal pommels attached to wooden stocks (Berlin, Museum für deutsche Geschichte W 1144, France the latter half of the sixteenth century[1], Tower of London XII: 922, 923, France, first quarter of the seventeenth century). Practically all the French pommels are angular at the beginning of the seventeenth century. There is evidence that these plum shaped pommels were compressed at the small of the butt as early as the 1610s and became pear shaped. Examples are the Rosenborg wheel-lock pistols mentioned above (Inv. Nos. 7–137, 7–147. Pl. 51:1). They can be dated by comparison with a gun in the Musée de l'Armée in Paris (Inv. No. M 95), which is dated 1613[2]. The material employed for pommels on these wooden stocks was horn. The group with cast silver ramrod-pipes and pommel mounts (Pl. 24:1) went still further and made the compression nearer the trigger-guard. Butt and pommel are angular. This was probably a brief fashion. It is also represented on the wheel-lock pistols dated 1628 of Wenzel Rotkirch, a Master of the royal Danish household, in the Wrangel Armoury at Skokloster (No. 27). They are not, however, French. Their pommels with engraved silver mounts are made in one piece with the stocks and belong, therefore, to the first group described above.

Pommels made in a separate piece and of a different wood or other material were also

given sculptural treatment. It is uncertain when this began. We have evidence in Picquot's album of these sculptural pommels in western Europe in the 1630s. We have seen how his teacher Marin Le Bourgeoys excelled in the designing of original gun-butts. The pupil may be expected to have followed his master in this respect. But all these sculptured, chased or cast pommels may be regarded as variations of a popular theme. They can be studied on the Langon pistol in the Löwenburg (Pl. 21:10) or on the pistols in the Malta armoury (Inv. Nos. 96, 98), both dating from the 1640s. These are signed on the barrels and locks 'Mathieu Desforests fecit à Paris'[3], their pommels are cast in silver in the form of combined lions' masks and eagles' heads. To this can be added the Devie pistols in Dresden (Pl. 21:8) with their very expressive negro heads of high quality, carved in ebony. These last are of particular importance for our investigations.

The pistols 2–4 on Pl. 24 have embossed butt-pommels of thin silver plate. Their place of manufacture has not yet been determined but they belong to the northern French or Netherlands cultural area and provide examples of the sculptural treatment of pommels in a different material from the rest of the stocks and evidence that this was not an unusual feature in the 1630s and 1640s. We find such pommels in Metz on pistols by Montaigu (Pl. 28:3) in the form of cast eagles' heads in silver, in Sedan on pistols by Gourinal in the Livrustkammare (Nos. 1694, 1695), such as lions' heads in wood and, in Zutphen, on pistols by van den Sande (Pl. 30:1). Somewhat later, but still dating from the middle of the century, is a pair of very beautiful and richly ornamented pistols in the Moscow armoury (No. 8252) with pommels of silver. Their signature can most probably be read as being 'Jan Ceule Utrecht'[4].

The Wrangel Armoury at Skokloster contains a pair of Northern French or Netherlands flintlock pistols (No. 66. Pl. 51:3, 5) with iron pommels chiselled in the form of upturned boys' heads which are not without a certain quality. Their closest relations are another pair of earlier pistols from the Lamm collection at Näsby, near Stockholm (Nos. 1090, 1091. Pl.

51:2), previously preserved at Akerö, Sweden. Their ivory pommels are in the form of dragons' heads. The same material has also been used for the laurel wreathed heads on the pistol No. W 1159 formerly in the Löwenburg at Cassel (now missing), signed by Johan Ortman of Essen (Pl. 51:4, 6). We now come to a group which has attracted attention and has hitherto been treated as an isolated phenomenon.* This is the pistols with ivory stocks. They have long been highly appreciated by collectors and connoisseurs and have been published by Emil Ilgner in the *Zeitschrift für historische Waffen- und Kostümkunde*[5]. Ilgner points out that a large number of the pistols fitted with ivory stocks are signed by masters resident in Maastricht and dates them from the period round about 1700. Research in the archives by A. Kessen following this dating has not given the information hoped for[6]. His research tends rather to support the redating suggested here. The group should, namely, be regarded as belonging rather to the earlier pistols with pommels carved in a different material from the rest of the stock. When ivory became one of the most highly treasured *de luxe* materials of the Baroque[7], extant forms were adopted for this new material. This accounts for the manufacture of ivory stocks, principally in Maastricht. Ivory comes into use at the same time in other places for firearms and their accessories. We have, for example, Charles XI's two *de luxe* guns of the mid seventeenth century in the Livrustkammare (Inv. Nos. 1327, 1328)[8], or the arms published by Stöcklein with stocks by Hieronymus Borstorffer of Munich for barrels and locks decorated by Daniel Sadeler[9], and, furthermore, pieces by Johan Michael Maucher of Schwäbisch Gmund, later of Würzburg[10]. The present book deals only with the Maastricht manufacture.

A pair of pistols in the Wrangel Armoury at Skokloster (No. 56. Pl. 51:7, 52:1), signed on the lock-plate 'Louroux à Maestricht' (not Johan Louroux as Ilgner states) affords several points of comparison with the pieces discussed above. The lock-plate is bellied—this applies to the entire group—and is fairly wide behind the cock, like the last of the groups with relief

decoration, and has an abrupt finish to the rear with a short tongue. The cocks are carved in pronounced relief and are, in a way, more in keeping with the large figured group decorated in relief than with the flat cocks of the small figured group. But they have the high relief typical of the latter on the cock-screw head and the pear shaped head of the jaw-screw with a slightly upturned outline towards the base. A new feature to be noted is a carved leaf rising from the neck of the cock and filling up part of the space between the jaws. The back of the steel, too, is provided with a chiselled ornament, the lower arm of the steel-spring is carved with stylized leaves and the spur of the steel is turned in a volute and decorated with a row of pearls. The triangular gap made by splitting the front end of the trigger-guard is partly filled with a staff of pearls. We have previously seen this feature on one of the Wijk (Sweden) pistols with chiselled decoration (cf. Pl. 44:2). The barrels have octagonal chambers, bordered by turned rings towards the muzzle, and the muzzles reinforced with rings. Ivory has been used for the entire stock. The pommels (Pl. 51:7) are carved from separate pieces of ivory as helmeted warriors' heads bending downwards and defined towards the small of the butts by two black rings at the point where the earlier pommels were joined to the stock. Bold foliage ornament is carved in the ivory round the tang of the barrel, behind the lock-plate and at corresponding places on the left side of the pistols. A slightly curved 's' shaped design is formed on both sides where the ramrods enter the fore-stock. The pistols have only one ramrod-pipe each; it has slight turned mouldings.

When dating these pistols we have to consider the earlier examples from which they develop. We find that they were manufactured in the 1650s at the earliest. The pistols by 'De la Pierre à Maastricht' in the Töjhus Museum, Copenhagen (Pl. 53:1, 6, 7) mentioned above can serve as a guide in establishing the later types. They belonged to King Christian V of Denmark (Regent 1670–99), whose crowned cypher is engraved on the side-plates. The pommels of this pair of pistols are made in one

piece with the rest of the stocks and have caps with half-length spurs. These, as mentioned above, date them from the period about 1660. They may have been acquired while Prince Christian was visiting the Netherlands, Belgium, England, and France in 1662–63. A comparison with the Skokloster pistols just described shows resemblances as well as differences. The locks are convex in both cases, the plates broad behind the cock and truncated. The cocks of the De la Pierre pistols are considerably simpler and attached by screws with smaller, grooved heads. There are chiselled scroll ornaments with pearls in both cases on cocks, steels and the feet of the latter. The steel-springs are divided by carved foliage ornaments. The chamber of the barrel of the De la Pierre pistol is divided into eight and sixteen sided sections. The stocks have metal fore-ends and side-plate of the kind we recognize from the Wender group, and a coarser trigger-guard rounded off and filled up on both sides of the fore-finger rest. Christian V's pistols show the latest possible date for the Louroux pistols at Skokloster to be the first years of the 1660s. As these are more old fashioned than the Christian V pistols they should be dated to the 1650–60 decade.

A pair of pistols in the Ilgner collection (Pl. 52:2) should also be dated for the same reason from the 1650s, probably towards the close. They are signed by the same 'Louroux Maestricht'. Their pommels are carved from the same prototype as the Louroux pistols at Skokloster. Barrels and stocks mostly correspond, but the locks are simplified and a simple, open-work side-plate has been let into the stock. The most important difference is to be seen, however, in the constricted rounded forms of the trigger-guard. Here we see clearly the origin of the type in the forked trigger-guards. The ends of the trigger-guard are very broad when seen in profile, but narrow when seen in the longitudinal direction of the pistols. This is so because the type originated from filling up the divided ends of the earlier type of trigger-guard.

We can compare this pair of pistols with a pair by 'Jacob Kosters à Mastrich' in the

Plate 69.

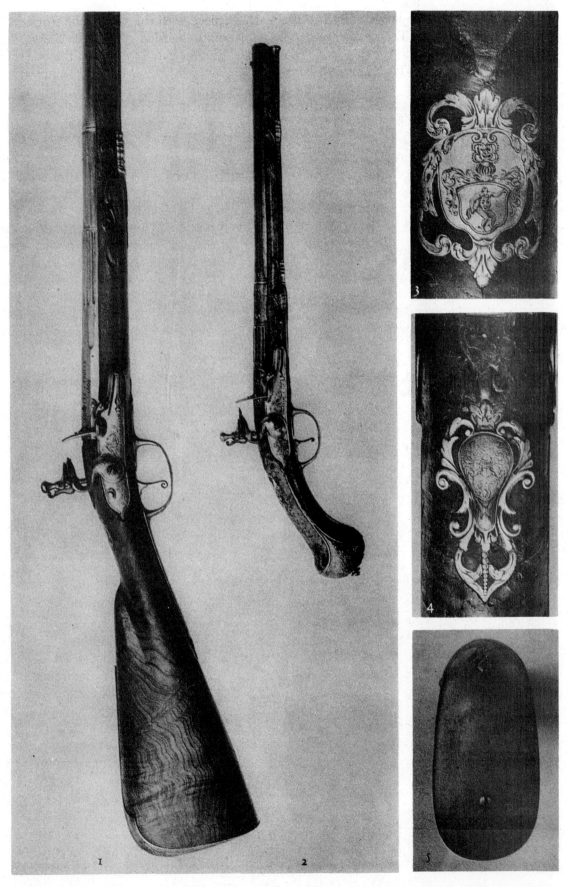

France, Paris.
1669.

Gun 1, 3 and 5, and pistol, one of a pair, 2 and 4 garniture by Thuraine of Paris. Owner's name Corfitz Trolle and date 1669 on the gun; Copenhagen, Töjhusmuseet B 664, B 665.

Plate 70.

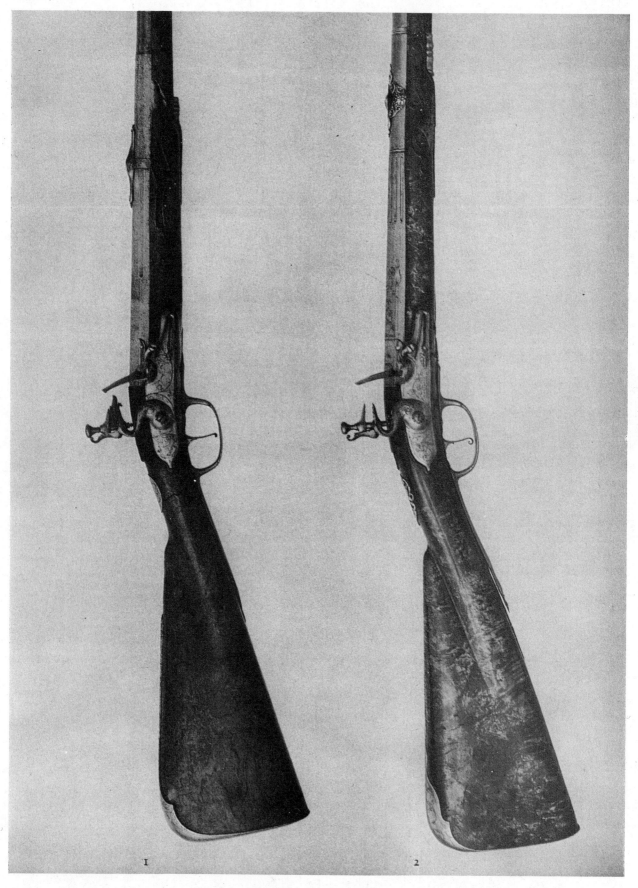

1 2

France, Paris. Charles XI's guns. 1. By De Foullois le jeune. 2. By Alex-
c. 1670. andre Masson, both of Paris. Gift by Louis XIV in 1673;
 Stockholm, Livrustkammaren 1336 and 1339.

Plate 71.

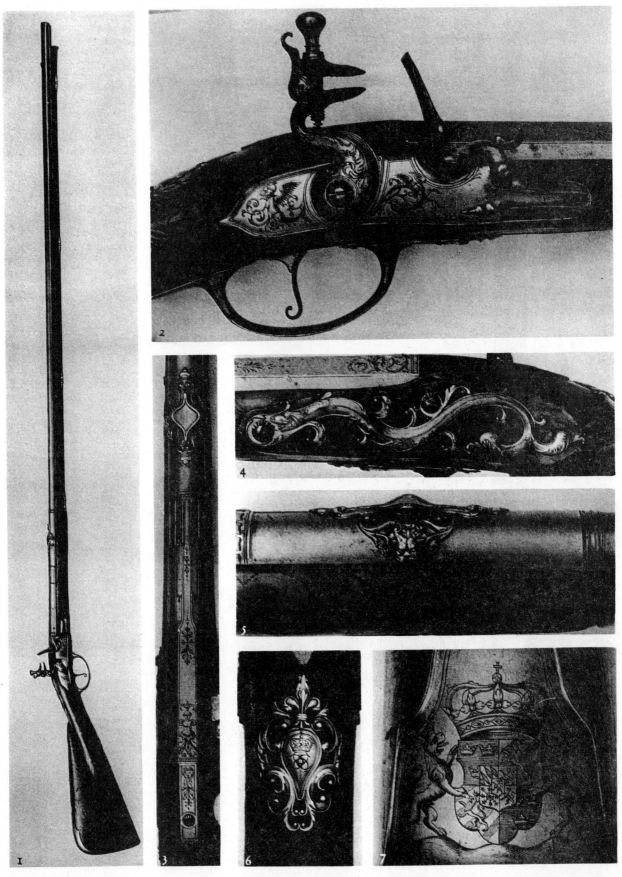

France, Paris.
1673.

Charles XI's gun signed 'Piraube au gallerie à Paris'.
Given by Louis XIV in 1673; Stockholm, Livrutskammaren
1337.

Plate 72.

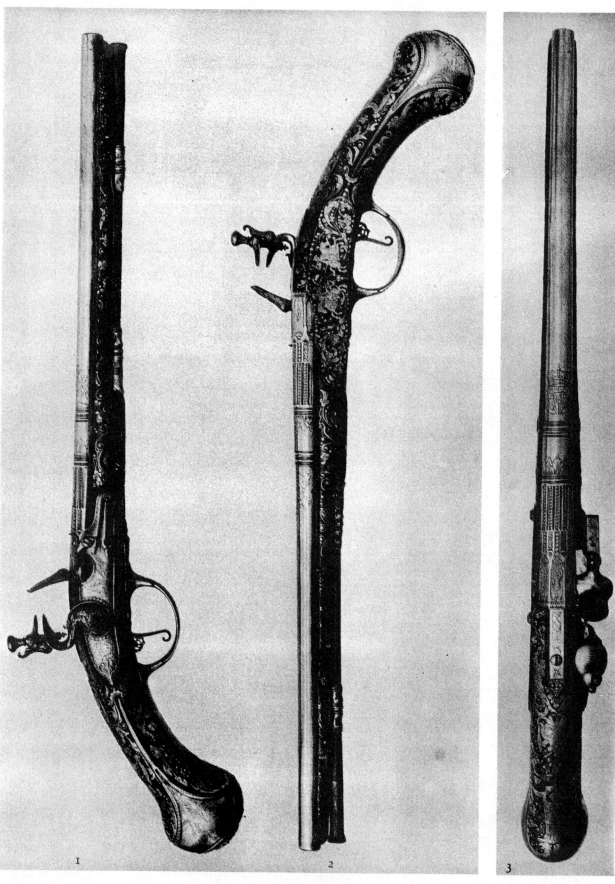

France, Paris.

Charles XI's pistols by De Foullois le jeune of Paris.
Given by Louis XIV in 1673; Stockholm, Livrustkammaren
1631–2.

Töjhus Museum, Copenhagen (Inv. Nos. B 920, B 921. Pl. 52:3, 5) and again with the pistols mentioned above by 'Johan Louroux Maestricht' in the Hallwyl Museum, Stockholm (Inv. No. 'A' 16. Pl. 52:4, 6)[11]. We discover a development characterized by simplified forms of lock and trigger-guard, the introduction of a rear ramrod-pipe and a more pronounced profile in the ramrod pipes, the adoption of side-plates which in the last mentioned pair cover the entire part of the left side of the stock, a change in the jaw-screws which are flattened from above, a change in the lock-plate which becomes narrower behind the cock and more pointed, a return to the spur of the earlier steel and the use of chambers with eight sided, followed by sixteen sided sections. There is, on the other hand, a progressive deterioration in the quality of the ivory carving. This can be the more easily verified as the pommels of all these pistols go back to the same prototype. With the Louroux pistols in the Hallwyl Collection we have passed the De la Pierre pistols in Copenhagen by ten years and have reached about 1670 (cf. Pl. 66–68). A pair of pistols in the Rosenborg, Copenhagen (Inv. Nos. 13–484, 13–485. Pl. 53:2) signed 'De la Haye à Maestricht' are, broadly speaking, of the same period. Ordinary metal caps with spurs extending right up to the lock supplant the sculptural type of pommel. Where, in later years, the thumb-plates were mounted, we find on the smalls of the butts the monogram of the Danish king Frederick IV (Regent 1699–1730) in a shield under a royal crown. As Frederick IV was born in 1671 there is a possibility that these may have been put there when the pistols were supplied. This is by no means certain, however, they are probably of more recent date. Such plates were in frequent use in France from the late 1660s.

Other pistols with ivory stocks can be dated in accordance with this series. As Ilgner has pointed out, there are also examples of other designs of pommels, such as the Turk-heads on a pair by De la Pierre at Skokloster (Wrangel Armoury No. 8)[12], laurelled heads of youths by Jacob Kosters in the Livrustkammare (Inv. Nos. 5657, 5658), etc.

The great majority of the ivory stocked pistols whose place of manufacture can be determined were made at Maastricht. The pair reproduced by Ilgner from Veste Coburg (Inv. Nos. V 71, V 72) should be regarded as an offshoot of these[13]. They are signed 'La Marre à Vienne'. This also applies to the two flintlock pistols in Moscow (Inv. Nos. 8311, 8312). These Ilgner considers to have been made in Russia by Russians in co-operation with Netherlands gunsmiths[14]. They are purely European in form. The downward curve of the lock-plate, in keeping with the wheel-locks, is perhaps Dutch and the slender forms, in keeping with mid seventeenth century and earlier, justify their being regarded as the earliest known pistols in west European style with ivory stocks. Further investigation would have to be made of these pistols and of the Russian manufacture of firearms during the seventeenth century to enable a more definite opinion to be expressed. The Rose-Ilgner hypothesis of the ivory pommels on the pistols of Inv. 8306 in the Moscow armoury can be rejected. According to it these pommels are carved with portraits of Czar Peter the Great and Catharine I[15]. In fact they resemble many other ivory stocked pistols and can be dated from the period round about 1660.

The evidence we have been able to acquire concerning the ivory stocked pistols is considerable. At the same time as the group with small figures were made and immediately after it, that is in the 1650s, we have a group of convex locks with very broad plates behind the cock and with an abrupt finish, but with a narrower and more pointed one as the 1660s advance. The heads of the jaw-screws are pear shaped right up to the years before 1660. After that they become flattened on the top with turned cavities underneath. The earlier cocks also have a clumsy scrolled steel spur. Later they revert to the older more slender type. The steel with its leaf-spring and its edge broken with foliage ornamentation must also be regarded as an earlier form. A smooth steel-spring with turned leaf-finial appears at the same time, and soon becomes predominant. Parallel with this is the forked trigger-guard rounded and finished off

with lobate leaves. Only the later firearms have a rear ramrod-pipe and a side-plate. Some of the earlier ones have a somewhat oblique ledge on the fore-stock defined by a faintly curved line. This ledge develops into a long moulding with a projecting edge on some of the later weapons. The locks provide examples of the evolution of the bridle (cf. Pl. 53:6). We shall have occasion to revert to this when dealing with corresponding phenomena in France. We will now only add to these ivory stocked pistols a pair with wooden stocks one of which is in the Musée de l'Armée in Paris (No. M 1705), the other in Mr U. Buch's collection in Copenhagen (Pl. 53:3, 5). They are signed 'H. Renier' on the barrel tangs. Robert says that the pistol in the Musée de l'Armée is French of the mid eighteenth century[16]. The correct dating is, however, the 1660s. As to the country of manufacture, they undoubtedly belong to the Netherlands group and can help in clarifying the relationship between French and Netherlands manufacture in the decades subsequent to 1650.

Another group related in style to the ivory stocked ones has iron stocks (Pl. 53:4). They are mostly pistols, but there are also guns. This group is not of much use as regards dating and style problems and is not therefore treated further*.

Editor's Note

* Ivory-stocked pistols are discussed by E. von Philippovitch, 'Elfenbeinpistolen'. *Zeitschrift für historische Waffen- und Kostumkünde*. 1963. P. 96.

† This group has since been discussed by G. M. Silferstolpe: 'An uncommon flintlock construction during the middle of the seventeenth century'. *Livrustkammaren*. Vol. IV. P. 203.

Notes to Chapter Seven

1. Binder, 'Neuerwerbungen des Berliner Zeughaus'. *Zeitschrift für historische Waffen- und Kostumkünde*. Bd. X. Pp. 93–96.

2. Le Musée de l'Armée, *Armes et armures anciennces*. Pp. 123, 124. Pl. XL.

3. Laking, *A Catalogue of the armour and arms in the armoury . . . in the palace, Valetta, Malta*. P. 10. Pl. VII.

4. *Opis moskovskoj oružejnej palati*. V-VII. Pp. 323, 324. Picture 418.

5. Ilgner, 'Maastrichter Elfenbeinpistolen'. *Zeitschrift für historische Waffen- und Kostumkünde*. Bd. XII. Pp. 210–14. Ibid. Bd. XIII. P. 19. 'Elfenbeinpistolen Peters des Grossen?.' P. 68.

6. Kessen, *Over de wapenindustrie te Maastricht in vroeger tijden* (De Maasgouw, Limburg's jaarboek voor geschiednis, taal en kunst, 56: te jaargang. Pp. 18–21). Translated and reprinted in *Zeitschrift für historische Waffen- und Kostumkünde*. Bd. XVII. Pp. 27–60.

7. Cf. Pelka, 'Elfenbein'. *Bibliothek für kunst) und Antiquitatensammler*. Bd. XVII. Pp. 235, 238.

8. *Livrustkammarinventarium 1683*. (Zacharias Renberg's inventarium 1686.) P. 260. No. 2. Palace Archives. Livrustkammaren. *Vägledning 1921*. P. 59. Nos. 435, 436.

9. Stöcklein, *Meister des Eisenschnittes*. Pl. XXIII–XXV.

10. Boeheim, *Meister der Waffenschmiedkunst*. Pp. 129, 130.

11. [Claudelin], *Catalogue of the Collection of arms in the Hallwyl Museum, Stockholm*. P. 69.

12. Ilgner, 'Maastrichter Elfenbeinpistolen'. *Zeitschrift für historische Waffen- und Kostumkünde*. Bd. XII. P. 212. Ill. 9.

13. Ibid. P. 212. Ill. 11.

14. *Opis moskovskoj oružejnej palati*. Picture 418. Ilgner, 'Maastrichter Elfenbeinpistolen'. *Zeitschrift für historische Waffen- und Kostumkünde*. Bd. XIII. P. 19.

15. *Opis moskovskoj oružejnej palati*. Picture 418. Ilgner, 'Elfenbeinpistolen Peters des Grossen'. *Zeitschrift für historische Waffen- und Kostumkünde*. Bd. XIII. Pp. 68, 69.

16. Robert, *Catalogue des collections composant le Musée de l'Artillerie*. T. IV. P. 306.

CHAPTER EIGHT

The Thuraine and Le Hollandois Style

THE INCREASING improvement of the French flintlock firearms shows a steadily rising curve during the period 1630–50. A remarkably strong, one might almost say a mercurial, development set in in the 1650s. It was undoubtedly due to some definite, though as yet unknown, cause. The economic boom under Fouquet's direction might provide one explanation, the immigration of prominent foreign masters another. We find both a 'La Hollandois' (cf. p. 80) and a 'Lallemand'[1] settled in Paris during this decade.

It is also tempting to think that gunsmiths who had moved in from the Barrois district of Lorraine may have contributed to this rapid development. Le Barrois and its capital Saint-Mihiel has been exposed to French military invasion and economic despoliation as a consequence of Duke Charles IV of Lorraine's mistaken policy. Finally the district was ravaged by the plague. To succour the inhabitants relief measures were organized by evacuating them to better favoured communities. It is known that among those who left le Barrois in the 1640s was Jean Berain the gunsmith, father of the famous designer of ornament of the same name. It is known that Jean Berain

Sr.'s brother Claude, also a gunsmith, lived and worked in Paris in 1645 and until the 1650s[2].

There is a pair of Charles X Gustavus's pistols in the Livrustkammare (Inv. Nos. 1614, 1615. Pl. 54:1)[3], inscribed 'Barroy' in an engraved Baroque cartouche on the locks. These closely resemble the locks on Louis XIV's pistols in the Wallace Collection (cf. Pl. 50:3). But their squat cocks, plum shaped jaw-screw and steel-springs with a short lower arm without springs are more old fashioned. The trigger-guards, divided at the front end, also indicate that the pistols date from the period about 1650, perhaps even earlier. Finally, the flat pommels, distinctly rounded in profile, are so typical with their fluted butt-caps that there should be no doubt of this dating. A four barrelled Wender gun in the Kunsthistorisches Museum, Vienna (Waffensammlung No. D 362) has a lock of similar forms and is signed in the same manner. There may be doubt whether 'Barroy' is a personal name—the signature 'P. Baroie' on a Wender pistol in the Keller collection[4] implies this—or should be regarded as a parallel to the 'Lallemand' and 'Le Hollandois' instances just mentioned. If

the latter is the case he could hardly have stayed on in the Barrois district.

In type the pistols in the Livrustkammare mentioned above, signed 'Gilbin à Paris' (Inv. Nos. 1629, 1630. Pl. 54:2)[5] develop from the Barroy pistols. They have unfortunately not reached us in their original state, having probably been shortened. They have certainly been fitted with new fore-sights and their jaw-screws do not seem convincing. They are important as immediate precursors of the type of firearms with which this chapter proposes to deal. The same can be said of a pistol formerly in the Löwenburg on Wilhelmshöhe at Cassel (Inv. No. W 1210. Pl. 54:3) but now missing with the inscription 'A Lesconné' on the lock-plate. In this instance the fore-stock has been shortened but the pistol is otherwise intact. The inscription has the calligraphic flourishes of the 1650s (even Gilbin made use of Roman capitals). The trigger-guard is divided at both ends with a suggestion of filling ornament. Underneath is the medallion typical of Netherlands weapons. The butt is closely related to those with a distinctly rounded contour and has a butt-cap with half-length spurs and a central screw as yet slightly developed. On the lock we find practically all the features of the early ivory stocked pistols: the convex forms, the small chiselled details, the scrolled spur of the steel and a small, conical cock screw with a groove. The pistol in the Löwenburg is definitely late enough in period for the new style to have had its breakthrough in Paris. But, even so, both this and the two pairs of pistols just mentioned represent the new phase that French gun making reached in the middle of the seventeenth century.

The consistency in the design of the early ivory stocked pistols in the 1650s and the fact that these forms constitute the basis of Paris fashion during that same decade justifies us in calling the new French style after the firm of Thuraine and Le Hollandois. This name suggests a style continuing, on the one hand, along the old French lines, while showing, on the other hand, new features which were probably introduced from abroad.

Very little is known of the personalities of these two masters[6]. Thuraine was probably a Frenchman. It is very possible that he alone—after his collaboration with Le Hollandois ceased—signed a number of weapons in the Töjhus Museum, Copenhagen (Inv. Nos. B 664–666, *et al.*) and in the Livrustkammare. We shall return to these. A garniture in the Töjhus Museum signed 'Les Thuraines à Paris' (No. B955)[7], presumably denotes co-operation between father and son. Nothing is known as to whence he came, when he was born and when he died. This also applies to his partner, except that Boeheim contributed the valuable item of information that his real name was Adrien Reynier and that he was born about 1630. Boeheim, unfortunately, does not mention his source, nor for his statement that Reynier had a son of the same christian name who was also called 'Le Hollandois' and was born about 1680. We know, however, that this younger Le Hollandois became 'Arquebusier ordinaire du Roi' in 1723 and that he was granted a 'brevet de logement' in the Louvre on 18 January 1724, after 'sieur Boyer, peintre du Roy'[8]. Boeheim mentioned several pieces with his signature. According to the same writer the firm of Thuraine and Le Hollandois received the title of 'arquebusiers ordinaires du Roi' about 1650. As belonging to 'Les artistes de la maison du Roi' they were certainly identified with the Court circles, but nothing is known of a 'brevet de logement' for them. Their case appears to corroborate the saying 'Tous les bons maîtres ne logent pas à la galerie du Louvre'. It is not known where they had their workshop.

The most important source of information concerning the nature of the production of the two masters is the pattern book *Plusieurs models* already mentioned (cf. p. 143. Pl. 115, 116).

The three first pages after the title page are for several reasons worthy of special mention. One is the fact that they contain twenty-five Parisian signatures including the publishers' own name. This figure indicates that the extent of the gun making trade must have been imposing. The signatures given are as follows: Casin, Choderlot, De Foullois, De Narcy, De

Neuf Maisons, Des Trois Maisons, Des Granges, Druart, Durié, Frenel, Galle, Garret, La Cousture, Laligan, La Marre, Le Bourgignon, Le Conte, Mascon, Alexandre Masson, Jean Masson, Mayer, Nanty, Naudin and Prebes. We have already encountered Choderlot on the Töjhus Museum's Wender pistols (cf. above p. 50). The name La Marre we have found in Vienna and Mayer in Lyon. We will find some of the rest as masters of other surviving weapons. The list for that matter is not complete as it does not include Gilbin, Lallemand or 'Gaultier'[9], nor such an influential master as François le Couvreux, who lived in the Louvre. He moved from there to the Palais Royal in 1653 and was allowed to build a smithy at his new abode as compensation for the heavy expenditure he had incurred as an inventor. This applied especially to a machine which could fire 250 shots in less than a quarter of an hour. His eldest son Jean was granted this dwelling 'en survivance' on condition that he permitted his mother, Antoinette Potier, to live with him. In 1657 this benevolence was augmented with permission to build a shop also at this meeting place and promenade of the fashionable world[10].

The French material available for the study of the Thuraine and Le Hollandois style might be expected to be vast and varied. This is not the case. As far as these two masters working together are concerned it is limited to the pattern book and two guns in the Töjhus Museum, Copenhagen (Inv. Nos. B 662, B 663. Pl. 56, 57)[11]. Berain's well-known pattern book *Diverses pièces très utile pour les archebuzières* ... (Pl. 117, 118) also belongs primarily to this group.

Still another pattern sheet belongs to the style, viz. the last one in Marcou's album signed: Marcou Inuenit 1657 Jacq[uinet] scul[psit] (Pl. 113:2).

Apart from the two guns in Copenhagen the following pieces show the same style: a pistol by Gaultier of Paris, unfortunately restocked; a pair of pistols by Casin of Paris in the Historisches Museum, Dresden (Inv. No. H 19. Pl. 55)[12]; a pair of pistols by Monlong of Angers in the Schwarzburg Zeughaus (Inv.

Nos. 1288, 1289. Pl. 61:1–5)[13]; a gun in the Musée de l'Armée, Paris, with Le Couvreux's signature (Inv. No. M 588. Pl. 58); and a Wender in the Livrustkammare (Inv. No. 3888. Pl. 59, 60). Its lock is signed by le Conte, the inlay of the stock 'Berain fecit'[14]. Both these last mentioned weapons and the pistols in Dresden belong on account of their form as well as their rich decoration to the very finest Parisian gunsmiths work.

The new features in the Thuraine and Le Hollandois style are: the convex forms, a certain style of chiselled decoration which appears on cocks, steels and steel-springs and also fills the triangular holes in the forked ends of the trigger-guards, the finish of the trigger-guards at both ends in lobate leaves, the peep-sight, the rear ramrod-pipes and characteristic forms of butt and bridle.

To find an explanation of the convex forms we must begin with the pistols of 1630 by Ezechias Colas of Sedan (Pl. 27) mentioned on p. 53. The lock of one of the pistols has flat, that of the other convex, forms. The rear point of the lock-plate is rounded and countersunk. An obvious peculiarity is that the screws do not pierce the plate as is the case with the flat shaped French flintlocks. The convex plates gave greater stability to the construction of the lock. The text of the illustration in the Diderot et d'Alembert's *Encyclopédie*[15] explains this by saying that the screws can be made longer and get a better grip in the heavier lock-plate.

The group treated on p. 56 with two locks to one barrel (Pl. 31:1, 2) explains how the convex form must have originated. It began on cocks and steels. On the pistol from the Rotunda at Woolwich*, which appears to date from the 1630s, only the rear part of the lock-plate is convex. This is distinctly defined by means of a curved edge. The plate has, in addition, what has previously been called 'broken' edges, as is the case with the gun at Skokloster and the pistol in Dresden. The Skokloster pistols, on the other hand, show entirely rounded edges while retaining a flat surface on the plate. The convex forms of the lock-plates developed through the rounding-off of plates with high bevelled edges. The need of

variation, perhaps also a practical necessity on account of the saddle-holsters, resulted in the countersunk rear point of the flat lock-plates. The screws penetrate the plates in the entire group with two locks.

All these early pieces with embryonic convex forms come from a region to the north of France. It is significant that the French wheel-locks, which may be considered to have played their part in the 1630s, are flat in form and the same applies to all flintlocks which have been definitely proved to be French from the period prior to 1650. When convex forms arrived they ran parallel with the flat forms. This parallelism can already be observed in older examples of the group with decoration in relief. It is also characteristic of the Thuraine and Le Hollandois style in which rounded forms were first adopted with a certain amount of hesitation. Contemporary flintlock weapons of northern provenance show entirely rounded forms, for example the ivory stocked pistols, even the earlier ones. A study of Netherlands wheel-lock arms of this period brings the same result. Roundness of forms, in itself a natural form of the Baroque, was an established fashion by the middle of the century.

The trigger-guard finials on firearms of the Thuraine and Le Hollandois style are designed as multilobate leaves. These have very tiny and simply designed prototypes in the group with relief decoration, more precisely, the variant with reliefs set in a frame of ovals made up of leaves and flowers and with trigger-guards of more graceful shapes: for example, garnitures Nos. 67 and 112 in the Wrangel Armoury at Skokloster (Pl. 43:4) and the Töjhus Museum's gun No. B 661. The leaves are also to be found in an inconspicuous form on springs in the Wender group. Larger and more lobate leaves occur on the pistols by Jean Dubois of Sedan at Skokloster (Pl. 28:1). Here it is a case of direct association with trigger-guards of the Thuraine and Le Hollandois group, whereas those of the Dubois pistols are of the same kind as we have found in France; gently curved and forked at the fore-ends. The custom of filling up the triangular openings between the trigger-guard arms was

begun here with a tiny lump hollowed out at the sides and inserted in the actual angle. The pistols can be dated from the period prior to 1650 but hardly earlier. They definitely indicate, however, that the origin of the small chiselled details is to be sought to the north of France. There is no difficulty in giving further examples. Louroux of Maastricht fills in the same space in the ivory stocked pistols at Skokloster (Pl. 52:1) with an ornament made up of rows of balls. So does the master of the above mentioned Wijk Collection (Pl. 44:2). Jan Knoop of Utrecht filled the entire front angle but left the rear one open on Admiral Martin Tromp's (d. 1653) pistols in the Rijksmuseum, Amsterdam (Pl. 30:5).

The partiality for minor chiselled details, characteristic of the Thuraine and Le Hollandois style, is an expression of the Baroque love of movement as in the case of the reliefs on the group dealt with in chapter six. Direct borrowings from the firearms chiselled with reliefs can be observed in Marcou's pattern sheets. We have also seen how the Skokloster Louroux pistols with ivory stocks depend to a certain extent on these. The chiselled leaves and other minor chiselled decorative details on firearms of Maastricht manufacture resemble those on Parisian firearms. The pistol mentioned above in the Löwenburg ('A Lesconné) also has these minor chiselled details on cock and steel.

The use of side-plates becomes a regular feature with the Thuraine and Le Hollandois style. The left side of the butt corresponding to the lock-plate lacked this reinforcement on the earlier snaphance and flintlock arms; this is still the case on the earlier ivory stocked pistols and those by Gilbin of Paris. The covering of the left side of the Bourgeoys gun in the Hermitage museum with a richly ornamented metal plate is an exception. So is the cartouche embellished with arms adorning the corresponding part of the early small-bore flintlock gun in Windsor Castle (Pl. 14:3). We occasionally find before the middle of the seventeenth century small washers for the side nails made of horn, bone or metal. Examples can be seen on the earlier relief decorated group, for

example Charles X Gustavus's guns in the Livrustkammare (Pl. 37:5 and 38:5). It must have been a fairly obvious idea to link up these plates with a 'bridge'. It is all the more natural that this idea should have been conceived in western Europe as the use of side-plates for another purpose, i.e. as bearings for the wheel-shaft, was common in the area of the French wheel-lock. These bearings are held by lock screws. The Livrustkammare Wender by David of Liège (Pl. 29:4) has been cited as an example of a flintlock weapon with side-plate of early type. The side-plate is also to be found on ordinary single barrelled arms, as on a pair of pistols in the Schwarzburg Zeughaus (Inv. Nos. 1290, 1291). They are signed 'P. Formentin'[16] on the lock-plates.

In the Wender group the side-plates are often in the form of a monster or fantastic creatures flanking a cartouche (Pl. 25:3, 4). This type is found on the Töjhus Museum's ivory stocked pistols by De la Pierre of Maastricht (Pl. 53:7). This and the two inter-twining monsters are well represented in Marcou and the two engravings in the Thuraine and Le Hollandois style in Jacquinet's album and also in Berain. These side-plates now mentioned serve only as a base for the heads of the lock screws and do not extend beyond the part of the stock corresponding to the lock-plate. They are inset so that their surface is flush with that of the stock and they are decorated with engraving. There will be occasion to refer to other types of side-plate that trace their origin to the 1650s in another connection. It should be pointed out here, however, that the Casin pistols in Dresden, the oldest arms in the group, have silver side-plates countersunk in the stock. They form a strip composed of symmetrically arranged ornament between the lock screws. The part on the left side of the stock corresponding to the lock-plate could also be decorated with metal inlay. There are examples of this both on pattern sheets and on existing weapons. Side-plates and this kind of decoration occur together in the Thuraine and Le Hollandois pattern book. It is doubtful if any of Berain's figures in metal should be considered as washers for the screw heads. They would in

such a case represent a starting point for this fashion.

The side-plates are a novelty both in decoration and construction. The bridle, on the other hand, is purely functional. Both the original form and its successor are found in the ivory stocked pistols and ones closely associated with them (Pl. 53:5, 6).

It has been mentioned, in the chapter on lock constructions, that Schön and Thierbach indicated two stages in the evolution of the bridle. There is first of all a 'bridge' crossing half the tumbler; then comes one with a point of attachment at the sear screw as well. As an example of the earlier type, 'the simple bridle', Thierbach mentions a pistol in the Historisches Museum in Dresden signed 'Lagatz' and illustrates its interior[17].

The development of the bridle on French territory can be studied on a pair of pistols in the Livrustkammare (the Sack Armoury) signed by De Foullois (Pl. 65:3), the intermediate stage prior the above mentioned pistols by Monlong of Angers at Schwarzburg (Pl. 61:5) and on the pattern sheets by Jacquinet after Thuraine and Le Hollandois. Of the two guns with the signature of these masters in the Töjhus Museum, Copenhagen, the former with flat forms has no bridle, the latter, which is convex, has a bridle of the older type. The fully developed bridle, the double one according to Thierbach, can be studied on the gun of the same style by Le Couvreux in the Musée de l'Armée in Paris (Pl. 58:3).

The various examples of the construction in question mentioned here were made within a few years of each other. From this it can be assumed that the designing of the bridle took a very short time. Pollard[18] quotes from Rodolphe Schmidt (*Armes à feu portatifs*, p. 31) that the bridle appears about 1645. This date would seem to be early. Material available here points to the 1650s.

With the introduction of rounded forms the use of a flange on the pan became general[19].

The screw securing the tang of the barrel passes from below on the earlier flintlock weapons[20]. In the middle of the century the end of the tang-screw passes through the tang only

in exceptional cases. There are examples as early as the 1640s of the screw passing downwards from above (cf. Pl. 134:18) and this becomes the rule from the middle of the century. To begin with, it is screwed into the trigger-guard, as on the Devie pistols in Dresden (Pl. 21:7). After that a plaque is placed in the stock in front of the trigger and, finally, the trigger-plate serves the same purpose. The stage with the separate plaque is illustrated by the Thuraine and Le Hollandois guns in Copenhagen and by the Monlong pistol at Schwarzburg (Pl. 61:2, 3).

Most of the earlier flintlocks are shotguns for shooting flying birds and running game. Many have fore-sights only. Prior to 1660 this was a round bead on a short neck, or sometimes a round bead only. A back-sight suitable for shooting flying birds was used at an early stage, beginning with a foot dove-tailed in the barrel with, at right angles to the latter, an upright plate with sharp edges and a triangular groove in the centre. On the Livrustkammare gun Inv. No. 1307 (Pl. 16:3) this upright plate, when seen from behind, is gently rounded off in its contour. Viewed from behind, the sight on No. M 410 of 1636 (Pl. 19:1) in the Musée de l'Armée shows the same profile. Sight and foot have merged in this instance, so that from the side the sight recalls the earlier ones in the form of a box with open ends. The development of this type of sight has been mentioned (pp. 65, 67) in dealing with firearms decorated in relief. The final result is a heart shaped back-sight with the elongated tip pointing forwards. Marcou also added a tip at the rear of a very similar sight, rounded off the contour, and surrounded the sight with decoration. One of the three sights illustrated on Pl. 113:1, too, has the bridge across the barrel showing that it is a fully developed back-sight. Marcou illustrates the sights on two sheets only, on this and on his last sheet, which shows the influence of the Thuraine and Le Hollandois style (Pl. 113:2). In Berain's pattern book the sight is represented more fully, and still more so in the Thuraine and Le Hollandois album. Summing up, we may say that the existing leaf shaped sight has been surrounded with chiselled

decoration and set on a ring which in some instances encircles the barrel but sometimes only extends over that part of the barrel that is not covered by the stock.

Neither the Thuraine nor the Le Hollandois gun in Copenhagen has a sight. It is not altogether improbable that they, like the guns by Jan Knoop of Utrecht illustrated on Pl. 62:2, 3, originally had sights in the form of ribbon-like rings passed over barrel and stock. The fore-sight of the one, No. B 603, is in the form of a slightly compressed bead on a short neck which develops in its turn into a rose shaped plate curved round the barrel. The fore-sight of the second, No. B 662, is a plate with a rounded top most closely resembling a nipple. The next stage in the evolution of the fore-sight, the laterally compressed half-drop, is represented in the Berain album.

Berain was the only designer working in the Thuraine and Le Hollandois style to have illustrated a complete flintlock gun (Pl. 118). The decoration in high relief is unusual in France. In this case it appears on the butt, at the tang of the barrel and, underneath the fore-stock, at the point where the ramrod enters the fore-stock. French stocks are otherwise plain at this time. Their carved decoration is limited to a small, even minute leaf design, on the left side at the rear end of the chamber. This is a heritage from the 1640s. We have, on the other hand, already called attention to a predilection for carved decoration on firearms made to the north of France. The ivory stocked pistols provide several examples.

The design of the butt was also mentioned among the novel features. The immediate starting point is represented by the Thobie Wender in the Löwenburg (Pl. 25:1) with its gently rounded forms such as the comb curving smoothly right on to the protuberant belly opposite the nose of the butt. The Thuraine and Le Hollandois group have straighter lines so that the curve of the butt-comb is hardly noticeable and the end of the butt is extended so that the contour of the underside forms a long, unbroken curve with the bend on the underside of the butt just as lightly suggested as on the comb. Seen from the side the butt

Plate 73.

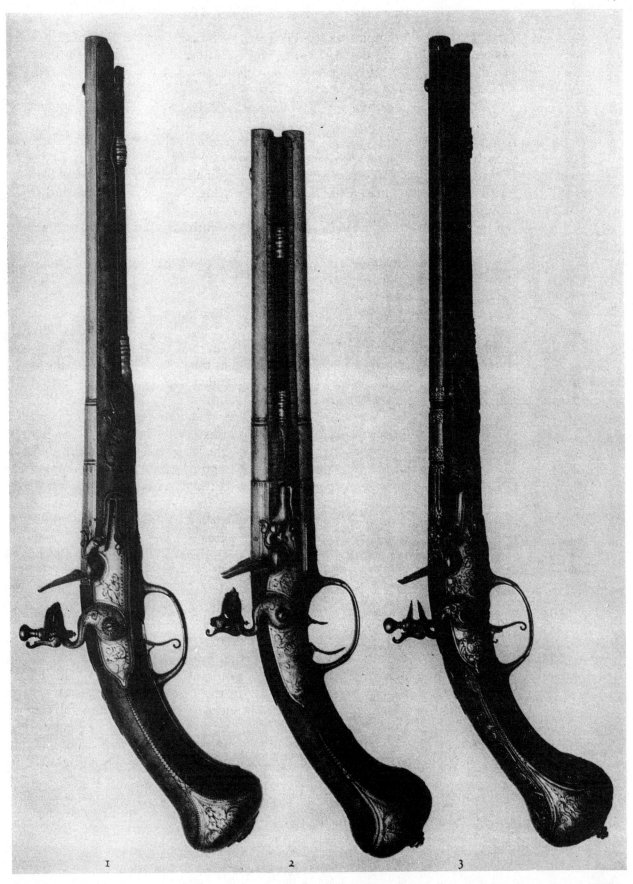

1 2 3

France, Paris. Charles XI's pistols. Given by Louis XIV in 1673. 1. One of a pair, by 'Piraube aux galerie à Paris'. 2. Double barrelled pistol by Alexandre Masson of Paris; Stockholm, Livrustkammaren 1626, 1701 and 3886.

Plate 74.

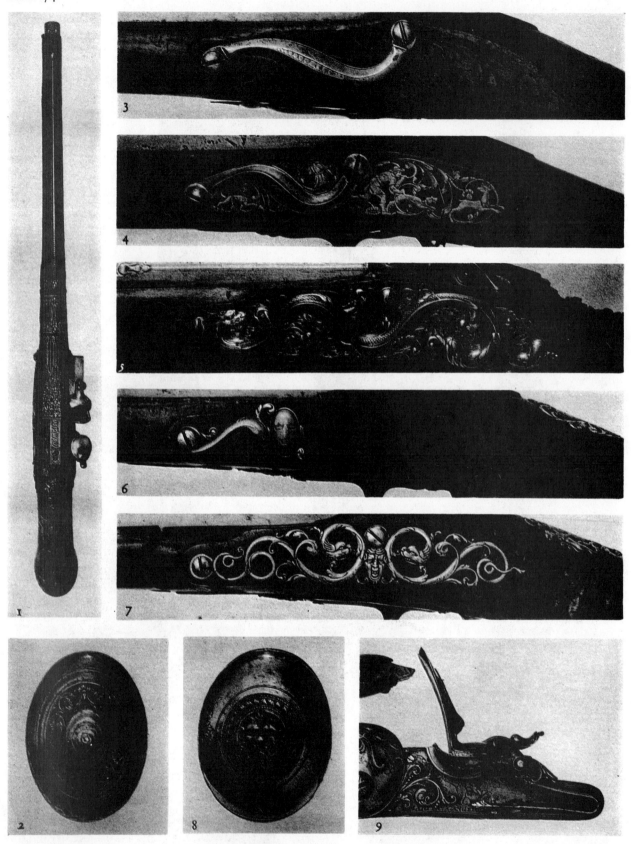

France, Paris and
Angers.
c. 1670

1 and 2. The pistol on Pl. 73:3. 3–7. Side-plate of gun by
Boular of Angers; Stockholm, Livrustkammaren 5329, on
the gun on Pl. 66:1, Charles XI's gun by 'Piraube aux
galleries à Paris'. Lowenburg Castle W. 1292, the gun on
Pl. 70:2, and gun by Alexandre Masson of Paris. Stockholm,
Livrustkammaren 1338. 8. Pommel of pistol on Pl. 73:1.
9. Pan with arm on gun by Martin of Angers. Stockholm,
Livrustkammaren 19/6.

Plate 75.

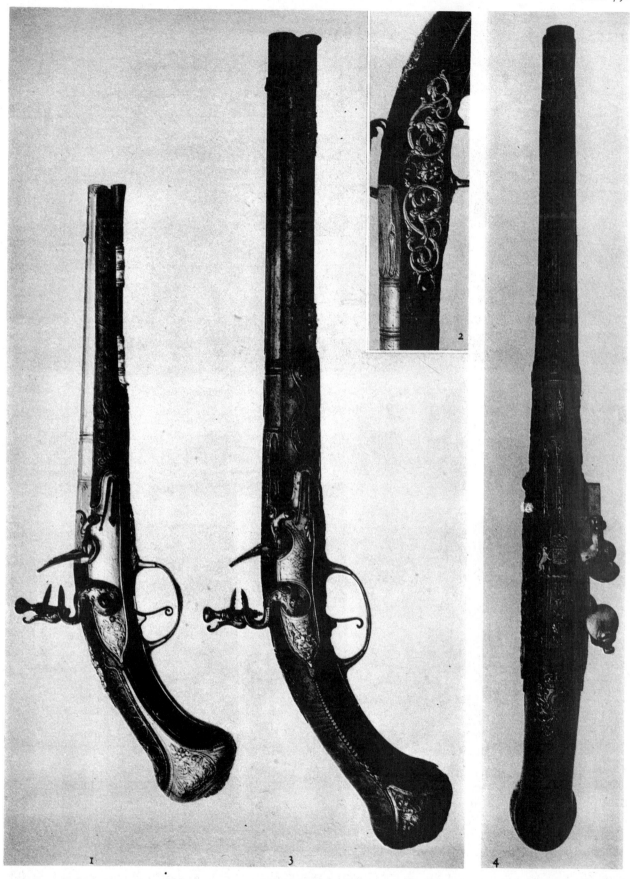

France, Paris.
1670s.

Charles XI's pistols, each one of a pair. 1 and 2. By 'Piraube aux galleries à Paris'. 3 and 4. By Frappier and Monlong of Paris; Stockholm, Livrustkammaren 4072 and 12/24.

Plate 76.

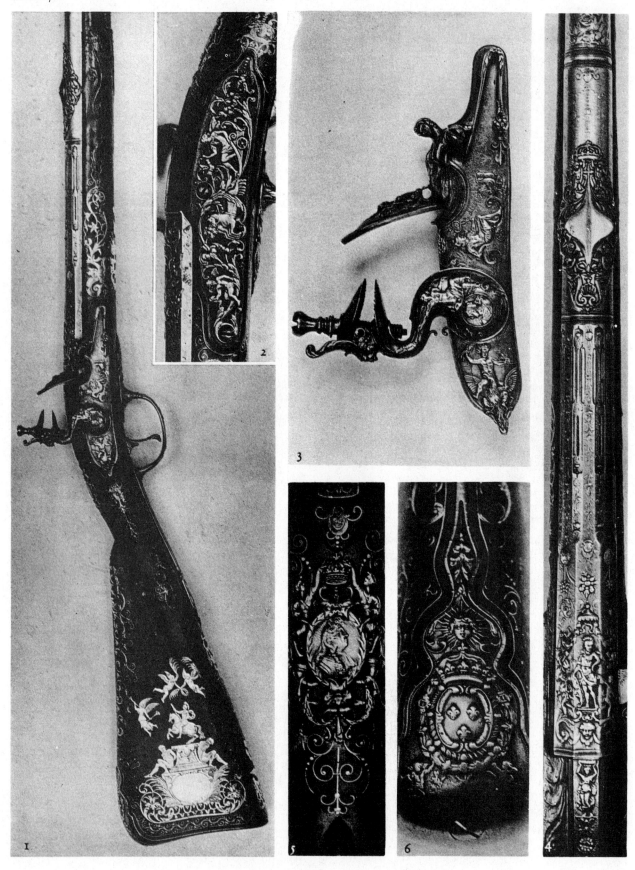

France, Paris.
1682.

Louis XIV's gun, signed 'Piraube aux galleries à Paris
1682'. Windsor Castle 425.

Plate 77.

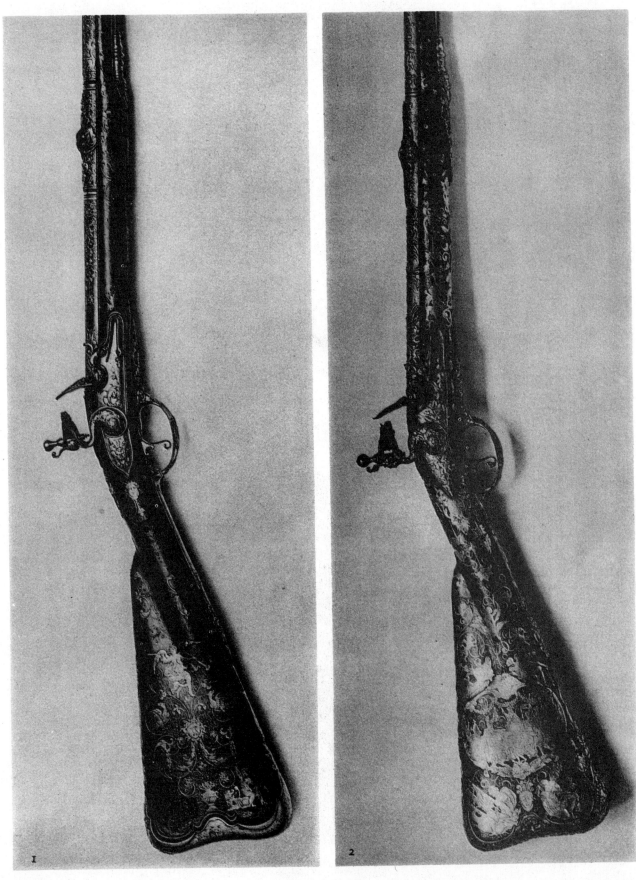

France, Paris.
1680s.

1. Gun by Gruché of Paris; Munich, Bayerisches National-museum 13/588. 2. Emperor Charles VI's gun by the same master; Vienna, Kunsthistorisches Museum, Waffensmm-lung. A 1674.

Plate 78.

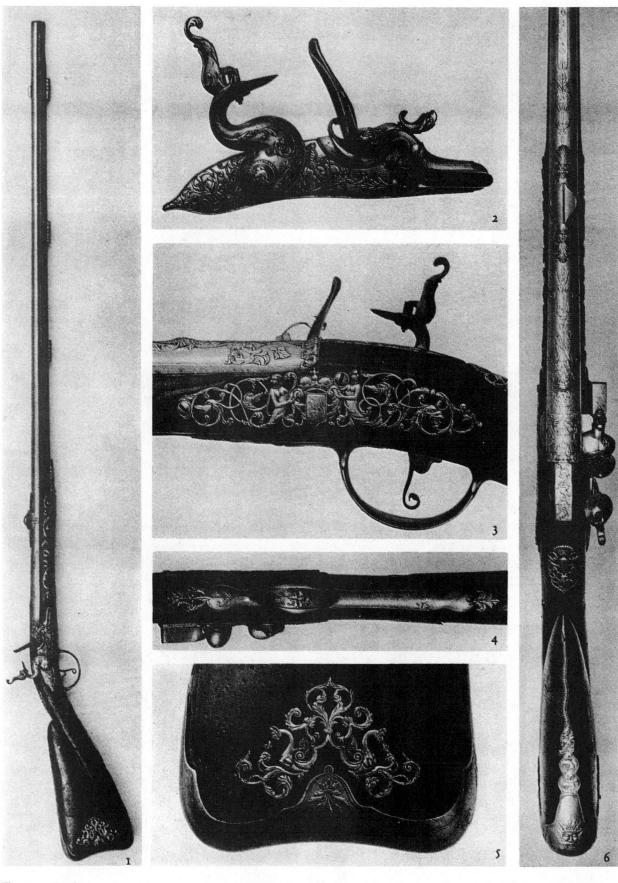

France, Paris.
1680s.

Gun by Laurent le Languedoc of Paris; Stockholm,
Livrustkammaren 30/10.

Plate 79.

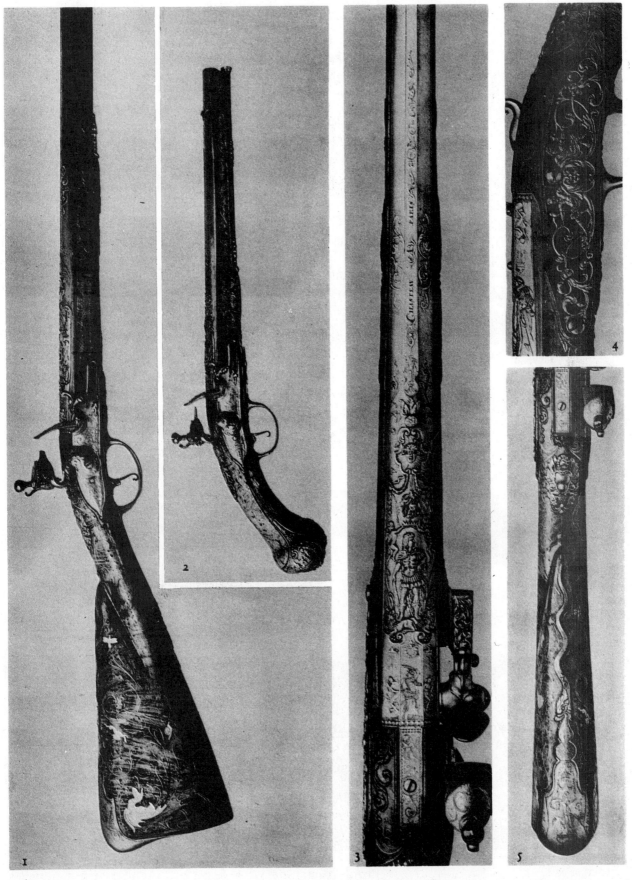

France, Paris.
1680s.

Garniture of gun and pistol, one of a pair by Chasteau of
Paris; Copenhagen, Töjhusmuseet B 960, B 961.

Plate 80.

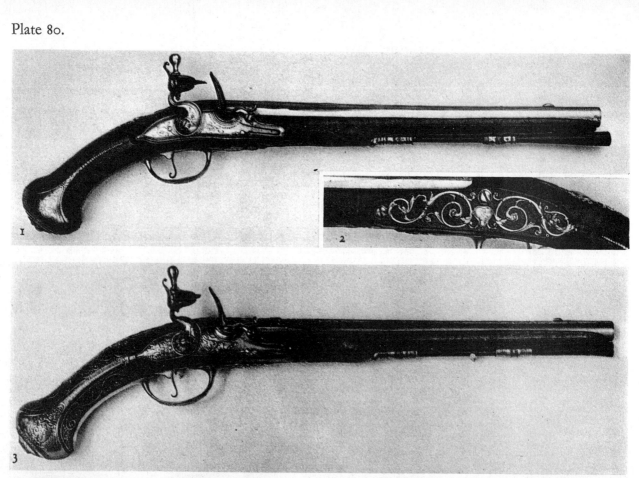

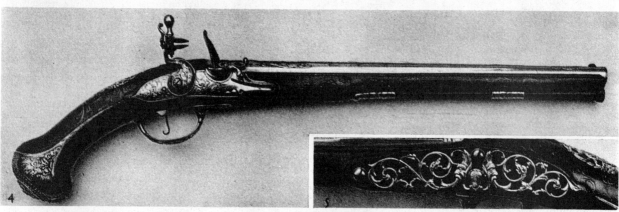

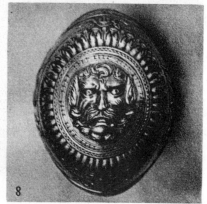

France, Paris.
1688–94.

Pistols each one of a pair, by 'Piraube aux galleries à Paris'. 1, 2 and 6. 1688; Copenhagen, Töjhusmuseet B 982. 3 and 7. 1690; Windsor Castle 496. 4, 5 and 8. 1694; Dresden, Gewehrgalerie 736.

Plate 81.

France, Paris.
c. 1690.

1–5. Gun by Le Languedoc of Paris; Dresden, Gewehr-galerie 735. 6. Detail of gun by Le Hollandois of Paris; Paris, Musée de l'Armée M 601.

Plate 82.

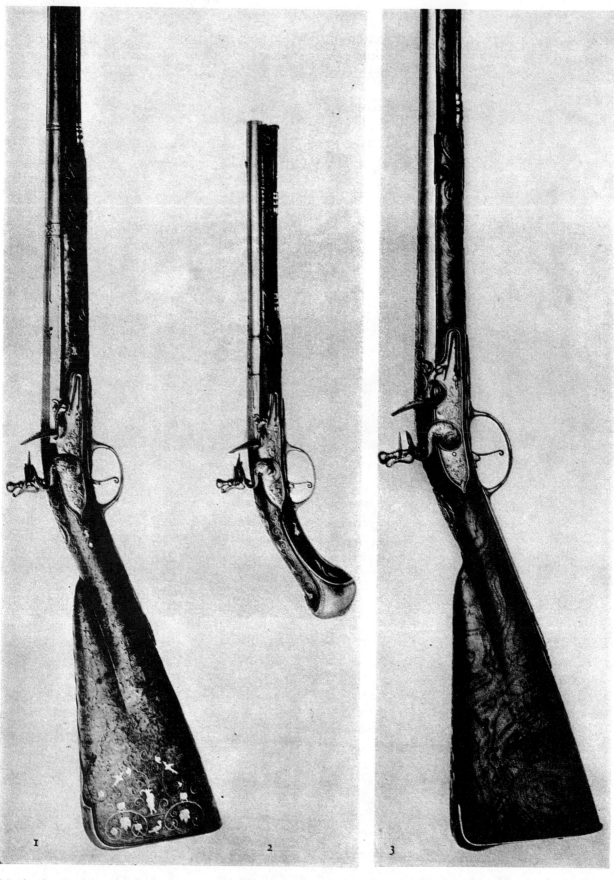

Netherland, Amsterdam.

1 and 2. Garniture of gun and pistol, one of a pair, by 'Pierre Stahrbus' (Amsterdam); Copenhagen, Töjhusmuseet B 934–5. 3. Charles XI's gun by 'Starbus à Amsterdam'. Given by Starbus in 1687; Stockholm, Livrustkammaren 1331.

becomes distinctly triangular. A suggestion of a flange, i.e. a moulding, accentuating the extension of the small into the butt begins to be manifest (cf. Pl. 56–59).

The butts of the immediately preceding decade were thin with parallel sides when seen from behind. The progressive increase in volume of the butt during the second quarter of the 1600s was maintained. The butts were rounded off still more and a widening can be observed at the bottom, but parallel sides still predominate about 1660 (cf. Pl. 56, 60).

A further detail on the stocks deserves mention—the simple carving in the form of an 's' extending from the rear ramrod-pipe right along each side of the stock. It is not found on all the ivory stocked pistols nor on all the surviving firearms of the Thuraine and Le Hollandois group; it is, however, present on both the guns in Copenhagen (Pl. 56:4 and 57:5).

Arms of the Thuraine and Le Hollandois group have no fore-end plate and the earlier ones no rear ramrod-pipe. The butt-plates are attached with the usual three screws placed in a vertical row and are bent over the heel (Pl. 56:5, 60:2). A short tongue extends from the butt-plate along the comb of two of the extant guns (Paris, Musée de l'Armée No. M 588 and the Livrustkammare No. 3888). This tongue is definitely linked with the spurs on the pistol pommels, but it arrives later. Once it appeared both these features accompany each other in the development of the next stylistic group among French flintlock arms.

After this general introduction we may choose some of the weapons belonging to the group for further examination. They are not numerous. If more could be traced they would be welcome additions to the scanty material available at present. We must remember that Jacquinet's album, after engravings by Thuraine and Le Hollandois, appeared not later than 1660, that Berain's album was available in 1659 and Marcou's only pattern sheet in the new style is dated 1657. We may, of course, assume that some time passed between the first appearance of the new fashion and its becoming 'en usage en l'art d'arquebuzerie', as Jacquinet put it, and it was considered opportune to publish the pattern plates. If we suppose that it took the fashion a few years prior to 1657 to break through, this would give us the beginning of the 1650s as a *terminus post quem*. The *terminus anti quem* is indicated by some weapons dating from 1668 and 1669. They constitute the introduction to the next style, the classical Louis XIV (Pl. 66, 69). This latter style may not have been entirely new at the time. The Thuraine and Le Hollandois style must consequently have flourished at the beginning of the 1650s and lasted until about 1665.

Typologically, the Casin pistols in Dresden are the oldest of the group (Pl. 55). The barrels are round, with the chambers partly eight sided and partly sixteen sided. The forms of the locks are flat with a ledge at the back of the plate, the characteristic breadth of the mid seventeenth century and the short, blunt tongue and the volute spur on the steel. They have steel-springs attached from the inside but with the lower arm still not developed to the same length as the upper one. The jaw-screw heads are constricted at the middle. This is recorded as early as the 1640s. The spurs of the butt-cap are half length, the triangular spaces in the trigger-guard, which is divided both in front and behind, are filled with ornaments of a moderate size. In them we recognize the rows of beads at the forked fore-end of the trigger-guards on the relief decorated pistols from the Wijk Collection (Pl. 44:2) and on the ivory stocked pistols in the Wrangel Armoury at Skokloster signed by Louroux (Pl. 52:1). The Casin pistols also have volutes in the front triangle. The carving of the stocks around the position of the rear ramrod-pipe (in this case absent) is not quite typical but is nevertheless present. The single ramrod-pipe is short and has a very restrained profile. The Casin pistols date from the beginning of the 1650s.

Of the two Thuraine and Le Hollandois guns in the Töjhus Museum, Copenhagen (Pl. 56, 57), which come next in date, the forms of the one are flat, those of the other rounded. The pattern book shows the same parallelism. The flat forms simply follow French tradition. The absence of a bridle on the gun with flat

forms is perfectly consistent. It has, too, the tiny carved leaf on the stock in the angle, to the left of the rear end of the chamber. The profile of the ramrod-pipes is less pronounced although the gun follows the new fashion in having a rear pipe. The long chamber, eight sided in the rear half and sixteen sided in the front half, is finished off in front with a turned ring instead of the broader and more elaborately profiled ring and foliate wreath of the second gun.

The volutes which were relics of the projecting parts of the cock after their practical function had disappeared lost all contact with their original purpose in the Thuraine and Le Hollandois style. They are now small and stunted, and tend increasingly to disappear. It is symptomatic that the gun with round forms has a cock in which the projecting ornaments are even more rudimentary than in the flat type. There are pattern sheets with such cocks without any volutes at all. The convex cocks are in fact more slender; this may well be because they are made of thicker metal and therefore do not run much risk of being broken. The upper jaw now slides with a projection in a groove on the spur of the cock. This is straight and narrows off into two ribs. In the case of the locks with the flat forms, it merges directly into the lower jaw. In the convex forms it curves more smoothly and fits better into the contour of the rear. The jaw-screw heads derive from the pear shaped type compressed at the top, which we have found in the chiselled group of the 1650s, as well as the earlier pistols with ivory stocks. The conical heads of these jaw-screws are turned out somewhat, rendering them 'mushroom shaped'.

The flat forms are combined with angular pans and steels cut off straight at the top; the convex with rounded pans and rounded tongue shaped steels with sharp edges. On the former the rear of the lock-plate is sunk and decorated with engraving or chiselling. It also has a broader edge than the rest of the plate. In the case of round-faced locks, the rear of the plate is only indicated by decoration, usually engraved. In both instances the plate finishes at the rear in a short, blunt tongue. The flat locks

often have a small notch in the edge of the lock-plate behind the pan. This is so on the Töjhus Museum's Thuraine and Le Hollandois gun. This feature can be proved to have existed as early as the 1630s. There is not much more to be said about the two Thuraine and Le Hollandois guns in Copenhagen, apart from the above explanation of the origin of the style, unless it be that the convex lock-plate has not yet become entirely convex. In front of the cock it is still flat. The observations made above concerning the breadth at the rear and the rounded off tongue also apply[21].

The forms of both the other guns which are submitted as typical of the Thuraine and Le Hollandois style are flat. The earliest is signed 'Le Couvreux au Palais Royal': it is in the Musée de l'Armée in Paris (Inv. No. M 588. Pl. 58). There is no indication which of the two masters, father or son, made this gun. They both lived in the Palais Royal. Robert dates it from the latter half of the eighteenth century and lays stress on its outstanding aesthetic quality[22]. We can unreservedly agree with this opinion and even emphasize it. As regards the dating we are bound to differ.

Thanks to the coat of arms in the decoration of the left side of the stock corresponding to the lock (Pl. 58:6) and the initials 'N N' on the trigger-guard it can be shown with fair probability that the gun was made for Nicolas Nicolay, Marquis de Goussainville, premier président de la chambre des comptes 1649, orator and scholar, patron of literature, who died in 1686[23].

This beautiful gun has no side-plate and the ramrod-pipes are cylindrical. It should nevertheless be dated later than the Copenhagen guns as the lock has a fully developed bridle, extending to the sear-screw, and the butt seen from behind is considerably broader than that of the earlier arms. The 's' shaped carvings on the fore-stock above the rear ramrod-pipe are, it is true, very shallow but they extend further to the rear than the corresponding carving on the guns in Copenhagen. The other type which passes more or less across the stock is represented, however, on the same gun in the engraving which ornaments the lock-plate (Pl.

58:2). A hunter shown in it leans on a gun in the Thuraine and Le Hollandois style and on it the ledge-like carving is distinctly shown.

The Livrustkammare double barrelled Wender (Pl. 59, 60) signed 'Le Conte à Paris' on the lock and 'Berain fecit' on the silver inlays of the stock is the most richly decorated French firearm of the seventeenth century. The entire gun is completely covered with engraved decoration, open-work and chiselled ornaments, gold damascening and silver inlay. That the decoration nevertheless does not impress one as exaggerated is quite remarkable. In 1673 this magnificent gun formed part of the gift, regal in every respect, which Louis XIV sent to Charles XI of Sweden (cf. p. 96). Most of the firearms included in this gift have features which associate them with a garniture of 1669 in Copenhagen. We shall revert to this garniture which bears the arms and cypher of the Swedish king. The Le Conte gun belongs, however, to the Thuraine and Le Hollandois style and bears Louis XIV's cypher on the comb of the butt. This gun differs from the others in the way the chamber is divided up and designed. The rear half is eight sided, the forward one divided up into a sixteen sided zone and a round zone. The latter is separated from the polygonal zone, and from the rest of the barrel, by turned rings. This kind of division which implies adding a round section to the earlier eight and sixteen sided chambers, is something new. It subsequently becomes typical of the earlier forms of the next, the classical Louis XIV style. The gun lacks a back-sight but has the same conical nipple-like fore-sight as one of the Thuraine and Le Hollandois guns in Copenhagen.

The Monlong pistols of Schwarzburg (Pl. 61:1–5) are interesting on account of their blend of earlier and later forms. The barrel is divided in the same way as the Le Conte Wender in the Livrustkammare. The strongly curved neck of the cock may well indicate the decade 1650–60, as do the entirely rounded forms of the lock. The butt-cap spurs of more than half length also give reason for dating about 1660. But the absence of a rear ramrod-pipe and side-plate is an archaic sign; this may

probably be explained by the manufacture of the pistols in a provincial area. The trigger-guard, only filled up at its forward end with ornament, and the bridle which passes right across the tumbler but does not embrace the sear-axis, can be explained in the same way.

Some of the novel features in the Thuraine and Le Hollandois style were probably developed outside France. They were rapidly assimilated with traditional French forms and developed with them. As an example of this phenomenon we can quote a gun in the Pauilhac collection (Pl. 61:6) signed by De Foulois le jeune. From the sun inlaid on the small of the butt and the motto 'nec pluribus impar' it must have been made for Louis XIV. The gun must be dated rather late in the 1660s, mainly on account of the form of the butt. The latter has, in comparison with the last of the three guns just discussed, a distinctly rounded heel—it has become plumper as seen from behind and been given a more accentuated flange. The earlier triangular shape is abandoned. The tang of the butt-plate passes along the greater part of the comb. Another reason for this dating is that the chamber of the barrel is proportionately shorter than that of the Le Conte-Berain Wender in the Livrustkammare. It also has two fluted sections between the sixteen sided part and the round one. The profile of the ramrod-pipes, finally, is fuller and higher.

The gun No. B 674 of the Danish Töjhus Museum, signed on the lock 'Manyeu à Libourne'[24], is typologically earlier than Louis XIV's gun in the Pauilhac collection. The earlier features include its long chamber, the low profile of the ramrod-pipes and the breadth of the lock-plate at the rear. The latter is, however, more convex than that of M. Pauilhac's gun while the butt is of the same form. The ornament carved on both sides of the fore-stock is of the same kind as that we find on definitely French weapons of the 1670s. This gun should therefore also be dated later.

To acquire a profounder understanding of the Thuraine and Le Hollandois style and its development it will be necessary to make a more thorough investigation.

Although there are convincing parallels certain differences can be recognized between the French and Netherlandish styles in the mid seventeenth century and subsequently. The study of pieces made in Maastricht has contributed important information. The Cornelis Coster gun of 1652 in Copenhagen (Pl. 30:3) and Admiral Martin Tromp's pistols in Amsterdam (Pl. 30:5) have robust trigger-guards of a type unknown in France. Another gun in the Töjhus Museum (Inv. No. B 608. Pl. 62:1)[25] is of interest. It is not signed, but its origin is indicated by the City of Utrecht's arms on the barrel. It can be dated, by the form of the butt and the lock, from about 1660 or perhaps slightly earlier. Details to be noted are the round barrel, the carved stock and the decoration of the lock-plate.

Barrels of round section from breech to muzzle are usual in the Netherlands but exceptional in France. A pair of pistols by Du Bois of Paris in the Wrangel Armoury at Skokloster (No. 40. Pl. 65:1) is evidence of their occurrence in France while Berain shows a round chamber on one of his pattern sheets. They must otherwise be regarded as Netherlandish.

Carved stocks did not gain a footing in any of the central French manufacturing areas. A trend in this direction is to be found on the Dauphin's gun in the Berlin Zeughaus (cf. Pl. 19:5), and the signed Wenders in Paris reproduced on Pl. 25 have carved leaves behind the barrel-tang screw. This seems to be exceptional and more likely a sign of external influence than of French form. Inlay was the common form of stock decoration in France. The Töjhus Museum gun No. B 608 has carved foliage decoration, not only at the barrel tang but also behind the lock, and in the corresponding position on the left side of the forestock. In support of the view that this carved decoration is Netherlandish it can be said that it is encountered in other areas in which flintlock manufacture was carried on by immigrants from the Netherlands before the French style had secured a position of monopoly. This is the case in Sweden for example. A gun dating from the 1670s made by Peter Froomen, who had moved to Stockholm from Maastricht, and by

the stock maker Johan Christopher Wolff (Livrustkammare Inv. No. 5616)[26], has a stock of this Netherlands type with carved ornament which also occurs in the Berain pattern album.

The lock on the Töjhus Museum gun No. B 608 belongs to the same type as that on sheet '4' of the Thuraine and Le Hollandois album (Pl. 116:2). Its decoration follows the same scheme, but it accentuates the floral ornament which there is reason to regard as Netherlandish.

We have a very interesting parallel to French flintlock arms in some guns by Jan Knoop of Utrecht†. He is particularly well represented in the Töjhus Museum in Copenhagen and in a manner that ensures him a prominent place even among the masters of applied art. Most of these weapons in the Töjhus Museum belonged to Ove Bielcke of Östraat, Chancellor of Norway (b. 1611, d. 1674). Two guns in the Artillery Museum at Akershus, Oslo (Inv. Nos. A 26 c and A 53 d) formerly went with them. They were transferred from the Töjhus of Copenhagen[27] and from the chronological collection of the Danish kings in Rosenborg. Four of the original collection are flintlocks; Akershus A 53 d, two of the guns in the Töjhus Museum (Inv. Nos. B 602, B 603. Pl. 62:2–4)[28] and a gun in Rosenborg (Inv. No. 7–176). Two very similar guns are at Skokloster (the Brahe-Bielke Armoury).

When endeavouring to decide whether the Thuraine and Le Hollandois style first appeared in France or in the Netherlands these guns provide important material for study and it would be valuable if they could be dated exactly. Even if this is not at present possible we can assume that all these Jan Knoop guns of Ove Bielcke are of approximately the same period. The inscription which can be read on two of the wheel-lock guns in the Töjhus Museum (Inv. Nos. B 592, B 593)[29], 'M. Bielcke Den 15 Aprilis 1652' will also serve as a criterion for dating the others. As we must remember that the Thuraine and Le Hollandois style had already become fully developed in Paris by then, the problem must remain unsolved. Nor must we forget that the gun by Cornelis Coster (Pl. 30:3) dating from

the same year shows more old fashioned forms.

Two guns made for Charles XI as a child, now in the Livrustkammare, one double barrelled under and over (Inv. No. 1342) and one ordinary single barrelled (Inv. No. 1354)[30] also represent Utrecht firearms of about 1660. The locks are signed 'Utrecht' and have the town mark on the barrels. The locks are of simple, convex type. The trigger-guard of the single barrelled gun is thin and forked at the fore-end, that of the double barrelled one is closed and rounded off.

Reminiscences of the western European style of the 1640s and of the period about 1650 predominated well into the 1660s with the possible exception of the western border districts where it was easiest for the new forms to obtain a footing. A number of flintlock weapons signed 'David René à Heydelberg' in the Wrangel Armoury, Skokloster, demonstrates this. For the engraving of the lock-plate on one of them (No. 100. Pl. 62:5) a pattern in Berain's album was followed. They also show the influence of the Thuraine and Le Hollandois style in other respects, with the exception of the entirely closed and rounded trigger-guards.

The Thuraine and Le Hollandois style also exercised a marked influence on Italian flintlock manufacture. The relief decoration of the Berain album is characteristic of it too, and it may well be suggested that a direct connection is not out of the question.

The Livrustkammare possesses very good specimens of this phase in Italian gun making. We may choose from among them Charles XI's gun signed 'Vinsenso Lanse' on the barrel (Inv. No. 1335. Pl. 63:1, 5)[31], and the same king's pistols, with the barrels signed 'Lazaro Lazarino Cominazzo', the locks 'Paolo Francese Brescia' (Inv. Nos. 1635, 1636. Pl. 63:2–4)[32]. All three pieces are fine examples of Brescian gun making which was highly appreciated in its day.

Information on the date of the appearance of the flintlock in England is conflicting‡. It would seem that the English 'dog-lock' (cf. p. 21 and Pl. 4) enjoyed great popularity for a long time and that snaphances were in use for

so long that they delayed a more general use of the flintlock in England. It will be remembered that the inventory of the French *Cabinet d'Armes* calls a snaphance gun 'fusil à l'Angloise'. This probably expresses the opinion of the compiler of the inventory on English conservatism as regards lock types. A modern writer on the flintlock in England, J. N. George, defines the flintlock as a lock with a steel and pan-cover[33], and pays no attention to the rest of the construction. In the captions to his illustrations he nevertheless distinguishes between snaplocks and flintlocks in the same way as in the present thesis. George considers that the English royalists' purchases of Netherlands weapons during the Civil War of the 1640s must have involved the importation of flintlock firearms. In this he is most probably correct. He frequently quotes reports of arms having been confiscated during the Commonwealth (1649–60), but there is no reliable evidence that such arms were provided with flintlocks§. A four barrelled pocket pistol, confiscated in 1657, may of course be suspected of being a Wender, but details are lacking. There is at any rate no indication in George's book of English flintlock manufacture at this time, even if he does mention that there was a boom in the manufacture of fine weapons during the Commonwealth. George calls attention to a common assumption, which he does not believe himself, that the better quality London arms made subsequent to 1660 were turned out by foreign craftsmen who had accompanied the emigrants returning to England after the Restoration in that year[34]. Against this supposition he alleges that Englishmen were greatly in the majority among the gunsmiths in England during the period in question and that English production, which was still further improved in the later half of the seventeenth century, follows purely national lines both as regards form and decoration‖. The pistol which he illustrates on Pl. 111:5 as an example of this national production is nevertheless a flintlock pistol with purely Continental forms. It is asserted in the text that it has a normal flintlock[35]. The caption to the plate, on the other hand, calls it a 'dog-lock'.

The earlier English manufacture of hand firearms has always been dependent on the Continent, especially on the Netherlands¶. A deeper understanding of firearms made in England therefore calls for an exhaustive study of corresponding Netherlandish phenomena. This has been overlooked in research work and applies particularly to the earliest English flintlock arms. Both those illustrated by George and some others in Swedish and Danish possession fully confirm the assumptions of foreign influence on English flintlock manufacture during the Commonwealth and at the Restoration. George is not convinced of this.

In the pistol which George illustrates on Pl. 111:5 we recognize west European forms of about 1650. It is not clear from the picture but it looks as if the neck and body of the cock were designed as a monster, similar to corresponding cocks in the Wender group. The acorn shaped trigger on the contrary must be considered to be an example of English tradition. We find it again on a pair of pistols in the Wrangel Armoury at Skokloster (No. 93. Pl. 64:1). These are signed 'W Parket' on the locks, and bear the London Gunmaker's Company marks on the barrel[36]. Their locks are distinctly reminiscent of the Thuraine and Le Hollandois style as we know it from the Casin pistols in Dresden (Pl. 54:4). The trigger-guards are of the same type as on certain Wenders and the butt-caps with the half length spurs are typical of the 1650s. Another pair of pistols at Skokloster (the Brahe-Bielke Armoury) (Pl. 64:2, 3) should just as obviously be dated from about 1660 at the latest. They are signed by the same master and struck with the Gunmaker's Company marks. The Gilbin pistols in the Livrustkammare and the pistols signed 'A Lesconné' in the Löwenburg (Pl. 54:2, 3) provide a useful comparison. The pistols at Skokloster have locks of wholly convex type. Large, boldly carved leaves on the upper side of the butt confirm that the prototype is to be found in Dutch gun making.

Breech-loaders with rifled, removable barrels were extremely popular in England: there is a very beautiful pair in the collection at Skottorp in the Swedish province of Holland (Pl. 54:4)[37].

They are signed by Harman Barne, Prince Rupert's gunsmith during the Civil War and London's foremost master at the time of the Restoration[38]. It is probably correct to date them about 1660, even if a slightly earlier dating might be acceptable**. According to George 'screw-barrelled or cannon-barrelled pistols' are recorded in literary sources from a date before the outbreak of the Civil War in 1642[39]. Among the personal belongings of Charles I which fell into the hands of the insurgents at Wistow Hall, Leicestershire, after the Battle of Naseby was such a pistol††. Firearms of so early a period have yet to be produced. From what we have hitherto seen the pistols at Skottorp are among the earlier. These, too, are distinctly reminiscent of Continental flintlock weapons, in their ornament among other features.

Not much later is another pair of pistols of the same construction, improved by an ingenious arrangement to prevent the barrel being lost. They are in the Töjhus Museum, Copenhagen (Inv. Nos. B 1019, B 1020. Pl. 64:5); the lock and barrels are signed 'R. Hewse of Wooton Basset'. Here, too, the link with the Netherlands is very definite, primarily through the trigger-guard. This pair of pistols has side-plates of an early type, in contrast to all the pistols of English make mentioned above, which have no side-plates.

The question of the introduction of the manufacture of flintlocks into England should be examined. It will then most certainly be found that this manufacture begins during the Commonwealth, that it was in full swing about 1660 and that the prototypes were Netherlandish.

Editor's Notes

* Now in the Victoria and Albert Museum, No. M86–1949.
† Firearms made by Jan Knoop have been discussed in detail by Dr A. Hoff in *Vaabenhistoriske Aarbøger*, Vol. Va, p. 15.
‡ An English flintlock pistol in the W. Keith Neal Collection is dated 1630. This appears to be the earliest recorded example, but some of the pistols with the so-called

English lock (a compromise between snaphance and flintlock) may be earlier.

§ There is every likelihood that they were flintlocks. For further information on this point see J. F. Hayward *The earliest forms of the flintlock in England, Livrustkammaren,* Vol. IV, p. 185, and also *The Art of the Gunmaker,* Vol. I, p. 206. English mid seventeenth century pistols are illustrated on Pl. 52 of the same work.

‖ The Huguenot gunmakers who came to England between 1685 and 1700 exercised a very strong influence. The finest pieces they made in England adhered to the fashionable Louis XIV style.

¶ Dr Lenk tends to place too much emphasis on foreign influence. The earliest English wheel-locks and snaphances certainly resemble contemporary Continental ones, but there is some reason to think that the Dutch gunmakers may have derived the snaphance from England rather than vice-versa. The English lock (see J. F. Hayward, *The Art of the Gunmaker,* Vol. I, p. 274) was evolved independently in England. Towards the middle of the century Dutch influence predominated in England.

** Harman Barne died in 1661, so 1660 is the latest possible date for the pistols. They are now in the W. Keith Neal Collection, Warminster. Barne was probably himself of Dutch origin.

†† The pistol at Wistow, traditionally of Charles I, is, in fact, of later date—after 1660.

Notes to Chapter Eight

1. His signature, 'Lallemand à Paris', is on the lock of a pistol that indicates a direct continuation of the style of the 1640s. *Grosse Auktion. Mobilia . . . Waffen . . . am 2–5 juni 1937 in Zunfthaus sur Meise in Zürich.* P. 162. No. 2522. Picture XVII.
2. Weigert, *Jean I Berain,* I. Pp. 7–9.
3. *Livrustkammarinventarium 1683.* P. 57. No. 3. Palace Archives. Livrustkammaren. *Vägledning 1921.* P. 61. No. 469.
4. [Cederström], *List of Count Keller's Collection.* (Auction catalogue.) P. 49. No. 301.

5. Livrustkammaren. *Vägledning 1921.* P. 100. No. 800. The statement that these pistols belong to one of Louis XIV's presentation saddles appears to be due to a mistake in the Livrustkammare inventory of 1821.
6. Cf. Boeheim, *Meister der Waffenschmiedekunst.* Pp. 176–78, 210, 211.
7. Smith, *Det kongelige partikulaere Rustkammer.* P. 38. No. 59.
8. Guiffrey, *Logements d'artistes du Louvre.* (Nouvelles archives de l'art français. T. II. P. 86.)
9. Wender pistol in the Jacobi Collection, Stocksund, Sweden.
10. *Brevets accordés . . . à diverses artistes.* (Archives de l'art français. V. III. Pp. 277–82, 286.
11. Lenk, *Två bössor av Thuraine & Le Hollandois i Töjhusmuseet.* (Vaabenhistoriske Aarböger I. Pp. 13–24.) Smith, *Det kongelige partikulaere Rustkammer.* Pp. 61, 62.
12. Ehrenthal, *Führer durch das Königliche Historische Museum.* P. 171.
13. Ossbahr, *Das fürstliche Zeughaus in Schwarzburg.* P. 158.
14. *Livrustkammarinventarium 1683.* (Zacharias Renbergs inventarium 1686). P. 253. No. 1. Palace Archives. Livrustkammaren. *Vägledning 1921.* Pp. 87, 88. No. 704.
15. Diderot et d'Alembert. *Encyclopédie,* Suite du receuil de planche⌐. T. III. Pp. 59, 60.
16. Ossbahr, *Das fürstlicht Zeughaus in Schwarzburg.* P. 158.
17. Thierbach, *Die geschichtliche Entwickelung der Handfeuerwaffen.* P. 67. Fig. 146. Ehrenthal, *Führer durch das Königliche Historische Museum.* P. 141. No. F 472. The pistol belongs to a group from the period about 1700 with lock-plate and mounts of gilt brass. It cannot therefore provide any information as to the date of the origin of the bridle.
18. Pollard, *A history of firearms.* P. 62.
19. A flange is a projection on the pan that lies at right angles to the lock-plate and covers the edge of the latter in the recess for the pan. There is earlier evidence of this construction. The pistols by Choderlot in the Töjhus Museum (Pl. 25:2) have a flange on the pan.

20. The screw which fixes the barrel-tang to the stock.

21. One of these guns has been mentioned earlier in literature, apart from the *Vaabenhistoriske Aarböger*, chiefly in the Töjhus catalogue of 1877. [Boeck and Christensen], *Katalog over den historiske Vaabensamling paa Köjobenhavns Töjhus*. P. 60. No. A 577. The writer of the section of the catalogue dealing with hand firearms, Georg Christensen, Curator of Artillery, attributes one of the guns to Christian V's reign (1670–99). It is probably this attribution that accounts for Boeheim (*Meister der Waffenschmiedekunst*. P. 210) regarding this gun as considerably later ('weit jüngerer') than Corfitz Trolle's gun of 1669 (No. B 664. Cf. p. 95) which is signed by Thuraine alone. He nevertheless considers that the weapons signed with both names are older. (Ibid. P. 176.)

22. Roberts, *Catalogue des collections composant le Musée d'Artillerie*. T. IV. P. 126.

23. Hozier, *Armorial général de la France*. Pp. 405, 406.

24. Smith, *Det kongelige partikulaere Rustkammer*. P. 45. No. 85. 'Ca. 1655.'

25. Smith, *Det kongelige partikulaere Rustkammer*. P. 50. No. 104. 'Ca. 1670.'

26. Cf. Lenk, 'Charles XII's barnbössa. (*Livrustkammaren 1938*. P. 89.)

27. *Katalog over Artilleri-Museet paa Akershus 1904*. Pp. 24, 27.

28. Smith, *Det kongelige partikulaere Rustkammer*. Pp. 21, 22. Nos. 3, 5. Pl. 22. 'Ca. 1655.'

29. Smith, *Det kongelige partikulaere Rustkammer*. Pp. 178, 179. Nos. 414, 415.

30. *Livrustkammarinventarium 1683* (Zacharias Renbergs inventarium 1686). P. 263. Nos. 22, 23. Palace Archives.

31. *Livrustkammarinventarium 1696*. No. 14. Palace Archives. Livrustkammaren. *Vägledning 1921*. P. 86. No. 692.

32. Gift to Charles XI by Count Gustavus De la Gardie. *Livrustkammarinventarium 1683* (Zacharias Renbergs inventarium 1686). P. 257. No. 2. Palace Archives. Called there 'persianska' (Persian). Livrustkammaren. *Vägledring 1921*. P. 89. No. 709.

33. George, *English pistols and revolvers*. P. 6.

34. George, *English pistols and revolvers*. P. 31.

35. Ibid. P. 32.

36. Greener, *The gun and its developments*. P. 287. Pollard, *A history of arms*. P. 47.

37. Communicated by Baron Rudolf Cederström, who also furnished a photograph.

38. George, *English pistols and revolvers*. P. 31.

39. Ibid. P. 15.

Plate 83.

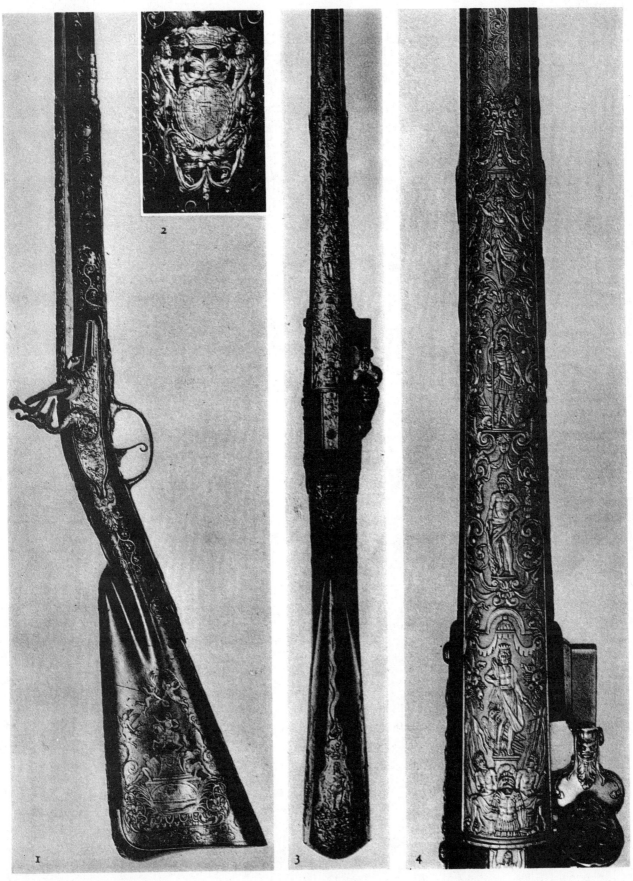

Germany, Dresden.
Close of seventeenth cen-
tury.

Augustus the Strong's gun by Andreas Erttel of Dresden.
Destroyed by fire in 1934.

Plate 84.

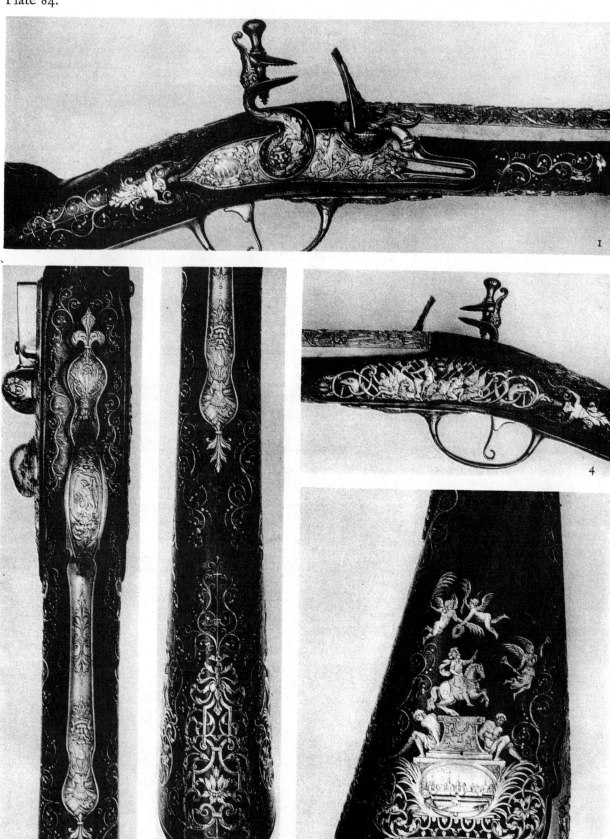

Germany, Dresden.
Close of seventeenth cen-
tury.

Details of the gun on Pl. 83.

Plate 85.

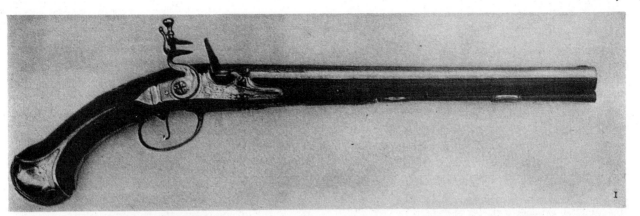

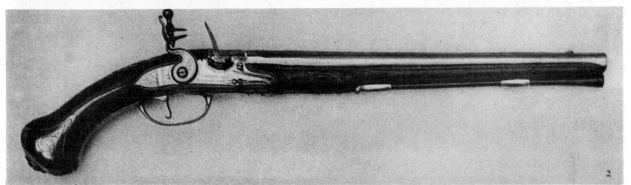

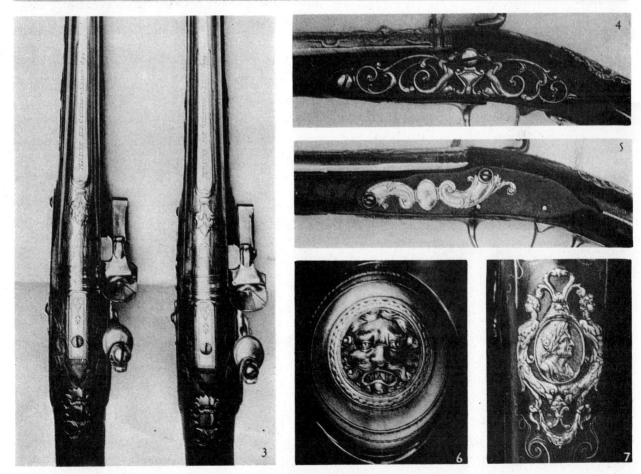

France, Paris.
1696. 1699.

Pistols, each one of a pair, by 'Piraube aux galleries à Paris'.
1, 4 and 7. 1696; Dresden, Arméemuseum EX 105. 2, 3, 5
and 6. 1699; formerly Berlin, Zeughaus 09. 124.

Plate 86.

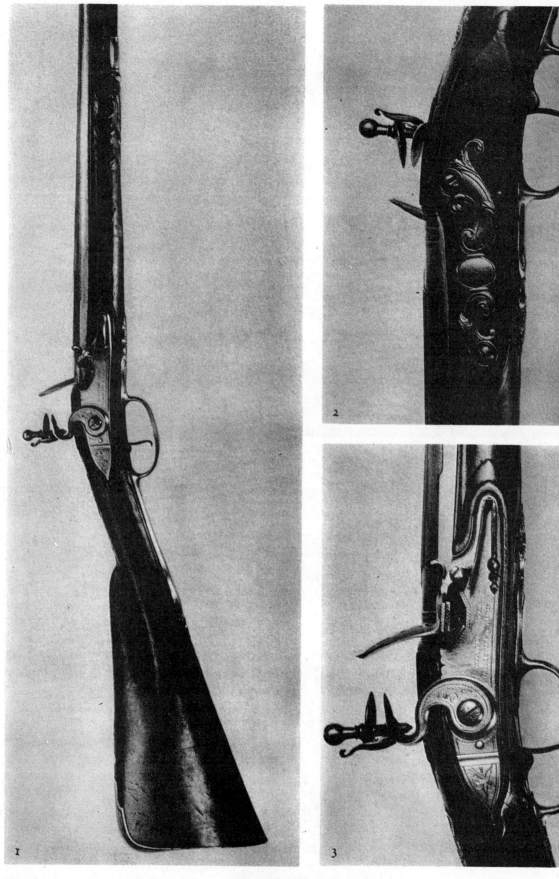

France, Paris.
1699.

Gun by 'Piraube aux galleries à Paris 1699'; Kranichstein,
Darmstadt, Jagdmuseum 264.

CHAPTER NINE

The Classical Louis XIV Style

WE HAVE shown in the preceding chapters that thin, divided trigger-guards occur in the 1650s at the same time as massive, solid rounded ones in the ivory stocked pistol group (Pl. 52:1, 2). We find this parallel use of different forms also in France although there early weapons with convex forms are rare. The arms in the Thuraine and Le Hollandois group had divided trigger-guards and were elaborately ornamented. As has already been pointed out a lock with simplified forms (Pl. 116:2) can nevertheless be discovered in the album of these two masters' works. *De luxe* articles are, as a rule, preserved while ordinary utility ones become worn-out, or are thrown away once they are out of fashion. This probably explains why so few of the earlier arms with massive, rounded trigger-guards can be found now. It is difficult to determine at present how large this manufacture of the 1650s was, but evolution did at any rate follow in the line of the simplified forms. A pair of pistols with over and under barrels by 'Du Bois à Paris' in the Wrangel Armoury, Skokloster (No. 49. Pl. 65:1), provides a good illustration of the earliest phase, and a pistol in the Livrust-

kammare (the Sack Armoury. Pl. 65:2–4) signed by 'De Foullois à Paris' is an even better illustration. The date is confirmed by comparison with the lock mentioned above in the Jacquinet series. Determining factors in dating are also the breadth of the lock-plates behind the cocks and, in the case of the De Foullois pistol, the length of the pommel spurs. These have not yet reached half way up the small of the butt. Further the 's' curved carving of the fore-stock where the ramrod enters is significant. Corresponding to this is the simple carved 's' shaped ridge on both sides of the barrel tang.

Continuing with the De Foullois pistol we can note the presence of a bridle in its earliest form and the absence of the side-plate.

These pistols mark the introduction to that brilliant period in the history of French gun-making which is called the classical Louis XIV style in this thesis. It is no mere chance that its origin can be traced to those very years when French handicrafts as a whole experienced a regeneration.

The gunsmiths appear to have succeeded in long withstanding the absolute rule of the Lebrun style. A turn of the tide set in, however,

the effects of which can be observed at the close of the 1660s in certain firearms in Swedish and Danish collections.

Erik Dahlberg resided in Paris from 1667 to 1668 to secure the co-operation of Parisian copperplate engravers in preparing the publication of his *Svecia antiqua et hodierna*. In addition to his official commission he received private requests, among them to acquire arms for his father-in-law, Drakenhjelm, President of the Board of Customs and Excise, and also for Svante Svantesson Banér, Privy Councillor, Djursholm. Erik Wennberg gives some interesting information about this in the new edition of *Svecia antiqua et hodierna*[1]. This is taken from the portion of the correspondence between Erik Dahlberg and Samuel Mansson Agriconius (Åkerhielm) and Agriconius's notes on commissions preserved in Uppsala University Library (U. 147). If we go direct to Wennberg's sources and to two other letters, one in the State Archives (Dahlberg No. 18) and another in the Royal Library (Dahlberg Collection No. M 11) we obtain supplementary data that enable us to identify some of the arms mentioned in the correspondence and also acquire important evidence about Parisian flintlock arms at the close of the 1660s.

Banér writes to Dahlberg on 26 October, 5 November 1667, that he has arranged for the making of a flintlock gun ('Un Arquebugi Francese Fusil') which he asks Dahlberg to bring back, as he was anxious that it should not be damaged at sea. It is of moderate length and strongly constructed ('d'una longezza moderate e forte di ferro') so that it could be easily handled. Banér promises to communicate the name of the gunsmith by next post. In another letter Banér requests Dahlberg to procure walnut planks for gun-stocks.

This was probably how Dahlberg came into contact with the gunsmith Des Granges, who lived at Marais de Temple in the old Rue du Temple ('above the little strolling players'). He seems to have been a master who was in great request, judging by the fact that quite a number of very fine weapons with his signature are preserved. Dahlberg not only fulfilled the Privy Councillor's request but also ordered a

lock with accessories for Dahlberg's father-in-law and a pair of pistols for himself. He assisted at the same time by ordering two pairs of pistols for two members of the Gyllenstierna family. Wennberg mentions the date of a contract between Dahlberg and Des Granges. This very interesting document (appendix two) is amongst Agriconius's papers in Uppsala. Apart from terms and other data of value it enables us to identify a pair of the Gyllenstierna pistols. Dahlberg sent this contract from Calais with a letter of 16 September 1668, when he was on his way to England and from there to Sweden. The letter contains several commissions, among them one concerning Des Granges, 'the wanton bird' with whom Dahlberg is dissatisfied. The pistols were ready and he asks Agriconius to pay the outstanding amount although he considers that they were badly engraved. He has arranged with the gunsmith for the manufacture of 'two locks for "fusils" (flintlock guns)'. One lock is to be fitted with a barrel of large calibre which was also ordered, the other to be sent with the pistols. Dahlberg had offered Des Granges 110 livres (another letter states 105) for the gun complete, but Des Granges had wanted 10 louis d'or. They had not agreed: Dahlberg, however, now accepts the gunsmith's price on the ground that his father-in-law insists on having the gun and asks Agriconius to make out the contract. In his next letter, written on 28 September, Dahlberg again expresses his dissatisfaction with the engraving on the pistols and requests Agriconius to impress upon Des Granges the need of greater care with the lock and the gun. He otherwise threatens to have M. Boneau informed that he must not pay so much, or perhaps have the pistols he has ordered for the Gyllenstiernas valued before he pays for them. It is evident from Dahlberg's letter to Agriconius of 18 November of the same year that the price agreed for the locks, fifty livres apiece, was a condition for the Gyllenstiernas' order of two pairs of pistols for which Dahlberg had undertaken to supply a drawing of the family coat of arms.

Agriconius reports in letters of 2 and 12 October 1668, that Des Granges was at work

on the order, of which one lock and the pistols would be finished 'in time for the Colonel's departure'. 'He swears that he has not promised and cannot give the "platines" (locks) for less than 60 livres, that he would otherwise prefer to keep them, although they would be difficult to dispose of on account of the dog-catch holding the cock.' Des Granges is unyielding concerning the price, but Agriconius nevertheless succeeded in signing a contract with him for one of the guns at a price of 110 livres. The letter continues: 'he (Des Granges) is at last willing to assemble the second "platine" here too, claiming that should it be assembled other than in his presence this would neither be done well nor could the engravings be conserved; to which he awaits an answer'. To all appearances Des Granges's sense of money matters was well developed.

Africonius's 'memorandum on the Colonel's affairs contains a note on Dahlberg's pistols and two locks, one of which was Dahlberg's, the other Drakenhielm's. There is also a note in the margin to the effect that the commission has been completed and 'the ouvrage' sent to Sweden by a M. Olivet on 1 April 1669.

The sources do not state whether the gunlock made for Dahlberg was assembled by Des Granges, or what happened to the Gyllenstierna pistols. But there is reason to believe that one pair of the latter and the lock can be identified. This lock is incorporated in the gun ordered by Banér which is now in the Bielke gun armoury at Sturefors. It is No. 40 in the inventory of 1846 (Pl. 66:1)[2]. It was already in this location in 1758[3]. It is above all possible to identify it by the dog-catch ('the hook that holds the cock') a construction which seems to have enjoyed great popularity in Sweden and is to be found both on sporting and military weapons. In Paris it must have been regarded as unnecessary and very much out of fashion in the 1660s. The gun has the Banér coat of arms engraved on the lock-plate. The barrel is signed 'Des Granges à Paris' with his monogram and also the engraved name of the owner Gustaf Swantez Banér'. This is the son of the Lieut. Col. Gustav Carl Banér, b. 1652, d. 1697, who ordered the gun.

The Livrustkammare has a pair of pistols (Nos. 1637, 1638. Pls. 66:2-5, 68:1, 2) on the butt of which is the baronial coat of arms of the Gyllenstierna family of Ulaborg. Charles XI received them as a present from Count Gustav Oxenstierna[4]. They are also signed by Des Granges and made in the same style as the gun at Sturefors. What is more they tally in almost every respect with the description of the pistols in Dahlberg's contract. This agreement as regards master, purchaser and period justifies their identification with the pair of the pistols ordered by M. Boneau.

The picture of Parisian gunmaking of the 1660s can be completed by three guns in the Töjhus Museum, Copenhagen (Nos. N 664. Pl. 69:1, 3, 5. B 667, B 668) signed by 'Thuraine à Paris' and dated 1669. They belonged to Corfitz Trolle, Privy Councillor of State and Assessor of the Department of Administration (which succeeded the Council of State and the Danish Supreme Court of Judicature), b. 1628, d. 1684. His name, together with the date, is engraved on the barrels[5]. The Trolle coat of arms is also reproduced on the thumb-plate of a pair of pistols (Nos. B 655, B 666. Pl. 69:2, 4). These form a garniture with one of the guns (No. B 664). To this dated material we can add a pair of pistols in the Rosenborg Nos. 7–180, 7–184) signed 'Des Granges à Paris'. They belonged to King Frederick III of Denmark and cannot be later than 1670, the year of the king's death. They are probably somewhat earlier.

Some other guns resemble so closely those just mentioned that they can be dated to the same period. Amongst these is a pair of pistols by Des Granges at Sturefors (No. 54 in the inventory of 1846). They were presented in that year by Colonel Count C. N. Kalling. They have, however, been restored and probably shortened. Quite typical and in splendid condition is a pair of pistols by 'Cuny et Lahitte à Paris' in the Brahe-Bielke Armoury, Skokloster (Pl. 67:2, 3, 68:4, 7) and a gun by 'Deverre à Paris' in the Wrangel Armoury (Nos. 116. Pl. 67:1,4, 68:6). Baron Rudolf Cederström pointed out concerning this gun that the mirror monogram in gold made up of the letters 'o w' and

'к' under a Swedish count's coronet on the chamber of the barrel can be interpreted as Otto Wilhelm von Königsmarck. Königsmarck resided in Paris as ambassador from December 1671 to May 1672. The gun, however, is probably some years older.

Our knowledge of Parisian gunmaking of the early 1670s is greatly enlarged by reference to the flintlock firearms preserved in the Livrustkammare. These formed parts of Louis XIV's gift to Charles XI in 1673. It was prepared during the spring and early summer of that year, despatched from Paris in June, presented to the King at the Palace of Stockholm on 12 December: the gift comprised twelve richly caparisoned horses and weapons[6].

The following guns in the Livrustkammare can be traced back to 1686. They were entered in the inventory by Zacharias Renberg, Chief Comptroller of 'His Royal Majesty's Little Armoury'[7]. The list begins with 'The King of France's Presents': Wender, the lock-plate signed 'Le Conte à Paris', the stock 'Berain fecit' (Inv. No. 3888. Pls. 59, 60, cf. p. 87), gun by 'Piraube au gallerie (*sic*.) à Paris (Inv. No. 1337. Pl. 71), gun by 'Alexandre Masson à Paris' (Inv. No. 1338), gun by same master (Inv. No. 1339. Pl. 70:2), revolver gun by same master (Inv. No. 1345)[8].

There is evidence in the same inventory to show that the following pistols belonged to saddles which were part of the gift: a pair by 'Piraube aux galerie (*sic*.) à Paris. (Inv. Nos. 1626 and 29/11. Pl. 73:1, 74:8). They probably form a set with gun No. 1337, a pair by 'Le Couvreux à Paris' (Inv. Nos. 1627, 1628), a pair by 'Foulois le jeune à Paris' (Inv. Nos. 1631, 1632. Pl. 72), a pistol by 'Alexandre Masson à Paris (Inv. No. 1701. Pl. 73:2) and a pair by 'Champion à Paris' (Inv. Nos. 3886, 3887. Pl. 73:3, 74:1, 2) and a pair by 'Des Granges à Paris' (Inv. Nos. 1699, 1700)[9].

Of these pistols the last mentioned are breech-loaders with turn-off barrels. The pistols by Alexandre Masson have over and under barrels with their characteristic lock construction (cf. Pl. 119:2).

There was a definite reason for making a gift of firearms that were not absolutely new

and that was the shortness of time. The Marquis Isaac Pas de Feuquières, the French envoy, arrived at Stockholm at the New Year with the task of studying the young king's interests. He soon became convinced that riding and hunting were among these and sent home reports to that effect. But the consignment was already on its way in July. This must have called for work at top pressure. It is not therefore surprising if some weapons that were not exactly new were included. The magnificent Wender by Le Conte and Berain is one of the earlier weapons. The most advanced ones are the pistols by Le Couvreux and Champion, both the guns by Alexandre Masson, as well as the gun and pistols by Piraube.

It is a matter of great satisfaction to be able to include the works of Louis XIV's most famous gunsmith among these characteristic arms. Bertrand Piraube was granted a 'brevet de logement' (the eighth) in the Louvre, on 25 January 1670, and confirmation of this in March 1671. He succeeded Gravet, the goldsmith. Germain Brice speaks of him in his book on Paris as a gunsmith in whose work rare beauty was to be found[10]. In 1725 the eighth 'logement' in the Louvre had a new occupant[11]. Boeheim has devoted a monograph to Piraube in *Meister der Waffenschmiedekunst*[12], and we shall often encounter his name as we continue our present study. Weapons signed 'Piraube aux galleries à Paris' are to be found in most armouries and collections of ancient arms. They are of inestimable value for acquiring a knowledge of the very best in French gunmaking in the time of Louis XIV. A large number are dated.

The remaining firearms in Louis XIV's gift occupy an intermediate position between the arms of 1668–69 and the most modern of the year 1673. This applies to a pair of pistols and two guns by De Foullois le jeune, that is, the revolver gun just mentioned and the breechloader. An ordinary flintlock gun by the same master was the late 'lamented Colonel Borstell's' gift to Charles XI (Inv. No. 1336. Pl. 70:1)[13] which we include in our typological material. An analysis of it gives the following information.

When Erik Dahlberg signed the contract with Des Granges for a pair of pistols in 1668, it was especially required that the barrels were to be fluted (cf. Pl. 66:3). These flutings were then a novelty. The firearms of the immediately preceding period in the late Thuraine and Le Hollandois style have a round section separated by moulded rings in front of the eight and sixteen sided chamber. The sixteen sided section was furnished with longitudinal grooves during the latter half of the 1660s. The round part in front of the sixteen sided section was retained. The gun at Sturefors has not reached this stage although it is contemporary with the pistols. The evolution continues towards a still greater differentiation in higher quality arms. Piraube's gun of 1673 is an example of this (Pl. 71:3). But there is not always conformity and the chambers vary very much in length. The back-sights remain simple. Their wings become proportionately narrower while the bottom of the sight-groove tapers off into finials at back and front, finishing in the same way as the ends of the trigger-guards. 'The belt' might be widened or elaborately decorated (cf. Pl. 67:4 and 71:3, 5). The fore-sights are formed like a hog's back.

In the contract just mentioned the convexity of the lock is emphasized as being modern. The consistently convex forms, 'rondez à la mode' are distinctive features of the classical style. We have made their acquaintance earlier, first to the north of Paris, occurring consistently on ivory stocked pistols and their 'family relations', then cautiously and incompletely within the Thuraine and Le Hollandois group. On French firearms all lock-plates are rounded in smooth curves from the middle of the 1660s. The 1668 gun at Sturefors and the Deverre gun still have broad plates behind the cock, but the tip has been lengthened—a tendency which continued in the firearms of 1673 so that the entire plate tapers off backwards. It is also slightly more curved, thus giving the lock greater elegance.

With the convex forms of the late 1660s went simplified locks with either embryonic volutes or none at all and a clumsy, swollen base to the cock. By 1673 the forms became

more slender and serpentine, while the heads of the jaw screws were rounded off at the top. The cock was attached by a screw from outside. The former had previously been attached sometimes from without, sometimes from within. Where during the immediately preceding period a cock-screw was fitted, it had a large slightly convex head and foliage ornament in low relief as well as two cross grooves at right angles. With the convex lock-plate the cock-screws acquired small conical heads and a single groove. Those of the classical style follow the same rule. They, as well as the heads of the jaw-screws, the upper jaw of the cock, the steel spring and the barrel were often blued in the clear, medium tone which was formerly called 'couleur d'eau' and against which gold especially, but also bright steel, produced a striking effect. Ramrod-pipes with much more pronounced profiles accompanied these high screw-heads. The spur of the steel ended in a scroll again and was formed as a drop with an elongated point turned upwards. The steels were tongue shaped, broad and blunt at the top. The spring-finial had no longer the lobate form and was flat and turned. The same applies to the ends of the trigger-guards. The front end of these still sometimes had a pierced leaf ornament, as on the pistols by Cuny et Lahitte at Skokloster.

Certain of the arms in the Thuraine and Le Hollandois group have triggers with a pierced plate and the point scrolled backwards. The plate was still pierced in 1668 but was smaller in size. In 1673 it was smaller still and had no piercing. All triggers throughout the entire classical period have their points turned up backwards.

The side-plates provide useful evidence for dating. During the preceding period they were simply a connecting link between the side-nails, generally slightly curved and with a distinct centre. We have noticed that some ivory-stocked pistols which must be dated in the late 1660s have flat, pierced and engraved side-plates let into the stock (Pl. 52:6). The two flintlocks by Jan Knoop of Utrecht (Töjhus Museum, Copenhagen, Nos. B 602, B 603. Pl. 62:2,3) also have side-plates made on

the same principle, even if one is provided with a thin frame.

Flat, pierced and engraved side-plates inset in the stock are typical of the late 1660s in France. They are to be found on the 1668 pistols in the Livrustkammare, on those by Thuraine in the Töjhus Museum (Nos. B 665, B 666), on the pistols by Cuny and Lahitte at Skokloster and in particularly elegant work-manship on the gun by Deverre (Pl. 68:6, 7). There are, too, examples without a side-plate: in this case, the surface of the left side of the stock corresponding to the lock was decorated with elaborate inlay as suggested on Berain's engravings. This is done on Nicolas Nicolay's gun by Le Couvreux in the Musée de l'Armée in Paris (Pl. 58:6). The pistols in the Livrust-kammare (Inv. Nos. 1631, 1632) by 'Foullois le jeune' are so decorated (Pl. 72). On the Des Granges pistols of King Frederick III of Denmark (Rosenborg 7–180, 7–184), a plaque covering the lock-screws decorated with scenes of horsemen is set in the stock at this point.

The contract quoted previously states that the side-plates shall be made in the form of a serpent with volutes in relief. This is early evidence of a type which is more fully repre-sented on the guns in the royal gift. Typologic-ally this kind of side-plate begins with a slightly curved and reversed 's' shaped connecting link in relief between the lock-screws. A gun by 'Boular à Angers' in the Livrustkammare (Inv. No. 5329. Pl. 74:3) provides an example of this. Louis XIV's gun, mentioned previously, by De Foullois le jeune in the Pauilhac Collection (Pl. 61:6), which is earlier, has moved further and added sprays of leaves and grotesque scrolls in low relief. This combination is also shown on the gun by Des Granges at Sturefors (Pl. 74:4). The gun by 'Boular à Angers' just mentioned shows how this type of side-plate originated through the ornament set in the stock being transformed into a part of the side-plate. Amongst the firearms of 1673 we find several examples of the high, 's' shaped 'bridge' having developed into a serpent coiling over the entire length. At times it is surrounded by ornament in low relief, at times branches off into a number of flourishes of approximately

the same height (Pl. 74:5). The guns by Alexandre Masson afford examples of still another type of side-plate (Pl. 74:6, 7) that became usual during the following decades alongside those with the coiling serpent. They are arranged around a cartouche or a central feature. This latter lies, as a rule, under the rear lock-screw. Otherwise they consist of grotesque scrolls; these are always executed in relief and repeated on the flat, engraved side-plates which are set in the stock. They con-stitute yet another illustration of the transition from flat forms to convex.

The designing of the thumb-plate proceeds parallel with the evolution of the side-plates. It first appears as an ornament on the upper side of the butt during the preceding period and continues on arms of the 1660s belonging to the classical style. The pistols by Cuny and Lahitte have in this position an engraved silver plate in the form of a grotesque figure sur-rounded by scrolls (Pl. 67:3). On the Des Granges pistols in the Livrustkammare the Gyllenstierna coat of arms is inlaid in the small of the butt (Pl. 66:4) in the same way, but without the surrounding decoration, as Frederick IV's cypher on the ivory stocked pistols by De la Pierre of Maastricht at Rosen-borg (Pl. 53:2). A simple thumb-piece is also present on the afore-mentioned gun (p. 80) by 'Les Thuraine à Paris' and Corfitz Trolle's gun of 1669 (Pl. 69:3) in the Töjhus Museum. The resemblance to the flat, pierced side-plates let into the stock is manifest here. The pistols forming a garniture with this gun have, how-ever, thumb-plates with convex centres en-graved with the Trolle coat of arms and sur-rounded by relief scrolls. Above and below, however, the scrolls are inset (Pl. 69:4). These thumb-plates constitute a transition to the relief cartouches of the firearms in the royal gift which are engraved with coats of arms or a cypher or crowned coats of arms with sup-porting lions, the latter chiselled in relief (cf. Pl. 71:6).

Another feature that coincides in an interest-ing manner with the fashion for flat engraved side-plates inset in the stock, is the engraved barrel signature in the form of a monogram

(cf. Pl. 134:13). Des Granges's signature is found on the Sturefors gun, Thuraine's on the gun of 1669 in the Töjhus Museum, and on the one by 'Les Thuraines'¹⁴. In the Livrustkammare the breech-loading gun by De Foullois le jeune in the. royal gift (Inv. No. 1345) bears a monogram, there is also a gun with the crowned cypher of the Queen Dowager Hedvig Eleonora on the thumb-plate and the signature 'P D' on the barrel (Inv. No. 1546)¹⁵. This gun and the Deverre gun at Skokloster are strikingly alike. Could they have been made by the same master?*

The gun butts, like cocks and lock-plates were very sensitive to development and fashion. The wood during the classical period was as a rule, walnut. In the 1660s there was a change over on fine quality arms to walnut root ('bois noyer bien marbre et beau de Grenoble' well figured and beautiful from Grenoble—Dahlberg's contract with Des Granges). The butts of the Thuraine and Le Hollandois style are broad and triangular. On pieces dating from the transition to the classical style, such as Louis XIV's gun by De Foullois le jeune in the Pauilhac collection (Pl. 61:6), the butt was considerably narrower when seen from the side, and the heel distinctly rounded. The gun at Sturefors by Des Granges is more old fashioned with its triangular form and its very short neck. It was probably made in Sweden, but all the other guns hitherto mentioned up to the end of 1673 have the same kind of butts as the Pauilhac gun, very low with a low comb and a neck which reaches approximately to the middle of the butt. There seems to have been an effort to attain the same balance in the guns even after the butts had become thicker. This eliminates the earlier parallel treatment between the sides. Instead of the three butt-plate screws on earlier pieces there are now only two (cf. Pl. 69:5). The tang of the butt-plate has at the same time been elongated until, as early as the late 1660s, it extends along the greater part of the comb. The tails of the pistol butt-caps correspond with this long tang and reach right up to the lock. These butt-caps embrace pommels which widen laterally (cf. Pl. 68:2, 3). Their bosses are

low, profiled ovals (Pl. 68:2) as on the Gyllenstierna pistols in the Livrustkammare. On the pistols of 1669 in the Töjhus Museum they have high, turned bosses (Pl. 68:5). This last type also figures in the royal gift together with lion masks or grotesque masks in relief. These bosses or masks are surrounded by a decorated cartouche.

The carved ornament of the stocks is reduced in the Thuraine and Le Hollandois group to a leaf in the angle on the left side of the breech and an 's' shaped scroll on each side of the rear ramrod-pipe. There is sometimes also a scroll with a curved edge round the barrel tang. The leaf has disappeared by the close of the 1660s and the 's' shaped scroll at the rear ramrod-pipe has become a winding groove with raised edges ending in a volute (cf. Pls. 66, 67). This groove is no longer on the Piraube gun or on the Masson guns of 1673 in the Livrustkammare. The raised edges remain, but of more complicated form. Similar ornament has been added on both sides of the barrel-tang (cf. Pl. 71:4, 5).

These observations on the evolution of the earlier arms in the classical group of the Louis XIV period confirm that the Deverre gun and the Cuny and Lahitte pistols (Pl. 67) can be included amongst the firearms of the late 1660s. Hedvig Eleonora's gun in the Livrustkammare (Inv. No. 1546) which has been mentioned in passing, also belongs here. It is perhaps the oldest of all. An archaic detail such as the nipple-like fore-sight suggests this. The gun by Les Thuraines in the Töjhus Museum (Inv. No. B 955) closely resembles those now mentioned, as also all three guns and the pistols by De Foullois le jeune in the Livrustkammare.

Some other flintlock weapons with the Swedish coat of arms of the Palatine period or with Charles XI's monogram can be dated from the period of the royal gift. There is a pair of pistols in the Livrustkammare signed 'Cuny à Paris' (Inv. Nos. 1649, 1650) which may be dated in this manner. The Löwenburg at Cassel possesses a gun by Piraube of Paris (Inv. No. W 1292) with practically the same coat of arms on the butt-plate as the gun in the

Livrustkammare; it is exactly the same in style though richer. The Töjhus Museum, Copenhagen, has a gun by Le Couvreux (Inv. No. B 970)[16], which so closely resembles the pistols of the Livrustkammare by the same master that one can assume it forms a garniture with them. Finally, there is a pair of pistols by 'Gautier à Paris' (Inv. Nos. B 980, B 981) in the Töjhus Museum. Considering the close connections that prevailed between Paris and Stockholm and knowing that French arms were in demand we cannot be certain that there were part of Louis XIV's gift, but it is very probable.

A gun of approximately 1670 signed 'Martin à Angers' (Inv. No. 19/6) is preserved in the Livrustkammare. It has an interesting new feature in its construction; the bridle on the pan (Pl. 74:9), otherwise best known from the French musket M/1728[17] and other later military models as well as firearms for civilian use.

Some barrel makers' marks can be dated from the examples cited here[18]. We do not know where these people worked; it was probably in Paris.

Some details on the firearms of Louis XIV's gift introduce or forecast coming developments. These include the butt-heel hinted at on the Piraube gun in the Löwenburg and emphasized by Le Couvreux on his gun in the Töjhus Museum, the steel with a distinct point on the pistols by Gautier in the same museum and, furthermore, a medial sighting rib running along the barrel with which the pistols by Champion in the Livrustkammare are fitted (cf. Pl. 74:1). The design of the very short eight sided chamber on gun No. 1338 by Alexandre Masson in the Livrustkammare, on the other hand, probably has no connection with the main line of development.

The next year in respect of which such extensive material is available is 1685. This year can be read on the title page of the first edition of Simonin's engraved pattern book based on firearms by Laurent Le Languedoc (Pls. 119, 120). In the interval between the presentation of the gift and the year 1685 we can insert some dated guns and pistols—and four further pairs of similar but undated pistols.

One of these pairs, two magnificent pistols in the Livrustkammare (Inv. Nos. 4072, 4073. Pl. 75:1, 2) transferred from the royal stables in 1851, are signed 'Piraube aux galleries à Paris'[19]. (Piraube continues to use the form 'galleries' instead of 'gallerie' as on the weapons of 1673.) The barrels are of silver gilt with diamond foresights, the locks lavishly decorated with engraving and scrolls in relief; the butt-caps likewise and the stocks richly inlaid in silver and carved with sprays of foliage and a grotesque mask. Lock, side and thumb-plates and butt-caps are of silver gilt. Identical mounts are to be found on a pair of pistols in the Musée de l'Armée in Paris (Inv. No. M 1725) by another master 'Jean Reyniers à Paris'[20]. In other respects these two pairs of pistols have most of their decoration in common, the division of the barrels into eight, sixteen sided and round chambers followed by the round section of the part of the barrel with sighting rib along the top. The cocks are more curvacious than ever and have the jaw-screw heads rounded off still more, pointed and tapering rear ends of the lock-plates, and in keeping with this, tapering steels with rounded edges. Finally we find a partiality for decoration in relief and for movement.

Both these pairs of pistols should be dated from between 1673 and 1680. Between them and Simonin's pattern album comes a pair of pistols by 'Frappier à Paris' in the Livrustkammare (Inv. No. 5689, 5690). They belonged to Count C. G. Oxenstierna of Södermöre (1656-87)[21]. Then there is another pair in the same institution (Inv. No. 12/24) which belonged to Charles XI and is signed 'Frappier et Monlong à Paris' (Pl. 75:3, 4)[22].

The forms shown in Simonin's collections of engravings are very closely associated with the firearms of the 1670s, but the details are more delicate and rhythmic. This later variant in style evolved from the previous one, certain details being eliminated and new ones added, while minor changes were made in those retained.

The slenderness and elegance that distinguish the designs on Simonin's pattern plates are also to be found on the weapons of the same

Plate 87.

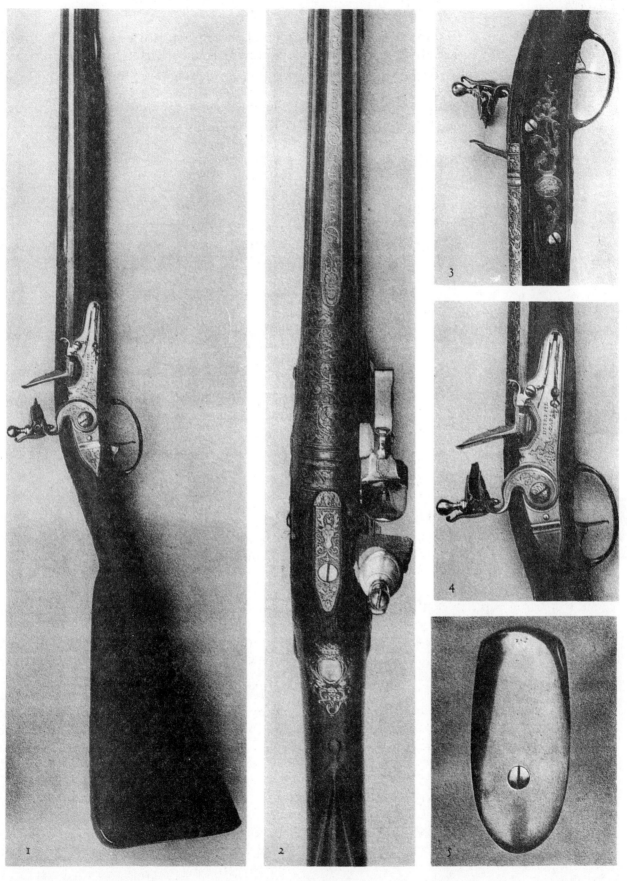

France, Paris.
Beginning of eighteenth
century.

Gun by Dutrevil of Paris; Dresden, Gewehrgalerie 730.

Plate 88.

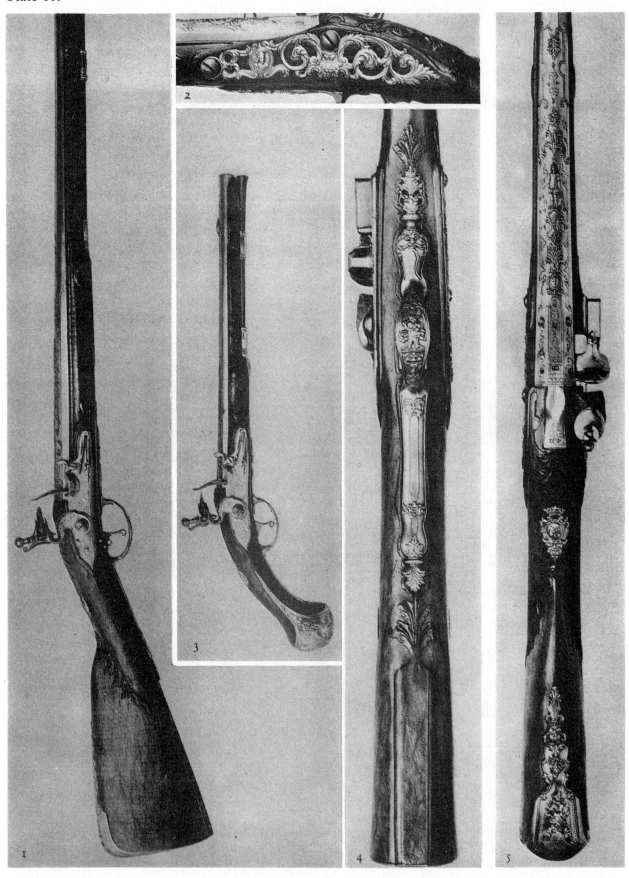

France (?)
c. 1700.

Garniture of gun and pistol, one of a pair, by Daniel
Thiermay; Copenhagen, Töjhusmuseet B 1233–4.

Plate 89.

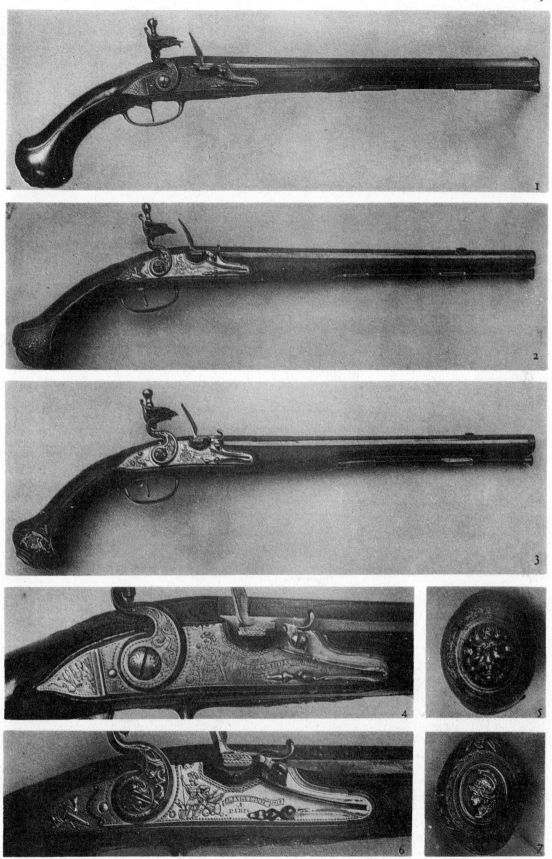

France, Paris.
1716, 1718 and *c*. 1720.

Pistols, each one of a pair. 1, 4 and 5. By Le Hollandois of
Paris 1716. Liége, Musée d'Armes 5116. 2 and 6. By Lang-
uedoc of Paris 1718; Dresden, Gewehrgalerie 746. 3 and 7.
By De Crens of Paris; Dresden, Gewehrgalerie 744.

Plate 90.

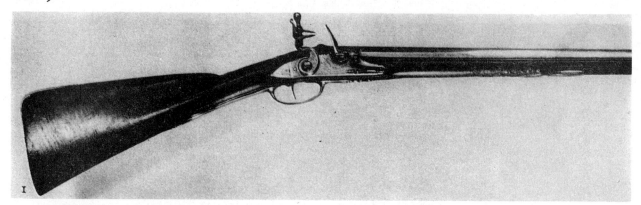

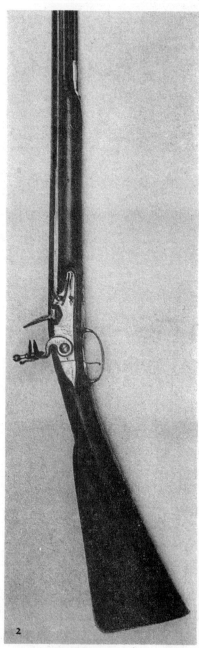

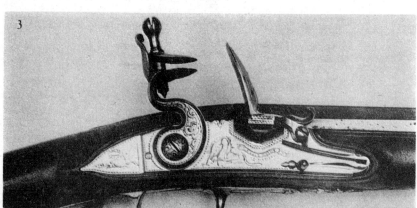

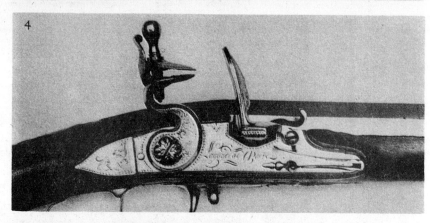

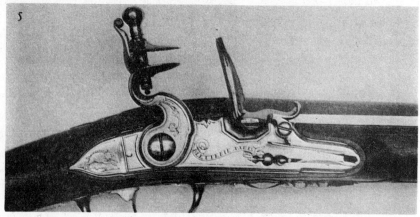

France, Paris.
1716 and 1720s.

1. Gun by 'Languedoc à Paris 1716'; Kranichstein, Darm-
stadt, Jagdmuseum 238. 2 and 3. Gun by same master 1722.
4. Lock of gun by Languedoc of Paris. 5. Lock of gun by
Bletterie of Paris. 2–5; Dresden, Gewehrgalerie 1276, 1289,
1308.

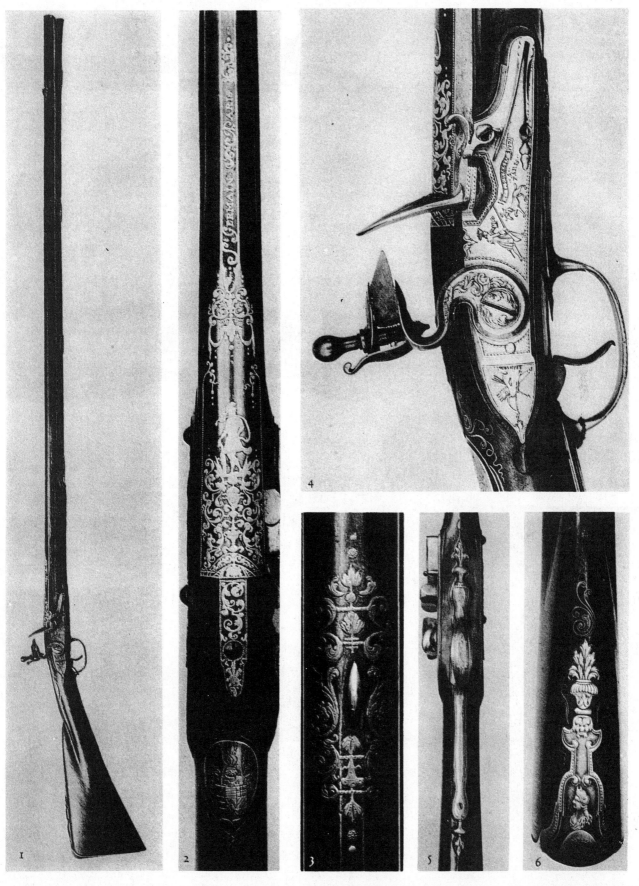

Plate 91.

France, Paris.
1721.

Gun by St. Germain of Paris 1721. From the Armoury of
the Grand Dukes of Saxony in Schloss Ettersburg.

Plate 92.

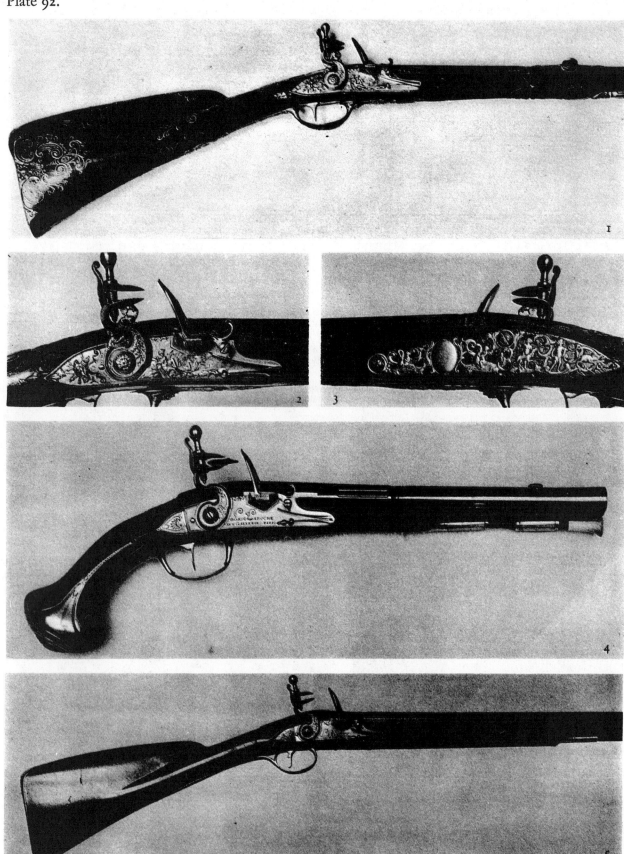

France, Paris.
Middle of eighteenth
century.

Firearms by 'Les La Roche aux galleries du Louvre à
Paris'. 1–3; Brussels Musée de la Porte de Hal 2653. 4;
Dresden, Gewehrgalerie 737 A. 5; Windsor Castle 262.

Plate 93.

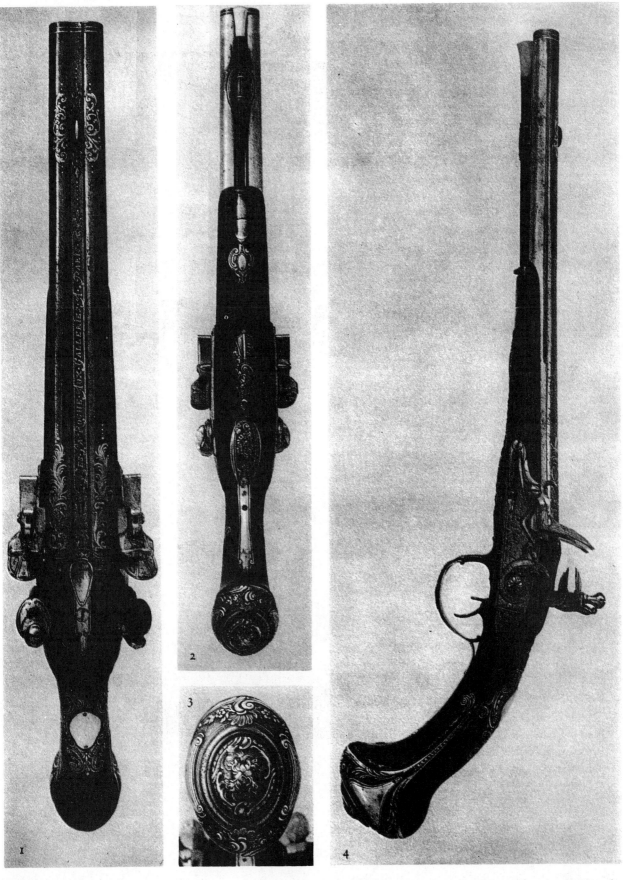

France, Paris.
Middle of eighteenth
century.

Double barrelled pistol by 'Les La Roche aux galleries du
Louvre à Paris'; Lofstad, Sweden.

Plate 94.

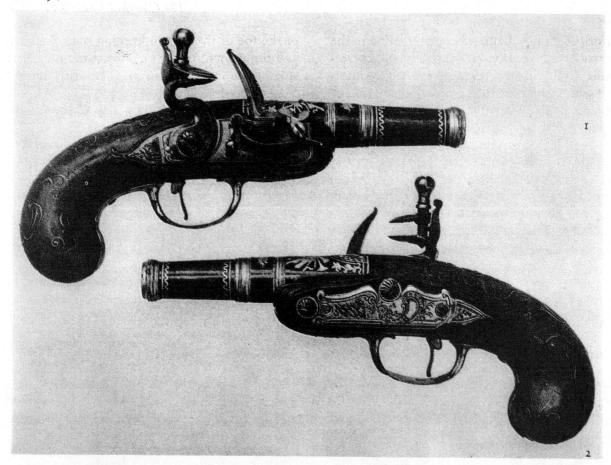

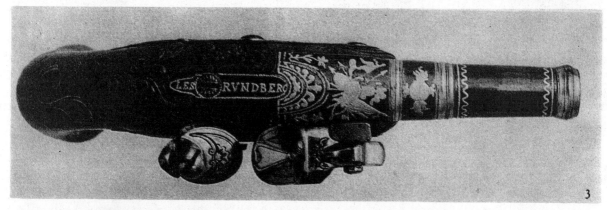

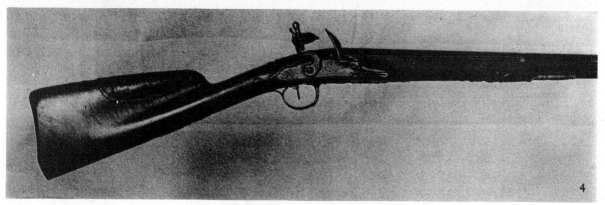

France, Paris.
c. 1750 and *c.* 1770.

1–3. Pistols, pair, by 'Les Rundberg, Svedois, à Paris (the brothers Gustav and Peter Rundberg from Jönköping); Stockholm, Livrustkammaren 5257, 5259. 4. Gun by 'Croizier à Paris Cour Neuve du Palais'.

period. A gun by Laurent Le Languedoc in the Livrustkammare (Inv. No. 30/10. Pl. 78) corresponds in so many respects with Simonin's engravings, even as to the identity of some of the ornament, that one may state that the engraver had such a weapon as his prototype. Le Languedoc undoubtedly made more elegant weapons than this gun. It is rather coarse but it provides a very interesting comparison with the engravings. Certain details of ornament in the latter, which would otherwise have been difficult to understand, are explained by this gun.

First the barrel is round with the longitudinal sighting rib between the back-sight and fore-sight and flat on the sides of the chamber. The latter is ornamented in low relief. The same treatment is to be found on Simonin's pattern sheet '6' (Pl. 120:1). The lock is similar to those on both the last mentioned pairs of pistols, but more slender. The plate is narrower and the curve of its lower edge longer and more pronounced. A raised edge just begins to appear on lock-plates at the beginning of the 1670s. This becomes more and more marked. In the middle of the 1680s it is omitted at the fore end of the lock-plate. Instead the front edges are bevelled. This is characteristic of the great majority of flintlocks from the mid 1680s onwards. The tip of the steel is decidedly bent forward and develops a small lump on the front. Lock-plate, cock and steel are chiselled in low relief, and a lobate leaf is substituted for the turned spring-finial which was so distinctive of the immediately preceding period. Lobate leaves also appear on the fore ends of the trigger-guards and on the fore-sights. Manifest evidence of the urge for movement is the design of the tang of the butt-plate. It has become a coiling serpent angrily biting a boldly profiled ornament (cf. Pl. 78:6). This is a consistent feature. It is forecast on the gun by Le Couvreux in the Töjhus Museum just mentioned and is consistently used from the 1680s onwards until the serpent disappears in the next period and the ornament is designed otherwise.

Another new feature is the duplication of the butt-heel, or more correctly the redesigning of the toe of the butt in keeping with the heel, and the growth of a short broad tail on either side of the butt. The Livrustkammare gun by Le Languedoc is an example (Pl. 78:5). An identical design is shown on sheet '5' of Simonin's pattern album (Pl. 119:2). The identity extends to the low relief ornament surrounding the tails that are inlaid in the stock. New too, is the acanthus ornament, also in low relief, which decorates both sides of the stock, between the rear ramrod-pipe and the lock, and the side-plate respectively. It can be interpreted as the translation into metal of an ornament formerly carved in wood. It has its equivalent on number '8' of the pattern sheets. The same ornaments around and behind the rear ramrod-pipe and on both sides of the barral tang can also be seen. These, however, might just as well or, perhaps preferably, be carved in the wood.

The Livrustkammare gun by Languedoc has a side-plate (Pl. 78:3) designed as a crowned escutcheon (Palatinate) with two supporters. These develop into elegant scrolls ending in dragon's heads. This type also occurs on the pattern sheets in the same delicate form. But the serpent coiling the entire length of the side-plate, or the 'bridge' with thin spreading spirals and grotesques were the more popular forms. In comparison with the pattern of 1670s however, this design (Pl. 78:3) is delicate and graceful.

The thumb-plates developed in the same way as the side-plates. The profile of the ramrod-pipes has become still further pronounced even to the point of clumsiness, a form they retain as long as the convex forms survive.

It should finally be mentioned that the butt, seen from the side, is of arched form: this became more and more common. Seen from above it has a bulging form. This is usual but was not invariably so (cf. Pl. 78:5, 6).

In addition to another album by the same Claude Simonin and his son Jacques for the year 1693, invaluable documents for illustrating the evolution of the classical style are available in a number of dated weapons by Bertrand Piraube.

The series includes the following weapons:

Louis XIV's gun 1679, Pauilhac collection (Paris); pistols 1681, Musée d'Armes (Liège), Nos. 1367, 1368[22]; Louis XIV's *de luxe* gun 1682 (Pl. 76), Windsor Castle, No. 425[23]; pistols 1685 (Pl. 134:19), the Brahe-Bielke Armoury at Skokloster; pistols 1685, the Hallwyl Museum, Stockholm, No. A 11[24]; pistols 1688 (Pl. 80:1, 2, 6), the Töjhus Museum, Copenhagen, Nos. B 982, B 983[25]; gun 1689, the Jagd Museum in Kranichstein at Darmstadt, No. 295[26]; pistols 1690 (Pl. 80:3, 7), Windsor Castle, Nos. 495, 496[27]; gun 1693, the Jagd Museum in Kranichstein, No. 236[26]; pistol 1694 (Pl. 80:4, 5, 8), Gewehrgalerie (Dresden), No. 736; pistol 1694, the Metropolitan Museum of Art, Nos. 32, 75, 133[28]; pistols 1715, the Louvre, Paris, Nos. 7534, 7535.

The locks of all these weapons are convex in form. In this series by one master the transition from the 1670 forms comes with the two pairs of pistols of 1685. The barrels on the firearms of 1679–82 have chambers divided into an eight, a sixteen and thirty-two sided portion and also a round sector bordered by rings (cf. Pl. 71:1,3) followed by the remaining length of the barrel. This round part of the chamber has in the case of the pistols of 1681 a flat along the top, which is interrupted by the ring bordering the main length of the barrel, and continues along it. From 1685 the barrels are round with a longitudinal sighting rib and flattened sides to the chamber.

The only barrel in Simonin's album of 1685 is also divided up in this manner. On the pattern sheets of 1693 there are examples of this, of an eight, sixteen sided and round chamber, as well as an entirely round one. It is extremely doubtful if this last type was manufactured in the central French area.

In both the albums the jaw-screw heads are drop shaped, rather clumsy and often somewhat conical. The type is also characteristic of the Piraube firearms of 1685. The jaw-screw heads of the earlier weapons are flatter at the top.

The gun of 1679 and 1682 still have a straight butt-plate tang, the pattern sheets of 1685 and 1693 consistently coiling serpents. The pommels of the pistols become clumsier in the 1680s.

The side-plates are not consistent, but it can be established, from surviving weapons and engravings, that side-plates with delicate sparse ornament are typical of French flintlock arms, with convex locks, of the last two decades of the seventeenth century.

If the dated Piraube material now presented were homogeneous it would be possible to draw several conclusions from it. This, however, is not the case. The gun of 1679 is a good utility weapon of outstanding and elegant workmanship but lacking luxury features. This is also the case with the pistols of 1681 in Liège. The Louis XIV gun of 1682 in Windsor, on the other hand, is a most magnificent weapon with elaborate chiselled decoration on barrel, lock and mounts as well as profuse silver inlays on the stock. This induced Gottfried Semper to mention this gun above all others as an example of good decoration of weapons[30]. The two pairs of pistols of 1685 at Skokloster and in the Hallwyl Museum are ordinary weapons of a good standard. So too are the Töjhus Museum pistols of 1688, whereas the pistols of 1690 in Windsor rise to the highest luxury class. The pistols of 1694 in the Gewehrgalerie, Dresden, are lavishly decorated, and the pistols of 1715 in the Louvre again are very richly embellished.

These last mentioned pistols can primarily be regarded as an example of isolated manufacture in a style which no longer corresponded to current fashion†.

Now that the main outlines of evolution have been made clear by this dated series of a single master we can compare undated arms by other gunsmiths. Among the many possibilities for the 1680s there are two *de luxe* guns by Gruché of Paris. One is in the Bavarian National Museum (Inv. No. 13/588. Pl. 77:1)[31], the other in the Kusthistorisches Museum, Vienna (Waffensammlung No. A 1674. Pl. 77:2)[32], also a garniture of a gun and a pair of pistols signed by Chasteau of Paris in the Töjhus Museum, Copenhagen (Inv. Nos. B 960–62. Pl. 79)[33], and still another gun by the same master in Kunsthistorisches Museum, Vienna (Waffensammlung No. A 1759)[34]. A gun by 'Le Hollandois à Paris' with signed

barrel and lock in the Musée de l'Armée of Paris (Inv. No. M 601. Detail, Pl. 81–6)[35], dated from the 1690s. A very elegant gun in the Gewehrgalerie, Dresden (Inv. No. 735. Pl. 81:1–5)[36], with the lock signed 'A Paris par le Languedoc' dates from about 1700. From approximately the same period a pair of very beautiful pistols by Piraube in the same Gewehrgalerie (No. 739) can be dated. They are precursors of the pistols of 1715 and still testify to the master's unimpaired power.

We can now summarize the ideas which we have thus acquired of French flintlock weapons from the 1660s to about 1700.

Three stages can be distinguished. The boundary line between the first and the second stage lies not later than at 1673. That between the second and the third is established by Simonin's first pattern album of 1685. The convex forms of the locks dominate entirely in the first stage. These arms are comparatively slender. From then onwards they become increasingly clumsy, reaching a peak in the 1680s and then becoming less so at the turn of the century. About the close of the 1660s the rear part of the lock-plate is still broad and terminates in a projecting, blunt finial. The steel has a fairly blunt contour truncated and rounded at the top. A raised edge is added on the lock-plates at the beginning of the 1670s. It is omitted at the front end of the plate in the mid 1680s. In 1685 the uppermost point of the steel is pressed forward forming a small lump on the plate. The heads of the cock-screws are small and tall as long as the lock-face is convex. The jaw-screw heads first acquire the contour of a more or less outward-curved cone: then about 1685 they again become more conical and inversely drop shaped. The minor chiselled details—the volutes of the cocks, the shaped profile and the lobate leaves of the steel springs and the correspondingly complex treatment of the trigger-guards—are superseded towards about 1670 by simple forms. Thus simpler and earlier forms were preferred to more elaborate ones which were more difficult to manufacture. Lobate leaves reappear on steel-springs and on the ends of the trigger-guards in the 1680s.

Tangs attain their full length on butt-plates and butt-caps already by the close of the 1660s. In the 1670s these tangs on the guns are straight. In 1685 they have become spirals, usually in the form of serpents. From the end of the 1660s the butt-plates of the guns are attached by two screws instead of three. A coiling serpent or dragon designed in high relief is often the main element in the side-plates. They usually point towards the hindmost lock-screw. During the 1660s the side-plates are flat and inset flush with the stock. In 1673 they were raised in relief. In the 1670s the elements of the side-plates are rather coarse. In the 1680s and 1690s the forms are delicate and wide apart. The profiles of the ramrod-pipes become more pronounced and clumsy during the 1660s and 1670s. This clumsiness prevails while the locks are convex. There is always a rear ramrod-pipe. The thumb-plate will first be found in the form of an engraved ornament or a plaque with engraved coat of arms inlaid in the stock. The evolution of the thumb-plate keeps pace with that of the side-plate. Thus in 1673 we have thumb-plates in relief and in 1685 thumb-plates with the same delicate ornament as the side-plates.

The butts of the guns become long, narrow and triangular with a distinctly rounded heel and neck as early as the close of the 1660s. Walnut root is used as a rule for stocks of fine quality weapons. A concave 'impact side', an 'arch', appears already in the 1670s. This becomes more common during the two final decades of the century. A straighter butt-end also occurs though always with a distinctly rounded heel. Seen from behind the butts have been widened considerably, especially at the foot, in comparison with those of the earlier 1660s. In the 1680s the butts look stuffed or inflated. Towards the end of the century the butt, when seen from behind, becomes approximately oval in form with a tendency to taper off into a point at the toe.

Of the carved decoration of the stocks that at the rear ramrod-pipe attracts attention. At the end of the 1660s it is an 's' shaped groove with raised edges, open in front and proceeding backwards from the ramrod-pipe. In 1673 the groove has disappeared but the edges remain embellished with volutes. The ornament is

subsequently split up more and more and embellished with foliage as are the trigger-guards and steel springs. These ornaments are usually executed in metal. On very richly embellished arms silver inlay is sometimes substituted.

During the last quarter of the seventeenth century the French style sets its stamp entirely on flintlock manufacture in Europe. It is actually during this period that this manufacture spreads on a large scale both in the production of sporting guns and for military purposes. Boeheim considered that the craftsmen and artists who sought a livelihood abroad after the revocation of the Edict of Nantes in 1685 constituted an important factor in spreading the manufacture of the flintlock[37]. This statement should perhaps be checked. The problem requires further research[38].

We have seen how the Netherlands were a centre of flintlock manufacture in the middle of the seventeenth century, to such an extent that it is difficult to decide whether certain features should be regarded as French or Netherlandish, and that France in many instances was inspired by, and borrowed from, her northern neighbour[39]. Two decades later the roles were exchanged; this was a natural sequel to Louis XIV's victories and, among other events, the destruction of Maastricht. Thereafter the French style had the monopoly in Dutch gunmaking. In 1692 De la Feuille and Pieter Schenck published pattern albums with plates engraved after Simonin's original illustrations of 1685 but with new title pages (Pl. 122:1). It can be established, however, that French predominance had set in even earlier. Information on gunmaking fashion in Amsterdam in the 1680s can be acquired from the arms made by the Pomeranian Pieter Starbus[40] who had moved up to Stockholm. The most elaborately embellished of these is a set of a gun and a pair of pistols in the Copenhagen Töjhus Museum (Inv. Nos. 934-36. Pl. 82:1, 2) signed on barrel, lock, stock and mounts[41]. This shows that its master wished to demonstrate his talent in all branches of gunmaking. Ordinarily a craftsman takes pains to do so on one occasion only—when he is making

his masterpiece. In this case a desire to show his skill to the Swedish authorities and primarily to the king, with whom decision as to his future rested, may have been his motive. The presence of this garniture particularly in Copenhagen, the capital of the country of Charles XI's father-in-law and brother-in-law, supports the supposition that it is the 'fusil and pair of pistols of his workmanship'[42] that the Swedish envoy at the Hague brought home in 1684. Comparing the set with Louis XIV's *de luxe* gun by Piraube in Windsor Castle (Pl. 76) I consider that it might very well date from 1684. It has a great deal in common with Simonin's engravings, but still more with the Windsor gun. The lock of the gun bears the signature 'Fecit Piere Stahrbus' without, that is, indicating that the master lived in Amsterdam, where his oldest child was christened in 1678. The French form of his christian name is appropriate on the weapon.

There is another gun signed 'Starbus à Amsterdam' in the Löwenburg at Cassel (Inv. No. W 1298), where it may have been received with the articles inherited from King Frederick I of Sweden. It resembles the gun in Copenhagen but is simpler. In certain details, such as the plain engraved lock-plate, it is somewhat more old fashioned. The gun which Starbus presented as a gift to Charles XI after his arrival in Stockholm is now preserved in the Livrustkammare (Inv. No. 1331. Pl. 82:3)[43]. It is quite typical of the French fashion of the 1680s in the style of Le Languedoc and Simonin. It is also signed *Amsterdam*.

Knowledge of the classical Louis XIV style in gunmaking was also introduced in Germany by Simonin's pattern sheets, undoubtedly in the original, but also copied and published by Johan Jakob von Sandrart. The circumstances that his album *Neues Büchlein Unterschidlicher Stück und Zirahten Büxenmacher Arbeit* (Pl. 122:2) was published in Nuremberg, and that the prototype is Simonin's album of 1685, enable us to date the appearance of the publication between that year and the year of von Sandrart's death, 1697, or the beginning of 1698[44]. Another edition copied from the same original, engraved by Heinrich Raab, was published in

Nuremberg by David Funck (cf. p. 149, fig. 5). Both these pattern books undoubtedly supplied a need and left their mark. There is evidence that there was a direct French influence on German gunmaking even earlier than the reign of Louis XIV. A member of the gunsmith family of Moritz of Cassel signed three guns and a pair of pistols in the French style of the 1670s. They are now preserved in the Töjhus Museum, Copenhagen (Nos. 891–95). According to the inventory of *Det Kongelige partikulaere Rustkammer* two of these guns belonged to Landgrave Charles of Hessen. His coat of arms and initials are on the thumb-plates[45].

Boeheim has called attention to the part played by Armand Bongarde of Düsseldorf at an early stage in introducing the French style into German gunmaking[46]. The gun of Duke Charles Leopold of Lorraine (1643–90) in the Kunsthistorisches Museum, Vienna (Waffensammlung A 1636)[47] is a good representative of French style in the 1680s‡.

A third centre of production of flintlock weapons in an entirely French style was Dresden. The gunsmith Andreas Örttel (Erttel) worked there at the close of the seventeenth century and the beginning of the eighteenth. He was one of the court gunmakers and was admitted into burghership in 1692[48]. A gun, a magnificent piece of the highest class in purely French style (Pl. 83, 84) which had long been in the family of the Counts Mörner, probably represented his best work. This weapon, materially of extreme value, and historically most interesting, was lost when the manorhouse of Hålbonäs in the province of Södermanland was destroyed by fire in June 1934. The signature 'Andreas Erttel à Dresden' was inscribed in gold lettering on the breech of the round barrel decorated in relief and 'Erttel' on the lock below the steel spring. The nearest equivalent to this precious treasure is Louis XIV's *de luxe* gun by Piraube in Windsor (Pl. 76). It was on a par with it in richness but maybe not in fineness of detail. The two guns show such great similarity in several details, for example, the butt, silver inlay work and the thumb-plate, that one is inclined to suppose

that Erttel had studied in Paris. If this should not be the case, we must assume the existence of drawings which both masters used. The French royal crown, surmounting the portrait of Louis XIV in relief on the gun at Windsor, surmounts on Erttel's thumb-plate the arms of Poland engraved in a cartouche (cf. Pl. 76:5 and 83:2). The coat of arms of the Electorate of Saxony is seen in a cartouche on the lockplate, though without a crown (cf. Pl. 84:1).

This gun of Augustus the Strong, for the arms indicate that he was its owner, must be dated from 1697 at the earliest, when Augustus became king of Poland. If we bear in mind that the heraldic coats of arms are engraved on cartouches which could easily be altered for this purpose, that the crown of the Polish king differs in appearance from that of the French on the thumb-plate[50], that this Polish crown would have been expected in 1697 or later, and that the gun distinctly bears the impress of the French style of 1680, we must conclude that it should be dated earlier than the Polish crown indicates. The long pointed toe of the butt nevertheless denotes that it could date from the close of the seventeenth century.

Walentin Rewer worked in the same style and in the same town as Erttel from the year 1703[51]. A pair of pistols in the Livrustkammare (Inv. Nos. 5687, 5688)[52] confirms what has been said regarding the style.

As regards Berlin we can note a *de luxe* garniture by Demrath in the Zeughaus which belonged to King Frederick I of Prussia (1701–13). Binder dates it from about 1710[53]. Judging on stylistic grounds it must be older, but a retarded style can of course be found so far away from its source. There is evidence of this in manufacture in Denmark as well as Sweden, where French forms of the close of the seventeenth century still determined firearms design in the 1710s and 1720s.

In England the manufacture of flintlock arms after French prototypes in the classical Louis XIV style soon develops into a distinct national type§. In Italy the national style was so firmly developed that the Italian flintlock weapons are distinctive from the outset and remain so. A good deal more could be added

about this and also about the transformation of the classical Louis XIV style in other flintlock weapons made outside France, but we desist in order to revert to subsequent evolution in France.

Editor's Notes

* Deverre's Christian name was Pierre, a fact which makes Dr Lenk's suggestion more likely. He was a Huguenot and came to England some time after 1685 but before 1692.

† Another pair of pistols, signed *Piraube fec.*, without reference to his logement, appear to date from about 1715, but are in a manner that recalls an earlier period. These are now in the Pasold Collection, Langley, England.

‡ In spite of his name, Bongarde was not of French birth. He was born in the village of Suchteln, near Viersen.

§ For information concerning the introduction of the Louis XIV style to England, see J. F. Hayward: 'Pierre Monlong', *Vaabenhistoriske Aarbøger*, Vol. VIII, 1956, p. 104 ff.

Notes to Chapter Nine

1. Dahlberg, *Svecia antiqua et hodiernal.* New edition 1920–24. Pp. 39, 40.
2. List of the Refle collection at Sturefors drawn up in 1846 (by Count Axel Bielke), at Sturefors.
3. Extract from inventory at Sturefors. MS. at Sturefors.
4. *Livrustkammarinventarium 1683.* (Zacharias Renberg's inventarium 1686.) P. 257. No. 3. Palace Archives. Livrustkammaren. *Vägledning 1921.* P. 91. No. 724.
5. Cf. Lenk, 'Två bössor av Thuraine and Le Hollandois i Töjhusmuseet'. (*Vaabenhistoriske Aarböger* I. Pp. 13–24.)
6. Suède 1672–88. *Histoire des négociations,* Feuquières's correspondence, reports to Louis XIV. Archives du Ministère des Affaires Etrangères, Paris.
7. *Livrustkammarinventarium 1683.* (Zacharias Renbergs inventarium 1686.) Pp. 236–71. Palace Archives.
8. Ibid. Pp. 253–55. Nos. 1, 3–6. Livrustkammaren. *Vägledning 1921.* Pp. 85, 87, 88. Nos. 686, 687, 700–2, 704.
9. Ibid. Pp. 238–69. Saddles Nos. 1, 2, 6, 9, 10, 11. Livrustkammaren. *Vägledning 1921.* Pp. 89–91, 99. Nos. 711, 712, 715, 718, 722, 792.
10. Guiffrey, 'Logements d'artistes au Louvre'. (*Nouvelles archives de l'art francais.* T. II. P. 73.)
11. Brice, *Description de la ville de Paris.* T. I. P. 104.
12. Guiffrey, 'Logements d'artistes au Louvre'. (*Nouvelles archives de l'art francais.* T. II. P. 130.)
13. Boeheim, *Meister der Waffenschmiedekunst.* Pp. 168, 169.
14. *Livrustkammarinventarium 1683.* (Zacharias Renbergs inventarium 1686.) P. 256. No. 10 Palace Archives. Livrustkammaren. *Vägledning 1921.* P. 85. No. 685.
15. Smith, *Det Kongelige partikulaere Rustkammer* I. Pp. 40, 41.
16. *Livrustkammarinventarium 1683.* (Zacharias Renbergs inventarium 1686.) P. 256. No. 9. Palace Archives. Livrustkammaren. *Vägledning 1921.* P. 106. No. 865.
17. Smith, *Det Kongelige partikulaere Rustkammer* I. P. 33. Pl. 33.
18. Bottet, *Monographie de l'arme à feu portative des armeés françaises de terre et de mer de 1718 à nos jours.* P. 7.

Barrel marks. 1. On gun by Des Granges of Paris 1668 (Pl. 66:1). 2. On pistol by same master 1668 (Pl. 66:2). 3. On gun by De Foullois le jeune of Paris. c. 1670 (Pl. 70:1). Livrustkammaren. *Vägledning 1921.* P. 179. Mark No. 415.

19. Livrustkammaren. *Vägledning 1921.* P. 89. No. 713.
20. Robert, *Catalogue des collections composant le Musée d'Artillerie en 1889.* T. IV. Pp. 309, 310.
21. Livrustkammaren, *Vägledning 1921.* P. 99. No. 791.

22. Ibid. P. 90. No. 716:1.

23. [Falise], *Musée d'Armes*. P. 243. No. E j 26.

24. Laking, *The armoury of Windsor Castle. European Section*. Pp. 129, 130. L. gives both 1672 and 1682 there as the date of the gun. The latter is correct.

25. [Claudelin], *Katalog öfver vapensamlingen i Hallwylska huset*. P. 67.

26. [Boeck and Christensen], *Katalog over den historiske Vaabensamling paa Køjbenhavns Töjhus*. P. 83. No. A 1511.

27. Communicated by H.R.H. Prince Louis of Hessen.

28. Laking, *The armoury of Windsor Castle. European Section*. P. 143. [Gardner], *Exhibition of chased and embossed steel and iron work of European origin*. P. 35. Pl. 63.

29. Grancsay, 'The bequest of Guilia T. Morosini' (*Bulletin of the Metropolitan Museum of Art 1939*. P. 17). Further data communicated to the writer.

30. Semper, *Der Stil in den technischen und tektonischen Künsten oder praktische Aestetik*. II. P. 549, note.

31. Jacobs, 'Die Kgl. Gewehrkammer in München'. (*Zeitschrift für historische Waffenkunde*. Bd. VI. P. 169. Abb. 12, 14.)

32. Boeheim, *Album hervorragender Gegenstände*. P. 16. Pl. XLV. Grosz and Thomas, *Katalog der Waffensammlung in der neuen Burg. Schausammlung*. Pp. 207, 208.

33. [Boeck and Christensen], *Katalog over den historiske Vaabensamling på Køjbenhavns Töjhus*. Pp. 61, 84. Nos. A 582, 1522. Smith, *Det Kongelige partikulaere Rustkammer*. Pp. 51, 52. Pl. 31, 32.

34. Boeheim, *Album hervorragender Gegenstände*. P. 15. Pl. XLV. Grosz and Thomas, *Katalog der Waffensammlung in der neuen Burg. Schausammlung*. P. 237.

35. Robert, *Catalogue des collections composant le Musée d'Artillerie*. P. 129. R. dates this gun to the close of the eighteenth century. This is obviously absurd.

36. Ehrenthal, *Führer durch die Königliche Gewehr-Galerie zu Dresden*. Pp. 43–45. III. P. 44.

37. Boeheim, 'Die Luxusgewehr-fabrication in Frankreich im XVII und XVIII. Jahr-

hundert.' (*Blätter für Kunstgewerbe*. Jahrg. 1886. Heft. VIII. Pp. 38, 39.)

38. In London we find a member of the Monlong gunsmith family who has signed a pair of *de luxe* pistols in best French style. They were exhibited at the Burlington Fine Arts Club in London in 1900. (Gardner), *Exhibition of chased and embossed steel and iron work of European origin*. 1900. P. 35. Pl. 43. As to northern Europe reference is invited to the following papers: Lenk, 'Flintlåstillverkningens införande i Sverige. Personhistoriska bidrag.' (Rig. 1935.) Same writer, 'Flintlåstillverkningens införande i Sverige. Armémodellerna.' (*Karolinska förbundets ärsbok* 1937). Otto Smith, 'Flintelaasens Indförelse i den danske Haer.' (*Vaabenhistoriske Aarboger* II, b. 1938.)

39. Cf. Lenk 'Zur Frage der holländischen Büchsenmacher'. (*Zeitschrift für historische Waffen- und Kostümkunde*. Bd. XIII. Pp. 239–41.)

40. Cf. Lenk, 'Flintlåstillverkningens införande i Sverige. Personhistoriska bidrag.' (Rig. 1935. P. 147 ff.)

41. [Boeck and Christensen], *Katalog over den historiske Vaabensamling paa Köjbenhavns Töjhus*. Pp. 64, 85, Nos. A 701, A 1545. Smith, *Det Kongelige partikulaere Rustkammer* I. Pp. 43, 44. No. 86. Pl. 31.

42. Malmborg, *Stockholm bössmakare*. P. 183.

43. *Livrustkammarinventarium 1683*. (Diarium 1696. P. 30. No. 13.) Palace Archives. Livrustkammaren. *Vägledning 1921*. P. 87. No. 699.

44. Berliner, *Ornamentale Vorlage-Blätter Textbd*. P. 80.

45. [Boeck and Christensen], *Katalog over den historiske Vaabensamling paa Köjbenhavns Töjhus*. P. 64. Nos. A 707–9. P. 85. No. A 1550.

46. Smith, *Det Kongelige partikulaere Rustkammer*. I. P. 37. Nos. 57, 40. Nos. 65, 64. No. 159.

47. Boeheim, 'Die Luxusgewehr-Fabrication in Frankreich im XVII und XVIII. Jahr. (*Blätter für Kunstgewerbe* 1886. P. 36). Same author, *Meister der Waffenschmiedkunst*. Pp. 21, 22. Same author, 'Uber einige

Jagd waffen und Jagdgeräte des Aller Höchsten Kaiserhauses' (*Jahrbuch der Kunsthistorischen Sammlungen des A. H. Kaiserhausen*. Bd. V. Pp. 102–5. Taf. XIII: figs. 1, 3–5). Weyersberg. 'Der Büchsenmacher, Eisenschneider und Graveur Hermann Bongard (d. 1727) und seine Familie.' (*Zeitschrift für historische Waffen- und Kostumkunde*. Bd. X. P. 232.)

48. [Grosz and Thomas], *Katalog der Waffensammlung in der neuen Burg Schausammlung*. P. 232.

49. Ehrenthal, 'Führer durch die Königliche Gewehr-Galerie zu Dresden. P. 99. Holzhausen, Regestan über die Dresdner Büch-senmacher.' (*Zeitschrift für historische Waffen- und Kostümkunde*. Bd. XIV. P. 188.)

50. Cf. Rudolph, 'Die polnische Königskrone Augusts des Starken im Bilde' (*Berliner Münzblätter* No. 302. Pp. 207, 209).

51. Ehrenthal, *Führer durch die Königliche Gewehr-Galerie zu Dresden*. P. 105.

52. Livrustkammaren. *Vägledning 1921*. P. 105. No. 854.

53. Binder, 'Neuerwerbungen des Berliner Zeughauses.' (*Zeitschrift für historische Waffen- und Kostümkunde*. Bd. X. P. 94.) 'Sitzungsberichte der Berliner Mitglieder im Zeughaus. (Ibid. Bd. XI. P. 242.)

Plate 95.

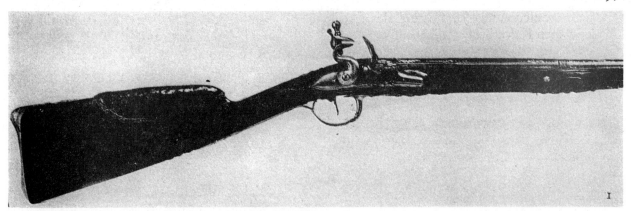

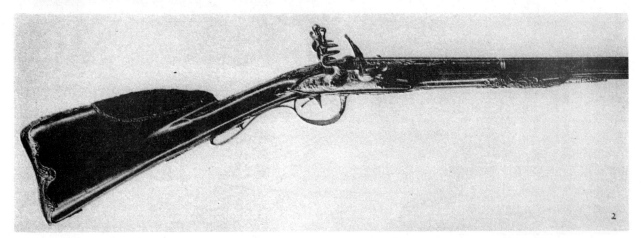

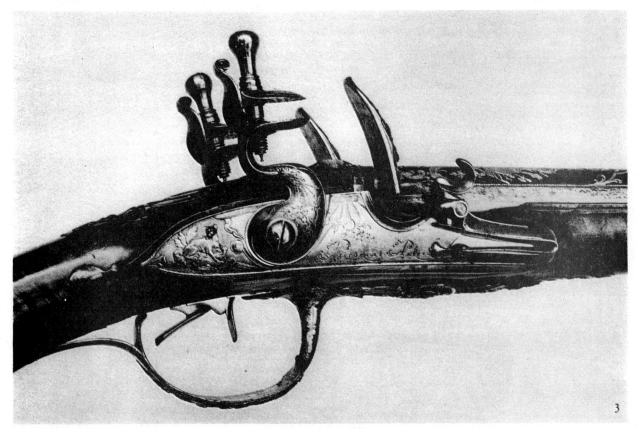

France, Paris.
1750–60s.

1. Child's gun by 'Les Le Page à Paris'; Brussels, Musée de la Porte de Hal 785. 2 and 3. Double barrelled gun by Puiforcat of Paris. 1756–57; Stockholm, Hallwyl Museum Å 31.

Plate 96.

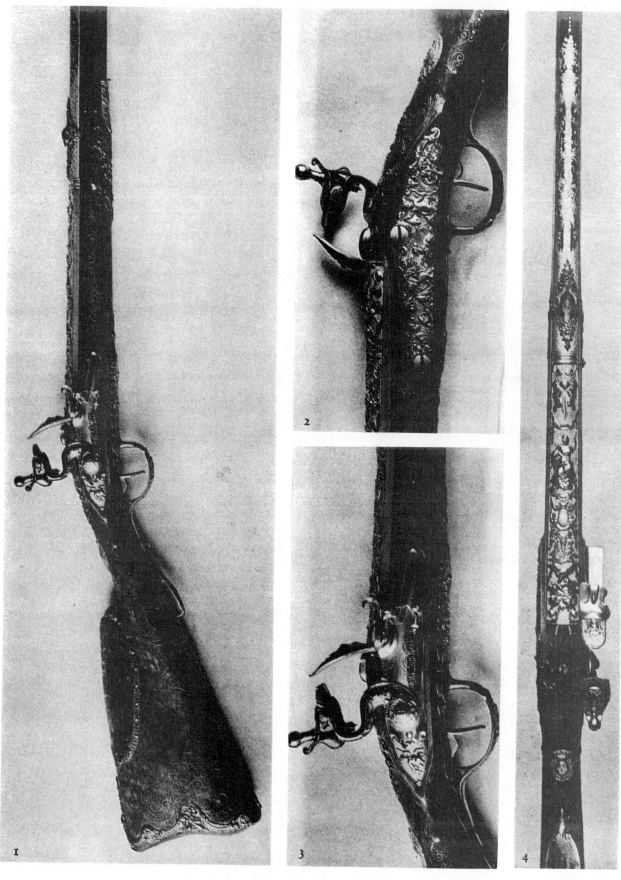

France, Paris.
c. 1760

Child's gun by Bouillet à Paris; Paris, Louvre M. R. 435.

Plate 97.

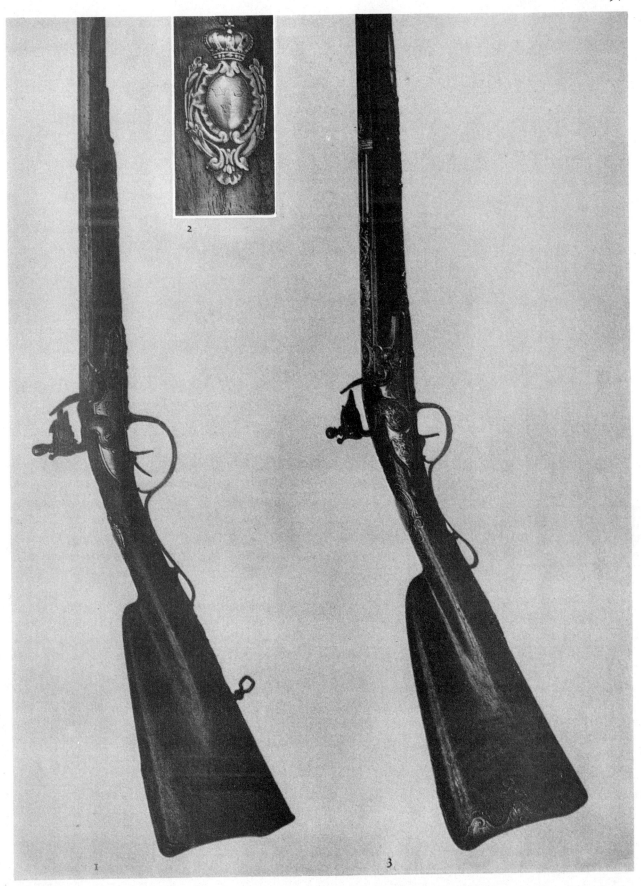

France, Paris.
c. 1770.

1–2. Gustavus III's (?) double barrelled gun by 'Chasteau à Paris Rue de Sts. Peres'; Stockholm, Livrustkammaren 39/70. 3. Gun by 'Brifaud à Paris Rue St. Honoré'; Stockholm, Livrustkammaren 19/7.

Plate 98.

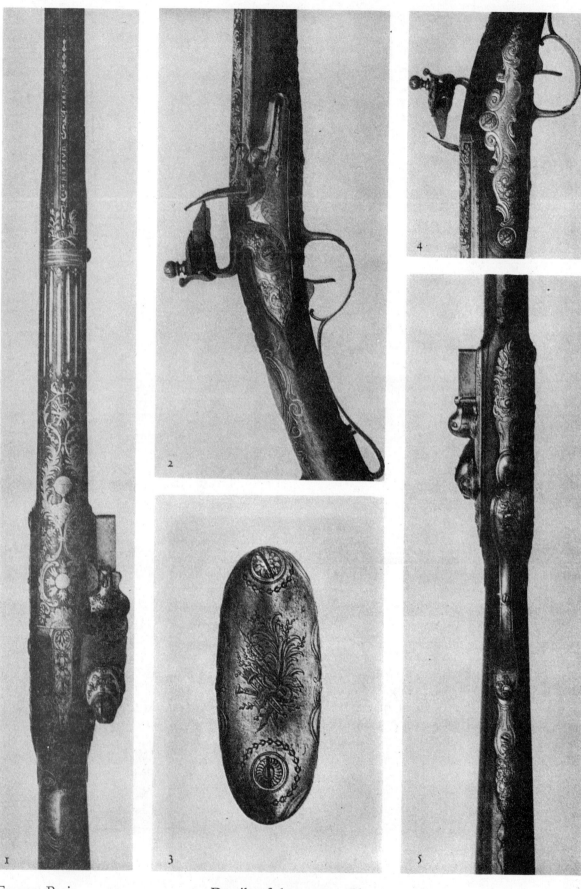

France, Paris.
c. 1770.

Details of the gun on Pl. 97:3.

CHAPTER TEN

The Berain style.
French flintlock firearms of the
eighteenth and nineteenth centuries

FRENCH INDUSTRIAL art and handicrafts in the last decade of the seventeenth century and the beginning of the eighteenth century show the strong influence of the designer, Jean Bérain. This also applies to gunmaking. Among the engravers, Nicolas Guérard and De Lacollombe produced pattern books for gunsmiths in his style (cf. Pl. 123, 124, 127, 128). The former claims that he works under the direction of the most skilled gunsmiths in Paris ('sous la conduite des plus habils Arquebuziers de Paris'). The latter works after 'Languedoc à Paris'. This is mentioned on some of his sheets. One is dated 1702, another 1705. The year of Guérard's album is not known. It appears to be more or less contemporary with De Lacollombe's earliest engravings. This agrees with Guilmard's statement that Guérard worked in Paris in 1670–96. Thieme-Becker gives 1719 as the year of his death[1]. In any case there existed in Paris about 1700 a style of flintlock firearm which differs considerably from that dealt with in the preceding chapter. The prototypes for the designs were taken from the middle of the seventeenth century; flat forms with shaped profiles, carved ornament between the pan and the cock as well as a sunk rear part were reintroduced. Large cock-screw heads decorated in relief, volutes on the cocks (though only in exceptional cases) and longer drop shaped jaw-screw heads, short tangs on the butt-plates and side-plates. The latter became just 's' shaped, curved straps between the lock-screws, symmetrically designed around a central medallion. The pans became angular. The steels were also angular and abruptly cut at the top and cock-jaws were angular. The ramrod-pipes became polygonal. There are, also, forms taken over from the immediately preceding period, such as the barrels divided into different sections, steels with tips curved forward, the rear of the lock-plates very elongated, chiselled decoration at the rear ramrod-pipes, pierced side-plates executed in low relief with thin elegant forms, silver inlay-work on the stocks, relief decoration on the barrels, lobate leaves on steel-springs and trigger-guards. There are in addition similar leaves on the tangs of the butt-plates. This is only to be expected inasmuch as

the styles at first ran parallel. There are thumb-plates both of the old kind and the new, a convex medallion surrounded by metal inlay. One can compare the Corfitz Trolle pistols in the Töjhus Museum (Pl. 69:4). The chiselled boss of the pistol butt-caps has become smaller and taller thus giving the cap a conical appearance. This also indicates a reversion to the earlier forms (cf. Pl. 54:3 and 117). Moreover, the earlier chiselled cartouche round the decorated butt-cap heads has, as a rule, disappeared. This is usually surrounded by a narrow ring, while outside the ring the ornament was no longer confined in a cartouche.

The lock-plate is sometimes pierced by the sear-screw about 1680. This becomes more and more common towards the close of the century and standard from about 1700 onwards.

Although convex and flat forms occur at the same time no sets comprising arms of both kinds are recorded. The pattern sheets invariably represent locks with flat forms. The convex ones appear only as survivals, such as a turned ramrod-pipe in Guérard, a convex pan and steel in De Lacollombe, but these are exceptions. Even among the extant weapons there are transitional forms, as for instance a pair of pistols in the Livrustkammare with locks and barrels signed, 'Ch. Doucin à Paris' (see Editor's Notes) (Inv. Nos. 4080, 4081)[2] They correspond on the whole with the late seventeenth century pieces dealt with in the previous chapter. But the clumsy pommels are rounded off and have the framework of ornament mentioned above. Another novelty in these pistols is the form of the ramrod-pipe which looks forward to the later angular forms. A pair of magnificent pistols, otherwise characterized by convex forms, by Piraube in the Gewehrgalerie, Dresden (Inv. No. 739)[3], has cylindrical ramrod-pipes with pointed terminals, in which a trend towards angular forms can be recognized.

The period of transition from convex to flat shapes is suggested by the rather heavy proportions of the gun and pistol butts in Guérard and De Lacollombe. They closely resemble those we know from the 1680s and 1690s. But a pair of dated pistols in the Dresden His-

torisches Museum (Pl. 85:1, 4, 7) gives us an exact year for such arms. The master is Piraube again. He has signed the pistols on barrels and lock 'Piraube aux galleries à Paris', with the year 1696 added on the barrels. Still another pair of pistols in the same style and by the same gunsmith dated 1699, formerly belonged to the Zeughaus, Berlin (Inv. No. 09.124. Pl. 85:2, 3, 5, 6). Finally there may be mentioned a gun, also by Piraube, in the Jagd-Museum at Kranichstein (No. 264. Pl. 86). It is also dated 1699[4].

All these weapons illustrate the new style. Although they are so close to one another in time a development from the earlier to the later is discernible. The barrels are in perfect agreement as regards disposition and decoration and continue the features of the 1680s. The pistols of 1696 still have the clumsy pommels, but on the pistols of 1699 they are already more elegant. The former have pierced side-plates of the type we know from a previous period. The latter have side-plates in the form of a 'rib' between the lock-screws formed by two volute-like ornaments flanking a medallion. The pistols of 1696 have the cock-screw designed more like the chiselled screw-heads with cruciform groove of the Thuraine and Le Hollandois style. In 1699 the cock-screws have only a single groove, a pattern that is maintained in the future. In both instances the barrel-tang is finished off straight at the back. Finally, the ramrod-pipes on the older pair of pistols are cylindrical with longitudinal and pointed oval finials, those of the later ones are facetted. The material assembled thus points to the 1690s as a transitional period from the classical Louis XIV style to that of Bérain. Guérard's album, some sheets from De Lacollombe, the two dated pairs of pistols, and the gun in Kranichstein with flat surfaces by Piraube denote a first stage.

Before proceeding further it may be as well to consider a group which has a wider distribution than France and which belongs to the first stage of the flat surfaces. Its chief characteristic is the lavish use of brass for lock-plates, mounts and at times, also for barrels. The group is well represented in the Töjhus Museum, Copenhagen, with a pair of pistols

by Philippe Selier (Inv. Nos. 1248, 1249) and two garnitures of a gun and pistols, one with Daniel Thiermay's marks and signature (Inv. Nos. B 1233–B 1235. Pl. 88), the other signed by Louis Servais (Inv. Nos. B 1243–B 1245). Boeheim states, without quoting his source, that Selier had worked in Paris[5]. An 'L. Servais Orleans' has signed a gun in the Moscow Armoury (Inv. No. 7099)[6]. Whether the same master also made the pistols in the Töjhus Museum must remain an open question. As to date Christensen assigns the gun by Thiermay and the Servais garniture to the reign of Frederick IV, consequently between 1699 and 1730, but the Selier and Thiermay pistols to that of Christian VI, i.e. the period 1730–46[7]. The inventory of *Det kongelige partikulaere Rustkammer* of 1775 states, however, that the Servais gun was delivered to the armoury on 16 March 1711. Smith dates it from about 1710[8]. A target rifle with a flintlock in the Rotunda, Woolwich, with the coat of arms of the Austrian family von Hohenfeldt bears the signature 'Philippe de Sellier l'an 1734' (Inv. No. IV: 124)[9]. Two guns in the Musée de l'Armée, Paris (Inv. Nos. M 569, M 570) are likewise signed 'Philippe de Selier'[10]. Perhaps Philippe Selier and Philippe de Sellier are one and the same person. The similarity of the names is the only reason given for this assumption (see Editor's Notes).

A very similar gun by 'T Thiermay' with the signature on the lock is in the Rijksmuseum in Amsterdam (Inv. No. 3287). It is defective; the ramrod-pipes and the thumb-plate are later additions. A pair of pistols in the Livrust-kammare, signed 'Gille Damour' (Inv. No. 15/117) also belong to the group. No place of manufacture is given.

Ehrenthal dates nine guns by Thiermay 'in Paris'* with the same marks as the Copenhagen arms from the period 1720–30[11].

Such a marked retardation in style, as so late a manufacture would imply, does occur but one must feel sceptical of such late dating of arms belonging to the group. The comparison to the French material from the 1690s definitely prompts one to assign the entire group to the period around 1700. The date on

the gun in the Rotunda will doubtless be explained on closer study†.

First among the Copenhagen arms come, typologically, the pistols by Philippe Selier (Inv. Nos. B 1248, B 1249) with tall bevelled edges to the lock-plate and cock and also a small grotesque mask on the cock-screw head. There is a mark on the chamber with the initials 'P S' beneath an open crown stamped three times. The side-plate is rather coarse and composed of grotesque monsters placed symmetrically round a mask below the head of the rear lock-screw.

The lock-plates on the Servais garniture of the Töjhus Museum are quite flat. The section behind the cock is also on the same level as the rest of the plate. The cock too is flatter than those of the Selier pistols and attached by a screw. Its large slightly convex head permits no doubt as to the prototype. The more so as the grooves which cross one another at right angles and the small ornaments in relief at their ends distinctly recall Thuraine and Le Hollandois weapons of the 1650–60s. The gun is slightly clumsier than the arms of the 1680s, for example: that in the garniture by Chasteau of Paris in the Töjhus Museum (Pl. 79). Both these guns have otherwise much in common. The chiselled ornament on the barrels of the Servais gun is, however, lower, lighter and farther apart. That on lock, butt-plate and trigger-guard has the same characteristics, but the cartouche of the thumb-plates surrounded with trophies and prisoners and crowned with helmets is of the same kind as the thumb-plates of the late seventeenth century. The carved decoration of the stock is more graceful on the Chasteau gun than on the Servais gun. This is coarse and strong with lobate leaves at the rear ramrod-pipe. The turned ramrod-pipes are almost without exception emphasized towards the middle. The highest points of the profile of those of the Servais garniture are at the ends. They are moreover polygonal.

The Thiermay garniture in the Töjhus Museum is, on the whole, of the same character as that by Servais. In some details it is more advanced. Its lock-plate coincides with what

has been said above of the distinctive features of the Berain style. The form of the cock is influenced by the 's' curve of the Berain style with, however, a straight middle section which we recognize from the pattern sheets of Guérard and De Lacollombe. Another novel feature is the butt which is flat underneath. It is presented in a restrained form as a plane with profiled edges terminating forward in a broad, lobate leaf; the tips of which meet the metal leaves of the trigger-guard. The neck and the point of the comb are accentuated with carved foliage.

All of the arms belonging to the group have broad barrel-tangs which expand backwards (cf. Pl. 88:5). Where there is a back-sight it is formed either by a hollow filed in the barrel-tang or as a semi cylindrical groove with a foliage finish on each side at the rear end of the barrel. The fore-sight is remarkably long. The barrels are of thick material. This is necessary as the casting is of bronze or brass, though the iron barrels also show the same peculiarity. Although the barrels of French flintlock weapons are generally very thin at the muzzle, there are examples of French barrels of heavy casting. These coarse barrels need not therefore be inconsistent with the assumption that they are of French manufacture. Dating can be checked by comparison with a garniture in the Kunsthistorisches Museum, Vienna, Waffen-sammlung (Inv. Nos. A 1639, A 1640/1)[12], which belonged to Landgraf Ludwig Wilhelm von Baden, d. 1709. It is dated in the most recent catalogue of the museum as about 1702 and provides great similarities with the group in Copenhagen. The garniture is probably German. The auction catalogue of the armoury in Schloss Ettersburg gives reliable information of German manufacture of this type of weapon. Several of the guns included in it as belonging to the group bear the signature of J. J. Behr and one gun (No. 52) is signed 'J. H. Jung à Sülli' (Suhl)[13].

We have already established the fact that there was a development in the first stage of the period in French gunmaking which begins with the reintroduction of the flat shapes at the close of the seventeenth century. This may primarily be characterized as abandoning the forms of the late seventeenth century in stages; first of all the convexity, then the clumsiness. A typical feature of the flintlock of the later seventeenth century is that the lower edge of the lock-plate follows a downward line. This also applies to the firearms of 1696 and 1699 just mentioned. This shape is again met with in Guérard and on the oldest of De Lacollombe's engravings. This relic from the beginning of the seventeenth century was soon to disappear, judging by a pair of pistols signed 'Mazelier à Paris' and dated 1708. They were sold by auction at the Galerie Fischer in Lucerne in June 1937[14]. With this we reach uniformity in the designing of French flintlock weapons that can be followed up with dated arms into the 1720s and with undated ones still further. The dated ones that can be cited are: a pair of pistols of 1716 by 'Le Hollandois à Paris' in the Musée d'Armes in Liège (Inv. No. 5116. Pl. 89:1, 4, 5)[15], a gun of the same year by 'Languedoc à Paris' in the Jagd-museum in Kranichstein at Darmstadt (Inv. No. 238. Pl. 90:1)[16], a pair of pistols of 1718 by the same master in the Gewehrgalerie, Dresden (Inv. No. 746. Pl. 89:2, 6)[17], a gun of 1721 by 'St. Germain à Paris' from the armoury in the Ettersburg, later in the Jakobsson Collection, Stockholm[18] (Pl. 91) and finally a gun of 1722 by 'Languedoc à Paris' in the Historisches Museum, Dresden (Inv. No. 1276. Pl. 90:2, 3)[19]. There can be added to this material a pair of pistols in the Historisches Museum, Dresden (Inv. No. EX 12), signed 'Alegre à Paris' which can be dated not later than 1725 on account of the coat of arms on the thumb-plate of Louis, vicomte d'Aubusson, duc de la Feuillade et de Roannès, d. 1725[20].

The uniformity in this group of dated weapons finds expression in the division of the barrels by a long, metal ridge on the upper side, and side-plates on the chambers as well as spreading barrel-tangs. The locks are always flat with a countersunk rear point, simple 's' shaped cocks, large slightly conical cock-screws with a single groove and drop shaped jaw-screw heads. Trigger-guards and butt-plates terminate in leaves. The side-plates are pierced and are made up of scrolls grouped round a

medallion. The ramrod-pipes are angular. This angularity is at times merely indicated by engraving on the cylindrical ramrod-pipes, which are reinforced with rings at both ends. The pommels of the pistols are smaller on arms dating towards the 1720s; the pommel boss is raised so that its edge forms a pronounced ledge. Furthermore, the spur of the steel is larger and curves upwards. At the end of the seventeenth century a finial begins to develop on the stock from the back of the flat border surrounding the lock and side-plates, and a broad, rounded ledge projects at the front. This finial continues to grow during the earlier half of the eighteenth century, but the ledge is biggest about 1720, becomes smaller after that and then disappears. Finally, French flintlock weapons become considerably lighter and more elegant during the beginning of the eighteenth century.

Starting from this basis other arms can be correctly dated. As the number of surviving weapons of this period is large it will be sufficient to give a few examples. A number of those in the Historisches Museum, Dresden, provide suitable material for study. A very beautiful gun by 'Dutrevil à Paris', signed on the barrels and lock (Gewehrgalerie No. 730. Pl. 87)[21], belongs to this period. The curved lock-plate suggests early dating; there is nothing against its being dated from about 1720. A pair of extremely beautiful pistols by 'De Crens à Paris' in the same collection (Gewehrgalerie No. 744. Pl. 89:3, 7)[22] are of the same period. Their butt-caps with a Minerva head on the oval boss are an excellent illustration of what has been said above. The thumb-plates bear the Polish arms of Rawicz under a French ducal coronet. The mark of the Parisian barrelsmith, Nicolas Pierron, stamped on the underside of the barrels provides confirmation of the dating. According to Magné de Marolles he died in 1735[23].

In the history of the west European flintlock the evolution up to the death of Louis XIV is the most interesting phase. It is this evolution that has served as the main subject of the present thesis. The succeeding period can be dealt with very briefly here.

Louis XIV's death in 1715 does not involve any sudden break in French gunmaking. The acute economic crisis during the subsequent decade after the fall of Law and the death of the sovereign undoubtedly affected the volume of production considerably, but the style continued to be just the same. An analysis of De Lacollombe's patterns of the 1730s (cf. p. 150 and Pls. 128:2, 129) shows that arms at this time were lighter and slenderer. This implied a continuation of the earlier trend. Particularly obvious is the distinctly arched lower contour of the gunstocks which runs out into the pointed butt-toe. The gun-butts once more have the pierced decorative plate which we know from Simonin's engravings and Le Languedoc's gun of 1680 in the Livrustkammare (Pl. 78). There it helps to give an effect of symmetry but here it develops from the pointed toe of the butt. Along with the earlier pierced type of side-plates we now have solid plates, with more or less elaborate profiles chiselled with bright ornament or planes against a punched ground.

The continued existence of this style can be followed to about the middle of the century. Among the earlier weapons we may note a gun by 'La Roche à Paris', with signature on barrel and lock, in Count Magnus Brahe's collection in the Brahe-Bielke Armoury at Skokloster. From the coat of arms of the French king on the thumb-plate and the crowned mirror monogram of the sovereign on the butt-plate the gun can be identified as a personal weapon of King Louis XV of France. The butt-plate is bent round at the foot and the sides, the profile corresponding to that on the pattern sheets of the 1730s. According to Guiffrey, Jean-Baptiste La Roche was granted a 'brevet de logement' on 21 August 1743, after Le Hollandois junior[24]. If he had had this 'brevet' when Louis XV's gun was made, the signature would undoubtedly have included 'aux galleries'. The gun can therefore serve as an example of the persistence of the style of the late seventeenth century into the 1730s. Nearly contemporary is a pair of guns in the Historisches Museum, Dresden, one (No. 1308. Pl. 90:5) is signed by 'Bletterie à Paris', the

other (No. 1289. Pl. 90:4) by Languedoc[25]. As regards the former, it is to be noted that the barrel bears the mark of the Nicolas Pierron mentioned above. The gun should therefore be dated from the mid 1730s, the period of Pierron's death. The Languedoc gun has an irregular trigger-guard which looks as if it were copied from a German prototype. The style is represented in the Livrustkammare by a pair of pistols with locks signed 'Bourdiec à Paris' (Inv. Nos. 1760, 1761)[26]. The marks on the silver mounts of the pistols give the period October 1744–1 October 1750 for their manufacture. This shows that firearms in the Berain style could still be made in Paris at the middle of the eighteenth century. The barrels are of special interest from their being of Damascus construction, a technique which became common in France during the second half of the eighteenth century[27].

Further evidence of this slow evolution of fashion is given by a gun and a pair of pistols by 'Les La Roche aux galleries à Paris'. The former is in the Musée de la Porte de Hal in Brussels (Inv. No. 2653. Pl. 92:1–3), the latter in the Historisches Museum, Dresden (No. 737 A. Pl. 92:4). The gun closely resembles the more elaborate of De Lacollombe's engravings, although no single detail has been taken directly from them. The period of both gun and pistols can be fixed between 21 August 1743, the date of the grant of the 'brevet de logement' to one of the La Roches in the Louvre, and 1769, the year of his death[28]. The gun is still in the Régence style with some Rococo features. The lock could have been taken direct from the pattern sheets. It differs slightly in its decoration, but the composition and ornament are the same. The full signature is on the lock. The barrel has the signature 'La Roche à Paris' inlaid in gold on the upper side of the chamber. The latter is round with flat sides, channelled and bordered by ring mouldings front and back. A silver ring back-sight with small wings on a shaped foot is set in front of the chamber. The stock is carved at the ramrod-pipe and has carved leaves at both ends of the lock and side-plates. Prototypes of these details are also to be found in De Lacollombe. New features are the chequered grip on the fore-stock, the elongated flange, which precedes the very thin small of the butt, and a high gently curved comb. This continues a characteristic feature of French guns. Other features include the slides by which the barrel is attached to the stock instead of pins and the ramrod-pipes formed like elongated barrels. On these the former angularity is replaced by fluting. The thumb-plate is let into the small of the butt with a ducal coat of arms in relief.

The pistols in the Historisches Museum, Dresden, are further advanced and show certain Neo-Classic features in their ornament. This enables us to date them slightly later than the gun just mentioned. As to the barrels; the earlier octagonal type of chamber has been reintroduced along with a sixteen sided and a fluted, practically round portion, finished at the front with a round ring moulding. This octagonal treatment becomes more common during the later eighteenth century, as does the fluting on chambers, which are otherwise angular or round. The pistols by Les La Roche in Dresden have solid side-plates decorated with engraving.

The steels of flintlocks from the second quarter of the eighteenth century become increasingly heavy, the spurs larger and upwards curving. Another detail which developed during the same period is the finial carved in the stock behind the lock and side-plates. It became longer by the middle of the eighteenth century and detached so that it is often only connected with the border by a thin ridge. A third detail which is re-modelled in the middle of the eighteenth century is the trigger-guard, this is now divided at the rear. Examples are to be found on a gun signed on the lock-plate by the same 'Les La Roche aux galleries du Louvre à Paris', in the armoury of Windsor Castle (Inv. No. 262. Pl. 92:5)[29]. Cylindrical ramrod-pipes and a round jaw-screw head with a long neck are also to be noted.

A double-barrelled pistol signed by the same master with fully developed Rococo forms is preserved at Lövstad in the province of Ostergötland (Pl. 93). It has a triangular pan

and a slightly clumsier head on the jaw-screw than the arms listed here. The pistol should be dated from the middle of the eighteenth century. The lock-plate is still flat with a ledge at the back. The same applies to a pair of very elegant pocket pistols in the Livrustkammare (Inv. Nos. 5257-5259. Pl. 94:1-3)[30]. One is signed 'Les Rundberg', the other 'Svedois' on the spurs of the breech-blocks, and both 'Les Rundberg à Paris' (the brothers Peter and Gustav Rundberg from Jonkoping, Sweden) on the lock-plates. The pistols can be dated from the brothers' stay in Paris from 1747-51 and the death of the second one on his way home in 1751[31]. The pistols must therefore date from the years 1747-51, probably nearer the latter.

Examples could be multiplied many times over. It will suffice, however, to mention two more guns with fully developed Rococo ornaments and flat-faced locks. The one by 'Cazes arquebuzier du Roi à Paris' belongs to the Windsor Castle Collection (Inv. No. 253)[32], the other by 'Croizier à Paris Cour neuve du Palais' (the signature likewise on the lock, on the barrel 'Croizier à Paris') was handed to the firm of Le Page of Paris for sale in December 1931 (Pl. 94:4). Both of these have a pan which is almost triangular in section, a clumsy steel and a steel spur with a pronounced curve backward and upward and also narrow curved cocks with elongated heads on the jaw-screws and small heads on the cock-screws. The trigger-guards are divided behind, the butts have characteristic conical swellings on the heels and round the lower butt-plate screw. The small of the butt has now become long and thin, the flange long broad and smoothly grooved. This makes the comb of the butt high and thin. The pan is fitted with a bridle (cf. p. 99), a feature not unusual at this time. Croizier's gun bears the mark 'No. 2' stamped twice in gold on the chamber of the barrel maker, Nicolas Le Clerc. Magné de Marolles states that Le Clerc began to use this mark about 1768. This gives a *terminus a quo* for the two guns[33].

The pistol at Lövstad by Les La Roche coincides in several respects with some of De

Marteau's pattern sheets. One of these is dated 1743, two others 1744 and 1749 (Pl. 130). The style is the most exuberant Rococo. The sheet dated 1749 shows a flat lock-plate, elongated and pointed at the back, a curvaceous, rather thin cock, and a pan profile that has not yet become fully triangular. In date the pistol should be placed between De Marteau's pattern sheets and the two guns just mentioned. The form of the jaw-screws and steels is identical, as is the ornament, carved in the stock behind the lock and detached from the lock-plate border apart from a very thin connecting link. The wood follows the edge of the lock-plate forming a flat border. The contours of the pan, lock-plates and cocks differ.

From these details, to which we can add the shape of the butt, we may date a child's gun in the Musée de la Porte de Hal in Brussels (Inv. No. 785. Pl. 95:1). Its lock-plate and barrel are signed 'Les Le Page à Paris'. The arms of the Dukes of Orléans are included in gold inlay of the chamber. The gun is only 98.2 cm. in length and its calibre a good 12 mm. It must consequently have been made for a child, probably Louis Philippe Joseph, known by the name of Philippe Egalité which he assumed during the Revolution. He was born in 1747 and would have been about the right age for the gun in 1760, when it was probably made. What interests us most is that the lock is convex in form and similar in style to those dating from the close of the seventeenth century, while the side-plate is designed in relief as an asymmetrical cartouche, developing into foliage of a characteristic Rococo design.

The richness characteristic of De Marteau's pattern sheets is also found on another child's gun with the lock signed 'Bouillet à Paris' (Pl. 96). It is preserved in the Louvre[34]. Its chiselled decoration is truly magnificent not only on barrel and mounts, but also on the lock and inlay work with thin silver wire in the stock. The gun is said to have been a gift from the city of Paris to Prince Louis, son of the Dauphin Louis (d. 1765). Whether this refers to the prince who died in 1761, or to the

later Louis XVI, the arms on the thumb-plate are those of 'les enfants de France' and the gun dates from prior to the death of the Dauphin Louis. This dating is also arrived at by comparison with the Lövstad pistol and the two pistols with flat locks mentioned in connection with it. This delicate jewel can be compared in its composition with a double barrelled gun by 'Puiforcat à Paris' (signature on barrel and lock) in the Hallwyl Museum, Stockholm (Inv. No. Å 31. Pl. 95:2, 3)[35], which can be dated by the silver marks from the years 1756–57. This has not yet acquired the characteristic swelling around the lower screw of the butt-plate to such a degree and the lock reminds one most of that on the 'Les Le Page' gun in Brussels. The child's gun in the Louvre has, like the contemporary flat locks, a recessed rear end, in this case decorated in relief. Both the conical heel and the swelling round the lower screw of the butt-plate are fully developed. Both this gun and that in the Hallwyl Museum have an additional novelty as regards the part of the trigger-guard behind the finger-rest. This is raised from the stock and looped round terminating in the usual leaf finial. The comb of the butt has almost assumed the high form typical of the close of the century.

A pair of guns in the Livrustkammare are very closely related to those just mentioned of about 1760. One, signed on barrels and locks by 'Chasteau à Paris Rue de St Peres' is a double barrelled fowling piece. It was acquired from the Lamm Collection at Näsby (Pl. 97:1, 2). The thumb-plate is composed of the lesser arms of Sweden surrounded by ornament. Below the barrels is Nicolas Le Clerc's mark and an oval mark with a heraldic fleur-de-lis[36], the former once on each barrel, the latter twice. The convex lock is very simple and resembles the forms of the seventeenth century except for such details as the spur of the cock, the steel, and the finish of the lock-plate, which with its rectangular edges is typical of the whole eighteenth century. As a double barrelled gun with soldered barrels and rib, the direct precursor of the modern double barrelled gun, this gun deserves special notice. The rib is still quite short; it merely corresponds to the

chambers and constitutes a grooved extension of the back-sight fitted to the barrel tang. The barrels are further held together by rings, the first made in one piece with the rib, the second connected with the front ramrod-pipe[37].

Such double barrels were first manufactured in Paris by Jean Le Clerc (d. 1739) in 1738. The idea was brought from Saint Etienne where they had been made some years previously.

Guidance in dating this double barrelled gun can be found in the Livrustkammare No. 19/7, with the barrel signed 'Brifaud à Paris', and the lock and side-plate 'Brifaud à Paris Rue St Honoré' (Pls. 97:3, 98). The decoration on the barrel of this gun is in gold inlay, not in relief. The style is Rococo with Neo-Classic features. The recessed rear end of the lock-plate is pinched, as on most of the locks from the period around 1770 and into the 1800s. The head of the jaw-screw is globular in shape. The mark of the Parisian barrelsmith Jean Titeux is stamped below the barrel. Titeux died in 1770[38], which provides, if not an exact, nevertheless an approximate *terminus ante quem* for its manufacture.

Since both these guns correspond to forms which were still current about 1770, it is tempting to conjecture that the Chasteau double barrelled gun formed part of the hunting equipment used by Gustavus III of Sweden during his visit to the French court in the winter of 1770–71. It was there that he received the news of the death of his father, Adolphus Frederick.

The Rococo had such a long span of life in the manufacture of French flintlock arms that the Louis XVI style had no chance of asserting itself. The Livrustkammare nevertheless possesses a child's gun by 'Le Sage à Paris' (Inv. No. 1550. Pl. 99:1, 6)[39], the trigger-guard of which has Neo-Classic forms. It is very like the guns just mentioned in the same institution. The small of its butt, however, is chequered like the Empire weapons and the marks of the barrelsmith Le Clerc are stamped on the top of the barrels. This only became the custom in Paris towards the middle of the 1770s[40]. The presence of the cheek-pad should be noted as a novel feature. The lock is rounded in shape.

Plate 99.

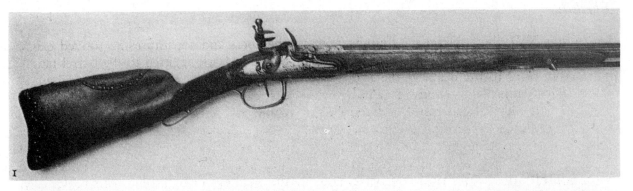

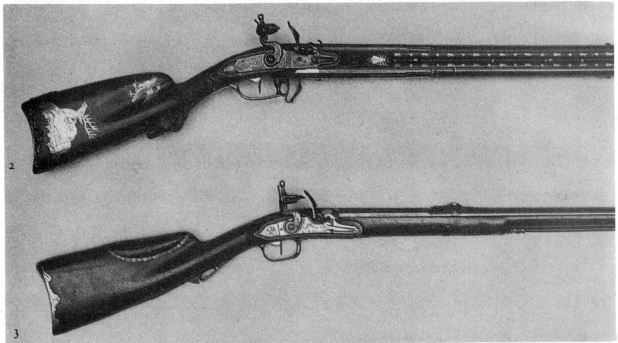

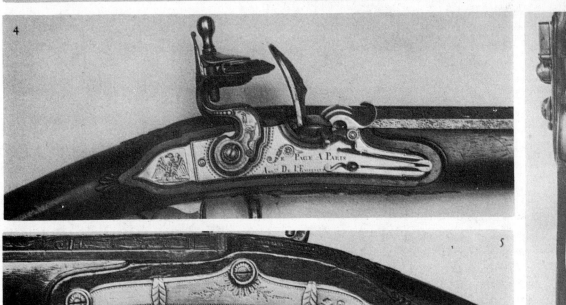

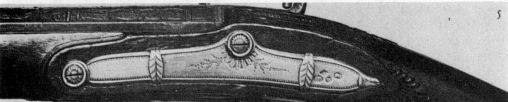

France, Paris.
1780–1810.

1 and 6. Child's gun by Le Sage of Paris; Stockholm, Livrustkammaren 1550. 2. Frederick Augustus I's Wender gun by Le Page of Paris. Gift from Napoleon I in 1808; Dresden, Gewehrgalerie 1891. 3–5. Gun by 'Le Page A Paris Arqer De L'Empereur'; Dresden, Historisches Museum Z. K. 664/1.

Plate 100.

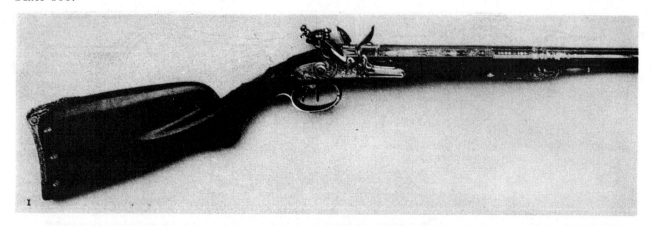

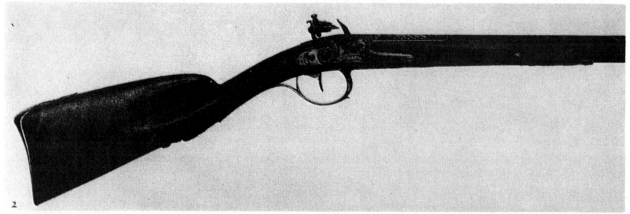

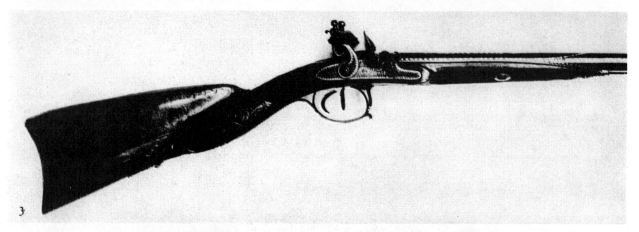

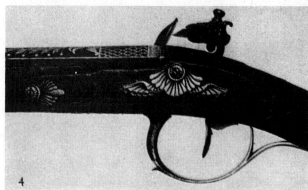
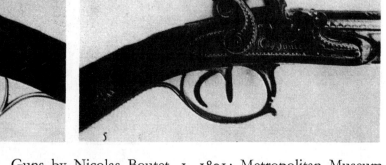

France, Versailles and Paris. 1800–20.

Guns by Nicolas Boutet. 1. 1801; Metropolitan Museum of Art 36. 58. 2 and 4; Jacobi Collection Stocksund (Sweden). 3 and 5; Brussels, Musée de la Porte de Hal 3151.

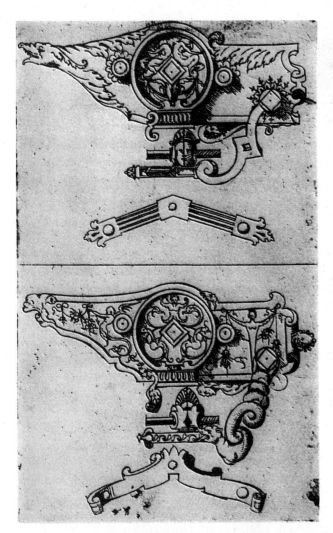

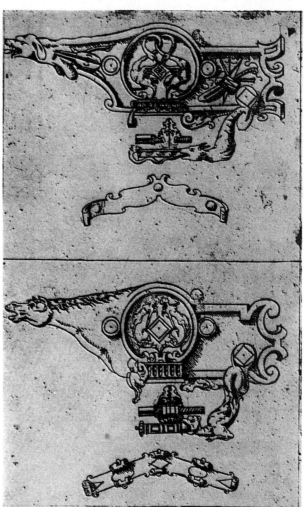

Plate 101.

2

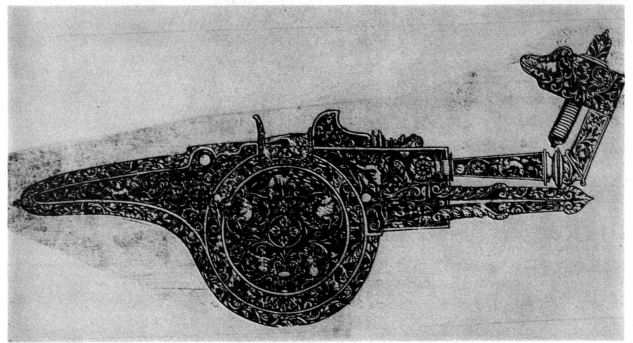

France.
Late half of sixteenth early seventeenth centuries.

Patterns for wheel-lock decoration. 1 and 2. Androuet Du Cerceau's school; Ex. Berlin, Staatliche Kunstbibliothek O.S. 1326. 3. By 'M.N.' the monogrammist; Ex. Vienna, Staatliches Kunstgewerbemuseum.

Plate 102.

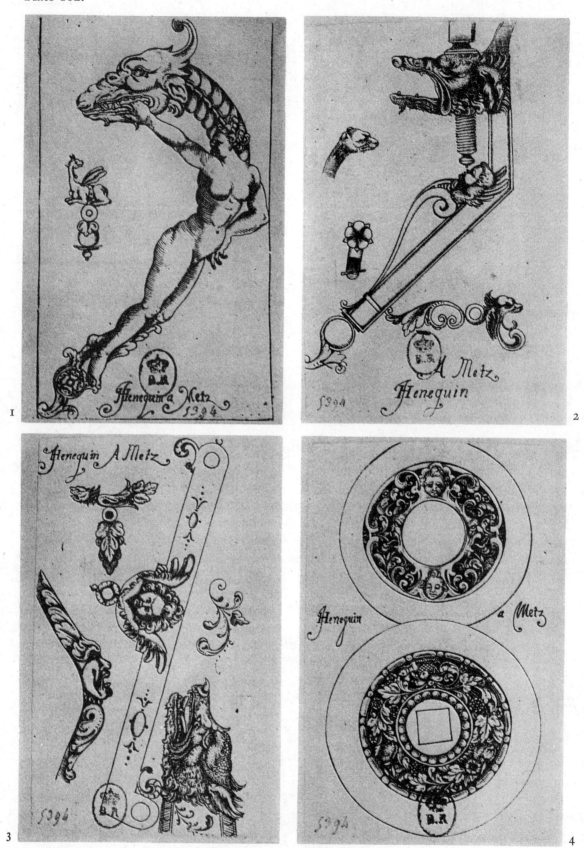

France, Metz.
c. 1620.

Jean Henequin, patterns for decoration of wheel-lock weapons; Ex. Paris, Bibliothèque Nationale, Cabinet des estampes, Vol. Le 24.

Plate 103.

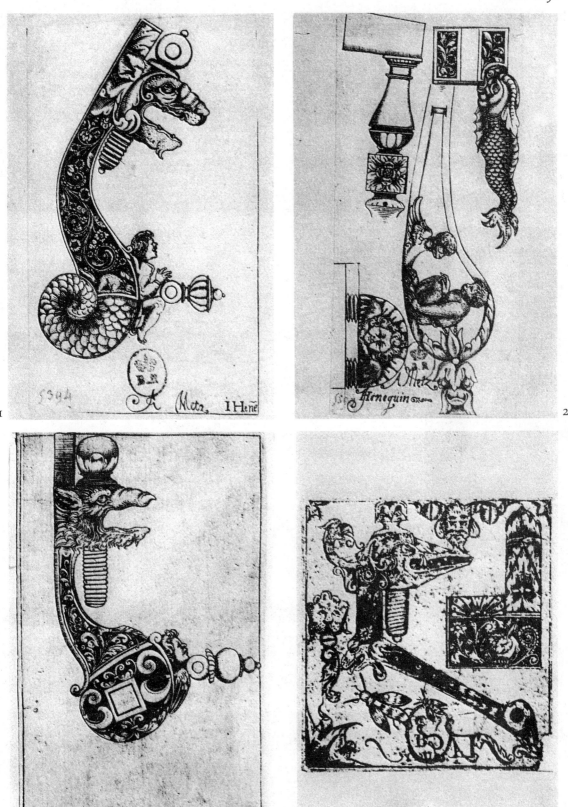

France, Metz and France. Jean Henequin. 1. Pattern for flintlock cock (?) for wheel-
c. 1620. 1630–40s. lock weapons. From same series as the patterns on Pl. 102.
3. Pattern for flintlock cock (?); Ex. Hamburg, Kunstge-
werbemuseum. 4. Pattern called 'La Guere'; Ex. Paris,
Bibliothèque Nationale, Cabinet des estampes, Vol. Le 24.

Plate 104.

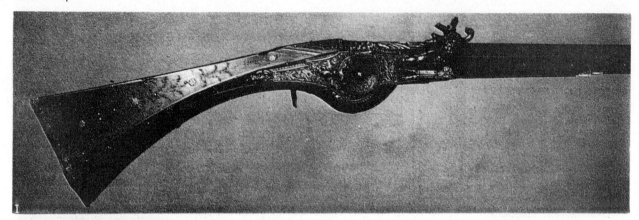

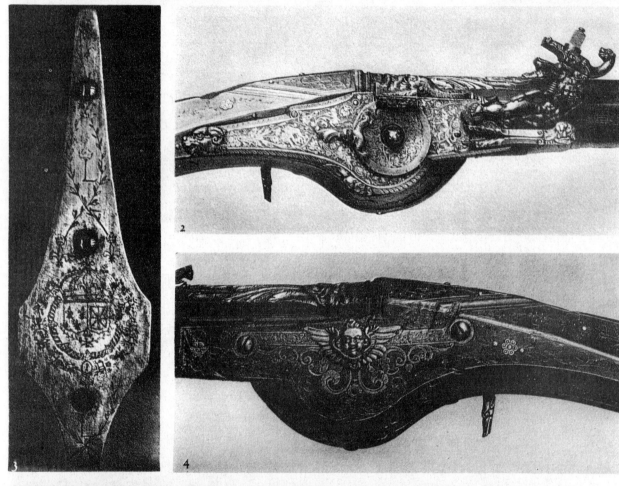

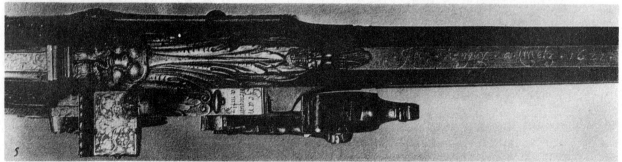

France, Metz.

Louis XIII's wheel-lock gun by 'Jean Henequin à Metz 1621'; Munich, Bayerisches Nationalmuseum 1733.

Plate 105.

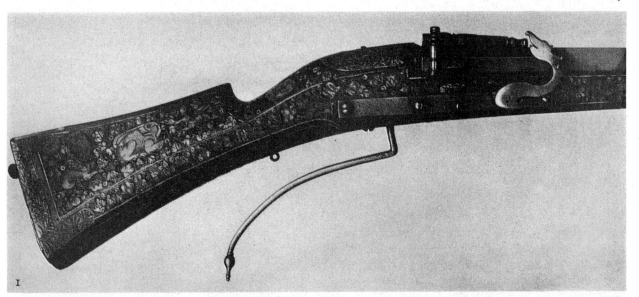

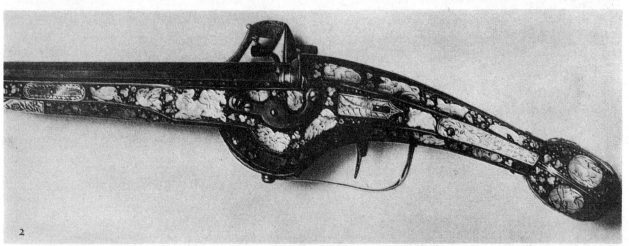

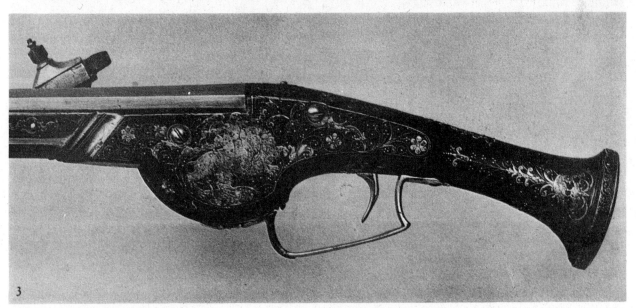

Western Europe.
End of sixteenth and
beginning of seventeenth
centuries.

1. Matchlock musket; Kasteel Doorwerth, Het Leger museum, sal Willem III, No. 3. 2. Wheel-lock pistol; London, Wallace Collection 840. 3. Wheel-lock pistol by Matteus Nutten of Aachen; Copenhagen, National Museum, Dept. II 21760.

Plate 106.

Germany (?)
Early seventeenth century.

Box with bone inlay; Paris, Musée de Cluny 21366.

It looks as if these round-faced locks were common after the middle of the eighteenth century. Locks with flat shapes still occur at the same time.

French flintlock manufacture experienced a last brilliant period during the first Empire. Gunsmiths with names one recognizes from the *ancien régime* worked in Paris, and in Versailles the manufacture was headed by the famous Nicolas Boutet. Two guns by Le Page can be mentioned as examples of Parisian manufacture. One is a Wender with most costly furniture, a gift from the Emperor Napoleon to King Frederick I of Saxony on 8 October 1808 during the Congress at Erfurt (Dresden, Gewehrgalerie Inv. No. 1891. Pl. 99:2), the second a single barrelled gun signed 'Le Page A Paris Arqer De L'Empereur' on the lock (Dresden, Historisches Museum Inv. No. 664/1. Pl. 99:3–5). The latter is the earlier. It must, however, be dated from after 18 May 1804, when Napoleon I declared himself Emperor of France. Many features of the eighteenth century can be recognized on this gun, although much has been changed. The barrel is round with an eight sided chamber, has a back-sight and is attached by slides. The lock is flat in form with a recessed rear end, the cock with a pronounced curve so that its middle section is horizontal when the lock is at half-cock. The steel-spring is very clumsy and has a marked notch at the foot of the front. The bridle of the pan is coarse and turned definitely upwards, the spur of the steel curves upwards so emphatically that its point acquires a downward trend. The steel-spring is longer, as is the front end of the lock-plate. The stock forms a flat border around the lock-plate. Behind the lock a palmette shaped leaf is carved. The small of the butt is now shorter and coarser, but the flange is still long and smoothly hollowed. The comb of the butt forms, in profile, a slightly upward curved line, and the underside of the butt curves in the opposite direction. The butt-heel was already pointed at an earlier stage. Now that part of the back below the lower screw of the butt-plate, is filled out so that the toe has become pointed and the entire butt-plate forms a flat, inturned surface. The ramrod-pipes are short and clumsy with rings at the ends and in the middle.

There were of course numerous gunsmiths in Paris during this period. We mention only Pirmet who signed a gun which is now in the Metropolitan Museum of Art and is dated 1809[41].

The arms to which Nicolas Boutet devoted his main interest during the period of prosperity of the Versailles manufacture are among the most costly ever made in France. The earlier ones possess the same characteristic features as the single barrelled gun by Le Page mentioned above. The French author Bottet has published a work on Boutet and his production. He deals in his text and illustrations with a number of the *de luxe* weapons from the factory. They cost their purchasers fantastic sums of money and were also presented as national awards. As specimens of this earlier manufacture can be mentioned a rifle and a double barrelled gun which are reproduced by Bottet under Nos. 37, 38[42]. Both were made during the Directoire and belonged to one of its members, Reubell. Bottet states that the sculpture in the stock behind the extreme end of the trigger-guard, which acted as a support for the hand in place of the sling, originated from the famous 'directeur-artiste' of the Versailles factory[43]. This addition to the butt soon becomes bigger and bigger and is to be found on Boutet's earlier guns in varying form. Cheek-rests are also to be noted on French arms from this period. The link connecting the hook of the mainspring and the spur of the tumbler is a novel feature. It helped to reduce friction. Magné de Marolles says in the editions of his book published in the years prior to his death in 1792, that these chain-locks were of recent construction 'dans ce dernier temps'[44]. Such locks usually have a friction roller on the upper arm of the steel-spring and a waterproof pan. The latter was a special form of pan devised to lead off rain water (cf. Pl. 100:5). It will be seen on the firearms signed by Boutet that the upper part of the cock with the jaws is set at a more acute angle in relation to the neck. This shape justifies still more its description as 'col de cygne'. Bottet also declares that Nicolas Boutet was

the originator of the very curved pistol butts and that this form became fashionable in the year III, i.e. 1794[45]. It may be remembered in this connection that a very curved pistol butt was usual in England throughout the eighteenth century, and that the duelling pistols which had been developed to such perfection in England at the close of the century had such butts, eight sided, heavy barrels, friction roller, waterproof pan and only a screw washer instead of a side-plate. The acute angle between the head and neck of the cock can be observed on English military arms of the close of the eighteenth century. In view of the marked English influence on French culture, for example in dress fashions, at the close of the eighteenth and the beginning of the nineteenth century there is every reason to ask whether the prototypes of the new forms of firearms of the Versailles factory should be sought on the other side of the Channel[46].

For knowledge of the arms manufactured by Boutet it is sufficient to study the extensive illustrations in Bottet's book *La manufacture de Versailles* quoted above. We only illustrate three weapons signed by Boutet which show the evolution during the two first decades of the nineteenth century. The top gun on Pl. 100 is dated 1801[47], the middle one (Pl. 100:2, 4) from the Jacobi collection, Stocksund, has already acquired a more pronounced nineteenth century character, whereas the bottom one (Pl. 100:3, 5) represents the latest forms of French flintlock arms. This double barrelled gun is signed 'N. Boutet à Versailles' on the barrels and is preserved in the Musée de la Porte de Hal, Brussels (Inv. No. 3151). A mark on the chambers with a fleur-de-lis stamped in gold implies that the gun was manufactured after the Restoration. But the signature also dates it from the period after 1818 when Boutet following on the lapse of his licence and other misfortunes fought an uneven struggle for his business and his art in Paris[48].

In general, French eighteenth-century flint-lock arms do not possess the artistic and mechanical worth of the preceding century. New constructions did not appear until the close of the century and they were perhaps borrowed from abroad. As products of industrial arts and crafts they display little advance right up to the Revolution. After the final brilliant period of the flintlock during the Napoleonic Empire the leadership was taken over by other countries, especially by England. The flintlock was at the same time ousted by the percussion lock.

When Louis XIV died, flintlock manufacture based on French prototypes had already gained ground practically all over Europe. In Spain local types put up a successful resistance. But in the Netherlands, England, Germany, Italy, Scandinavia and Northern Europe, the French fashion prevailed. In Germany Joh. Chr. Weigel published an edition of Guérard's pattern sheets in his own name. Among skilled gunsmiths, e.g. J. A. Köck of Mainz, direct French influence can be traced[49]. These countries, however, developed their own national style in different ways. In Sweden the German style derived from French sources was followed along with the purely French fashion. Earlier Swedish types give rise to variations which render the study of the flintlock arms of the Swedish eighteenth century interesting as well as difficult[50].

Editor's Notes

This important pair of pistols, in the design of which Jean Berain had a part, is fully discussed and illustrated by Dr. C. Hernmarck; 'Daniel Cronströms Gåva till Karl XI 1696', *Livrustkammaren*. Vol. 7. P. 203.

De Selier (or De Sellier) was, in fact, a Liège maker. A pair of pistols formerly in the author's collection bore his name with that of the town. Like Thiermay his style owed much to the designs of Nicolas Guérard.

* Thiermay was apparently a Liège maker and either had a retail outlet in Paris or put the spurious signature 'Paris' on his productions to make them more saleable.

† This whole group of firearms is of Liège origin—hence the difference in style from

the more fashionable Paris made guns, which were twenty years ahead. The dating to the 1720s is very probably correct.

Notes to Chapter Ten

1. Thieme-Becker, *Allgemeines Lexikon der bildenden Künstler*. B. XV. P. 215.

2. Livrustkammaren. *Vägledning 1921*. P. 90. No. 719.

3. Ehrenthal, *Führer durch die Königliche Gewehr-Galerie zu Dresden*. P. 43.

4. Communicated by H. R. H. Prince Louis of Hessen.

5. Boeheim, *Handbuch der Waffenkunde*. P. 658.

6. *Opis moskovskoj oružejnej palati*. V. P. 196.

7. [Boeck and Christensen], *Katalog over den historiske Vaabensamling paa Kjöbenhavns Töjhus*. Pp. 65, 86 (Nos. A 715, A 716, A 1560, A 1569, A 1573).

8. Smith, *Det kongelige partikulaere Rustkammer*. I. Pp. 24, 25. No. 16.

9. *Official catalogue of the Museum of Artillery in the Rotunda, Woolwich*. 1934. P. 54.

10. Robert, *Catalogue des collection composant le Musée d'Artillerie*. T. IV. P. 123.

11. Ehrenthal, *Führer durch die Königliche Gewehr-Galerie zu Dresden*. S. 81. Nos. 1835–43.

12. Grosz and Thomas, *Katalog der Waffensammlung in der neuen Burg. Schausammlung*. Pp. 237, 239.

13. [Binder], *Grossherzoglich sächsische Gewehrsammlung Schloss Ettersburg*. Versteigerung am 2. August 1927. Passim.

14. *Grosse Auktion. Mobilia . . . Waffen . . . Auktion . . . juni 1937 im Zunfthaus zur Meise in Zürich*. P. 161. No. 2517. Tafel XVII.

15. [Falise], *Le Musée d'Armes*. P. 241. No. E j 2.

16. Communicated by H. R. H. Prince Louis of Hessen.

17. Ehrenthal, *Führer durch die Königliche Gewehr-Galerie zu Dresden*. P. 45.

18. [Binder], *Grossherzoglich sächsische Gewehrsammlung Schloss Ettersburg*. Versteigerung am 2. August 1927. P. 6. No. 27.

19. Ehrenthal, *Führer durch die Königliche Gewehr-Galerie zu Dresden*. Pp. 43, 44.

20. [Aubert] de la Chesnay-Desbois et Badier, *Dictionnaire de la noblesse*. T. I. P. 977. A reservation must be made here for the ducal coronet on the thumb-plate as this seems to be very common in such a position and decorates several non ducal arms.

21. Ehrenthal, *Führer durch die Königliche Gewehr-Galerie zu Dresden*. P. 43.

22. Ibid. P. 45.

23. Magné de Marolles, *La chasse au fusil*. Illustration of mark.

24. Guiffrey, 'Logements d'artistes au Louvre'. *Nouvelles archives de l'art français*. II. P. 89.

25. Ehrenthal, *Führer durch die Königliche Gewehr-Galerie zu Dresden*. P. 68.

26. Livrustkammare. *Vägledning 1921*. P. 99. No. 796.

27. Magné de Marolles, *La chasse au fusil*. Pp. 65–67.

28. Boeheim, *Handbuch der Waffenkunde*. P. 657.

29. Laking, *The armoury of Windsor Castle. European section*. P. 84.

30. Cederström, 'Pistol- och stockmakaren Peter Rundberg i Jönköping'. *Svenska vapenhistoriska sällskapets årsskrift, 1926*. Pp. 1–11. Livrustkammaren. *Vägledning 1921*. P. 104. No. 846.

31. Malmborg, *Stockholms bössmakare*. P. 211.

32. Laking, *The armoury of Windsor Castle. European section*. P. 81.

33. Magné de Marolles, *La chasse au fusil*. P. 73.

34. Inv. No. M. R. 435. Barbet de Jouy, *Notices des antiquitets . . . composant le musée des souverains*. P. 179. No. 130.

35. *The Hallwyl Collection. Descriptive catalogue, Groups XXXIV and XXXV*. Pp. 294–97. Illustrated in an accompanying volume.

36. Magné de Marolles, *La chasse au fusil*. Illustration of mark and pp. 73, 74.

37. Ibid. P. 63, note.

38. Ibid. Illustration of mark.

39. Livrustkammaren. *Vägledning 1921*. No. 825.

40. Magné de Marolles, *La chasse au fusil*. Pp. 74, 75.

41. Grancsay, 'A presentation fowling piece'. *Bulletin of the Metropolitan Museum of Art.* 1928. Pp. 246–49.

42. Bottet, *La manufacture d'armes de Versailles.* P. 57 and unnumbered illustration.

43. Ibid. P. 45.

44. Magné de Marolles, *La chasse au fusil.* P. 36.

45. Bottet, *La manufacture d'armes de Versailles.* P. 42.

46. George, *English pistols and revolvers.* Pp. 68, 71 and 72. Pl. VII–XI. Greener, *The gun and its development.* P. 100. (Duelling pistol 1789.)

47. Grancsay. 'A Versailles gun by Boutet, directeur-artiste.' *Bulletin of the Metropolitan Museum of Art,* 1936. Pp. 163–66.

48. Bottet, *La manufacture d'armes de Versailles.* P. 35.

49. Gun, dated 1740, in Musée de la Porte de Hal, Brussels. Inv. No. 2484.

50. Cf. Lenk, 'Notser kring några flintlåsvapen i Kulturen'. *Kulturen, Årsbok* 1938. Pp. 118–35.

CHAPTER ELEVEN

The decoration of French firearms during the earlier half of the seventeenth century

DATING BY FORM is in itself an art-historical method. The word style has often been mentioned on previous pages and the decoration of firearms has in some instances been given prominence. The illustrations show that the better-quality fire-arms can be accepted as examples of applied art, some of a very high standard. Gottfried Semper's complaint[1] that there was no adequate art-historical study of the treasures of the arms museums is now no longer fully justified. There is nevertheless still some ground for it*.

Since the close of the nineteenth century art-historical study has, however, been applied to weapons. Amongst the earlier publications is Hans Stöcklein's book *Meister des Eisenschnittes* in which the author treats a richly decorated South German group of arms, and more recently the contributions made by Post, Klapsia and Thomas[2] to the history of arms as a branch of the general history of art. Thomas has studied the sources of the decoration of a gun amongst engraved ornament. In doing so he dealt with a subject very close to this treatise[3].

The originator of the art-historical treatment of the branch of the history of arms covered by this thesis is Wendelin Boeheim. In his article 'Die Luxusgewehr Fabrication in Frankreich im XVII und XVIII Jahrhundert' quoted above, in *Blätter für Kunstgewerbe*, Vienna 1886, and in *Meister der Waffenschmiedekunst* this aspect often finds expression. This is especially so in the article in which Boeheim lists the various pattern books for gunsmiths, and endeavours to solve the question of the connection between the patterns and the weapons. Research, rendered possible by the greater availability of engraved ornament collections, has led to amendments of Boeheim's opinions, but one cannot but admire his pioneer work.

This treatise cannot claim to change present views on the development of style. The writer hopes on the other hand that he has been able to attribute the weapons and the designs in accordance with the accepted system and also to extend our knowledge of the relationship between extant arms and engraved pattern books.

The pattern books for gunsmiths are almost

without exception French or derive from French originals. They begin as early as the third quarter of the sixteenth century. Two sheets with two wheel-locks each (Pl. 101:1, 2) date from this period. They belong to a series of patterns for door locks, keys, key hole escutcheon, door handles, etc., which is represented both in the Bibliothèque Nationale, Cabinet des Estampes, Paris (in volume 'Le 24') and in the Staatliche Kunstbibliothek, Berlin (O. S. No. 1326). This series belongs to the larger number of pattern engravings attributed on various grounds to Jacques Androuet Ducerceau. They do not attain the elegance of his manner even if the grotesques in them resemble those in Ducerceau's series of small sheets of 1550[4].

The artist who executed these drawings had no knowledge of firearms construction. Even if we regard them as reversed the ornaments are still upside down. It is at any rate clear that the artist meant to represent French wheel-locks and we thereby obtain definite proof that this construction existed in the French sphere of culture shortly after the middle of the sixteenth century. This cultural sphere need not necessarily coincide with French political boundaries. A comparison with the short gun with a French lock in the Armería, Madrid (Inv. No. K 62, cf. p. 3 above) published by Hoopes shows that the artist used this lock construction as his basis. This in turn suggests its existence in the French sphere of culture even before the middle of the sixteenth century. On these sheets the lock-plates terminate at the rear with monsters' heads. This may be regarded in this case as an influence of the grotesque style. But these animal heads cannot fail to remind us of locks dating from *c.* 1620 and before, and also about the middle of the seventeenth century, which we encounter in the north-east of France and in the group decorated in relief (dealt with in Chapter Six). The sculptural design of the cocks reminds one of the form used by Jean Henequin of Metz in the 1620s (cf. p. 32 and Pls. 102, 103). All this may locate the designs in the north-east of France and consequently the Armería gun as well. This would not be surprising as the Madrid gun dates from the reign of Charles V and this Emperor held Burgundy as a hereditary possession. The fact that the French wheel-lock could thereby be located nearer the actual country of origin of the wheel-lock would be a satisfactory result. The stock of the gun in Madrid is, like German arms, decorated with inlays of engraved horn or bone. This also applies to the pistols in the Metropolitan Museum of Art (Inv. No. 14.25.1433)[5] and the gun No. M 66 (p. 3)[6] of the Paris Army Museum. All provide evidence of affinity to German gunmaking customs. Mother-of-pearl and metal are added to the vocabulary of decoration at the close of the century. The former was used in France in exceptional cases as late as the 1630s and 1640s†, as were also horn and bone. But metal, especially silver, becomes the dominant material at an early stage and continues to be so.

The decoration of French wheel-lock arms provides interesting examples of Classic features. Some of these are of exactly the same kind as certain elements in the decoration of the ceilings in the rooms dating from Henry II's period at Fontainebleau. The decoration of French wheel-locks derives—one might perhaps say principally—from German sources. This decoration is characteristic of French firearms for a long time ahead. In many cases the technical execution is French in its superior clarity and precision even if the ornament has been borrowed from external sources.

Before proceeding further it is necessary to remove Anthoine Jacquard from consideration. Boeheim mentions him as the first French artist to have engraved pattern sheets for gunsmiths[7]. This is probably due to the wrong title on the back of volume 'Le 23' in the Cabinet des Estampes, Paris, 'Arquebuserie par Jacquard' and to Guilmard's statement that some designs in this volume should perhaps be attributed to Jacquard[8]. 'Le 23' does not contain any sheets with gunlocks by this master. The title and the year 1624 given by Boeheim still remain unexplained. For the time being Jacquard must be omitted from the list of pattern engravers for gunsmiths. This we do with regret because his designs for sword hilts are of a high standard both technically and aesthetically.

In Jacquard's place and considerably earlier comes the unknown artist of the sheets just mentioned. Immediately after him we must place the monogrammist 'M N' whose only known work is a sheet with a wheel-lock in the Staatliches Kunstgewerbemuseum, Vienna (Pl. 101:3)[9]. Details for a wheel-lock, cock, pan, wheel-guide and some decoration are also reproduced on a sheet marked 'La Guere' in volume 'Le 24' in Cabinet des Estampes, Paris (Pl. 103:4).

Among the French engravers of gunsmiths' patterns is Jean Henequin (cf. pp. 33–34). He worked in Metz about 1620. A sheet signed by him is in the Kunstgewerbemuseum, Hamburg (No. O. 1905:226. Pl. 103:3) and there are six in the Cabinet des Estampes, Paris (in volume 'Le 24'. Pl. 102 and 103:1, 2) five of which give details of wheel-locks and two cocks probably intended for the earliest flintlocks. Philippe Cordier Daubigny also belongs to these earlier French engravers of gunsmiths' designs.

The cock on the sheet signed 'La Guere' is of so late a type that it can be dated from the 1630s if not later. It is not of great interest and its artistic qualities are not such that it deserves further space. It suffices to point out that the decoration of the pan-cover derives from Flemish ornament of the early seventeenth century.

The monogrammist 'M N', on the other hand, was a more experienced engraver though he lacked the urge to raise his artistic talents to any higher degree of refinement. In contrast to the unknown sixteenth century engravers he fully understood construction of the lock and he illustrates distinctly a French wheel-lock of the late sixteenth or early seventeenth century. Of the large number of weapons with French wheel-locks discussed in the earlier part of this treatise extremely few locks have the same kind of decoration as the sheet in Vienna. This engraver on the other hand is clearly associated with the ornamentation of the stocks on a group of pistols with French wheel-locks that are to be found in several ancient armouries and which seem to have been fashionable at the beginning of the seventeenth century[10]. A lavishly, but not particularly artistically, inlaid

matchlock musket No. 3 in the William III Room in Kasteel Doorwerth at Arnhem, Holland (Pl. 105:1) can be included in the same group on account of the stock inlay. The material is engraved horn or bone, partly coloured green. The surface is almost entirely covered with flowers, leaves and small round fruits. Among these are large plaques cut in the shape of animals. The barrel-tang is surrounded by larger plaques engraved with leaves and flowers on coiling thin stalks. This same decoration is to be found on the Livrustkammare pistol No. 1602[11], on a very characteristic pistol in the Wallace Collection No. 840, formerly in the San Donato Collection (Pl. 105:2)[12] and on the pattern sheet in Vienna. It is most distinct on the neck of the cock, in particular on the part on which the lower jaw slides, a part which is otherwise only decorated in exceptional cases. Similar to this is the arabesque on the margin of sheet by the monogrammist 'M N'. Laking rightly dates the pistol from about 1605. If we seek further evidence for dating this group of weapons it can be found on a knife in the Louvre dated 1608 (no number). The handle is inlaid in brass in thin wire like stalks with tiny leaves, a decoration which is also to be found on the Livrustkammare pistols (Inv. Nos. 1578, 1579)[13] for example.

There are a number of stockmakers who decorated objects other than gun and pistol stocks, when they had the opportunity to make use of their material and technique. A casket in the Musée de Cluny, Paris (Inv. No. 21 366. Pl. 106) is an example. According to the inventory it is German of the seventeenth century[14]. There are similar caskets in several collections[15]. The most important is that in the Wallace Collection (Inv. No. 111:2): this is signed 'fait en Massuuaux par Jean Conrad Tornier Monsteur d'harquebisses. L'an 1630'. Its decoration is typical as regards both materials (mother-of-pearl, bone and metal) and designs‡.

Massevaux in southern Alsace was still a German town in 1630. It is situated near the upper course of the Moselle. On this river are the towns of Epinal, Nancy and Metz, and on

the Meurthe, a tributary of the Moselle, Luné-ville. All were centres for the manufacture of arms from an early date. The decoration of arms was general within this area, but inlay-work of the same or a similar kind can also be found in southern Germany, as on a gun of the beginning of the seventeenth century in the Livrustkammare (Inv. No. 4732)[16]. Its stock is signed by Hieronymus Borstorffer of Munich[17].

The material of the inlays is chiefly bone, horn, and mother-of-pearl. Tornier also used metal. Similar ornament in silver inlay can be seen on a pair of pistols in the National Museum, Copenhagen (Dept. II, Inv. No. 21760. Pl. 105:3). They bear the mark of the Aix la Chapelle master Matteus Nutt(en) (a stag's head)[18] and the initials 'M N' on the barrels. This ornament is characterized by fixed centres surrounded by spirals.

In his sense of form the monogrammist 'M N' is anything but French. A Gothic touch that recalls the engravings of the master 'E. S.' is expressed in the trailing arabesques rising symmetrically from a Renaissance vase with hunter, dog, game, and falcon. The decoration of the lock-plate is, perhaps, even closer to the Gothic by reason of its dense trailing orna-ments with figure subjects. This kind of ornament still survived at the middle of the seventeenth century in Hendrik Janssen's borders for the edges of dishes. We shall also find that this style with its Nordic inspiration still dominates within the area covered by this treatise until the general break through of Classical forms after the middle of the century.

The floral and foliage decoration on the neck of the cock on the Vienna sheet is found in very similar form on two engravings in a series by an unknown Netherlands artist (Pl. 107:2, 3)[19] of the beginning of the seventeenth century. These ornaments cover a long, narrow horizontal area bordered by a ribbon on the upper edge of the engraving. The central group on this engraving, and on other sheets from the same series, consists of birds perched on a bunch of fruit and naturalistic flowers suspended from a ribbon, triangular flower motifs, animals or lilies in the spandrels and, on both sides below the large central group,

smaller animals on bunches of fruits and flowers. Michel Le Blon published in 1611 a series of engravings with the same arrangement (Pl. 107:1) but composed of other elements[20]. Similar details also recur in other masters at the same time and in the same field. According to Jessen[21] its origin can be found among the silver engravers of Nuremberg during the last quarter of the sixteenth century. In the earlier half of the seventeenth century this type of ornament was a favourite source for arms decorators.

The French manufacture of firearms during the first half of the seventeenth century lies on the borderline between the two large southern and northern areas. Traces of both these main trends in decoration occur at times on the same weapon. This is the case with the gun in the National Museum, Munich (Inv. No. 1733. Pl. 104, cf. p. 33), signed by Jean Henequin of Metz in 1621. We find on the lock-plate the foliate ornament inhabited by figures, hunters, dog, and animals, in this case a wild bull jumping over or attacking a prostrate man. On the wheel are symmetrically arranged vines emerging from a grotesque faun together with hares and a worm. The side-plate is obviously designed under the influence of the engraved ornament of Le Blon and contemporary Dutch artists. It consists of a cherub's head in relief flanked by lateral panels with trailing vines and curved scrolls below. A side-plate on one of Henequin's engravings in the Cabinet des Estampes, Paris, is of similar design (Pl. 102:3). On the actual rib, however, instead of trailing vines are arrangements of lines and dots in the Fontainebleau manner. This graceful style is still more pronounced in the inlaid stock dating from 1621 (Pl. 104:1). Its decoration is typical of French influence on western European fire-arms manufacture. An important feature is the small-leaved laurel, common in Italian arabes-ques and especially in their French and Nether-landish offshoots. This laurel is used profusely on certain sheets by Cornelis Floris and Hans Vredeman de Vries, and also on French book-bindings dating from Henry II's reign[22]. It is particularly common on French wheel-locks of about 1600 and shortly after. At first the

Plate 107.

1

2

3

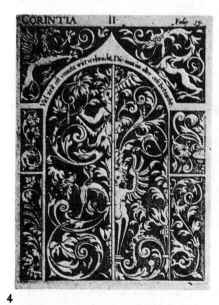

4

CORINTIA II Fol. 19.

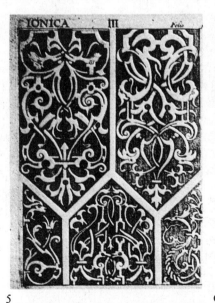

5

IONICA III Folio

6

CORINTIA III Folio 28

Western Europe.
Early seventeenth century.

Patterns for silver engraving. 1. By Michel le Blond.
2–3. By unknown artist. 4–6. Krammer, Schweiff-Bvchlein;
Ex. Berlin, Staatliche Kunstbibliothek O.S. 742, 1014, 1173.

Plate 108.

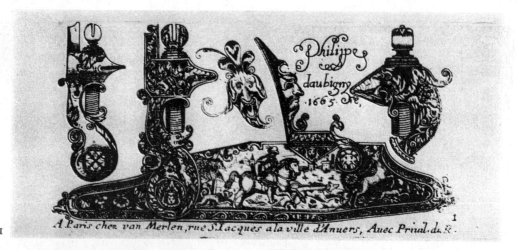

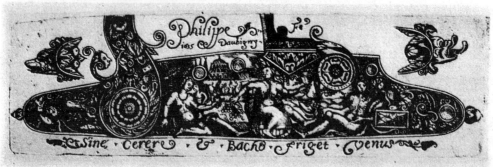

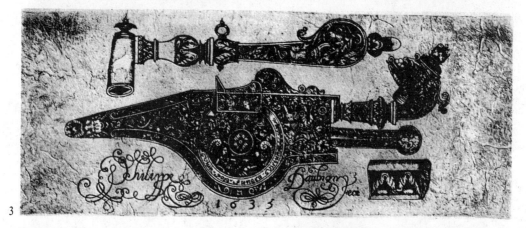

France.　　　　　Philippe Cordier Daubigny, patterns for firearms decoration. 1. Date changed from 1635 to 1665; Ex. Vienna, Staatliches Kunstgewerbemuseum. 2; Ex. Stockholm, Livrustkammaren. 3–5; Ex. Pauilhac Collection, Paris.

Plate 109.

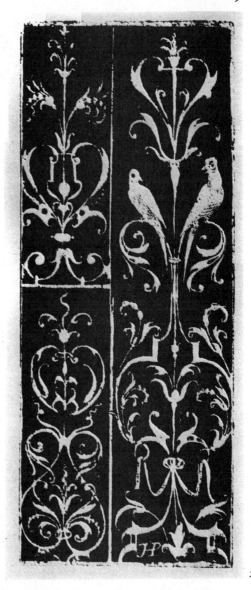

1

2

3

France, Paris.
1638.

Thomas Picquot, *Livre de diverses ordonnances* . . . Paris
1638; Ex. Berlin, Staatliche Kunstbibliothek O.S. 812.

Plate 110.

1

2

3

France, Paris.
1638.

Picquot, three sheets from same series as Pl. 109.

treatment is naturalistic but during the reign of Henry IV it becomes very small and finally disappears in a mere conglomeration. The leaves are very small on the Henequin gun. The broad sides of the comb of the butt are adorned with highly stylized plants executed in a precise fashion. They spring from a vase, within a framework formed by thin-lined silver ribbons inlaid in the wood edgewise. Stamped flowers and studs are driven along the centre line of the design. The other surfaces of the stock are decorated in the same technique with running scrolls or—as on the fore-stock—with short sprays arranged symmetrically. On butts of this type the edge is often accentuated on one side. Here it is done with a silver plate with stamped decoration consisting of palmettes, laurels and trophies under canopies. The same stamped plates are found on three pairs of wheel-lock pistols in the Historisches Museum, Dresden (Inv. Nos. F 280–283)[23]. This may be one of the starting points for the future investigation of French wheel-locks. This use of stamped silver plate as a decoration for firearms can be traced still further back with the wheel-lock pistol No. O 5010 in the Musée de l'Armée, Paris (No. 221 in the Inventory of the French royal *Cabinet d'Armes*)[24], and with a magnificent partisan in Windsor Castle[25] both from royal French ownership.

Having established this association with French sources in the decoration of the gun in Munich, it is less surprising to find on Jean Henequin's engraving with the earliest flintlock cock (Pl. 103:1), a scrolling decoration with volutes adorned with a compact row of beads, of the kind we recognize from the engraved ornament of Theodor de Bry or Anthoine Jacquard or from Netherlandish ornament of the beginning of the seventeenth century (Adriaen Collaert, etc.). This ornament derives from these sources and we can also find among them trailing vines with the same thin stalks as on the inlays of the French hand firearms. Before leaving the subject of Jean Henequin's ornament mention should be made of two wheels on one of the sheets in Bibliothèque Nationale, Paris (Pl. 102:4). One is embellished with symmetrical trails, inhabited

by figures growing from a vase, the other with scrolling and trailing plants. This latter decoration is also on the sheet with the flintlock cock in Hamburg.

The wheel-lock dogs, the heads of the flintlock cocks, the rear terminal of the lock-plate, etc., are chiselled in relief, both on the gun in Munich and on the pattern engravings. This predilection for sculptural relief is perpetually being encountered in the borderland between north and south and deserves to be noticed and remembered.

In studying the decoration of French firearms of the beginning of the seventeenth century we come to the conclusion that the elements of this decoration have been borrowed from widely differing sources, including some which originally had little or nothing to do with the decoration of arms. We have seen how the stockmakers decorated objects other than weapons and it is to be assumed that persons from other crafts contributed in producing guns and pistols. Artists like Marin Le Bourgeoys were more independent and were able to carry on their profession without interference from officialdom by the grant of living quarters in the French royal palace.

According to an ordinance relating to the Paris gunmakers which is dated September 1576, and was supplemented on 4 May 1634[26], the latter were entitled to decorate their products with engravings and chiselling in any kind of metal whatsoever. Jean Henequin was apparently gunsmith and decorator in one and the same person. We know that at a much later period the gunsmiths enrolled the help of professional engravers[27] and it can be assumed that this was an expression of a very long tradition. There is every reason to believe that the engravers who signed patterns for gunsmiths also decorated guns.

The oldest engraved patterns with complete locks that can definitely be defined as flintlocks are signed by Philippe Cordier Daubigny. Boeheim devotes one of the monographs in *Meister der Waffenschmiedekunst*[28] to him. In his paper 'Die Luxusgewehr-Fabrication in Frankreich im XVII und XVIII Jahrhundert' he wrote some brief notices on Daubigny and pub-

lished one of his engravings which he regarded as a flintlock cock[29]. Stöcklein made a summary of the printed sources on Daubigny[33] and Post used this summary when publishing a pair of wheel-lock pistols in Zeughaus, Berlin, signed 'Isaar Cordier à Fontenai'[31].

Aubigny is the name of two places in Flanders, but there are also five places so named in the vicinity of Paris[32]. There is also one in Belgium near Tournai and one in Vendée. Stöcklein considers that Cordier worked in Paris[33]. Research in archives might definitely solve the question of the Cordier family's origin. It may be assumed that Philippe and Isaac belonged to one and the same family of gunsmiths. There is definite evidence for them both in pattern books and firearms. The mysterious Jean only occurs in Boeheim's statement which is based on a notice by another person concerning a rubbing in the Institut de France in Paris[34]. Both this rubbing and the many impressions of lock-plates mentioned in this connection have been proved to be non-existent. Boeheim's informant was probably thinking of the collection of rubbings in the Bibliothèque Nationale (Cabinet des Estampes), where the sheet illustrated here (Pl. 14:4) signed 'P. Cordier' is preserved.

As Post has pointed out, the numbered sheets signed by Philippe Cordier in the Staatliche Kunstbibliothek, Berlin, belong to a later edition that was published by Van Merlen in Paris in the 1660s. The original states of these sheets bear dates from 1634 to 1637 and another the date 1644[35].

There are sixteen sheets in the Staatliche Kunstbibliothek. Two of them are photographic copies from an original preserved elsewhere. In addition one of the photographs is a duplicate[36]. Only eleven are firearm designs and of these four are for flintlocks. Post illustrates the three most important of the wheel-lock engravings, among them the only sheet with a complete lock[37]. On the edge of the wheel it bears the inscription: 'Vivit post funera virtu[s]'. Its original date is 1635; this is shown on a copy in the Pauilhac collection (Pl. 108:3). If it were to be dated by the cock we should look back to the sixteenth century. The decora-

tion is of exactly the same kind as that on the monogrammist M.N.'s sheet in Vienna and on Jean Henequin's gun in Munich. We have already noticed a preference for flowers in their ornament. This finds striking expression in another sheet (Pl. 108:4) which shows a highly 's' curved side-plate with an almost circular, distinctive widening in the middle. All Daubigny's wheel-lock cocks and most of the flintlock cocks have the jaws designed as monsters' heads. Among the flintlock sheets there is only one that illustrates a complete lock, that used by Boeheim to illustrate the monograph in *Meister der Waffenschmiedekunst*[38]. The reproduction shown here from the original in the Museum für angewandte Kunst in Vienna (Pl. 108:1)[39] depicts two cocks, a wheel-lock cock which Boeheim has included, and a flintlock cock which has been excluded. We find in the decoration of the lock-plate that the figures, which were usually included in the trailing vines, have been replaced by scenes with horsemen and dogs in a landscape, whereas the pursued stag and a dog retain their place among the vines outside this scene. On another sheet, whose original date 1635 and the motto 'sine Cerere et Bacho friget Venus' can be read on the specimen in the Livrust-kammare (Pl. 108:2), the scene is made up of figures from Classical sources. The figures enclosed within the vines are replaced by a lion killing a dog. Another sheet dated 1634 (Pl. 108:5), showing the rear part of a lock-plate, contains still another hunting scene.

The rest of Daubigny's engravings do not give us much more in the way of ornament. Among them two figure scenes, a heraldic shield with a sun and three leaves and two bold acanthus arabesques can be observed.

Philippe Cordier Daubigny's style belongs to the northern group based on Netherlandish sources with which we have already become acquainted. In other respects his artistic qualities are insignificant. His role as an artist or practising decorator of firearms cannot be judged. He seems chiefly to have been an average French arms decorator of his age but not an originator. The only known example of his work as a practising decorator is the

rubbing of a lock-plate in the Bibliothèque Nationale in Paris referred to above. The signature on this rubbing is of exactly the same kind as on the pattern sheets. In date this rubbing must be earlier than the latter. The subject of the decoration is Orpheus playing to the wild beasts, an early example of a type which becomes more and more common during the first half of the seventeenth century. The treatment is primarily naturalistic with suggestions of highly stylized vines.

The signed pairs of pistols in the Berlin Zeughaus and the Pauilhac collection, Paris, are decorated in the same style as Philippe Cordier Daubigny's engravings. In date they should be placed closer to the middle of the century than Post puts them, the flintlock pistols in the Pauilhac Collection even to about 1650.

In Thomas Picquot's *Livre de diverses ordonnances*, issued in Paris, 1638 (Pl. 109, 110), we find designs for the decoration of locks, mounts and barrels. In order to comprehend this decoration properly we must turn back to the Lisieux group of firearms. The engraving here is confined to details of the inlay on the stocks, whereas the locks and mounts are etched and the barrels decorated with gold damascening on a blued ground. The inventory of the French royal *Cabinet 'd Armes* often refers to gold ornament against a 'couleur d'eau'. The beautifully drawn trailing vines on the arms by Marin Le Bourgeoys in the Musée de l'Armée, Paris, still show up against a clear blue colour with a very striking effect.

Damascening is carried out by roughening a metal surface with a sharp instrument and then hammering on thin gold foil. Both technique and patterns are considered to have come from the Orient at the beginning of the sixteenth century by the familiar routes via Venice and Spain. The ornaments were abstract moresques and flowers and sheaths springing from the same slender stalks as the moresques. After the middle of the sixteenth century these moresques are combined with the scrolls, thus giving rise to a type of surface decoration which is called 'Schweif' in German, meaning a tail. This ornament is considered to have originated with

the silver engravers in Nuremberg: it was exploited by Georg Wechter and Paul Flindt and their contemporaries. The Dutch Adriaen Muntinck and others exploited the style and it finally reached France. It can be combined with other kinds of ornamentation to form 'Schweif'—grotesques, etc.[40]

The decoration of the barrel on the gun in the Hermitage Museum, Leningrad (Pl. 8), signed by Marin le Bourgeoys, is very similar to the moresque and is executed in the technique mentioned above. The same kind of technique and ornament but more European in character and with grotesque features embellishes the barrel of the flintlock gun (Inv. No. M 435) also signed by 'M le bourgeoys' in the Musée de l'Armée, Paris. It is also etched with a recessed ground on the butt-plate, trigger-guard, and lock-plate (Pl. 12:3–6). By reference to this gun one can attribute to Le Bourgeoys the decoration of the early flintlock gun (Inv. No. M 529. Pl. 11:1,2, 12:1) in the same museum and of the matchlock gun No. M 369 (Pl. 12:2). The latter is of a particularly lavish character. The former follows the design of No. M 435. This talented painter of Lisieux used the same kind of 'Schweif' grotesque decoration on the signed gun in Paris and on the matchlock gun. For the butts he has used in the one case gold on a blue ground, in the other case a red ground. On M 529 we find in the same place a dolphin painted in gold. Otherwise the decoration of the stocks is confined to very thin, inlaid silver lines which follow the edges of the butt and the fore-stock up to the muzzle.

We find Marin Le Bourgeoys' typical 'Schweif' on the lock-plate and etched on the trigger-guard, and other parts of the Hermitage Museum gun (Pl. 8). For the decoration of the plates on the sides of the small of the butt he has used the same technique but also shows that, as regards ornament, he possessed a knowledge of the forms which the Fontainebleau style borrowed from Italy.

The inlaid work on the stock is also worthy of notice. The material is metal and mother-of-pearl in extremely precise and bold design, symmetrical 'Schweif' ornament in which the

moresque element is distinctly prominent. Some of the leaves are executed in dashes; mother-of-pearl has been used for flowers and fruits. Some small leaves similar to the laurel mentioned above occur in this decoration, though very sparsely. Comparison with the inlaid work on the stock of the early flintlock gun in the Renwick Collection (Pl. 9) suggests that both were done by the same hand. The large areas on the sides of the butt—the place where the decoration of the guns in the Musée de l'Armée is painted—are treated in the same manner. A grotesque monster's head, birds, a hair, and a snail have, however, been executed in engraved silver sheet. This ornament is no other than a modified 'Schweif' technique as we know it from the etched metal surfaces and the pattern sheets of the ornament engravers.

Similar compact ornaments in which moresque details are prominent also decorate the barrel of the gun in the Renwick Collection and that of a wheel-lock gun in the Wallace Collection (Inv. No. 1133. Pl. 13:3, 4). The double barrelled pistol in the Paulhac collection (Pl. 13:1, 2) provides a variety of Marin Le Bourgeoys's ornaments executed in his particular technique and embraces in a single unit the group with Marin Le Bourgeoys's signature and that with the mark containing the initials 'I. B.' which it has been suggested was used by Marin's brother Jean. The pair of pistols No. 211 in the inventory of the French royal *Cabinet d'Armes* (cf. p. 31) also belongs to this latter group. The same ornament appears on this but on a smaller scale, especially on barrel and pommels.

Within the Lisieux group the development of ornament can be traced from the stiff precise stage on the last mentioned pair of pistols to freer 'Schweif' and trailing vine ornaments in combination with grotesques on the signed gun of the 1620s in the Musée de l'Armée (Inv. No. M 435. Pls. 11:3, 12:3–6). This development takes place over a period of some thirty years. Among contemporary ornament engravings there is a series which greatly resembles these last, viz. Gabriel Krammer's *Schweifbüchlein*, printed in Cologne by Johan Bussemacher in 1611 (Pl. 107:4–6). Krammer describes himself

on the title page as a carpenter. Certain of his patterns are obviously intended to be prototypes for intarsia, a surface decoration which largely coincides in its effect with gold ornamentation against a blue ground or with 'Schweif' ornaments based on an enamel technique. The fact that this kind of ornament is better represented in German pattern books than in French ones is probably a mere coincidence. We may quote as an example of its occurrence in French territory the painted decoration in Château d'Ansy-le-Franc and in Château d'Orion, both of the middle of the sixteenth century[41]. The former in particular provides splendid opportunities for comparison with the ornament of Le Bourgeoys.

Krammer's *Schweifbüchlein* also contains sheets with floral decoration that is perhaps intended to be at least partly naturalistic. This is typical of the period. In the ornament derived from Germany (cf. Pl. 107:1), followed by the decorators of west European firearms at the beginning of the seventeenth century, stylized flowers were common. Naturalistic flowers occur also in the work of Abraham De Bruyn and Theodor de Bry and in ornament in their manner. The Baroque style made much use of these naturalistic forms and they are to be found to an increasing extent until the middle of the seventeenth century. In Paris Jean Robin made a garden with exotic flowers which could serve as examples for craftsmen. This garden, the first of its kind, was taken over by Henry IV and a publication with seventy-three foolscap pages of exotic flowers was issued in Paris in 1608 by Pierre Vallet, 'brodeur ordinaire du Roy', with the title *Le Jardin du Roy très chrestien Henry IV*[42]. The lavish use of naturalistic flowers on embroidery during the beginning of the seventeenth century, on gloves for example, must undoubtedly be viewed against this background, but this lies beyond the scope of this treatise. This work can be mentioned, however, as an expression of French interest in naturalistic flowers at the beginning of the seventeenth century, as well as the remarkable transformation of 'Schoten' into naturalistic flowers which takes place in the 1630s[43]: this

can be studied in Delabarre, Hedouyns and Lefebure.

A panel of flower designs very similar to those in Krammer's *Schweifbüchlein* is to be found on a sheet in Thomas Picquot's pattern album (Pl. 109:3). The complete title of this album is: *Livre de diverses ordonnances de fevillages morseqves toutes nouuelles et non encore usitée en France pour l'enrichisement du fer et de lacier propre aux arquebuziers forbisseurs horlogers et generallement a tous ceux qui ce servent du cizeau de la forge et de la lime. De dié au Roy. Par Thomas Picquot, peintre 1638. A` Paris chez Michel van Lochom graueur et imprimeur du Roy demeurant rue St Iacque a la Rose Blanche Couro. Avec priviligé du Roy.* This work (Pl. 109, 110) is known only in one copy, that in the Staatliche Kunstbibliothek in Berlin (O. S. 812)[44]. Picquot also made two portraits of Marin le Bourgeoys, a medal and an engraving (the frontispiece)[45]. Judging by the style of the ornament on the engraved portrait, the date 1637 and the signature 'Th.P.' Robert-Dumesnil attributes the thirteen pattern sheets in his catalogue in the Cabinet des Estampes, Paris (Tome 'Le 24')[46] to Thomas Picquot. Guilmard does not seem to have shared Robert-Dumesnil's opinion as he attributes them to a 'Maître au Monogramme H. P.'[47]. Robert-Dumesnil's opinion, with which Huard agrees[48], is however correct. The sheets in the Cabinet des Estampes are loose pages from the *Livre des diverses ordonnances* and include still another page which is missing in the Berlin copy[49].

Page '2' in Berlin contains Louis XIII's rather unflattering portrait in a Baroque cartouche, surrounded by trophies, palm leaves and laurel as well as the king's crowned cypher and a very diffuse dedication. From it one can make out that his Majesty worked at gun making and that those patterns were also novel in their technique, thus repeating the untruth of the title page.

It will be seen from the title and the dedication that the book as a whole should be regarded as consisting of patterns for arms decoration. The last page is perhaps an exception but it is interesting as a study of Picquot's technique. Most show white orna-

ments against a dark ground. On pages '7' and '8' in Berlin the opposite is the case. Picquot calls himself a painter and he is mentioned as such by Michel de Marolles[50], but he is also styled 'faiseur de sphére'[51]. He says himself on one of the pattern sheets that he was born at Lisieux. He was granted his first 'brevet de logement' in the Louvre gallery after the late 'sieur Boule, menusier en ébène' on 2 January 1636. He had to share this with the gunsmith François Duclos[52], who was succeeded by F. Belocq while Picquot continued to live there. When he entered the premises in 1636 he was 'peintre, ayant chargé du globe ou sphère de Sa Majesté'. Bénézit states from unquoted sources that Picquot was a painter, etcher and goldsmith, that he engraved portraits and patterns for goldsmiths and embroiderers, that he was 'valet de chambre' to Henry IV and Louis XIII, that he was a very talented artist and pupil of Marin Le Bourgeoys[53]. Bénézit's source of information was undoubtedly Robert-Dumesnil, who in turn bases his information on Michel de Marolles's catalogue of 1666. He mentions Picquot on page 112 and states that the latter engraved pattern illustrations for goldsmiths' work and embroidery and adds a list of his works. The information that he had been 'valet de chambre' to Henry IV is not given by de Marolles.

In his capacity of 'chargé du globe ou sphère de Sa Majesté' Picquot succeeded Marin Le Bourgeoys, of whom Huard says that he was buried in the Church of Saint Germain at Lisieux 3 September 1634[54]. Picquot continued the work of his teacher in other ways. The *Livre de diverses ordonnances* proves to be largely based on Marin Le Bourgeoys. The lock on sheet '3' in Berlin (Robert-Dumesnil 12 (11)), (Pl. 110:2) is decorated with trailing vines of exactly the same kind as those on the guns in the Musée de l'Armée. This also applies to the sheet with the pommels on Berlin sheet '6' (Robert-Dumesnil 14 (13)), and Berlin sheet '10' (Robert-Dumesnil 7 (6)), which according to Robert-Dumesnil, and probably rightly, are considered to show two 'lance points', and also other sheets. There is a good deal to indicate, however, that a new epoch had arrived. The

influence of the Baroque has dissolved the symmetrical 'Schweif' ornament on the Berlin sheet '3' and also on sheet '16'. On sheet '14' (Robert-Dumesnil 2 (1)) dated 1637 we encounter a preliminary stage of 'Schoten' together with 'Schweif' and grotesque. The naturalism which served as a connecting link to Krammer's *Schweifbüchlein* finds expression in flowers, ears of corn and bunches of fruit. The Berlin sheet '20' gives an original example of a composition of this ornament together with 'Schweif' and grotesque. An auricular cartouche is to be seen on the title page, and another less pronounced cartouche surrounds the portrait of the king on the dedication page.

There are not many details of weapons on Picquot's pattern sheets, but what there are are particularly valuable as dated material for comparison. A flintlock with trailing vine decoration has already been mentioned (Pl. 110:2). A lock-plate and two ends of lock-plates are the main features on Berlin sheet '19' (Robert-Dumesnil 13 (12)). A lock, but without the steel, like that on Berlin sheet '3' is also on sheet '4' (Robert-Dumesnil 11 (10)); this lock-plate is decorated with a hare shoot with dogs, a sportsman on foot and two horsemen (Pl. 110:1). Trigger-guards seen from below are illustrated on Berlin sheet '17'. Of special interest are the two sheets each with two pommels seen from the side, sheets '21' and '22' in Berlin. The former bears the signature 'Th. Picquot Peintre inv[enit] et fe cit natif de Lisieux' (Pl. 110:3), the latter 'Th. Picqot fe[cit]'. Their design in which scrolls and grotesques are the essential features, differs, however, from all extant pommels. These are simpler and nearer to the design consisting of a head alone which we later find on ivory stocked pistols. One of these pommels by Picquot bears Louis XIII's portrait, another his monogram and heraldic fleur-de-lis.

It is difficult to say what significance Picquot's pattern illustrations had. The first impression is that they constituted a publication of Marin Le Bourgeoys's pattern drawings for the decoration of firearms. In comparison with pieces definitely decorated by him they

nevertheless show several more advanced features. This does not prevent their being derived from Le Bourgeoys, since he was still alive in 1634 and the latest weapon with his decoration that can be dated was made in the 1620s. There are, however, some arms manufactured after Le Bourgeoys's death which are decorated in his manner. This decoration may quite well have been carried out by Thomas Picquot. Of these the gun No. M 410 in the Musée de l'Armée, Paris (Pl. 17:1, 19:1) and the wheel-lock pistols (Pl. 19:2, 134:17) in the Metropolitan Museum of Art bear the signature 'F de clos' = François Duclos, that is, the gunsmith with whom Picquot shared his abode and shop in the Louvre from 2 January 1636. The reason for granting this privilege to these two masters may have been that they were already associated or wished to be so. All we know of Duclos is that he left the Louvre in 1659, and he may well have been a pupil of Marin Le Bourgeoys. The form and decoration of these three firearms which show a definite affinity to the work of the older master might be explained in this way. Le Bourgeoys seems to have desired to give the gun butts an original and individual form. Duclos had the same intention in designing the butt of the gun in the Musée de l'Armée (cf. Pls. 17:1 and 19:1). This gun and that signed by Marin Le Bourgeoys in the Hermitage Museum, Leningrad (Pl. 8) both have the same Minerva herm and Pan masks, though they are differently placed. This is one of the consistent features in the Lisieux weapons. Another applies to the decoration of the stock and barrel. They belong to the group signed with a cross-bow and the initials 'I B' (cf. Pl. 9 and Pl. 13). This embellishment is a pronounced symmetrical 'Schweif'. On the gun in Paris it develops into a grotesque in which the French national coat of arms plays the role of the ordinary cartouche in the later grotesques. The barrels of the pistols in the Metropolitan Museum of Art are more simply decorated but in exactly the same fashion. They probably made up a garniture with the gun in Paris. The same decoration appears on the pommels of the pistols. These are of iron and extend some distance along the

small of the butt. The same ornament is inlaid in the stock of the gun.

The trailing vines referred to above occur also on the cartouche on the small of the butt enclosing Justice and an 'L' below the French crown, and most distinctly on the lock-plate (Pl. 18:1). There they emerge from the bunches of fruit which are placed symmetrically on each side of a cartouche. The silver lines, known from the Le Bourgeoys arms, are also found on the gun in Paris. They frame the butt and follow the line of the fore-stock on both sides. Two decorative features on the left-hand side of the pistols, in front of the side-plates, are a novelty. They resemble auricular ornament. This in turn corresponds with Picquot's album.

Most of the motifs in this album are the standard type of panel with 'Schweif', trailing vines and grotesques, suitable for decorating barrels. This seems to have been a popular form of decoration. It is also to be found on later arms, most of which are signed by Parisian masters. In one instance both the choice of motifs and technique agree so closely with Picquot's engravings that the inlay might very well be by his hand, viz. the barrel decoration on the 1640 set signed by P. Thomas, Paris, in the Livrustkammare (Pl. 20:4, 5). We find on this gun symmetrical 'Schweif' and trailing decoration, on the pistols naturalistic trailing vines arranged symmetrically.

The gilt surface of the decoration on this garniture is practically level with the barrels. About 1650 the decoration occasionally rises above the surface and becomes at the same time slightly smaller in scale. This is the case with the trailing vines on the barrels of the Wender gun signed by Thobie, Paris, in the Löwenburg (Pl. 25:1, 4). We find this ornamentation also on the Barroy pistols in the Livrustkammare (Pl. 54:1) and in the Netherlands on ivory stocked pistols (Pl. 53:1). In the earliest year associated with Marcou, 1657, and in the pattern book published in that year this ornament is shown on a butt-cap with the short spurs of about 1650 (Pl. 113:1). Still later, in the Thuraine and Le Hollandois group of the 1650s–60s this long established ornament

can be traced even as late as the beginning of the 1670s (Pl. 74:1).

The engraved ornament employed, for example, by Philippe Cordier Daubigny is characteristic of flintlocks up to the middle of the seventeenth century; then other kinds of ornament appear together with the Classical breakthrough. Locksmiths on the periphery of the flintlock manufacturing areas, Werder of Zürich, Jean Paul Klett of Salzburg (pistols, Carolino-Augusteum Museum, Salzburg), Kasper Dinckels of Utrecht, etc., still use a pronounced trailing vine ornamentation without figures.

Vine trails with figures are found on pistols by Van den Sande of Zutphen (Pl. 30:1), Cunet à Lyon (Pl. 26:2) and others, and finally, on two sheets in Marcou's pattern album of 1657. This ornament combined with scrolling and grotesques in an early form decorates the lock of the small bore gun, 'Faict A Turene m.d.' in Windsor (Pl. 14:2). One of Picquot's sheets with a complete flintlock shows a hunting scene covering the entire plate. It is usual, however, for both ends of the plate to be decorated with flowers. Examples include the Dauphin gun in the Berlin Zeughaus (Pl. 18:2), the Livrustkammare gun (Pl. 22:1) signed by P. Thomas of Paris and rubbings in Berlin of locks signed by Mayer of Lyons, Meunier and Auber of Geneva, 'A Bergerac' Raguet and Beradier (Pl. 22, 23). An early example is the rubbing in the Bibliothèque Nationale, Paris, of the lock signed 'P. Cordier' (Pl. 14:4).

As the result of a change in fashion, instead of whole scenes, a group or a figure is presented in front of the cock and under the pan. These are linked up with flowers on the recessed rear point and on the cock. The locks of the pistols by Devie in the Historisches Museum, Dresden, illustrate the type (Pl. 23:6). This kind of lock decoration, which, in contrast to the trailing vine and the scenes with many figures, leaves parts of the lock-plate empty, was not new. It became increasingly common in the 1640s, P. Cordier's rubbing in the Bibliothèque Nationale actually belongs to it, as does another rubbing on an early lock in the same collection[55]. The decoration of this recalls designs

on engraved silver. A direct borrowing from a particular pattern book illustration can be found on the pistol in Berlin (Pl. 27:2) signed by Ezechias Colas of Sedan. The squirrel sitting on a bunch of fruit is to be seen at the foot of the engraving illustrated on Pl. 107:2. Typical of this lock decoration is a larger figure on the centre of the plate and flowers on its rear tip, sometimes at both ends. This is the same arrangement that characterizes Parisian lock decoration with a figure or group on the centre of the plate. As late as the middle of the century we find lock decoration related to pattern books of Dutch silver engravers, for example, on pistols by Jean Prevot of Metz (Pl. 28:2), Le Pierre of Maastricht (Pl. 29:3) and Cornelis Coster of Utrecht (Pl. 30:3) as well as on the group datable from the 1630s–40s which have their pommels covered with stamped silver plate (Pl. 24:1).

The embellishment of early flintlock firearms up to the middle of the seventeenth century varies little and consists chiefly of trailing ornaments enriched with figures and, finally with whole figure subjects. In the 1640s this type is varied by another deriving from Dutch design books for silver engravers. This later type appears in the 1630s; it resulted in a decoration of detached figures of Classical type, sometimes combined with trophies in front of the cock and under the pan, and with more or less naturalistic flowers on the recessed rear point of the lock-plate and the cock. This wealth of naturalistic flowers, which plays a part generally in French ornamentation during the second quarter of the seventeenth century, became standardized on the flintlocks but could also, when executed by a competent hand, retain a certain freshness.

Editor's Notes

* Since the war much more interest has been shown in the decorative aspect of firearms. The main publications are: J. F. Hayward, *The Art of the Gunmaker*. 2 vols. London 1962 and 1964. B. Thomas, O. Gamber and H. Schedelmann, *Die schönsten Waffen und Rüstungen*, Heidelberg 1963.

† Later still, as on the magnificent fowling piece by Berthault of Paris of about 1660–70 in the collection of Field-Marshal Sir Francis Festing.

‡ A further contribution to the history of Tornier has since been made by H. Schedelmann, *Journal of the Arms and Armour Society*, London. Vol. II, p. 261. 'Jean Conrad Tornier, an Alsatian Gunstockmaker.'

Notes to Chapter Eleven

1. Semper, *Der Stil in den technischen und tektonischen Künsten oder praktische Aestetik*. II. P. 549, note.

2. Lauts, *Alte deutsche Waffen*. P. 23, note.

3. Thomas, 'Eine deutsche Radschlossbüchse von 1593 mit Beineinlagen nach Adriaen Collaert'. *Die graphischen Kunste*, Neue Folge Bd. III (1938). H. II. Pp. 72–77.

4. As regards the ornaments the same terms used by Paulsson in *Skånes dekorativa konst* have been adopted here (see especially pp. 12–32). The term arabesque is used in its original sense of trailing vines and, moreover, the German term 'Schweif' (a tail). 'Norden' and 'Nordisk' (Nordic, the northern countries and northern) refer in this connection to the countries north of the Alps in contrast to Italy.

5. Dean, *Handbook of arms and armor*. P. 92. Pl. LI.

6. Le Musée de l'Armée. *Armes et armures anciennes*. T. II. Pp. 111, 112. Pl. XXXVIII. II.

7. Boeheim, *Meister der Waffenschmiedekunst*. P. 102.

8. Guilmard. *Les maîtres ornemanistes*. P. 41. No. 22.

9. Ritter, *Illustrierter Katalog der Ornamentstichsammkung des K. K. Österreich. Museums für Kunst und Industrie. Erwerbungen seit dem Jahre 1871*. P. 162.

10. Guilmard, *Les maîtres ornemanistes*. P. 49. No. 50.

11. Cf. Cederström and Malmborg, *Den äldre Livrustkammaren 1654*. Pl. 74.

Plate III.

1

2

3

France, Paris.
1657 (?)

François Marcou, *Plusieurs Pieces d' Arquebuzerie* . . .
Paris 1657 (?); Ex. Berlin, Staatliche Kunstbibliothek O.S.
820.

Plate 112.

1

2

Frankrike, Paris.
1657 (?)

Marcou, two sheets from same series as Pl. 111.

Plate 113.

1

2

France, Paris.
1657 (?)

Marcou, two sheets from same series as Pl. 111.

Plate 114.

1

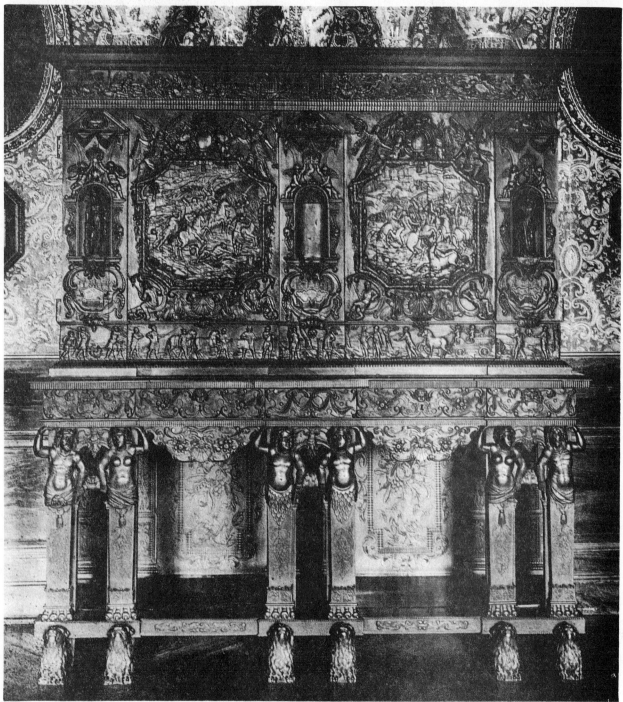

2

France (?)

Dauphin Louis (XIV's) cabinet. According to tradition a gift from Louis XIV to Nils Bielke, Sturefors.

Plate 115.

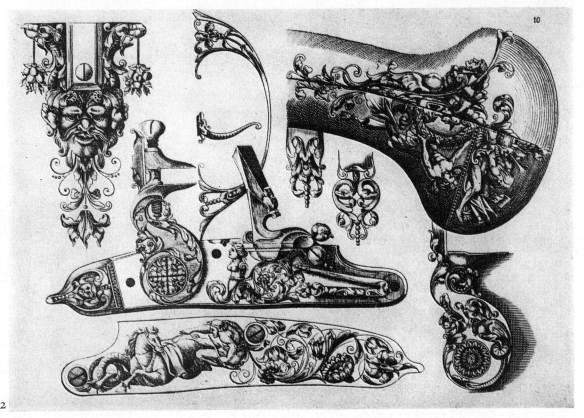

France, Paris.

Thuraine and Le Hollandois, *Plusieurs Models* ... Paris,
undated; Ex. Stockholm, Livrustkammaren.

Plate 116.

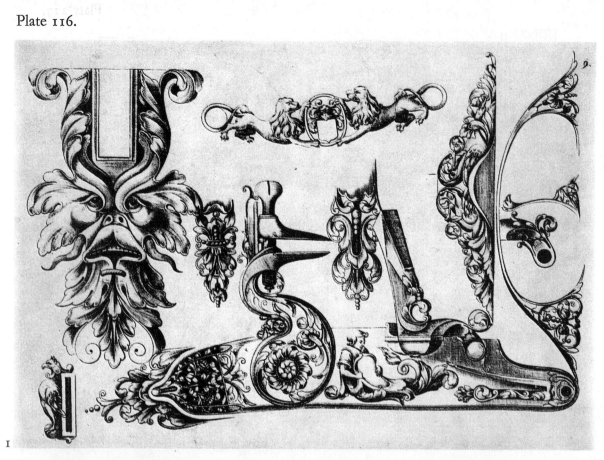

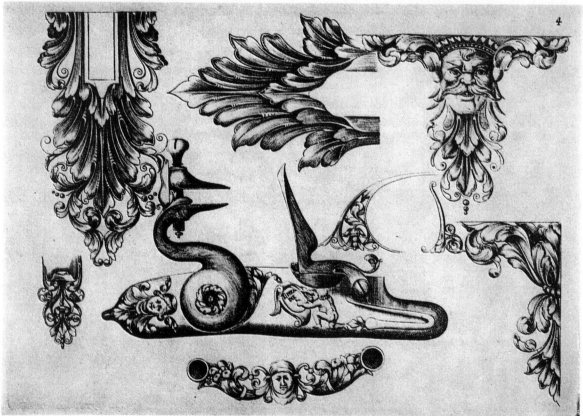

France, Paris.
c. 1660.

Thuraine and Le Hollandois, two sheets from same series
as Pl. 115.

Plate 117.

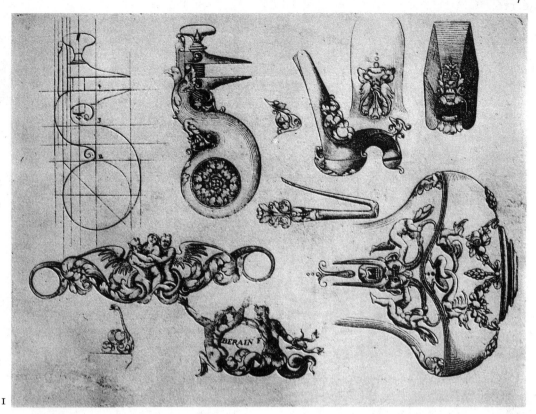

1

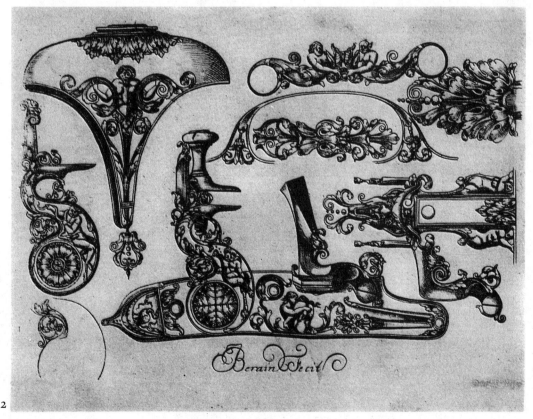

2

France, Paris.
1659.

Jean Berain, *Diverses pieces très utile pour les Arquebuzières*
... Paris 1659; Ex. Stockholm, Livrustkammaren. From
Foulc Collection.

Plate 118.

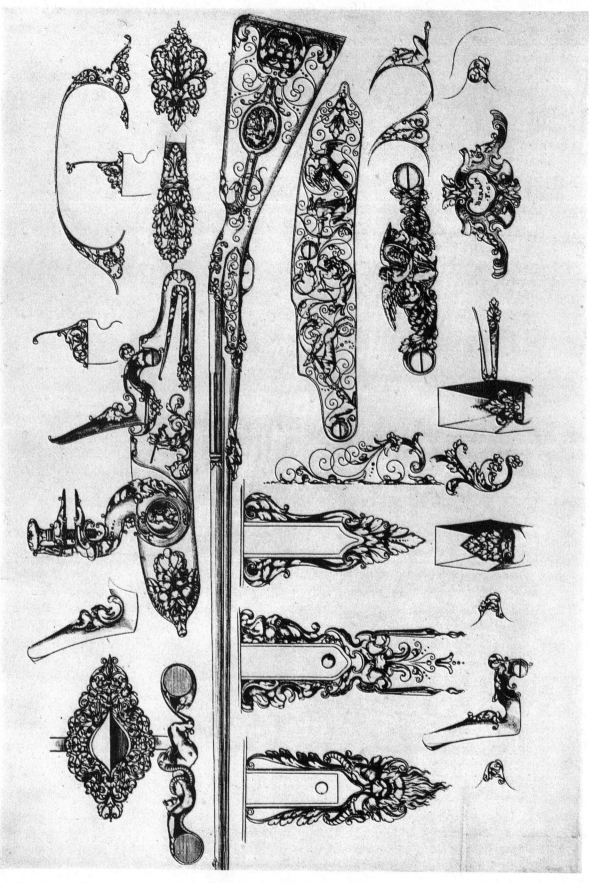

France, Paris.
1659.

Berain, sheet from same series as Pl. 117.

12. Laking, *Catalogue of the European armour and arms in the Wallace Collection at Hertford House*. Pp. 230, 231.

13. Cederström and Malmborg, *Den äldre Livrustkammaren, 1654*. Pl. 71.

14. Communicated by Gunnar W. Lundberg, Ph.L. The casket has according to the same source been transferred from the Louvre where it was received in 1856 with 'Donation Sauvageot', in whose catalogue it is No. B 134.

15. Cf. Stöcklein, *Meister des Eisenschnittes*. P. 79. Abb. 13. Pl. XXVIII.

16. Livrustkammaren. *Vägledning 1921*. P. 54. No. 381.

17. See also Stöcklein and others. Pl. XL.

18. Stöckel, *Haandskydevaabens Bedömmelse*. I. P. 229.

19. [Lotz], *Katalog der Ornamentstichsammlung der Staatlichen Kunstbibliothek, Berlin*. P. 147. No. 1014.

20. [Lotz], *Katalog der Ornamentstichsammlung der Staatlichen Kunstbibliothek, Berlin*. P. 147. No. 1015.

21. Jessen, *Der Ornamentstich*. P. 823.

22. *L'art pour tous*. T. VIII. P. 823.

23. Ehrenthal, *Führer durch das Königliche Historische Museum zu Dresden, 1899*. P. 131.

24. Guiffrey, *Inventaire général du mobilier de la couronne*. T. II. P. 71.

25. Laking, *The armoury of Windsor Castle. European section*. No. 39. Pl. V.

26. Lespinasse, *Les métiers et corporations de la ville de Paris*. T. II. Pp. 350–56.

27. Wille, *Mémoires et journal*. T. I. Pp. 66, 67.

28. Boeheim, *Meister der Waffenschmiedekunst*. Pp. 55, 56.

29. Boeheim, 'Die Luxusgewehr-Fabrication in Frankreich im XVII und XVIII Jahrhundert'. *Blätter für Kunstgewerbe 1886*. P. 34.

30. Thieme-Becker, *Allgemeines Lexikon der bilddenden Künstler*. Bd. VII. P. 403.

31. Cf. Post, 'Ein Paar französischer Radschloss-pistolen von Isaak Cordier Daubigny'. *Zeitschrift für historische Waffen- und Kostümkunde*. Bd. XIII. P. 237. Cf. also Post, 'Ein Paar Steinschlosspistolen von Isaak Cordier Daubigny'. *Zeitschrift für*

32. Stöckel, *Haandskydevaabens Bedömmelse* I. P. 345.

33. Thieme-Becker, *Allgemeines Lexikon der bildenden Künstler*. Bd. VII. P. 403.

34. Boeheim, *Meister der Waffenschmiedekunst*. P. 56.

35. Cf. Guilmard, *Les maîtres ornemanistes*. P. 53. No. 67.

36. [Lotz], *Katalog der Ornamentstichsammlung der Staatlichen Kunstbibliothek, Berlin*. P. 119. No. 809.

37. Post, Ein Paar französischer Radschloss-pistolen von Isaak Daubigny. *Zeitschrift für historische Waffen- und Kostümkunde*. Bd. XIII. P. 238.

38. Boeheim, *Meister der Waffenschmiedekunst*. P. 56.

39. [Schestag], *Illustrierter Katalog der Ornamentstichsammlung des K. K. Österr Museums für Kunst und Industrie*. P. 146.

40. Jessen, *Der Ornamentstich*. P. 115 ff.

41. Rouyer et Darcel, *L'art architectural en France*. T. I. Pp. 41–43. Pls. 38–42. T. II. Pp. 7, 8. Pl. 9.

42. Lotz, *Bibliographie der Modelbücher*. P. 5.

43. [Lotz], *Katalog der Ornamentstichsammlung der Staatlichen Kunstbibliothek, Berlin*. P. 119. Nos. 806, 807, 811.

44. Lenk, 'De äldsta flintlåsen'. *Konsthistorisk tidskrift*, 1934. P. 133. [Lotz], 'Katalog der Ornamentstichsammlung der Staatlichen Kunstbibliothek. Berlin'. P. 119.

45. Huard, 'Thomas Picquot et les portraits de Marin Bourgeoys'. *Aréthuse. 1927*. Pl. XXII.

46. Robert-Dumesnil, *Le peintre-graveur français*. T. VI. Pp. 233–39.

47. Guilmard, *Les maîtres ornemanistes*. P. 49. No. 51.

48. Huard, 'Thomas Picquot et les portraits de Marin Bourgeoys'. *Aréthuse, 1927*. P. 139.

49. The following sheets in the Berlin copy are in Vol. Le 24 in Paris (B = Berlin, RD = Robert-Dumesnil), B 3 = RD 12(11), B 4 = RD 11 (10), B 5 = RD 4 (3), B 6 = RD 14 (13), B 9 = RD 10 (9), B 10 = RD 7 (6), B 14 = RD 2 (1), B 15 = ? RD 6 (5), B 18

= RD 3 (2), B 19 = RD 13 (12) and B 23 = RD 9 (8). RD 5 (4) is not in Berlin, RD 6 (5) is probably in the Berlin copy.

50. Marolles, Michel de, 'Suite des peintres qui ont vécu en Frence depuis 1600'. *Le livre des peintres et graveurs. Bibliothèque Elzevirienne*. T. 46. P. 53.

51. 'Brevets de logements sous la grande galerie du Louvre.' *Archives de l'art francais*. I.P. 198.

52. Guiffrey, 'Logements d'artistes au Louvre.' *Nouvelles archives de l'art francais*. T. 11. Pp. 65, 128.) Not with Boulle as Baron de Cosson states in the catalogue of the Duke of Dino's arms collection (p. 100) and Huard in *Aréthuse* (see below).

53. Bénézit, *Dictionnaire . . . des peintres*. T. III. P. 483.

54. Huard, 'Marin Le Bourgeoys, Peintre du Roi'. *Bulletin de la Société historique de Lisieux. 1913*. P. 35.

55. Lenk, 'De äldsta flintlåsen'. *Konsthistorisk tidskrift, 1934*. Pp. 130, 131. Fig. 14.

CHAPTER TWELVE

Patterns and decoration during the middle of the seventeenth century

THE FULL TITLE of Marcou's pattern book for gunsmiths (Pl. III:1) is: *Plusieurs Pieces d'Arquebuzerie Receuillies et Inuentées Par François Marcou Maistre Arquebuzier A Paris. C. Iaquinet Sculpsit. Et se uendent chez l' Autheur a Paris rue S:t Anthoine au Roy de Suede avec priuilege du Roy.* This title is surrounded by a composition resembling a chimney-piece, consisting of a wreath of oak and laurel, by trophies, prisoners, Minerva and Fortitude, and at the top, Fame standing on a mask. This is an example of the late use of Baroque auricular ornament in France. The page immediately following the title page shows Marcou's portrait (Fig. 3). The twelve following pages are numbered 2–13. There are in addition three unnumbered, in all seventeen pages, including the title. This is the make-up of the copy in the Staatliche Kunstbibliothek, Berlin (O. S. 820)[1]. Guilmard[2], however, knows of one copy in the Bérard collection with another sheet with a larger illustration surface (20 × 15.5 cm) than the others, which are 10 × 15 cm. Most of the illustrations are signed 'C Jacquinet fecit, Marcou excudit'. One illustration, however, simply states 'Marcou ex.' and the last one 'Marcou inuenit 1657 Iacq. scul'. It is difficult to say to what extent these signatures justify conclusions as to the nature of the collaboration. It is most probable that Marcou represents the practical knowledge of the gunsmith and Jacquinet that of the artist and that this co-operation parallels the actual work on the firearms themselves.

Marcou's pattern book has been mentioned already in connection with the decoration of flintlocks in the 1630–50 period. His designs cover a long period and are to all appearances examples of what he saw and himself made during the period he worked as master gunsmith. This must have begun in the 1620s, that is to say the last decade in which the wheel-lock and snap-lock were common on French firearms. It is not surprising that the sheets marked '3' and '7' are devoted to wheel-locks. Of these the latest is most French in character. As a type it is quite typical of the 1620s, even earlier, but the naturalistic flowers of the decoration only became usual in arms decoration during the following decade. The same flowers are also found on sheet '3' and in the same place, viz. on the lock-plate. This is large and broad behind the wheel and provides for the mounting of the mainspring, on the usual German

Fig. 3. Gunsmith François Marcou. Portrait by R. Ochon. Original in Staatliche Kunstbibliothek, Berlin (O. S. 820).

principle, on the plate instead of in the stock. We have found this construction applied earlier on a gun that in other respects is otherwise quite French, viz. that signed by Jean Henequin of Metz in the Bayerisches Nationalmuseum, Munich (Pl. 104). In other features, such as the monster's head at the rear of the lock-plate and also the sculptural treatment of the neck and jaws of the cock, Marcou's sheet '3' resembles Jean Henequin's gun and its engraved orna-

ment. The marked angularity of the butt on the same sheet, with its staff—like reinforcement of the comb, is also a feature which Marcou must have encountered in his earlier days as 'maître arquebusier'.

All the flintlocks illustrated by Marcou have flat plates, and with one exception, angular pans and frizzens. They are thus of the earlier type which was obsolescent when the pattern book was published. This applies also to much of

the decoration. Trailing vines and running scrolls with figures extending over the whole surface of the lock ornament the two wheel-lock designs already mentioned, two flintlock plates on sheets '10' and '11' and several of the cocks. Complete scenes are to be found on sheet '2' (Pl. 111:3), on sheet '9' and on the penultimate unnumbered sheet. The smaller groups of figures are represented on sheets '4', '8', and '12' (Pl. 112), each with a Minerva or Mars seated on a trophy. Various trends are represented on the same sheet in the earlier flintlock designs, as on sheet '12' (Pl. 112:1). Here the cock is embellished with floral running scrolls and grotesques. The lock-plate is decorated with a landscape behind the cock and in front with Mars and trophies. The recessed rear end is decorated with a grotesque mask, a detail which is often repeated in this position about the middle of the seventeenth century. To the left of this same sheet beneath the lock is a warrior's head shown in profile with a strange, conical neck and an equally peculiar spiny visor extension of the pseudo-antique helmet. Similar heads are also to be found on other sheets of the series but only in conjunction with flintlocks. These peculiar heads are explained if one compares them with the tumblers on the locks of the Livrust-kammare's Thomas set (Pl. 21:4). The warrior heads are, in fact, suggestions for decoration of the flintlock tumblers.

The decoration on the lock-plate on Marcou's sheet '2' (Pl. 111:3) has a Latin sentence 'non sinit perire ars' as have the monogrammist M.N.'s sheets in Vienna, several of Philippe Cordier Daubigny's pattern sheets and the lock on the gun in the Livrustkammare Thomas set (Pl. 22:1). In view of this, and also of the scene with Arion on the dolphin's back that covers the entire lock-plate, the lock can be attributed to the most archaic period represented in the album. It is true that a steel-spring of the 1640 type has been inserted, but as the plate, contrary to the usual practice is engraved underneath it, the spring must have been mounted as a modernization as are the broadened rear points of the lock-plates all through the album[3]. In this instance an ordinary recessed

rear tip with floral decoration is attached as an alternative, but the plate has a monster's head which clearly indicates that it is intended to be executed in relief like the cock designed as a dolphin and the steel as a scallop-shell. As an alternative there is also a cock with a neck chiselled as a mermaid. Such details are to be found on seven more sheets, all unmistakably related to the earlier, large figured group with relief decoration dealt with in chapter six. This frequent occurrence of chiselled decoration in a pattern book published by a Parisian gun-smith is one of the weightiest reasons for considering that the relief decorated group might be French. This very group in western European gunmaking belongs to a fashion which endured for a generation. It is an expression of the interest of that age in relief decoration as a whole, like the sculptured ebony cupboards that constitute a parallel phenomenon. It is known that some of these cupboards were made in the Netherlands, others in Flanders and others yet again in Paris either by immigrant foreigners or Frenchmen who had studied abroad[4].

For the dating of these cupboards we have an interesting document in the example which is traditionally said to have been presented by Louis XIV to Count Nils Bielke and is now preserved at Sturefors in the province of Östergötland, Sweden (Pl. 114)[5]. The initial 'L'[ouis] is to the right on a top drawer and the coats of arms of France and Navarre under the open crown for 'les enfants de France'. To the left there is a figure with the French royal crown. The outsides of the doors are decorated with dolphins below royal French crowns in three places. The cupboard must therefore refer to a dauphin named Louis. This cannot be 'le grand dauphin' (b. 1661) whose monogram would have been crowned by the dauphin's crown confirmed in 1662. Our only choice then is the royal donor himself as dauphin. This gives as the dating of this cupboard the period 1638–43, that is the same period as the earlier large figured group of the relief decorated flintlock arms.

Hunting scenes are such common motives and their component features so very much

alike that too great importance should not be attached to agreement between them. It is, however, worth noticing that the longitudinal reliefs on some of the earlier guns in the group (Pl. 40:1) resemble friezes with hunting scenes on Dutch furniture. A similar frieze will be found on a chest reproduced in Michel's *History of Art* from the Rijksmuseum, Amsterdam[6].

Other firearms mentioned above have the chiselled ornament enclosed in auricular cartouches which have not the diffuse, flabby forms of the Dutch or the German auricular ornament, but are more concentrated, firm and symmetrical. Information as to their source can be obtained by comparing Lucas Kilian's *Newes Schildtbyhlin*, published at Augsburg in 1610, with *Diferents compartiements et Chapiteaux* engraved by Tavernier and published by P. Partiette in Paris in 1619[7]. The latter is a copy of the former, though with sheets added at the end in which the cartouches are formed like rolled or gathered cloth, firmer and simpler. The restraining effect of French taste can be discerned in them. In French Louis XIII architecture these restrained auricular cartouches are a common feature. A similar firm and simplified form will be found in the chiselled group on the gun in the Livrustkammare (Pl. 40:4), presented by Charles Gustavus Wrangel to Charles X Gustavus, on the gun No. M 15 in La Sala d'Armi in Venice, and on the gun No. D 316 in the Kunsthistorisches Museum, Vienna (Pl. 40:3).

We have seen how exactly the same figure groups appear in Baroque cartouches and Classicizing oval frames composed of leaves and flowers (Livrustkammare No. 1298. Pl. 41:2, and Skokloster, the Wrangel Armoury No. 112). The smith working in iron has followed the general trend towards Classical ideals. In both cases the scheme of decoration is the same, with a vigorous acanthus leaf at the breech, rows of cartouches or medallions one above the other, a chiselled area inlaid with silver in front of these surrounded by rings and foliage wreaths and, finally punched ornament. This design is very much the same in the entire relief decorated group, if we except those firearms with longitudinal relief decoration. This is most apparent in those with large figures, but it can also be discovered in those with small figures, for example on the barrels of the pistols in the Livrustkammare (Pl. 47:2, 4), and tight wreaths with flowers, though much wider apart, are to be found surrounding the heroic scenes on the pommels (Pl. 48:4). The small figured reliefs serve as a connecting link on one of the guns in Vienna (Inv. No. D 316. Pl. 40:3).

The part of the barrel in front of the cartouches is, as a rule, spirally twisted (Pl. 40) on the earlier arms. This is in keeping with the Baroque fashion of turned and spiral columns. On the later ones this portion is given a firm, symmetrical decoration with the exception of gun No. D 362 in Vienna. In this case we find a feature that has no French association, a symmetrical running scroll (Pl. 41:3). Purely French are, on the other hand, the lines formed by inlaid twisted silver wires on the stocks of the garniture of gun and pistols in the Wrangel Armoury at Skokloster (Nos. 112, 67). They belong to the sub group with large figures framed by foliage and floral wreath. A similar setting of thin lines is also to be found on the Livrustkammare gun No. 1297 (Pl. 37:3), but in that case with inlaid horn. The relief decorated flintlock arms can in this way also be connected with France or her immediate neighbourhood.

The lock-plates are decorated either with scenes covering the entire plate or with individual figures in front of the cock and beneath the pan. This position is occupied by the figure of a warrior in Roman armour seated on a trophy of arms on the Livrustkammare gun just mentioned. The same feature is to be found on Marcou's sheet '12' (Pl. 42:1 and 112:1). The mermaid on the cock is the same as that on the separate cock of sheet '2'. The antique mask of the steel is very similar to a steel on sheet '8'. For the grinning monster's head at the rear of the lock-plate approximate prototypes are to be found on the engravings. The cock-screw in the shape of a vase is identical with that on the lock of sheet '12'. This indicates that they belong approximately to the same period. The fact that so many

elements in the decoration of a gun are to be found in a Parisian work on gunsmiths' ornament is more than a mere coincidence. It presupposes a definite connection. Whether it means that Marcou was the maker of the gun must, however, remain uncertain in the absence of definite evidence.

The choice of motifs for the figure groups varies considerably. The animal friezes have already been adequately dealt with. Playing children are a common motif in the art of this period (François Duquesnoy), and the same applies to the winged figures in scrolls. All this is to be seen on the barrel and lock of the gun No. M 14 in La Sala d'Armi in Venice (Pl. 40:2). The four cartouches on No. M 15 in the same museum contain scenes from the story of the prodigal son, and the gun No. 1545 in the Livrustkammare likewise shows in four panels Hercules wrestling with Geryon, the Lernean hydra and the Nemean lion as well as a scene in which the demi god finds recreation in pleasant company after his labours (Pl. 41:1). In the foliage and floral wreaths we find Renaissance versions of figures from Greek mythology only, Leda and the Swan, Venus and Amor, Bacchus, etc. On the gun No. D 362 in Vienna, Venus is seen in the company of Ceres and Bacchus, which, according to Philippe Cordier Daubigny, is necessary for her well being. In all of these instances the figures are affected and elongated. It may of course be mere chance that Venus in Etienne Delaunes' allegorical series of the celestial bodies is so similar to the female figures on the butt-plate of Töjhus Museum gun No. B 661 (Pl. 43:2). It may be, however, that this figure is a copy, perhaps at second or third hand, of this very engraving. For the sub group with small figures, paintings or engravings with motifs from contemporary history may have served. The arms decorators in chiselled iron took their ideas from some very heterogeneous sources. The quality of their work also varies a great deal and only rises to true heights in exceptional cases.

The last sheet in Marcou (Pl. 113:2) belongs, as has been pointed out above, to the group which has been named after the firm of Thuraine and Le Hollandois. This is also the case with Berain's pattern book (Pl. 117, 118) 'Diverses pièces très utile pour les Arquebuzières . . .'. There are three editions, or at any rate states of this. One of these editions is dated 1659, another 1667. A third edition comes in between these dates.[8] The complete title (Fig. 4) of the edition of 1659 is as follows: DIVERSES PIECES tres Vtile (*sic.*) pour les Arquebuzieres Nouuellement Inuentés et Graues par Jean Berain le Jeune et ce Vendent chez lauteur a Paris Auec Priuilege du Roy 1659.' The second edition has had its title changed to '. . . et ce vendent chez le Blond Rue Saincts Iacques à la Cloche d'Argent à Paris. Avec Privilege de Roy'. The year 1667 has been added to the third edition.

Weigert knows of seven sheets of this work and the title. The Berlin copy, however (edit. 1667)[9] and a copy in the Livrustkammare, the latter without a title page, have two more sheets, one of the same size as those included in Weigert's list (120 × 168 mm), the other 193 × 323 mm. According to Guilmard the whole series with nine sheets and title is also in the Bibliothèque de Paris (Bibliothèque Nationale, Cabinet des Estampes) in volume 'Le 24'.[10]

Boeheim attributed a most important role to Berain in the development of flintlock firearms and compared it with that of Aldegrever in the Germany of his day. According to Boeheim the credit for the transformation of firearms after the invention of the flintlock about the year 1635 was largely due to Berain. As Berain was not a gunsmith but a draughtsman it is only natural to find him associated with the most famous masters such as Thurenne and Reynier (i.e. Thuraine and Le Hollandois)[11]. Weigert's research into Berain and his family has now brought new light to bear upon the part played by the famous French decorator in gunmaking[12]. It can be observed that Berain was born in 1640 and was consequently only nineteen years old. The fact that Jean Berain engaged in the decoration of arms at so early a stage can be explained in a different and much more reasonable way. His father and paternal grandfather were gunsmiths (cf. p. 79). It is

*Fig. 4. Title page of Berain's pattern book for gunsmiths of 1659. Original
in Bibliothèque Nationale, Paris.*

chiefly as a professional decorator of arms that
Jean Berain appeared before the public in his
youth with his pattern book and then less as
an originator than as a copyist of an existing
stock of designs. Borrowings from numerous
sources can be found in his sheets, among them
some from the group decorated in relief.
Pseudo-Classical influence is so pronounced in
Berain's work that the florid Baroque nature of
the relief decorated group had to yield to a
lighter style. Berain's reliefs take the form of

portraits, lion masks or flowers in sculptural
treatment on the heads of the jaw-screws, and
of leaves, masks or grotesque figures on cocks,
steels and on the rear point of the lock-plates.
The empty triangular spaces caused by the
splitting and folding of the ends of the trigger-
guards are filled by foliage, scrolls or gro-
tesques. This same ornament is also to be found
on the steels and has invaded the outer edge of
the lower arm of the steel-springs[18]. There are
also pure Louis XIII cartouches and, without

Plate 119.

1

2

France, Paris.
1685 (1705).

1. Claude Simonin, *Plusieurs pièces et ornements darquebuzerie* ... Paris 1685. 1. Title page; Ex. Berlin, Staatliche Kunstbibliothek O.S. 840:1. 2. Sheet from same work, Ed. 1705; Ex. Stockholm, Livrustkammaren. From Foulc Collection.

Plate 120.

6

1

7

2

France, Paris.
1685 (1705).

Simonin, two sheets from same series as Pl. 119:2.

Plate 121.

France, Paris.
1693.

Claude and Jacques Simonin, *Plusieurs pièces et autres
ornements . . .* Paris 1693; Ex. Berlin, Staatliche Kunst-
bibliothek O.S. 840:2.

Plate 122.

Netherlands, Amsterdam
and Germany, Nurem-
berg.
1692 and *c.* 1700.

1. Pierre Schenck, *Verschejde stucken en cieraden . . .*
Amsterdam 1692; Ex. Amsterdam, Rijksmuseum, Copper-
plate Cabinet. 2. Jakob von Sandrart, *Plusieurs pièces et
ornements darquebuzerie . . .* Nuremburg, undated; Ex.
Dresden, Kupferstichkabinet B 1158.

any specific function, a pair of figures in the spirit of Callot. Large acanthus leaves also figure among the pattern subjects. We have seen them on contemporary Dutch stocks, both in wood and ivory. They also occur on the only gun stock illustrated by Berain, which is on the large sheet (Pl. 118). They also appear at the ends of the trigger-guards from which they spring in chiselled or engraved rendering. They belong to the Classicizing elements in Berain ornament, like the grotesques which are to be seen on almost every sheet, arranged to fit into different spaces.

The ornament in Berain's pattern book includes slender running scrolls which emerge from a fuller ornament and usually terminate in a scroll of diminishing width, a leaf or a flower with a row of beads. This also becomes thinner as it proceeds. Figures are inserted in these line ornaments. The latter are based on the technique of metal inlays in the wooden stocks, which was practised by Marin Le Bourgeoys and his school. It was probably common on better quality French firearms during the earlier half of the seventeenth century.

Among the details of firearms on Berain's pattern sheets we find such ornament on the side-plate and on the butt of the gun shown on the large sheet. The thin lines rise from a mask on the side of the butt and surround a medallion in the centre from which a rib extends to the thumb-plate.

The butt of the magnificent Wender gun in the Livrustkammare (Pls. 59, 60), the lock of which is signed 'Le Conte à Paris' and the inlays 'Berain fecit', is lavishly decorated in the same way. Symmetrical trailing vines which change into the familiar slender spirals rise from a mask (cf. Pl. 60:4) flanked by Venus and Minerva on one side of the butt, and by monkeys on the other. The spirals pass through a floral crown on the one side and verge upon a basket of fruit on the other. They then pass round a medallion with a reclining Minerva or Mars. The medallions are set at right angles to the rest of the design as in the pattern: the design then continues up towards a canopy-like frame with Apollo on one side playing to the

animals among vines and trailing scrolls, and Amor on the other side grasping his bow and arrow between seated cupids. The ornament continues to the small of the butt with bunches of fruit hanging in ribbons from grotesque arabesques, crowns and—at the rear point of the lock-plate and in the corresponding position on the left side—grotesque masks in the Louis XIII style. There is another grotesque mask on the small of the butt behind the tang of the barrel. Below this the arabesques meet from the sides, the nose of the butt is covered by an acanthus leaf underneath which Fama rides on an eagle holding a medallion with the initials 'L D G R' (Ludovicus Dei Gratia Rex). Below that again we have arabesques and, finally in profile, grotesque masks on both sides of the short tang of the butt-plate. The fore-stock is adorned on the one side with groups of allegorical figures and 'Schweif' ornaments. On the other side the corresponding space is partly covered by the ramrod.

The lock (Pl. 60:1) has engraved decoration except for a chiselled and gilt lion's mask on the cock-screw. The decoration consists of arabesques of leaves which terminate in grotesque figures on and behind the cock. On the recessed rear tip of the lock-plate an owl is perched on a pendant swag.

The decoration of the barrel and butt-plate (Pl. 59:21, 60:2,3) is inlaid with gold on a ground that was originally blued. The uppermost planes of the chambers are embellished with longitudinal groups of figures, those on the sides with grotesque scrolls enclosing sportsmen and game. A sixteen sided section decorated with arabesques within lined borders follows. On one barrel, in front of the chamber, is the figure of Minerva in an oval cartouche surrounded by symmetrical foliage arabesques emerging from eagle heads and a basket of fruit. The longitudinal lines extend right up to the muzzle interrupted three times by groups of symmetrical 'Schweif' ornaments, and around the fore-sight by foliage scrolls.

The butt-plate is oval flattened from the sides and ends and is bordered with trailing vines. The remaining part is covered by symmetrical scrolls with grotesque figures similar

to those of the inlaid work of the stock, although the technique has necessitated wider lines and pearls.

The decoration of the butt-plate and barrels in front of the chambers and around the butt affords interesting similarities to that on a number of the sheets in a pattern book for locksmiths. Its title-page reads 'DIVERSES PIECES de Serruriers inuentées par Hugues Brisuille Maître Serrurier AParis Et grauez par Jean Berain. AParis chez N. Langlois rue St. Jacques a la Victoire avec Privileges du Roy'. Another edition was published by I. Mariette[14]. This latter is represented in the National Museum, Stockholm; it lacks the dedication which, according to Weigert, introduced the example in the Bibliothèque Nationale, Paris, issued by Langlois. It has, however, more sheets than the eleven apart from the dedication which are known to Weigert.

It would be very interesting if it could be proved that the Brisville book, the Berain pattern plates for gunsmiths and the decoration on the Wender gun in the Livrustkammare were executed by the same hand and that this was Jean Berain's (b. 1640, d. 1711). Agreement in type between certain ornaments in the locksmith patterns and on the gun confirm such an assumption and likewise the fact that the side-plate on the gun is of practically identical design to that on the sheet (Pl. 117:1) next to the title in the gunsmith's pattern book (Weigert No. 2). The signature on several sheets in both engraved pattern books is likewise identical (BERAIN F.). Weigert considers that all three can be attributed to the same person[15]. One cannot help observing, however, that the Brisville book was engraved by a less sure hand than that which was responsible for the gunsmith's patterns and the inlays on the barrel and stock of the gun. Weigert dates the Brisville-Berain book to 1663 from a portrait of Hugues Brisville with this date, which is bound in with the copy in the Bibliothèque Nationale, Paris. This seems to be convincing. The dating of the three works would then be: the gunsmith patterns 1659, the locksmith patterns 1663 and the gun the beginning of the 1660s. Is it, however, likely that a person who

obviously had a thorough mastery of his subject in 1659 should four years later show weakness in technique and that between the ages of twenty and twenty-five, should be familiar with iron and silver engraving, etching and gold damascening in a way that would otherwise call for both lengthy and thorough training? Documents that have hitherto been found provide very little guidance in answering this question. But it surely seems more probable to attribute the decoration of the gun to an earlier generation of the family, to assume that the patterns for gunsmiths were executed under the supervision of this earlier generation, and also that the pattern engravings of the year 1663 derived from works by the locksmith Brisville.

On the whole, the decoration of arms both in Berain's patterns and also on the gun, in spite of all their technical skill, are retarded in style in comparison with the new Classicizing style that was rapidly gaining ground in practically all spheres of art in Paris in the 1660s. The same applies also to the few surviving arms in the Thuraine and Le Hollandois style. The earliest known representatives of this style are the magnificent pistols in the Historisches Museum, Dresden (Inv. No. H. 19. Pl. 55), mentioned above. They have been dated here to the 1650s, which is confirmed by the decoration set in a cartouche composed of thin lines. They are similar to the Duclos firearms of the 1630s; they also retain the Baroque cartouche enclosing the signature in the middle of the lock-plate. On the barrels—one is, it is true, a later copy[16]—the chambers are embellished with symmetrical 'Schweif' ornaments growing out of vases. Symmetrical 'Schweif' ornaments of a type which might well have been found at the beginning of the century are applied in damascening further up the barrels. The flowers on slender stalks of the later Louis XIII style appear on the sides of the butts. All this ornament is very firm and strictly symmetrical. It is firmly rooted in the Baroque but aspires to Classical ideals.

This aspiration is still more manifest in the decoration of the gun signed 'Le Couvreux au Palais Royal' in the Musée de l'Armée, Paris

(Pl. 58). It finds expression in the adoption of archaic Renaissance grotesques in Etienne Delaune's style on the chamber on the barrel tang and ramrod-pipes. It is very clearly illustrated in the ornament along the edge of the butt in which strictly symmetrical Baroque foliage forms a rhythmic frieze over a base formed by lines and a beaded staff. The inlay on the comb of the butt is a brilliant example of naturalistic flowers on slender arabesques combined with grotesques. This also applies to the ornament on the small of the butt opposite the lock. On the lock are figures in Callot's style and grotesque masks in relief, and finally, engraved Classical medallions in rows with laurel crowned Roman heads in profile.

The same trend characterizes the ornament of firearms signed 'Thuraine et Le Hollandois' (Pl. 56 and 57). It can be assumed that these masters, attached as they were to the French royal house, manufactured arms which were just as richly decorated as those shown in their pattern books. Unfortunately none are known. The two guns with which we have become acquainted are considerably simpler and contribute nothing new to the discussion. The inlaid work on the chamber of the one in Copenhagen (Inv. No. B 663. Pl. 57:2) shows slender, symmetrical arabesques adorned with flowers growing out of a grotesque mask and terminating in front with rows of pearls. The material in this case is silver. Acanthus leaves and pearls make up a sculptured crown in front of the chamber. This sculptural treatment is also applied to the triangular openings of the trigger-guard, finials on the cock, steel and steel-spring. The Classical element is discernible but occurs more frequently in the pattern book (Pl. 115:2 and 116), 'Plusieurs Models des plus nouuelles manieres qui sont en usage en l'Art de Arquebuzerie auec ses Ornements les plus Conuenables Le tout tiré des Ouurages de Thurages de Thuraine et le Hollandois Arquebuziers Ordinaires de sa Maiesté et graué par C. Jacquinet. Et se Vend le present liure Chez les Autheurs auec privilege'. The edition with this title is probably the oldest. There is one copy in the Livrustkammare, Stockholm. There are two others, one dated 1660, in which the

title-page is missing—it constituted the basis for a new edition published by Bernhard Quaritch of London in 1888—and another in which the title after Jacquinet's name continues 'A Paris chez N. Langlois rüe St. Iacque à la Victoire au coin de la rüe de la Parcheminerie avec Privilege du roy'. All the following sheets in the last mentioned edition, of which there is a copy in the National Museum, Stockholm (Receuil d'ornement et d'architecture), bear the publisher's name and address 'N. Langlois rüe St. Jacques' and are numbered from the title-page, which is No. '1', to No. '11', inclusive. Guilmard knew of a copy of this latter and one of 1660 in the Bibliothèque Nationale as well as a copy in the Bérard Collection containing three sheets with interiors of rooms and workshops and verses on the apprentice Janot, and also signatures (cf. p. 80)[17]. Boeheim only knew the edition of 1660[18]. The picture of a flintlock which he reproduces on p. 177 in *Meister der Waffenschmiedekunst* with the statement that it is taken from this edition, is in fact the last sheet in Marcou's book, signed and dated 1657. The mistake can be readily understood as the form and style of this lock closely resemble those shown in several sheets of the Thuraine and Le Hollandois book. This in turn implies that the style as a whole must be dated well into the 1650s.

The title quoted above (Pl. 115:1) is set in an architectural frame with a garland of fruits and seated Minerva and Diana, with a ruined wall behind. Then come the three sheets of interiors, next ten sheets numbered '1' to '10' and finally two unnumbered, one with a right and a left-hand back action lock, etc., the other reproducing, among other things, a pistol pommel, rows of foliage ornaments closely related to those on the butt of the Le Couvreux gun in Paris, decoration for the small of a butt, etc. There is no need to repeat what has already been said about the relief ornament, naturalistic flowers on slender stalks, Baroque cartouches and Baroque grotesque masks. It is more important to point out the clear Classical style that distinguishes the ornament on the sheet marked '1' on a pistol butt and the small of a butt. There is

very similar ornament on sheet '10', also on a pistol butt. This ornament has lost the lively quality of its predecessor. In both cases we are dealing with copies, but if there can be any talk of individuality this applies to the earlier decoration.

It is difficult to say to what extent the two pattern books of Berain and of Thuraine and Le Hollandois influenced the decoration of fire-arms. There are seldom direct points of agreement between them and extant weapons. It may be mentioned that a grotesque figure holding a shield with the signature 'Cunet à Lyon' on the lock of a gun with chiselled decoration, in private possession in Sweden, occupies the same place on sheet '9' in the Thuraine and Le Hollandois book. Also that a huntsman, whose legs develop into foliate arabesques, is to be found between cock and steel-spring on the large sheet in the Berain series as well as on a gun in the Wrangel Armoury at Skokloster by 'David René a Heydelberg' (No. 100. Pl. 62:5). It can also be pointed out that Italian flintlocks dating from the decades after the 1650s follow the Berain book. The pistols in Pl. 63 in the Livrustkammare[19] can be quoted as an example. The connection might well be investigated and give interesting results.

Even if direct borrowings cannot be proved it is nevertheless interesting to observe that certain features of this style are still to be found well into the next group of forms. The plan for the decoration of the lock-plates according to Thuraine and Le Hollandois is as follows: on the rear point an ornament or a mask, in relief or engraved; this is so arranged that the bottom is towards the point and the top towards the cock. Where this ornament is chiselled in relief it is often coupled with an engraved part nearest the cock. On the lock-plate between the cock and the steel-spring there is, as a rule, a cartouche or a figure so placed that the top is towards the flashpan. This plan is usual in the 1660s and is also met with until about 1680. Examples are the pistols by Champion of Paris (Livrustkammare Inv. Nos. 3886, 3887. Pl. 73:3). The pistols Nos. 4072 and 4073 by Piraube of Paris (Pl. 75:1) and the *de luxe* gun by

Gruché of Paris (Munich, Bayerisches National-museum 13/588. Pl. 77:1) are arranged in this way.

The inlaid work on the stocks indicates a strong professional tradition. In comparison with the inlays of the beginning of the century the ornament as a rule is flaccid, but we also find brilliant exceptions such as the inlaid work on the Wender gun in the Livrustkammare signed by Berain. This decoration, too, contains quite a number of features taken over from previous periods. The inlay on Louis XIV's gun by De Foullois le jeune in the Pauilhac Collection in Paris (Pl. 61:6) is an example of the flaccid forms, and the stock maker who helped Des Granges to decorate a pair of breech-loading pistols with turn-off barrels (Nos. 1699, 1700) in the Livrustkammare was unable to maintain his art at a 'living' level. This kind of inlaid work is found in a better state of preservation on the pistols by De Foullois le jeune Nos. 1631, 1632 in the Livrustkammare (Pl. 72) and on the breech-loading gun No. 1345 by the same master in the same collection. It is also found on the Champion pistols (Pl. 73) just mentioned and in the Nationalmuseum (13/588) and Kunsthistorisches Museum, Vienna (Waffensammlung No. A 1674. Pl. 77). With these firearms we have entered the 1680s and approach the type of decoration which characterized the French flintlock arms at the close of the seventeenth century and the beginning of the eighteenth century.

Notes to Chapter Twelve

1. [Lotz], *Katalog der Ornamentstichsammlung der Staatlichen Kunstbibliothek, Berlin.* P. 121.
2. Guilmard, *Les maîtres ornemanistes.* P. 86. No. 19.
3. Dr L. has written in pencil in the margin of his copy: 'does not agree' Translator. 25/3/63.
4. Michel, *Histoire de l'art.* T. VI:2. Pp. 916, 917.
5. Cf. *Svenska slott och herresäten* (*Swedish Mansions and Country houses*). Bd. IV: 1. Pp. 8, 9.
6. Michel, *Histoire de l'art.* T. VI. P. 916. Fig. 599.

7. (Lotz), *Katalog der Ornamentstichsammlung der Staatlichen Kunstbibliothek, Berlin.* P. 8. No. 31. P. 47. No. 307.

8. Weigert, *Jean I Berain.* T. II. Pp. 29–32.

9. [Lotz], *Katalog der Ornamentstichsammlung der Staatlichen Kunstbibliothek, Berlin.* P. 122. No. 832.

10. Guilmard, *Les maîtres ornemanistes.* P. 89. No. 27.

11. Boeheim, *Meister der Waffenschmiedekunst.* Pp. 15–17.

12. Weigert, *Jean I Berain.* P. 1. P. 4 ff. Cf. also the same author, 'Berain-Pistols in the Tojhus Museum'. *Vaabenhistoriske Aarböger*, II. 1937—39. Pp. 68–72.

13. These ornaments of the Berain book, like other patterns in this style, and the completed arms are closely akin to contemporary goldsmiths work. Légaré, *Liure des Ouurages d'Orfeurerie* contains very similar ornament. [Lotz], *Katalog der Ornamentstichsammlung der Staatlichen Kunstbibliothek, Berlin.* P. 122. No. 827. A ring in the Livrustkammare which can be dated to the mid seventeenth century actually has such ornaments close to the inset stone. Those ornaments probably originated from 'Schwarzornament' with enamel omitted.

14. Weigert, *Jean I Berain.* T. II. Pp. 32–38.

15. Weigert, *Jean I Berain.* T. I. Pp. 113, 114. The author states in it that the gun is preserved in the Nordiska Museum. If he means the actual building his statement is correct. The gun belongs, however, to the Livrustkammare. The information sought by W. as regards Louis XIV's gift to Charles XI is in the French Ministry of Foreign Affairs archives.

16. The original barrel exploded. Inventar Pistolen Cammer, 1717. No. 338. Dresden Historisches Museum. Contributed by Dr Erna v. Watzdorf.

17. Guilmard, *Les maîtres ornemanistes.* P. 86. No. 18.

18. Boeheim, *Meister der Waffenschmiedekunst.* P. 178.

19. Livrustkammare. *Vägledning 1921.* P. 89. No. 709.

CHAPTER THIRTEEN

Patterns and decoration from the Classical Louis XIV style to Empire, inclusive

Aᴛᴛᴇʀ COLBERT assumed control following Fouquet's fall in 1661 and after the death of Mazarin the applied arts in France entered upon a new phase. They were made to serve Colbert's economic policy and figured more prominently than before as a background for the king's person. The centralisation which characterizes Louis XIV's *régime* in all spheres merged the arts and crafts in the French Academy of Painting and Sculpture. Fouquet's right hand man, Charles Le Brun, hastily entered the king's service after the fall of his chief and became the leading personage in the Academy as well as in a newly established stronghold of the applied arts. This was set up in 'Les Gobelins' under the name of 'Manufacture Royale du mobilier de la couronne'. It had the task of supplying the royal palaces with furniture and fixtures, to begin with those already existing and then the new ones, Versailles and Marly being the most important. Le Brun continued his task as decorator of both these and several private palaces including the Hotel Lambert and Vaux le Vicomte. He had a large staff to help him in his multifarious tasks, among whom were several of the great names in contemporary French art. Under Le Brun's management the French applied arts became strikingly homogeneous. The Classicizing style which resulted from Le Brun's activities was not effective in gun making until the 1680s, but the arms decorators were greatly influenced by the new style as early as the latter half of the 1660s, and Paris made firearms of the 1670s display the Louis XIV style as developed by Le Brun.

We know that the colony of artists in 'Les Gobelins' which was directed by Le Brun delivered patterns to the artisans in the Louvre. The gunsmiths may also have enjoyed this privilege. Nothing is known of this, nor was it necessary since the decoration of flintlock firearms was, as a rule, quite simple in comparison with the wainscotting of rooms, furniture inlays and tapestry borders. It was, therefore, a simple matter for an expert gunmaker to choose his patterns from the store of ornament which had met with His Majesty's approval. Traditional forms accompanied the new fashion well into the 1660s.

A characteristic feature of the lock decoration of the Classical Louis XIV period is that the ornament behind the cock was intended to be seen when the firearm was horizontal. Apart

from ornament in the Classical style of the period we find figure scenes combined with motifs from Classical antiquity. Ornament like that on 1336 in the Livrustkammare by De Foullois le jeune (Pl. 70:1) constitutes an exception. It is composed of grotesques in the style of Hieronymus Bosch. Earlier designs of this type were also used for the flat, engraved, and pierced side-plates which were set flush in the stock (cf. Pl. 68). These were succeeded by other forms at the beginning of the 1670s.

The gun signed by 'Piraube au gallerie à Paris' in the Livrustkammare (Pl. 71) is a good but not very luxurious example of the Classical period. Its lock-plate is embellished with simple grotesque sprays in an engraved border following the edges of the lock-plate and cock. The latter is chiselled with a simplified version of an acanthus leaf, and a simple, symmetrical foliage ornament, also in relief, decorates the front of the steel. Symmetrical, engraved foliage issuing from a grotesque female figure is the basic element in the decoration on the chamber of the barrel, and firm, symmetrical sprays are spread around the back-sight and the thumb-plate. The side-plate is in the form of a crawling serpent with a cloven tail and tiny foliate excrescences. This shape is determined by function and has no actual prototype in contemporary French pattern books.

The description given in Chapter Nine explains the difference between the forms of the 1670s with the straight tang on the butt-plate of the guns and the jaw-screw heads compressed from above and those of the 1680s with the serpentine butt-plate tangs and drop shaped jaw-screw heads. As regards decoration the distinction is not so clear. For these decades, and subsequently as long as the rounded forms held their own against the flat Berain ones, the Simonin albums are representative. The first one (Pl. 119, 120) appeared in 1685 under the title 'PLVSIEVRS PIECES ET ORNEMENTS Darquebuzerie Les plus en Vsage tiré des Ouurages de Laurent le Languedoc Arquebuziers Du Roy et Dautres Ornement Inuenté et graué Par Simonin et Se Vend Ledit livre Chez ledit Simonin a Lantree du Faubour St Anthoine A Paris Auec Priuilege du Roy 1685'. The title

page is unnumbered. The other pages are numbered '2' to '8'.

As in the case of the pattern album engraved by Jacquinet after Marcou and Thuraine and Le Hollandois, Simonin's album was copied from Le Languedoc's oeuvres and should really be listed under the latter's name. The reason why the gunsmiths' names have been placed before the engravers' when dealing with the earlier patterns is: these patterns differ so fundamentally from one another that treatment of them in Jacquinet's name would cause uncertainty and misunderstanding. As Simonin's work comprises two albums in the same consistent style taken from the works of anonymous masters and as most of the sheets are signed 'Simonin in [venit] et fecit', both albums can be appropriately presented in his name.

Boeheim states of Simonin, whose Christian name according to the later album was Claude (he died not later than 1693), that he was assistant to Languedoc ('Er bediente sich für seine Arbeiten des berühmten Zeichners und Graveurs Claude Simonin . . .' He availed himself in his work of the renowned Draughtsman and Engraver Claude Simonin . . .)[1]. This collaboration probably also included the manufacture of arms. Laurent becomes 'Laurence' and 1685 '1684' in Boeheim[2]. The album is represented in the Bibliothèque Nationale (Cabinet des Estampes, Vol. 'Le 24')[3], the Staatliche Kunstbibliothek, Berlin (O. S. 840:1)[4] and elsewhere.

The title (Pl. 119:1) is framed within a Louis XIII cartouche with grotesque masks at the foot and top and is flanked by elaborate trophies and two captives. The cartouche is surmounted by a distinguished horseman who, judging by the monogram and dolphin on the trumpet banners of the two flanking angels, may represent 'Le grand Dauphin'.

The second album, which bears Simonin's name (Pl. 121), appeared in 1693 and was sold by Claude Simonin's widow. His son Jacques seems to have carried on his father's business. Boeheim states that this album does not deal with weapons ('Aus einem anderen das Waffenfach nicht berührenden Kupferstichwerke von selbem [Simonin] 'Les plus beaux ouvrages de

147

Paris' erfahren wir' ... From another set of engravings not concerned with firearms by the same (Simonin) ... we learn)[5]. This statement is surprising as the nature of the publication is evident from the actual title: 'PLVSIEVRS PIECES ET AVTRES Ornaments pour les Arquebuziers et Les brizures demontée et Remontée Le tous designé graué par Simonin et des plus beaux Ouurages de paris Ce Vend Chez le Veufüe a L' entrée du faubourg St Anthoine A Paris A l'enseignei du Cabinet a fleurs AVEC PRIVILEGE 1693.' In this instance too the title is framed (Pl. 121:1) by a cartouche flanked by trophies and finished off at the top by a smaller cartouche enclosing a fight between horsemen, at the foot by a grotesque masque and two cornucopiae with flowers. In the lower corner is a line giving the following information: 'Le tout dessigne et grauee Par Claude Simonin et Jacques Simonin Son fils auec Priulege de Roy.' The title-page is unnumbered, the others are numbered '2' to '11'. Pages '2' to '11' are chiefly devoted to details of gun locks, the other designs mostly to ornament. There is a copy in the Staatliche Kunstbibliothek, Berlin (O.S. 840:2)[6], another in the Bibliothèque Nationale, Paris (Cabinet des Estampes, Vol. 'Le 24')[7].

In regard to their style both the Simonin pattern albums are more or less alike. The ornament is simpler than that of the patterns of the period about 1660. This applies at least to the first album. In the later one the need of elaboration is given slightly stronger expression. In 1685 a few figures only and an occasional simple spray decorate the locks. In 1693 there are battle scenes with several participants and other representations covering larger surfaces. Both figures and ornament are more delicate in the 1693 album than in that of 1685. For ordinary weapons engraved decoration may be expected on lock-plates and barrel, in the case of the more elaborate ones decoration in relief.

Festoons with or without grotesques are the most usual ornaments on both metal parts and stocks in these pattern books. Very similar ornament is found in contemporary French woven tapestry borders, but the gunsmiths have, as a rule, simplified them. In the later

album the inlaid ornament common at the close of the seventeenth century appears on sheet '10' (pistol butt) and '11' (free ornament). A very good example of what this ornament looks like when executed is the inlay of the stock on gun No. 735 in the Gewehrgalerie at Dresden, signed 'A Paris par Le Languedoc' (Pl. 81:1). The decoration adopts the thin lines necessitated by the technique and proceeds, in contrast to the earlier butt decoration, asymmetrically in the form of a dragon's tail on the heel of the butt and spreads out across the entire side of the butt in the form of a widespreading arabesque. Both the dragon and a serpent suspended enclosed within the foliations are executed in thin wire. Leaves are merely outlined. A new element has been introduced into the arabesques, namely, an oval with dashes which is both separated and connected downwards and upwards by means of dots.

The Simonin albums were issued at a time when the manufacture of flintlocks spread over large parts of Europe. Both this fact, the triumphal progress of the French style, and the circumstance that these pattern books were comparatively simple and suitable for general use, led to their being copied outside France in pirated editions. In France the plates for the album of 1685 were taken over by the gunsmith Languedoc. He issued a new edition in 1705, the title-page of which was changed as regards the year and the penultimate line which read as follows: 'et Se Vend Ledit Liure Chez ledit Languedoc rue de bretagne aux marais.' In all other respects the plates were untouched[8].

In the Netherlands two publishers, Pieter Schenck and Daniel de la Feuille, each issued his 'replica edition' in 1692 of Simonin's 1685 album. The title of the former's (Pl. 122:1) runs: 'VERSCHEIDE STUCKEN EN CIERADEN Van Roermakers gereedschap nieuweleghs uitgevonden en uit de vornaamste Meesters van Europe getrocken. PLVSIEVRS PIECES ET ORNEMENTS Darquebuzerie [N.B. the similarity to the original], le plus nouellement Inuentées et Tirees des premiers Maistres de l'Europe Par Pierre Schenk a Amsterdam 1692.' The title is surrounded by a cartouche crowned with the

Plate 123.

France, Paris. Nicolas Guérard, *Diverses pièces d'arquebuserie* . . . Paris,
Early eighteenth century. undated; Berlin, Staatliche Kunstbibliothek O.S. 858 a.

Plate 124.

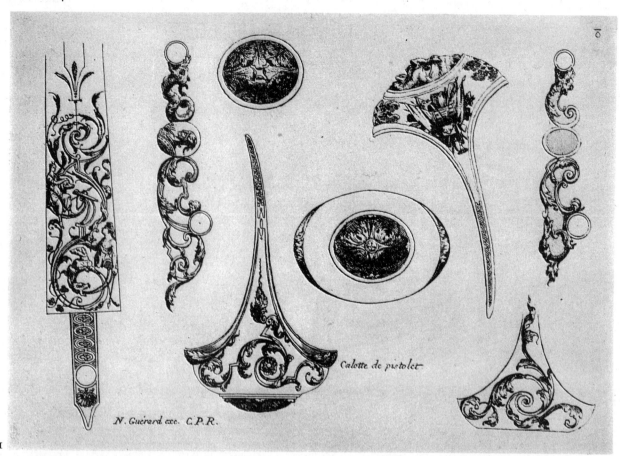

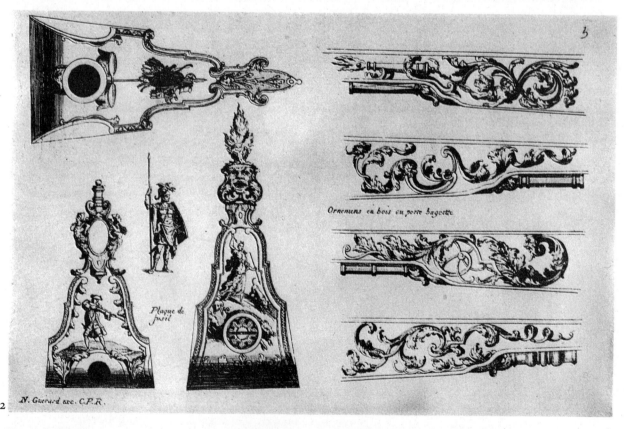

France, Paris.
Early eighteenth century.

Guérard, two sheets from same series as Pl. 123.

Plate 125.

1

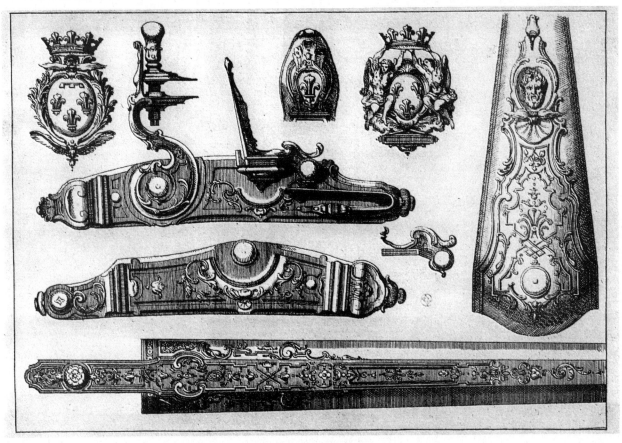

2

France, Paris.
(1710) 1715–22.

Claude Gillot, *Nouveaux desseins d'arquebuserie* . . . Paris,
undated; Ex. Stockholm, Royal Library.

Plate 126.

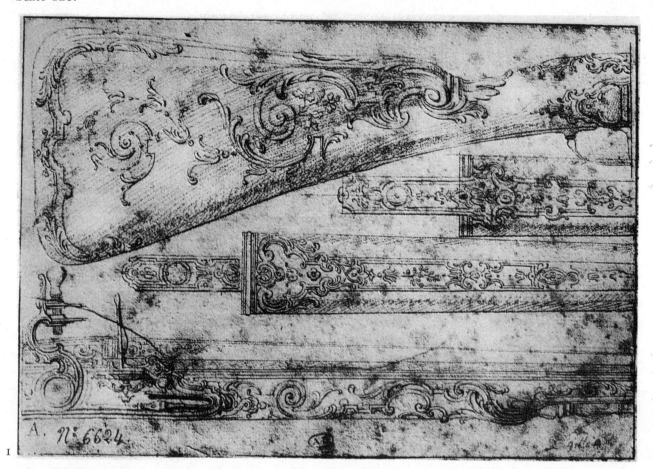

France, Paris and St. Lo.
1710–20s.

1. Claude Gillor, red crayon drawing for *Nouveaux desseins d'arquebuserie* . . . ; Paris, Musée des arts décoratifs. 2. Le Conardel, pattern for weapon decorators; Ex. Berlin, Staatliche Kunstbibliothek O.S. 861.

Plate 127.

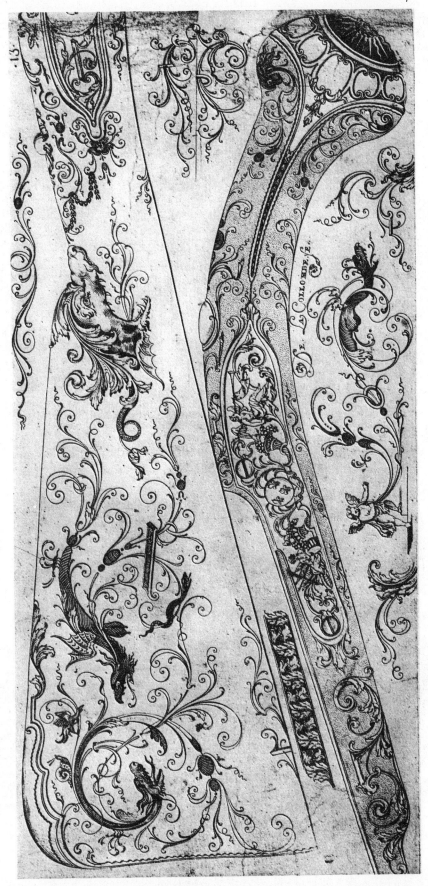

France, Paris. De Lacollombe, pattern for weapon decorators;
c. 1700. Ex. Stockholm, Livrustkammaren. From Foulc
Collection.

Plate 128.

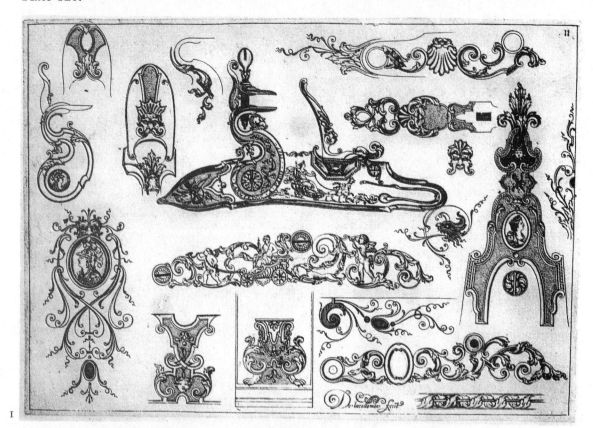

France, Paris.
c. 1700, 1730.

De Lacollombe. 1. Sheet from same series as Pl. 127.
2. *Nouveaux desseins d'arquebuseries* . . . 1730. Title page;
From Foulc Collection.

Plate 129.

1

2

France, Paris.
1730.

De Lacollombe, *Nouveaux desseins d'arquebuseries* . . . Paris
1730; Ex. Stockholm, Livrustkammaren. From Foulc
Collection.

Plate 130.

1

2

France, Paris.
1743 and 1749.

De Marteau, designs for arms decorators; Ex. Stockholm,
Livrustkammaren. From Foulc Collection.

Amsterdam coat of arms and flanked by figures of Fame blowing trumpets, trophies and putti sitting with palms of peace. The signature 'P. Schenck fe: Cum: Privil:' is printed in the right-hand corner. The other pages are slightly coarser copies. There is a complete copy in the Kupferstich Cabinet of the Rijksmuseum, Amsterdam. Guilmard also includes a complete copy but calls the engraver Schentz[9]. He is also aware that the prototypes of the publication are French ('la plupart d'après des modèles français').

The text on the title-page of the second copy edition of Simonin's album of 1685, published by Daniel de la Feuille of Amsterdam, is identical with the Schenck edition except as regards the name of the publisher. The framing is also very similar to the French original. There is an example of this edition in the Bibliothèque Royale, Brussels[10].

The Simonin album of 1685 was distributed in Germany by Jakob von Sandrart. Its title (Pl. 122:2) is: 'PLUSIEURS PIECES ET ORNEMENTS Darquebuzerie, le plus nouuellement Inuentées et Tirees des premiers Maistres de l'Europe. Neues Büchlein Unterschidlicher Stück und Ciraten Büxenmacher Arbeit nach besten Meistern dieser Kunst, allen dieser Profession Zugethanen seer nützlich. Zu Nürnberg bej I Sandrart zufinden.' This title is surrounded by a cartouche with an oak leaf wreath, trophies, captives, a Goddess of Fame blowing a trumpet, etc. The title-page is new, the other pages are copies though with different numbering from that of the original[11]. The date of the publication of these copies must fall between 1685 and Jakob von Sandrart's death in 1708[12], but probably in the 1690s, seeing that new forms had already replaced the old ones in France and the fashion spread rapidly.

Sandrart's copies after Simonin are the work of a heavier hand than the original. This is still more the case with another pirate edition from the same original which was published by David Funck, also of Nuremberg. The plates in it are engraved by Heinrich Raab. A copy of page '6' of the original serves as the title-page. On it a lock-plate decoration at the top has been omitted and its place taken by a cartouche

with the inscription: 'Neues Büchsenmacher Büchlein zufinden beij David Funck in Nürnberg' (Fig. 5). There is an example in the Museum für angewandte Kunst, Vienna[13].

While the forms and decoration that introduce the Classical epoch in French gunmaking were developing, the second edition of Philippe Cordier Daubigny's pattern sheets from the 1630s appeared, and in 1687, when the Classical style was at its peak, Gerard Iollain issued a pattern book: 'Divers Ornemens, Platines, Chiens, Bassinets, Visses, Escroüe, Feuillages, et festons propre pour les Armuriers, dessignés et jnventez par Alexandre de Rochetaille Armurier ordinaire du Roy. 1687. Se vend a Paris Chez Gerard Iollain rue St: Iacq. a l'Enfant Iesu excum P.R.' The only copy known to exist is in the National Museum, Stockholm[14]. It consists of six sheets including the title-page. The title does not fulfil its promises when examined. The title-page itself proves to be a copy of Marcou, 'Plusieurs pièces d'arquebuzerie . . .', pages '7' and '4' according to the Berlin copy, but reversed. The locks on four of the other sheets are also copies from Marcou, and in addition, de Rochetaille has made constant use of Stephano della Bella: 'Raccolta di varii cappricii . . .' as well as of other earlier engravings. Daubigny also provided the material for page '4'. The entire publication is very inferior, technically as well as artistically. It can only have served a purely commercial purpose.

Louis XIV constantly met his own image in the panelling of the palace rooms, on the tapestries, in the groups of statuary in the parks, etc. This did not generally apply when he picked up one of his own guns. In one instance, however, the famous gunsmith Piraube has followed the maxim, pronounced by Le Brun, that official art should be an apotheosis of the monarch. This is on the 1682 gun in the collection of Windsor Castle (Pl. 76). Louis XIV's profile is chiselled beneath the French royal crown. The part of the butt-plate on top of the butt is also decorated with the crowned arms of France and the radiant sun, the royal symbol to which Apollo driving his team on the side-plate also alludes. The king's image is

Fig. 5. Title page of the edition published by David Funk of Nuremberg copied from Simonin's Plusieurs pieces et ornements *of 1685. Original in Oesterreichisches Museum f. angewandte Kunst, Vienna. Cf. Pl. 120:1.*

again encountered on the butt in an equestrian monument, resembling his statue on horseback above the entrance to the *Hôtel des Invalides* in Paris, and on Coyzevox's relief in the *Salon de la guerre* at Versailles, where he is also surrounded by a figure of Fame and by genii carrying palm leaves and a laurel wreath.

The gun provides a fitting proof of the application of Le Brun's decoration. Such a distinctive product by a master attached to the Court also shows how strong the tradition of a craft can be in the minute details of the inlay work of the stock. Some of these are direct survivals from the Thuraine and Le Hollandois' epoch. Piraube used the same thumb-plate and the same side-plate some fifteen years later on a pair of magnificent pistols in the Gewehrgalerie, Dresden (Inv. No. 739). As far as the design of the details is concerned he no longer achieved the same high level. This deterioration is still more noticeable on the 1715 pistols in the Louvre, Paris. The Dresden pistols are, in

other respects, good examples of the later type of silver inlay on stocks characterized above. The fact that Erttel of Dresden took Louis XIV's Windsor gun as the prototype of the gun in private Swedish ownership (Pl. 83, 84), now unfortunately lost, is an excellent parallel to the role Augustus the Strong wished to play in Saxony, also in the French manner.

Other luxurious weapons of the same period deserve to be mentioned on account of their ornament, such as the two guns of the 1680s by 'Gruché à Paris' in the Kunsthistorisches Museum, Vienna, and the Bayerisches Nationalmuseum, Munich (Pl. 77) and also the slightly later garniture by Chasteau in the Töjhus Museum, Copenhagen (Pl. 79) and a gun by the same master in Vienna (Waffensammlung No. A 1579). In all their opulence they are nevertheless merely variations on the theme we already know. The oval, pierced plate on the butt of the Emperor Charles VI's gun in Vienna (Pl. 77:2) derives from Le Brun's

painting *Alexander's entry into Babylon* now in the Louvre[16].

The mid 1690s witnessed a change in French gunmaking which led to a return to mid century form together with the adoption of the Berain ornament. It is not known to what extent Jean Berain drew patterns for flintlock arms during his middle age, but in 1697 he at any rate made drawings for a pair of pistols which Daniel Cronström, Assesor and later Minister Resident in Paris, intended to offer Charles XII as a present[17]. This was probably not the only occasion, and it would be but natural if the elements in flintlock design about the turn of the century, that revert to the middle of the seventeenth century, could be explained by Berain's collaboration. The earliest known dated examples of the new style are the Piraube pistols of 1696 in the Dresden Army Museum (Pl. 85:1, 4, 7), the oldest among the engraved patterns two sheets by De Lacollombe dated 1702 and 1705 respectively (Pl. 128-1), the latter with Le Languedoc's name on a lock. The details on these sheets manifestly belong to the 1680s and 1690s but the locks are flat in shape (cf. Pls. 127 and 128:1). These sheets belong to a series of which the remainder are lost.

These revived forms are also represented in the patterns by Guérard and Gillot and by later engravings by De Lacollombe. Among these Guérard's pattern illustrations are the earliest.

According to Nagler there were two engravers named Nicolas Guérard, probably father and son[18]. Thieme-Becker only knows of one, d. 1719, the same man, who according to Jessen, based his art entirely on Berain[19]. This is also the impression given by his album, the complete title of which, according to the specimen in the Staatliche Kunstbibliothek, Berlin[20] (Pl. 123:1) is: 'DIVERSES PIECES D'ARQUEBUSERIE. Enrichies de figures et d'ornements, de Damasquine et d'Argent de raport Inventeé, Dessignez et gravez par Nicolas Guérard. Sous la conduite des plus habiles Arquebusiers de Paris. Se vendent Paris chez ledit N. Guérard graveur rüe S:t Jacques proche S:t Yves. C.P.R.' The title on the copy

in the Bibliothèque de l'Arsenal, Paris, is similarly worded but fills up more of the frame and is slightly enlarged. In both instances it is surrounded by a very ample frame with many figures, mostly emblematic of war, but also of the chase and target shooting. Minerva on the one side and Diana on the other represent the use of arms. The naturalism of the eighteenth century is conspicuous on the title-page as well as in the scenes from the chase which decorate locks and mounts. Two of these hunting scenes derive from prototypes by Jean-Baptiste Oudry[21].

There is no uncertainty as to the period they represent. This is established sufficiently by the arms dating from 1708 to the beginning of the 1720s discussed in chapter ten. The sideplates with engraved hunting scenes look forward, but other elements appear old fashioned, for example the drawing for the silver inlay round a thumb-plate on sheet '9'. On sheets '9' and '10', the last in the series, Guérard produced patterns for very elaborate stock inlays. They follow the late seventeenth-century designs mentioned above, but the foliate scrolls are more complex and the figures incorporated in them more numerous. These figures are intended to be executed in the form of engraved and silver plate nailed to the stock. This is also the case as regards three guns which are decorated in the manner of Guérard's engravings. Two of these guns are in the Moscow Kremlin. They are numbered 7203 and 7217[22]. The third is in the Töjhus Museum in Copenhagen (Inv. No. B 1533). The last mentioned one belonged to the Empress Elizabeth of Russia, is dated 1749 and was, like the others, manufactured in Tula.

As has already been mentioned Guérard's series contains ten sheets including the title. It is represented in the Staatliche Kunstbibliothek, Berlin (O. S. 858a), the Livrustkammare, Stockholm, the Bibliothèque de l'Arsenal[23], Musée des Arts décoratifs, Paris, and elsewhere. It was probably, like Simonin's designs, widely used. This is also indicated by the fact that it, like the others, was distributed in a facsimile edition, in this instance by Johann Christoph Weigel, Nuremberg. As he died in 1725 this

Fig. 6. Title-page of Johann Christoph Weigel's edition of copies of Guerard's Diverses Pieces d'arquebuserie. *Original in Staatliche Kunstgewerbebibliothen, Dresden.*

gives us a *terminus ante quem* both for the facsimile edition and for the original. This dating tallies with what we have already gathered from the dated arms. The title of the Weigel edition (Fig. 6) reads: 'Unterschiedliche Stücke vom BÜCHSENMACHEN reichlich versehen mit allerhand Figuren und Zierrathen, vom Schmeltz Damascener und eingelegtem Silber-Werck, vorgestellet unter Anleitung der geschicktesten Buchsen-Schmite zu Paris. Johann Christoph Weigel Excudit.' The border of the title is also copied in this case. This series is rare.

Claude Gillot (1673–1722) is known as Watteau's teacher, but he also deserves to be remembered as a highly skilled draughtsman. Gillot produced a series of designs for gunsmiths. It contains eight sheets including the title. One of his original drawings is fortunately preserved and belongs to the Musée des Arts

Décoratifs in Paris (Pl. 126:1). It is executed in red crayon in the lightest of hands, the sureness of which is impressive. The composition has been slightly simplified in the engraving, but there is no doubt that this drawing is the source of one of the sheets in 'NOUVEAUX DESSEINS D'ARQUEBUSERIE Inventez et Gravez Par Le S:r Gillot. Ce vend a Paris rüe S:t Jacques chez F. Chereau aux deux Pilliers d'or. In. par Gillot Peintre. de l'Academie Royalle de Peinture' (Pl. 125:1). The work is undated. The date of publication must however be between 1715, when he became 'agrée', and 1722, the year of his death[24]. Gillot's patterns for gunsmiths belong to the Régence style.

Gillot's sheets do not seem to have been employed in the manufacture of weapons. Some of the details nevertheless recall the group with gilded brass furniture by masters such as

Plate 131.

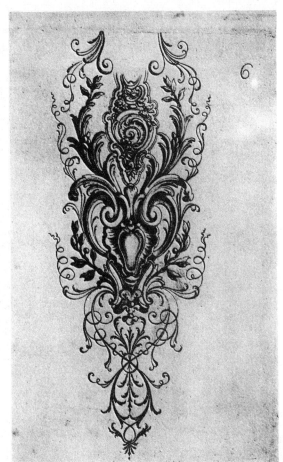

France, Paris.
Mid eighteenth century,
early nineteenth century.

1. De Marteau, *Nouveaux Ornemens D'Arquebuseries* ... Paris, undated. 1. Title page; Ex. Berlin, Staatliche Kunstbibliothek O.S. 863. 2. De Marteau, pattern sheet for shaftmakers; Ex. Stockholm, Livrustkammaren. 3 and 4. Lucas, patterns for firearms decorations; Ex. Paris, Bibliothèque Nationale. Cabinet des estampes, Vol. Le 24.

Plate 132.

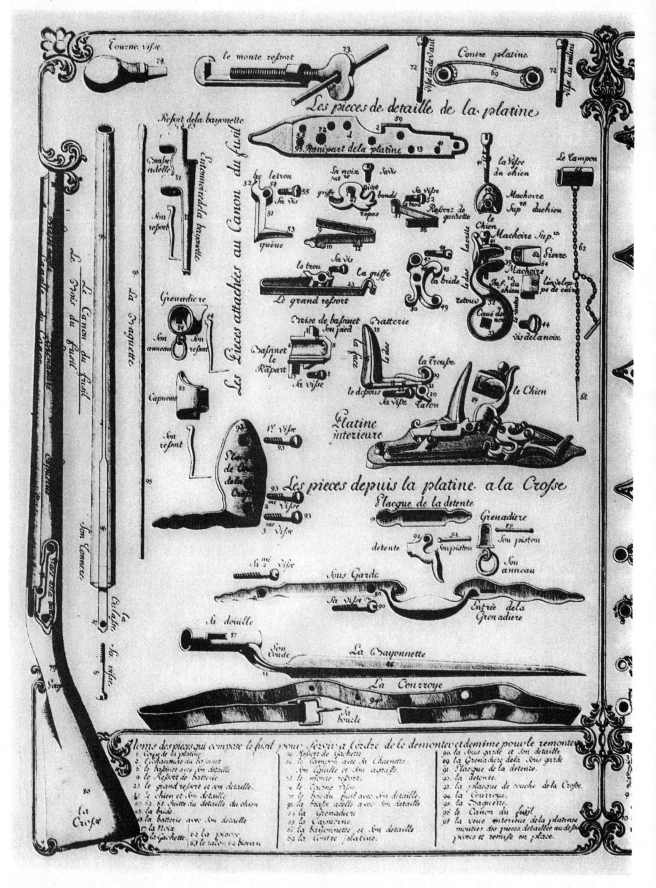

France, Strasbourg.
Mid eighteenth century.

Terminology plate published by Perrier, dealer in engravings, Strasbourg. Military rifles; Ex. Berlin. Staatliche Kunstbibliothek O.S. 862.

Plate 133.

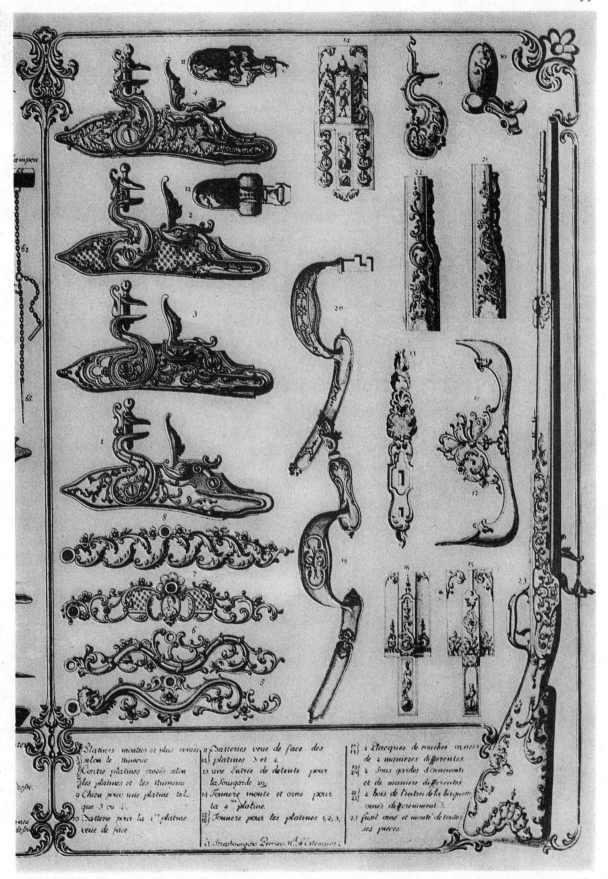

France, Strasbourg.
Mid eighteenth century.

Terminology plate, same as on Pl. 132. Sporting rifles.

Plate 134.

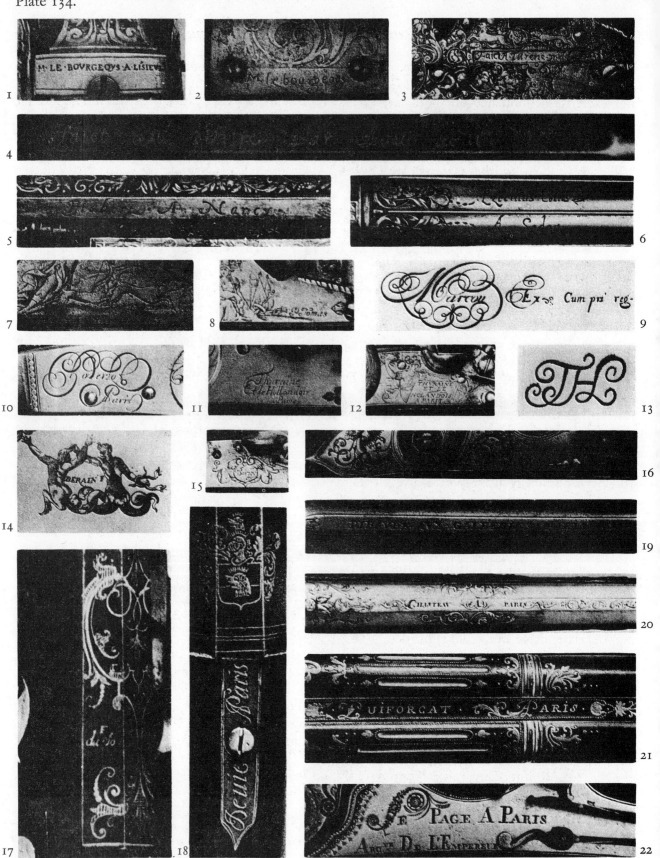

France.
1600–1810.

Signatures. See also Chapter Fourteen on this subject.

Thiermay, Servais and Selier (cf. p. 110 and Pl. 88). It is regrettable in a way that Gillot did not exert more influence on flintlocks, as his contribution is original in comparison with the archaising forms of the middle of the seventeenth century that so long remained in use.

Closely related to the material which has been dealt with are two sheets with the signature 'Le Conardel A St LO' in the Staatliche Kunstbibliothek, Berlin (O. S. 861. Pl. 126:2)[25]. This signature is reversed on parts of two lock-plates on one of the sheets. The ornament, technique and quality are in keeping with the ordinary flintlocks of the period and it would not be surprising if the engraver were a gunsmith who had engraved two copper plates with the ornaments with which he was accustomed to embellish his productions.

As has been pointed out only a part of De Lacollombe's earlier series (Pls. 127, 128:1) is known, but it can be concluded from the uniform nature and numbering of the extant sheets that one existed or was planned. The sheets which have formed the basis of this study and obviously also of Guilmard's notes[26], are part of a volume with engraved patterns for gunsmiths that belonged to the Foulc Collection. They bear the numbers '9', '10', '11' and '13', which implies rather a large series. What the other sheets in this series look like, their number, title and when the series was published is all unknown. It is to be hoped that research will fill this gap. Of the four sheets now known three are wholly or partly very much in the spirit of the seventeenth century, sheet '9' dated 1702, because it illustrates a Wender construction, sheet '10' because a rounded steel and pan are reproduced, sheet '13' (Pl. 127) and, furthermore, on account of the form of the butts and the inlaid ornament shown. The latter is of the same kind as that in the Simonin album of 1692 and on the gun by Le Languedoc in Dresden (cf. Pl. 81:1). We also find Le Languedoc's name on a lock on Le Lacollombe's sheet '10' and on sheet '11' (Pl. 128:1), which is dated 1705. The other pattern sheets signed by De Lacollombe were assembled by his pupil De Marteau to form a series (Pls. 128:2, 129, 130) with the title:

'NOUVEAUX DESSEINS D'ARQUEBVSERIES Dessiné &graué par De Lacollombe à Paris 1730. Se Vend Chez De Marteav Elève De Feu Mr De Lacollombe.' This title-page is consequently dated 1730 and De Lacollombe is described as 'the late' although his name can be read on another sheet dated 1736. Apart from details of decoration, adapted for different parts of weapons, a large oval cartouche is to be seen on this latter sheet with a palatial interior in which a distinguished gentleman seated at a table receives a bumper 'bag' from a sportsman, while two others with guns on their shoulders supervise or guard at the sides. Below this oval frame and linked with it by globes and goddesses of Fame is another cartouche with a deer chase in a large, open landscape with mountains and a lake. The various elements are more closely packed on this sheet than on the four earlier ones. The same applies to the five pattern sheets proper, all unnumbered, which, as far as the nature of the ornament is concerned, are directly linked with this sheet. Le Languedoc's name has disappeared from these and De Lacollombe's is also substituted on the lock-plates. One (Pl. 129:1) is dated 1730, and taking this with other known facts (cf. chapter ten) we may conclude that the series with the title, the sheet with the palace interior and the five associated sheets represent a style which had been employed in gunmaking from the beginning of the century. A characteristic feature is the punched ground, which was probably intended to be gilded, and against which the bright decoration showed up. These engravings show the solid side-plates which developed when the ground of the earlier pierced ones was filled with punched work. Another popular type follows the outline of the lock-plate.

De Lacollombe probably died between the years 1737 and 1743. His name appears, together with De Marteau's, on some of the earlier sheets, but from 1743 De Marteau's name is alone (Pl. 130). It is true that there are details in De Lacollombe's style on these sheets but they have become very 'soft'. The rest of the ornament, which is heavy and compact, is executed in the Louis XV style. The undated

sheet has very large cartouches in each corner with figure scenes, a cavalry fight, a monkey dressed as a sportsman, dogs, and game, etc., which are not at first recognizable as decorations for firearms. They rarely, if ever, occur in French gunmaking, but there are examples by German gunsmiths. A very beautiful gun by J. A. Köck of Mainz, dated 1740, in the Musée de la Porte de Hal in Brussels (Inv. No. 1484) is a good specimen. It has chiselled cartouches and figure scenes on silver plates which are securely nailed to the stock. They can be regarded as a more solid version of the figures enclosed in the inlaid scrolls. One of the motifs in De Marteau's engravings, two boys on a see-saw, is taken from *Second livre de taille d'espargne . . . per I. Bourguet Marchand Orfevre a Paris 1723*[27]. De Marteau produced on the same sheet two decorative designs for carving gun and pistol stocks around and behind the breechtang. There are similar ones on two other sheets. They are composed of rococo scrolls terminating in sprays of leaves or flowers, or entire sprays, catkins and rocailles. De Marteau produced variations on this theme in the series 'Nouveaux Ornemens D'Arquebuzeries Dessiné et Graué Par De Marteau Lainé. Se Vend Chez Lauteur A Paris. Prix 3ᵗᵗ' (Pl. 131:1). The title is enclosed in a cartouche of the same type. The album contains twenty-three sheets, the title-page included. There is a copy with this title in the Staatliche Kunstbibliothek, Berlin (O. S. 863)[28]. Three of the sheets are reproduced in Hirth's *Formenschatz vol. 21* (1897) on Pl. 13 and are ascribed to Jean-Louis Durant (known 1670–78). This, on account of the style alone, should have aroused suspicion. Another series entitled 'DE MARTEAU Le Ieune Graveur sur tour Metaux, Demeure au coin du Quay Pelletier du coté de la Greve A PARIS' is in the Livrustkammare and contains the same kind of ornament for carving on gunstocks. A sheet is reproduced on Pl. 131:2.

A chart of terminology published by Perrier, a dealer in engravings of Strasbourg (Pl. 132, 133) also dates from the mid eighteenth century. The left side shows the infantry rifle, the right the superior shotgun. There is a copy in the Staatliche Kunstbibliothek, Berlin (O. S. 862)[29], another in the National Museum, Stockholm.

The ornament on the surviving firearms has been described in chapter ten. It follows the usual trend from the Baroque of Louis XIV via the Régence, which had definite influence on the craft of the gunmaker, to the Louis XV style. This appears surprisingly late, not until the 1740s, and persists so long that the Louis XVI style gets very little chance of making itself felt until the stock of ornament of *l'ancien régime* has to give way to the Empire style. The gun signed by Le Page in the Historisches Museum, Dresden (Inv. No. Z.K. 664. Pl. 99:3–5) may be regarded as a continuation of the Louis XVI style. In the Wender gun of not later than 1808 in the same museum (Gewehrgalerie 1891. Pl. 99:2) both form and decoration are more characteristic of the Empire style. For this later trend we have the most typical examples in Boutet's production Pl. 100). During the subsequent Restauration period the ornament became lighter and more delicate but as late as 1829 Napoleonic eagles decorate the barrels of the engravings for gun ornament. Some of these were signed 'Lucas' and thirteen are preserved in the Bibliothèque Nationale, Paris (Cabinet des Estampes, Le 25. Pl. 131:3, 4)[30]. The style is Empire. No lock is shown on these engravings, but it is just as probable that the drawings were originally made for the flintlock arms as for the percussion-lock guns which were being manufactured on an ever increasing scale. Lucas's sheets are therefore well suited to conclude this brief survey of the decoration of the French flintlock arms and the patterns which are associated with them.

Notes to Chapter Thirteen

1. Boeheim, *Meister der Waffenschmiedekunst.* P. 111.
2. This latter statement is probably taken from Guilmard, *Les maîtres ornemanistes.* P. 109. No. 61.
3. Guilmard, *Les maîtres ornemanistes.* P. 109. No. 61. G. gives the number of sheets as twelve.

4. [Lotz], *Katalog der Ornamentstichsammlung der Staatlichen Kunstbibliothek, Berlin.* P. 123.

5. Boeheim, *Meister der Waffenschmiedekunst.* P. 111.

6. [Lotz], *Katalog der Ornamentstichsammlung der Staatlichen Kunstbibliothek, Berlin.* P. 123.

7. Guilmard, *Les maîtres ornemanistes.* P. 109. No. 61. Guilmard considers both the editions to be identical though with different titles.

8. The Livrustkammare possesses a copy of the 1705 edition.

9. Guilmard, *Les maîtres ornemanistes.* P. 511. No. 42.

10. Hymans, *Catalogue des estampes d'Ornement ...de la Bibliothèque Royale de Belgique.* P. 260.

11. These observations have been made on the copy in the Staatliche Kupferstichkabinett, Dresden. B 1158.

12. Thieme-Becker, *Allgemeines Lexikon der bildenden Kunstler,* Vol. XXIX (published by Hans Vollmer). 397.

13. Ritter, *Illustrierter Allgemeines Katalog der Ornamentstichsammlung des K. K. Österreich.* Museums für Kunst und Industrie. Erwerbungen seit dem Jahre 1871. P. 161, note. Photographs of this series contributed by Dr Bruno Thomas, Vienna.

14. Engraving and pencil drawings Section. *Receuil d'ornemens et d'architecture.* P. 192.

15. Title-page of the edition published by David Funck of Nuremberg—copies of Simonin's 'Plusieurs pieces et ornements' of 1685. Original in the Staatliches Kunstgewerbmuseum in Vienna. Cf. Pl. 120:1.

16. *Le Musée National du Louvre.* P. 80. No. 513. Michel, *Histoire de l'art.* T. VI:2. Pl. VIII.

17. Weigert, *Jean I Berain.* T. I. P. 113, not. 5.

18. Nagler, *Neues allgemeines Künstler-Lexikon.* Vol. V. Pp. 427, 428.

19. Jessen, *Der Ornamentstich.* Pp. 219, 221.

20. [Lotz], *Katalog der Ornamentstichsammlung der Staatlichen Kunstbibliothek, Berlin.* P. 125. No. 858 a.

21. *L'art pour tous.* Troisième année. P. 349.

22. *Opis moskovskoj oružejnej palati.* Vol. III. Pp. 210, 212. Pict. 394.

23. Guilmard, *Les maîtres ornemanistes.* P. 108. No. 58.

24. Thieme-Becker, *Allgemeines Lexikon der bildenden Künstler.* Vol. XIV. P. 44.

25. [Lotz], *Katalog der Ornamentstichsammlung der Staatlichen Kunstbibliothek, Berlin.* P. 125.

26. Guilmard, *Les maîtres ornemanistes.* Pp. 158, 159. No. 20.

27. [Lotz], *Katalog der Ornementstichsammlung der Staatlichen Kunstbibliothek, Berlin.* P. 124. No. 849:3.

28. Ibid. P. 125.

29. Ibid. P. 125.

30. Bouchot, *Le Cabinet des estampes de la Bibliothèque Nationale.* P. 202.

CHAPTER FOURTEEN

Signatures

FLINTLOCK WEAPONS have in general been signed since the middle of the seventeenth century. The signature is most often on the lock at this period but sometimes on both barrel and lock. Previously there was no hard and fast rule. French sixteenth century firearms are only signed with stamps, which have not yet been interpreted. This also applies to a considerable number of seventeenth century flintlock arms. The stamps have mostly been recorded but little work has been done on them otherwise. 'M. LE BOVRGEOYS A LISIEVL' engraved his name at the beginning of the seventeenth century on the earliest known flintlock gun (Pl. 8) behind the trigger-guard (Pl. 134:1). The other signed by him (Pl. 11:3) bears the inscription 'M le bourgeoys' also engraved or rather incised at the foot of the butt-plate (Pl. 134:2). This form with the name only is used by 'La SVZE' on the wheel-lock gun, Inv. No. 94D in the Musée de la Porte de Hal, Brussels (French Royal Armoury Inv. No. 64) and by 'D. IVMEAV' on a wheel-lock gun of 1616, No. M 102 in the Musée de l'Armée, Paris (French Royal Armoury Inv. No. 357), in both cases engraved on the barrel in front of the back-sight. '1613 AVOM FAIT TEL' can be read on the barrel of the wheel-lock gun No. 40 in the French Royal Armoury (Musée de l'Armée, Paris, No. M 95) and the initials 'F P' on the lock-plate between the wheel and the cock[1]. The following inscription is inlaid in gold on a pistol barrel: 'a Vitré par MARIN MAZUE 1612' (The Tower of London Inv. No. XII:1075). This type of signature recurs in 'Faict A Turene m.d.' in the early flintlock gun in the collection of arms in Windsor Castle (Pl. 14:2 and Pl. 134:3), in 'a Vitré par Me Jacques de Goulet' (Pistols, French *Cabinet d'Armes* No. 207: the inscription is obliterated), and in 'Faict A Vitré Par Paul Paindeblé', on a pistol in the Livrustkammare (Inv. No. 4784) inlaid in gold on the barrel (Pl. 134:4).

In the 1620s the formula with the name and place in this order and with or without the date was established. Examples are 'Jean Henequy à Metz 1621' in the gold inlay on the barrel of the wheel-lock gun Inv. No. 1733 in the Bayerisches Nationalmuseum, Munich, and 'Jean Henequy à Metz', engraved on the upper edge of the lock-plate, on the same gun (Pl. 104:5). Another example is: 'J. Habert à Nancy', engraved on the left side of the chamber of the wheel-lock gun No. 43 in the French Royal Armoury (Collection Pauilhac, Paris. Pl. 134:5) and 'Jean Simonin à Lunéville 1627' inlaid in silver on the comb of the

butt (Musée de l'Armée, Paris No. M 131)[2].

In the 1630s we find the signature 'Ezechias Colas à Sedan' engraved as part of the decoration on pistol barrels (Pl. 134:6) and likewise 'Isaac Cordier' (wheel-lock pistols in the Berlin Museum für deutsche Geschichte, Inv. No. W 1145 a,b, cf. p. 126), in the former case along the barrel, in the latter straight across, a system which recurs twenty years later on the pistols by 'Monlong à Anger' in the armoury of Schwarzburg (Pl. 61:2). 'Philippe Cordier' signs on the rear part of the lock-plate (Pl. 14:4). The elaborate decoration of the lock-plates necessitated the placing of the signature on the 'interrupted' edge of the lock-plate, especially when it might interfere with the decoration. This practice was followed in the case of the unknown 'A BERGERAC' (rubbings in the Staatliche Kunstbibliothek, Berlin. O.S. 825. Unfortunately the gunsmith's name is obliterated) and also 'P. Thomas à Paris' on the gun in the Livrustkammaren garniture of the 1640s. On the pistols of the garniture the signature has moved to the plate (Pl. 134:7,8). During the 1640s in the case of lock-plates embellished with numerous figures the signature is placed wherever there is an empty space. In the mid seventeenth century another type of signature appears, first on the Wenders, recalling the manner of the Netherlandish calligraphists. Marcou employs it in his pattern book (Pl. 134:9) and Choderlot's signature is engraved in this style on the pistols in the Töjhus Museum, Copenhagen (Pl. 134:10). At the same time gunsmiths began to engrave their own name and that of the town in a shield or cartouche placed between the cock and the pan or on the lock-plate behind the cock. This type of signature is frequently found in the Thuraine and Le Hollandois group (Pl. 134:12,14,15). The numerous signatures on the first three sheets in the Thuraine and Le Hollandois book show the use of italic characters with large and small letters in calligraphic style. Roman letters also appear and these finally oust the others as a result of ever increasing Classical influence. Berain usually employs signatures with capital letters in a cartouche. The type with luxuriant flourishes is associated with a species of barrel signatures, all dating from about 1670 or a little earlier. They are represented in the Töjhus Museum, Copenhagen, on arms by Thuraine or Les Thuraines (Pl. 134:13).

The signature 'F de clos' is inlaid in gold on the chambers of both the wheel-lock pistols in the Metropolitan Museum of Art (Pl. 134:17). Devies's signature on the pistols in Dresden of the 1640s (Pl. 134:18) and Casin's on August the Strong's pistols of the 1650s in the same museum (Pl. 55:3) are inscribed on the tang of the barrel, in the latter case engraved in a cartouche on the locks as well. The style is in every case italic with capital initial letters. The signature on the barrel tang still occurs in exceptional cases during the 1670s (Pl. 74:1). It sometimes moves up the barrel (gun by Thuraine in the Töjhus Museum, Copenhagen, Inv. No. B 948)[2]. Cf. also Pl. 67:3.

From the close of the 1660s onwards signatures on the locks are consistently designed with Roman capitals. A single row at the bottom of the lock-plate is the rule, as used by Piraube on the gun No. 1337 in the Livrustkammare (Pl. 134:16). Variations are met with, of course, depending on tradition and on the difficulty in placing the signature on richly decorated locks, especially if 'aux galleries' or 'aux galleries du Louvre' had to be added between the name and 'à Paris'. The course Piraube then adopted was to engrave the signature in several lines round the pan or, in several examples, on the front edge of the lock-plate along the steel-spring.

When the flat raised sighting rib was introduced on the barrels about 1680 it was tempting to repeat the signature there (pistols at Skokloster, Brahe-Bielke Armoury. Pl. 134:19). Le Languedoc's name appears in this position in Simonin's album of 1685 in the same simple Roman capitals which we recognize from the locks. But Chasteau in Paris has combined these engraved capitals on the Töjhus Museum gun No. B 960 with inlaid gold ornament in low relief (Pl. 134:20). In the 1720s the entire barrel signature might be inlaid with gold and the decoration merged into the initial and the final letters. The type still persists into the

mid 18th century (gun: The Hallwyl Museum Inv. No. A 31. Pl. 134:21).

With the transition to the Berain style at the end of the seventeenth century lock signatures enclosed in a cartouche were reintroduced. The use of these is not consistent but frequent. The practice of signing on a ribbon or scroll soon followed. The type is illustrated in De Lacollombe's pattern sheets dated 1730 (Pl. 129:1) and by the signature on the gun by 'St Germain à Paris 1721' (Pl. 91:4). The type of signature in which the initial letters develop into ornamental features is also found on mid eighteenth century locks.

With the neo-Classical style the capitals return

and finally capitals alone are used. The Empire style uses both capital and italic letters, sometimes in the same signature (Pl. 134:22), and the late Boutet gun in Brussels (Pl. 100:5) is signed in neo-Gothic letters.

Notes to Chapter Fourteen

1. Le Musée de l'Armée. *Armes et armures anciennes*. T. II. P. 123. Pl. XL bis.
2. Ibid. P. 130.
3. Smith, *Det kongelige partikulaere Rustkammer*. Pp. 38, 40, 41.
4. Ibid. Pl. 32.

Sources and Bibliography

UNPUBLISHED DOCUMENTS

The Swedish Public Record Office (Riksarkivet), Principal Section, Stockholm; Correspondence between Erik Dahlberg and Svante Banér. Dahlberg Collection. Vol. 18;

The Swedish Public Record Office, Stockholm (Kammararkiv—Exchequer Rolls Records); Miscellaneous administrative documents . . . 9. Inventory of the small archives . . . 1557.

The War Archives, Stockholm (Krigsarkivet); *Norrköping Factory Accounts 1688.*

The Palace Archives, Stockholm. (Slottsarkivet); *Wardrobe Accounts 1654. Livrustkammare Inventories 1683. Livrustkammare Inventories 1696.*

The Livrustkammare, Stockholm (The Royal Armoury); *Livrustkammare Inventory 1821.*

The Royal Library, Stockholm (Kungliga biblioteket) Manuscript Section; Dahlberg Collection. M. 11.

The University Library, Uppsala (Universitetsbiblioteket); Correspondence between Erik Dahlberg and Samuel Månsson Agriconius (Åkerhielm). U. 147.

The University Library, Lund (Universitetsbiblioteket); De la Gardie Library. De la Gardie No. 9 d. Inventory in Hans G: N: de the General's Armoury, Anno 1628 the 30 May.

The Sturefors Archives. Sturefors Archives. List of the Gun Collection at Sturefors drawn up 1846 (by Count Axel Bielke). Extract from the inventory at Sturefors (1758).

The Tower, London; Petrini, Antonio; *De Arte fabrile.*

Archives Nationales, Paris; *Inventaire du mobilier de la couronne* (1729). T. IV. O¹ 3334.

Archives du Ministère des Affaires Etrangères, Paris; *Suède 1672–1688. Histoire des négociations.* Feuquières's correspondence. Reports to Louis XIV.

BIBLIOGRAPHY

I. GENERAL

Allgemeines Lexikon der bildenden Künstler von der Antike bis zur Gegenwart. [Hrsg.] von U. Thieme, F. Becker & H. Vollmer. Bd I–XXXII. Lpz. 1907–38. (Cit. Thieme-Becker.)

Alm, J.; *Eldhandvapen.* I. Från deras tidigaste förekomst till slaglåsets allmänna införande. Sthlm 1933. (Militärlitteraturföreningens förlag. 166.)

— Svenska muskötsnapplås på Carl XI:s tid. (Svenska vapenhistoriska sällskapets årsskrift. 1934–37. Sthlm 1937. Pp. 89 ff.)

L'art pour tous, encyclopédie de l'art industriel et décoratif. Emile Reiber directeur-fondateur. Année 1–20. Paris 1861–81.

Ashdown, C. H.; *British and foreign arms and armour* Lond. 1909.

Aubert de la Chesnaye-Desbois, [F. A.] & Badier; *Dictionnaire de la noblesse.* T. I. Paris 1843.

Bénézit, E.; see: *Dictionnaire critique* . . .

Berliner, R.; *Ornamentale Vorlage-Blätter des 15. bis 18. Jahrhunderts.* [I–II: Tafeln; III: Text.] Lpz. 1925–26.

Beroaldo Bianchini, de; *Abhandlung über die Feuer- und Seitengewehre* . . . I–II. Wien 1829.

Berty, A.; *Histoire générale de Paris. Topographie historique du vieux Paris.* (Continuée par H. Legrand . . .) 3:2. Paris 1868.

Blom, O.; *Kristian IV:s Artilleri, hans Töihuse og Vaabenforraad.* Cphgen. 1877.

Boeheim, W.; *Handbuch der Waffenkunde. Das Waffenwesen in seiner historischen Entwickelung vom Beginn des Mittelalters bis zum Ende des 18. Jahrhunderts.* Lpz. 1890. (Seemann's Kunsthandbücher. VII.)

—'Die Luxusgewehr-Fabrication in Frankreich im XVII und XVIII. Jahrhundert'. *Blätter für Kunstgewerbe.* Jahrg. 1886. H. VII–VIII. Wien. Pp. 33–36, 38, 39.

— *Meister der Waffenschmiedekunst vom XIV. bis ins XVIII. Jahrhundert.* Berl. 1897.

— 'Über einige Jagdwaffen und Jagdgeräte des Allerhöchsten Kaiserhauses'. *Jahrbuch der kunsthistorischen Sammlungen des A. H. Kaiserhauses.* Bd V. Wien 1887. Pp. 97–109.

—'Über die Entwicklung des Steinschlosses'. *Zeitschrift für historische Waffenkunde.* Bd III. Berl. 1902–05. Pp. 305–311.

—'Die Waffe und ihre einstige Bedeutung im Welthandel'. *Zeitschrift für historische Waffenkunde.* Bd I. Pp. 171–182.

Bonfadini, V.; *La caccia dell'archibugio* . . . Bologna [1672].

Bottet, M.; *La manufacture d'armes de Versailles.* Paris 1903.

— *Monographie de l'arme à feu portative des armées françaises de terre et de mer de 1718 à nos jours.* Paris [1905].

'Brevets accordés par les rois Henri IV, Louis XIII, Louis XIV et Louis XV à divers artistes . . . Communiqués et annotés par A. L. Lacordaire.' *Archives de l'art français.* V. Recueil de documents inédits. T. III. Paris 1853–55. Pp. 189–286.

'Brevets de logements sous la grande galerie du Louvre.' *Archives de l'art français.* T. I. Paris 1851–52. Pp. 193–256.

Brice, G.; *Description de la ville de Paris et de tout ce qu'elle contient de plus remarquable. 7e éd., rev. et augm.* T. I. Amsterd. 1718.

Budde-Lund, C.; *Haandskydevaabnenes Historie fra Krudtets Opfindelse og indtil Udgangen af Aaret 1853.* Cphgen. 1855.

Cederström, R.; 'Ha gevärslåsen uppstått ur elddon?' *Livrustkammaren.* Bd I. H. 4. Sthlm 1937. Pp. 65–76.

—'Pistol- och stockmakaren Peter Rundberg i Jönköping.' *Svenska vapenhistoriska sällskapets årsskrift.* 1926. Sthlm. Pp. 10–14.

Dahlberg, E.; *Svecia antiqua et hodierna.* [Text utarb. av E. Vennberg.] [Text] + T. [1]–3. Sthlm 19 [20]–24.

Demmin, A.; *Die Kriegswaffen in ihren geschichtlichen Entwickelungen von den ältesten Zeiten bis auf die Gegenwart. Eine Encyklopädie der Waffenkunde. 3 . . . Auflage.* Gera-Untermhaus 1891.

Dictionnaire critique et documentaire des peintres, sculpteurs, dessinateurs et graveurs de tous les temps et de tous les pays . . . sous la dir. de E. Bénézit. T. I–III. [Nouv. éd.] Paris 1924.

Diderot, D., & Alembert, J. d'; *Encyclopédie ou dictionnaire raisonné des sciences, des arts et des métiers* . . . T. I–XVII. Paris & Neufchâtel 1751–65.

[Encyclopédie . . .] *Suite du recueil de planches sur les sciences, les arts libéraux el les arts méchaniques. Avec leur explication.* T. III. Genève 1779.

Dillon, H. A.; 'On the development of gunlocks, from examples in the Tower.' *Archaeological journal.* Vol. L. Lond. 1893. Pp. 115–132.

Enander, T. A.; *Anvisning till handgevärens kännedom, vård och iståndsättande.* Sthlm 1832.

Evelyn, J.; *Diary . . . Ed. by W. Bray . . .* Vol. I. Lond. 1879.

Feldhaus, F. M.; 'Das Radschloss bei Leonardo da Vinci.' *Zeitschrift für historische Waffenkunde.* Bd IV. Dresd. 1906–08. Pp. 153, 154.

—'Feuerwaffen bei Leonardo da Vinci.' *Zeitschrift für historische Waffenkunde.* Bd VI. Dresd. 1912–14. Pp. 30, 31.

Flilon, M. B.; 'Marin Le Bourgeois. Peintre du roi (1591–1605).' *Nouvelles archives de l'art français* [IV.] Paris 1876. Pp. 141–145.

Fleetwood, G. W.; *Svenska 1600-talsbössor i Hessen.* (Rig. 1923. Sthlm. Pp. 25–36.)

Fleming, H. F. v.; *Der vollkommene teutsche Jäger* ... I. Lpz. 1719.

Franklin, A.; *Dictionnaire historique des arts, métiers et professions exercés dans Paris depuis le XIIIe siècle.* Paris & Lpz. 1905.

Gamillscheg, E.; Etymologisches Wörterbuch der französischen Sprache. Heidelb. 1926–29. (*Sammlung romanischer Elementar- und Handbücher.* R. 3:5.)

Gay, V.; *Glossaire archéologique du Moyen Age et de la renaissance.* T. I: A—Guy. Paris 1887.

Gelli, J.; *Gli archibugiari milanesi. Industria, commercio, uso delle armi da fuoco in Lombardia.* Milan 1905.

George, J. N.; *English pistols and revolvers.* Holland Press, Lond. 1961.

Gessler, E. A.; 'Ein Dreischussgewehr mit Steinschloss aus der Mitte des 17. Jahrhunderts.' *Zeitschrift für historische Waffenkunde.* Bd VI Dresd. 1912–14. Pp. 139–140.

—'Der Gold- und Büchsenschmied Felix Werder von Zürich, 1591–1673. *Anzeiger für schweizerische Altertumskunde.* Neue Folge. Bd XXIV. Zürich 1922. Pp. 113–117.

Gobert, T.; *Liège à travers les âges. Les rues de Liège.* T. II: A–E. Liège 1925.

Grancsay, S. V.; 'The bequest of Giulia P. Morosini.' *Bulletin of the Metropolitan Museum of Art.* Vol. 34 (1939):1. New York. Pp. 15–19.

—'A pair of seventeenth century Brescian pistols.' *Art bulletin. 1936.* Chicago. Pp. 240–246.

—'A presentation fowling-piece.' *Bulletin of the Metropolitan Museum of Art. 1928.* New York. Pp. 246–249.

—'A Versailles gun by Boutet, directeur-artiste.' Ibid. Vol. 31. (1936) :8. New York. Pp. 163–166.

Greener, W. W.; *The gun and its development.* 7th ed. Lond. 1899.

Grose, F.; *A treatise on ancient armour and weapons* ... Lond. 1786.

Guiffrey, J. J.; *Inventaire général du mobilier de la couronne sous Louis XIV.* T. II. Paris 1886.

[Guiffrey, J. J.]; 'Liste des peintres, sculpteurs, architectes, graveurs et autres artistes de la maison du roi, de la reine ou des princes du sang pedant les 16e, 17e at 18e siècles.' *Nouvelles archives de l'art français.* [1]. Paris 1872. Pp. 55–108.

Guiffrey, J. J.; 'Logements d'artistes au Louvre.' *Nouvelles archives de l'art français.* (II). *Recueil de documents inédits* ... Paris 1873. Pp. 1–222.

Guilmard, D.; *Les maîtres ornemanistes, dessinateurs, peintres, architectes, sculpteurs et graveurs. École française, italienne, allemande et des Pays-Bas (flamande et hollandaise)* ... Paris 1880.

Hellberg, K.; *Eskilstuna. En svensk märkesstad. Kloster-, slotts- och industristadens öden genom seklerna i historisk belysning.* D. I. Katrineholm 1919.

Héroard, J.; *Journal sur l'enfance et la jeunesse de Louis XIII (1601–28). Extrait des manuscrits originaux et publié par E. Soulié et E. de Barthélemy.* T. I–II. Paris 1868.

Hewitt, J.: *Ancient armour and weapons in Europe: from the iron period of the northern nations to the end of the 17th century. Suppl. comprising the 15th, 16th and 17th centuries.* Oxf. & Lond. 1860.

Holzhausen, W.; 'Regesten über die Dresdner Büchsenmacher.' *Zeitschrift für historische Waffenkunde. Neue Folge.* Bd V. H. 8. Berl. 1936. Pp. 185–191.

Hoopes, T. T.; 'Changes in the Armor Study Room.' *Bulletin of the Metropolitan Museum of Art.* Vol. XXII. New York 1927. Pp. 198, 199.

—'Ein Beitrag zum französischen Radschloss.' *Zeitschrift für historische Waffen- und Kostümkunde.* Bd XIV. Berl. 1935–36. Pp. 50–53.

d' Hozier, L. P.; *Armorial général de la France.* Paris 1738.

Huard, G.; *Étude de topographie lexovienne. La maison canoniale du titre de Saint-Martin, le manoir de l'image Notre-Dame et la maison de Marin Bourgeoys.* Paris 1934.

—'Marin Bourgeoys, peintre du Roi.' *Bulletin de la Société historique de Lisieux.* Année 1913. No: 21. Caen. Pp. 5–37.

—'Marin Bourgeoys, peintre de Henri IV et de Louis XIII.' *Bulletin de la Société de l'histoire de l'art français.* Année 1926. Paris 1927. Pp. 174–181.

—'Thomas Picquot et les portraits de Marin

Bourgeoys.' *Aréthuse*. IV. Paris 1927. Pp. 137–141. Pl. XXII.

Ilgner, E.; 'Elfenbeinpistolen Peters des Grossen?' *Zeitschrift für historische Waffen- und Kostümkunde*. Bd XIII. Berl. 1932–34. Pp. 68–69.

—'Maastrichter Elfenbeinpistolen um 1700.' Ibid. Bd XII. Berl. 1929–31. Pp. 210–214; Bd XIII. Berl. 1932–34. P. 19.

Jackson, H. J.; *European hand firearms of the 16th, 17th and 18th centuries. With a treatise on Scottish hand firearms by C. E. Whitelaw*. Lond. 1923. Holland Press London, 1958.

Jacobs, J.; 'Die Kgl. Gewehrkammer in München.' *Zeitschrift für historische Waffenkunde*. Bd VI. Dresd. 1912–14. Pp. 164–172.

Jakobsson, T.; *Lantmilitär beväpning och beklädnad under äldre Vasatiden och Gustav II Adolfs tid. (Sveriges krig 1611–1632.* [Utg. av Generalstaben.] Bilagsbd II. Sthlm 1938.)

ssen, P.; *Der Ornamentstich. Geschichte der Vorlagen des Kunsthandwerks seit dem Mittelalter*. Berl. 1920.

Jähns, M.; *Entwicklungsgeschichte der alten Trutzwaffen. Mit einem Anhange über die Feuerwaffen*. Berl. 1899.

—'Geschichte der Kriegswissenschaften vornehmlich in Deutschland. Abt. 1–3. Münch. & Lpz. 1889–91.' *Geschichte der Wissenschaften in Deutschland. Neuere Zeit*. Bd XXI.

Kessen, A.; 'Over de Wapenindustrie te Maastricht in vroeger Tijden.' *De Maasgouw*. Jaarg. 56. Maastricht 1936. Pp. 1861–1881. *Zeitschrift für historische Waffen- und Kostümkunde*. Bd. XV. Berl. 1937–39. Pp. 57–60.

Lauts, J.; 'Alte deutsche Waffen. Burg. b. M. 1938.' *Heimbücher der Kunst*. Bd. VI.

Le Francq van Berkhey, J.; Beschrijving van een aanmerkelijke snaphaan, met het wapen en spreuk des heeren van der Does, van Noortwijk van Ao 1573; benevens twee stukken geschut gevonden in de verlatene legerschantzen der Spanjaarden bij het roemruchtige ontzet der stad Leyden, Ao 1574. U. o. o. å.

Lenk, T.; 'Flintlåstillverkningens införande i Sverige.' Armémodellerna. *Karolinska förbundets årsbok. 1937*. Sthlm. Pp. 202–241.

—'Flintlåstillverkningens införande i Sverige.

Personhistoriska bidrag.' *Rig. 1935*. Sthlm. Pp. 135–164.

—'Den förgyllda bössan.' *Gustav Vasaminnen*. Sthlm 1938. Pp. 135–141.

—'Karl XII:s barnbössa.' *Livrustkammaren*. Bd I. H. 5. Sthlm 1938. Pp. 85–90.

—'Notiser kring några flintlåsvapen i Kulturen.' *Kulturen. Årsbok 1938*. Lund 1939. Pp. 118–135.

—'Två bösser av Thuraine & Le Hollandois i Töjhusmuseet.' *Vaabenhistoriske Aarböger*. I. Cphgen. 1934. Pp. 13–24.

—'De äldsta flintlåsen, deras dekoration och dekoratörer.' *Konsthistorisk tidskrift. Årg. 3 (1934)*. Sthlm. Pp. 121–139.

—'Zur Frage der holländischen Büchsenmacher.' *Zeitschrift für historische Waffen- und Kostümkunde*. Bd XIII. Berl. 1934. Pp. 239–241.

Lespinasse, R. L. de; *Les métiers et corporations de la ville de Paris*. T. II. Paris 1892. (*Histoire générale de Paris*. 12:2.)

Liander, R.; 'De vanligaste gevärslåstyperna.' *Föreningens Armémusei vänner meddelanden*. I. Sthlm 1938. Pp. 56–71.

Littré, E.; *Dictionnaire de la langue française*. T. I–II; Suppl. Paris 1863–77.

Lotz, A.; *Bibliographie der Modelbücher. Beschreibendes Verzeichnis der Stick- und Spitzenmusterbücher des 16. und 17. Jahrh*. Lpz. 1933.

Magné de Marolles, [G. F.] see: Marolles, [G. F.] Magné de.

Malmborg, G.; Stockholms bössmakare. G. Malmborgs efterlämnade anteckningar på uppdrag fullständigade och utg. av Å. Meyerson. Sthlm 1936. (*Kungl. Livrustkammaren. Akter och utredningar*.)

Marolles, [G. F.] Magné de; *La chasse au fusil*. Nouv. éd. . . . Paris 1836.

Marolles, Michel de; *Le livre des peintres et graveurs*. Nouv. éd., rev. par G. Duplessis. Paris 1855. (*Bibliothèque elzévirienne*. 46.)

Mews, K.; *Die Geschichte der Essener Gewehrindustrie. Ein Beitrag zur Geschichte der rheinisch-westfälischen Industrie*. Essen—Ruhr 1909. (Diss., Münster.)

Meyrick, S. R.; *A critical inquiry into antient armour, as it existed in Europe, but particularly in England, from the Norman conquest to the reign*

of King Charles II. Vol. III 2nd ed. Lond. 1842.

—'Observations upon the history of hand fire-arms, and their appurtenances'. *Archæologia* ... Vol. XXII. Lond. 1829. Pp. 59–105.

Michel, A.; *Histoire de l'art.* T. VI. Paris 1922.

Micol, J. M.; *Panoplie européenne.* U. o. 1858.

Nagler, G. C.; *Neues allgemeines Künstler-Lexikon.* Bd I–XXII. Münch. 1835–52.

Paulsson, G.; *Skånes dekorativa konst under tiden för den importerade renässansens utveckling till inhemsk form.* Sthlm 1915. (Akad. avh.)

Peiresc, N. C. F. de; Lettres. Publ. par P. Tamizey de Larroque. Paris 1898. (*Collection de documents inédits sur l'historie de France.* Sér. 2. T. VII.)

Pelka, O.; 'Elfenbein. Berl. 1920.' *Bibliothek für Kunst und Antiquitätensammler.* Bd XVII.

Plon, E.; *Benvenuto Cellini, orfèvre, médailleur, sculpteur.* Paris 1883.

Polain, A.; *Recherches historiques sur l'épreuve des armes à feu au pays de Liège.* Liège 1863. (Armurerie liégeoise.)

Pollard, H. B. C.; *A history of firearms.* Plymouth 1926.

Post, P.; 'Ein Paar französischer Radschlosspis-tolen von Isaak Cordier Daubigny.' *Zeit-schrift für historische Waffen- und Kostümkunde.* Bd XIII. Berl. 1934. Pp. 235–238.

—'Ein Paar Steinschlosspistolen von Isaac Cordier Daubigny.' Ibid. Bd XIV. Berl. 1935. Pp. 54, 55.

Poumerol, F., *Quatrains au Roy.* Paris 1631. (*Variétés historiques et littéraires.*) (*Biblio-thèque Elzévirienne.* 79:VI. Paris 1856.)

'Proceedings of the meeting of the Archaeologi-cal Institute.' *Archaeological journal.* Vol. XVI. Lond. 1859. Pp. 353–356.

Robert-Dumesnil, A. P. F.; *Le peintre-graveur français ou catalogue raisonné des estampes gravées par les peintres et les dessinateurs de l'école française.* T. I–XI. Paris 1835–71.

Romdahl, A.; 'Sturefors ...' *Svensak slott och herresäten vid 1900-talets början.* H. 6. Öster-götland. Sthlm 1909. Pp. 1–13.

Rouyer, E., & Darcel, A.; *L'art architectural en France depuis François Ier jusqu' à Louis XIV* ... T. I–II. Paris 1867, 1866.

Rudolph, G.; 'Die polnische Königskrone Augusts des Starken im Bilde.' *Berliner*

Münzblätter. No: 302. Februar 1928. Berlin. Pp. 207–209.

Saint-Remy, S. de; *Mémoires d'artillerie.* T. I. Paris 1697.

Schmidt, Rud.; *Die Handfeuerwaffen, ihre Entste-hung und technisch-historische Entwicklung bis zur Gegenwart.* Basel 1875.

Schröder, G.; *Jaktminnen från fjäll och sjö.* 1–2. Sthlm 1920. (Schröder, G.; *Samlade skrifter.* 3:1–2.)

Schröderstjerna, P.; 'Om arméns handgevär, deras sammansättning, vård och reparation.' *Krigsvetenskapsakademiens handlingar,* 1811–15. Sthlm 1817.

Schön, J.; *Geschichte der Handfeuerwaffen.* Dresd. 1858.

Semper, G.; *Der Stil in den technischen und tectonischen Künsten oder praktische Aestetik.* Bd I–II. Frankf. a. M. & Münch. 1860–63.

Smith, Otto; 'Flintelaasens Indförelse i den danske Hær.' *Vaabenhistoriske Aarböger.* II b. Khvn 1938. Pp. 130–144.

Solér, I.; *Compendio histórico de los arcabuceros de Madrid desde su origen hasta la época presente* ... Madrid 1795.

Stöckel, J. F.; *Haandskydevaabens Bedömmelse.* Udg. af Töjhusmuseet. I. Khvn 1938.

Stöcklein, H.; *Meister des Eisenschnittes. Beiträge zur Kunst- und Waffengeschichte im 16. und 17. Jahrhundert.* Stuttg. 1922.

Thiébaud, J.; *Bibliographie des ouvrages français sur la chasse.* Paris 1934. (*Collection Les maîtres de la vénerie.*)

Thieme, U., Becker, F., & Vollmer, H., see: *Allgemeines Lexikon der bildenden Künstler* ...

Thierbach, M.; *Die geschichtliche Entwickelung der Handfeuerwaffen, bearb. nach den in den deutschen Sammlungen noch vorhandenen Origina-len.* Dresd. 1886–88.

— *Nachträge.* Dresd. 1899.

Thierbach, M.; 'Über die Entwickelung des Steinschlosses.' *Zeitschrift für historische Waf-fenkunde.* Bd III. Dresd. 1902–05. Pp. 305–311.

Thomas, B.; 'Eine deutsche Radschlossbüchse von 1593 mit Beineinlagen nach Adrian Collaert.' *Die graphischen Künste. Neue Folge.* Bd III. Baden b. Wien 1938. Pp. 72–77.

Weigert, R. A.; 'Berain-Pistolerne i Töjhusmuseet.' *Vaabenhistoriske Aarböger*. II. Khvn 1937–39. Pp. 68–72.

— *Jean I Berain, dessinateur de la Chambre et du Cabinet du Roi*. P. 1–2. Paris 1937.

Weyersberg, A.; 'Der Büchsenmacher, Eisenschneider und Graveur Hermann Bongarde und seine Familie.' *Zeitschrift für historische Waffen- und Kostümkunde*. Bd X. Berl. 1923–25. P. 140.

Whitelaw, C. E.; *A treatise on Scottish hand firearms*, see: Jackson, H. J.

—'Variations of the dog lock found on Scottish firearms of the 17th century.' *Proceedings of the Society of antiquaries of Scotland*. Vol. XI. 5th ser. Session 1924–25. Edinb. Pp. 211–221.

Wille, J. G.; *Mémoires et journal*. T. I–II. Paris 1857.

II. MUSEUMS AND COLLECTIONS

BARCELONA.

Museo-armería de D. José Estruch y Cumella. Barcelona 1896.

BERLIN.

'Neuerwerbungen der Sammlung Major Emil Ilgner, Berlin-Lichterfelde-West.' *Zeitschrift für historische Waffen- und Kostümkunde*. Bd XIII. Berl. 1932–34. P. 288.

[Lotz, A.]; *Katalog der Ornamentstichsammlung der Staatlichen Kunstbibliothek, Berlin*. Berl. 1936–39.

Binder, M. J.; 'Neuerwerbungen des Berliner Zeughauses.' *Zeitschrift für historische Waffen- und Kostümkunde*. Bd X. Berl. 1923–25. Pp. 93–98.

Post, P.; *Das Zeughaus. Die Waffensammlung*. T. I. *Kriegs-, Turnier- und Jagdwaffen vom frühen Mittelalter bis zur 30-jährigen Krieg. Ein Handbuch der Waffenkunde*. [3., verb. u. erw. Aufl.] Berl. 1929.

'Sitzungsberichte der Berliner Mitglieder (des Vereins für historische Waffen- und Kostümkunde] im Zeughaus.' *Zeitschrift für historische Waffen- und Kostümkunde*. Bd XI. Berl. 1926–28. Pp. 241–243.

BRUSSELS.

Hymans, H.; *Catalogue des estampes d'ornement faisant partie des collections de la Bibliothèque royale de Belgique* . . . Brux. 1907. (Publication du Ministère des sciences et des arts.)

Fierens-Gevaert, & Laes, A.; *Musée royal des beaux-arts de Belgique. Catalogue de la peinture ancienne*. Brux. 1922.

DRESDEN.

Ehrenthal, M. v.; *Führer durch die Königliche Gewehr-Galerie zu Dresden*. Dresd. 1900.

— *Führer durch das Königliche Historische Museum zu Dresden*. 3. Aufl. Dresd. 1899.

Kurze Darstellung der geschichtlichen Entwicklung der Handfeuerwaffen, zugleich ein Führer durch die Thierbach'sche Sammlung in der Königlichen Arsenalsammlung zu Dresden. Dresd. 1906.

EMDEN.

Potier, O.; *Führer durch die Rüstkammer der Stadt Emden* . . . Emden 1903.

— *Inventar der Rüstkammer der Stadt Emden*. Emden 1903.

KRANICHSTEIN.

Inventar über die in der Grossherzoglichen Gewehrkammer befindlichen Waffen und sonstigen Gegenstände. Darmst. 1867.

COPENHAGEN.

Smith, Otto; *Det kongelige partikulære Rustkammer*. I. Cphgen. 1938.

(Boeck, B. & Christensen, G.); *Katalog over den historiske Vaabensamling paa Kjöbenhavns Töjhus* . . . Cphgen. 1877.

LENINGRAD.

Lenz, E. v.; *Collection d'armes de l'Ermitage impérial*. St. Petersburg 1908.

— *Imperatorskij Ermitaž*. St Petersburg 1908.

— *Die Waffensammlung des Grafen S. D. Scheremetew in St. Petersburg*. Lpz. 1897.

LIÈGE.

[Falise, J.]; *Musée d'armes*. [Liège 1931.]

LONDON.

ffoulkes, C. J.; *Inventory and survey of the armouries*

of the Tower of London. Vol. II. Lond. 1915.
(Gardner, J. S.); *Exhibition of chased and embossed steel and iron work of European origin.* Lond. 1900. (Burlington Fine Arts Club.)
Laking, G. F.; *Catalogue of the European armour and arms in the Wallace Collection at Hertford House.* 4th ed. Lond. 1910.

MADRID.
Valencia de Don Juan, V. de; *Catálogo histórico-descriptivo de la Real Armería de Madrid.* Madrid 1898.

MOSCOW.
Opis moskovskoj oružejnej palati. Moscow 1884–86.

NEW YORK.
Dean, B.; *Handbook of arms and armor, European and Oriental including the William H. Riggs collection.* The Metropolitan Museum of Art. New York 1921.
[Grancsay, S. V.]; *The Metropolitan Museum of Art. Loan exhibition of European arms and armor.* New York 1931.

OSLO.
Katalog over Artilleri-Museet paa Akershus. Christiania 1904.

OXFORD.
ffoulkes, C.; *European arms and armor in the University of Oxford. (Principally in the Ashmolean and Pitt-Rivers museums.)* Oxf. 1912.

PARIS.
Bouchot, H.; *Le Cabinet des estampes de la Bibliothèque Nationale. Guide du lecteur et du visiteur. Catalogue général et raisonné des collections qui y sont conservées.* Paris.
Le Musée National du Louvre, [Catalogue].
Le Musée de l'Armée. Armes et armures anciennes et souvenirs historiques les plus précieux. Publ. sous la dir. du Général [A.] *Mariaux.* T. II. Paris 1927.
Robert, L.; *Catalogue des collections composant le Musée d'Artillerie en 1889.* T. IV. Paris 1893.

Barbet de Jouy, H.; *Notices des antiquités . . . composant le Musée des souverains,* 2me éd. Paris 1868.
Cosson, [C. A.] de; *Le cabinet d'armes de Maurice de Talleyrand-Périgord, duc de Dino. Étude descriptive . . .* Paris 1901.

SCHWARZBURG.
Ossbahr, C. A.; *Das fürstliche Zeughaus in Schwarzburg.* Rudolstadt 1895.

ST. PETERSBURG, see: LENINGRAD.

STOCKHOLM.
[Claudelin, B.]; *Hallwylska samlingen, Beskrivande förteckning. Grupperna XXXIV och XXXV.* Sthlm 1926.
— *Planscher.* Sthlm 1926.
— *Katalog över vapensamlingen i Hallwylska huset i Stockholm.* Sthlm 1927.
Kungl. Livrustkammaren. Bilder av märkligare föremål. Sthlm 1927.
Vägledning för besökande i Lifrustkammaren och därmed förenade samlingar. 4:e uppl. Sthlm 1915.
Vägledning för besökande i Livrustkammaren och därmed förenade samlingar. 7 uppl. Upps. 1921.
Cederström, R., & Malmborg, G.; *Den äldre Livrustkammaren 1654.* Sthlm 1930. (*Kungl. Livrustkammaren. Inventariepublikationer.*)
Lenk, T.; *Kort sammanfattad vägledning för besökande i Livrustkammaren och därmed förenade samlingar.* Sthlm 1929.
Ossbahr, C. A.; *Vägledning för besökande i Lifrustkammaren och därmed förenade samlingar. 3 uppl., omarb. . . .* Sthlm 1894.

TURIN.
Armeria antica e moderna di S. M. il Re d'Italia in Torino. Ser. 3. [Torino 1898.]
Angelucci, A.; *Catalogo della Armeria Reale, illustrato con incisioni in legno . . .* Torino 1890.

VALETTA.
Laking, G. F.; *A catalogue of the armour and arms in the armoury of the Knights of St. John of Jerusalem, now in the palace, Valetta, Malta.* Lond.

VENICE.

Lucia, G. de; *La Sala d'armi*. Rome 1908.

VIENNA.

Boeheim, W.; *Album hervorragender Gegenstände aus der Waffensammlung des Allerhöchsten Kaiserhauses*. [I.] Vienna 1894.

Grosz, A., & Thomas, B.; *Katalog der Waffensammlung in der neuen Burg. Schausammlung*. Vienna 1936. (*Führer durch die kunsthistorischen Sammlungen in Wien . . . H. 28.*)

Ritter, F.; *Illustrierter Katalog der Ornamentstichsammlung des K. K. Österreich. Museums für Kunst und Industrie. Erwerbungen seit dem Jahre 1871*. Vienna 1889.

Schestag, F.; *Illustrierter Katalog der Ornamentstichsammlung des K. K. Österr. Museums für Kunst und Industrie*. Vienna 1871.

WINDSOR.

Laking, G. F.; *The armoury of Windsor Castle. European section*. Lond. 1904.

WOOLWICH.

Official catalogue of the Museum of Artillery in the Rotunda, Woolwich . . . 1934. [Lond. 1934.]

ZÜRICH.

Gessler, E. A.; *Schweizerisches Landesmuseum. Führer durch die Waffensammlung*. Aarau 1928.

III. AUCTION CATALOGUES

[Binder, M. J.]; *Grossherzoglich sächsische Gewehrsammlung Schloss Ettersburg. Versteigerung am 2. Aug. 1927*. Zürich [1927].

Catalogue of a choice collection of swords, fire arms and other weapons, defensive armour, etc. The property of Major Th. Jakobsson of Stockholm. Lond. [1932].

Catalogue of valuable armour and weapons . . . which will be sold by auction by Messr Sotheby & Co: 2nd of July, 1936 . . . Lond. 1936.

Catalogue of a valuable collection of armour and weapons . . . which will be sold by auction by Messrs. Sotheby & Co . . . on Tuesday, July 29th, 1930 . . . Lond. 1930.

[Cederström, R.]; *Förteckning över greve Kellers samling av orientaliska och europeiska vapen. Samlingen försäljes genom A.-B. H. Bukowskis konsthandel . . . 5 mars 1920*. Sthlm 1920.

Grosse Auktion. Mobilia . . . Waffen. Auktion am 2., 3., 4. und 5. Juni 1937 im Zunfthaus zur Meise i Zürich . . . Theodor Fischer (Galerie Fischer, Luzern) und Kunstsalon Dr Pfisterer . . . Zürich. Zürich 1937.

Appendices

APPENDIX I.
Arms from the 1729 inventory of the French
Royal Cabinet d'Armes of known location.

Inv. No.

Present location

3. Trente quatre arquebuses touttes simples, de 6 pieds de long ou environ.

London. Victoria and Albert Museum, M 12–1949.
Paris. Musée de l'Armée, M 99, M 165.
Warsaw. Army Museum, 50448.

4. Quarante neuf arquebuses touttes simples, de 4 pieds de long ou environ.

Paris. Musée de l'Armée, M 104, M 132, one unnumbered, another from Ruffin Collection.
Pauilhac Collection, three.
London. Wallace Collection V: 1129.
Rome. Odescalchi Collection 1523.

5. Quarante trois arquebuses touttes simples, de 3 pieds ou environ.

Paris. Musée de l'Armée, M 101, M 103.
Pauilhac Collection, one.
London. Victoria & Albert Museum 603–1864.
Warsaw. Army Museum, 477 MWR.

6. Une carabine, de 2 pieds 8 pouces; le canon rayé, à fleurs de lis damasquiné, les armes de France et de Navarre sur la culasse du bois.

Paris. Musée de l'Armée, M 96.

8. Une carabine pour porter au costé, avec son attache, toutte unie, longue de 3 pieds; à six pams, servant à mousquet et à rouet.

Paris. Musée de l'Armée, M 230.

9. Une carabine de 4 pieds, gravée de ronds sur la culasse et un peu sur le bout, le bois tout uny, longue de 3 pieds 10 pouces.

Paris. Musée de l' Armée, M 143.

Inv. No.	*Present Location*
22. Une grande arquebuse de 3 pieds 4 pouces, le canon tout ciselé d'or moulu, terminé en chapiteau carré, gravé sur la visière de l'an 1573, la platine et le chien aussy gravez d'or moulu, sur un bois noircy tout uny.	Berlin. Zeughaus, A D 9050.
30. Une arquebuse de 4 pieds 1/2, le canon rayé par dehors de plusieurs fillets, montée sur un bois où il y a quelque peu d'ornemens de fer.	(?) Paris. Musée de Cluny, 5564.
31. Une arquebuse de 4 pieds, le canon à six pams, tout uny, de Colombo, le roüet à deux chiens avec plusieurs ornemens de relief de fer poly, montée sur un bois rouge enrichy de pareils ornemens de relief de fer poly et de huit fueüilles sur la crosse, avec sa clef de mesme.	Paris. Musée de l'Armée, M 383.
32. Une arquebuse pareille à peu près à celle cy-dessus, de Lazari Cominaz, sans clef.	Paris. Musée de l'Armée, M 385.
40. Une carabine de 4 pieds, le canon rond, couleur d'eau avec un fillet enrichy de petits ornemens d'or et de rapport sur les deux bouts; la visière, la culasse et les petits ornemens de la platine dorez; le bois enrichy de petits ornemens d'argent et des armes de France et de Navarre sur la plaque de la crosse.	Paris. Musée de l'Armée, M 95.
43. Une carabine de 3 pieds 9 pouces, le canon couleur d'eau, enrichy d'or et d'argent, où sont deux aigles dans le milieu, le roüet uny sur un bois de poirier garny de petits ornemens d'argent, faite par Haber, à Nancy.	Pauilhac Collection, Paris.
48. Une arquebuse de 4 pieds 8 pouces de long, couleur d'eau, toutte unie, avec un roüet d'une manière extraordinaire, montée sur un bois peint de fleurs de lis et d'une L couronnée, et sur la crosse les armes de France portées sur un croissant.	Paris. Musée de l'Armée, without number.
50. Une carabine à porter au costé, de 3 pieds 2 pouces de long, le canon à huit pams,	Paris. Musée de l'Armée, M 144.

damasquiné sur les deux bouts en couleur
d'eau et ornemens de cuivre doré, la
visière dorée, le roüet blanc, avec quel-
ques ornemens aussy dorez; montée sur
un bois de poirier tout uny.

61. Une arquebuse de 3 pieds 4 pouces, le
canon rond, un petit pam tout au long
doré en couleur d'eau, le roüet tout uny,
montée sur un bois rouge orné de quel-
ques fleurons d'argent, de cuivre et de
nacre de perle; il y a aux deux costez de
la crosse deux L couronnées.

London. Wallace Collection V:1133.

62. Une carabine de costé, de 2 pieds 1/2 de
long, le canon à huit pams, blanc, tout
uny, servant à roüet et à serpentin,
montée sur un bois de poirier orné de
quelques petits fleurons de cuivre, dont
la crosse s'allonge avec un ressort.

Paris. Musée de l'Armée, M 386.

64. Une carabine de costé, de 3 pieds 1/2 de
long, le canon à huit pams, tout uny, sur
le milieu duquel il y a un cercle ciselé en
manière de baston rompu, le roüet tout
uny, montée sur un bois de cormier orné
de plusieurs animaux et d'un Dauphin
couronné, le tout d'acier poly; ladite
carabine faite par La Suze.

Bruxelles. Musée de la Porte de Hal, 94 D.

65. Une carabine de costé, de 3 pieds 2
pouces, le canon à huit pams, orné par
le bout et par la culasse de fleurons et
petittes figures d'argent de rapport, le
fonds couleur d'eau; sur la platine il y a
deux roüets servants à tirer deux coups,
entourez de fleurons d'argent de rapport;
montée sur un bois de cormier tout uny.

Paris. Musée de l'Armée, M 399.

76. Une arquebuse de 3 pieds 10 pouces, le
canon à huit pams, gravé en trois endroits
et ciselé sur la culasse des figures de
Pallas, Mars et Mercure de relief, ayant
un lion pour visière, le roüet tres beau,
sur un bois de poirier sculpé des armes
de France et de Navarre sur la crosse, où
il y a eu autresfois un médaillon, est
escrit autour proche le roüet: Vive le Roy.

Collection Sommeson, Paris 24.1.1848, lot 206.

Present location

81. Trois gros mousquetons communs à roüet, de 2 pieds 1/2 ou environ, avec leurs attaches pour le costé, le canon à huit pams.

London. Tower, XII:1087.

86. Une arquebuse de 4 pieds 5 pouces, le canon couleur d'eau à quatre moulures en cercle aux fillets, ciselé de 2 mascarons sur le bout et sur la culasse, le roüet uny sur un bois rouge.

Collection André, Paris.

91. Une pareille ayant deux dauphins sur la crosse.

Pauilhac Collection, Paris.

93. Une arquebuse d'un pied 10 pouces, le canon à huit pams, couleur d'eau doré sur la culasse, avec son roüet tout uny, ayant un dragon doré sur la roüe, montée sur un bois de cormier orné de fleurs de cuivre, d'argent et de nacre de perle; ladite arquebuse, longue, avec son allonge de canon, de 3 pieds 8 pouces.

Sothebys 30.XI.1962, lot 201 (Formerly the property of the Howard Vyse family)

103. Une autre arquebuse, aussy pour tirer dedans l'eau, de 5 pieds, le canon couleur d'eau, rond sur le devant, à huit pams sur la culasse; la platine unie, gravée d'un trophée d'armes; la roüe enfermée dedans sur un bois noircy, orné de fillets de cuivre et de quelques compartimens d'estain.

Paris. Musée de l'Armée, M 405.

106. Une grosse carabine de costé, ancienne, avec son attache, le canon rayé par dedans à huit pams, tout uny comme le roüet, sur un bois rouge, la crosse à l'allemande, dans laquelle est enfermé une lame de poignard arresté, couverte d'une plaque d'yvoire, longue de 4 pieds 1 pouce.

Paris. Musée de l'Armée, M 175.

122. Un fusil de très gros calibre, de 4 pieds 4 pouces, le canon couleur d'eau, doré de rinceaux sur le bout et sur la culasse; la platine gravée en taille d'espargne sur un bois de poirier, dont la crosse est vuidée en consolle, peinte de rinceaux d'or sur un fond rouge des deux costez, dans laquelle il y a un crapau de plomb.

Paris. Musée de l'Armée, M 435.

Inv. No.

Present location

129. Un petit fusil irlandois de 4 pieds, le canon couleur d'eau, doré en trois endroits sur le bout, le milieu et la culasse, sur laquelle est gravé 1614; la platine de cuivre doré gravée en taille d'espargne, le chien et la batterie gravez sur un bois rouge enrichy de quelques ornemens de pointes d'argent et d'une rose, et un chardon sur la crosse.

London. Tower, XII:63.

130. Un fuzil à l'angloise, de 3 pieds 10 pouces, le canon rond dont le bois est haché, enrichy de six moulures d'argent de rapport, cizelé de quatre serpens et d'un petit Satir de relief; la platine unie sur un bois noircy enrichy de fillets de cuivre et d'argent et pointes de cuivre et de trophées, bestions et oyseaux de nacre de perle de rapport, et deux pots à fleurs aussy de nacre de perle sur la crosse, et gravé sur la couverture du bassinet 1622.

Collection Renwick, Arizona, USA

134. Un beau fusil de 4 pieds 4 pouces, fait à Lizieux, le canon rond, couleu d'eau, ayant une arreste sur le devant et à pams sur le derrière, doré de rinceaux en trois endroits, la platine unie ornée de quelques petittes dorées sur un beau bois de poirier noircy, enrichy de plusiers petits ornemens d'argent et de nacre de perle, la crosse terminée en consolle par le dessous, sur laquelle il y a une longue fueüille de cuivre doré de rapport, et sur le poulcier un mascaron d'argent et une L couronée vis à vis la lumière.

Collection Renwick, Arizona, USA.

138. Dix huit fuzils françois, tout simples et communs, despuis 5 jusqu'à 6 pieds de long ou environ.

London. Tower, XII: 1131.
Victoria and Albert Museum, M4–1949, M5–1949.

139. Six gros mousquetons à gros calibres, tous simples et communs à fuzils, longs de 4 pieds ou environ.

Paris, Musée de l'Armée, without number.
Tower, XII: 1441.
Victoria and Albert Museum, M6–1949.

151. Un très beau fuzil, de 4 pieds 7 pouces, pour servir à mesche et à fusil, le canon doré en couleur d'eau sur le bout et sur

Paris. Musée de l'Armée, M 410.

Present location

la culasse où sont les armes de France;
la platine gravée en taille douce et taille
d'espargne, ayant un mascaron doré et
appliqué sur le milieu sur un bois noir,
dont la crosse est gravée d'une pièce de
rapport de cuivre doré, représentant la
Justice, au bas de laquelle est escrit haec
Lodoice oculos tibi caeca reliquit, fait
par Duclos.

152. Un beau fuzil, de 4 pieds 3 pouces, le
canon rond avec un petit pan doré en
couleur d'eau sur le bout, et sur la culasse
de rinceaux; la platine couleur d'eau,
gravée en blanc, ayant un rond doré uny
sur le milieu, sur un bois de poirier qui
forme un pied de biche dans la crosse,
fait par Bourgeois à Lizieux.

Leningrad. Hermitage Museum, F 281.

157. Un gros fuzil de 3 pieds 7 pouces, le
canon tout rond, avec une arreste dessus
en couleur d'eau, doré de rinceaux sur
la culasse et au bout d'un petit cercle
tout uny; la platine gravée en taille
d'espargne, enrichie d'une médaille de
Louis XIII de cuivre doré, montée sur
un bois jaune.

Paris. Musée de l'Armée, M 529.

163. Un grand fuzil très riche, de 5 pieds 1/2,
le canon couleur d'eau, rond par devant
et à pams sur la culasse enrichie de fleurs
de lis, dauphins et d'L couronnées, ayant
un dragon de cuivre doré de relief qui
sert de visière; la platine gravée d'une
chasse de cerf en taille douce sur un bois
d'ébeine; la crosse persée dans laquelle
est enchassé un dauphin de cuivre doré;
sur la queüe de la culasse est escrit:
Desrogez m'a donné au Roy.

Berlin. Zeughaus, A D 9404.

164. Un grand et gros fuzil turc, de 5 pieds
5 pouces, le canon rond terminé en trom-
pette en arondissant, orné de fleurons
d'or de rapport par le milieu et sur les
deux bouts tout à plein, enrichy de quatre
cercles de chattons de turquoises, la
visière qui est sur l'extrémité de la culasse
aussy enrichie de cinq turquoises et de

Paris. Musée de l'Armée, M 2199.

quatre amatistes; la platine à l'espagnole
sur un bois de cormier sculpé de mas-
carons et testes de lion, où il y a dans les
yeux des grenats et autres pierres en-
chassées.

169. Un beau mousquet manière de Turquie, Paris. Musée de l'Armée, M 37.
de 5 pieds, le canon fonds couleur d'eau
carré sur la culasse où sont gravées trois
figures de héraults dans trois médailles
dorées ovalles, le reste du canon rond à
trois, cannelures, dont le fonds est doré;
le bout en chapiteau de colonne à jour
supporté par quatre petits Termes; la
visière de deux testes de béliers, la
platine fonds doré, ciselée de deux fes-
seaux dedans et un mascaron au milieu,
le petit serpentin d'une teste de dragon,
sur un bois de cormier soustenu d'um
dauphin en bosse; et à la crosse il y a une
plaque où sont ciselées les armes du
cardinal de Richelieu.

171. Cinq autres mousquets turcs communs, Paris. Musée de l'Armée, M 2173.
de 4 à 5 pieds, montez sur leurs bois.

176. Un mousquet de 4 pieds 2 pouces, à deux Paris. Musée de l'Armée. M 369.
canons séparez par leurs deux baguettes
qui se tournent sur la culasse, liées d'un
cercle et d'une grande plaque sous le
canon, gravez en taille d'espargne, un
seul chien pour tous les deux coups, sur
un bois rouge, dont la crosse se termine
en consolle ouverte par le dessus et
peinte sur le dessus d'ornemens couleur
d'or sur un fonds noir, la plaque de ladite
crosse gravée.

177. Un mousquet de 4 pieds, d'un seul Paris. Musée de l'Armée, M 1067.
canon, à huit pams, qui tire cinq coups
par un tambour qui se vire, où il y a cinq
bassinets et un seul serpentin sur un bois
simple, ayant quatre bandes de fer sur la
crosse et une plaque toutte unie.

178. Un autre mousquet de 4 pieds 1/2, d'un Paris. Musée de l'Armée, M 105.
seul canon à huit pams, qui tire cinq
coups aussy par un tambour tout uny,

avec un seul bassinet et serpentin, sur un bois commun, dont la crosse est garnie de quatre bandes de fer et la plaque toutte unie.

179. Un mousquet de 4 pieds 3 pouces, qui tire deux coups par un seul canon, à pams sur la culasse et rond sur le devant; la platine ouverte sur le milieu où se conduit le serpentin à deux bassinets, sur un bois de poirier tourné en consolle sur la crosse.

Paris. Musée de l'Armée, M 401.

182. Trois autres mousquets communs, de 5 pieds.

Berlin. Zeughaus, A D 9208.

193. Un pistolet de 15 pouces, le canon de cuivre jaune, gravé en taille d'espargne de grandes roses et fruits dans des compartimens, avec son crochet à porter au costé, la platine de cuivre aussy gravée en taille d'espargne; le chien et la batterie de fer gravez de mesme; monté sur un fust de cuivre; fait en 1620.

Collection Pauilhac, Paris.

203. Une paire de pistolets à roüet, de 20 pouces, le canon blanc tout uny à huit pams; la platine de cuivre doré gravée d'un ornement de fueüilles, fleurs et fruits, au milieu duquel est escrit: A Grenoble, par Pierre Bergier horloger etc., fait pour tirer deux coups.

Collection Renwick, Arizona, USA.

204. Une autre paire de pistolets, de 19 pouces, le canon de cuivre doré tout uny, à huit pams, la platine de mesme; la roüe et le chien de fer tout unis, montez sur de l'ébeine cannelée, et la calotte couverte d'un gros masque de cuivre doré.

Collection W. K. Neal, Warminster.

207. Une paire de pistolets à roüet, de 24 pouces, le canon rond sur le devant, à huit pams sur le derrière, sur lequel est escrit: à Vitré par Me Jacques de Goulet, damasquiné d'or et d'argent en trois endroits, sur un bois noircy orné de marqueterie d'argent.

London. Tower, XII: 1072 (one of the pair). The other in the W. K. Neal Collection.

Inv. No.

Present location

208. Une paire de pistolets à roüet, de 27 pouces, le canon à seize pams sur le devant et à huit sur le derrière, gravé d'une rose et de quelques fueüilles, le roüet tout uny, montée sur un bois de poirier cannelé, enrichy de quelques fillets de cuivre et autres ornemens d'estain et d'ébeine.

Collection W. K. Neal, Warminster.
Walter's Art Gallery, Baltimore, USA.

211. Une paire de pistolets à roüet, de 26 pouces, le canon de fort petit calibre couleur d'eau, rond sur devant, à huit pams sur le derrière, doré aux deux bouts; viv à visla lumière il y a une petitte arbaleste estempée entre un J et un B; le roüet tout uny sur un bois rouge enrichy de petits ornemens de marqueterie de cuivre et d'argent; le bout de la poignée de fer rond en forme d'oeuf.

London. Wallace Collection, 842.
Berlin. Zeughaus, A D 9178.

212. Une autre paire de pistolets, de 24 pouces, le canon rond sur le devant, à huit pams sur le derrière, tout uny, le roüet de mesme, monté sur un bois de noyer tout simple, avec un crochet pour porter à costé.

London. Victoria & Albert Museum, M 52–1949 (one of the pair).

214. Une autre paire de pistolets à roüet, de 19 pouces, le canon rond ciselé d'escaille, au bout sur la poignée desquels est escrit: Sola Jovis jaculator dextera fulmen.

Pauilhac Collection, Paris (one of the pair).

215. Une autre paire de pistolets à roüet, de 23 pouces, le canon à huit pams, tout uny, le roüet de mesme, montée sur un bois rouge, tout uny, le pommeau de bois noircy à huit pams.

London. Victoria & Albert Museum, M7–1947. (one of the pair)

216. Une autre paire de pistolets à roüet, de 23 pouces, le canon à huit pams tout uny, le roüet de mesme, montée sur un bois rouge; le bout de la poignée entouré d'un cercle de cuivre doré.

London. Tower, XII: 1077. (one of the pair)

217. Une paire de pistolets de François premier, de 26 pouces 1/2, le canon rond sur le devant qui est enrichy d'un orne-me de branches et fueüilles d'argent de

London. Tower, XII: 731. (one of the pair)

rapport, tortillé à l'entour, à huit pams
sur le derrière, aussy enrichy d'un autre
ornement et de plusieurs F couronnées;
la platine de mesme.

220. Un pistolet à roüet, de 22 pouces, le
milieu du devant du canon rond tout
uny en couleur d'eau, le bout et le
derrière à huit pams gravez en taille
d'espargne, dorez et enrichis de quelques
petits ornemens d'argent, de tables d'acier
taillées en forme de diamans, le roüet de
mesme; monté sur un bois rouge enrichy
de petits ornemens d'argent et cuivre
doré.

Collection W. K. Neal, Warminster.

221. Un pistolet à roüet, de 2 pieds, le canon
à huit pams, doré par les deux bouts,
blanc et uny par le milieu, la platine unie,
sur laquelle il y a une F et un P, monté
sur un bois noircy, orné presque comme
le précédent.

Paris. Musée de l'Armée. Previously Ruffin
Collection.

226. Un autre pistolet à roüet, de 25 pouces,
le canon à huit pams, couleu d'eau,
gravé d'un double fillet; le roüet tout
uny, monté sur un bois rouge tout
parsemé de petits fillets de cuivre et de
petittes fueüilles d'estain.

Berlin. Zeughaus.

227. Un autre pistolet à roüet, fort riche, de
25 pouces 1/2, le canon couleur d'eau,
tout couvert d'ornemens d'or et d'argent
de rapport très riches, parmy lesquels il
y a une devise d'un soleil dont les rayons
frappent sur un escu d'un trophée d'armes
avec ce mot: Ex reverberatione splendi-
dior; le fust de fer tout couvert de mesmes
ornemens.

Pauilhac Collection, Paris.

237. Un autre pistolet, aussy à deux canons
et deux roüets, tout pareil au précédent,
excepté que les canons sont dorez et
qu'il n'a que 18 pouces de long.

London. Victoria & Albert Museum, M13–1923.
The number cannot be found on the pistol but
the description corresponds exactly.

238. Un autre pistolet à deux canons, de 25
pouces, les canons ronds et séparez sur
le devant, unis et à huit pams inégaux

Pauilhac Collection, Paris.

Inv. No. *Present location*

sur le derrière, dorez en couleur d'eau;
les roüets unis, montez sur un bois de
poirier orné de quelques fillets de cuivre
et de nacre de perle.

257. Un autre pistolet à roüet, de 24 pouces, London. Tower, XII: 1075.
le canon rond sur le devant, à huit pams
sur le derrière, sur lequel est escrit en
lettres d'or: à Vitré, par Marin Mazué
1612.

258. Un autre pistolet à roüet, de 26 pouces, André Collection, Paris.
le canon à huit pams, tout unis; sur la
culasse est gravé une H; le roüet tout
uny sur un bois rouge; le pommeau orné
de petittes bandes d'argent.

259. Un autre pistolet à roüet, de 25 pouces, Collection W. K. Neal, Warminster.
tout de fer, le canon à huit pams sur le
devant, partie blanc et partie doré, et le
derrière tout ciselé d'or et d'argent de
rapport; le fust de mesme.

279. Une masse d'armes dans laquelle il y a un Paris. Musée de l'Armée, K 58.
pistolet dont le manche est d'argent
vermeil doré, ciselée de plusieurs orne-
mens en entre autres de plusieurs testes
de Méduze, d'argent blanc, longue de
22 pouces.

286. Une espée dont la garde est ornée d'une Paris. Musée de l'Armée, J 362.
médaille d'Henry IV, le pommeau d'une
teste d'aigle, la lame acconpagnée d'un
pistolet à fuzil, longue de 3 pieds 3 pouces.

317. Une autre rondache de fer en forme Paris. Musée de l'Armée, I 55.
presque ovalle, gravée d'une grande
figure nüe tenant un baston de com-
mandant avec une draperie sur les es-
paules, doublée de satin rouge, picquée
par carreaux.

357. Un choc . . . D Jumeau. Paris. Musée de l'Armée, M 102.

365. Un mousquet . . . Dijon. Paris. Musée de l'Armée, M 36.

367. Un mousqueton pour porter au côté. Paris. Musée de l'Armée, M 395.

452. Une armure ou chemise de mailles de fer. Paris. Musée de l'Armée, H 455.

APPENDIX 2.

Erik Dahlberg's contract with Desgranges of Paris. Original in the University Library, Uppsala (U. 147).

Je Soubsigne Confesse d'avoir fait Marche avec Mons: Dahlbergh Gentilhomme Suedois d'un par des Pistolets que je luy dois faire à raison de Cens livres tournois dont le Pistolets doivent estre fait de ma propre main et des Conditions Suivantes.

1. les Canons doivent estre Cannales au petits pans, bien nett pollies de hors et le dedans, aveque un petit guidon d'Argent au bout.

2. les Platines bien limes et rondez à la mode. les Batteries Cannalees, les Chiens Canalles avec un petit ruoleau de devant et de derriere, avec encor un rouleau double qui desend au millieu du Chien façon de relief, pas trop petit, guarni de fleuron. le Clou du Chien bien eleuè et gravee. il y aura à l'autour du Platines une gravure. les Platines doivent estre gravee des figures et des autres Ornements selon le Desseing que Mons: Dahlbergh en donnera, le quel ne sera plus charge que les autres que M: de Granges desia à montre.

3. les Culottes doivent estre Cannales et Graves autour avec une ovale que sera mis a derriere, et le Culottes bien gravees.

4. les Porte vices en Serpent avec des rouleaus en relief. bien limee.

5. les Chiffres seront mis dans une petite ovale au deriere de la Culasse d'Argent.

6. les Sauvegardes bien limees, graves, et la destente avec quelque trous de Vidange bien Gravees.

7. les Ports de Baguette bien limees et tournees.

8. les Bois montees d'un bois noyen bien marbre et beau de Grenoble de plus beauz que se trouvera.

Au reste Mons: de Granges promett de faire tout bien et nett et tellement que Mons: Dahlberg sera bien Contant. Et les livrer bien finj et acheveè le dernier jour de Mois d'Aoust prochain. sur quoy M: de Granges a receu aujourdhuy Quarante Cinq livres tournois pour les airs. le reste sera payé en livrant les pistolets.

Fait à Paris le 29 de Juillet Ao: 1668.

Index